[CONTACTS 2007]

96th edition published by The Spotlight, 7 Leicester Place, London WC2H 7RJ
t: 020 7437 7631 f: 020 7437 5881 e-mail: info@spotlight.com www.spotlight.com
Editor: Kate Poynton Production: Kathy Norrish

What is Contacts?

Contacts is the essential handbook for everyone working or wanting to work in the entertainment industry. It has been published by The Spotlight since 1947. It contains over 5000 listings for companies, services and individuals across all branches of Television, Stage, Film and Radio. These are updated annually to bring you the most accurate information available.

Also watch out for the 'information pages', designed to tell you more about those listed and why you might want to contact them. They include invaluable advice from key industry figures – especially useful if you are just starting out in the industry.

As ever, please send any feedback or suggestions for the next edition to marketing@spotlight.com

How can I / my company appear in the next edition of Contacts?

Contacts is published annually. If you would like to appear in the next edition please contact us by June 2007:

e: advertising@spotlight.com for advertising

e: info@spotlight.com for free, text-only entries

t: 020 7437 7631

How do I buy copies of Contacts?

To purchase additional copies of Contacts, please e-mail sales@spotlight.com, visit www.spotlight.com/shop or call 020 7440 5032. It is also available from most good bookshops.

Contents

Index To Advertisers See page 386

[CONTACTS 2007]

F

G

H

O

P

R

S

T

V

A

Agents
Advertising
Agents & Personal Managers

Key to areas of specialisation:
C Cabaret F Films G General M Musicals
Md Models PM Personal Managers
S Singing TV Television V Variety

For information regarding membership of the
Personal Managers' Association please contact:
Personal Managers' Association Limited
1 Summer Road, East Molesley, Surrey KT8 9LX
w: www.thepma.com
t: 020 8398 9796 e-mail: info@thepma.com
* Denotes PMA Membership

For information regarding membership of the
Co-operative Personal Management Association
please contact: Secretary
CPMA, c/o 1 Mellor Road, Leicester LE3 6HN
t: 07981 902525 e-mail: cpmauk@yahoo.co.uk
• Denotes CPMA Membership

Children's & Teenagers'
Dance
Literary & Play

For information regarding membership of the
Personal Managers' Association please contact:
Personal Managers' Association Limited
1 Summer Road, East Molesley, Surrey KT8 9LX
w: www.thepma.com
t: 020 8398 9796 e-mail: info@thepma.com
* Denotes PMA Membership

Presenters
Voice-Over
Walk-on & Supporting Artist

For information regarding membership of National
Association of Supporting Artistes Agents (NASAA)
please contact: w: www.nasaa.org.uk
e-mail: info@nasaa.org.uk
■ Denotes NASAA Membership

Animals
Arts Centres
Arts Councils

[CONTACTS 2007]

ABBOT MEAD VICKERS BBDO Ltd
151 Marylebone Road, London NW1 5QE
Website: www.amvbbdo.com
Fax: 020-7616 3600 Tel: 020-7616 3500

AKA
1st Floor, 115 Shaftesbury Avenue, London WC2H 8AF
Website: www.akauk.com
e-mail: aka@akauk.com
Fax: 020-7836 8787 Tel: 020-7836 4747

BARTLE BOGLE HEGARTY
60 Kingly Street, London W1B 5DS
Fax: 020-7437 3666 Tel: 020-7734 1677

BDH/TBWA
St Paul's, 781 Wilmslow Road
Didsbury Village, Manchester M20 2RW
Website: www.bdhtbwa.co.uk
e-mail: info@bdhtbwa.co.uk
Fax: 0161-908 8601 Tel: 0161-908 8600

BURNETT Leo Ltd
Warwick Building, Kensington Village
Avonmore Road, London W14 8HQ
Fax: 020-7348 3855 Tel: 020-7751 1800

CDP TRAVIS SULLY
9 Lower John Street, London W1F 9DZ
Fax: 020-7437 5445 Tel: 020-7437 4224

CELEBRITY ENDORSEMENTS
PO Box 981, Wallington, Surrey SM6 8JU
Website: www.celebrityendorsements.co.uk
e-mail: info@nmp.co.uk
Fax: 020-8404 2621 Tel: 020-8669 3128

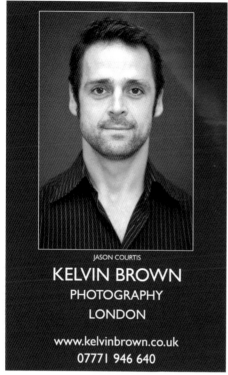

JASON COURTIS

KELVIN BROWN
PHOTOGRAPHY
LONDON

www.kelvinbrown.co.uk
07771 946 640

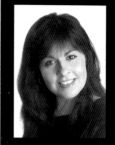
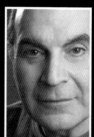
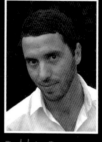

COGENT ELLIOT
Heath Farm, Hampton Lane, Meriden, West Midlands CV7 7LL
Website: www.cogent.co.uk
Fax: 0121-627 5038 Tel: 0121-627 5040

DDB LONDON
12 Bishops Bridge Road, London W2 6AA
Fax: 020-7402 4871 Tel: 020-7258 3979

DEWYNTERS Plc
48 Leicester Square, London WC2H 7QD
Website: www.dewynters.com
Fax: 020-7321 0104 Tel: 020-7321 0488

DONER CARDWELL HAWKINS
26-34 Emerald Street, London WC1N 3QA
Website: www.doner.co.uk
Fax: 020-7437 3961 Tel: 020-7734 0511

EURO RSCG LONDON
Cupola House, 15 Alfred Place, London WC1E 7EB
Fax: 020-7467 9210 Tel: 020-7240 4111

FCB LONDON
55 Newman Street, London W1T 3EB
Website: www.london.fcb.com
Fax: 020-7947 8001 Tel: 020-7947 8000

GOLLEY SLATER & PARTNERS (LONDON) Ltd
St George's House, 3 St George's Place
Church Street, Twickenham TW1 3NE
Fax: 020-8892 4451 Tel: 020-8744 2630

GREY WORLDWIDE
215-227 Great Portland Street
London W1W 5PN
Fax: 020-7637 7473 Tel: 020-7636 3399

rocco redondo
photographer

mb:07770 694 686
www.roccoredondo.com
rocco@roccoredondo.co.uk

HERESY
102 Sydney Street, London SW3 6NJ
Website: www.heresyhq.com
Fax: 020-7349 6801 Tel: 020-7349 6800

JWT Ltd
1 Knightsbridge Green, London SW1X 7NW
Website: www.jwt.co.uk
e-mail: firstname.lastname@jwt.com
Fax: 020-7656 7010 Tel: 020-7656 7000

LEAGAS DELANEY LONDON Ltd
1 Alfred Place, London WC1E 7EB
Website: www.leagasdelaney.com
Fax: 020-7758 1760 Tel: 020-7758 1758

LEITH AGENCY The
37 The Shore, Edinburgh EH6 6QU
Fax: 0131-561 8601 Tel: 0131-561 8600

LOWE & PARTNERS
60 Sloane Avenue, London SW3 3XB
Website: www.loweworldwide.com
Fax: 020-7584 9557 Tel: 020-7584 5033

McCANN-ERICKSON ADVERTISING Ltd
7-11 Herbrand Street, London WC1N 1EX
Fax: 020-7837 3773 Tel: 020-7837 3737

MEDIACOM
180 North Gower Street, London NW1 2NB
Fax: 020-7874 5999 Tel: 020-7874 5500

MEDIAJUNCTION
40A Old Compton Street
Soho, London W1D 4TU
Website: www.mediajunction.co.uk
e-mail: mailbox@mediajunction.co.uk
Fax: 020-7439 0794 Tel: 020-7434 9919

MUSTOES
2-4 Bucknall Street, London WC2H 8LA
Website: www.mustoes.co.uk
Fax: 020-7379 8487 Tel: 020-7379 9999

OGILVY & MATHER Ltd
10 Cabot Square, Canary Wharf, London E14 4QB
Fax: 020-7345 9000 Tel: 020-7345 3000

PUBLICIS Ltd
82 Baker Street, London W1U 6AE
Website: www.publicis.co.uk
Fax: 020-7487 5351 Tel: 020-7935 4426

RKCR / Y & R
Greater London House, Hampstead Road, London NW1 7QP
Fax: 020-7611 6011 Tel: 020-7404 2700

RPM 3
William Blake House, 8 Marshall Street, London W1F 7EJ
Fax: 020-7439 8884 Tel: 020-7434 4343

SAATCHI & SAATCHI
80 Charlotte Street, London W1A 1AQ
Fax: 020-7637 8489 Tel: 020-7636 5060

SMEE'S ADVERTISING Ltd
3-5 Duke Street, London W1U 3BA
Fax: 020-7935 8588 Tel: 020-7486 6644

TBWA/LONDON
76-80 Whitfield Street, London W1T 4EZ
Fax: 020-7573 6667 Tel: 020-7573 6666

TMP WORLDWIDE
Chancery House, 53-64 Chancery Lane, London WC2A 1QS
Website: www.tmpw.com
Fax: 020-7406 5001 Tel: 020-7406 5000

TV MANAGEMENTS
Brink House, Avon Castle ,Ringwood, Hants BH24 2BL
e-mail: etv@tvmanagements.com Tel: 01425 475544

WCRS
5 Golden Square, London W1F 9BS
Website: www.wcrs.com
Fax: 020-7806 5099 Tel: 020-7806 5000

YOUNG & RUBICAM Ltd
Greater London House, Hampstead Road, London NW1 7QP
Fax: 020-7611 6570 Tel: 020-7387 9366

Who are Agents and Personal Managers?

There are hundreds of Agents and Personal Managers in the UK, representing thousands of actors and artists. It is their job to promote their clients to casting opportunities and negotiate contracts on their behalf. In return they take commission ranging from 10-15%. Larger agencies can have hundreds of clients on their books, smaller ones may only have a handful. A personal manager is someone who manages an artist's career on a more one-on-one basis. Co-operative agencies are staffed by actors themselves, who take turns to handle the administrative side of the agency and promote themselves to casting opportunities as a team. Agents usually try to represent a good range of artists (age, sex, type) to fill the diverse role types required by casting directors.

How should I use these listings?

If you are an actor getting started in the industry, or looking to change your agent, the following pages will supply you with up-to-date contact details for many of the UK's leading agencies. Every company listed is done so by written request to us. Members of the Personal Managers' Association (PMA) are shown with the symbol * in this book. Members of the Co-operative Personal Management Association (CMPA) are labelled with the symbol • in this book. When writing to agencies, try to research the different companies instead of just sending a 'blanket' letter to every single one. This way you can target your approaches to the most suitable agencies and avoid wasting their time (and yours). Remember that agents receive hundreds of letters each week, so try to keep your communication concise, and be professional at all times. If you include a stamped-addressed envelope (SAE) you will increase your chances of getting a reply (make sure it is big enough so that they can return your 10 x 8 photo). We also recommend that your letter has some kind of focus: perhaps you are telling them about your next showcase, or where they can see you currently appearing on stage. Include a photograph which has your name written on the back. Only send showreels if you have checked with the agency first.

Should I pay an Agent to join their books? Or sign a contract?

Equity (the performers' trade union) does not recommend that artists pay an agent to join their client list. Before signing a contract, you should be very clear about the terms and commitments involved. For advice on both of these issues, or if you experience any problems with a current agent, we recommend that you contact Equity (www.equity.org.uk). They also publish the booklet 'You and your Agent' which is free to all Equity members.

How do I become an agent?

Budding agents will need experience of working in an agent's office, usually this is done by working as an assistant. It can be extremely hard work, and you will be expected to give up a lot of your evenings to attend productions. There are two organisations you may find it useful to contact: Agents' Association (www.agents-uk.com) and the Personal Managers' Association (www.thepma.com).

MICHELLE BRAIDMAN ASSOCIATES
2 Futura House
169 Grange Road
London SE1 3BN

T: 020-7237 3523
F: 020-7231 4634
e: info@braidman.com

MICHELLE BRAIDMAN formed Michelle Braidman Associates with her husband in 1984. Michelle trained on the Stage Management course at The Bristol Old Vic Theatre School from 1970-1971, and worked as a stage manager in the regions, West End, Canada and the first Actors Company. In 1976, she changed direction to become an agent with a leading theatrical agency whose name had been suggested to her by Spotlight. Apart from actors, she also represents directors and creative talent. Her agency has been a member of the Personal Managers' Association (PMA) for over eighteen years. Michelle now co-chairs the artist side of the PMA.

In common with other agents, I meet with acting students on a regular basis to discuss an agent's role within the industry. One of the most frequently asked questions is 'Does an Agent offer a more personalised service to their clients if they are a member of the PMA'? This is a common misconception and, in the UK, the answer is 'No, they do not'. In America, most actors have an agent and a personal manager. Here, we are usually one and the same.

The PMA is a trade association composed of literary, artist and creative talent agents. Members form working parties with broadcasters, PACT and Equity to improve working practices and to discuss common problems, including how to face the challenges of the digital age. Our aims are to ensure that the industry runs as smoothly as possible, and that the clients we represent are suitably rewarded for their talents as their careers develop.

As an agent, I feel it is my responsibility to represent my artists' interests as diligently and comprehensively as possible. The relationship between artist and agent has been likened to a marriage. Over many years as an agent you hopefully guide your client's career, get to know each others' tastes and a feeling of mutual trust develops.

Many agencies, including mine, have their own client contracts in addition to the PMA Code of Conduct. Our contract sets out terms of trade, responsibilities for both parties, commission charges and how and when we remit monies. I believe it is the most transparent means of commencing the business aspect of a relationship with a client. It should form the basis of a trust which we hope underpins a lasting partnership.

Call me old-fashioned, but discipline is the one word which remains in my memory ever since my first day at Drama School when the Principal addressed all the students. Nothing upsets me more than actors who do not arrive on time, are not prepared, who neither practice their skills nor add to them. There is always something you can do to improve your chances of being offered work. It is an overcrowded and competitive profession, one full of highs and lows. If you are late, ill-prepared, do not know your lines or look as though you don't care, then be warned: there is a long list of more dedicated actors for casting directors and agents to choose from.

It is a privilege for me to represent artists who have enriched my life and who continue to inspire me and many other people in the profession.

For more information about the PMA please visit (www.thepma.com)

1984 PERSONAL MANAGEMENT Ltd•
PM Co-operative
Suite 508, Davina House
137 Goswell Road, London EC1V 7ET
Website: www.1984pm.com
e-mail: info@1984pm.com
Fax: 020-7250 3031 Tel: 020-7251 8046

21ST CENTURY ACTORS MANAGEMENT Ltd•
Co-operative
E10 Panther House, 38 Mount Pleasant, London WC1X 0AN
Website: www.21stcenturyactors.co.uk
email: twentyfirstcenturyactors@yahoo.co.uk
Fax: 020-7833 1158 Tel: 020-7278 3438

2MA
(Sports & Stunts)
Spring Vale, Tutland Road
North Baddesley, Hants SO52 9FL
Website: www.2ma.co.uk
e-mail: mo@2ma.co.uk
Fax: 023-8074 1355 Tel: 023-8074 1354

41 MANAGEMENT*
74 Rose Street North Lane, Edinburgh EH2 3DX
e-mail: mhunwick@41man.co.uk
Fax: 0131-225 4535 Tel: 0131-225 3585

A & B PERSONAL MANAGEMENT Ltd*
PM (Write)
Suite 330, Linen Hall, 162-168 Regent St, London W1B 5TD
e-mail: billellis@aandb.co.uk
Fax: 020-7038 3699 Tel: 020-7434 4262

A@B (AGENCY AT BODYWORK)
25-29 Glisson Road, Cambridge CB1 2HA
e-mail: agency@bodyworkds.co.uk
Fax: 01223 358923 Tel: 01223 309990

A & J MANAGEMENT
242A The Ridgeway
Botany Bay, Enfield EN2 8AP
Website: www.ajmanagement.co.uk
e-mail: info@ajmanagement.co.uk
Fax: 020-8342 0842 Tel: 020-8342 0542

A-LIST LOOKALIKES & ENTERTAINMENTS Ltd
1 Hodson Fold
Bradford, West Yorkshire BD2 4EB
e-mail: info@alistlookalikes.co.uk
Website: www.alistlookalikes.co.uk
Mobile: 07866 583106 Tel: 0113-243 6245

A LIST MODELS & ENTERTAINERS AGENCY
The Innovation Centre
2 Adelaide Street, Luton, Bedfordshire LU1 5DU
e-mail: info@alistentertainers.co.uk Tel: 01582 523938

A PLUS
(16-26 year olds)
2 Foresters Cottages
Barnet Wood Road, Bromley BR2 8HJ
Website: www.kidsplusagency.co.uk
e-mail: office@kidsplus.wanadoo.co.uk
Mobile: 07704 583352 Tel/Fax: 020-8462 4666

A AND D MANAGEMENT
9 Moss Lane, Romford, Essex RM1 2PT
Website: www.andmanagement.co.uk
e-mail: info@andmanagement.co.uk
Mobile: 07861 234891 Tel: 01708 787517

ABA (ABACUS ADULTS)
The Studio, 4 Bailey Road
Westcott, Dorking, Surrey RH4 3QS
Fax: 01306 877813 Tel: 01306 877144

Charles Griffin®

Photography

Chester

tel: 01244 535252

Film/Digital

studio/location/student rates

www.charlesgriffinphotography.co.uk

Stephanie de Leng Photography

I did it to Ciaran...

...Let me do it to you!

LIVERPOOL BASED PHOTOGRAPHY FOR ALL ARTISTS!!

www.stephaniedeleng.co.uk 07740 927765 sa@deleng.co.uk

ABBOTT June ASSOCIATES
The Courtyard, 10 York Way
King's Cross, London N1 9AA
Website: www.thecourtyard.org.uk
e-mail: jaa@thecourtyard.org.uk
Fax: 020-7833 0870 Tel: 020-7837 7826

ABSOLUTE MODELS & ACTORS Ltd
(Character & Fashion Models)
64 High Street
Esher, Surrey KT10 9QS
Website: www.absolutemodels.co.uk
e-mail: enquiries@absolutemodels.co.uk
Fax: 01372 479798 Tel: 01372 479797

ACADEMY CASTINGS
Blue Square, 272 Bath Street, Glasgow G2 4JR
Website: www.academycastings.co.uk
e-mail: robert@academycastings.co.uk
Fax: 0141-354 8876 Tel: 0141-354 8873

ACCESS ASSOCIATES
PO Box 39925, London EC1V 0WN
Website: www.access-associates.co.uk
e-mail: mail@access-associates.co.uk Tel: 020-8505 1094

ACROBAT PRODUCTIONS
(Artists & Advisors)
12 Oaklands Court, Hempstead Road, Watford WD17 4LF
Website: www.acrobatproductions.com
e-mail: roger@acrobatproductions.com Tel: 01923 224938

ACTING ASSOCIATES
PM
71 Hartham Road, London N7 9JJ
Website: www.actingassociates.co.uk
e-mail: fiona@actingassociates.co.uk
Tel/Fax: 020-7607 3562

ACTITUDE
(Write SAE)
Studio 224, 186 St Albans Road, Watford WD25 4AS
Website: www.actitudemanagement.co.uk
Tel/Fax: 020-8728 3484

ACTIVATE DRAMA SCHOOL
Priestman Cottage
Sea View Road, Sunderland SR2 7UP
e-mail: activate_agcy@hotmail.com
Fax: 0191-551 2051 Tel: 0191-565 2345

ACTOR MUSICIANS @ ACCESS
PO Box 39925, London EC1V 0WN
Website: www.access-associates.co.uk
e-mail: musicians@access-associates.co.uk
Tel: 020-8505 1094

ACTORS AGENCY
1 Glen Street, Tollcross, Edinburgh EH3 9JD
Website: www.stivenchristie.co.uk
e-mail: info@stivenchristie.co.uk
Fax: 0131-228 4645 Tel: 0131-228 4040

ACTORS ALLIANCE•
Co-operative
Disney Place House, 14 Marshalsea Road, London SE1 1HL
e-mail: actors@actorsalliance.fsnet.co.uk
Tel/Fax: 020-7407 6028

ACTORS' CREATIVE TEAM•
Co-operative, Albany House
82-84 South End, Croydon CR0 1DQ
Website: www.actorscreativeteam.co.uk
e-mail: office@actorscreativeteam.co.uk
Fax: 020-8239 8818 Tel: 020-8239 8892

ACTORS DIRECT Ltd
Gainsborough House
109 Portland Street, Manchester M1 6DN
Website: www.actorsdirect.org.uk
e-mail: actorsdirect@aol.com Tel/Fax: 0161-237 1904

CLAIRE NEWMAN-WILLIAMS
PHOTOGRAPHY

07963 967444

claire@clairenewmanwilliams.com
www.clairenewmanwilliams.com

ACTORS FILE The•
PM Co-operative
Spitfire Studios
63-71 Collier Street, London N1 9BE
Website: www.theactorsfile.co.uk
e-mail: mail@theactorsfile.co.uk
Fax: 020-7278 0364 Tel: 020-7278 0087

ACTORS' GROUP The (TAG)•
PM Co-operative
21-31 Oldham Street, Manchester M1 1JG
Website: www.theactorsgroup.co.uk
e-mail: enquiries@theactorsgroup.co.uk
Tel/Fax: 0161-834 4466

ACTORS IN SCANDINAVIA
Vuorimiehenkatu 20
00150 Helsinki
Finland
Website: www.actors.fi
e-mail: lauram@actors.fi
Fax: 00 358 9 68 40 4422 Tel: 00 358 9 68 40 440

ACTORS INTERNATIONAL Ltd
Conway Hall
25 Red Lion Square
London WC1R 4RL
e-mail: mail@actorsinternational.co.uk
Fax: 020-7831 8319 Tel: 020-7242 9300

Steve Lawton

PHOTOGRAPHY
LONDON

07973 307487

www.stevelawton.com

Student rates

Helen Koya Robert Kazinsky Gerard McCarthy

Nathalie Cox Trey Farley Natalie Anderson

Kim Medcalf

Todd Carty

chris baker

photographer

www.chrisbakerphotographer.com

020 8441 3851

e: chrisbaker@photos2000.demon.co.uk

digital/film studio/location

ACTORS IRELAND
Crescent Arts Centre
2-4 University Road, Belfast BT7 1NH
Website: www.actorsireland.com
e-mail: geraldine@actorsireland.com Tel: 028-9024 8861

ACTORS WORLD CASTING
13 Briarbank Road, London W13 0HH
Website: www.actors-world-production.com
e-mail: katherine@actors-world-production.com
Tel: 020-8998 2579

ACTORUM Ltd
PM Co-operative
3rd Floor, 21 Foley Street, London W1W 6DR
Website: www.actorum.com
e-mail: actorum2@ukonline.co.uk
Fax: 020-7636 6975 Tel: 020-7636 6978

ACT OUT AGENCY
22 Greek Street
Stockport, Cheshire SK3 8AB
e-mail: ab22actout@aol.com Tel/Fax: 0161-429 7413

ACTUAL MANAGEMENT Ltd
Website: www.actualmanagement.co.uk
e-mail: agents@actualmanagement.co.uk
Fax: 0870 8741199 Tel: 020-7613 4006

ADAMS Juliet MODELS & TALENT CASTINGS
19 Gwynne House
Challice Way, London SW2 3RB
Website: www.julietadams.co.uk
e-mail: bookingdesk@julietadams.co.uk
Fax: 020-8671 9314 Tel: 020-8671 7673

AFFINITY MANAGEMENT
The Coach House
Down Park, Turners Hill Road, Crawley Down
West Sussex RH10 4HQ
e-mail: jstephens@affinitymanagement.co.uk
Fax: 01342 715800 Tel: 01342 715275

AGENCY Ltd The
(Teri Hayden)
47 Adelaide Road, Dublin 2, Eire
Website: www.the-agency.ie
e-mail: info@tagency.ie
Fax: 00 353 1 6760052 Tel: 00 353 1 6618535

AGENCY PLANITOLOGY
Studio G7
Shakespeare Business Centre
245A Coldharbour Lane, London SW9 8RR
Website: www.agencyplanitology.co.uk
e-mail: info@agencyplanitology.co.uk
Fax: 020-7900 6292 Tel: 020-7733 2995

AHA
(See HOWARD Amanda ASSOCIATES Ltd)

AIM (ASSOCIATED INTERNATIONAL MANAGEMENT)*
45-53 Sinclair Road
London W14 0NS
Website: www.aimagents.com
e-mail: info@aimagents.com
Fax: 020-7300 6656 Tel: 020-7300 6506

ALANDER AGENCY
TV F S V
10 Ingram Close, Stanmore
Middlesex HA7 4EW Tel: 020-8954 7685

ALEXANDER PERSONAL MANAGEMENT Ltd
PO Box 834
Hemel Hempstead, Herts HP3 9ZP
Website: www.apmassociates.net
e-mail: apm@apmassociates.net
Fax: 01442 241099 Tel: 01442 252907

HOBSON'S [actors]

stage film
movies Drama
theatre
television
commercials
Corporate & promos
Commercial
videos idents

HOBSON'S INTERNATIONAL: **ACTORS** • **KIDS** • **SINGERS** • **STUDIO** • **VOICES**

62 Chiswick High Road | T. +44 (0)20 8995 3628 | email. actors@hobsons-international.com
London W4 1SY | F. +44 (0)20 8996 5350 | www.hobsons-international.com

Faye Jackson

Robert Webb

ROBERT WORKMAN Superb casting photographs
Tel: 020 7385 5442 www.robertworkman.demon.co.uk

Sarah Woodward

Photography

07973 158 901

ALLSORTS DRAMA FOR CHILDREN
(In Association with Sasha Leslie Management)
34 Pember Road
London NW10 5LS
e-mail: sasha@allsortsdrama.com
Fax: 020-8969 3196 Tel: 020-8969 3249

ALLSORTS MODEL AGENCY
Three Mills Film Studios
Unit 1, Sugar House Business Centre
24 Sugar House Lane, London E15 2QS
Website: www.allsortsagency.com
e-mail: bookings@allsortsagency.com
Fax: 020-8555 0909 Tel: 020-8555 0099

ALL TALENT UK
Central Chambers
93 Hope Street, Glasgow G2 6LD
Website: www.alltalentuk.co.uk
e-mail: enquiries@alltalentuk.co.uk
Fax: 0141-221 8883 Tel: 0141-221 8887

ALPHA PERSONAL MANAGEMENT Ltd•
PM Co-operative
Studio B4
3 Bradbury Street, London N16 8JN
Website: www.alphaactors.com
e-mail: alpha@alphaactors.com
Fax: 020-7241 2410 Tel: 020-7241 0077

ALRAUN Anita REPRESENTATION*
(Write with SAE, no e-mails)
5th Floor, 28 Charing Cross Road
London WC2H 0DB
e-mail: anita@cjagency.demon.co.uk
Fax: 020-7379 6865 Tel: 020-7379 6840

ALTARAS Jonathan ASSOCIATES Ltd*
11 Garrick Street
Covent Garden, London WC2E 9AR
e-mail: kathryn@jaa.ndirect.co.uk
Fax: 020-7836 6066 Tel: 020-7836 8722

ALVAREZ MANAGEMENT
86 Muswell Road, London N10 2BE
e-mail: sga@alvarezmanagement.fsnet.co.uk
Fax: 020-8444 2646 Tel: 020-8883 2206

ALW ASSOCIATES
1 Grafton Chambers
Grafton Place, London NW1 1LN
e-mail: alweurope@onetel.com
Fax: 020-7813 1398 Tel: 020-7388 7018

A M ENTERTAINMENTS
Suite 1, Townsend House
22-25 Dean Street, London W1D 3RY
e-mail: hils@amentertainments.com
Mobile: 07970 524234 Tel: 020-7734 4588

AMBER PERSONAL MANAGEMENT Ltd
PM
189 Wardour Street
London W1F 8ZD
e-mail: amberlondon@btconnect.com
Fax: 020-7734 9883 Tel: 020-7734 7887

28 St Margaret's Chambers
5 Newton Street, Manchester M1 1HL
Website: www.amberltd.co.uk
e-mail: info@amberltd.co.uk
Fax: 0161-228 0235 Tel: 0161-228 0236

MAGNUS HASTINGS 07905 304 705

www.magnushastings.co.uk/headshots

Hugh Bonneville

Sarah Ozeke

Tom Burke

SOPHIE BAKER
Photography

020-8340 3850 *Special rates for students*

Martin Nigel Davey

DARREN SEYMOUR • PHOTOGRAPHER
WORCESTERSHIRE 07712 605486

AMC MANAGEMENT
(Anna McCorquodale)
43 St Maur Road, London SW6 4DR
e-mail: anna@amcmanagement.co.uk
Fax: 020-7371 9048 Tel: 020-7731 1721

AMCK MANAGEMENT Ltd
103 Westbourne Studios, 242 Acklam Road
Notting Hill, London W10 5JJ
Website: www.amck.tv
e-mail: info@amck.tv
Fax: 020-7524 7789 Tel: 020-7524 7788

AMERICAN AGENCY The
14 Bonny Street, London NW1 9PG
Website: www.americanagency.tv
e-mail: americanagency@btconnect.com
Fax: 020-7482 4666 Tel: 020-7485 8883

ANA (Actors Network Agency)•
PM Co-operative
55 Lambeth Walk, London SE11 6DX
Website: www.ana-actors.co.uk
e-mail: info@ana-actors.co.uk
Fax: 020-7735 8177 Tel: 020-7735 0999

ANDREWS Amanda AGENCY
30 Caverswall Road
Blythe Bridge, Stoke-on-Trent
Staffordshire ST11 9BG
e-mail: amanda.andrews.agency@tesco.net
 Tel/Fax: 01782 393889

ANDREWS HAMILTON Ltd
BCM Box 3054, London WC1N 3XX
e-mail: info@andrewshamilton.com
Fax: 020-8551 3685 Tel: 020-8491 7904

Frazer Douglas

GEMMA MOUNT PHOTOGRAPHY

www.gemmamountphotography.com

tel. 020 8342 9318 / 07976 824923

student discount available

Martine McCutcheon

Peter Hall
Photographer
Special Student Rates
Friendly Unhurried Atmosphere

020 8981 2822
mob 07803345495
www.peterhall-photo.co.uk

 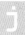

castingphoto.co.uk
077 7599 1834

STEPHEN MARSHALL JOHNSTON PHOTOGRAPHY

FILM & DIGITAL
STUDIO & LOCATION

ANGEL Susan & FRANCIS Kevin Ltd*
(Write, no e-mails)
1st Floor, 12 D'Arblay Street, London W1F 8DU
e-mail: angelpair@freeuk.com
Fax: 020-7437 1712 Tel: 020-7439 3086

ANTONY Christopher ASSOCIATES
The Old Dairy, 164 Thames Road, London W4 3QS
Website: www.christopherantony.co.uk
e-mail: info@christopherantony.co.uk
Fax: 020-8742 8066 Tel: 020-8994 9952

ANUBIS AGENCY Ltd
Mobile: 07748 608821 Tel/Fax: 0870 0852288

A.P.M. ASSOCIATES (Linda French)
(See ALEXANDER PERSONAL MANAGEMENT Ltd)

ARAENA/COLLECTIVE
10 Bramshaw Gardens
South Oxhey
Herts WD19 6XP Tel/Fax: 020-8428 0037

ARC ENTERTAINMENTS
10 Church Lane, Redmarshall
Stockton on Tees
Cleveland TS21 1EP
Website: www.arcents.co.uk
e-mail: arcents@aol.com Tel: 01740 631292

ARCADIA ASSOCIATES
18B Vicarage Gate, London W8 4AA
e-mail: info.arcadia@btopenworld.com
Tel/Fax: 020-7937 0264

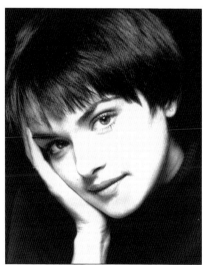

Rachel Weisz

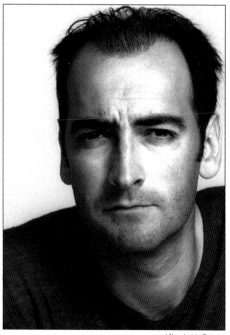

Alistair McGowan

CAROLE LATIMER
PHOTOGRAPHY
113 Ledbury Road W11
Tel: 020 7727 9371 Fax: 020 7229 9306
www.carolelatimer.com

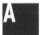

ARENA ENTERTAINMENT CONSULTANTS
(Corporate Entertainment)
Regent's Court, 39 Harrogate Road, Leeds LS7 3PD
Website: www.arenaentertainments.co.uk
e-mail: stars@arenaentertainments.co.uk
Fax: 0113-239 2016 Tel: 0113-239 2222
ARENA PERSONAL MANAGEMENT Ltd
Co-operative
Room 11, East Block, Panther House
38 Mount Pleasant, London WC1X 0AP
Website: www.arenapmltd.co.uk
e-mail: arenapmltd@aol.com Tel/Fax: 020-7278 1661
A R G (ARTISTS RIGHTS GROUP Ltd)*
4 Great Portland Street, London W1W 8PA
e-mail: argall@argtalent.com
Fax: 020-7436 6700 Tel: 020-7436 6400

ARGYLE ASSOCIATES
PM (Richard Argyle) (SAE for Unsolicited Mail)
St John's Buildings
43 Clerkenwell Road, London EC1M 5RS
e-mail: argyle.associates@virgin.net
Fax: 0871 4336130 Tel: 020-7608 2095
ARTIST MANAGEMENT UK Ltd
PO Box 96, Liverpool L9 8WY
Website: www.artistmanagement.com
e-mail: chris@artistmanagementuk.com Tel: 0151-523 6222
ARTS MANAGEMENT
First Floor, 10 Goddard Place
Maidenbower, West Sussex RH10 7HR
Website: www.artsmanagement.co.uk
e-mail: artsmanagementltd@hotmail.com Tel: 01293 885746

Terry Sweeney Lauren Cohan Elizabeth Marmur

ric bacon

07970 970799

www.ricbacon.co.uk

SHEILA BURNETT
PHOTOGRAPHY

Simon Pegg

Imelda Staunton

Patsy Palmer

Ewan McGregor

020 7289 3058
www.sheilaburnett-photography.com

Student Rates

ARTSWORLD INTERNATIONAL MANAGEMENT Ltd
1 Farrow Road
Whaplode Drove, Nr Spalding PE12 0TS
e-mail: bob@artsworld.freeserve.co.uk
Fax: 01406 331147　　　　　　　Tel: 01406 330099

ASH PERSONAL MANAGEMENT
3 Spencer Road
Mitcham Common, Surrey CR4 1SG
e-mail: ash_personal_mgmt@yahoo.co.uk
　　　　　　　　　　　Tel/Fax: 020-8646 0050

ASHCROFT ACADEMY OF DRAMATIC ART & AGENCY
Malcolm Primary School
Malcolm Road, Penge, London SE20 8RH
Website: www.ashcroftacademy.com
e-mail: geri.ashcroftacademy@tiscali.co.uk
Mobile: 07799 791586　　　Tel/Fax: 020-8693 8088

ASHCROFT Sharron MANAGEMENT Ltd
Dean Clough, Halifax
West Yorkshire HX3 5AX
Website: www.sharronashcroft.com
e-mail: info@sharronashcroft.com
Fax: 01422 343417　　　　　　　Tel: 01422 343949

ASQUITH & HORNER
PM (Write with SAE)
The Studio, 14 College Road, Bromley, Kent BR1 3NS
Fax: 020-8313 0443　　　　　　Tel: 020-8466 5580

ASSOCIATED ARTS
(Directors, Designers, Lighting Designers)
8 Shrewsbury Lane, London SE18 3JF
Website: www.associated-arts.co.uk
e-mail: karen@associated-arts.co.uk
Fax: 020-8856 8189　　　　　　Tel: 020-8856 4958

ASSOCIATED SPEAKERS
(Lecturers & Celebrity Speakers)
24A Park Road, Hayes
Middlesex UB4 8JN　　　　　　Tel: 020-8848 9048

ASTRAL ACTORS MANAGEMENT
7 Greenway Close, London NW9 5AZ
Website: www.astralactors.com
e-mail: info@astralactors.com
Fax: 020-8200 3694　　　　　　Tel: 020-8728 2782

AVALON MANAGEMENT GROUP Ltd
4A Exmoor Street, London W10 6BD
e-mail: enquiries@avalonuk.com
Fax: 020-7598 7300　　　　　　Tel: 020-7598 8000

AVENUE ARTISTES Ltd
C G TV
8 Winn Road, Southampton SO17 1EN
Website: www.avenueartistes.com
e-mail: info@avenueartistes.com
Fax: 023-8090 5703　　　　　　Tel: 023-8055 1000

AWA - ANDREA WILDER AGENCY
23 Cambrian Drive, Colwyn Bay, Conwy LL28 4SL
Website: www.awagency.co.uk
e-mail: casting@awagency.co.uk
Fax: 07092 249314　　　　　Mobile: 07919 202401

AXM*
Actors' Exchange Management
PM Co-operative
206 Great Guildford Business Square
30 Great Guildford Street, London SE1 0HS
Website: www.axmgt.com
e-mail: info@axmgt.com
Fax: 020-7261 0408　　　　　　Tel: 020-7261 0400

Lenora Crichlow

Alexis Owen-Hobbs

Mike Grady

Olivia Busby

Harry Myers

Emma Stone

Dudley Sutton

James Woolley

Antony Costa

Photographs
by
Brandon Bishop

07931 383830 0207 275 7468
www.brandonbishopphotography.com

AZA ARTISTES
(Existing Clients only)
652 Finchley Road
London NW11 7NT Tel: 020-8458 7288

BALLROOM, LONDON THEATRE OF
(Ballroom/Social Dancers for Film/TV/Theatre)
24 Ovett Close
Upper Norwood, London SE19 3RX
Website: www.londontheatreofballroom.com
e-mail: office@londontheatreofballroom.com
Mobile: 07958 784462 Tel: 020-8771 4274

B A M ASSOCIATES
Benets Cottage
Dolberrow, Churchill, Bristol BS25 5NT
Website: www.ebam.tv
e-mail: casting@ebam.tv Tel: 01934 852942

BARKER Gavin ASSOCIATES Ltd*
(Gavin Barker, Michelle Burke)
2d Wimpole Street
London W1G 0EB
Website: www.gavinbarkerassociates.co.uk
e-mail: amanda@gavinbarkerassociates.co.uk
Fax: 020-7499 3777 Tel: 020-7499 4777

BASHFORD Simon
(See GLOBAL ARTISTS)

B.A.S.I.C./JD AGENCY
C V S
3 Rushden House
Tatlow Road, Glenfield
Leicester LE3 8ND
e-mail: jonny.dallas@ntlworld.com Tel/Fax: 0116-287 9594

john | clark
photo | digital

London's leading theatrical portrait photographer
Finest digital pictures - Same day web contact sheets
Spotlight update - Repro service - Retouching - Portfolio CD
0208 854 4069 - 07702 627 237
No other photographer offers the same service

For information about sessions, the casting shot, fees and portfolio
info@johnclarkphotography.com
www.johnclarkphotography.com

BEATTIE BEAU Ltd
54 Harley Street, London W1G 9PZ
Fax: 020-7486 5664 Tel: 020-7486 0746

BECKER Paul Ltd*
223A Portobello Road
London W11 1LU
Fax: 020-7221 5030 Tel: 020-7221 3050

BELCANTO LONDON ACADEMY MANAGEMENT
(Children & Young Adults)
Performance House
20 Passey Place
Eltham, London SE9 5DQ
e-mail: bla@dircon.co.uk
Fax: 020-8850 9944 Tel: 020-8850 9888

BELFRAGE Julian ASSOCIATES
Adam House
14 New Burlington Street
London W1S 3BQ
Fax: 020-7287 8832 Tel: 020-7287 8544

BELL Olivia Ltd
189 Wardour Street
London W1F 8ZD
e-mail: info@olivia-bell.co.uk
Fax: 020-7439 3485 Tel: 020-7439 3270

BENJAMIN Audrey AGENCY
278A Elgin Avenue
Maida Vale, London W9 1JR
e-mail: aud@elginavenue.fsbusiness.co.uk
Fax: 020-7266 5480 Tel: 020-7289 7180

BETTS Jorg ASSOCIATES*
Gainsborough House
81 Oxford Street
London W1D 2EU
e-mail: jorg@jorgbetts.com
Fax: 020-7903 5301 Tel: 020-7903 5300

BILLBOARD PERSONAL MANAGEMENT
Unit 5
11 Mowll Street
London SW9 6BG
Website: www.billboardpm.com
e-mail: billboardpm@btconnect.com
Fax: 020-7793 0426 Tel: 020-7735 9956

BILLY MARSH DRAMA Ltd
(Actors & Actresses)
(See MARSH Billy DRAMA Ltd)

BIRD AGENCY
(Personal Performance Management)
Birkbeck Centre
Birkbeck Road
Sidcup
Kent DA14 4DE
Fax: 020-8308 1370 Tel: 020-8300 6004

BLOND Rebecca ASSOCIATES
69A Kings Road
London SW3 4NX
e-mail: info@rebeccablondassociates.com
Fax: 020-7351 4600 Tel: 020-7351 4100

Martin Freeman

Lindsey Coulson

Stephen Tompkinson

Claire Grogan
P h o t o g r a p h y

020 7272 1845

mobile 07932 635381
www.clairegrogan.co.uk
student rates

BLOOMFIELDS MANAGEMENT*
34 South Molton Street
London W1K 5BP
Website: www.bloomfieldsmanagement.com
e-mail: emma@bloomfieldsmanagement.com
Fax: 020-7493 4449 Tel: 020-7493 4448

BLUE WAND MANAGEMENT
2nd Floor, 12 Weltje Road
Hammersmith, London W6 9TG
e-mail: bluewandproltd@btinternet.com Tel: 020-8741 2038

BMA MODELS
(Models)
346 High Street, Marlow House
Berkhamsted, Herts HP4 1HT
Website: www.bmamodels.com
e-mail: info@bmamodels.com
Fax: 01442 879879 Tel: 01442 878878

BODENS AGENCY
PM
Bodens Studios & Agency
99 East Barnet Road
New Barnet, Herts EN4 8RF
Website: www.bodensagency.com
e-mail: bodens2692@aol.com
Fax: 020-8449 5212 Tel: 020-8447 0909

BOOKERS UK
7 Green Avenue, Mill Hill
London NW7 4PX Tel/Fax: 020-8201 1400

BOYCE Sandra MANAGEMENT*
1 Kingsway House
Albion Road, London N16 0TA
e-mail: info@sandraboyce.com
Fax: 020-7241 2313 Tel: 020-7923 0606

BRAIDMAN Michelle ASSOCIATES*
2 Futura House
169 Grange Road, London SE1 3BN
e-mail: info@braidman.com
Fax: 020-7231 4634 Tel: 020-7237 3523

BRAITHWAITE'S THEATRICAL AGENCY
8 Brookshill Avenue, Harrow Weald
Middlesex HA3 6RZ Tel: 020-8954 5638

BREAK A LEG MANAGEMENT Ltd
Units 2/3 The Precinct
Packington Square, London N1 7UP
Website: www.breakalegman.com
e-mail: agency@breakalegman.com
Fax: 020-7359 3660 Tel: 020-7359 3594

BROAD CASTING AGENCY Ltd
Unit 23, Canalot Studios
222 Kensal Road, London W10 5BN
e-mail: info@broadcastingcompany.tv
Fax: 020-8960 5031 Tel: 0871 210 0035

BROOD MANAGEMENT
3 Queen's Garth
Taymount Rise, London SE23 3UF
Website: www.broodmanagement.com
e-mail: broodmanagement@aol.com
Mobile: 07932 022635 Tel: 020-8699 1071

BROOK Dolly AGENCY
PO Box 5436
Dunmow CM6 1WW
e-mail: dollybrookcasting@btinternet.com
Fax: 01371 875996 Tel: 01371 875767

BROOK Valerie AGENCY
10 Sandringham Road
Cheadle Hulme, Cheshire SK8 5NH
e-mail: colinbrook@freenetname.co.uk
Fax: 0161-488 4206 Tel: 0161-486 1631

BROOKS Claude ENTERTAINMENTS
1 Burlington Avenue
Slough, Berks SL1 2JY
Fax: 01753 520424 Tel: 01753 520717

BROOKS PERSONAL MANAGEMENT
58 Lockwood House
Oval, London SE11 5TA
Website: www.brooks-management.com
e-mail: info@brooks-management.com Tel: 020-7582 0052

BROWN & SIMCOCKS*
PM (Write)
1 Bridgehouse Court
109 Blackfriars Road, London SE1 8HW
e-mail: mail@brownandsimcocks.co.uk
Fax: 020-7928 1909 Tel: 020-7928 1229

BROWNING Malcolm
Lafone House, Unit 2.4, The Leathermarket
Weston Street, London SE1 3ER
e-mail: info@malcolmbrowning.com
Fax: 0870 4581766 Tel: 020-7378 1053

BRUNSKILL MANAGEMENT Ltd*
PM M S TV (Write)
Suite 8A, 169 Queen's Gate, London SW7 5HE
e-mail: contact@brunskill.com
Fax: 020-7589 9460 Tel: 020-7581 3388

The Courtyard, Edenhall
Penrith, Cumbria CA11 8ST
Website: www.brunskill.com
e-mail: contact@brunskill.fsbusiness.co.uk
Fax: 01768 881850 Tel: 01768 881430

BSA Ltd
(See HARRISON Penny BSA Ltd)

BUCHANAN Bronia ASSOCIATES Ltd*
Nederlander House
7 Great Russell Street, London WC1B 3NH
Website: www.buchanan-associates.co.uk
e-mail: info@buchanan-associates.co.uk
Fax: 020-7631 2034 Tel: 020-7631 2004

BUMPS & BABIES
53 Westover Road, London SW18 2RF
Website: www.bumps-n-babies.co.uk
e-mail: judi@bumps-n-babies.co.uk Tel: 020-8874 4484

BURNETT GRANGER ASSOCIATES Ltd*
(Barry Burnett, Lindsay Granger, Lizanne Crowther)
3 Clifford Street, London W1S 2LF
e-mail: associates@burnettgranger.co.uk
Fax: 020-7287 3239 Tel: 020-7437 8008

rob savage photography

07901 927597
www.robsavage.co.uk

Marc Baylis
Anna Madeley

Personal Management

(Formerly known as Michael Garrett Associates)

Agents:
Simon Bashford
Michael Garrett
Niki Winterson

GLOBAL ARTISTS
23 Haymarket London SW1Y 4DG
Tel: 020 7839 4888 Fax: 020 7839 4555
email: info@globalartists.co.uk
www.globalartists.co.uk
www.theatricalagent.co.uk

Members of the Personal Managers' Association

Michael Garrett Associates Ltd. Registered No. 4404385
Registered Office: 23 Haymarket, London SW1Y 4DG

ETHNICS ARTISTE AGENCY
Talent of Colour. Talent of Foreign Language.

| Film | TV | Radio | Commercials | Theatre
| Photographic Work | Voice Overs

T: 020-8523 4242
F: 020-8523 4523

John Colclough Advisory

Practical independent guidance for actors and actresses

t: 020 8873 1763 e: john@johncolclough.org.uk www.johncolclough.org.uk

BWH AGENCY Ltd The*
Barley Mow Business Centre
10 Barley Mow Passage, Chiswick, London W4 4PH
e-mail: info@thebwhagency.co.uk
Fax: 020-8996 1662 Tel: 020-8996 1661

BYRON'S MANAGEMENT
(Children & Adults)
North London Performing Arts Centre
76 St James Lane, Muswell Hill, London N10 3DF
Website: www.byronsmanagement.co.uk
e-mail: byronscasting@aol.com
Fax: 020-8444 4040 Tel: 020-8444 4445

C.A. ARTISTES MANAGEMENT
26-28 Hammersmith Grove, London W6 7BA
Website: www.caartistes.com
e-mail: casting@caartistes.com Tel: 020-7967 8067

CAM*
PM (Write)
First Floor
55-59 Shaftesbury Avenue, London W1D 6LD
Website: www.cam.co.uk
e-mail: info@cam.co.uk
Fax: 020-7734 3205 Tel: 020-7292 0600

CAMBELL JEFFREY MANAGEMENT
(Set, Costume, Lighting Designers)
11A Greystone Court, South Street
Eastbourne BN21 4LP
e-mail: cambell@theatricaldesigners.co.uk
Fax: 01323 411373 Tel: 01323 411444

CAMPBELL Alison MODEL & PROMOTION AGENCY
381 Beersbridge Road, Belfast BT5 5DT
Website: www.alisoncampbellmodels.com
e-mail: info@alisoncampbellmodels.com
Fax: 028-9080 9808 Tel: 028-9080 9809

CAPITAL VOICES
(Anne Skates) (Session Singers, Studio, Stage, TV & Film)
PO Box 364
Esher, Surrey KT10 9XZ
Website: www.capitalvoices.com
e-mail: capvox@aol.com
Fax: 01372 466229 Tel: 01372 466228

CARDIFF CASTING•
Co-operative Actors Management
Chapter Arts Centre
Market Road, Cardiff CF5 1QE
Website: www.cardiffcasting.co.uk
e-mail: admin@cardiffcasting.co.uk Tel: 029-2023 3321

CAREY Roger ASSOCIATES*
PM
Garden Level
32 Charlwood Street, London SW1V 2DY
e-mail: info@rogercareyf2s.com
Fax: 020-7630 0029 Tel: 020-7630 6301

CARNEY Jessica ASSOCIATES*
PM Write
4th Floor, 23 Golden Square, London W1F 9JP
e-mail: info@jcarneyassociates.co.uk
Fax: 020-7434 4173 Tel: 020-7434 4143

CAROUSEL EVENTS
(Entertainment for Corporate & Private Events)
18 Westbury Lodge Close
Pinner, Middlesex HA5 3FG
Website: www.carouselevents.co.uk
e-mail: info@carouselevents.co.uk
Fax: 0870 7518668 Tel: 0870 7518688

CARR Norrie AGENCY
Holborn Studios
49-50 Eagle Wharf Road, London N1 7ED
Website: www.norriecarr.com
e-mail: info@norriecarr.com
Fax: 020-7253 1772 Tel: 020-7253 1771

CARTEURS
170A Church Road, Hove, East Sussex BN3 2DJ
Website: www.stonelandsschool.co.uk
Fax: 01273 770444 Tel: 01273 770445

CASAROTTO MARSH Ltd
(Film Technicians)
National House
60-66 Wardour Street, London W1V 4ND
Website: www.casarotto.uk.com
e-mail: casarottomarsh@casarotto.uk.com
Fax: 020-7287 5644 Tel: 020-7287 4450

Victor Spinetti as Einstein

Shelaine Brown

Giles Vickers-Jones

JAMES GILL 020 7735 5632 *Photographer with Attitude & Imagination*

CASTAWAY ACTORS AGENCY
30-31 Wicklow Street, Dublin 2, Eire
Website: www.irish-actors.com
e-mail: castaway@clubi.ie
Fax: 00 353 1 6719133 Tel: 00 353 1 6719264

CASTCALL & CASTFAX
(Casting & Consultancy Service)
106 Wilsden Avenue, Luton LU1 5HR
Website: www.castcall.co.uk
e-mail: casting@castcall.co.uk
Fax: 01582 480736 Tel: 01582 456213

CASTING COUCH PRODUCTIONS Ltd
(Moira Townsend)
213 Trowbridge Road, Bradford-on-Avon, Wiltshire BA15 1EU
e-mail: moiratownsend@yahoo.co.uk
 Mobile: 07932 785807

CASTING DEPARTMENT The
Elysium Gate, Unit 15
126-128 New Kings Road, London SW6 4LZ
e-mail: jillscastingdpt@aol.com
Fax: 020-7736 2221 Tel: 020-7384 0388

CASTING FACES UK
Global House
1 Ashley Avenue
Epsom, Surrey KT18 5AD
Website: www.castingfaces.com
e-mail: office@castingfaces.com
Fax: 0871 4337304 Tel: 0870 7709330

CASTING UK
10 Coptic Street, London WC1A 1NH
Website: www.castinguk.com
e-mail: info@castinguk.com Tel: 020-7580 3456

leslie ash

katie vandyck
digital photographer
07941 940259
www.iphotou.co.uk

HUGO SPEER

CATHERINE SHAKESPEARE LANE
PHOTOGRAPHER
020 7226 7694

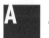

Lyndsey Marshal | Dominic Cooper | Victoria Hasted

Luke Varley Shoots Actors

Casting Headshots | Production/Rehearsal Stills

T: 020 8674 9919 | M: 07711 183 631 | www.lukevarley.com

C B A INTERNATIONAL
e-mail: cba_office@yahoo.co.uk Mobile: 07932 110555
(Cindy Brace)
31 rue Milton, 75009 Paris, France
Website: www.cindy-brace.com
e-mail: c_b_a@club-internet.fr
Fax: 00 33 148 74 51 42 Tel: 00 33 145 26 33 42

C C A MANAGEMENT*
PM (Write) (Actors and Technicians)
Garden Level, 32 Charlwood Street, London SW1V 2DY
e-mail: cca@ccamanagement.co.uk
Fax: 020-7630 7376 Tel: 020-7630 6303

CCM•
Co-operative
Panther House, 38 Mount Pleasant, London WC1X 0AP
Website: www.ccmactors.com
e-mail: casting@ccmactors.com
Fax: 020-7813 3103 Tel: 020-7278 0507

CDA
(See DAWSON Caroline ASSOCIATES)

CELEBRITY GROUP The
13 Montagu Mews South, London W1H 7ER
Website: www.celebrity.co.uk
e-mail: info@celebrity.co.uk Tel: 0871 2501234

CENTRAL LINE•
PM Co-operative
11 East Circus Street, Nottingham NG1 5AF
Website: www.the-central-line.co.uk
e-mail: centralline@btconnect.com Tel: 0115-941 2937

CENTRE STAGE AGENCY*
7 Rutledge Terrace, South Circular Road, Dublin 8, Eire
e-mail: geraldinecenterstage@eircom.net
Tel/Fax: 00 353 1 4533599

CHAMBERS Hannah MANAGEMENT
23 Long Lane
Barbican, London EC1A 9HL
Website: www.chambersmgt.co.uk
e-mail: hannah@chambersmgt.com
Fax: 020-7796 3676 Tel: 020-7796 3588

CHAPMAN AGENCY
The Link Building
Paradise Place, Birmingham B3 3HJ
e-mail: agency@bssd.ac.uk
Fax: 0121-262 6801 Tel: 0121-262 6807

CHARLESWORTH Peter & ASSOCIATES
68 Old Brompton Road
London SW7 3LQ
e-mail: petercharlesworth@tiscali.co.uk
Fax: 020-7589 2922 Tel: 020-7581 2478

CHATTO & LINNIT Ltd
123A Kings Road, London SW3 4PL
e-mail: info@chattolinnit.com
Fax: 020-7352 3450 Tel: 020-7352 7722

CINEL GABRAN MANAGEMENT*
PO Box 5163, Cardiff CF5 9BJ
Website: www.cinelgabran.co.uk
e-mail: info@cinelgabran.co.uk
Fax: 0845 0666601 Tel: 0845 0666605

CIRCUIT PERSONAL MANAGEMENT Ltd•
Suite 71 S.E.C.,
Bedford Street, Shelton
Stoke-on-Trent, Staffs ST1 4PZ
Website: www.circuitpm.co.uk
e-mail: mail@circuitpm.co.uk
Fax: 01782 206821 Tel: 01782 285388

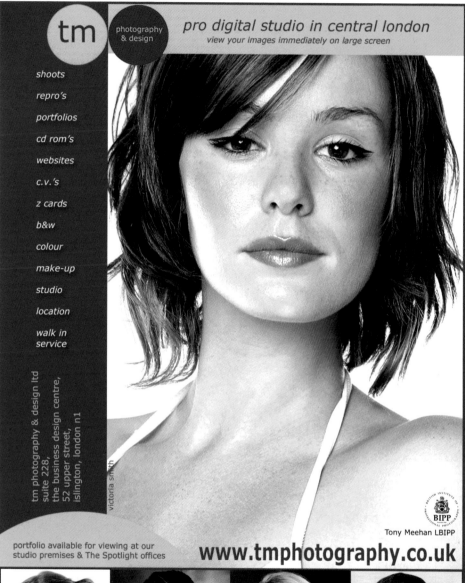

 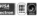

Artist Management
adults children

Byron's Management
Tel: 020 8444 4445
Fax: 020 8444 4040
byronscasting@aol.com
www.byronsmanagement.co.uk

CIRCUS MANIACS AGENCY
(Physical Artistes & Corporate Events)
Office 8A, The Kingswood Foundation
Britannia Road, Kingswood, Bristol BS15 8DB
Website: www.circusmaniacsagency.com
e-mail: agency@circusmaniacs.com
Mobile: 07977 247287 Tel/Fax: 0117-947 7042

CITY ACTORS' MANAGEMENT•
PM Co-operative
Oval House, 52-54 Kennington Oval, London SE11 5SW
Website: www.cityactors.co.uk
e-mail: info@cityactors.co.uk
Fax: 020-7793 8282 Tel: 020-7793 9888

C.K.K. ENTERTAINMENT
PO Box 24550, London E17 9FG
e-mail: ckk.entertainment@virgin.net
Fax: 020-7515 6373 Tel: 020-7531 6300

CLARKE & BROOK MANAGEMENT
International House
223 Regent Street, London W1B 2EB
e-mail: clarkebrook@btconnect.com
Fax: 020-7495 7742 Tel: 020-7495 2424

CLARKE AND JONES Ltd
28 Fordwych Court
Shoot Up Hill, London NW2 3PH
e-mail: mail@clarkeandjones.plus.com
Fax: 0870 1313391 Tel: 020-8438 0185

CLASS - CARLINE LUNDON ASSOCIATES
25 Falkner Square, Liverpool L8 7NZ
Website: www.stagescreenandbroadcast.co.uk
e-mail: carline.lundon@ukonline.co.uk
Mobile: 07958 509155 Tel: 0151-703 0600

CLAYMAN Tony PROMOTIONS Ltd
Vicarage House
58-60 Kensington Church Street, London W8 4DB
Website: www.tonyclayman.com
e-mail: tony@tonyclayman.com
Fax: 020-7368 3338 Tel: 020-7368 3336

CLAYPOLE MANAGEMENT
PO Box 123, DL3 7WA
Website: www.claypolemanagement.co.uk
e-mail: claypole_1@hotmail.com
Fax: 0870 1334784 Tel: 0845 6501777

CLOUD NINE AGENCY
96 Tiber Gardens
Treaty Street, London N1 0XE
Website: www.cloudnineagency.co.uk
e-mail: cloudnineagency@blueyonder.co.uk
Tel/Fax: 020-7278 0029

CMP MANAGEMENT
8-30 Galena Road, Hammersmith, London W6 0LT
e-mail: info@ravenscourt.net
Fax: 020-8741 1786 Tel: 020-8741 3400

COCHRANE Elspeth PERSONAL MANAGEMENT*
(Helen Smith)
16 Old Town, Clapham, London SW4 0JY
e-mail: info@elspethcochrane.co.uk
Fax: 020-7819 4297 Tel: 020-7819 6256

COLE KITCHENN PERSONAL MANAGEMENT Ltd
Vaudeville Theatre Offices
404 Strand, London WC2R 0NH
Website: www.colekitchenn.com
e-mail: stuart@colekitchenn.com
Fax: 020-7240 8477 Tel: 020-7836 2502

Jennie McAlpine 2006

Craig Stein 2006

Photography by

PETER SIMPKIN

020 8883 2727
e-mail: petersimpkin@aol.com
website: www.petersimpkin.co.uk

COLLINS Shane ASSOCIATES*
11-15 Betterton Street, Covent Garden, London WC2H 9BP
Website: www.shanecollins.co.uk
e-mail: info@shanecollins.co.uk
Fax: 0870 460 1983 Tel: 020-7470 8864

COLLIS MANAGEMENT
182 Trevelyan Road, London SW17 9LW
e-mail: marilyn@collismanagement.co.uk
Fax: 020-8682 0973 Tel: 020-8767 0196

COMEDY CLUB Ltd The
2nd Floor, 28-31 Moulsham Street
Chelmsford, Essex CM2 0HX
Website: www.hahaheehee.com
e-mail: info@hahaheehee.com
Fax: 01245 255507 Tel: 08700 425656

COMIC VOICE MANAGEMENT
2nd Floor
28-31 Moulsham Street
Chelmsford, Essex CM2 0HX
Website: www.comicvoice.com
e-mail: info@comicvoice.com
Fax: 01245 255507 Tel: 08700 425656

COMMERCIAL AGENCY Ltd The
(See TCA)

COMPLETE ARTISTES
N&S Tower, 4 Selsdon Way
City Harbour, London E14 9GL
Website: www.completeartistes.com
e-mail: lisa.dawson@nasnet.co.uk
Fax: 020-7308 6001 Tel: 020-7308 5351

ACTORS/ACTRESSES PORTRAITS
Photography for all your publicity and Spotlight needs

A Big Thank You to the following:

Richard Burton	Virginia McKenna	Diana Dors	Marie Helvin
Brigitte Bardot	Don Johnson	David Bellamy	Sam Fox
Sophia Loren	Grace Jones	Michael Bolton	Shirley Anne Field
Kojak	Roger Moore	Eric Morecambe	Will Young
Ronkey Philips	Bruce Willis	Vivien Creegor	Gareth Gates
Peter Sellers	Demi Moore	Frank Muir	Charles Dance
Dame Judi Dench	Patrick Swayze	Miyako Yoshida	*and the rest too*
Derek Jacobi	Sir Richard Branson	Papillon Soo Soo	*many to mention...*
John Lennon	Sylvia Kristel	Richard O'Sullivan	

**Phone or email for our special package.
A minimum of 80 colour and 80 B&W photos.
2 high resolution CDs to take away at the end of shoot.
Top hair and make-up artist supplied on request.**

Tel +44 (0) 208 438 0303
Mobile 07712 669 953
Email billy_snapper@hotmail.com

www.london-photographer.com
www.theukphotographerexhibition.co.uk
www.theukphotographer.com
www.billysnapper.com

Will C - Photographer to the Stars

Picture Credits Sinitta *actresss and singer*, Natalie Palys *Madness of King George*, Sir Richard Branson *Duo Magazine*, Andy Hamilton *Whitbread*, Anabel Kutay *ballerina and dancer Phantom of the Opera*, Miss Pinto and Rat, Benjamin and Rebecca Green *dancers*

Will C specialises in actors, actresses and personalities in advertising, editorial, film and television. He has been principal photographer in over 30 major films and 40 commercials. Actors and actresses portraits can be taken in our fully equipped film and digital studio in NW2 - just 15 minutes from Marble Arch or Baker Street.

Tokyo • New York • Amsterdam • Paris • London

Dancers	**I-MAGE**	Productions
Singers		Show Openers
Models	**Hospitality & Castings**	Trade Shows
Presenters	Regent House Business Centre	Speciality Acts
Actors/Actresses	Suite 22, 24-25 Nutford Place, Marble Arch, London W1H 5YH	Choreographers
Corporate Events	Tel: 020 7725 7003 Fax: 020 7725 7004 Website: www.i-mage.uk.com	Award Ceremonies

CONTI Italia AGENCY Ltd
S M TV F (Write or Phone)
23 Goswell Road, London EC1M 7AJ
e-mail: agency@italiaconti.co.uk
Fax: 020-7253 1430 Tel: 020-7608 7500

CONWAY Clive CELEBRITY PRODUCTIONS Ltd
32 Grove Street, Oxford OX2 7JT
Website: www.celebrityproductions.info
e-mail: info@celebrityproductions.org
Fax: 01865 514409 Tel: 01865 514830

CONWAY VAN GELDER GRANT Ltd*
PM
3rd Floor, 18-21 Jermyn Street
London SW1Y 6HP
Fax: 020-7287 1940 Tel: 020-7287 0077

COOKE Howard ASSOCIATES*
19 Coulson Street, Chelsea, London SW3 3NA
Fax: 020-7591 0155 Tel: 020-7591 0144

COOPER Tommy AGENCY The
(Comedy, Magicians)
6 Marlott Road
Poole, Dorset BH15 3DX
Website: www.tommycooperremembered.co.uk
Mobile: 07860 290437 Tel: 01202 666001

CORNER Clive ASSOCIATES
3 Bainbridge Close
Ham, Middlesex TW10 5JJ
e-mail: cornerassociates@aol.com Tel/Fax: 020-8332 1910

CORNISH Caroline MANAGEMENT Ltd*
(Technicians Only)
12 Shinfield Street, London W12 0HN
Website: www.carolinecornish.co.uk
e-mail: carolinecornish@btconnect.com
Fax: 020-8743 7887 Tel: 020-8743 7337

COULSON Lou ASSOCIATES Ltd*
1st Floor
37 Berwick Street, London W1F 8RS
Fax: 020-7439 7569 Tel: 020-7734 9633

COULTER MANAGEMENT AGENCY Ltd
(Anne Coulter)
333 Woodlands Road, Glasgow G3 6NG
e-mail: cmaglasgow@btconnect.com
Fax: 0141-357 6676 Tel: 0141-357 6666

COVENT GARDEN MANAGEMENT
5 Denmark Street, London WC2H 8LP
Website: www.coventgardenmanagement.com
e-mail: agents@coventgardenmanagement.com
Fax: 020-7240 8409 Tel: 020-7240 8400

The Agents Association (Great Britain)

Promoting good practice amongst agents internationally

Telephone: +44 (0)20 7834 0515
Fax: +44 (0)20 7821 0261
Email: association@agents-uk.com

54 Keyes House, Dolphin Square
London SW1V 3NA

www.agents-uk.com

Sarah Jayne Dunn

Ashlea Thomson

Chucky Venice

Dan Harwood-Stamper
photographer

email:dan@denbryrepros.com

Tel: 020-7930 1372
Mob: 07779-165777

et/nik/a
Prime Management
and Castings Limited

view our artists
online at:
et-nik-a.com
commercials/
film/personal
representation/
theatre/tv
where culture
and talent meet

CPA MANAGEMENT
The Studios, 219B North Street
Romford, Essex RM1 4QA
Website: www.cpamanagement.co.uk
e-mail: david@cpamanagement.co.uk
Fax: 01708 766077 Tel: 01708 766444

CRAWFORDS
PO Box 44394, London SW20 0YP
Website: www.crawfords.tv
e-mail: cr@wfords.com
Fax: 020-3258 5037 Tel: 020-8947 9999

CREATIVE MEDIA
PM (Write)
11 Asquith Road, Bentley DN5 0NS
Mobile: 07787 784412 Tel: 01302 874540

CREATIVE MEDIA MANAGEMENT*
(No Actors - Film, TV & Theatre Technical Personnel only)
3B Walpole Court, Ealing Studios
Ealing Green, London W5 5ED
Website: www.creativemediamanagement.com
e-mail: enquiries@creativemediamanagement.com
Fax: 020-8566 5554 Tel: 020-8584 5363

CREDITS ACTORS AGENCY Ltd
29 Lorn Road, London SW9 0AB
e-mail: credits@actors29.freeserve.co.uk
 Tel: 020-7737 0735

CRESCENT MANAGEMENT•
PM Co-operative
10 Barley Mow Passage, Chiswick, London W4 4PH
e-mail: mail@crescentmanagement.co.uk
Fax: 020-8987 0207 Tel: 020-8987 0191

CROUCH Sara MANAGEMENT
17 Harvey Road, Middlesex TW4 5LX
e-mail: sara.crouch@btinternet.com
Fax: 020-8563 8558 Tel: 020-8894 7978

CROWD PULLERS
(Street Performers)
14 Somerset Gardens, London SE13 7SY
e-mail: jhole@crowdpullers.co.uk
Fax: 020-8469 2147 Tel: 020-8469 3900

CRUICKSHANK CAZENOVE Ltd*
(Directors, Designers, Choreographers)
97 Old South Lambeth Road
London SW8 1XU
e-mail: office@cruickshankcazenove.com
Fax: 020-7582 6405 Tel: 020-7735 2933

CS MANAGEMENT
The Croft, 7 Cannon Road
Southgate, London N14 7HE
Website: www.csmanagementuk.com
e-mail: carole@csmanagementuk.com
Fax: 020-8886 7555 Tel: 020-8886 4264

C.S.A.
(Christina Shepherd Advertising)
4th Floor, 45 Maddox Street, London W1S 2PE
e-mail: csa@shepherdmanagement.co.uk
Fax: 020-7499 7535 Tel: 020-7499 7534

CSM (ARTISTS)
PM
Room 212, 77 Oxford Street, London W1D 2ES
e-mail: csmartists@aol.com
Fax: 020-8839 8747 Tel: 020-7659 2399

CURTIS BROWN GROUP Ltd*
(Actors, Producers, Directors)
Haymarket House
28-29 Haymarket, London SW1Y 4SP
e-mail: cb@curtisbrown.co.uk
Fax: 020-7393 4401 Tel: 020-7393 4400

D Lisa MANAGEMENT Ltd
PO Box 4050
Bracknell RG42 9BZ
e-mail: agents@lisad.co.uk Tel/Fax: 01344 643568

DALY PEARSON ASSOCIATES
(David Daly & Paul Pearson)
586A King's Road, London SW6 2DX
Website: www.dalypearson.co.uk
e-mail: agent@dalypearson.co.uk
Fax: 020-7610 9512 Tel: 020-7384 1036

DALY PEARSON ASSOCIATES (MANCHESTER)
16 King Street, Knutsford WA16 6DL
Website: www.dalypearson.co.uk
e-mail: north@dalypearson.co.uk
Fax: 01565 755334 Tel: 01565 631999

DALZELL & BERESFORD Ltd
26 Astwood Mews, London SW7 4DE
Fax: 020-7341 9412 Tel: 020-7341 9411

DANCERS
1 Charlotte Street, London W1T 1RD
Website: www.features.co.uk
e-mail: info@features.co.uk
Fax: 020-7636 1657 Tel: 020-7636 1473

DARRELL Emma MANAGEMENT
(Producers, Directors & Writers)
Hazelbank, 3 Chalfont Lane, Chorleywood, Herts WD3 5PR
e-mail: emma.mc@virgin.net
Fax: 01923 284064 Tel: 01923 284061

DAVID ARTISTES MANAGEMENT AGENCY Ltd The
F TV Md (Write or Phone)
26-28 Hammersmith Grove, London W6 7BA
Website: www.davidagency.net
e-mail: casting@davidagency.net Tel: 020-7967 7001

DAVIS Lena, JOHN BISHOP ASSOCIATES
Cotton's Farmhouse
Whiston Road, Cogenhoe
Northants NN7 1NL Tel: 01604 891487

DAWSON Caroline ASSOCIATES*
125 Gloucester Road, London SW7 4TE
e-mail: cda@cdalondon.com
Fax: 020-7373 1110 Tel: 020-7373 3323

DEALERS AGENCY BELFAST
22-31 Waring Street, Belfast BT1 2DX
Website: www.dealersagency.co.uk
e-mail: patrickduncan609@msn.com
Fax: 028-9043 6699 Tel: 028-9024 2726

DENMAN CASTING AGENCY
Burgess House, Main Street
Farnsfield, Notts NG22 8EF Tel/Fax: 01623 882272

DENMARK STREET MANAGEMENT•
PM Co-operative (Write SAE)
Packington Bridge Workspace
Unit 11, 1B Packington Square, London N1 7UA
Website: www.denmarkstreet.net
e-mail: mail@denmarkstreet.net
Fax: 020-7354 8558 Tel: 020-7354 8555

DEREK'S HANDS AGENCY
(Hand & Foot Modelling)
26-28 Hammersmith Grove, London W6 7BA
Website: www.derekshands.com
e-mail: casting@derekshands.com Tel: 020-8834 1609

Eva Pope

Lee Williams

Paris Jefferson

P H O T O G R A P H E R

07876 586601

Jack Blumenau Photography

020 8133 7012
07742 506757

info@blumenauphotography.co.uk
www.blumenauphotography.co.uk

Jonathan Keeble

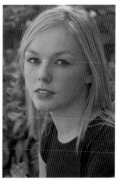

Zoe Russ

de WOLFE Felix*
PM (Write)
Kingsway House
103 Kingsway, London WC2B 6QX
e-mail: info@felixdewolfe.com
Fax: 020-7242 8119 | Tel: 020-7242 5066

DIAMOND MANAGEMENT*
31 Percy Street
London W1T 2DD
e-mail: agents@diman.co.uk
Fax: 020-7631 0500 | Tel: 020-7631 0400

DIESTENFELD Lily
(Personal Manager for 50+ ages)
(No unsolicited Mail/Calls from Actors)
28B Alexandra Grove
London N12 8HG | Tel: 020-8446 5379

DIMPLES THEATRICAL ACADEMY
84 Kirkhall Lane
Leigh, Lancs WN7 5QQ
e-mail: info@dimplesacademy.com
Fax: 01942 262232 | Tel: 01942 262012

DIRECT PERSONAL MANAGEMENT•
(Personal Manager: Daphne Franks)
St John's House
16 St John's Vale, London SE8 4EN
Website: www.directpm.co.uk
e-mail: daphne.franks@directpm.co.uk
Tel/Fax: 020-8694 1788

Park House
62 Lidgett Lane
Leeds LS8 1PL | Tel/Fax: 0113-266 4036

DOE John ASSOCIATES
26 Noko, 3/6 Banister Road, London W10 4AR
Website: www.johndoeassociates.com
e-mail: info@johndoeassociates.com
Mobile: 07979 558594 | Tel: 020-8960 2848

DON CAPO ENTERTAINMENT PRODUCTIONS
Suite B
5 South Bank Terrace
Surbiton, Surrey KT6 6DG
Website: www.doncapo.com
e-mail: info@doncapo.com
Mobile: 07884 056405 | Tel/Fax: 020-8390 8535

DOUBLE ACT CELEBRITY LOOK ALIKES
PO Box 25574, London NW7 3GB
Website: www.double-act.co.uk
e-mail: info@double-act.co.uk
Fax: 020-8201 1795 | Tel: 020-8381 0151

DOUBLEFVOICES
(Singers Agency)
1 Hunters Lodge, Bodiam, East Sussex TN32 5UE
e-mail: rob@doublefvoices.com
Mobile: 07976 927764 | Tel: 01580 830071

DOWNES PRESENTERS AGENCY
96 Broadway, Bexleyheath, Kent DA6 7DE
Website: www.presentersagency.com
e-mail: downes@presentersagency.com
Tel: 020-8304 0541

DP MANAGEMENT
1 Euston Road, London NW1 2SA
e-mail: danny@dpmanagement.org
Fax: 020-7278 3466 | Tel: 020-7843 4331

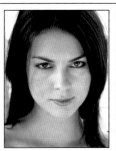
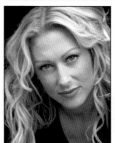
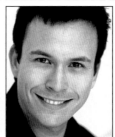
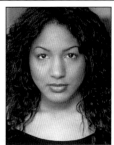

KAREN SCOTT PHOTOGRAPHY

07958 975 950
www.karenscottphotography.com

DQ MANAGEMENT
Suite 21, Kingsway House
134/140 Church Road, Hove, East Sussex BN3 2DL
Website: www.dqmanagement.com
e-mail: info@dqmanagement.com
Fax: 01273 779065 Tel: 01273 721221

DRB ENTERTAINMENT AGENCY
28 Blakes Quay, Gas Works Road, Reading, Berks RG1 3EN
Website: www.drbentertainment.co.uk
e-mail: info@drbentertainment.co.uk Tel: 0118-958 3936

DREW Bryan Ltd
PM Write
Mezzanine, Quadrant House
80-82 Regent Street, London W1B 5AU
e-mail: bryan@bryandrewltd.com
Fax: 020-7437 0561 Tel: 020-7437 2293

DUDDRIDGE Paul MANAGEMENT
32 Rathbone Place, London W1T 1JJ
Website: www.paulduddridge.com
e-mail: mail@paulduddridge.com
Fax: 020-7580 3480 Tel: 020-7580 3580

DYNAMITE MANAGEMENT
Performance House, 20 Passey House, London SE9 5DQ
Website: www.dynamitemanagement.com
e-mail: rs@dynamitemanagement.com Tel: 020-8859 4010

EARLE Kenneth PERSONAL MANAGEMENT
214 Brixton Road, London SW9 6AP
Website: www.entertainment-kennethearle.co.uk
e-mail: kennethearle@agents-uk.com
Fax: 020-7274 9529 Tel: 020-7274 1219

EARNSHAW Susi MANAGEMENT
PM
68 High Street, Barnet, Herts EN5 5SJ
Website: www.susiearnshaw.co.uk
e-mail: casting@susiearnshaw.co.uk
Fax: 020-8364 9618 Tel: 020-8441 5010

EAST 15 MANAGEMENT
(Only represent E15 Graduates)
East 15 Acting School, Rectory Lane
Loughton, Essex IG10 3RY
e-mail: e15management@yahoo.com
Mobile: 07748 704718 Tel/Fax: 020-8508 3746

EDEN Shelly ASSOCIATES Ltd
The Old Factory, Minus One House
Lyttelton Road, London E10 5NQ
e-mail: shellyeden@aol.com Tel/Fax: 020-8558 3536

EDLER Debbie MANAGEMENT (DEM)
37 Russet Way, Peasedown St John, Bath BA2 8ST
Website: www.dem.1colony.com
e-mail: dem2005@eircom.net Tel/Fax: 01761 436631

EDWARDS REPRESENTATION Joyce
PM (Write)
4 Turner Close, London SW9 6UQ
e-mail: joyce.edwards@virgin.net
Fax: 020-7820 1845 Tel: 020-7735 5736

EJA ASSOCIATES
Lower Ground Floor
86 Vassall Road, London SW9 6JA
e-mail: ejaassociates@aol.com
Mobile: 07891 632946 Tel: 020-7564 2688

EKA MODEL & ACTOR MANAGEMENT
The Warehouse Studios, Glaziers Lane
Culcheth, Warrington WA3 4AQ
Website: www.eka-agency.com
e-mail: kate@eka-agency.com
Fax: 01925 767563 Tel: 01925 767574

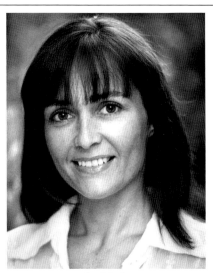

rachael lindsay

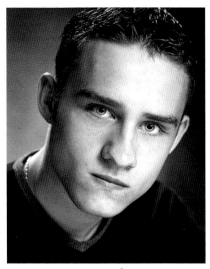

peter ash

michael pollard
photographer
manchester

tel : 0161 456 7470
email : info@michaelpollard.co.uk
website : www.michaelpollard.co.uk

studio/location/student rates

ELLIOTT AGENCY The
94 Roundhill Crescent, Brighton BN2 3FR
Website: www.elliottagency.co.uk
e-mail: info@elliottagency.co.uk Tel: 01273 683882

ELLIS Bill Ltd
(See A & B PERSONAL MANAGEMENT Ltd)

EMPTAGE HALLETT*
24 Poland Street, London W1F 8QL
e-mail: mail@emptagehallett.co.uk
Fax: 020-7287 4411 Tel: 020-7287 5511

2nd Floor, 3-5 The Balcony
Castle Arcade, Cardiff CF10 1BU
e-mail: gwen.price@emptagehallett.co.uk
Fax: 029-2034 4206 Tel: 029-2034 4205

ENGLISH Doreen '95
(Write or Phone)
4 Selsey Avenue
Aldwick, Bognor Regis
West Sussex PO21 2QZ Tel/Fax: 01243 825968

EPSTEIN June ASSOCIATES
(Write)
Flat 1, 62 Compayne Gardens
London NW6 3RY
e-mail: june@june-epstein-associates.co.uk
Fax: 020-7328 0684 Tel: 020-7328 0864

ESOTERIC ENTERTAINMENTS Ltd
(For Psychics & Mystics)
Maidstone TV Studios
New Cut Road, Vintners Park
Maidstone, Kent ME14 5NZ
Website: www.esoteric-e.co.uk
e-mail: info@esoteric-e.co.uk Tel: 08700 111331

ESSANAY*
PM (Write)
PO Box 44394, London SW20 0YP
e-mail: info@essanay.co.uk
Fax: 020-3258 5037 Tel: 020-8879 7076

ETHNICS ARTISTE AGENCY
86 Elphinstone Road
Walthamstow, London E17 5EX
Fax: 020-8523 4523 Tel: 020-8523 4242

ET-NIK-A PRIME MANAGEMENT & CASTINGS Ltd
30 Great Portland Street
London W1W 8QU
Website: www.et-nik-a.com
e-mail: info@et-nik-a.com
Fax: 020-7299 3558 Tel: 020-7299 3555

EUROKIDS & ADULTS INTERNATIONAL CASTING & MODEL AGENCY
The Warehouse Studios
Glaziers Lane, Culcheth, Warrington WA3 4AQ
Website: www.eka-agency.com
e-mail: becky@eka-agency.com
Fax: 01925 767563 Tel: 01925 767574

EVANS & REISS*
100 Fawe Park Road
London SW15 2EA
e-mail: marcia@evansandreiss.co.uk
Fax: 020-8877 0307 Tel: 020-8877 3755

EVANS Jacque MANAGEMENT Ltd
Top Floor Suite
14 Holmesley Road, London SE23 1PJ
Website: www.jacqueevansltd.com
Fax: 020-8699 5192 Tel: 020-8699 1202

EVOLUTION TALENT MANAGEMENT
The Truman Brewery Building
Studio 21, 91 Brick Lane, London E1 6QL
Website: www.evolutionmngt.com
e-mail: info@evolutionmngt.com
Fax: 020-7375 2752 Tel: 020-7053 2128

EYE The
Website: www.theeyecasting.com
e-mail: jody@theeyecasting.com Tel: 020-7735 2094

FARNES Norma MANAGEMENT
9 Orme Court, London W2 4RL
e-mail: irenefawkes@btconnect.com
Fax: 020-7792 2110 Tel: 020-7727 1544

FAWKES Irene MANAGEMENT
2nd Floor
91A Rivington Street, London EC2A 3AY
e-mail: irenefawkes@btconnect.com
Fax: 020-7613 0769 Tel: 020-7729 8559

FBI AGENCY Ltd The
PO Box 250, Leeds LS1 2AZ
Website: www.fbi-agency.ltd.uk
e-mail: casting@fbi-agency.ltd.uk
Fax: 0113-279 7270 Tel: 07050 222747

FEAST MANAGEMENT Ltd*
10 Primrose Hill Studios
Fitzroy Road, London NW1 8TR
e-mail: office@feastmanagement.co.uk
Fax: 020-7586 9817 Tel: 020-7586 5502

FEATURES
1 Charlotte Street, London W1T 1RD
Website: www.features.co.uk
e-mail: info@features.co.uk
Fax: 020-7636 1657 Tel: 020-7637 1487

FIELD Alan ASSOCIATES
3 The Spinney, Bakers Hill
Hadley Common, Herts EN5 5QJ
e-mail: alan@alanfield.com
Fax: 020-8447 0657 Tel: 020-8441 1137

FILM RIGHTS Ltd
PM (Write)
Mezzanine, Quadrant House
80-82 Regent Street, London W1B 5AU
Fax: 020-7734 0044 Tel: 020-7734 9911

FINCH & PARTNERS
4-8 Heddon Street, London W1B 4BS
Website: www.finchandpartners.com
e-mail: kat@finchandpartners.com
Fax: 020-7287 6420 Tel: 020-7851 7140

FIRST ACT PERSONAL MANAGEMENT
2 Saint Michaels
New Arley, Coventry CV7 8PY
Website: www.spotlightagent.info/firstact
e-mail: firstactpm@aol.com
Fax: 01676 542777 Tel: 01676 540285

FIRST CALL MANAGEMENT
29-30 Dame Street, Dublin 2, Eire
e-mail: fcm@indigo.ie
Fax: 00 353 1 679 8353 Tel: 00 353 1 679 8401

FITZGERALD Sheridan MANAGEMENT
(For representation write only with SAE)
87 Western Road, Upton Park
London E13 9JE Tel: 020-8471 9814

FLAIR TALENT
43 Bevin Square, London SW17 7BB
Website: www.flairtalent.com
e-mail: aaron@flairtalent.com Tel: 020-8672 6486

FLETCHER ASSOCIATES
(Broadcast & Media)
25 Parkway, London N20 0XN
Fax: 020-8361 8866 Tel: 020-8361 8061

FLETCHER JACOB
(Artist Management)
First Floor, 77 Leonard Street
London EC2A 4QS
e-mail: info@fletcherjacob.co.uk Tel: 020-7613 7234

FOSTER Sharon MANAGEMENT
318 The Greenhouse
Custard Factory
Gibb Street, Birmingham B9 4AA
Website: www.sharonfoster.co.uk
e-mail: mail@sharonfoster.co.uk Tel: 0121-224 8228

FOX Clare ASSOCIATES
(Designers & Lighting Designers)
9 Plympton Road, London NW6 7EH
e-mail: cimfox@yahoo.co.uk
Fax: 020-7328 7494 Tel: 01483 535818

FRENCH Linda
(See ALEXANDER PERSONAL MANAGEMENT Ltd)

FRESH MANAGEMENT
7 Marshall Road
Levenshulme, Manchester M19 2EG
e-mail: freshmanagement@btconnect.com
 Tel/Fax: 0161-434 8333

FRESH PARTNERS Ltd
19-21 Nile Street, London N1 7LL
Website: www.fresh-partners.com
e-mail: hello@fresh-partners.com
Fax: 020-7566 1789 Tel: 020-7566 1770

FRONTLINE ACTORS' AGENCY DUBLIN
30/31 Wicklow Street, Dublin 2, Eire
Website: www.frontlineactors.com
e-mail: frontlineactors@eircom.net Tel: 00 353 1 6359882

FRONTLINE MANAGEMENT•
PM Co-operative
(Agent Katherine Gregor)
Colombo Centre, 34-68 Colombo Street, London SE1 8DP
Website: www.frontlinemanagement.org
e-mail: agents@frontlinemanagement.org
 Tel/Fax: 020-7261 9466

FUNKY BEETROOT CELEBRITY MANAGEMENT Ltd
(Actors, TV Celebrities, Casting & Personal Management)
PO Box 143, Faversham, Kent ME13 9LP
Website: www.funky-beetroot.com
e-mail: info@funky-beetroot.com
Fax: 01227 752300 Tel: 01227 751549

FUSHION PUKKA BOSH
(London & New York)
27 Old Gloucester Street, London WC1N 3XX
e-mail: enquirieslondon@fushion-uk.com
Fax: 08700 111020 Tel: 08700 111100

GAGAN Hilary ASSOCIATES*
PM
187 Drury Lane, London WC2B 5QD
e-mail: hilary@hgassoc.freeserve.co.uk
Fax: 020-7430 1869 Tel: 020-7404 8794

GALLIARDS MANAGEMENT
Dunans, Glendaruel
Argyll PA22 3AD
Website: www.galliardsmanagement.co.uk
e-mail: galliards@arbu.co.uk Tel: 01369 820116

Michael Douglas Thora Birch Dennis Quaid Vin Diesel

jamie hughes 07850 122977
photography www.jamiehughesphotography.com/headshots

GALLOWAYS ONE
15 Lexham Mews, London W8 6JW
e-mail: hugh@gallowaysone.com
Fax: 020-7376 2416　　　　Tel: 020-7376 2288

GARDNER HERRITY Ltd*
24 Conway Street, London W1T 6BG
e-mail: info@gardnerherrity.co.uk
Fax: 020-7388 0688　　　　Tel: 020-7388 0088

GARRETT Michael
(See GLOBAL ARTISTS)

GARRICKS*
5 The Old School House
The Lanterns, Bridge Lane, London SW11 3AD
e-mail: info@garricks.net
Fax: 020-7738 1881　　　　Tel: 020-7738 1600

GAY Noel ARTISTS
19 Denmark Street, London WC2H 8NA
Website: www.noelgay.com
Fax: 020-7287 1816　　　　Tel: 020-7836 3941

GILBERT & PAYNE
Room 236, 2nd Floor, Linen Hall
162-168 Regent Street, London W1B 5TB
e-mail: ee@gilbertandpayne.com
Fax: 020-7494 3787　　　　Tel: 020-7734 7505

GLASS Eric Ltd
25 Ladbroke Crescent
Notting Hill, London W11 1PS
e-mail: eglassltd@aol.com
Fax: 020-7229 6220　　　　Tel: 020-7229 9500

GLOBAL ARTISTS*
23 Haymarket, London SW1Y 4DG
Website: www.globalartists.co.uk
e-mail: info@globalartists.co.uk
Fax: 020-7839 4555　　　　Tel: 020-7839 4888

GLYN MANAGEMENT
The Old School House
Brettenham, Ipswich IP7 7QP
e-mail: glyn.management@tesco.net
Fax: 01449 736117　　　　Tel: 01449 737695

GO ENTERTAINMENTS Ltd
(Circus Artistes, Chinese State Circus, Cirque Surreal,
Bolshoi Circus "Spirit of The Horse")
The Arts Exchange
Congleton, Cheshire CW12 1JG
Website: www.arts-exchange.com
e-mail: info@arts-exchange.com
Fax: 01260 270777　　　　Tel: 01260 276627

GOLDMAN KING
(Comedians, Comic Performers, Actors, Studio Warm-ups,
Voice-Overs)
16 St Albans Road
Kingston, Surrey KT2 5HQ
Website: www.goldmanking.com
e-mail: contacts@goldmanking.com　　Tel: 020-8287 1199

GORDON & FRENCH*
(Write)
12-13 Poland Street, London W1F 8QB
e-mail: mail@gordonandfrench.net
Fax: 020-7734 4832　　　　Tel: 020-7734 4818

GOSS Gerald Ltd
19 Gloucester Street, London SW1V 2DB
e-mail: info@geraldgoss.co.uk
Fax: 020-7592 9301　　　　Tel: 020-7592 9202

G.O.T. PERSONAL MANAGEMENT
38 Garrison Court
Mount Garrison
Hitchin, Herts SG4 9AA
e-mail: info@gotproductions.co.uk　　Tel: 01462 420400

Caroline Summers

Session includes make up artist

020-7223 7669
07931 301234

www.homepage.mac.com/carolinesummers

Short notice possible

GRAHAM David PERSONAL MANAGEMENT (DGPM)
The Studio
107A Middleton Road, London E8 4LN
e-mail: infodgpm@aol.com Tel/Fax: 020-7241 6752

GRANTHAM-HAZELDINE Ltd
Suite 605, The Linen Hall
162-168 Regent Street, London W1B 5TG
e-mail: agents@granthamhazeldine.com
Fax: 020-7038 3737 Tel: 020-7038 3739

GRAY Darren MANAGEMENT
(Specialising in representing/promoting Australian Artists)
2 Marston Lane
Portsmouth, Hampshire PO3 5TW
Website: www.darrengraymanagement.co.uk
e-mail: darren.gray1@virgin.net
Fax: 023-9267 7227 Tel: 023-9269 9973

GRAYS MANAGEMENT & ASSOCIATES
PM
Panther House
38 Mount Pleasant, London WC1X 0AP
Website: www.graysman.com
e-mail: e-mail@graysmanagement.idps.co.uk
Fax: 020-7278 1091 Tel: 020-7278 1054

GREEN & UNDERWOOD
PM (Write)
PO Box 44394, London SW20 0YP
e-mail: info@greenandunderwood.com
Fax: 020-3258 5037 Tel: 020-8879 1775

GREIG Miranda ASSOCIATES Ltd*
92 Englewood Road, London SW12 9NY
e-mail: mail@mirandagreigassoc.co.uk
Fax: 020-7228 1400 Tel: 020-7228 1200

GRESHAM Carl GROUP
PO Box 3, Bradford
West Yorkshire BD1 4QN
Website: www.carlgresham.com
e-mail: gresh@carlgresham.co.uk
Fax: 01274 827161 Tel: 01274 735880

GRIDMODELS AGENCY
(Models)
8 Kerry Path, Arklow Road
London SE14 6DY
Website: www.gridmodels.com
e-mail: info@gridmodels.com
Fax: 020-8694 9159 Tel: 020-8694 9126

GRIFFIN Sandra MANAGEMENT
6 Ryde Place, Richmond Road
East Twickenham, Middlesex TW1 2EH
e-mail: office@sandragriffin.com
Fax: 020-8744 1812 Tel: 020-8891 5676

GROUP 3 ASSOCIATES
PM (Henry Davies)
35D Newton Road
London W2 5JR Tel: 020-7221 4989

GURNETT J. PERSONAL MANAGEMENT Ltd
12 Newburgh Street, London W1F 7RP
Website: www.jgpm.co.uk
e-mail: mail@jgpm.co.uk
Fax: 020-7287 9642 Tel: 020-7440 1850

HALLY WILLIAMS AGENCY The
121 Grange Road
Rathfarnham, Dublin 14, Eire
e-mail: hallywilliams@eircom.net
Fax: 00 353 1 4933076 Tel: 00 353 1 4933685

HAMBLETON Patrick ASSOCIATES
Top Floor, 136 Englefield Road, London N1 3LQ
e-mail: patrick@patrickhambleton.co.uk
Fax: 0870 2848554 Tel: 020-7424 5832

JOE LONDON
PHOTOGRAPHY
www.joelondonphotography.com
07941 686 203.

SYLVESTER McCOY LYNSEY BAXTER HUGH ARMSTRONG

HAMILTON HODELL Ltd*
5th Floor
66-68 Margaret Street, London W1W 8SR
Website: www.hamiltonhodell.co.uk
e-mail: info@hamiltonhodell.co.uk
Fax: 020-7636 1226 Tel: 020-7636 1221

HandE CASTING ADVERTISING AGENCY
Epping Film Studios
Brickfield Business Centre
Thornwood High Road, Epping, Essex CM16 6TH
Website: www.hande.org
e-mail: info@hande.org
Fax: 01992 570601 Tel: 01992 570662

HARGREAVES Alison MANAGEMENT
(Designers/Lighting Designers/Directors)
89 Temple Road, London NW2 6PN
Website: www.alisonhargreaves.co.uk
e-mail: agent@alisonhargreaves.co.uk Tel: 020-8438 0112

HARRIS AGENCY Ltd The
52 Forty Avenue, Wembley Park
Middlesex HA9 8LQ
e-mail: theharrisagency@ukonline.co.uk
Fax: 020-8908 4455 Tel: 020-8908 4451

HARRIS Chris
(See ACTUAL MANAGEMENT Ltd)

HARRIS PERSONAL MANAGEMENT Ltd*
(Formerly Harrispearson Management Ltd)
64-66 Millman Street
Bloomsbury, London WC1N 3EF
Website: www.harrispersonalmanagement.com
e-mail: agent@harrispersonalmanagement.com
Fax: 020-7430 9229 Tel: 020-7430 9890

HARRIS PERSONAL MANAGEMENT Ltd (COMMERCIALS)*
64-66 Millman Street
Bloomsbury, London WC1N 3EF
Website: www.harrispersonalmanagement.com
e-mail: commercials@harrispersonalmanagement.com
Fax: 020-7430 9229 Tel: 020-7430 9890

HARRISON Penny BSA Ltd
Trinity Lodge
25 Trinity Crescent, London SW17 7AG
e-mail: harrisonbsa@aol.com
Fax: 020-8672 8971 Tel: 020-8672 0136

HAT MANAGEMENT
(Neil Howarth)
29 Cromwell Avenue, Denton, Stockport, Cheshire SK5 6GA
e-mail: hat.mgmt@hotmail.co.uk
Fax: 0161-336 1386 Tel: 0161-336 0252

HATSTAND CIRCUS
(Special Skills Perfomers)
98 Milligan Street, West Ferry, London E14 8AS
Website: www.hatstandcircus.co.uk
e-mail: helenahatstand@btconnect.com
 Tel/Fax: 020-7538 3368

HATTON McEWAN
PM (Write) (Stephen Hatton, Aileen McEwan)
PO Box 37385, London N1 7XF
Website: www.thetalent.biz
e-mail: info@thetalent.biz
Fax: 020-7251 9081 Tel: 020-7253 4770

HAZEMEAD Ltd
(Entertainment Consultants)
Camellia House, 38 Orchard Road
Sundridge Park, Bromley, Kent BR1 2PS
Fax: 020-8460 5830 Tel: 0870 2402082

Robert Kilroy-Silk Ruth Shephard Anthony Marsh Michelle C

Howard Sayer Photographer
www.howardsayer.com t: 020 8123 0251 howard@howardsayer.com

Nick Gregan
PHOTOGRAPHY

**The easiest and the best headshot you'll ever have -
By one of London's premier theatrical photographers.**

**For contemporary, natural headshots for the acting profession, contact Nick on
Tel: 020 75381249 | Mobile: 07774 421878 | www.nickgregan.com**

H C A
(See COOKE Howard ASSOCIATES)

HEATHCOTE George MANAGEMENT
58 Northdown Street, London N1 9BS
e-mail: gheathcote@freeuk.com
Fax: 020-7713 5233 Tel: 020-7713 5232

HENRIETTA RABBIT CHILDREN'S ENTERTAINMENTS AGENCY Ltd
(Magiciennes, Punch & Judy, Balloonologists, Stiltwalkers, Face Painters, Jugglers etc)
The Warren, 12 Eden Close, York YO24 2RD
Website: www.henriettarabbit.co.uk
e-mail: info@henriettarabbit.co.uk Tel: 01904 345404

HENRY'S AGENCY
53 Westbury, Rochford, Essex SS4 1UL
Website: www.henrysagency.co.uk
e-mail: info@henrysagency.co.uk Tel/Fax: 01702 541413

HICKS Jeremy ASSOCIATES
114-115 Tottenham Court Road, London W1T 5AH
Website: www.jeremyhicks.com
e-mail: info@jeremyhicks.com
Fax: 020-7383 2777 Tel: 020-7383 2000

HILL Edward MANAGEMENT
Dolphin House
2-5 Manchester Street BN2 1TF
e-mail: info@edagent.com Tel: 0870 0673505

HILTON Elinor ASSOCIATES
BAC
Lavender Hill, London SW11 5TF
Website: www.elinorhilton.com
e-mail: info@elinorhilton.com
Fax: 020-7924 4636 Tel: 020-7738 9574

HINDIN Dee ASSOCIATES
(Dee Hindin & Sara-Jane Hindin)
9B Brunswick Mews
Great Cumberland Place, London W1H 7FB
e-mail: dha@netbase.co.uk
Fax: 020-7258 0651 Tel: 020-7723 3706

HIRED HANDS
12 Cressy Road, London NW3 2LY
Website: www.hiredhandsmodels.com
e-mail: models@hiredhands.freeserve.co.uk
Fax: 020-7267 1030 Tel: 020-7267 9212

HOBBS Liz GROUP Ltd
(Artiste Management)
65 London Road, Newark, Notts NG24 1RZ
Website: www.lizhobbsgroup.com
e-mail: casting@lizhobbsgroup.com
Fax: 0870 3337009 Tel: 0870 0702702

HOBSON'S ACTORS
62 Chiswick High Road
Chiswick, London W4 1SY
Website: www.hobsons-international.com
e-mail: actors@hobsons-international.com
Fax: 020-8996 5350 Tel: 020-8995 3628

HOLLOWOOD Jane ASSOCIATES Ltd
Apartment 17
113 Newton Street, Manchester M1 1AE
e-mail: janehollowood@ukonline.co.uk
Fax: 0161-237 9142 Tel: 0161-237 9141

HOLLY Dave ARTS MEDIA SERVICES
The Annexe, 23 Eastwood Gardens
Felling, Tyne & Wear NE10 0AH
Fax: 0191-438 2722 Tel: 0191-438 2711

harris personal management

Melanie Harris Rosie Nimmo Georgina Coombs

Personal Representation	64 - 66 Millman St
Film	Bloomsbury
Television	London WC1N 3EF
Theatre	T: +44 (0)207 430 9890
Commercials	F: +44 (0)207 430 9229
	E: agent@harrispersonalmanagement.com
Members of the P M A	www.harrispersonalmanagement.com

Lucy Smith ~ photographer

Ruth Raymond

Victor Banerjee

Debra Teng

Jonny Weir

Cosima Shaw

Telephone
020 8521 1347

www.thatlucy.co.uk

Photos
for

Actors

Judith Jacob

Jennifer Glyn

Barry Ruth

Natural light.
Digital photography.
Sameday turnaround
on request.

Styling, Make-up
and Photography
by
Maxine Evans

You can contact Maxine on: 07966 130 426 / 020 8534 3002 maxinevans@aol.com

HOLMES Kim SHOWBUSINESS ENTERTAINMENT AGENCY Ltd
8 Charles Close
Ilkeston, Derbyshire DE7 5AF
Fax: 0115-946 1831 Tel: 0115-973 5445

HOPE Sally ASSOCIATES*
108 Leonard Street
London EC2A 4XS
Website: www.sallyhope.biz
e-mail: casting@sallyhope.biz
Fax: 020-7613 4848 Tel: 020-7613 5353

HORSEY Dick MANAGEMENT Ltd
Suite 1, Cottingham House
Chorleywood Road
Rickmansworth, Herts WD3 4EP
Website: www.dhmlimited.co.uk
e-mail: roger@dhmlimited.co.uk Mobile: 07850 112211
Tel/Fax: 01923 710614

HOWARD Amanda ASSOCIATES Ltd*
21 Berwick Street
London W1F 0PZ
Website: www.amandahowardassociates.co.uk
e-mail: mail@amandahowardassociates.co.uk
Fax: 020-7287 7785 Tel: 020-7287 9277

HOWARD Richard ASSOCIATES
6 Upper Hollingdean Road
Brighton BN1 7GA
Website: www.richardhowardassociates.co.uk
e-mail: info@richardhowardassociates.co.uk
 Tel/Fax: 01273 539530

HOWE Janet
40 Princess Street
Manchester M1 6DE
e-mail: info@janethowe.com
Mobile: 07801 942178 Tel/Fax: 0161-234 0142

56 The Ironmarket
Newcastle, Staffordshire ST5 1PE
e-mail: janet@jhowecasting.fsbusiness.co.uk
Mobile: 07801 942178 Tel: 01782 661777

HOWELL Philippa
(See PHPM)

HUDSON Nancy ASSOCIATES Ltd
3rd Floor
50 South Molton Street
London W1K 5SB
Website: www.nancyhudsonassociates.com
e-mail: agents@nancyhudsonassociates.com
 Tel: 020-7499 5548

Smile Talent Agents & Personal Managers

The Office Hope Cottage London Road Newport Essex CB11 3PN
t: 01799 541113 e: smile-talent@stepc.fsnet.co.uk

HUNTER Bernard ASSOCIATES
13 Spencer Gardens, London SW14 7AH
Fax: 020-8392 9334 Tel: 020-8878 6308

I C M (International Creative Management)*
Oxford House, 76 Oxford Street, London W1D 1BS
Fax: 020-7323 0101 Tel: 020-7636 6565

ICON ACTORS MANAGEMENT
Tanzaro House, Ardwick Green North
Manchester M12 6FZ
Website: www.iconactors.net
e-mail: info@iconactors.net
Fax: 0161-273 4567 Tel: 0161-273 3344

I-MAGE CASTINGS
Regent House Business Centre
Suite 22, 24-25 Nutford Pl, Marble Arch, London W1H 5YN
Website: www.i-mage.uk.com
e-mail: jane@i-mage.uk.com
Fax: 020-7725 7004 Tel: 020-7725 7003

IMAGE MANAGEMENT
The Media Centre
94 Roundhill Crescent, Brighton, East Sussex BN2 3FR
Website: www.imagemanagement.co.uk
e-mail: mail@imagemanagement.co.uk
Fax: 01273 680689 Tel: 01273 695290

I.M.L.•
PM Co-operative
Oval House, 52-54 Kennington Oval, London SE11 5SW
Website: www.iml.org.uk
e-mail: iml.london@btconnect.com Tel/Fax: 020-7587 1080

IMPACT INTERNATIONAL MANAGEMENT
2nd Floor, 16-18 Balderton Street, London W1K 6TN
e-mail: colin@impactinternationalgroup.com
Fax: 020-7495 6515 Tel: 020-7495 6655

INDEPENDENT THEATRE WORKSHOP The
2 Mornington Road, Ranelagh, Dublin 6, Eire
Website: www.independent-theatre-workshop.com
e-mail: info@independent-theatre-workshop.com
Tel/Fax: 00 353 1 4968808

INSPIRATION MANAGEMENT
PM Co-operative
Room 227, The Aberdeen Centre
22-24 Highbury Grove, London N5 2EA
Website: www.inspirationmanagement.org.uk
e-mail: mail@inspirationmanagement.org.uk
Fax: 020-7704 8497 Tel: 020-7704 0440

INTER-CITY CASTING
PM
Portland Tower, Portland Street, Manchester M1 3LF
Website: www.iccast.co.uk
e-mail: mail@iccast.co.uk Tel/Fax: 0161-238 4950

INTERNATIONAL ARTISTES Ltd*
4th Floor, Holborn Hall
193-197 High Holborn, London WC1V 7BD
Website: www.intart.co.uk
e-mail: reception@intart.co.uk
Fax: 020-7404 9865 Tel: 020-7025 0600

INTERNATIONAL ARTISTES MIDLANDS OFFICE
Lapley Hall, Lapley, Staffs ST19 9JR
e-mail: cdavis@intart.co.uk
Fax: 01785 841992 Tel: 01785 841991

INTERNATIONAL COLLECTIVE ARTIST MANAGEMENT
Golden Cross House
8 Duncannon Street, The Strand, London WC2N 4JF
Website: www.internationalcollective.co.uk
e-mail: enquiries@internationalcollective.co.uk
Fax: 020-7484 5100 Tel: 020-7484 5080

harry rafique
photography

07986 679 498
www.hr-photographer.co.uk
020 7266 5398

Markham & Marsden
Personal Management for Actors & Directors
in the fields of Film, Television, Theatre, Radio & Voice Work

405 Strand London WC2R 0NE
t: 020 7836 4111 f: 020 7836 4222
e: info@markham-marsden.com w: markham-marsden.com

INTERNATIONAL THEATRE & MUSIC Ltd
(Piers Chater Robinson)
Garden Studios
11-15 Betterton Street
Covent Garden, London WC2H 9BP
Website: www.internationaltheatreandmusic.com
e-mail: info@internationaltheatreandmusic.com
Fax: 020-7379 0801 Tel: 020-7470 8786

JAA
(See ALTARAS Jonathan ASSOCIATES Ltd)

JABBERWOCKY AGENCY
(Children, Teenagers & Adults)
Production House
The Hop Farm Country Park, Beltring
Paddock Wood, Kent TN12 6PY
Website: www.jabberwockyagency.com
e-mail: info@jabberwockyagency.com
Mobile: 07890 983090 Tel: 01622 871851

JACOB DRAMATICS MANAGEMENT
No 4 Raby Drive, East Herrington
Sunderland, Tyne & Wear S23 3QE
e-mail: jacobjky@aol.com Tel/Fax: 0191-551 2954

JAFFREY MANAGEMENT Ltd*
(Jennifer Jaffrey)
The Double Lodge
Pinewood Studios
Iver Heath, Bucks SL0 0NH
Website: www.jaffreyactors.co.uk
e-mail: castings@jaffreyactors.co.uk
Fax: 01753 785163 Tel: 01753 785162

JAMESON Joy Ltd
PM
21 Uxbridge Street
Kensington, London W8 7TQ
e-mail: joy@jote.freeuk.com
Fax: 020-7985 0842 Tel: 020-7221 0990

JAMES Susan
(See SJ MANAGEMENT Ltd)

JAY Alex PERSONAL MANAGEMENT
8 Higher Newmarket Road
Newmarket, Gloucestershire GL6 0RP
e-mail: alexjay@alex-jay-pm.freeserve.co.uk
 Tel/Fax: 01453 834783

JB ASSOCIATES*
First Floor
3 Stevenson Square, Manchester M1 1DN
Website: www.j-b-a.net
e-mail: info@j-b-a.net
Fax: 0161-237 1809 Tel: 0161-237 1808

JEFFREY & WHITE MANAGEMENT*
PM
9-15 Neal Street
London WC2H 9PW
Fax: 020-7240 0007 Tel: 020-7240 7000

J.G.M.
15 Lexham Mews, London W8 6JW
Website: www.jgmtalent.com
e-mail: mail@jgmtalent.com
Fax: 020-7376 2416 Tel: 020-7376 2414

JIGSAW ARTS MANAGEMENT
64-66 High Street
Barnet, Herts EN5 5SJ
Website: www.jigsaw-arts.co.uk/agency
e-mail: admin@jigsaw-arts.co.uk
Fax: 020-8447 4531 Tel: 020-8447 4530

JLM PERSONAL MANAGEMENT*
(Janet Lynn Malone, Sharon Henry)
259 Acton Lane, London W4 5DG
e-mail: jlm.pm@btconnect.com
Fax: 020-8747 8286 Tel: 020-8747 8223

J.M. MANAGEMENT
20 Pembroke Road
North Wembley
Middlesex HA9 7PD Tel/Fax: 020-8908 0502

JOHNSON WHITELEY Ltd
12 Argyll Mansions
Hammersmith Road
London W14 8QG
e-mail: jwltd@freeuk.com
Fax: 020-7348 0164 Tel: 020-7348 0163

JOHNSTON & MATHERS ASSOCIATES Ltd
PO Box 3167
Barnet EN5 2WA
Website: www.johnstonandmathers.com
e-mail: johnstonmathers@aol.com
Fax: 020-8449 2386 Tel: 020-8449 4968

JPA MANAGEMENT
30 Daws Hill Lane
High Wycombe, Bucks HP11 1PW
Website: www.jackiepalmer.co.uk
e-mail: jackie.palmer@btinternet.com
Fax: 01494 510479 Tel: 01494 520978

K ENTERTAINMENTS Ltd
140-142 St John Street
London EC1V 4UA
Website: www.k-entertainments.com
e-mail: info@k-entertainments.com
Fax: 07092 809947 Tel: 020-7253 9637

Clive Rowe

Joseph Millson

Caroline Fitzgerald

Natalie Ogle

P T P

Imaging
for the
Performing
Artist

KAL MANAGEMENT
(Write)
95 Gloucester Road, Hampton, Middlesex TW12 2UW
Website: www.kaplan-kaye.co.uk
e-mail: kaplan222@aol.com
Fax: 020-8979 6487 Tel: 020-8783 0039

KANAL Roberta AGENCY
82 Constance Road
Twickenham, Middlesex TW2 7JA
e-mail: roberta.kanal@dsl.pipex.com
Tel/Fax: 020-8894 7952 Tel: 020-8894 2277

KARUSHI MANAGEMENT
17 Dufferin Street, London EC1Y 8PD
Website: www.karushi.com
e-mail: lisa@karushi.com
Fax: 0845 9005522 Tel: 0845 9005511

KASTKIDZ
40 Sunnybank Road
Unsworth, Bury BL9 8HF
Website: www.kastkidz.com
e-mail: kastkidz@ntlworld.com
Fax: 0161-796 7073 Mobile: 07905 646832

KEDDIE SCOTT ASSOCIATES
107-111 Fleet Street, London EC4A 2AB
Website: www.ks-ass.co.uk
e-mail: fiona@ks-ass.co.uk
Fax: 020-7936 9100 Tel: 020-7936 9058

KELLY'S KIND
(Dance & Choreography Agency)
Third Floor, 17-18 Margaret Street
London W1W 8RP
e-mail: office@kellyskind.co.uk Tel: 0870 8701299

Nyland Management Ltd
Representing Actors & Actresses
Television ~ Film ~ Theatre ~ Commercials ~ Radio

20 School Lane, Heaton Chapel, Stockport, SK4 5DG

Tel/Fax: 0161 442 2224 Email: nylandmgmt@freenet.co.uk

KENIS Steve & Co*
Royalty House, 72-74 Dean Street, London W1D 3SG
e-mail: sk@sknco.com
Fax: 020-7287 6328 Tel: 020-7434 9055

KENT Tim ASSOCIATES Ltd
Pinewood Studios
Pinewood Road, Iver Heath, Bucks SL0 0NH
e-mail: castings@tkassociates.co.uk
Fax: 01753 655622 Tel: 01753 655517

KEW PERSONAL MANAGEMENT
PO Box 48458, London SE15 5WW
Website: www.kewpersonalmanagement.com
e-mail: kate@kewpersonalmanagement.com
Mobile: 07889 877127 Tel: 020-7277 1440

KING Adrian ASSOCIATES
33 Marlborough Mansions, Cannon Hill, London NW6 1JS
e-mail: akassocs@aol.com
Fax: 020-7435 4100 Tel: 020-7435 4600

K M C AGENCIES Ltd
PO Box 122
48 Great Ancoats Street, Manchester M4 5AB
e-mail: casting@kmcagencies.co.uk
Fax: 0161-237 9812 Tel: 0161-237 3009

11-15 Betterton Street, London WC2H 9BP
e-mail: london@kmcagencies.co.uk
Fax: 0870 4421780 Tel: 0870 4604868

KNIGHT AYTON MANAGEMENT
114 St Martin's Lane, London WC2N 4BE
Website: www.knightayton.co.uk
e-mail: info@knightayton.co.uk
Fax: 020-7836 8333 Tel: 020-7836 5333

KNIGHT Ray CASTING
21A Lambolle Place, London NW3 4PG
Website: www.rayknight.co.uk
e-mail: casting@rayknight.co.uk
Fax: 020-7722 2322 Tel: 020-7722 1551

KORT Richard ASSOCIATES
Theatre House, 2-4 Clasketgate, Lincoln LN2 1JS
Website: www.richardkortassociates.com
e-mail: richardkort@dial.pipex.com
Fax: 01522 511116 Tel: 01522 526888

KREATE PROMOTIONS
Unit 232, 30 Great Guildford Street, London SE1 0HS
e-mail: kreate@kreatepromotions.co.uk
Fax: 020-7401 3003 Tel: 020-7401 9007

KREMER ASSOCIATES
(See MARSH Billy DRAMA Ltd)

KSA-WALES
4 Tydu View, High Cross, Newport NP10 9BQ
Website: www.ks-ass.co.uk
e-mail: info@amt-wales.com Tel: 01633 264606

L.A. MANAGEMENT
10 Fairoak Close, Kenley, Surrey CR8 5LJ
Website: www.lamanagement.biz
e-mail: info@lamanagement.biz
Mobile: 07963 573538 Tel: 020-8660 0142

LADIDA
1st Floor, Swiss Centre
10 Wardour Street, London W1D 6QF
Website: www.ladidagroup.com
e-mail: m@ladidagroup.com
Fax: 020-7287 0300 Tel: 020-7287 0600

BILLY MARSH DRAMA LIMITED
LINDA KREMER ASSOCIATES
Personal Management / Representation
Film Television Theatre Commercials

11 Henrietta Street, Covent Garden, London WC2E 8PY
Tel: 020 7379 4800 Fax: 020 7379 7272 E-mail: info@billymarshdrama.co.uk

Stageworks

WORLDWIDE PRODUCTIONS

AGENCY

Agency Management

Ice skaters, gymnasts,
circus artistes,
street theatre entertainers,
singers, dancers, magicians,
illusionists, choreographers,
directors, extras

Tel **01253 342426/7** Fax: **01253 342702**
email: info@stageworkswwp.com www.stageworkswwp.com

LAINE Betty MANAGEMENT
The Studios, East Street
Epsom, Surrey KT17 1HH
e-mail: enquiries@betty-laine-management.co.uk
Tel/Fax: 01372 721815

LAINE MANAGEMENT Ltd
Laine House, 131 Victoria Road
Hope, Salford M6 8LF
Website: www.lainemanagement.co.uk
e-mail: info@lainemanagement.co.uk
Fax: 0161-787 7572 Tel: 0161-789 7775

LANGFORD ASSOCIATES Ltd
17 Westfields Avenue
Barnes, London SW13 0AT
e-mail: barry.langford@btconnect.com
Fax: 020-8878 7078 Tel: 020-8878 7148

LEE'S PEOPLE
16 Manette Street, London W1D 4AR
Website: www.lees-people.co.uk
e-mail: lee@lees-people.co.uk
Fax: 020-7734 3033 Tel: 020-7734 5775

LEE Wendy MANAGEMENT
2nd Floor
36 Langham Street
London W1W 7AP
e-mail: wendy-lee@btconnect.com Tel: 020-7580 4800

LEHRER Jane ASSOCIATES*
100A Chalk Farm Road
London NW1 8EH
Website: www.janelehrer.com
e-mail: janelehrer@aol.com
Fax: 020-7482 4899 Tel: 020-7482 4898

REBEKAH DOBBINS

VANESSA SHANKS

ELIZE DU TOIT

JAKE CANUSO

FIONA ALDRIDGE

PATRICK KENNEDY

HOLLY DAVIDSON

JEREMY EDWARDS

CASEY MOORE PHOTOGRAPHY
WWW.CASEYMOORE.COM
studio: 020 7193 1868
mobile: 07974 188 105
email: casey@caseymoore.com

PHOTOGRAPHY

07879 643 925
www.simonjtuck.co.uk
Student Rates

LEIGH MANAGEMENT
14 St David's Drive
Edgware, Middlesex HA8 6JH
e-mail: leighmanagement@aol.com Tel/Fax: 020-8951 4449

LESLIE Sasha MANAGEMENT
(In Association with Allsorts Drama for Children)
34 Pember Road, London NW10 5LS
e-mail: sasha@allsortsdrama.com
Fax: 020-8969 3196 Tel: 020-8969 3249

LIBERTY MANAGEMENT
4 Oxclose Drive
Dronfield Woodhouse, Derbyshire S18 8XP
Website: www.libertymanagement.co.uk
e-mail: office@libertymanagement.co.uk
Fax: 0871 6613566 Tel: 0114-289 9151

LIME ACTORS AGENCY & MANAGEMENT Ltd
Nemesis Court
1 Oxford Court
Bishopsgate, Manchester M2 3WQ
e-mail: georgina@limemanagement.co.uk
Fax: 0161-228 6727 Tel: 0161-236 0827

LINKS MANAGEMENT
34-68 Colombo Street, London SE1 8DP
Website: www.links-management.co.uk
e-mail: agent@links-management.co.uk
 Tel/Fax: 020-7928 0806

LINKSIDE AGENCY
21 Poplar Road
Leatherhead, Surrey KT22 8SF
e-mail: linkside_agency@yahoo.co.uk
Fax: 01372 801972 Tel: 01372 802374

Dan Stevens

Freema Agyeman

Jasper Britton

SIMON ANNAND
Photographer

t: 020 7241 6725 m: 07884 446 776 www.simonannand.com

concessions available

PLA

PAT LOVETT ASSOCIATES

Pat Lovett, Dolina Logan

43 Chandos Place London WC2N 4HS Tel: 020 7379 8111 Fax: 020 7379 9111

5 Union Street Edinburgh EH1 3LT Tel: 0131 478 7878 Fax: 0131 478 7070 www.pla-uk.com

LINTON MANAGEMENT
3 The Rock, Bury BL9 0JP
e-mail: carol@linton.tv
Fax: 0161-761 1999 Tel: 0161-761 2020

LINTOTT Julia
32 Fordington Road, London N6 4TJ
e-mail: julialintott@london.com Tel/Fax: 020-8883 9119

LITTLE ACORNS PROMOTIONS Ltd
London House, 271-273 King Street
Hammersmith, London W6 9LZ
Fax: 020-8390 4935 Tel: 020-8563 0773

LONDON AGENCY The
Studio 7, St Georges Parade
Perry Hill, London SE6 4DT
Website: www.thelondonagency.com Tel: 020-8291 0190

LONDON MUSICIANS Ltd
(Orchestral Contracting)
Cedar House, Vine Lane
Hillingdon, Middlesex UB10 0BX
e-mail: mail@londonmusicians.co.uk
Fax: 01895 252556 Tel: 01895 252555

LONG Eva AGENTS
107 Station Road
Earls Barton, Northants NN6 0NX
e-mail: evalongagents@yahoo.co.uk
Fax: 01604 811921 Mobile: 07736 700849

LONGRUN ARTISTES AGENCY
(Gina Long)
3 Chelsworth Drive
Plumstead Common, London SE18 2RB
Website: www.longrunartistes.co.uk
e-mail: gina@longrunartistes.co.uk Mobile: 07748 723228

LONGTIME MANAGEMENT
(Existing Clients only)
36 Lord Street
Radcliffe, Manchester M26 3BA
e-mail: longtime_mgt@btopenworld.com
Tel/Fax: 0161-724 6625

LOOKALIKES (Susan Scott)
26 College Crescent, London NW3 5LH
Website: www.lookalikes.info
e-mail: susan@lookalikes.info
Fax: 020-7722 8261 Tel: 020-7387 9245

LOOKS
12A Manor Court
Aylmer Road, London N2 0PJ
Website: www.lookslondon.com
e-mail: lookslondonltd@btconnect.com
Fax: 020-8442 9190 Tel: 020-8341 4477

LOVETT Pat ASSOCIATES
(See PLA)

LSW PROMOTIONS
PO Box 31855, London SE17 3XP
Website: www.londonshakespeare.org.uk/promos
e-mail: londonswo@hotmail.com Tel/Fax: 020-7793 9755

LYNE Dennis AGENCY*
108 Leonard Street, London EC2A 4RH
e-mail: info@dennislyne.com
Fax: 020-7739 4101 Tel: 020-7739 6200

MAC-10 MANAGEMENT
Office 69, 2 Hellidon Close, Ardwick, Manchester M12 4AH
Website: www.mac-10.co.uk
e-mail: info@mac-10.co.uk
Fax: 0161-275 9610 Tel: 0161-275 9510

MACFARLANE CHARD ASSOCIATES Ltd*
33 Percy Street, London W1T 2DF
Website: www.macfarlane-chard.co.uk
e-mail: enquiries@macfarlane-chard.co.uk
Fax: 020-7636 7751 Tel: 020-7636 7750

MACFARLANE CHARD ASSOCIATES IRELAND
57 Main Street, Blackrock, Co. Dublin, Ireland
e-mail: derick@macfarlane-chard.co.uk
 Tel: 00 353 1 2056946

MACNAUGHTON LORD 2000 Ltd*
(Writers, Designers, Directors, Composers/Lyricists/Musical Directors/Lighting Designers)
19 Margravine Gardens, London W6 8RL
Website: www.ml2000.org.uk
e-mail: info@ml2000.org.uk
Fax: 020-8741 7443 Tel: 020-8741 0606

MADELEY Paul ASSOCIATES
17 Valley Road, Arden Park
Bredbury, Stockport, Cheshire SK6 2EA
e-mail: celebrities@amserve.com Tel/Fax: 0161-430 5380

MAIDA VALE SINGERS
(Singers for Recordings, Theatre, Film, Radio & TV)
7B Lanhill Road, Maida Vale, London W9 2BP
Website: www.maidavalesingers.co.uk
e-mail: maidavalesingers@cdtenor.freeserve.co.uk
Mobile: 07889 153145 Tel/Fax: 020-7266 1358

MAITLAND MANAGEMENT
PM (Anne Skates)
PO Box 364, Esher, Surrey KT10 9XZ
Website: www.maitlandmusic.com
e-mail: maitmus@aol.com
Fax: 01372 466229 Tel: 01372 466228

Lindsay Duncan Alan Rickman

Mike S. Photography ————————

Most types of photography undertaken Studio or location

Contact Mike on: t: 0121 323 4459 m: 07850 160311
e: mike@mbmphoto.fsnet.co.uk w: www.mikephotos.co.uk

MANAGEMENT 2000
23 Alexandra Road
Mold, Flintshire CH7 1HJ
Website: www.management-2000.co.uk
e-mail: jackey@management-2000.co.uk
 Tel/Fax: 01352 771231

MANS Johnny PRODUCTIONS Ltd
PO Box 196
Hoddesdon, Herts EN10 7WG
e-mail: real@legend.co.uk
Fax: 01992 470516 Tel: 01992 470907

MANSON Andrew PERSONAL MANAGEMENT Ltd*
288 Munster Road
London SW6 6BQ
Website: www.andrewmanson.com
e-mail: post@andrewmanson.com
Fax: 020-7381 8874 Tel: 020-7386 9158

MARCUS & McCRIMMON MANAGEMENT
1 Heathgate Place
75 Agincourt Road
Hampstead, London NW3 2NU
Website: www.marcusandmccrimmon.com
e-mail: info@marcusandmccrimmon.com
Fax: 020-8347 0006 Tel: 020-8347 0007

MARKHAM & FROGGATT Ltd*
PM (Write)
4 Windmill Street
London W1T 2HZ
e-mail: admin@markhamfroggatt.co.uk
Fax: 020-7637 5233 Tel: 020-7636 4412

MARKHAM & MARSDEN Ltd*
405 Strand
London WC2R ONE
Website: www.markham-marsden.com
e-mail: info@markham-marsden.com
Fax: 020-7836 4222 Tel: 020-7836 4111

MARSH Billy ASSOCIATES Ltd*
76A Grove End Road
St Johns Wood, London NW8 9ND
e-mail: talent@billymarsh.co.uk
Fax: 020-7449 6933 Tel: 020-7449 6930

MARSH Billy DRAMA Ltd
(Actors & Actresses)
11 Henrietta Street
Covent Garden
London WC2E 8PY
e-mail: info@billymarshdrama.co.uk
Fax: 020-7379 7272 Tel: 020-7379 4800

Emma Stansfield

Stéphan Grégoire
photographer

07869 141510

www.studio-sg.com

Headshots - Production - Publicity

WEST END
Studio
Location

Fantastic
Prices
and
Discounts

Karla
07941871271

www.
Karlagowlett
.co.uk

MARSH Sandra MANAGEMENT
(Film Technicians)
c/o Casarotto Marsh Ltd, National House
60-66 Wardour Street, London W1V 4ND
e-mail: casarottomarsh@casarotto.uk.com
Fax: 020-7287 5644 Tel: 020-7287 4450

MARSHALL Ronnie AGENCY
S F M PM TV (Write or Phone)
66 Ollerton Rd, London N11 2LA Tel/Fax: 020-8368 4958

MARSHALL Scott PARTNERS Ltd*
2nd Floor, 15 Little Portland Street, London W1W 8BW
e-mail: smpm@scottmarshall.co.uk
Fax: 020-7636 9728 Tel: 020-7637 4623

MARTIN Carol PERSONAL MANAGEMENT
19 Highgate West Hill, London N6 6NP
Fax: 020-8340 4868 Tel: 020-8348 0847

MAY John
Top Floor
46 Golborne Road, London W10 5PR
e-mail: may505@btinternet.com Tel: 020-8962 1606

MAYER Cassie Ltd*
5 Old Garden House
The Lanterns, Bridge Lane
London SW11 3AD
e-mail: info@cassiemayerltd.co.uk
Fax: 020-7350 0890 Tel: 020-7350 0880

MBA (Formerly John Mahoney Management)
Concorde House
18 Margaret Street, Brighton BN2 1TS
Website: www.mbagency.co.uk
e-mail: mba.concorde@virgin.net
Fax: 01273 818306 Tel: 01273 685970

LEON WEBSTER

KATHERINE PEACHEY

Natasha Greenberg

07932 618111 020 8653 5399

www.ngphotography.co.uk

McKINNEY MACARTNEY MANAGEMENT Ltd
(Technicians)
The Barley Mow Centre
10 Barley Mow Passage, London W4 4PH
Website: www.mckinneymacartney.com
e-mail: mail@mckinneymacartney.com
Fax: 020-8995 2414 Tel: 020-8995 4747

McLEAN Bill PERSONAL MANAGEMENT
PM (Write)
23B Deodar Road, London SW15 2NP Tel: 020-8789 8191

McLEAN-WILLIAMS MANAGEMENT
212 Piccadilly, London W1J 9HG
e-mail: info@mclean-williams.com
Fax: 020-7917 2805 Tel: 020-7917 2806

McLEOD HOLDEN ENTERPRISES Ltd
Priory House
1133 Hessle Road, Hull HU4 6SB
Website: www.mcleod-holden.com
e-mail: peter.mcleod@mcleod-holden.com
Fax: 01482 353635 Tel: 01482 565444

McREDDIE Ken ASSOCIATES Ltd*
PM
36-40 Glasshouse Street, London W1B 5DL
Website: www.kenmcreddie.com
e-mail: email@kenmcreddie.com
Fax: 020-7734 6530 Tel: 020-7439 1456

MCS AGENCY
47 Dean Street, London W1D 5BE
Website: www.mcsagency.co.uk
e-mail: info@mcsagency.co.uk
Fax: 020-7734 9996 Tel: 020-7734 9995

MEDIA LEGAL
PM F TV Voice-overs (Existing Clients only)
West End House, 83 Clarendon Road
Sevenoaks, Kent TN13 1ET Tel: 01732 460592

MEDIA MODELLING & CASTING AGENCY
17 Wolfe Road, Maidstone, Kent ME16 8NX
Website: www.mediamc.co.uk
e-mail: info@mediamc.co.uk
Mobile: 07812 245512 Tel: 01622 220320

MHM
Heather Barn
Cryers Hill Lane
High Wycombe, Bucks HP15 6AA
e-mail: mhmagents@gmail.com
Fax: 01494 716448 Tel: 01494 711400

MILNER David MANAGEMENT
40 Whitehall Road, London E4 6DH
e-mail: milner.agent@btinternet.com
Tel/Fax: 020-8523 8086

MIME THE GAP
(Mime & Physical Theatre Specialists)
23 Manor Place
Staines, Middlesex TW18 1AE
Website: www.mimethegap.com Mobile: 07970 685982

MINT MANAGEMENT
e-mail: lisi@mintman.co.uk Mobile: 07792 107644

MIRTH CONTROL MANAGEMENT Ltd
62 Station Road
Petersfield, Hants GU32 3ES
Website: www.mirthcontrol.org.uk
e-mail: chaz@mirthcontrol.org.uk
Mobile: 07766 692322 Mobile: 07976 283456

MITCHELL MAAS McLENNAN Ltd
Offices of Millennium Dance 2000
Hampstead Town Hall Centre
213 Haverstock Hill, London NW3 4QP
Website: www.mmm2000.co.uk
e-mail: agency@mmm2000.co.uk Tel/Fax: 01767 650020

ML 2000 Ltd
(See MACNAUGHTON LORD 2000 Ltd)

MONDI ASSOCIATES Ltd
30 Cooper House
2 Michael Road
London SW6 2AD
e-mail: info@mondiassociates.com Mobile: 07817 133349

MONTAGU ASSOCIATES
Ground Floor
13 Hanley Road, London N4 3DU
Fax: 020-7263 3993 Tel: 020-7263 3883

michael david smith photography

+44(0)7903 948 603

www.mds-photography.com

jodie read tommy sherlock nicola blackman

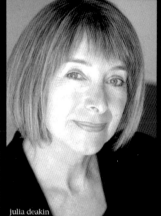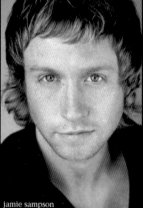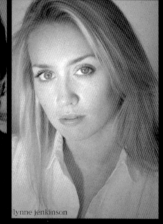

julia deakin jamie sampson lynne jenkinson

MOORE Jakki
18 Main Street, Haverigg, Cumbria LA18 4EX
e-mail: jakki@jakkimoore.com
Mobile: 07967 612784 Tel/Fax: 01229 776389

MORGAN & GOODMAN
Mezzanine, Quadrant House
80-82 Regent Street, London W1B 5RP
e-mail: mg1@btinternet.com
Fax: 020-7494 3446 Tel: 020-7437 1383

MORGAN Lee MANAGEMENT
The Strand, Golden Cross House
8 Duncannon Street, London WC2N 4JF
Website: www.leemorganmanagement.co.uk
e-mail: leemorganmgnt@aol.com
Fax: 020-7484 5100 Tel: 020-7484 5331

MORRIS Andrew MANAGEMENT
Penthouse Offices, 60 Reachview Close
Camden Town, London NW1 0TY
e-mail: morrisagent@yahoo.co.uk Tel/Fax: 020-7482 0451

MOUTHPIECE CASTING
PO Box 145, Inkberrow, Worcestershire WR7 4ZG
Website: www.mouthpiececasting.co.uk
e-mail: karin@mouthpieceuk.co.uk
Mobile: 07900 240904 Tel: 01527 850149

MPC ENTERTAINMENT
(Write or Phone)
MPC House 15-16 Maple Mews, Maida Vale, London NW6 5UZ
Website: www.mpce.com
e-mail: mpc@mpce.com
Fax: 020-7624 4220 Tel: 020-7624 1184

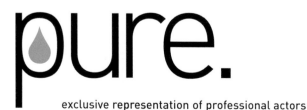

MR.MANAGEMENT
29 Belton Road, Brighton, East Sussex BN2 3RE
e-mail: mr.management@ntlworld.com
Fax: 020-8579 6360 Tel: 01273 232381

MUGSHOTS AGENCY
153 Buckhurst Avenue
Carshalton, Surrey SM5 1PD
e-mail: mail@mugshots.co.uk
Fax: 020-8296 8056 Tel: 020-8296 0393

MURPHY Elaine ASSOCIATES
Suite 1, 50 High Street, London E11 2RJ
e-mail: elaine@elainemurphy.co.uk
Fax: 020-8989 1400 Tel: 020-8989 4122

MUSIC INTERNATIONAL
M
13 Ardilaun Road, London N5 2QR
Website: www.musicint.co.uk
e-mail: music@musicint.co.uk
Fax: 020-7226 9792 Tel: 020-7359 5183

MV MANAGEMENT
Ralph Richardson Memorial Studios
Kingfisher Place, Clarendon Road, London N22 6XF
e-mail: theagency@mountview.ac.uk
Fax: 020-8829 1050 Tel: 020-8889 8231

MYERS MANAGEMENT
63 Fairfields Crescent
London NW9 0PR Tel/Fax: 020-8204 8941

NARROW ROAD COMPANY The*
22 Poland Street, London W1F 8QH
e-mail: agents@narrowroad.co.uk
Fax: 020-7439 1237 Tel: 020-7434 0406

182 Brighton Road, Coulsdon, Surrey CR5 2NF
e-mail: richard@narrowroad.co.uk
Fax: 020-8763 2558 Tel: 020-8763 9895

2nd Floor, Grampian House
144 Deansgate, Manchester M3 3EE
e-mail: manchester@narrowroad.co.uk
 Tel/Fax: 0161-833 1605

NCI MANAGEMENT Ltd
51 Queen Anne Street
London W1G 9HS
Fax: 020-7487 4258 Tel: 020-7224 3960

NCM MANAGEMENT
Unit 4, 121 Long Acre
Covent Garden, London WC2E 9PA
Website: www.ncmmanagement.com
e-mail: admin@ncmmanagement.com
Fax: 020-7836 3347 Mobile: 07980 807062

NE REPRESENTATION
38 Coniscliffe Road, Darlington DL3 7RG
Website: www.nerepresentation.co.uk
e-mail: info@nerepresentation.co.uk
Fax: 01325 488390 Tel: 01325 488385

NEVS AGENCY
Regal House, 198 King's Road, London SW3 5XP
Website: www.nevs.co.uk
e-mail: getamodel@nevs.co.uk
Fax: 020-7352 6068 Tel: 020-7352 4886

NEW CASEY AGENCY
The Annexe, 129 Northwood Way
Northwood HA6 1RF Tel: 01923 823182

NEW FACES Ltd
2nd Floor, The Linen Hall
162-168 Regent Street, London W1B 5TB
Website: www.newfacestalent.co.uk
e-mail: val@newfacestalent.co.uk
Fax: 020-7287 5481 Tel: 020-7439 6900

NFD - THE FILM & TV AGENCY
PO Box 76, Leeds LS25 9AG
Website: www.film-tv-agency.com
e-mail: info@film-tv-agency.com Tel/Fax: 01977 681949

NICHOLSON Jackie ASSOCIATES
PM
Suite 44, 2nd Floor, Morley House
320 Regent Street, London W1B 3BD
Fax: 020-7580 4489 Tel: 020-7580 4422

N M MANAGEMENT
16 St Alfege Passage
Greenwich, London SE10 9JS
e-mail: nmmanagement@hotmail.com
Tel: 020-7581 0947 Tel: 020-8853 4337

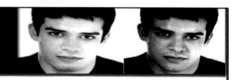
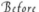
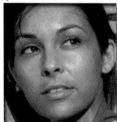
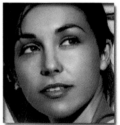

NMP LIVE Ltd
PO Box 981
Wallington, Surrey SM6 8JU
Website: www.nmpmanagement.co.uk
e-mail: management@nmp.co.uk
Fax: 020-8404 2621 Tel: 020-8669 3128

NORTH OF WATFORD ACTORS AGENCY
Co-operative
Bridge Mill, Hebden Bridge, West Yorks HX7 8EX
Website: www.northofwatford.com
e-mail: info@northofwatford.com
Fax: 01422 846503 Tel: 01422 845361

NORTHERN LIGHTS MANAGEMENT Ltd
Dean Clough Mills, Halifax, West Yorks HX3 5AX
e-mail: northern.lights@virgin.net
Fax: 01422 330101 Tel: 01422 382203

NORTHERN PROFESSIONALS
(Casting, Technicians, Action Safety, Boat & Diving
Equipment Hire)
21 Cresswell Avenue, North Shields, Tyne & Wear NE29 9BQ
Website: www.northernprocasting.co.uk
e-mail: bill@northernprocasting.co.uk
Fax: 0191-296 3243 Tel: 0191-257 8635

NORTHONE MANAGEMENT•
HG08 Aberdeen Studios
Highbury Grove, London N5 2EA
Website: www.northone.co.uk
e-mail: actors@northone.co.uk
Fax: 020-7359 9449 Tel: 020-7359 9666

NS ARTISTES MANAGEMENT
25 Claverdon House, Holly Bank Road
Billesley, Birmingham B13 0QY
Website: www.nsmanagement.co.uk
e-mail: nsmanagement@fsmail.net Tel: 0121-684 5607

NSM*
(Natasha Stevenson Management)
85 Shorrolds Road, Fulham, London SW6 7TU
Website: www.natashastevenson.co.uk
e-mail: nsm@netcomuk.co.uk
Fax: 020-7385 3014 Tel: 020-7386 5333

NUMBER ONE CASTING & MODEL MANAGEMENT Ltd
408F The Big Peg, 120 Vyse Street
The Jewellery Quarter
Birmingham B18 6NF
Website: www.numberonemodelagency.co.uk
e-mail: info@numberonemodelagency.co.uk
 Tel: 0121-233 2433

NUTOPIA-CHANG PERSONAL MANAGEMENT
Number 8, 132 Charing Cross Road, London WC2H 0LA
Website: www.nutopia-chang.com
Fax: 029-2070 5725 Tel: 029-2071 3540

NYLAND MANAGEMENT Ltd
20 School Lane
Heaton Chapel, Stockport SK4 5DG
e-mail: nylandmgmt@freenet.co.uk Tel/Fax: 0161-442 2224

OFFSTAGE-AGENCY.COM
No 199, 2 Lansdowne Row, Mayfair, London W1J 6HL
Website: www.offstageagency.com
e-mail: info@theoffstageagency.com
Fax: 020-7493 4935 Tel: 020-7193 7547

OFF THE KERB PRODUCTIONS
22 Thornhill Crescent, London N1 1BJ
Fax: 020-7700 4646 Tel: 020-7700 4477

3rd Floor, Hammer House
113-117 Wardour Street, London W1F 0UN
Website: www.offthekerb.co.uk
e-mail: info@offthekerb.co.uk
Fax: 020-7437 0647 Tel: 020-7437 0607

OI OI AGENCY
Pinewood Film Studios
Pinewood Road
Iver Heath, Bucks SL0 0NH
Website: www.oioi.org.uk
e-mail: info@oioi.org.uk
Fax: 01753 655622 Tel: 01753 655514

ONE MAKE UP/ONE PHOTOGRAPHIC Ltd
4th Floor, 48 Poland Street, London W1F 7ND
Website: www.onemakeup.com
e-mail: info@onemakeup.com
Fax: 020-7287 2313 Tel: 020-7287 2311

OPERA & CONCERT ARTISTS
M Opera
75 Aberdare Gardens, London NW6 3AN
e-mail: enquiries@opera-and-concert-artists.co.uk
Fax: 020-7372 3537 Tel: 020-7328 3097

ORDINARY PEOPLE
(Actors and Wardrobe/Stylists/Make-up Artists)
8 Camden Road, London NW1 9DP
Website: www.ordinarypeople.co.uk
e-mail: info@ordinarypeople.co.uk
Fax: 020-7267 5677 Tel: 020-7267 7007

ORIENTAL CASTING AGENCY Ltd (Peggy Sirr)
(Afro/Asian Artists) (Write or Phone)
1 Wyatt Park Road
Streatham Hill, London SW2 3TN
Website: www.orientalcasting.com
e-mail: peggy.sirr@btconnect.com
Fax: 020-8674 9303 Tel: 020-8671 8538

OTTO PERSONAL MANAGEMENT Ltd•
PM Co-operative
S.I.F., 5 Brown Street
Sheffield S1 2BS
Website: www.ottopm.co.uk
e-mail: admin@ottopm.co.uk
Fax: 0114-275 2471 Tel: 0114-275 2592

PADBURY David ASSOCIATES
44 Summerlee Avenue
Finchley, London N2 9QP
Website: www.davidpadburyassociates.com
e-mail: info@davidpadburyassociates.com
 Tel/Fax: 020-8883 1277

PAN ARTISTS AGENCY Ltd
Cornerways
34 Woodhouse Lane
Sale, Cheshire M33 4JX
e-mail: panartists@btconnect.com
Fax: 0161-962 6571 Tel: 0161-969 7419

PANTO PEOPLE
3 Rushden House, Tatlow Road
Glenfield, Leicester LE3 8ND
e-mail: jonny.dallas@ntlworld.com Tel/Fax: 0116-287 9594

PARAMOUNT INTERNATIONAL MANAGEMENT
Talbot House, 204-226 Imperial Drive
Harrow, Middlesex HA2 7HH
Website: www.ukcomedy.com
e-mail: mail@ukcomedy.com
Fax: 020-8868 6475 Tel: 020-8429 3179

PARK MANAGEMENT Ltd•
(Marcus Hamer)
e-mail: actors@park-management.co.uk Tel: 0870 0628763

PARR & BOND
The Tom Thumb Theatre
Eastern Esplanade, Cliftonville
Kent CT9 2LB Tel: 01843 221791

PAUL Yvonne MANAGEMENT
Elysium Gate, Unit 15
126-128 New Kings Road
London SW6 4LZ
e-mail: info@immmodels.com
Fax: 020-7736 2221 Tel: 020-7384 0300

P B J MANAGEMENT Ltd*
(Comedy)
7 Soho Street, London W1D 3DQ
Website: www.pbjmgt.co.uk
e-mail: general@pbjmgt.co.uk
Fax: 020-7287 1191 Tel: 020-7287 1112

Regency Agency Principal: Beverley Coles

Actors and Actresses available for Television, Films, Theatre, Commercials

T: 0113-255 8980 25 Carr Road Calverley Leeds LS28 5NE *Licensed under the Employment Agencies Act, 1973*

PC THEATRICAL & MODEL AGENCY
(Large Database of Twins)
12 Carlisle Road
Colindale, London NW9 0HL
Website: www.twinagency.com
e-mail: twinagy@aol.com
Fax: 020-8933 3418 Tel: 020-8381 2229

PELHAM ASSOCIATES*
PM (Peter Cleall)
The Media Centre
9-12 Middle Street, Brighton BN1 1AL
Website: www.pelhamassociates.co.uk
e-mail: petercleall@pelhamassociates.co.uk
Fax: 01273 202492 Tel: 01273 323010

PEMBERTON ASSOCIATES Ltd*
193 Wardour Street
London W1F 8ZF
Fax: 020-7734 2522 Tel: 020-7734 4144

Express Networks
1 George Leigh Street, Manchester M4 5DL
Website: www.pembertonassociates.com
e-mail: general@pembertonassociates.com
Fax: 0161-235 8442 Tel: 0161-235 8440

PEPPERPOT PROMOTIONS
(Bands)
Suite 20B
20-22 Orde Hall Street, London WC1N 3JW
e-mail: chris@pepperpot.co.uk
Fax: 01255 473107 Tel: 020-7405 9108

PERFORMANCE ACTORS AGENCY•
PM Co-operative
137 Goswell Road, London EC1V 7ET
Website: www.p-a-a.co.uk
e-mail: performance@p-a-a.co.uk
Fax: 020-7251 3974 Tel: 020-7251 5716

PERFORMERS DIRECTORY & AGENCY
(Actors, Dancers, Models and Extras)
PO Box 29942, London SW6 1FL
Website: www.performersdirectory.co.uk
e-mail: admin@performersdirectory.com
 Tel: 020-7610 6677

PERFORMING ARTS*
(Directors, Designers, Choreographers, Lighting Designers)
6 Windmill Street
London W1T 2JB
Website: www.performing-arts.co.uk
e-mail: info@performing-arts.co.uk
Fax: 020-7631 4631 Tel: 020-7255 1362

PERRY George
(See PROFILE MANAGEMENT)

PERSONAL APPEARANCES
20 North Mount
1147-1161 High Road, Whetstone N20 0PH
Website: www.personalappearances.biz
e-mail: patsy@personalappearances.biz
 Tel/Fax: 020-8343 7748

PFD*
PM
Drury House
34-43 Russell Street, London WC2B 5HA
Website: www.pfd.co.uk
e-mail: postmaster@pfd.co.uk
Fax: 020-7836 9544 Tel: 020-7344 1010

PHD ARTISTS
24 Ovett Close
Upper Norwood, London SE19 3RX
Website: www.phdartists.com
e-mail: office@phdartists.com Tel/Fax: 020-8771 4274

PHILLIPS Frances*
Elstree Film & Television Studios
Shenley Road
Borehamwood, Herts WD6 1JG
Website: www.francesphillips.co.uk
e-mail: derekphillips@talk21.com
Fax: 020-8324 2353 Tel: 020-8324 2296

PHPM
(Philippa Howell Personal Management)
184 Bradway Road, Sheffield S17 4QX
e-mail: philippa@phpm.co.uk Tel/Fax: 0114-235 3663

PHYSICK Hilda
PM (Write)
78 Temple Sheen Road
London SW14 7RR
Fax: 020-8876 5561 Tel: 020-8876 0073

PICCADILLY MANAGEMENT
PM
23 New Mount Street
Manchester M4 4DE
e-mail: piccadilly.management@virgin.net
Fax: 0161-953 4001 Tel: 0161-953 4057

PINEAPPLE AGENCY
Montgomery House
159-161 Balls Pond Road, London N1 4BG
Website: www.pineappleagency.com
e-mail: pineapple.agency@btconnect.com
Fax: 020-7241 3006 Tel: 020-7241 6601

JK PHOTOGRAPHY | 07816 825578

www.jk-photography.net

£125
Inc. hair & make-up
All images on cd

PLA*
(LOVETT Pat ASSOCIATES)
5 Union Street, Edinburgh EH1 3LT
Website: www.pla-uk.com
e-mail: edinburgh@pla-uk.com
Fax: 0131-478 7070 — Tel: 0131-478 7878

43 Chandos Place, London WC2N 4HS
e-mail: london@pla-uk.com
Fax: 020-7379 9111 — Tel: 020-7379 8111

PLAIN JANE
PO Box 2730
Romford
Essex RM7 1AB
Website: www.plain-jane.co.uk
e-mail: info@plain-jane.co.uk — Mobile: 07813 667319

PLATER Janet MANAGEMENT Ltd
D Floor
Milburn House
Dean Street
Newcastle upon Tyne NE1 1LF
Website: www.janetplatermanagement.co.uk
e-mail: magpie@tynebridge.demon.co.uk
Fax: 0191-233 1709 — Tel: 0191-221 2490

PLUNKET GREENE ASSOCIATES
(In conjunction with James Sharkey Assocs Ltd)
(Existing Clients only)
PO Box 8365
London W14 0GL
Fax: 020-7603 2221 — Tel: 020-7603 2227

Representing:-
Dancers, Choreographers and Singers in all aspects of TV, Film, Video, Theatre and Commercial Work.
Specialising in Musical Theatre.
Full Production Team available for Trade, Fashion & Corporate Events.

Visit our website: www.kmcagencies.co.uk

PO Box 122
48 Great Ancoats Street
Manchester M4 5AB
t: 0161 237 3009
f: 0161 237 9812
e: casting@kmcagencies.co.uk

11-15 Betterton Street
London WC2H 9BP
t: 0870 460 4868
f: 0870 442 1780
e: london@kmcagencies.co.uk

George McLean

Rachel Clare

Natasha James

Vidal Sancho

twenty years experience - relaxed and unhurried
successful - natural - location portraits for actors

Pierre Marcar
bespoke digital photography

07956 485584 pierremarcarpeople.com

POLLYANNA MANAGEMENT Ltd
PO Box 30661, London E1W 3GG
Website: www.pollyannatheatre.com
e-mail: pollyanna_mgmt@btinternet.com
Fax: 020-7480 6761 Tel: 020-7481 1911

POOLE Gordon AGENCY Ltd
The Limes, Brockley, Bristol BS48 3BB
Website: www.gordonpoole.com
e-mail: agents@gordonpoole.com
Fax: 01275 462252 Mobile: 01275 463222

POPLAR MANAGEMENT
22 Knightswood
Woking, Surrey GU21 3PY
Website: www.poplarmanagement.co.uk
e-mail: karenfoley@fsmail.net Tel/Fax: 01483 828056

POWER MODEL MANAGEMENT CASTING AGENCY
Capitol House
2-4 Heigham Street
Norwich NR2 4TE
Website: www.powermodel.co.uk
e-mail: info@powermodel.co.uk Tel: 01603 621100

POWER PROMOTIONS
PO Box 61, Liverpool L13 0EF
Website: www.powerpromotions.co.uk
e-mail: tom@powerpromotions.co.uk
Fax: 0870 7060202 Tel: 0151-230 0070

PREGNANT PAUSE AGENCY
(Pregnant Models, Dancers, Actresses)
11 Matham Road
East Molesey KT8 0SX
Website: www.pregnantpause.co.uk
e-mail: sandy@pregnantpause.co.uk Tel: 020-8979 8874

PRICE GARDNER MANAGEMENT
85 Shorrolds Road
London SW6 7TU
e-mail: info@pricegardner.com
Fax: 020-7381 3288 Tel: 020-7610 2111

PRINCIPAL ARTISTES
PM (Write)
4 Paddington Street
Marylebone, London W1U 5QE
Fax: 020-7486 4668 Tel: 020-7224 3414

PRODUCTIONS & PROMOTIONS Ltd
Apsley Mills Cottage, London Road
Hemel Hempstead, Herts HP3 9QU
Website: www.prodmotions.com
e-mail: reception@prodmotions.com
Fax: 0845 0095540 Tel: 01442 233372

PROFILE MANAGEMENT
(George Perry)
118 Mill Road
Royston, Herts SG8 7AJ
e-mail: georgeperryprofile@hotmail.com Tel: 01763 257355

PROSPECTS ASSOCIATIONS
(Singers, Sessions, Voice Overs for TV, Film & Commercials)
28 Magpie Close, Forest Gate
London E7 9DE Tel: 020-8555 3628

PURE ACTORS AGENCY & MANAGEMENT Ltd
44 Salisbury Road
Manchester M41 0RB
Website: www.pure-management.co.uk
e-mail: enquiries@pure-management.co.uk
Fax: 0161-746 9886 Tel: 0161-747 2377

PVA MANAGEMENT Ltd
Hallow Park, Worcestershire WR2 6PG
e-mail: clients@pva.co.uk
Fax: 01905 641842 Tel: 01905 640663

QUICK Nina ASSOCIATES
(See TAYLOR Brian ASSOCIATES)

RAGE MODELS
Tigris House
256 Edgware Road, London W2 1DS
Website: www.ragemodels.org
e-mail: ragemodels@ugly.org
Fax: 020-7402 0507 Tel: 020-7262 0515

RAINBOW REPRESENTATION
45 Nightingale Lane
Crouch End, London N8 7RA
e-mail: rainbowrp@onetel.com Tel/Fax: 020-8341 6241

RAMA GLOBAL Ltd
Huntingdon House
278-290 Huntingdon Street, Nottingham NG1 3LY
Website: www.rama-global.co.uk
e-mail: admin@rama-global.co.uk
Fax: 0115-948 3696 Tel: 0115-952 4333

RANDALL RICHARDSON ACTORS MANAGEMENT
2nd Floor
145-157 St John Street
London EC1V 4PY
Website: www.randallrichardson.co.uk
e-mail: mail@randallrichardson.co.uk
Fax: 0870 7623212 Tel: 020-7060 1645

RAVENSCOURT MANAGEMENT
8-30 Galena Road
Hammersmith, London W6 0LT
e-mail: info@ravenscourt.net
Fax: 020-8741 1786 Tel: 020-8741 0707

RAWHIDE COMEDY
PO Box 1127, Liverpool L69 3TL
Website: www.rawhidecomedy.com
e-mail: info@rawhidecomedy.com
Fax: 0870 7871241 Tel: 0870 7871240

RAZZAMATAZZ MANAGEMENT
Mulberry Cottage, Park Farm
Haxted Road, Lingfield RH7 6DE
e-mail: razzamatazzmanagement@btconnect.com
 Tel/Fax: 01342 835359

RbA MANAGEMENT Ltd•
Co-operative PM
The Annexe
13-15 Hope Street, Liverpool L1 9BH
Website: www.rbamanagement.co.uk
e-mail: info@rbamanagement.co.uk
Fax: 0151-709 0773 Tel: 0151-708 7273

RBM
PM (Comedy)
3rd Floor
168 Victoria Street, London SW1E 5LB
Website: www.rbmcomedy.com
e-mail: info@rbmcomedy.com
Fax: 020-7630 6549 Tel: 020-7630 7733

RDF MANAGEMENT
The Gloucester Building, Kensington Village
Avonmore Road, London W14 8RF
e-mail: debi.allen@rdfmanagement.com
Fax: 020-7013 4101 Tel: 020-7013 4103

REACTORS AGENCY
Co-operative
1 Eden Quay, Dublin 1, Eire
Website: www.reactors.ie
e-mail: reactors@eircom.net
Fax: 00 353 1 8783182 Tel: 00 353 1 8786833

REAL PEOPLE, REAL TALENT
Half Moon Chambers
Chapel Walks, Manchester M2 1HN
Website: www.realpeople4u.com
e-mail: info@realpeople4u.com
Fax: 0161-832 5219 Tel: 0161-832 8259

RE.ANIMATOR MANAGEMENT
5th Floor
Victoria House
125 Queens Road
Brighton BN1 3WB
Website: www.reanimator.co.uk
e-mail: re.animator@gmail.com
Fax: 01273 777753 Tel: 01273 777757

RED ONION AGENCY
(Session Fixer for Singers, Musicians and Gospel Choirs)
26-28 Hatherley Mews, London E17 4QP
Website: www.redonion.uk.com
e-mail: info@redonion.uk.com
Fax: 020-8521 6646 Tel: 020-8520 3975

REDDIN Joan
PM (Write)
Hazel Cottage
Frogg's Island, Wheeler End Common
Bucks HP14 3NL Tel: 01494 882729

REDROOFS ASSOCIATES
The Admin Building
Pinewood Studios
Iver Heath, Bucks SLO 0NH
e-mail: agency@redroofs.co.uk
Fax: 01753 785443 Tel: 01753 785444

REGAN RIMMER MANAGEMENT
(Leigh-Ann Regan, Debbie Rimmer)
Suite 4, Little Russell House
22 Little Russell Street, London WC1A 2HS
e-mail: thegirls@regan-rimmer.co.uk
Fax: 020-7404 9958 Tel: 020-7404 9957

Ynyslas Uchaf Farm
Blackmill, Bridgend CF35 6DW
e-mail: regan-rimmer@btconnect.com
Fax: 01656 841815 Tel: 01656 841841

REGENCY AGENCY
F TV
25 Carr Road, Calverley
Leeds LS28 5NE Tel: 0113-255 8980

REPRESENTATION JOYCE EDWARDS
(See EDWARDS REPRESENTATION Joyce)

REYNOLDS Sandra AGENCY
Md F TV
62 Bell Street, London NW1 6SP
Website: www.sandrareynolds.co.uk
e-mail: info@sandrareynolds.co.uk
Fax: 020-7387 5848 Tel: 020-7387 5858

35 St Georges Street, Norwich NR3 1DA
Fax: 01603 219825 Tel: 01603 623842

RHINO MANAGEMENT
Oak Porch House
5 Western Road
Nazeing, Essex EN9 2QN
Website: www.rhino-management.co.uk
e-mail: info@rhino-management.co.uk
Mobile: 07901 528988 Tel/Fax: 01992 893259

RICHARD STONE PARTNERSHIP The
(See STONE Richard PARTNERSHIP The)

RICHARDS Lisa
108 Upper Leeson Street, Dublin 2, Eire
e-mail: info@lisarichards.ie
Fax: 00 353 1 6671256 Tel: 00 353 1 6375000

RICHARDS Stella MANAGEMENT
(Existing Clients Only)
42 Hazlebury Road, London SW6 2ND
Fax: 020-7731 5082 Tel: 020-7736 7786

RIDGEWAY MANAGEMENT
Fairley House, Andrews Lane
Cheshunt, Herts EN7 6LB
e-mail: info@ridgewaystudios.co.uk
Fax: 01992 633844 Tel: 01992 633775

ROGUES & VAGABONDS MANAGEMENT Ltd•
PM Co-operative
The Print House
18 Ashwin Street
London E8 3DL
e-mail: rogues@vagabondsmanagement.com
Fax: 020-7249 8564 Tel: 020-7254 8130

THEATRICAL AGENTS • ACTORS
DANCERS • SINGERS
MODELS • PRESENTERS
CHOREOGRAPHERS

Success

ROOM 236, LINEN HALL
162-168 REGENT STREET
LONDON W1B 5TB
TEL: 020 7734 3356 FAX: 020 7494 3787
www.successagency.co.uk
e-mail: ee@successagency.co.uk

ROLE MODELS
12 Cressy Road, London NW3 2LY
Website: www.hiredhandsmodels.com
e-mail: models@hiredhands.freeserve.co.uk
Fax: 020-7267 1030 Tel: 020-7284 4337

ROSEBERY MANAGEMENT Ltd•
PM
Hoxton Hall
130 Hoxton Street, London N1 6SH
Website: www.roseberymanagement.com
e-mail: admin@roseberymanagement.com
Fax: 020-7684 0197 Tel: 020-7684 0187

ROSEMAN ORGANISATION The
51 Queen Anne Street
London W1G 9HS
Website: www.therosemanorganisation.co.uk
e-mail: info@therosemanorganisation.co.uk
Fax: 020-7486 4600 Tel: 020-7486 4500

ROSS BROWN ASSOCIATES
PM
Rosedale House, Rosedale Road
Richmond, Surrey TW9 2SZ
e-mail: sandy@rossbrown.eu
Fax: 020-8398 4111 Tel: 020-8398 3984

ROSS Frances MANAGEMENT
Higher Leyonne, Golant
Fowey, Cornwall PL23 1LA
Website: www.francesrossmanagement.com
e-mail: francesross@btconnect.com Tel/Fax: 01726 833004

ROSSMORE PERSONAL MANAGEMENT
70-76 Bell Street, London NW1 6SP
Website: www.rossmoremanagement.com
e-mail: agents@rossmoremanagement.com
Fax: 020-7258 0124 Tel: 020-7258 1953

ROWE ASSOCIATES
33 Percy Street, London W1T 1DE
Website: www.growe.co.uk
e-mail: agents@growe.co.uk
Mobile: 07887 898220 Tel/Fax: 01992 308519

ROYCE MANAGEMENT
29 Trenholme Road
London SE20 8PP
e-mail: office@roycemanagement.co.uk
Tel/Fax: 020-8778 6861

RSM ARTISTES MANAGEMENT
(Cherry Parker)
15 The Fairway SS9 4QN
Website: www.rsm.uk.net
e-mail: info@rsm.uk.net
Mobile: 07976 547066 Tel: 01702 522647

RUBICON MANAGEMENT
27 Inderwick Road
Crouch End, London N8 9LB
e-mail: rubiconartists@blueyonder.co.uk
Tel/Fax: 020-8374 1836

RUDEYE DANCE AGENCY
PO Box 38743, London E10 5WN
Website: www.rudeye.com
e-mail: info@rudeye.com Tel/Fax: 020-8556 7139

RWM MANAGEMENT
The Aberdeen Centre
22-24 Highbury Grove, London N5 2EA
e-mail: rwm.mario-kate@virgin.net
Fax: 020-7226 3371 Tel: 020-7226 3311

SANDERS Loesje Ltd*
(Designers, Directors, Choreographers, Lighting Designers)
Pound Square
1 North Hill, Woodbridge, Suffolk IP12 1HH
Website: www.loesjesanders.com
e-mail: loesje@loesjesanders.org.uk
Fax: 01394 388734 Tel: 01394 385260

SANGWIN ASSOCIATES*
Queens Wharf
Queen Caroline Street
Hammersmith, London W6 9RJ
Website: www.sangwinassoc.com
e-mail: info@sangwinassoc.com
Fax: 020-8600 2669 Tel: 020-8600 2670

SARABAND ASSOCIATES
(Sara Randall, Bryn Newton)
265 Liverpool Road, London N1 1LX
e-mail: brynnewton@btconnect.com
Fax: 020-7609 2370 Tel: 020-7609 5313

SCA MANAGEMENT
TV F S M (Write)
77 Oxford Street, London W1D 2ES
Website: www.sca-management.co.uk
e-mail: agency@sca-management.co.uk
Fax: 020-7659 2116 Tel: 020-7659 2027

SCHNABL Peter
The Barn House, Cutwell, Tetbury
Gloucestershire GL8 8EB
Fax: 01666 502998 Tel: 01666 502133

SCOTT-PAUL YOUNG ENTERTAINMENTS Ltd
S.P.Y. Promotions & Productions
Northern Lights House, 110 Blandford Road North
Langley, Nr Windsor, Berks SL3 7TA
Website: www.spy-artistsworld.web.com
e-mail: castingdirect@spy-ents.com Tel/Fax: 01753 693250

SCOTT Tim
284 Gray's Inn Road, London WC1X 8EB
e-mail: timscott@btinternet.com
Fax: 020-7278 9175 Tel: 020-7833 5733

SCREAM MANAGEMENT
The Red Door, 32 Clifton Street
Blackpool, Lancs FY1 1JP
Website: www.screammanagement.com
e-mail: info@screammanagement.com
Fax: 01253 750829 Tel: 01253 750820

SCRIMGEOUR Donald ARTISTS AGENT
(Dance)
49 Springcroft Avenue, London N2 9JH
Website: www.donaldscrimgeour.com
e-mail: vwest@dircon.co.uk
Fax: 020-8883 9751 Tel: 020-8444 6248

SEARS MANAGEMENT Ltd
2 Gumping Road, Orpington, Kent BR5 1RX
e-mail: lindasears@btconnect.com
Fax: 01689 862120 Tel: 01689 861859

SECOND SKIN AGENCY
Foxgrove House, School Lane, Seer Green
Beaconsfield, Bucks HP9 2QJ
e-mail: jenny@secondskinagency.com
 Tel/Fax: 01494 730166

SEDGWICK Dawn MANAGEMENT
3 Goodwins Court
Covent Garden, London WC2N 4LL
Fax: 020-7240 0415 Tel: 020-7240 0404

S.F.X.
(Sports Management Company)
35-36 Grosvenor Street
London W1K 4QX
Website: www.sfxsports.co.uk
Fax: 020-7529 4347 Tel: 020-7529 4300

SHALIT GLOBAL MANAGEMENT
7 Moor Street
Soho, London W1D 5NB
e-mail: rich@shalitglobal.com
Fax: 020-7851 9156 Tel: 020-7851 9155

SHAPER Susan MANAGEMENT
5 Dovedale Gardens
465 Battersea Park Road, London SW11 4LR
e-mail: shapermg@btinternet.com
Fax: 020-7350 1802 Tel: 020-7585 1023

SHAW Vincent ASSOCIATES Ltd*
(Andy Charles)
186 Shaftesbury Avenue, London WC2H 8JB
Website: www.vincentshaw.com
e-mail: info@vincentshaw.com
Fax: 020-7240 2930 Tel: 020-7240 2927

SHEDDEN Malcolm MANAGEMENT
1 Charlotte Street, London W1T 1RD
Website: www.features.co.uk
e-mail: info@features.co.uk
Fax: 020-7636 1657 Tel: 020-7636 1876

SHEPHERD MANAGEMENT Ltd*
4th Floor
45 Maddox StreetLondon W1S 2PE
e-mail: info@shepherdmanagement.co.uk
Fax: 020-7499 7535 Tel: 020-7495 7813

SHEPPERD-FOX
5 Martyr Road
Guildford, Surrey GU1 4LF
Website: www.shepperd-fox.co.uk
e-mail: info@shepperd-fox.co.uk Mobile: 07957 624601

SHOW TEAM PRODUCTIONS The
(Dancers & Choreographers)
18 Windmill Street
Brighton, Sussex BN2 0GN
Website: www.theshowteam.co.uk
e-mail: info@theshowteam.co.uk Tel: 01273 671010

SHOWSTOPPERS!
(Celebrity Booking Services, Promotions & Entertainments)
42 Foxglove Close
Witham, Essex CM8 2XW
Website: www.showstoppers-group.com
e-mail: mail@showstoppers-group.com
Fax: 01376 510340 Tel: 01376 518486

S I A MANAGEMENT
Wessex, 255 Brighton Road
Lancing, West Sussex BN15 8JP
Website: www.siamanagement.co.uk
e-mail: info@siamanagement.co.uk Tel: 01903 529882

SILVEY ASSOCIATES
11-15 Betterton Street, London WC2H 9BP
e-mail: info@silveyassociates.co.uk
Fax: 020-7379 0801 Tel: 020-7470 8812

SIMPSON FOX ASSOCIATES Ltd*
(Set, Costume and Lighting Designers, Directors,
Choreographers)
52 Shaftesbury Avenue, London W1D 6LP
e-mail: info@simpson-fox.com
Fax: 020-7494 2887 Tel: 020-7434 9167

SINGER Sandra ASSOCIATES
21 Cotswold Road
Westcliff-on-Sea, Essex SS0 8AA
Website: www.sandrasinger.com
e-mail: sandrasinger@btconnect.com
Fax: 01702 339393 Tel: 01702 331616

SINGERS INC/DANCERS INC Ltd
Golden Cross House
8 Duncannon Street
The Strand, London WC2N 4JF
Website: www.singersinc.co.uk
e-mail: enquiries@singersinc.co.uk
Fax: 020-7484 5100 Tel: 020-7484 5080

SIRR Peggy
(See ORIENTAL CASTING AGENCY Ltd)

SJ MANAGEMENT
8 Bettridge Road, London SW6 3QD
e-mail: sj@susanjames.demon.co.uk
Fax: 020-7371 0409 Tel: 020-7371 0441

SMILE TALENT
The Office
Hope Cottage, London Road
Newport, Essex CB11 3PN
e-mail: talent-smile@stepc.fsnet.co.uk Tel: 01799 541113

SOHO ARTISTES
The Loft, 204 The Valley Road, London SW16 2AE
Website: www.sohoartistes.com
e-mail: info@sohoartistes.com
Fax: 020-8769 0811 Tel/Fax: 020-7884 1295

SONGTIME/CHANDLER'S MANAGEMENT
Studio 64, Communications House
63 Woodfield Lane
Ashtead, Surrey KT21 2BT
Website: www.songtime.co.uk
e-mail: info@songtime.co.uk
Fax: 01372 275333 Tel: 01372 275222

SOPHIES PEOPLE
(Dancers & Choreographers)
40 Mexfield Road, London SW15 2RQ
Website: www.sophiespeople.com
e-mail: sophies.people@btinternet.com
Fax: 0870 7876447 Tel: 0870 7876446

SOUL MANAGEMENT
10 Coptic Street
London WC1A 1NH
Website: www.soulmanagement.co.uk
e-mail: info@soulmanagement.co.uk Tel: 020-7580 1120

SPEAK Ltd
59 Lionel Road North
Brentford, Middlesex TW8 9QZ
Website: www.speak.ltd.uk
e-mail: info@speak.ltd.uk
Fax: 020-8758 0333 Tel: 020-8758 0666

SPEAKERS CIRCUIT Ltd the
(After Dinner Speakers)
23 Tynemouth Street
Fulham, London SW6 2QS
e-mail: laura@allstarspeakers.co.uk
Fax: 020-7371 7466 Tel: 020-7371 7512

SPEAKERS CORNER
(Speakers, Presenters, Facilitation and Cabaret for the
Corporate Market)
Tigana House, Catlins Lane
Pinner, Middlesex HA5 2HG
Website: www.speakerscorner.co.uk
e-mail: info@speakerscorner.co.uk
Fax: 020-8868 4409 Tel: 020-8866 8967

SPIRE CASTING
PO Box 372, Chesterfield S41 0XW
Website: www.spirecasting.com
e-mail: mail@spirecasting.com Mobile: 07900 517707

SPLITTING IMAGES LOOKALIKES AGENCY
25 Clissold Court
Greenway Close, London N4 2EZ
Website: www.splitting-images.com
e-mail: info@splitting-images.com
Fax: 020-8809 6103 Tel: 020-8809 2327

SPORTABILITY Ltd
(Sporting Personalities)
Unit 2, 23 Green Lane
Dronfield, Derbyshire S18 2LL
Fax: 01246 290520 Tel: 01246 292010

SPORTS MODELS
1A Calton Avenue
Dulwich Village
London SE21 7DE
Website: www.sportsmodels.com
e-mail: info@sportsmodels.com
Mobile: 07973 863263 Tel: 020-8299 8800

SPORTS OF SEB Ltd
31 Ivor Place, London NW1 6DA
Website: www.sportsofseb.com
e-mail: info@sportsofseb.com Tel: 020-7723 1889

SPORTS WORKSHOP PROMOTIONS Ltd
(Sports Models)
PO Box 878, Crystal Palace
National Sports Centre, London SE19 2BH
e-mail: info@sportspromotions.co.uk
Fax: 020-8776 7772 Tel: 020-8659 4561

SPYKER Paul MANAGEMENT
PO Box 48848, London WC1B 3WZ
e-mail: belinda@psmlondon.com
Fax: 020-7462 0047 Tel: 020-7462 0046

SRA PERSONAL MANAGEMENT
Suite 84, The London Fruit and Wool Exchange
Brushfield Street, London E1 6EP
e-mail: agency@susanrobertsacademy.co.uk
Tel: 01932 863194 Tel: 020-7655 4477

STACEY Barrie PROMOTIONS
Apartment 8, 132 Charing Cross Road, London WC2H 0LA
Website: www.barriestacey.com
e-mail: hopkinstacey@aol.com
Fax: 020-7836 2949 Tel: 020-7836 4128

STAFFORD Helen MANAGEMENT
14 Park Avenue, Bush Hill Park, Enfield EN1 2HP
e-mail: helen.stafford@blueyonder.co.uk
 Tel: 020-8360 6329

STAGE AND SCREEN PERSONAL MANAGEMENT
20B Kidbrook Grove, Blackheath SE3 0LF
Website: www.stageandscreen.mfbiz.com
e-mail: stageandscreen1@yahoo.co.uk Mobile: 07958 648740

STAGE CENTRE MANAGEMENT Ltd•
PM Co-operative
41 North Road, London N7 9DP
Website: www.stagecentre.org.uk
e-mail: stagecentre@aol.com
Fax: 020-7609 0213 Tel: 020-7607 0872

STAGEWORKS WORLDWIDE PRODUCTIONS
525 Ocean Boulevard, Blackpool FY4 1EZ
Website: www.stageworkswwp.com
e-mail: simon.george@stageworkswwp.com
Fax: 01253 343702 Tel: 01253 342427

STAR MANAGEMENT Ltd
16A Winton Drive, Glasgow G12 0QA
Website: www.starmanagement.co.uk
e-mail: star@starmanagement.co.uk Tel: 0870 2422276

STARFISH ENTERPRISES Ltd
15 Leamington Road, Ainsdale
Southport, Merseyside PR8 3LB
Website: www.starfishents.co.uk
e-mail: info@starfishents.co.uk Tel: 01704 573779

STARLINGS THEATRICAL AGENCY
45 Viola Close
South Ockendon, Essex RM15 6JF
Website: www.webspawner.com/users/starlings
e-mail: julieecarter@aol.com Mobile: 07969 909284

STEVENSON Natasha MANAGEMENT
(See NSM)

STIVEN CHRISTIE MANAGEMENT
(Incorporating The Actors Agency of Edinburgh)
1 Glen Street
Tollcross, Edinburgh EH3 9JD
Fax: 0131-228 4645 Tel: 0131-228 4040

ST. JAMES'S MANAGEMENT
PM (Write SAE)
19 Lodge Close, Stoke D'Abernon
Cobham, Surrey KT11 2SG
Fax: 01932 860444 Tel: 01932 860666

STONE Ian ASSOCIATES
4 Masons Avenue
Croydon, Surrey CR0 9XS
Fax: 020-8680 9912 Tel: 020-8667 1627

STONE Richard PARTNERSHIP The*
2 Henrietta Street, London WC2E 8PS
e-mail: all@thersp.com
Fax: 020-7497 0869 Tel: 020-7497 0849

STRAIGHT LINE MANAGEMENT
(Division of Straight Line Productions)
58 Castle Avenue
Epsom, Surrey KT17 2PH
e-mail: hilary@straightlinemanagement.co.uk
Fax: 020-8393 8079 Tel: 020-8393 4220

STRANGE John MANAGEMENT
11 Ashley Street, Glasgow G3 6DR
Website: www.stangemanagement.co.uk
e-mail: lesley@strangemanagement.co.uk
Fax: 0141-333 9890 Tel: 0141-333 0233

SUCCESS
Room 236, 2nd Floor, Linen Hall
162-168 Regent Street, London W1B 5TB
Website: www.successagency.co.uk
e-mail: ee@successagency.co.uk
Fax: 020-7494 3787 Tel: 020-7734 3356

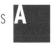
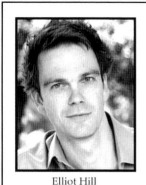

jack ladenburg
photography

07932 053 743

info@jackladenburg.com

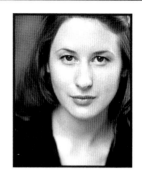

Elliot Hill Lydia Piechowiak

SUMMERS Mark MANAGEMENT
137 Freston Road
London W10 6TH
Website: www.marksummers.com
e-mail: info@marksummers.com
Fax: 020-7243 1987 Tel: 020-7229 8413

SUMMERTON Michael MANAGEMENT Ltd
PM M
Mimosa House
Mimosa Street, London SW6 4DS
Website: www.michaelsummerton.com
e-mail: msminfo@btconnect.com
Fax: 020-7731 0103 Tel: 020-7731 6969

TAKE FLIGHT MANAGEMENT
22 Streatham Close
Leigham Court Road
London SW16 2NQ
e-mail: morwenna@takeflightmanagement.co.uk
 Tel/Fax: 020-8835 8147

TALENT ARTISTS Ltd*
59 Sydner Road, London N16 7UF
e-mail: talent.artists@btconnect.com
Fax: 020-7923 2009 Tel: 020-7923 1119

TAVISTOCK WOOD
32 Tavistock Street, London WC2E 7PB
Website: www.tavistockwood.com
Fax: 020-7240 9029 Tel: 020-7257 8725

TAYLOR Brian ASSOCIATES*
50 Pembroke Road
Kensington, London W8 6NX
e-mail: briantaylor@nqassoc.freeserve.co.uk
Fax: 020-7602 6301 Tel: 020-7602 6141

TCA
(The Commercial Agency)
e-mail: mail@thecommercialagency.co.uk
Fax: 020-7233 8110 Tel: 020-7233 8100

TCG ARTIST MANAGEMENT
(Kristin Tarry, Rachel Cranmer-Gordon & Michael Ford)
Fourth Floor
6 Langley Street, London WC2H 9JA
Website: www.spotlightagent.info/tcgam
e-mail: info@tcgam.co.uk
Fax: 020-7240 3606 Tel: 020-7240 3600

TELFORD Paul MANAGEMENT (PTM)
PM (Write)
3 Greek Street, London W1D 4DA
Website: www.paultelford.net
e-mail: info@telford-mgt.com
Fax: 020-7434 1200 Tel: 020-7434 1100

T.G.R. DIRECT
88 Recreation Road
Poole, Dorset BH12 2AL
e-mail: tatianaroc.tgrdirect@virgin.net
Fax: 01202 721802 Tel: 01202 721222

THEATRE EXPRESS MANAGEMENT
(Write)
Spindle Cottage, Allens Farm
Digby Fen, Billinghay, Lincoln LN4 4DT
e-mail: info@theatre-express.com

THOMAS & BENDA ASSOCIATES Ltd
Top Floor
15-16 Ivor Place
London NW1 6HS Tel/Fax: 020-7723 5509

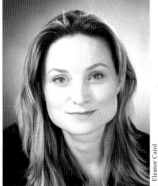

Neil Mason
Photography

www.neilmasonphotography.com
info@neilmasonphotography.com

020 8788 2449
07940507965

Eleanor Caird

Peter Maxian

THOMPSON Jim
Herricks, School Lane, Arundel, West Sussex BN18 9DR
e-mail: jim@jthompson42.freeserve.co.uk
Fax: 01903 885887 Tel: 01903 885757

THOMPSON Peggy OFFICE The
PM
1st & 2nd Floor Offices, 296 Sandycombe Road
Kew, Richmond, Surrey TW9 3NG
Fax: 020-8332 1127 Tel: 020-8332 1003

THORNTON AGENCY
(Specialist Agency for Small People)
72 Purley Downs Road, South Croydon CR2 0RB
Website: www.dwarfs4hire.com
e-mail: thorntons.leslie@tinyworld.co.uk
 Tel/Fax: 020-8660 5588

THRELFALL Katie ASSOCIATES
2A Gladstone Road, London SW19 1QT
e-mail: info@ktthrelfall.co.uk
Fax: 020-8543 7545 Tel: 020-8543 4344

THRESH Melody MANAGEMENT ASSOCIATES Ltd (MTM)
27 Ardwick Green North, Ardwick, Manchester M12 6FZ
e-mail: melodythreshmtm@aol.com
Fax: 0161-273 5455 Tel: 0161-273 5445

TILDSLEY Janice ASSOCIATES
8 Addison Road, London E17 9LT
e-mail: info@janicetildsleyassociates.co.uk
Fax: 020-8521 1174 Tel: 020-8521 1888

TINKER Victoria MANAGEMENT
(Technical, Non-Acting)
Birchenbridge House, Brighton Road
Mannings Heath, Horsham
West Sussex RH13 6HY Tel/Fax: 01403 210653

TMG
(Lisa-Anne Porter)
14 Hagan's Court
Lad Lane, Dublin 2, Ireland
e-mail: talentmanagementgroup@eircom.net
Fax: 00 353 1 661 9967 Tel: 00 353 1 661 9969

TOTAL VANITY Ltd
35 Wyvenhoe Road, South Harrow, Middlesex HA2 8LR
Website: www.totalvanity.com
e-mail: teresa.hellen@totalvanity.com
 Tel/Fax: 020-8426 4327

TOTS-TWENTIES
62 Buntingbridge Road, Newbury Park
Ilford, Essex IG1 7LR
Website: www.tots-twenties.co.uk
e-mail: sara@tots-twenties.co.uk
Fax: 020-8518 0212 Tel: 020-8518 0200

TRENDS AGENCY & MANAGEMENT Ltd
Sullom Lodge, Sullom Side Lane, Garstang PR3 1GH
Website: www.trendsgroup.co.uk
e-mail: info@trendsgroup.co.uk
Fax: 01253 407715 Tel: 0871 2003343

TROIKA*
3rd Floor, 74 Clerkenwell Road, London EC1M 5QA
e-mail: info@troikatalent.com
Fax: 020-7490 7642 Tel: 020-7861 8061

TUCKER Tommy AGENCY
Suite 66, 235 Earl's Court Road, London SW5 9FE
e-mail: TTTommytucker@aol.com
Fax: 020-7370 4784 Tel: 020-7370 3911

TV MANAGEMENTS
Brink House, Avon Castle
Ringwood, Hants BH24 2BL
e-mail: etv@tvmanagements.co.uk
Fax: 01425 480123 Tel: 01425 475544

TWINS
(See PC THEATRICAL & MODEL AGENCY)

TWINS & TRIPLETS
(Identical Babies, Children, Teenagers & Adults for
Film/Television)
15 Holmhurst Road
Upper Belvedere DA17 6HW
e-mail: twinsontv@aol.com Tel: 01322 440184

TWIST & FLIC SPORTS AGENCY
(Sports Model Agent)
1A Calton Avenue
Dulwich Village, London SE21 7ED
Website: www.sportsmodels.com
e-mail: info@sportsmodels.com
Mobile: 07973 863263 Tel: 020-8299 8800

'Connecting you with the best talent Worldwide!'

Part of Planitology Productions Limited, Agency Planitology offers a full entertainment, celebrity and crew booking service which charges no commission to the client if booked as part of a Planitology Productions event or party and at a very competitive rate if not. We make sure the client gets all the discounts as well as access to a full entertainment booking agency, working with some of the best names in the industry and supplying first class entertainment to some of the UK's and Europe's largest and best known Blue Chip companies and personal clients.

"....Well organised by Planitology and their staff. I would be more than happy to work with you again...." Colin Fry, International Medium

Planitology Productions Limited **Studio G7, Shakespeare Business Centre 245A Coldharbour Lane, London SW9 8RR**
david@planitology.co.uk www.planitology.co.uk t: +44 (0)20 7733 2995 f: +44 (0)20 7900 6292 m: +44 (0) 7970 251 618

TWO'S COMPANY
244 Upland Road, London SE22 0DN
e-mail: 2scompany@britishlibrary.net
Fax: 020-8299 3714 Tel: 020-8299 4593

UGLY MODELS
Tigris House,
256 Edgware Road, London W2 1DS
Website: www.ugly.org
e-mail: info@ugly.org
Fax: 020-7402 0507 Tel: 020-7402 5564

ULTIMATE MODELS
11 Worcester Court, Ranson Road
Norwich, Norfolk NR1 4AW
Website: www.ultimatemodels.net
e-mail: info@ultimatemodels.net Tel: 01603 432166

UNIQUE MANAGEMENT GROUP
Power Road Studios, 114 Power Road, London W4 5PY
Website: www.unique-management.co.uk
e-mail: celebrities@uniquegroup.co.uk
Fax: 020-8987 6401 Tel: 020-8987 6400

UNIQUE TALENT MANAGEMENT Ltd
(Dancers Only)
International House, Suite 501
223 Regent Street, London W1H 2QD
Website: www.utm.org.uk
e-mail: info@utm.org.uk Tel: 020-7569 8636

UNITED PRODUCTIONS
(Choreographers, Dancers, Stylists, Glamour Team)
Suite 265 Southbank House
Black Prince Road, London SE1 7SJ
Website: www.unitedproductions.biz
e-mail: info@unitedproductions.biz Tel/Fax: 020-7463 0655

UPBEAT MANAGEMENT
(Theatre Touring & Events - No Actors)
PO Box 63, Wallington, Surrey SM6 9YP
Website: www.upbeat.co.uk
e-mail: info@upbeat.co.uk
Fax: 020-8669 6752 Tel: 020-8773 1223

URBAN TALENT
Nemesis House, 1 Oxford Court
Bishopsgate, Manchester M2 3WQ
Website: www.urbantalent.tv
e-mail: liz@nmsmanagement.co.uk
Fax: 0161-228 6727 Tel: 0161-228 6866

UVA MANAGEMENT Ltd
118-120 Kenton Road, Harrow, Middlesex HA3 8AL
Website: www.uvamanagement.com
e-mail: berko@uvamanagement.com
Fax: 020-8909 9161 Tel: 0845 3700883

V A MANAGEMENT
393 High Street, Aldershot, Hants GU12 4NF
Website: www.viciousmanagement.com
e-mail: info@viciousmanagement.com
 Tel/Fax: 01252 668357

VACCA Roxane MANAGEMENT*
73 Beak Street, London W1F 9SR
Website: www.roxanevaccamanagement.com
Fax: 020-7734 8086 Tel: 020-7734 8085

VALLÉ ACADEMY THEATRICAL AGENCY The
The Vallé Academy Studios, Wilton House
Delamare Road, Cheshunt, Herts EN8 9SG
Website: www.valleacademy.co.uk
e-mail: agency@valleacademy.co.uk
Fax: 01992 622868 Tel: 01992 622861

Jacob Dramatics Management *"Your Ladder To Success"*

No.4 Raby Drive East Herrington Sunderland Tyne and Wear SR3 3QE
T: 0191 5512 954 **F:** 0191 5512 954 **E:** jacobjky@aol.com

Get Headshots that work 4u!
www.gapphotography.com
giovanni@gapphotography.com mob: 07939072419

Lucy Piper Kimberley Palmer Michael Palau

VAMP JAZZ
(Artists & Musicians)
Ealing House
33 Hanger Lane, London W5 3HJ
e-mail: vampjazz@aol.com Tel: 020-8997 3355

VIDAL-HALL Clare*
(Directors, Designers, Choreographers, Lighting Designers, Composers)
57 Carthew Road, London W6 0DU
e-mail: info@clarevidalhall.com
Fax: 020-8741 9459 Tel: 020-8741 7647

VINE Michael ASSOCIATES
(Light Entertainment)
29 Mount View Road, London N4 4SS
e-mail: mpvine@aol.com
Fax: 020-8348 3277 Tel: 020-8348 5899

VisABLE PEOPLE
(Artists with Disabilities only)
Website: www.visablepeople.com
e-mail: louise@visablepeople.com Tel/Fax: 01905 776631

VOCALWORKS INTERNATIONAL
Rivington House
82 Great Eastern Street
London EC2A 3JF
Website: www.vocalworks-international.com
e-mail: vocalworks@btinternet.com Tel/Fax: 0870 6092629

WALMSLEY Peter ASSOCIATES
(No Representation, Do Not Write)
37A Crimsworth Road
London SW8 4RJ
e-mail: associates@peterwalmsley.net
Mobile: 07778 347312 Tel: 020-7787 6419

WARING & McKENNA*
11-12 Dover Street
London W1S 4LJ
Website: www.waringandmckenna.com
e-mail: dj@waringandmckenna.com
Fax: 020-7629 4466 Tel: 020-7629 6444

WAVE ENTERTAINMENT
The Thatched House
Cheselbourne, Dorchester DT2 7NT
Website: www.wave-entertainment.co.uk
e-mail: paul@wave-entertainment.co.uk Tel: 0870 7606263

WEBSTER MANAGEMENT
75 Hewison Street
London E3 2HZ
e-mail: danniwebster@onetel.net Mobile: 07708 154250

WELCH Janet PERSONAL MANAGEMENT
Old Orchard
The Street
Ubley, Bristol BS40 6PJ
e-mail: info@janetwelchpm.co.uk Tel/Fax: 0870 8508874

WESSON Penny*
(Directors)
26 King Henry's Road
London NW3 3RP
e-mail: penny@pennywesson.demon.co.uk
Fax: 020-7483 2890 Tel: 020-7722 6607

WEST CENTRAL MANAGEMENT
Co-operative
Room 4, East Block
Panther House
38 Mount Pleasant, London WC1X 0AN
Website: www.westcentralmanagement.co.uk
e-mail: mail@westcentralmanagement.co.uk
 Tel/Fax: 020-7833 8134

WEST END MANAGEMENT
(Maureen Cairns)
188 St Vincent Street
Glasgow G2 5SP
Website: www.west-endmgt.com
e-mail: info@west-endmgt.com
Fax: 0141-226 8983 Tel: 0141-226 8941

WHATEVER ARTISTS MANAGEMENT Ltd
F24 Argo House
Kilburn Park Road, London NW6 5LF
Website: www.wamshow.biz
e-mail: wam@agents-uk.com
Fax: 020-7372 5111 Tel: 020-7372 4777

WHITEHALL ARTISTS
10 Lower Common South
London SW15 1BP
e-mail: mwhitehall@msn.com
Fax: 020-8788 2340 Tel: 020-8785 3737

WILDE Vivien Ltd
2A, 59-61 Brewer Street
London W1F 9UN
e-mail: info@vwilde.co.uk
Fax: 020-7439 1941 Tel: 020-7439 1940

WILKINSON David ASSOCIATES*
(Existing Clients Only)
115 Hazlebury Road
London SW6 2LX
Fax: 020-7371 5161 Tel: 020-7371 5188

WILLIAMSON & HOLMES
9 Hop Gardens, St. Martin's Lane, London WC2N 4EH
e-mail: info@williamsonandholmes.co.uk
Fax: 020-7240 0408 Tel: 020-7240 0407

WILLOW PERSONAL MANAGEMENT
(Specialist Agency for Short Actors)
151 Main Street, Yaxley, Peterborough, Cambs PE7 3LD
e-mail: email@willowmanagement.co.uk
 Tel/Fax: 01733 240392

WILLS Newton MANAGEMENT
The Studio, 29 Springvale Avenue
Brentford, Middlesex TW8 9QH
e-mail: newtoncttg@aol.com
Fax: 00 33 241 823108 Mobile: 07989 398381

WILSON-GOUGH MANAGEMENT
2nd Floor, Hammer House, 117 Wardour Street W1F 0UN
e-mail: info@wilson-gough.com
Fax: 020-7439 4173 Tel: 020-7439 4171

WINGS AGENCY
(Affiliated to Angels Theatre School)
133 Peperharow Road, Godalming, Surrey GU7 2PW
e-mail: wingsagency@hotmail.com
Fax: 01483 429966 Tel: 01483 428844

WINSLETT Dave ASSOCIATES
6 Kenwood Ridge
Kenley, Surrey CR8 5JW
Website: www.davewinslett.com
e-mail: info@davewinslett.com
Fax: 020-8668 9216 Tel: 020-8668 0531

WINTERSON Niki
(See GLOBAL ARTISTS)

WIS CELTIC MANAGEMENT
(Welsh, Irish, Scottish)
86 Elphinstone Road, Walthamstow, London E17 5EX
Fax: 020-8523 4523 Tel: 020-8523 4234

WISE BUDDAH TALENT
(Chris North)
74 Great Titchfield Street, London W1W 7QP
Website: www.wisebuddah.com
Fax: 020-7307 1602 Tel: 020-7307 1617

WOOD Louise AGENCY
16 Park Crescent, Twickenham, Middlesex TW2 6NT
Website: www.louisewoodagency.co.uk
e-mail: info@louisewoodagency.co.uk
 Tel/Fax: 020-8755 2715

WYMAN Edward AGENCY
F TV (English & Welsh Language)
67 Llanon Road
Llanishen, Cardiff CF14 5AH
Website: www.wymancasting.co.uk
e-mail: edward.wyman@btconnect.com
Fax: 029-2075 2444 Tel: 029-2075 2351

X-FACTOR MANAGEMENT Ltd
PO Box 44198, London SW6 4XU
Website: www.xfactorltd.com
e-mail: info@xfactorltd.com
Fax: 0870 2519560 Tel: 0870 2519540

XL MANAGEMENT
Edmund House, Rugby Road
Leamington Spa
Warwickshire CV32 6EL
Website: www.xlmanagement.co.uk
e-mail: office@xlmanagement.co.uk
Fax: 01926 811420 Tel: 01926 810449

YELLOW BALLOON PRODUCTIONS Ltd
(Mike Smith)
Freshwater House
Outdowns, Effingham
Surrey KT24 5QR
e-mail: yellowbal@aol.com
Fax: 01483 281502 Tel: 01483 281500

YOUNG ACTORS THEATRE MANAGEMENT
Young Actors Management
70-72 Barnsbury Road, London N1 0ES
Website: www.yati.org.uk
e-mail: agent@yati.org.uk
Fax: 020-7833 9467 Tel: 020-7278 2101

ZWICKLER Marlene & ASSOCIATES
2 Belgrave Place, Edinburgh EH4 3AN
Website: www.mza-artists.com Tel/Fax: 0131-343 3030

A & J MANAGEMENT
242A The Ridgeway
Botany Bay, Enfield EN2 8AP
Website: www.ajmanagement.co.uk
e-mail: info@ajmanagement.co.uk
Fax: 020-8342 0842 Tel: 020-8342 0542

ABACUS AGENCY
The Studio, 4 Bailey Road
Westcott, Dorking, Surrey RH4 3QS
Website: www.abacusagency.co.uk
e-mail: admin@abacusagency.co.uk
Fax: 01306 877813 Tel: 01306 877144

ACADEMY MANAGEMENT
123 East Park Farm Drive, Charvil
Reading, Berks RG10 9UQ Tel: 0118-934 9940

ACT 1 KIDZ
14 Mossy Bank Close
Queensbury, Bradford BD13 1PX
Website: www.act1kidz.org.uk
e-mail: ali@act1kidz.org.uk
Mobile: 07920 789606 Tel: 01274 883460

ACT OUT AGENCY
(Children, Teenagers & New Graduates)
22 Greek Street, Stockport, Cheshire SK3 8AB
e-mail: ab22actout@aol.com Tel/Fax: 0161-429 7413

ACTIVATE DRAMA SCHOOL
(Drama School & Agency)
Priestman Cottage
Sea View Road, Sunderland SR2 7UP
e-mail: activate_agcy@hotmail.com Tel: 0191-565 2345

How do child actors get started?

If a child is interested in becoming an actor, they should try to get as much practical experience as possible. For example, joining the drama club at school, taking theatre studies as an option, reading as many plays as they can, and going to the theatre on a regular basis. They could also attend local youth theatres or drama groups. Some theatres offer evening or Saturday classes.

What are the chances of success?

As any agency or school will tell you, the entertainment industry is highly competitive and for every success story there are many children who will never be hired for paid acting work. Child artists and their parents should think very carefully before getting involved in the industry and be prepared for disappointments along the way.

What is the difference between stage schools and agencies?

Stage schools provide specialised training in acting, singing and dancing for the under 18's. They offer a variety of full and part-time courses. Please see the 'Drama Training, Schools and Coaches' section for listings (marked 'SS'). Children's and Teenagers' agencies specialise in the representation of child artists, promoting them to casting opportunities and negotiating contracts on their behalf. In return they will take commission, usually ranging from 10-15%. A number of agents are listed in the following pages. Always research an agency carefully to make sure it is suitable for your child. As a general rule, you should not pay an upfront joining fee. Some larger stage schools also have agencies attached to them.

Why do child actors need licenses? Who are chaperones?

Strict regulations apply to children working in the entertainment industry. These cover areas including the maximum number of performance hours per day / week, rest times, meal times and tutoring requirements. When any child under 16 performs in a professional capacity, the production company must obtain a Child Performance Licence from the child's Local Education Authority. Child artists must also be accompanied by a chaperone at all times when they are working. Registered chaperones are generally used instead of parents as they have a better understanding of the employment regulations involved, and they have professional experience of dealing with production companies. Registered chaperones have been police checked and approved by their local education authority to act *in loco parentis*. Always contact your local education authority if you have any questions or concerns.

What is the Spotlight Children and Young Performers directory?

Children who are currently represented by an agent or attend a stage school can appear in the Spotlight Children and Young Performers directory. This is a casting directory, used by production teams to source child artists for TV, film, stage or commercial work. Please speak to your child's school or agency about joining Spotlight.

Redroofs Associates
Littlewick Green
Maidenhead
Berkshire SL6 3QY

Tel: 01628 822982
Fax: 01628 882461

SAMANTHA KESTON is a partner in Redroofs Theatre School in Maidenhead. Founded in 1947 by June Rose, Principal, Redroofs offers performance training to children from four, full time from nine years and students of sixteen plus. It also has an affiliated agency which represents pupils who are a part of its school and graduates of its college.

Historically speaking, there are more children's agents than ever before, all clambering to put your son or daughter on the stage! But the fact that anyone can set up an agency with no track record means that parents should always carry out their own checks before appointing an agent.

This would be my personal checklist:

• Are my children going to be safe? Will the agency let me take my own children to castings, or must chaperones be used? If my child needs a licensed chaperone at the last minute, will that be possible? If I am a working parent, can the agency help me to find a chaperone to fetch and carry, and what happens if my son or daughter feels unhappy for whatever reason on set?

• When castings come in, will the agency know my child well enough to suggest him/her for the right part, or will all the other children at the audition be titian redheads when my child is a dusty brunette? Will the agency keep updated records of their skills and measurements? Do they know my child's personality, acting abilities, and also their limits?

• If my child is lucky enough to be offered a role, is the agency well placed to get him/her licensed without disappointment, to negotiate a deal, to consider practicalities so the child (and you, their parent) feels totally comfortable with every detail of the arrangement, whether in the studio, on location, or overseas?

• Is the agency in a position to create further opportunities, or will my capable child be the next One-Ad-Wonder?

• What are the costs involved? Most agencies will probably require the child to take a paid entry in the Spotlight Children and Young Performers Directory and some will arrange photo sittings for you at a very reasonable rate. After this, any further charges are deemed to be bad practice until the child obtains work via the agency, when commission will be charged on the earnings.

• What sort of opportunities are you and your child hoping for? Try to match these expectations with an appropriate agent. Are you prepared for your child to take days, sometimes weeks out of school, and how does your child's school view the potential absence? Whoever you choose to represent your child, do be wary of agents prepared to 'collect' pupils, however talented they may be, from other agencies. Some are newer, with a fresh perspective, and others have seen many children come and go, grow up, develop from little mouse to *Les Mis*, meet with fame, and dealt with its consequences. Seek recommendations based on what you are looking for.

• Finally: is this what your child really wants? In putting children 'to work' we must be sure that their experiences are well chosen: we must not 'make a business' out of them. If your child is strikingly pretty, or characterful, a chatterbox or one of life's bookworms, they will be considered 'a catch': but don't forget - there are people out there looking at your kid as the next face of Milky Bar and anticipating their financial cut! Children are not a commodity: for them these must be, first and foremost, the best years of their lives.

For more information about Redroofs Theatre School and Agency please visit (www.redroofs.co.uk)

THE VALLÉ ACADEMY THEATRICAL AGENCY

Over 400 talented and professional performers from toddlers to adults available for:

TV, FILMS, CORPORATE VIDEOS, COMMERCIALS, THEATRE, VOICE OVERS, EXTRAS & MODELLING WORK
* Licensed Chaperones
* Workshops can be arranged for casting directors
* Audition space available

Tel: 01992 622 861

Fax: 01992 622 868 Email: agency@valleacademy.co.uk
The Vallé Academy Theatrical Agency, The Vallé Academy Studios, Wilton House, Delamare Road, Cheshunt, Herts EN8 9SG

International Casting & Model Agency
Specialising in child & adult actors & artists from 0 to 80 yr
Television : Film : Commercials
Extras/Supporting & Main Actors
Quality artists for crowd scenes
Casting Studios, Reception Facilities in Manchester/Liverpool Area
TEL: 01925 767574
email: castings@eka-agency.com
Artists & CV's on-line:
www.eka-agency.com
All Children Licensed - Chaperones & Tutors

Agent to
Lilli-Ella Kelleher
'Young Sophie Neveu'
in
Da Vinci Code

ADAMS Juliet CHILD MODEL & TALENT AGENCY
19 Gwynne House, Challice Way, London SW2 3RB
Website: www.julietadams.co.uk
e-mail: models@julietadams.co.uk
Fax: 020-8671 9314 Tel: 020-8671 7673

ALLSORTS DRAMA FOR CHILDREN
(In Association with Sasha Leslie Management)
34 Pember Road, London NW10 5LS
e-mail: sasha@allsortsdrama.com
Fax: 020-8969 3196 Tel: 020-8969 3249

ALLSTARS CASTING
PO Box 28, Walton, Liverpool L10 6NN
Website: www.allstarsweb.co.uk
e-mail: allstarsweb@hotmail.co.uk
Fax: 0151-476 1135 Mobile: 07739 359737

ALPHABET KIDZ TALENT & MODELLING AGENCY
189 Southampton Way, London SE5 7EJ
Website: www.alphabetkidz.co.uk
e-mail: contact@alphabetkidz.co.uk
Fax: 020-7252 4341 Tel: 020-7252 4343

ANNA'S MANAGEMENT
(Formerly of ALADDIN'S CAVE)
25 Tintagel Drive, Stanmore
Middlesex HA7 4SR
e-mail: annasmanage@aol.com
Fax: 020-8238 2899 Tel: 020-8958 7636

AQUITAINE PERSONAL MANAGEMENT
PO Box 1896, Stanford-Le-Hope, Essex SS17 0WR
Website: www.apm.aquitaine.org.uk
e-mail: apm@aquitaine.org.uk Tel: 01375 488009

Altea Claveras, Charlotte Byker Grove

YOUR IMAGINATION
Drama School and Agency

Actors, Extras, Models, Licensed Chaperones and Tutors with all round training for Theatre, T.V., Film and Commercial work

Contact: Lesley McDonough BA (Hons)

Priestman Cottage, Sea View Road, Sunderland SR2 7UP

Tel: 0191 565 2345 Mob: 07989 365737

www.lineone.net/~lesley.mcdonough
e-mail: activate_agcy@hotmail.com

JACKIE PALMER AGENCY

30 Daws Hill Lane
High Wycombe, Bucks
HP11 1PW
Office 01494 520978
Fax 01494 510479

E-mail jackie.palmer@btinternet.com
Website: www.jackiepalmer.co.uk

Well behaved, natural children, teenagers and young adults.
All nationalities, many bi-lingual.
Acrobatics are a speciality.
Pupils regularly appear in West End Theatre, including RSC, National Theatre and in Film and Television.

We are just off the M40 within easy reach of London, Oxford, Birmingham and the South West.
Licensed tutors and chaperones

Elisabeth Smith

The MODEL AGENCY for
- BABIES
- CHILDREN
- TEENAGERS
- FAMILIES

020-8863 2331 (5 LINES) FAX 020-8861 1880

Website: http://www.elisabethsmith.co.uk

81 Headstone Road · Harrow · Middlesex · HA1 1PQ

Expressions

Academy of Performing Arts Casting Agency

CHILDREN & YOUNG ADULTS up to 21 years
TV · FILM · COMMERCIALS · THEATRE · MODELLING
Children Open License · Licensed Chaperones

www.expressions-uk.com

Children from London & All Over UK.

3, Newgate Lane, Mansfield, Nottingham NG18 2LB
Phone: 01623 424334 Fax: 01623 647337
e-mail: expressions-uk@btconnect.com

ARAENA/COLLECTIVE
10 Bramshaw Gardens
South Oxhey
Herts WD19 6XP Tel/Fax: 020-8428 0037
ARTS ACADEMY (T.A.A.) The
15 Lexham Mews, London W8 6JW
e-mail: jill@galloways.ltd.uk
Fax: 020-7376 2416 Tel: 020-7376 0267
ASHCROFT ACADEMY OF DRAMATIC ART & AGENCY
Malcolm Primary School
Malcolm Road, Penge
London SE20 8RH
Website: www.ashcroftacademy.com
e-mail: geri.ashcroftacademy@tiscali.co.uk
Mobile: 07799 791586 Tel: 020-8693 8088
AWA - ANDREA WILDER AGENCY
23 Cambrian Drive
Colwyn Bay, Conwy LL28 4SL
Website: www.awagency.co.uk
e-mail: casting@awagency.co.uk
Fax: 07092 249314 Mobile: 07919 202401
BABY BODENS
Bodens Studios & Agency
99 East Barnet Road
New Barnet, Herts EN4 8RF
Website: www.bodensagency.com
e-mail: babybodens@aol.com
Fax: 020-8449 5212 Tel: 020-8447 1035
BABYFACE MODELLING AGENCY
51B Agate Road, Hammersmith, London W6 0AL
Website: www.babyfacemodels.com
e-mail: info@babyfacemodels.com Tel/Fax: 020-8932 7579

BABYSHAK
Bizzy House, 73A Mayplace Road West
Bexleyheath, Kent DA7 4JL
Website: www.babyshak.com
e-mail: bookings@babyshak.com
Fax: 020-8303 2730 Tel: 020-8303 2627
BARDSLEY'S Pamela UNIQUE AGENCY
161-163 Bispham Road, Churchtown, Southport PR9 7BL
e-mail: pamela_bardsley@hotmail.com
Mobile: 07738 122109 Tel: 01704 231101
BELCANTO LONDON ACADEMY Ltd
(Stage School & Agency)
Performance House
20 Passey Place, London SE9 5DQ
e-mail: bla@dircon.co.uk
Fax: 020-8850 9944 Tel: 020-8850 9888
BIZZYKIDZ
Bizzy House, 73A Mayplace Road West
Bexleyheath, Kent DA7 4JL
Website: www.bizzykidz.com
e-mail: bookings@bizzykidz.com
Fax: 020-8303 2730 Tel: 020-8303 2627
BODENS AGENCY
99 East Barnet Road, New Barnet, Herts EN4 8RF
Website: www.bodensagency.com
e-mail: bodens2692@aol.com
Fax: 020-8449 5212 Tel: 020-8447 1226
BOURNE Michelle ACADEMY & AGENCY The
Studio 1, 22 Dorman Walk, Garden Way, London NW10 0PF
Website: www.michellebourneacademy.co.uk
e-mail: info@michellebourneacademy.co.uk
Mobile: 07956 853564 Tel/Fax: 020-8451 8808

BIZZYKIDZ AGENCY

THE ULTIMATE COMMERCIAL AND PHOTOGRAPHIC AGENCY FOR CHILDREN AGED 0-17 YEARS

Extremely high success rate at auditions.
Very well behaved, natural and confident children of all ages
and nationalities & from all areas.

BIZZYKIDZ
Tel: 020 8303 2627 Fax: 020 8303 2730
Website: www.bizzykidz.com (children's details updated daily)
Bizzy House, 73a Mayplace Road West, Bexleyheath, Kent DA7 4JL
BIZZYKIDZ is a DTI regulated Agency

BOURNEMOUTH YOUTH THEATRE (BYT) The
14 Cooper Dean Drive, Bournemouth BH8 9LN
Website: www.thebyt.com
e-mail: klair@thebyt.com
Fax: 01202 393290 Tel: 01202 854116

BRUCE & BROWN
203 Canalot Studios, 222 Kensal Road, London W10 5BN
Website: www.bruceandbrown.com
e-mail: info@bruceandbrown.com
Fax: 020-8964 0457 Tel: 020-8968 5585

BUBBLEGUM
Pinewood Studios, Pinewood Rd, Iver Heath, Bucks SLO 0NH
Website: www.bubblegummodels.com
e-mail: kids@bubblegummodels.com
Fax: 01753 652521 Tel: 01753 632867

BYRON'S MANAGEMENT
(Babies, Children & Adults)
North London Performing Arts Centre
76 St James Lane
Muswell Hill
London N10 3DF
Website: www.byronsmanagement.co.uk
e-mail: byronscasting@aol.com
Fax: 020-8444 4040 Tel: 020-8444 4445

CAPITAL ARTS
Wyllyotts Centre, Darkes Lane
Potters Bar,
Herts EN6 2HN
e-mail: capitalarts@btconnect.com
Mobile: 07885 232414 Tel/Fax: 020-8449 2342

CARR Norrie MODEL AGENCY
(Babies, Children & Adults)
Holborn Studios, 49-50 Eagle Wharf Road, London N1 7ED
Website: www.norriecarr.com
e-mail: info@norriecarr.com
Fax: 020-7253 1772 Tel: 020-7253 1771

CARTEURS THEATRICAL AGENCY
170A Church Road, Hove, East Sussex BN3 2DJ
Website: www.stonelandsschool.co.uk
e-mail: dianacarteur@stonelandsschool.co.uk
Fax: 01273 770444 Tel: 01273 770445

CHILDSPLAY MODELS LLP
114 Avenue Road, Beckenham, Kent BR3 4SA
Website: www.childsplaymodels.co.uk
e-mail: info@childsplaymodels.co.uk
Fax: 020-8778 2672 Tel: 020-8659 9860

CHRYSTEL ARTS AGENCY
6 Eunice Grove, Chesham, Bucks HP5 1RL
e-mail: chrystelarts@beeb.net Tel: 01494 773336

CIRCUS MANIACS AGENCY
(Circus, Theatre, Dance, Extreme Sports)
Office 8A, The Kingswood Foundation
Britannia Road, Kingswood, Bristol BS15 8DB
Website: www.circusmaniacsagency.com
e-mail: agency@circusmaniacs.com
Mobile: 07977 247287 Tel/Fax: 0117-947 7042

COLIN'S PERFORMING ARTS AGENCY
(Colin's Performing Arts Ltd)
The Studios, 219B North Street, Romford, Essex RM1 4QA
Website: www.colinsperformingarts.co.uk
e-mail: agency@colinsperformingarts.co.uk
Fax: 01708 766077 Tel: 01708 766444

CONTI Italia AGENCY Ltd
23 Goswell Road, London EC1M 7AJ
e-mail: agency@italiaconti.co.uk
Fax: 020-7253 1430 Tel: 020-7608 7500

CS MANAGEMENT
(Children & Young Adults)
The Croft, 7 Cannon Road
Southgate, London N14 7HE
Website: www.csmanagementuk.com
e-mail: carole@csmanagementuk.com
Fax: 020-8886 7555 Tel: 020-8886 4264

D & B MANAGEMENT & THEATRE SCHOOL
470 Bromley Road
Bromley, Kent BR1 4PN
Website: www.dandbperformingarts.co.uk
e-mail: bonnie@dandbmanagement.com
Fax: 020-8697 8100 Tel: 020-8698 8880

DD'S CHILDREN'S AGENCY
6 Acle Close
Hainault, Essex IG6 2GQ
Website: www.debdaystudio.com
e-mail: ddsagency@debdaystudio.com
Mobile: 07725 556231 Tel: 020-8502 6866

DEBUT KIDS
25 Crossways, Shenfield, Essex CM15 8QX
Website: www.debutkids.co.uk
e-mail: team@debutkids.co.uk Mobile: 07946 618328

DIMPLES MODEL & CASTING ACADEMY
(Children, Teenagers & Adults)
84 Kirk Hall Lane, Leigh, Lancs WN7 5QQ
e-mail: info@dimplesacademy.com
Fax: 01942 262232 Tel: 01942 262012

The Stagecoach Agency (UK) Ltd

THE UK'S LARGEST CHILDREN AND YOUNG PERFORMERS AGENCY

We represent over 2200 children and young performers aged between 4 and 19, all of whom attend one of our 570 schools throughout the UK. Our students are available for West End and Regional Theatre, Films, TV, Commercials, Corporate Video, Promotions, Modelling, Voice-Overs and Radio Drama. The Stagecoach Agency can arrange and organise casting workshops and auditions anywhere in the UK. Please contact us for details

0845 4082468

The Stagecoach Agency (UK) Ltd, PO Box 127, Ross-on-Wye, HR9 6WZ
E-mail: agent@thesca.co.uk Web: www.thesca.co.uk

DMS AGENCY
30 Lakedale Road, Plumstead
London SE18 1PP Tel/Fax: 020-8317 6622

DRAGON DRAMA
(Drama for Children)
347 Hanworth Road TW12 3EJ
Website: www.dragondrama.co.uk
e-mail: info@dragondrama.co.uk Tel/Fax: 020-8255 8356

DRAMA STUDIO EDINBURGH The
(Previously Juno Casting Agency)
19 Belmont Road, Edinburgh EH14 5DZ
Website: www.thedramastudio.co.uk
e-mail: thedra@thedramastudio.co.uk
Fax: 0131-453 3108 Tel: 0131-453 3284

EARNSHAW Susi MANAGEMENT
68 High Street, Barnet, Herts EN5 5SJ
Website: www.susiearnshaw.co.uk
e-mail: casting@susiearnshaw.co.uk
Fax: 020-8364 9618 Tel: 020-8441 5010

ENGLISH Doreen '95
(Gerry Kinner)
4 Selsey Avenue, Aldwick, Bognor Regis
West Sussex PO21 2QZ Tel: 01243 825968

EUROKIDS & ADULTS INTERNATIONAL CASTING & MODEL AGENCY
The Warehouse Studios, Glaziers Lane
Culcheth, Warrington, Cheshire WA3 4AQ
Website: www.eka-agency.com
e-mail: info@eka-agency.com
Fax: 01925 767563 Tel: 01925 767574

EXPRESSIONS CASTING AGENCY
3 Newgate Lane, Mansfield, Nottingham NG18 2LB
e-mail: expressions-uk@btconnect.com
Fax: 01623 647337 Tel: 01623 424334

FBI AGENCY Ltd The
PO Box 250, Leeds LS1 2AZ
e-mail: casting@fbi-agency.ltd.uk Tel/Fax: 07050 222747

FIORENTINI Anna THEATRE & FILM SCHOOL & AGENCY
25 Daubeney Road, Hackney, London E5 0EE
Website: www.annafiorentini.co.uk
e-mail: info@annafiorentini.co.uk Tel/Fax: 020-7682 1403

FOOTSTEPS THEATRE SCHOOL CASTING AGENCY
55 Pullan Avenue, Eccleshill, Bradford BD2 3RP
e-mail: helen@footsteps.fslife.co.uk
Tel/Fax: 01274 637429 Tel: 01274 636036

FOX Betty AGENCY
The Friends Institute
220 Moseley Road, Birmingham B12 0DG
e-mail: bettyfox.school@virgin.net
Mobile: 07703 436045 Tel/Fax: 0121-440 1635

GLYNNE Frances MANAGEMENT
Flat 9, Elmwood, The Avenue, Hatch End HA5 5BL
e-mail: franandmo@yahoo.co.uk Mobile: 07950 918355

GO FOR IT CHILDREN'S AGENCY
(Children & Teenagers)
47 North Lane, Teddington, Middlesex TW11 0HU
Website: www.goforitts.com
e-mail: agency@goforitts.com Tel: 020-8943 1120

GOBSTOPPERS MANAGEMENT
37 St Nicholas Mount, Hemel Hempstead, Herts HP1 2BB
e-mail: chrisgobstoppers@btopenworld.com
Mobile: 07961 372319 Tel: 01442 269543

GOLDMAN'S Shana STAGE SCHOOL & AGENCY
74 Braemore Road, Hove, East Sussex BN3 4HB
Website: www.shana-goldmans.com
e-mail: casting@shana-goldmans.co.uk
Mobile: 07967 203433 Tel/Fax: 01273 329916

Sasha Leslie Management
in association with
allsorts™ drama for children
ages 3-16

☏ : 020 8969 3249
e : sasha@allsortsdrama.com
w : www.allsortsdrama.com
34 Pember Road,
London NW10 5LS

G. P. ASSOCIATES
4 Gallus Close, Winchmore Hill, London N21 1JR
e-mail: info@gpassociates.co.uk
Fax: 020-8882 9189 Tel: 020-8886 2263

GRAYSTONS
843-845 Green Lanes, Winchmore Hill, London N21 2RX
e-mail: graystons@btinternet.com
Fax: 020-8364 2009 Tel: 020-8360 5700

GREVILLE Jeannine THEATRICAL AGENCY
Melody House, Gillotts Corner
Henley-on-Thames, Oxon RG9 1QU
Fax: 01491 411533 Tel: 01491 572000

HARLEQUIN STUDIOS AGENCY FOR CHILDREN
122A Phyllis Avenue, Peacehaven
East Sussex BN10 7RQ Tel: 01273 581742

HARRIS AGENCY Ltd The
52 Forty Avenue, Wembley Park, Middlesex HA9 8LQ
e-mail: theharrisagency@ukonline.co.uk
Fax: 020-8908 4455 Tel: 020-8908 4451

HEWITT PERFORMING ARTS
Website: www.hewittperformingarts.co.uk
e-mail: hewittstudios@aol.com Tel: 01708 727784

HOBSON'S KIDS
62 Chiswick High Road, London W4 1SY
Website: www.hobsons-international.com
e-mail: kids@hobsons-international.com
Fax: 020-8996 5350 Tel: 020-8995 3628

HORNIMANS MANAGEMENT
31 Stafford Street, Gillingham, Kent ME7 5EN
Mobile: 07866 689865 Tel/Fax: 01634 576191

HOWE Janet CHILDREN'S CASTING & MODELLING AGENCY
40 Princess Street, Manchester M1 6DE
e-mail: info@janethowe.com
Mobile: 07801 942178 Tel/Fax: 0161-234 0142

56 The Ironmarket, Newcastle, Staffordshire ST5 1PE
e-mail: janet@howecasting.fsbusiness.co.uk
Mobile: 07801 942178 Tel: 01782 661777

INTER-CITY KIDS
Portland Tower, Portland Street, Manchester M1 3LF
Website: www.iccast.co.uk
e-mail: mail@iccast.co.uk Tel/Fax: 0161-238 4950

ITV JUNIOR WORKSHOP
(Birmingham Group)
Central Court, Gas Street, Birmingham B1 2JT
e-mail: colin.edwards@itv.com
Fax: 0121-634 4835 Tel: 0121-634 4347

ITV JUNIOR WORKSHOP
(Nottingham Group)
Terry Lloyd House
Chetwynd Business Park
1 Regan Way, Chilwell
Nottingham NG9 5FH
e-mail: ian.smith1@itv.com Tel: 0115-901 6643

JABBERWOCKY AGENCY
(Children, Teenagers & Adults)
Production House, The Hop Farm Country Park
Beltring, Paddock Wood, Kent TN12 6PY
Website: www.jabberwockyagency.com
e-mail: info@jabberwockyagency.com
Mobile: 07899 983090 Tel: 01622 871851

JB ASSOCIATES
(Children & Teenagers 10-18 Years)
3 Stevenson Square, Manchester M1 1DN
Website: www.j-b-a.net
e-mail: info@j-b-a.net
Fax: 0161-237 1809 Tel: 0161-237 1808

JIGSAW ARTS MANAGEMENT
(Representing Children & Young People from Jigsaw
Performing Arts Schools)
64-66 High Street, Barnet, Herts EN5 5SJ
Website: www.jigsaw-arts.co.uk/agency Tel: 020-8447 4530

JOHNSTON & MATHERS ASSOCIATES Ltd
PO Box 3167, Barnet, Herts EN5 2WA
Website: www.johnstonandmathers.com
e-mail: johnstonmathers@aol.com
Fax: 020-8449 2386 Tel: 020-8449 4968

KASTKIDZ
40 Sunnybank Road
Unsworth, Bury BL9 8HF
Website: www.kastkidz.com
e-mail: kastkidz@ntlworld.com
Fax: 0161-796 7073 Mobile: 07905 646832

Tuesdays Child
Television & Model Agency
(Est. 1976)

Children and Adults from all parts of the UK
Casting Suite available - 40 mins from
Manchester. Direct rail links -
Euston: Birmingham: Macclesfield

Tel: 01625 501765

info@tuesdayschildagency.co.uk
www.tuesdayschildagency.co.uk

KENT YOUTH THEATRE AGENCY
Pinks Hill House, Briton Road
Faversham, Kent ME13 8QH
Website: www.kentyouththeatre.co.uk
e-mail: info@kyt.org.uk Tel/Fax: 01795 534395

KIDS LONDON
67 Dulwich Road, London SE24 0NJ
Website: www.kidslondonltd.com
e-mail: kidslondon@btconnect.com
Fax: 020-7924 9766 Tel: 020-7924 9595

KIDS PLUS
2 Foresters Cottages
Barnet Wood Road, Bromley BR2 8HJ
Website: www.kidsplusagency.co.uk
e-mail: office@kidsplus.wanadoo.co.uk
Mobile: 07704 583352 Tel/Fax: 020-8462 4666

KIDZ Ltd
10 Ellendale Grange, Manchester M28 7UX
Website: www.kidzltd.com e-mail: info@kidzltd.com
Tel/Fax: 0870 2416260 Tel: 0870 2414418

K M C AGENCIES
PO Box 122, 48 Great Ancoats Street, Manchester M4 5AB
e-mail: casting@kmcagencies.co.uk
Fax: 0161-237 9812 Tel: 0161-237 3009

KRACKERS KIDS THEATRICAL AGENCY
6/7 Electric Parade, Seven Kings Road, Ilford, Essex IG3 8BY
Website: www.krackerskids.co.uk
e-mail: krackerskids@hotmail.com Tel/Fax: 01708 502046

LAMONT CASTING AGENCY
94 Harington Road, Formby, Liverpool L37 1PZ
Website: www.lamontcasting.co.uk
e-mail: diane@lamontcasting.co.uk Mobile: 07736 387543

Representing children and young adults 0-18+ years
You can count on us for confident, talented and trained young actors

T/F 01865 340333
E donna@childactors.tv W www.childactors.tv
Jennifer Daykin NANNY MCPHEE

THAMES VALLEY

theatrical agency

THE MICHELLE BOURNE ACADEMY & AGENCY

A MULTICULTURAL AGENCY SPECIALISING IN CHILD DANCERS, MODELS, ACTORS & EXTRAS OF ALL NATIONALITIES.

Head Office: Studio 1, 22 Dorman Walk, London, NW10 0PF **Tel/Fax:** 020 8451 8808
E-mail: info@michellebourneacademy.co.uk
Website: www.michellebourneacademy.co.uk

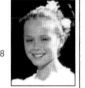

LESLIE Sasha MANAGEMENT
(In Association with Allsorts Drama for Children)
34 Pember Road, London NW10 5LS
e-mail: sasha@allsortsdrama.com
Fax: 020-8969 3196 Tel: 020-8969 3249

LIFE AND SOUL THEATRE AGENCY
Oatfields, Dodds Lane, Piccotts End
Hemel Hempstead, Herts HP2 6JJ
Website: www.lifeandsoultheatreacademy.co.uk
e-mail: lifeandsoulta@hotmail.com Tel/Fax: 01442 233050

LIL DEVILS CHILD MODEL AGENCY
1st Floor, 76 School Rd, Tilehurst, Reading, Berks RG31 5AW
Website: www.lildevils.co.uk
e-mail: kids@lildevils.co.uk
Fax: 0118-941 7273 Tel: 0118-943 3057

LINTON MANAGEMENT
3 The Rock, Bury BL9 0JP
e-mail: carol@linton.tv
Fax: 0161-761 1999 Tel: 0161-761 2020

LITTLE ACORNS
London House, 271-273 King Street, London W6 9LZ
e-mail: acorns@dircon.co.uk
Fax: 020-8390 4935 Tel: 020-8563 0773

LITTLE ADULTS ACADEMY & MODELLING AGENCY Ltd
Studio 1, Essex House, 375-377 High Street
Stratford, London E15 4QZ
e-mail: info@littleadults.demon.co.uk
Fax: 020-8519 9797 Tel: 020-8519 9755

LITTLE GEMS
11 Thorn Road, Farnham, Surrey GU10 4TU
e-mail: littlegems30@hotmail.com
Mobile: 07778 840179 Tel/Fax: 01252 792078

LIVE & LOUD
The S.P.A.C.E., 188 St Vincents St, 2nd Floor, Glasgow G2 5SP
e-mail: info@west-endmgt.com
Fax: 0141-226 8983 Tel: 0141-222 2942

MILLENNIUM KIDZ
73 Hatfield Road
Dagenham, Essex RM9 6JS
Website: www.millenniumkidz.co.uk
e-mail: millkidz@btconnect.com Tel: 020-8517 5999

MONDI ASSOCIATES Ltd
30 Cooper House, 2 Michael Road, London SW6 2AD
e-mail: info@mondiassociates.com Mobile: 07817 133349

MOVIEMITES AGENCY
41 Chestnut Avenue, Great Notley, Braintree, Essex CM7 7JY
Website: www.moviemitesagency.com
e-mail: kids@moviemitesagency.com Tel/Fax: 01376 326562

MRS WORTHINGTON'S
(6-17 Years)
16 Ouseley Road, London SW12 8EF Tel/Fax: 020-8767 6944

NFD - THE FILM AND TV AGENCY
PO Box 76, Leeds LS25 9AG
Website: www.film-tv-agency.com
e-mail: info@film-tv-agency.com Tel/Fax: 01977 681949

NORTHERN STAR ACTING ACADEMY
83 The Avenue, Sale, Cheshire M33 4YA
e-mail: djr@northernstar.org.uk
Mobile: 07957 862317 Tel: 0161-718 5835

NUTOPIA-CHANG PERSONAL MANAGEMENT
Number 8, 132 Charing Cross Road, London WC2H 0LA
Website: www.nutopia-chang.com
Fax: 029-2070 5725 Tel: 029-2071 3540

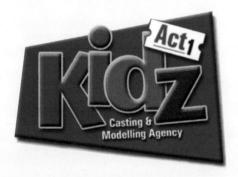

Representing
Children & Teenagers
For Film, TV, Theatre,
Commercials & Modelling

telephone: 07970 008710
or 01274 883460
email: ali@act1kidz.org.uk

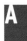
CS Management

Representing Children & Young Adults For Television, Film, Theatre & Commercials

The Croft, 7 Cannon Road, Southgate, London N14 7HE Tel: 020 8886 4264 Fax: 020 8886 7555

email: carole@csmanagementuk.com www.csmanagementuk.com

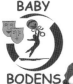 **BABY BODENS**

Providing Babies & Toddlers for work in Film, Television & Commercials

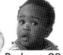 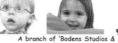 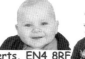

A branch of 'Bodens Studios & Agency'

Bodens. 99 East Barnet Road, New Barnet, Herts. EN4 8RF

020 8447 1035 07717 502 144 babybodens@aol.com

O'FARRELL STAGE & THEATRE SCHOOL
(Babies, Children, Teenagers & Young Adults)
36 Shirley Street, Canning Town, London E16 1HU
Mobile: 07956 941497 Tel: 020-7511 9444

ORR MANAGEMENT AGENCY
(Children, Teenagers & Adults)
1st Floor, 147-149 Market Street, Farnworth BL4 8EX
Website: www.orrmanagement.co.uk
e-mail: barbara@orrmanagement.co.uk
Mobile: 07773 227784 Tel: 01204 579842

OSCARS
43 The Street, Wittersham, Kent TN30 7EA
Website: www.oscarskidz.co.uk
e-mail: oscarstma@aol.com Tel/Fax: 01797 270190

PALMER Jackie AGENCY
30 Daws Hill Lane, High Wycombe, Bucks HP11 1PW
Website: www.jackiepalmer.co.uk
e-mail: jackie.palmer@btinternet.com
Fax: 01494 510479 Tel: 01494 520978

PATMORE Sandra SCHOOL & AGENCY
(Dancing, Drama & Acrobatic)
173 Uxbridge Road, Rickmansworth
Herts WD3 2DW Tel/Fax: 01923 772542

PAUL'S THEATRE AGENCY
Fairkytes Arts Centre
51 Billet Lane, Hornchurch, Essex RM11 1AX
Website: www.paulstheatreschool.co.uk
e-mail: info@paulstheatreschool.co.uk
Fax: 01708 475286 Tel: 01708 447123

PC THEATRICAL & MODEL AGENCY
12 Carlisle Road, Colindale NW9 0HL
Website: www.twinagency.com
e-mail: twinagy@aol.com
Fax: 020-8933 3418 Tel: 020-8381 2229

PHA YOUTH
Tanzaro House, Ardwick Green North, Manchester M12 6FZ
Website: www.pha-agency.co.uk
e-mail: youth@pha-agency.co.uk
Fax: 0161-273 4567 Tel: 0161-273 4444

POLLYANNA MANAGEMENT Ltd
PO Box 30661, London E1W 3GG
e-mail: pollyanna_mgmt@btinternet.com
Fax: 020-7480 6761 Tel: 020-7481 1911

POWER MODEL MANAGEMENT CASTING AGENCY
Capitol House, 2-4 Heigham Street, Norwich NR2 4TE
Website: www.powermodel.co.uk
e-mail: info@powermodel.co.uk Tel: 01603 621100

RASCALS MODEL AGENCY
13 Jubilee Parade, Snakes Lane East
Woodford Green, Essex IG8 7QG
Website: www.rascals.co.uk
e-mail: kids@rascals.co.uk
Fax: 020-8559 1035 Tel: 020-8504 1111

RAVENSCOURT MANAGEMENT
8-30 Galena Road, Hammersmith, London W6 0LT
e-mail: info@ravenscourt.net
Fax: 020-8741 1786 Tel: 020-8741 0707

REBEL SCHOOL OF THEATRE ARTS AND CASTING AGENCY
46 North Park Avenue, Roundhay, Leeds LS8 1EJ
e-mail: rebeltheatre@aol.com
Mobile: 07808 803637 Tel: 0113-305 3796

REDROOFS THEATRE SCHOOL AGENCY
The Admin Building, Pinewood Studios, Iver, Bucks SL0 0NH
e-mail: agency@redroofs.co.uk
Fax: 01753 785443 Tel: 01753 785444

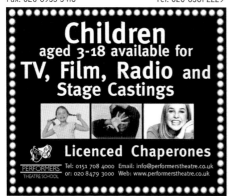

Artist Management
adults children

Byron's Management
Tel: 020 8444 4445
Fax: 020 8444 4040
byronscasting@aol.com
www.byronsmanagement.co.uk

REFLECTIONS AGENCY
9 Weavers Terrace, Fulham, London SW6 1QE
Mobile: 07951 191468 Tel/Fax: 020-7385 1537
RHODES AGENCY
5 Dymoke Road, Hornchurch, Essex RM11 1AA
e-mail: rhodesarts@hotmail.com
Fax: 01708 730431 Tel: 01708 747013
RIDGEWAY MANAGEMENT
Fairley House, Andrews Lane, Cheshunt, Herts EN7 6LB
Website: www.ridgewaystudios.co.uk
e-mail: info@ridgewaystudios.co.uk
Fax: 01992 633844 Tel: 01992 633775
SCALA KIDS CASTING
42 Rufford Avenue, Yeadon, Leeds LS19 7QR
Website: www.scalakids.com
e-mail: office@scalakids.com
Fax: 0113-250 8806 Tel: 0113-250 6823
SCALLYWAGS AGENCY Ltd
90-92 Ley Street, Ilford, Essex IG1 4BX
Website: www.scallywags.co.uk
e-mail: info@scallywags.co.uk
Fax: 020-8553 4849 Tel: 020-8553 9999
SCREAM MANAGEMENT
The Red Door, 32 Clifton Street, Blackpool, Lancs FY1 1JP
Website: www.screammanagement.com
e-mail: info@screammanagement.com
Fax: 01253 750829 Tel: 01253 750820
SEQUINS THEATRICAL AGENCY
Winsome, 8 Summerhill Grove
Enfield EN1 2HY Tel: 020-8360 4015
SHARONA STAGE SCHOOL AGENCY & MANAGEMENT
82 Grennell Road, Sutton, Surrey SM1 3DN
Fax: 020-8642 2364 Tel: 020-8642 9396

SINGER Sandra ASSOCIATES
21 Cotswold Road, Westcliff-on-Sea, Essex SS0 8AA
Website: www.sandrasinger.com
e-mail: sandrasinger@btconnect.com
Fax: 01702 339393 Tel: 01702 331616
SMITH Elisabeth Ltd
81 Headstone Road, Harrow, Middlesex HA1 1PQ
Website: www.elisabethsmith.com
e-mail: models@elisabethsmith.com
Fax: 020-8861 1880 Tel: 020-8863 2331
SOLE KIDZ @ PINEAPPLE AGENCY
Montgomery House, 159-161 Balls Pond Road, London N1 4BG
Website: www.solecentral.org
e-mail: pineapple.agency@btconnect.com
Fax: 020-7241 3006 Tel: 020-7241 6601
SPEAKE Barbara AGENCY
East Acton Lane, London W3 7EG
e-mail: speakekids2@aol.com
Fax: 020-8740 6542 Tel: 020-8743 6096
SRA AGENCY
Suite 84, The London Fruit and Wool Exchange
Brushfield Street, London E1 6EP
e-mail: agency@susanrobertsacademy.co.uk
Tel: 01932 863194 Tel: 020-7655 4477
STAGE 84 YORKSHIRE SCHOOL OF PERFORMING ARTS
Old Bell Chapel, Town Lane
Idle, Bradford, West Yorks BD10 8PR
e-mail: valeriejackson@stage84.com
Mobile: 07785 244984 Tel: 01274 569197
STAGECOACH AGENCY (UK) The
PO Box 127, Ross-on-Wye HR9 6WZ
Website: www.thesca.co.uk
e-mail: agent@thesca.co.uk Tel: 0845 4082468

Bright Northern Kids
Theatre/Film/TV/
Photographic
Annabelle Taylor UKTV Commercial
Paul Wormwell 'Dead Clever' Granada TV
Tel/Fax: 01274 818051
Mob: 07740 091 019
Email: liz@stardom.wanadoo.co.uk
www.stardom.org.uk

STAGE DOOR PERFORMERS
The Stage Door Centre, 27 Howard Business Park
Waltham Abbey, Essex EN9 1XE
Website: www.stagedoorschool.co.uk
e-mail: stagedoorschool@aol.com
Fax: 01992 652171 Tel: 01992 717994

STAGE KIDS DRAMA SCHOOL & AGENCY
1 Greenfield, Welwyn Garden City, Herts AL8 7HW
Website: www.stagekids.co.uk Tel: 01707 328359

STARDOM CASTING AGENCY & THEATRE SCHOOL
16 Pinebury Drive, Queensbury, Bradford BD13 2TA
e-mail: liz@stardom.wanadoo.co.uk Tel/Fax: 01274 818051

STARLINGS THEATRICAL AGENCY
45 Viola Close, South Ockendon, Essex RM15 6JF
Website: www.webspawner.com/users/starlings
e-mail: julieecarter@aol.com
Mobile: 07969 909284 Tel: 01708 402611

STARSTRUCK MANAGEMENT
85 Hewson Road, Lincoln, Lincolnshire LN1 1RZ
e-mail: starstruckacademy@hotmail.com Tel: 01522 887894

STOMP! MANAGEMENT
Holcombe House, The Ridgeway, Mill Hill, London NW7 4HY
Website: www.stompmanagement.com
e-mail: stompmanagement@aol.com Tel/Fax: 020-8959 5353

STONELANDS SCHOOL OF BALLET & THEATRE ARTS
170A Church Road, Hove, East Sussex BN3 2DJ
Website: www.stonelandsschool.co.uk
e-mail: www@stonelandsschool.co.uk
Fax: 01273 770444 Tel: 01273 770445

SUMMERS Mark MANAGEMENT & AGENCY
137 Freston Road, London W10 6TH
Website: www.marksummers.com
e-mail: info@marksummers.com
Fax: 020-7243 1987 Tel: 020-7229 8413

TALENTED KIDS PERFORMING ARTS SCHOOL & AGENCY
23 Burrow Manor, Calverstown, Kilcullen, Co. Kildare, Eire
Website: www.talentedkidsireland.com
e-mail: talentedkids@hotmail.com
Mobile: 00 353 87 2480348 Tel/Fax: 00 353 45 485464

TANWOOD
72 Nyland Road, Nythe, Swindon, Wilts SN3 3RJ
Website: www.tanwood.co.uk
e-mail: tanwood.agency2@ntlworld.com
 Mobile: 07774 517469

THAMES VALLEY THEATRICAL AGENCY
Dorchester House, Wimblestraw Road
Berinsfield, Oxfordshire OX10 7LZ
Website: www.childactors.tv
e-mail: donna@childactors.tv Tel/Fax: 01865 340333

THOMPSON Jim CHILDREN'S SECTION
(Jenny Donnison)
Herricks, School Lane, Arundel, West Sussex BN18 9DR
Fax: 01903 885887 Tel: 01903 885757

TOTS-TWENTIES AGENCY
62 Buntingbridge Road, Newbury Park, Ilford, Essex IG2 7LR
Website: www.tots-twenties.co.uk
e-mail: sara@tots-twenties.co.uk
Fax: 020-8518 0212 Tel: 020-8518 0200

TRULY SCRUMPTIOUS Ltd
66 Bidwell Gardens, London N11 2AU
Website: www.trulyscrumptious.co.uk
e-mail: bookings@trulyscrumptious.co.uk
Fax: 020-8888 4584 Tel: 020-8888 4204

TUESDAYS CHILD
(Children, Teenagers & Adults)
Oakfield House, Springwood Way, Macclesfield SK10 2XA
Website: www.tuesdayschildagency.co.uk
e-mail: info@tuesdayschildagency.co.uk Tel/Fax: 01625 501765

TWINS
(See PC THEATRICAL & MODEL AGENCY)

URBAN ANGELS
7 Burnage Court, Lawrie Park Avenue, London SE26 6HS
e-mail: info@urbanangelsagency.com
Fax: 0870 8710046 Tel: 0870 8710045

VALLÉ ACADEMY THEATRICAL AGENCY
The Vallé Academy Studios, Wilton House
Delamare Road, Cheshunt, Herts EN8 9SG
Website: www.valleacademy.co.uk
e-mail: agency@valleacademy.co.uk
Fax: 01992 622868 Tel: 01992 622861

W-A-P-A CASTING AGENCY
6-8 Akroyd Place, Halifax, West Yorkshire HX1 1YH
Website: www.w-a-p-a.co.uk
e-mail: enquiries@w-a-p-a.co.uk Tel/Fax: 01422 351958

WHITEHALL PERFORMING ARTS CENTRE
Rayleigh Road, Leigh-on-Sea
Essex SS9 5UU Tel/Fax: 01702 529290

WHIZZ KIDS STAGE & SCREEN AGENCY
3 Marshall Road, Cambridge CB1 7TY
Website: www.whizzkidsdrama.co.uk
e-mail: goforit@whizzkidsdrama.co.uk
Fax: 01223 512431 Tel: 01223 416474

WILLIAMSON & HOLMES
9 Hop Gardens, St Martin's Lane, London WC2N 4EH
e-mail: info@williamsonandholmes.co.uk
Fax: 020-7240 0408 Tel: 020-7240 0407

WINGS AGENCY
(Affiliated to Angels Theatre School)
133 Peperharow Road, Godalming, Surrey GU7 2PW
e-mail: wingsagency@hotmail.com
Fax: 01483 429966 Tel: 01483 428844

WYSE AGENCY
1 Hill Farm Road, Whittlesford, Cambs CB2 4NB
e-mail: frances.wyse@btinternet.com
Fax: 01223 839414 Tel: 01223 832288

YOUNG ACTORS FILE The
65 Stafford Street, Old Town, Swindon SN1 3PF
e-mail: young.actorsfile@tiscali.co.uk Tel/Fax: 01793 423688

YOUNG ACTORS THEATRE MANAGEMENT
70-72 Barnsbury Road, London N1 0ES
Website: www.yati.org.uk e-mail: info@yati.org.uk
Fax: 020-7833 9467 Tel: 020-7278 2101

YOUNG 'UNS AGENCY
Sylvia Young Theatre School
Rossmore Road, Marylebone, London NW1 6NJ
e-mail: enquiries@youngunsagency.co.uk
Fax: 020-7723 1040 Tel: 020-7723 0037

YOUNGBLOOD
BWH Agency, Barley Mow Centre
10 Barley Mow Passage, Chiswick, London W4 4PH
e-mail: info@thebwhagency.co.uk
Fax: 020-8996 1662 Tel: 020-8996 1661

YOUNGSTAR AGENCY
Youngstar Drama School, 5 Union Castle House
Canute Road, Southampton SO14 3FJ
Website: www.youngstar.tv
e-mail: info@youngstar.tv
Fax: 023-8045 5816 Tel: 023-8033 9322

YOUNGSTARS
(Coralyn Canfor-Dumas)
4 Haydon Dell, Bushey, Herts WD23 1DD
e-mail: youngstars@bigfoot.com
Fax: 020-8950 5701 Mobile: 07966 176756

A@B (AGENCY AT BODYWORK)
25-29 Glisson Road
Cambridge CB1 2HA
e-mail: agency@bodyworkds.co.uk
Fax: 01223 358923 Tel: 01223 309990

ACCELERATE PRODUCTIONS Ltd
223 Cranbrook Road
Ilford IG1 4TD
Website: www.accelerate-productions.co.uk
e-mail: info@accelerate-productions.co.uk
Fax: 020-8518 4018 Tel: 020-8514 4796

DANCERS
1 Charlotte Street
London W1T 1RD
Website: www.features.co.uk
e-mail: info@features.co.uk
Fax: 020-7636 1657 Tel: 020-7636 1473

DANCERS INC. INTERNATIONAL COLLECTIVE
Golden Cross House
8 Duncannon Street
The Strand
London WC2N 4JF
Website: www.internationalcollective.co.uk
e-mail: enquiries@internationalcollective.co.uk
Fax: 020-7484 5100 Tel: 020-7484 5080

DYNAMITE MANAGEMENT
Performance House
20 Passey Place
London SE9 5DQ
Website: www.dynamitemanagement.com
e-mail: rs@dynamitemanagement.com Tel: 020-8859 4010

FEATURES
1 Charlotte Street
London W1T 1RD
Website: www.features.co.uk
e-mail: info@features.co.uk
Fax: 020-7636 1657 Tel: 020-7637 1487

HEADNOD TALENT AGENCY
Unit D, 2 Leigh Street
London WC1H 9EW
Website: www.headnodagency.com
e-mail: nana@headnodagency.com Tel/Fax: 020-7209 1805

JK DANCE PRODUCTIONS
Battersea Road
Stockport SK4 3EA
Website: www.jkdance.co.uk
e-mail: julie@jkdance.co.uk
Fax: 0161-432 6800 Tel: 0161-432 5222

K ENTERTAINMENTS Ltd
140-142 St John Street, London EC1V 4UA
Website: www.k-entertainments.com
e-mail: london@k-entertainments.com
Fax: 07092 809947 Tel: 020-7253 9637

JK DANCE PRODUCTIONS
dedicated to developing talent

Manchester based Dance Production Company

South Manchester Film Studios, Battersea Road, Stockport. SK4 3EA
0161 4325222. email: info.jkdance.co.uk. web: www.jkdance.co.uk

Dancers –Choreographers- Stylist / Make-Up Artists – Children and Young People

KEW PERSONAL MANAGEMENT
PO Box 48458
London SE15 5WW
Website: www.kewpersonalmanagement.com
e-mail: info@kewpersonalmanagement.com
Tel: 020-7277 1440

KMC AGENCIES
11-15 Betterton Street
London WC2H 9BP
e-mail: london@kmcagencies.co.uk
Fax: 0870 4421780 Tel: 0870 4604868

PO Box 122
48 Great Ancoats Street
Manchester M4 5AB
e-mail: casting@kmcagencies.co.uk
Fax: 0161-237 9812 Tel: 0161-237 3009

LONGRUN ARTISTES
(Gina Long)
3 Chelsworth Drive
Plumstead Common
London SE18 2RB
Website: www.longrunartistes.co.uk
e-mail: gina@longrunartistes.co.uk Mobile: 07748 723228

MBK DANCE & ENTERTAINEMENT
10 St Julians Close
London SW16 2RY
Website: www.mbkonline.co.uk
e-mail: info@mbkonline.co.uk
Fax: 020-8488 9121 Tel: 020-8664 6676

MITCHELL MAAS McLENNAN
The Offices of Millennium Dance 2000
Hampstead Town Hall Centre
213 Haverstock Hill
London NW3 4QP
Website: www.mmm2000.co.uk
e-mail: agency@mmm2000.co.uk Tel/Fax: 01767 650020

PINEAPPLE AGENCY
Montgomery House
159-161 Balls Pond Road
Islington, London N1 4BG
Website: www.pineappleagency.com
e-mail: pineapple.agency@btconnect.com
Fax: 020-7241 3006 Tel: 020-7241 6601

RAZZAMATAZZ MANAGEMENT
Mulberry Cottage
Park Farm
Haxted Road, Lingfield RH7 6DE
e-mail: razzamatazzmanagement@btconnect.com
 Tel/Fax: 01342 835359

RE.ANIMATOR MANAGEMENT
5th Floor, Victoria House
125 Queens Road
Brighton BN1 3WB
Website: www.reanimator.co.uk
e-mail: re.animator@gmail.com
Fax: 01273 777753 Tel: 01273 777757

RUDEYE DANCE AGENCY
PO Box 38743, London E10 5WN
Website: www.rudeye.com
e-mail: info@rudeye.com Tel/Fax: 020-8556 7139

SCRIMGEOUR Donald ARTISTS AGENT
49 Springcroft Avenue
London N2 9JH
e-mail: vwest@dircon.co.uk
Fax: 020-8883 9751 Tel: 020-8444 6248

S.O.S.
3 Lind Street
St Johns
London SE8 4JE
Website: www.sportsofseb.com
e-mail: info@sportsofseb.com Tel: 020-7723 1889

TUCKER Tommy AGENCY
Suite 66
235 Earls Court Road
London SW5 9FE
e-mail: TTTommytucker@aol.com
Fax: 020-7370 4784 Tel: 020-7370 3911

UNIQUE TALENT MANAGEMENT Ltd
International House
Suite 501
223 Regent Street
London W1H 2QD
Website: www.utm.org.uk
e-mail: info@utm.org.uk Tel: 020-7569 8636

SAMUEL FRENCH LTD

Publishers of Plays • Agents for the Collection of Royalties
Specialist Booksellers
52 Fitzroy Street London W1T 5JR
Tel 020 7255 4300 (Bookshop) 020 7387 9373 (Enquiries)
Fax 020 7387 2161 www.samuelfrench-london.co.uk
e-mail: theatre@samuelfrench-london.co.uk

A & B PERSONAL MANAGEMENT Ltd*
Suite 330, Linen Hall, 162-168 Regent St, London W1B 5TD
e-mail: billellis@aandb.co.uk
Fax: 020-7038 3699 Tel: 020-7434 4262

ABNER STEIN
10 Roland Gardens, London SW7 3PH
e-mail: abner@abnerstein.co.uk
Fax: 020-7370 6316 Tel: 020-7373 0456

ACTAC
7 Isles Court, Ramsbury, Wiltshire SN8 2QW
Fax: 01672 520166 Tel: 01672 520274

AGENCY (LONDON) Ltd The*
24 Pottery Lane, Holland Park, London W11 4LZ
Website: www.theagency.co.uk
e-mail: info@theagency.co.uk
Fax: 020-7727 9037 Tel: 020-7727 1346

A J ASSOCIATES LITERARY AGENTS
Higher Healey House, Higher House Lane
White Coppice, Chorley PR6 9BT
e-mail: info@ajassociates.net Tel/Fax: 01257 273148

A M HEATH & Co Ltd
(Fiction & Non-Fiction only)
6 Warwick Court, London WC1R 5DJ
Fax: 020-7242 2711 Tel: 020-7242 2811

ASPER Pauline MANAGEMENT*
Jacobs Cottage, Reservoir Lane
Sedlescombe, East Sussex TN33 0PJ
e-mail: pauline.asper@virgin.net Tel/Fax: 01424 870412

BERLIN ASSOCIATES*
14 Floral Street, London WC2E 9DH
Fax: 020-7632 5280 Tel: 020-7836 1112

BLAKE FRIEDMANN
(Novels, Non-Fiction & TV/Film Scripts)
122 Arlington Road, London NW1 7HP
Website: www.blakefriedmann.co.uk
e-mail: julian@blakefriedmann.co.uk
Fax: 020-7284 0442 Tel: 020-7284 0408

BRITTEN Nigel MANAGEMENT*
Riverbank Hse, 1 Putney Bridge Approach, London SW6 3JD
e-mail: office@nbmanagement.com
Fax: 020-7384 3862 Tel: 020-7384 3842

BRODIE Alan REPRESENTATION Ltd*
(Incorporating Michael Imison Playwrights)
6th Flr, Fairgate Hse, 78 New Oxford St, London WC1A 1HB
Website: www.alanbrodie.com
e-mail: info@alanbrodie.com
Fax: 020-7079 7999 Tel: 020-7079 7990

BURKEMAN Brie*
14 Neville Court, Abbey Road, London NW8 9DD
e-mail: brie.burkeman@mail.com
Fax: 0870 199 1029 Tel: 0870 199 5002

CANN Alexandra REPRESENTATION*
2 St Thomas Square, Newport, Isle of Wight PO30 1SN
e-mail: alex@alexandracann.com
Tel: 020-7938 4002 Tel: 01983 556866

CASAROTTO RAMSAY & ASSOCIATES Ltd*
National House, 60-66 Wardour Street, London W1V 4ND
Website: www.casarotto.uk.com
e-mail: agents@casarotto.uk.com
Fax: 020-7287 9128 Tel: 020-7287 4450

CLOWES Jonathan Ltd*
10 Iron Bridge House
Bridge Approach, London NW1 8BD
Fax: 020-7722 7677 Tel: 020-7722 7674

COCHRANE Elspeth PERSONAL MANAGEMENT*
16 Old Town
Clapham, London SW4 0JY
e-mail: info@elspethcochrane.co.uk
Fax: 020-7819 4297 Tel: 020-7819 6256

CREATIVE MEDIA CONSULTANCY
(No unsolicited scripts, first instance synopsis only)
73 Low Road
Balby, Doncaster DN4 8PW
Mobile: 07787 784412 Tel: 01302 850728

CULVERHOUSE & JAMES Ltd
Shepperton Studios
Shepperton, Middlesex TW17 0QD
Fax: 01932 592233 Tel: 01932 592546

Suite 2, Galleon Buildings
16-18 Stanley Street
Southport PR9 0BY
Website: www.culverhousejames.co.uk
e-mail: culverhousejamesltd@btconnect.com
Fax: 01704 541144 Tel: 01704 542965

CURTIS BROWN GROUP Ltd*
5th Floor, Haymarket House
28-29 Haymarket, London SW1Y 4SP
e-mail: cb@curtisbrown.co.uk
Fax: 020-7393 4401 Tel: 020-7393 4400

DAISH Judy ASSOCIATES Ltd*
2 St Charles Place, London W10 6EG
Fax: 020-8964 8966 Tel: 020-8964 8811

DENCH ARNOLD AGENCY The*
10 Newburgh Street, London W1F 7RN
e-mail: contact@dencharnold.com
Fax: 020-7439 1355 Tel: 020-7437 4551

de WOLFE Felix*
Kingsway House, 103 Kingsway, London WC2B 6QX
e-mail: info@felixdewolfe.com
Fax: 020-7242 8119 Tel: 020-7242 5066

DREW Bryan Ltd
Mezzanine, Quadrant Hse, 80-82 Regent St, London W1B 5AU
e-mail: bryan@bryanandrewltd.com
Fax: 020-7437 0561 Tel: 020-7437 2293

FARNES Norma MANAGEMENT
9 Orme Court, London W2 4RL
Fax: 020-7792 2110 Tel: 020-7727 1544

FILLINGHAM Janet ASSOCIATES
52 Lowther Road, London SW13 9NU
Website: www.janetfillingham.com
e-mail: info@jfillassoc.co.uk
Fax: 020-8748 7374 Tel: 020-8748 5594

FILM RIGHTS Ltd
Mezzanine, Quadrant Hse, 80-82 Regent St, London W1B 5AU
Website: www.filmrights.ltd.uk
e-mail: information@filmrights.ltd.uk
Fax: 020-7734 0044 Tel: 020-7734 9911

FITCH Laurence Ltd
Mezzanine, Quadrant Hse, 80-82 Regent St, London W1B 5AU
Fax: 020-7734 0044 Tel: 020-7734 9911

FOSTER Jill Ltd*
9 Barb Mews, London W6 7PA
Fax: 020-7602 9336 Tel: 020-7602 1263

FRENCH Samuel Ltd*
52 Fitzroy Street, Fitzrovia, London W1T 5JR
Website: www.samuelfrench-london.co.uk
e-mail: theatre@samuelfrench-london.co.uk
Fax: 020-7387 2161 Tel: 020-7387 9373

FUTERMAN, ROSE & ASSOCIATES
(TV/Film/Stage Play Scripts, Showbiz & Music Biographies)
17 Deanhill Road, London SW14 7DQ
Website: www.futermanrose.co.uk
e-mail: guy@futermanrose.co.uk
Fax: 020-8286 4860 Tel: 020-8255 7755

GILLIS Pamela MANAGEMENT
46 Sheldon Avenue, London N6 4JR
Fax: 020-8341 5564 Tel: 020-8340 7868

GLASS Eric Ltd
25 Ladbroke Crescent, Notting Hill, London W11 1PS
e-mail: eglassltd@aol.com
Fax: 020-7229 6220 Tel: 020-7229 9500

HALL Rod AGENCY Ltd The*
6th Flr, Fairgate Hse, 78 New Oxford St, London WC1A 1HB
Website: www.rodhallagency.com
e-mail: office@rodhallagency.com
Fax: 020-7079 7988 Tel: 020-7079 7987

HANCOCK Roger Ltd*
4 Water Lane, London NW1 8NZ
e-mail: info@rogerhancock.com
Fax: 020-7267 0705 Tel: 020-7267 4418

HIGHAM David ASSOCIATES Ltd*
5-8 Lower John Street, Golden Square, London W1F 9HA
e-mail: dha@davidhigham.co.uk
Fax: 020-7437 1072 Tel: 020-7434 5900

HOSKINS Valerie ASSOCIATES Ltd*
20 Charlotte Street, London W1T 2NA
e-mail: vha@vhassociates.co.uk
Fax: 020-7637 4493 Tel: 020-7637 4490

HOWARD Amanda ASSOCIATES Ltd*
21 Berwick Street, London W1F 0PZ
Website: www.amandahowardassociates.co.uk
e-mail: mail@amandahowardassociates.co.uk
Fax: 020-7287 7785 Tel: 020-7287 9277

HURLEY LOWE MANAGEMENT*
27 Rosenau Crescent, London SW11 4RY
e-mail: kate@hurleylowemanagement.com
 Tel: 020-7978 7325

I C M (International Creative Management)*
Oxford House, 76 Oxford Street, London W1D 1BS
Fax: 020-7323 0101 Tel: 020-7636 6565

IMISON Michael PLAYWRIGHTS Ltd
(See BRODIE Alan REPRESENTATION Ltd)

KASS Michelle ASSOCIATES*
85 Charing Cross Road, London WC2H 0AA
e-mail: office@michellekass.co.uk
Fax: 020-7734 3394 Tel: 020-7439 1624

KENIS Steve & Co*
Royalty House, 72-74 Dean Street, London W1D 3SG
e-mail: sk@sknco.com
Fax: 020-7287 6328 Tel: 020-7434 9055

MACFARLANE CHARD ASSOCIATES Ltd*
33 Percy Street, London W1T 2DF
Website: www.macfarlane-chard.co.uk
e-mail: louise@macfarlane-chard.co.uk
Fax: 020-7636 7751 Tel: 020-7636 7750

MACNAUGHTON LORD 2000 Ltd*
19 Margravine Gardens, London W6 8RL
Website: www.ml2000.org.uk
e-mail: info@ml2000.org.uk
Fax: 020-8741 7443 Tel: 020-8741 0606

MANN Andrew Ltd*
1 Old Compton Street, London W1D 5JA
e-mail: manscript@onetel.com
Fax: 020-7287 9264 Tel: 020-7734 4751

MANS Johnny PRODUCTIONS Ltd
PO Box 196, Hoddesdon, Herts EN10 7WQ
e-mail: real@legend.co.uk
Fax: 01992 470516 Tel: 01992 470907

MARJACQ SCRIPTS Ltd
34 Devonshire Place, London W1G 6JW
Website: www.marjacq.com
e-mail: enquiries@marjacq.com
Fax: 020-7935 9115 Tel: 020-7935 9499

MARVIN Blanche*
21A St Johns Wood High Street, London NW8 7NG
e-mail: blanchemarvin17@hotmail.com
 Tel/Fax: 020-7722 2313

M.B.A. LITERARY AGENTS Ltd*
62 Grafton Way, London W1T 5DW
Website: www.mbalit.co.uk
e-mail: agent@mbalit.co.uk
Fax: 020-7387 2042 Tel: 020-7387 2076

McLEAN Bill PERSONAL MANAGEMENT
23B Deodar Road, London SW15 2NP Tel: 020-8789 8191

ML 2000 Ltd
(See MACNAUGHTON LORD 2000 Ltd)

MORRIS William AGENCY (UK) Ltd*
52-53 Poland Street, London W1F 7LX
Fax: 020-7534 6900 Tel: 020-7534 6800

NARROW ROAD COMPANY The*
182 Brighton Road, Coulsdon, Surrey CR5 2NF
e-mail: richardireson@narrowroad.co.uk
Fax: 020-8763 2558 Tel: 020-8763 9895

Culverhouse and James limited Literary Agents

Suite 2, Galleon Buildings, 16-18 Stanley Street, Southport PR9 0BY
t: 01704 542965 **f:** 01704 541144 **e:** culverhousejamesltd@btconnect.com

Shepperton Studios, Shepperton, Middx TW17 0QD
t: 01932 592546 **f:** 01932 592233 **e:** JillJames4@aol.com

PFD*
Drury House
34-43 Russell Street, London WC2B 5HA
Website: www.pfd.co.uk
e-mail: postmaster@pfd.co.uk
Fax: 020-7836 9539 Tel: 020-7344 1000

PLAYS AND MUSICALS
Lantern House, 84 Littlehaven Lane
Horsham, West Sussex RH12 4JB
Website: www.playsandmusicals.co.uk
e-mail: sales@playsandmusicals.co.uk
Fax: 0700 5938843 Tel: 0700 5938842

POLLINGER Ltd
9 Staple Inn, Holborn
London WC1V 7QH
Website: www.pollingerltd.com
e-mail: info@pollingerltd.com
Fax: 020-7242 5737 Tel: 020-7404 0342

ROSICA COLIN Ltd
1 Clareville Grove Mews, London SW7 5AH
Fax: 020-7244 6441 Tel: 020-7370 1080

SAYLE SCREEN Ltd*
(Screenwriters & Directors for Film & TV)
11 Jubilee Place, London SW3 3TD
Fax: 020-7823 3363 Tel: 020-7823 3883

SEIFERT Linda MANAGEMENT*
22 Poland Street, London W1F 8QQ
e-mail: contact@lindaseifert.com
Fax: 020-7292 7391 Tel: 020-7292 7390

SHARLAND ORGANISATION Ltd*
The Manor House
Manor Street, Raunds
Northants NN9 6JW
e-mail: tsoshar@aol.com
Fax: 01933 624860 Tel: 01933 626600

SHEIL LAND ASSOCIATES Ltd*
(Literary, Theatre & Film)
52 Doughty Street, London WC1N 2LS
e-mail: info@sheilland.co.uk
Fax: 020-7831 2127 Tel: 020-7405 9351

STEEL Elaine*
(Writers' Agent)
110 Gloucester Avenue, London NW1 8HX
e-mail: ecmsteel@aol.com
Fax: 020-8341 9807 Tel: 020-8348 0918

STEINBERG Micheline ASSOCIATES*
104 Great Portland Street, London W1W 6PE
Website: www.steinplays.com
e-mail: info@steinplays.com Tel: 020-7631 1310

STEVENS Rochelle & Co*
2 Terretts Place, Upper Street, London N1 1QZ
Fax: 020-7354 5729 Tel: 020-7359 3900

TENNYSON AGENCY The
10 Cleveland Avenue
Merton Park, London SW20 9EW
e-mail: mail@tenagy.co.uk Tel: 020-8543 5939

THEATRE OF LITERATURE
(c/o Calder Publications)
51 The Cut, London SE1 8LF
e-mail: info@calderpublications.com
Fax: 020-7928 5930 Tel: 020-7633 0599

THURLEY J M MANAGEMENT
Archery House
33 Archery Square, Walmer, Deal CT14 7AY
e-mail: jmthurley@aol.com
Fax: 01304 371416 Tel: 01304 371721

TYRRELL Julia MANAGEMENT*
57 Greenham Road, London N10 1LN
Website: www.jtmanagement.co.uk
e-mail: info@jtmanagement.co.uk
Fax: 020-8374 5580 Tel: 020-8374 0575

WARE Cecily LITERARY AGENTS*
19C John Spencer Square, London N1 2LZ
e-mail: info@cecilyware.com
Fax: 020-7226 9828 Tel: 020-7359 3787

WEINBERGER Josef Ltd*
12-14 Mortimer Street, London W1T 3JJ
Website: www.josef-weinberger.com
e-mail: general.info@jwmail.co.uk
Fax: 020-7436 9616 Tel: 020-7580 2827

ALEXANDER PERSONAL MANAGEMENT Ltd
PO Box 834, Hemel Hempstead, Herts HP3 9ZP
Website: www.apmassociates.net
e-mail: apm@apmassociates.net
Fax: 01442 241099 Tel: 01442 252907

A.P.M. (Linda French)
(See ALEXANDER PERSONAL MANAGEMENT Ltd)

ARLINGTON ENTERPRISES Ltd
1-3 Charlotte Street, London W1T 1RD
Website: www.arlingtonenterprises.co.uk
e-mail: info@arlington-enterprises.co.uk
Fax: 020-7580 4994 Tel: 020-7580 0702

BLACKBURN SACHS ASSOCIATES
2-4 Noel Street, London W1F 8GB
Website: www.blackburnsachsassociates.com
e-mail: presenters@blackburnsachsassociates.com
Fax: 020-7292 7576 Tel: 020-7292 7555

CAMERON Sara MANAGEMENT
(See TAKE THREE MANAGEMENT)

CANTOR WISE REPRESENTATION
(See TAKE THREE MANAGEMENT)

CHASE PERSONAL MANAGEMENT
Celebrity Division of Modelplan
1st Floor, 18 Lloyd Street
Manchester M2 5WA
e-mail: sue@sammon.fsnet.co.uk
Mobile: 00 33 6 11 09 01 40 Tel: 0161-819 1162

CINEL GABRAN MANAGEMENT
PO Box 5163, Cardiff CF5 9BJ
Website: www.cinelgabran.co.uk
e-mail: info@cinelgabran.co.uk
Fax: 0845 0666601 Tel: 0845 0666605

COAST 2 COAST PERSONALITIES Ltd
PO Box 50673, London SW6 4UT
Website: www.coast2coastpersonalities.com
e-mail: info@c2cp.co.uk
Fax: 0870 2519560 Tel: 0870 2519550

CRAWFORDS
PO Box 44394, London SW20 0YP
Website: www.crawfords.tv
e-mail: cr@wfords.com
Fax: 020-3258 5037 Tel: 020-8947 9999

CURTIS BROWN GROUP Ltd
Haymarket House
28-29 Haymarket, London SW1Y 4SP
e-mail: presenters@curtisbrown.co.uk
Fax: 020-7393 4401 Tel: 020-7393 4460

DAVID ANTHONY PROMOTIONS
PO Box 286, Warrington, Cheshire WA2 8GA
Website: www.davewarwick.co.uk
e-mail: dave@davewarwick.co.uk
Fax: 01925 416589 Tel: 01925 632496

DOWNES PRESENTERS AGENCY
96 Broadway, Bexleyheath, Kent DA6 7DE
Website: www.presentersagency.com
e-mail: downes@presentersagency.com Tel: 020-8304 0541

DUDDRIDGE Paul MANAGEMENT
32 Rathbone Place, London W1T 1JJ
Website: www.paulduddridge.com
e-mail: mail@paulduddridge.com
Fax: 020-7580 3480 Tel: 020-7580 3580

EVANS Jacque MANAGEMENT Ltd
Top Floor Suite
14 Holmesley Road, London SE23 1PJ
e-mail: jacque@jemltd.demon.co.uk
Fax: 020-8699 5192 Tel: 020-8699 1202

EXCELLENT TALENT COMPANY The
19-21 Tavistock Street, London WC2E 7PA
Website: www.excellentvoice.co.uk
e-mail: viv@excellentvoice.co.uk Tel: 020-7520 5656

FBI AGENCY Ltd The
PO Box 250, Leeds LS1 2AZ
Website: www.fbi-agency.ltd.uk
e-mail: casting@fbi-agency.ltd.uk
Fax: 0113-279 7270 Tel/Fax: 07050 222747

FLETCHER ASSOCIATES
(Broadcast & Media)
25 Parkway, London N20 0XN
Fax: 020-8361 8866 Tel: 020-8361 8061

FOX ARTIST MANAGEMENT Ltd
Concorde House
101 Shepherds Bush Road, London W6 7LP
Website: www.foxartistmanagement.tv
e-mail: fox.artist@btinternet.com
Fax: 020-7603 2352 Tel: 020-7602 8822

GAY Noel ARTISTS
19 Denmark Street, London WC2H 8NA
Website: www.noelgay.com
Fax: 020-7287 1816 Tel: 020-7836 3941

GRANT James MANAGEMENT
94 Strand on The Green, London W4 3NN
Website: www.jamesgrant.co.uk
e-mail: darren@jamesgrant.co.uk
Fax: 020-8742 4951 Tel: 020-8742 4950

 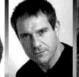 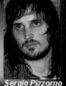

How do I become a Presenter?

There is no easy answer to this question. Some presenters start out as actors and move into presenting work, others may be 'experts' such as chefs, designers or sports people who are taken on in a presenting capacity. Others may have a background in stand-up comedy. All newsreaders are professional journalists with specialist training and experience. Often presenters work their way up through the production side of broadcasting, starting as a runner or researcher and then moving to appear in front of the camera. To get this kind of production work you could contact TV and Film Production companies, many of whom are listed in this book.

A number of Performing Arts Schools, Colleges and Academies also offer useful part-time training courses for presenters. See the 'Drama Training, Schools and Coaches' section of this book for college / school listings.

How should I use these listings?

The following pages contain contact details for the UK's leading presenter agencies. It is their job to promote their clients to job opportunities and negotiate contracts on their behalf. In return they take commission ranging from 10-15%. Before you approach any agency looking for representation, do some research into their current client list and the areas in which they specialise. Many have websites you can visit.

Once you have made a short-list of the ones you think are most appropriate, you should send them your CV with a covering letter and a good quality, recent photograph which is a genuine likeness of you. Showreels can also be a good way of showcasing your talents, but only send these if you have checked with the agency first. Enclosing a stamped-addressed envelope (SAE) will also give you a better chance of a reply.

Should I pay a Presenter's agent to join their books? Or sign a contract?

As with other types of agencies, Equity does not generally recommend that artists pay an agent to join their client list. Before signing any contract, you should be clear about the terms and commitments involved. Always speak to Equity (www.equity.org.uk) if you have any concerns or queries.

What is the Spotlight Presenters directory?

Spotlight Presenters is a specialist directory published annually by The Spotlight. It contains photographs and contact details for over seven hundred professional TV and radio presenters and is a great way of promoting yourself for work. It is used by production companies, casting directors, TV and radio stations, advertising agencies and publicists to browse and locate talent for future productions. Entry is available to any presenter with proven professional broadcast experience.
Please see (www.spotlight.com) for more information.

What are voice-over agencies?

These are smaller agencies which specialise in promoting clients specifically for voice-over work, mostly in the commercial and corporate sectors. Some actors and presenters will have both a main agent, representing them for acting / presenting work, and then a voice-over agent who looks after this separate side of their career.

See page 117 for more information.

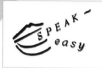

KATE MOON is the owner of Speak-easy, one of the leading UK agencies for Presenters, Journalists and Voiceovers. Kate opened the doors of Speak-easy in 1987 having spent several years working behind the microphone both at the BBC and Channel 4.

'There's a telling scene in the film Wimbledon. The notably absent US agent for a British tennis player suddenly reappears on the scene once his client begins to play well again. He justifies his reappearance by pointing out that agents are not 'miracle workers': but now that the player is doing well again, the agent is able to 'sell' him again. He just couldn't do this while his balls were in other courts....'

Harsh - and not the norm - honestly!

If you followed the advice from this column last year (written by the esteemed Take Three Management) and have found yourself the agent of your dreams... what next? Sit back and let the work come flooding in? Wait for the telephone to ring?

What is it that you think your presenting agent is and does? (at this stage I'm not even going to mention money!)

The first hurdle to overcome is to think of the agent as a person - rather than a beast, or worse, a disease! You need to build up a relationship with that 'person'. They need to know a lot about you, you need to know rather less about them (although it's nice if you remember their birthday!), but it must be a two-way thing.

An agent must feel that they can go out on a limb for their client, but by the same token the client must also take responsibility for him or herself. If the agent has 'sold' you through the door of that first screen test, or even arranged a visit to a commissioner they feel strongly you would get on with, are you then prepared? Are you on time? Are you polite to everyone from the doorman up and down?

You may have been told somewhere along the line that you are the new Vernon Kay, or Jeremy Paxman or Davina McCall... the problems will start when you begin to believe it. I believe that a slow growth up the presenting ladder leads to a stronger, wider and longer career. Today's flash talents tend not to last and the industry pavements are littered with those who believed the hype and became divas / divos before they'd even learnt the opera!

Get real and keep it real. A Media Studies degree no more gets you the main presenting gig on Big Brother than the first introduction to a television studio means that you have learnt the craft.

Always be prepared to learn, listen to those around you, and respect a producer's vision even if you don't agree with it (as you get more established your views will be heard). Use your agent as a sounding board - not the crew! An agent is there to guide, encourage, negotiate, cajole and sometimes - and I know this is hard - even to correct! Your agent is there to tell you the truth because trust me, the producer, commissioner, director and cameraman will rarely criticize for fear of upsetting the apple cart and losing time on a shoot.

Producers/directors are usually stressed: they may be over budget, have a large number of re-writes (which, incidentally, you may have to deal with!), or be at the mercy of the weather. So the last thing they want is an unprofessional presenter! But when the agent does what they have to do and reports back to their client that behaviour, dress-code, drinking habits, non-swear-quota, script familiarity etc. is less than expected, the reaction is rarely one of gratitude!

You might feel very badly done by when a bad report comes home, and you may well have good reason to feel this way, but to be able to talk to your agent and trust them to take up your cause is a fine thing. You should know your corner will be well fought and your agent in turn must know that you will do your bit, adapt if you have to, accept what you need to, learn as you must and at all times be professional.

Because it's true: agents are not miracle workers - or rarely!
For more information please visit (www.speak-easy.co.uk)

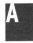

GURNETT J. PERSONAL MANAGEMENT Ltd
12 Newburgh Street, London W1F 7RP
Website: www.jgpm.co.uk
e-mail: mail@jgpm.co.uk
Fax: 020-7287 9642 Tel: 020-7440 1850

HICKS Jeremy ASSOCIATES
114-115 Tottenham Court Road, London W1T 5AH
Website: www.jeremyhicks.com
e-mail: info@jeremyhicks.com
Fax: 020-7383 2777 Tel: 020-7383 2000

HOBBS Liz GROUP Ltd
65 London Road, Newark, Notts NG24 1RZ
Website: www.lizhobbsgroup.com
e-mail: casting@lizhobbsgroup.com
Fax: 0870 3337009 Tel: 08700 702702

INCREDIBULL IDEAS
Unit 2/3 Bickels Yard
151-153 Bermondsey Street, London SE1 3HA
Website: www.incredibullideas.com
e-mail: talent@incredibullideas.com
Fax: 020-7940 3801 Tel: 020-7940 3800

INTERNATIONAL ARTISTES Ltd
4th Floor, Holborn Hall
193-197 High Holborn, London WC1V 7BD
e-mail: reception@intart.co.uk
Fax: 020-7404 9865 Tel: 020-7025 0600

IVELAW-CHAPMAN Julie
The Chase, Chaseside Close, Cheddington, Beds LU7 0SA
e-mail: jivelawchapman@gmail.com
Fax: 01296 662451 Tel: 01296 662441

JAYMEDIA
(Nigel Jay)
171 Sandbach Road, Lawton Heath End
Church Lawton, Cheshire ST7 3RA
e-mail: media@jaymedia.co.uk
Fax: 0870 1209079 Tel: 01270 884453

JLA (Jeremy Lee Associates Ltd)
(Supplies celebrities and after dinner speakers)
4 Stratford Place, London W1C 1AT
e-mail: talk@jla.co.uk
Fax: 020-7907 2801 Tel: 020-7907 2800

KBJ MANAGEMENT Ltd
(TV Presenters)
7 Soho Street, London W1D 3DQ
e-mail: general@kbjmgt.co.uk
Fax: 020-7287 1191 Tel: 020-7434 6767

KNIGHT AYTON MANAGEMENT
114 St Martin's Lane, London WC2N 4BE
Website: www.knightayton.co.uk
e-mail: info@knightayton.co.uk
Fax: 020-7836 8333 Tel: 020-7836 5333

KNIGHT Hilary MANAGEMENT Ltd
Grange Farm, Church Lane
Old, Northampton NN6 9QZ
Website: www.hkmanagement.co.uk
e-mail: hilary@hkmanagement.co.uk Tel: 01604 781818

LYTE Seamus MANAGEMENT Ltd
Apartment 5, Oswald Building
Chelsea Bridge Wharf
374 Queenstown Road
London SW8 4NU
e-mail: seamus@seamuslyte.com Mobile: 07930 391401

MACFARLANE CHARD ASSOCIATES Ltd
33 Percy Street, London W1T 2DF
Website: www.macfarlane-chard.co.uk
e-mail: enquiries@macfarlane-chard.co.uk
Fax: 020-7636 7751 Tel: 020-7636 7750

MARKS PRODUCTIONS Ltd
2 Gloucester Gate Mews
London NW1 4AD
Fax: 020-7486 2165 Tel: 020-7486 2001

 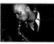 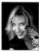
MARSH Billy ASSOCIATES Ltd
76A Grove End Road, St Johns Wood, London NW8 9ND
e-mail: talent@billymarsh.co.uk
Fax: 020-7449 6933 Tel: 020-7449 6930

MEDIA PEOPLE
13 Montagu Mews South, London W1H 7ER
Website: www.celebrity.co.uk
e-mail: info@celebrity.co.uk Tel: 0871 2501234

MILES John ORGANISATION
Cadbury Camp Lane
Clapton-in-Gordano, Bristol BS20 7SB
e-mail: john@johnmiles.org.uk
Fax: 01275 810186 Tel: 01275 854675

MONDI ASSOCIATES Ltd
30 Cooper House
2 Michael Road, London SW6 2AD
e-mail: info@mondiassociates.com Mobile: 07817 133349

MPC ENTERTAINMENT
MPC House, 15-16 Maple Mews, London NW6 5UZ
Website: www.mpce.com
e-mail: mpc@mpce.com
Fax: 020-7624 4220 Tel: 020-7624 1184

MTC (UK) Ltd
20 York Street, London W1U 6PU
Website: www.mtc-uk.com
e-mail: enquiries@mtc-uk.com
Fax: 020-7935 8066 Tel: 020-7935 8000

NCI MANAGEMENT Ltd
51 Queen Anne Street, London W1G 9HS
Website: www.nci-management.com
e-mail: info@nci-management.com
Fax: 020-7487 4258 Tel: 020-7224 3960

NOEL John MANAGEMENT
2nd Floor, 10A Belmont Street, London NW1 8HH
Website: www.johnnoel.com
e-mail: john@johnnoel.com
Fax: 020-7428 8401 Tel: 020-7428 8400

OFF THE KERB PRODUCTIONS
(Comedy Presenters & Comedians)
3rd Floor, Hammer House
113-117 Wardour Street, London W1F 0UN
Website: www.offthekerb.co.uk
e-mail: westend@offthekerb.co.uk
Fax: 020-7437 0647 Tel: 020-7437 0607

22 Thornhill Crescent, London N1 1BJ
e-mail: info@offthekerb.co.uk
Fax: 020-7700 4646 Tel: 020-7700 4477

PHA CASTING
Tanzaro House, Ardwick Green North, Manchester M12 6FZ
Website: www.pha-agency.co.uk
e-mail: casting@pha-agency.co.uk
Fax: 0161-273 4567 Tel: 0161-273 4444

PRINCESS TALENT MANAGEMENT
Princess Studios, Whiteleys Centre
151 Queensway, London W2 4SB
Website: www.princesstv.com
e-mail: talent@princesstv.com
Fax: 020-7985 1989 Tel: 020-7985 1985

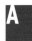

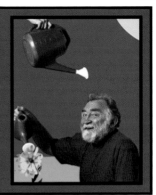
PVA MANAGEMENT Ltd
Hallow Park, Hallow, Worcester WR2 6PG
e-mail: clients@pva.co.uk
Fax: 01905 641842 Tel: 01905 640663

RAZZAMATAZZ MANAGEMENT
Mulberry Cottage, Park Farm
Haxted Road, Lingfield RH7 6DE
e-mail: razzamatazzmanagement@btconnect.com
 Tel/Fax: 01342 835359

RDF MANAGEMENT
The Gloucester Building, Kensington Village
Avonmore Road, London W14 8RF
e-mail: debi.allen@rdfmanagement.com
Fax: 020-7013 4101 Tel: 020-7013 4103

RHINO MANAGEMENT
Oak Porch House, 5 Western Road, Nazeing, Essex EN9 2QN
Website: www.rhino-management.co.uk
e-mail: kevin@rhino-management.co.uk
Mobile: 07901 528988 Tel/Fax: 01992 893259

ROSEMAN ORGANISATION The
51 Queen Anne Street, London W1G 9HS
Website: www.therosemanorganisation.co.uk
e-mail: info@therosemanorganisation.co.uk
Fax: 020-7486 4600 Tel: 020-7486 4500

SINGER Sandra ASSOCIATES
21 Cotswold Road, Westcliff-on-Sea, Essex SS0 8AA
Website: www.sandrasinger.com
e-mail: sandrasinger@btconnect.com
Fax: 01702 339393 Tel: 01702 331616

SOMETHIN' ELSE
(Grant Michaels)
Units 1-4, 1A Old Nichol Street, London E2 7HR
e-mail: grant.michaels@somethin-else.com
Fax: 020-7739 9799 Tel: 020-7613 3211

SPEAK-EASY Ltd
1 Dairy Yard, High Street
Market Harborough
Leicestershire LE16 7NL
Website: www.speak-easy.co.uk
e-mail: enquiries@speak-easy.co.uk
Fax: 01858 461994 Tel: 0870 0135126

STAR MANAGEMENT Ltd
16A Winton Drive
Glasgow G12 0QA
Website: www.starmanagement.co.uk
e-mail: star@starmanagement.co.uk Tel: 0870 2422276

TAKE THREE MANAGEMENT
110 Gloucester Avenue
Primrose Hill, London NW1 8HX
Website: www.take3management.co.uk
e-mail: info@take3management.co.uk
Fax: 020-7209 3770 Tel: 020-7209 3777

TFA GROUP
(Tony Fitzpatrick)
40 Bowling Green Lane
Clerkenwell, London EC1R 0NE
Website: www.tfa-group.com
e-mail: tony@tfa-group.com
Fax: 020-7415 7074 Tel: 07000 300707

TROIKA
3rd Floor
74 Clerkenwell Road, London EC1M 5QA
Fax: 020-7490 7642 Tel: 020-7336 7868

UNIQUE MANAGEMENT GROUP
Power Road Studios
114 Power Road, London W4 5PY
Website: www.unique-management.co.uk
e-mail: celebrities@uniquegroup.co.uk
Fax: 020-8987 6401 Tel: 020-8987 6400

V R M
1st Floor, 100 Talbot Road
Old Trafford, Manchester M16 0PG
Fax: 0161-888 2242 Tel: 0161-874 5741

WILLCOCKS John MEDIA AGENCY Ltd
34 Carisbrook Close
Enfield, Middlesex EN1 3NB
e-mail: john.willcocks@blueyonder.co.uk
Fax: 020-8292 5060 Tel: 020-8364 4556

ZWICKLER Marlene & ASSOCIATES
2 Belgrave Place, Edinburgh EH4 3AN
Website: www.mza-artists.com Tel/Fax: 0131-343 3030

ACCENT BANK
The Recording Studio, Unit 4, Suffolk Studios
127-129 Great Suffolk Street, London SE1 1PP
Website: www.accentbank.co.uk
e-mail: info@accentbank.co.uk Tel: 020-7403 1788

AD VOICE
Oxford House, 76 Oxford Street, London W1D 1BS
Website: www.advoice.co.uk
e-mail: info@advoice.co.uk
Fax: 020-7323 0101 Tel: 020-7323 2345

AMERICAN AGENCY VOICES The
14 Bonny Street, London NW1 9PG
Website: www.americanagency.tv
e-mail: americanagency@btconnect.com
Fax: 020-7482 4666 Tel: 020-7485 8883

ANOTHER TONGUE VOICES Ltd
The Basement, 10-11 D'Arblay Street, London W1F 8DS
Website: www.anothertongue.com
e-mail: info@anothertongue.com
Fax: 020-7494 7080 Tel: 020-7494 0300

ASQUITH & HORNER
(Write with SAE)
The Studio, 14 College Road, Bromley, Kent BR1 3NS
Fax: 020-8313 0443 Tel: 020-8466 5580

BIG MOUTH COMPANY Ltd The
PO Box 619, CT14 9YA
Website: www.thebigmouthcompany.com
e-mail: info@thebigmouthcompany.com
Tel/Fax: 0871 7500075

BURNETT GRANGER ASSOCIATES Ltd
3 Clifford Street, London W1S 2LF
e-mail: voiceover@burnettgranger.co.uk
Fax: 020-7287 3239 Tel: 020-7437 8029

CALYPSO VOICES
25-26 Poland Street, London W1F 8QN
Website: www.calypsovoices.com
e-mail: calypso@calypsovoices.com
Fax: 020-7437 0410 Tel: 020-7734 6415

CASTAWAY
Suite 3, 15 Broad Court, London WC2B 5QN
Website: www.castaway.org.uk
e-mail: sheila@castaway.org.uk
Fax: 020-7240 2772 Tel: 020-7240 2345

CINEL GABRAN MANAGEMENT
PO Box 5163, Cardiff CF5 9BJ
Website: www.cinelgabran.co.uk
e-mail: info@cinelgabran.co.uk
Fax: 0845 0666601 Tel: 0845 0666605

CONWAY VAN GELDER GRANT Ltd
3rd Floor, 18-21 Jermyn Street, London SW1Y 6HP
Website: www.conwayvangelder.com
e-mail: kate@conwayvg.co.uk
Fax: 020-7494 3324 Tel: 020-7287 1070

CUT GLASS VOICES
7 Crouch Hall Road, Crouch End, London N8 8HT
Website: www.cutglassproductions.com
e-mail: info@cutglassproductions.com
Tel/Fax: 020-8374 4701

DIAMOND MANAGEMENT
31 Percy Street, London W1T 2DD
e-mail: lj@diman.co.uk
Fax: 020-7631 0500 Tel: 020-7631 0400

DREW Bryan Ltd
Mezzanine, Quadrant House
80-82 Regent Street, London W1B 5AU
e-mail: bryan@bryandrewltd.com
Fax: 020-7437 0561 Tel: 020-7437 2293

STEPHAN CHASE is a successful actor, director, writer and producer. He coaches Managing Presence and founded the Rhubarb Agency in 1988.

I think two kinds of voice-over agencies have developed: the stand-alones, and more recently the ones within established theatrical agencies who field enquiries and submit ideas for their more well-known artists. Most work to the same contracts and fee structures, so long as you have a profile in one or the other you're in with a chance of voice work.

To be taken on by either type of agency, it may be useful to enquire when they are re-doing their agency showreel. This is a time when old artists may be dropped and new ones given their chance. A bit of research on each agency's website should reveal any gaps in their line-up which you might be able to fill, as well as noting who's in direct competition with you! You may also detect if certain agencies have a certain niche.

Any agency you approach will need to hear your demo CD. You must make a broadcast quality demo CD showreel with the right content and with a director who knows how to direct actors - not many do. Choose a studio which has direct experience of making commercials. Don't be tempted by studios where they let you choose from a pile of used scripts since the agency may already have received five similar demos that week. Demos should have, for example, five sound-alike radio ads plus two narrative pieces. Each ad should reveal a fresh aspect of your vocal talent. Be realistic about the kinds of work your voice, vocal age and style will attract and shape the content to that. Pay keen attention to what's in vogue on radio and TV and choose with thought. The CD artwork should have your contact details, photo, and a detailed list of the tracks.

Send your showreel to the voice agencies you select. Include a SAE for return and a picture and CV. Keep the letter simple and make it personal. Try to find a reason from your research why they may want you to join their particular agency and state it. If you hear nothing, call a few days later asking to find out where you stand. Remember though they probably have specific 'listening-to-demo-periods'.

Good artists regularly update their reels, more often than not with jobs they've done. Move with the times. You need to be committed, available, have a good attitude and be on time if you want regular work - and leave promptly with a smile when they've done with you. Most working voice-over artists are businesslike. Often they have a lighter touch and know not to outstay their welcome. A good approach combined with keeping your own detailed records of bookings makes for a comfortable relationship.

If you do get taken on, check-in regularly, keep it short and don't moan if there's no work - you haven't been taken on to stop you working! Always be on time for gigs and report back any anomalies to booking details. I suggest you turn up looking your best.

After a job your agency will probably not receive payment for eight weeks. Most voice agents take 15% of the fee and in order to be time-efficient have payment runs at the end of each month. So be patient.

Voice agencies tend to make quick decisions about a voice and the temperamental suitability of the artist to the work. Very often a good voice is turned down for reasons of logistics within the agency line-up, so don't be upset if you're turned down. Generally they don't expect or need the same close relationships with the talent that theatrical agents do.

Being a consistently working voice is not easy but the rewards are good if you are chosen for top campaigns.

For more information about Stephan Chase please visit (www.StephanChase.com)
Please note that he is no longer involved with the Rhubarb Agency.

EARACHE VOICES
177 Wardour Street, London W1F 8WX
Website: www.earachevoices.com
e-mail: alex@earachevoices.com
Fax: 020-7287 2288 Tel: 020-7287 2291

EVANS O'BRIEN
115 Humber Road, London SE3 7LW
Website: www.evansobrien.co.uk
e-mail: info@evansobrien.co.uk
Fax: 020-8293 7066 Tel: 020-8293 7077

EXCELLENT VOICE COMPANY
19-21 Tavistock Street, London WC2E 7PA
Website: www.excellentvoice.co.uk
e-mail: info@excellentvoice.co.uk
Fax: 020-7240 9344 Tel: 020-7520 5656

FOREIGN VERSIONS Ltd
(Translation)
60 Blandford Street, London W1U 7JD
Website: www.foreignversions.com
e-mail: info@foreignversions.co.uk
Fax: 020-7935 0507 Tel: 020-7935 0993

GAY Noel VOICES
19 Denmark Street
London WC2H 8NA
Website: www.noelgay.com
Fax: 020-7287 1816 Tel: 020-7836 3941

HAMILTON HODELL Ltd
5th Floor
66-68 Margaret Street, London W1W 8SR
Website: www.hamiltonhodell.co.uk
e-mail: info@hamiltonhodell.co.uk
Fax: 020-7636 1226 Tel: 020-7636 1221

HOBSON'S SINGERS
62 Chiswick High Road, London W4 1SY
Website: www.hobsons-international.com
e-mail: singers@hobsons-international.com
Fax: 020-8996 5350 Tel: 020-8995 3628

HOBSON'S VOICES
62 Chiswick High Road, London W4 1SY
Website: www.hobsons-international.com
e-mail: voices@hobsons-international.com
Fax: 020-8996 5350 Tel: 020-8995 3628

HOPE Sally ASSOCIATES
108 Leonard Street, London EC2A 4XS
Website: www.sallyhope.biz
e-mail: casting@sallyhope.biz
Fax: 020-7613 4848 Tel: 020-7613 5353

HOWARD Amanda ASSOCIATES
(See JONESES The)

JONESES The
21 Berwick Street, London W1F 0PZ
Website: www.meetthejoneses.co.uk
e-mail: mail@meetthejoneses.co.uk
Fax: 020-7287 7785 Tel: 020-7287 9666

JUST VOICES AGENCY The
140 Buckingham Palace Road, London SW1W 9SA
Website: www.justvoicesagency.com
e-mail: info@justvoicesagency.com
Fax: 020-7881 2501 Tel: 020-7881 2567

KIDZTALK Ltd
(Children's Voices aged 4-24 yrs)
Website: www.kidztalk.com
e-mail: studio@kidztalk.com
Fax: 01737 352456 Tel: 01737 350808

The voice agency of Amanda Howard Associates

www.meetthejoneses.co.uk +44 (0)20 7287 9666

LIP SERVICE
60-66 Wardour Street, London W1F 0TA
Website: www.lipservice.co.uk
e-mail: bookings@lipservice.co.uk
Fax: 020-7734 3373 Tel: 020-7734 3393

MANSON Andrew
(Genuine Americans only)
288 Munster Road
London SW6 6BQ
Website: www.andrewmanson.com
e-mail: post@andrewmanson.com
Fax: 020-7381 8874 Tel: 020-7386 9158

MARKHAM & FROGGATT Ltd
4 Windmill Street, London W1T 2HZ
e-mail: millie@markhamfroggatt.co.uk
Fax: 020-7637 5233 Tel: 020-7636 4412

MBA
2 Futura House, 169 Grange Road, London SE1 3BN
e-mail: info@braidman.com
Fax: 020-7231 4634 Tel: 020-7237 3523

McREDDIE Ken ASSOCIATES Ltd
36-40 Glasshouse Street, London W1B 5DL
Fax: 020-7734 6530 Tel: 020-7439 1456

NOEL John MANAGEMENT
2nd Floor, 10A Belmont Street, London NW1 8HH
Website: www.johnnoel.com
e-mail: john@johnnoel.com
Fax: 020-7428 8401 Tel: 020-7428 8400

NUTOPIA-CHANG VOICES
Number 8, 132 Charing Cross Road, London WC2H 0LA
Website: www.nutopia-chang.com
Fax: 029-2070 5725 Tel: 029-2071 3540

Broaden your horizons...
...for some of the best voices, look further afield

UK wide voices for
a UK wide audience

Voiceovers.co.uk

PEMBERTON ASSOCIATES Ltd
193 Wardour Street
London W1F 8ZF
Fax: 020-7734 2522 Tel: 020-7734 4144
Express Networks
1 George Leigh Street, Manchester M4 5DL
Website: www.pembertonassociates.com
e-mail: general@pembertonassociates.com
Fax: 0161-235 8442 Tel: 0161-235 8440

PFD
Drury House
34-43 Russell Street
London WC2B 5HA
Website: www.pfd.co.uk
e-mail: postmaster@pfd.co.uk
Fax: 020-7836 9544 Tel: 020-7344 1010

QVOICE
4th Floor
Holborn Hall
193-197 High Holborn, London WC1V 7BD
Website: www.qvoice.co.uk
e-mail: info@qvoice.co.uk
Fax: 020-7025 0659 Tel: 020-7025 0660

RABBIT VOCAL MANAGEMENT
2nd Floor
18 Broadwick Street
London W1F 8HS
Website: www.rabbit.uk.net
e-mail: info@rabbit.uk.net
Fax: 020-7287 6566 Tel: 020-7287 6466

RHINO MANAGEMENT
Oak Porch House
5 Western Road
Nazeing, Essex EN9 2QN
Website: www.rhino-management.co.uk
e-mail: info@rhino-management.co.uk
Mobile: 07901 528988 Tel/Fax: 01992 893259

RHUBARB
1st Floor
1A Devonshire Road, London W4 2EU
Website: www.rhubarb.co.uk
e-mail: enquiries@rhubarb.co.uk
Fax: 020-8742 8693 Tel: 020-8742 8683

RICHARD STONE PARTNERSHIP
(See STONE Richard PARTNERSHIP The)

SHINING MANAGEMENT Ltd
12 D'Arblay Street, London W1F 8DU
Website: www.shiningvoices.com
e-mail: info@shiningvoices.com
Fax: 020-7734 2528 Tel: 020-7734 1981

SPEAK Ltd
(No unsolicited mail or e-mails)
59 Lionel Road North
Brentford, Middlesex TW8 9QZ
Website: www.speak.ltd.uk
e-mail: info@speak.ltd.uk
Fax: 020-8758 0333 Tel: 020-8758 0666

SPEAK-EASY Ltd
1 Dairy Yard, High Street, Market Harborough
Leicestershire LE16 7NL
Website: www.speak-easy.co.uk
e-mail: enquiries@speak-easy.co.uk
Fax: 01858 461994 Tel: 0870 0135126

fo'reignversions

Voice Overs
Translations
Script Adaptation
Foreign Copywriting
Studio Production
Subtitles

Contact: Margaret Davies, Annie Geary
or Bérangère Capelle

On 020 7935 0993

Foreign Versions Ltd
60 Blandford Street
London W1U 7JD

e-mail: info@foreignversions.co.uk
www.foreignversions.com

do you know how to judge a quality voice-over showreel?

Very high quality.
I've always been impressed
Sheila Britten - Castaway Voice Agency

Consistently produce showreels
of the highest Standard.
David Hodge - Hobson's Voices

A professional and high
quality showreel
Penny Brown - Voicecall

Professional, sharp,
well presented quality demos
Ben Romer Lee – Vocal Point

Unfailingly produce
exceptional showreels
Vicky Crompton - Talking Heads

Definitely the best showreels
Leigh Matty - The Just Voices Agency

Outstanding quality reels
Alex Lynch White - Earache Voice Agency

Consistently the best
produced audio reels we receive
Victoria Braverman & Sean Bolger – Voicebookers.com

Professional and unique showreels, 2 very
important aspects for a top quality demo
Jennifer & Clair - Shining Management Ltd

the voice agencies do.

Register now for your introductory workshop

If you are thinking about getting into voice-overs, you need a Voice Showreel. You can't get work as a Voice Artist without one.
Your voice showreel is your calling card. It is the audio equivalent of an actor's head shot, and therefore it is essential that it represents the essence of who you are, so that any potential agent or client knows, just by listening, about your vocal quality, age, attitude, style, ability and personality. It must be carefully planned and professionally produced and only contain your best and most recent work. It is a waste of time and money to record a "bad" voice showreel, showing only a few poorly developed vocal styles and deliveries.

Our voice-over workshop is the ideal introduction to the voice industry.
In this workshop, you'll learn all about the voice-over business, from radio and TV commercials to cartoon and animation work, as well as corporate and industrial narrations.

Topics covered include mic technique, script interpretation, sight reading, session scenarios, studio etiquette, Voice Agents and self marketing techniques.

This is a great way to discover if voice-over work is for you.

Trust us to get it right
Voice-over artists are hired based on the quality of their Voice Showreel. In about a minute and a half, or less, a potential agent or client should be able to gain a clear picture of your vocal range and ability. You are competing with working professionals that have great voice showreels and yours must sound just as professional if you are to succeed.

Free colour on-body printed CDs.
We never put a sticky label on your duplicated CDs and lower the presentation of your final Showreel. Best of all we include duplicated CDs in each of our Showreel packages for FREE.

Your duplicated Showreel in your hand at the end of the session.
Because we produce our CDs in-house, you can have your Showreel duplications in your hand at the end of the session. So you don't have to wait for a delivery to move your career forward.

Comfortable, soundproofed, air-conditioned studios.
Our two studios and vocal booths are fully soundproofed and air-conditioned with ample room to relax and focus on recording your Showreel.

Industry Contacts provided for FREE.
Our website provides instant access to industry contacts along with a wealth of related information to help you succeed.

Still not convinced? Then the Audition Package is the best way to find out if voice-over is for you.
You're given several types of scripts to record to establish where your "natural" read and style lies. Once your performance level and abilities have been evaluated, together, we decide if you should take the next step and invest in a full Voice Showreel package. This session is designed to clarify for you as well as for us, the direction in which you need to focus.

Showreel Packages
Audition Package	£60
Bronze Package	£150
Silver Package	£230
Gold Package	£290

Call 020 7043 8660 to register for your free introductory Workshop or visit our website at http://www.theshowreel.com

theShowreel.com
trust us to get it right

Knightsbridge House, 229 Acton Lane, Chiswick, London W4 5DD studio (020) 8995 3232 email info@theshowreel.com

STONE Richard PARTNERSHIP The
2 Henrietta Street, London WC2E 8PS
e-mail: all@thersp.com
Fax: 020-7497 0869 Tel: 020-7497 0849

SUMMERS Mark MANAGEMENT
137 Freston Road, London W10 6TH
Website: www.marksummers.com
e-mail: info@marksummers.com
Fax: 020-7243 1987 Tel: 020-7229 8413

TALKING HEADS
2-4 Noel Street, London W1F 8GB
Website: www.talkingheadsvoices.com
e-mail: voices@talkingheadsvoices.com
Fax: 020-7292 7576 Tel: 020-7292 7575

TERRY Sue VOICES Ltd
3rd Floor, 18 Broadwick Street, London W1F 8HS
Website: www.sueterryvoices.co.uk
e-mail: sue@sueterryvoices.co.uk
Fax: 020-7434 2042 Tel: 020-7434 2040

TONGUE & GROOVE
3 Stevenson Square, Manchester M1 1DN
Website: www.tongueandgroove.co.uk
e-mail: info@tongueandgroove.co.uk
Fax: 0161-237 1809 Tel: 0161-228 2469

VACCA Roxane VOICES
73 Beak Street, London W1F 9SR
Website: www.roxanevaccamanagement.com
Fax: 020-7734 8086 Tel: 020-7734 8085

VOCAL POINT
25 Denmark Street, London WC2H 8NJ
Website: www.vocalpoint.net
e-mail: enquiries@vocalpoint.net
Fax: 020-7419 0699 Tel: 020-7419 0700

VOICE BOX AGENCY Ltd
1st Flr, 100 Talbot Road, Old Trafford, Manchester M16 0PG
Website: www.thevoicebox.co.uk
Fax: 0161-888 2242 Tel: 0161-874 5741

VOICE MASTER STUDIO
(Specialising in Foreign Language Voice-Overs)
88 Erskine Hill, London NW11 6HR
Website: www.voicemaster.co.uk
e-mail: stevehudson@voicemaster.co.uk Tel: 020-8455 2211

VOICE SHOP
First Floor, Thomas Place
1A Devonshire Road, London W4 2EU
Website: www.voice-shop.co.uk
e-mail: info@voice-shop.co.uk
Fax: 020-8742 7011 Tel: 020-8742 7077

VOICE SQUAD
1 Kendal Road, London NW10 1JH
Website: www.voicesquad.com
e-mail: voices@voicesquad.com Tel: 020-8450 4451

VOICEBANK, THE IRISH VOICE-OVER AGENCY
The Barracks
76 Irishtown Road, Dublin 4, Eire
Website: www.voicebank.ie
e-mail: voicebank@voicebank.ie
Fax: 00 353 1 6607850 Tel: 00 353 1 6687234

VOICECALL
67A Gondar Gardens, London NW6 1EP
e-mail: voices@voicecall-online.co.uk Tel: 020-7209 1064

VOICEOVER GALLERY The
PO Box 213, Chorlton
Manchester M21 9ZA
Website: www.thevoiceovergallery.co.uk
e-mail: info@thevoiceovergallery.co.uk
Fax: 0161-718 1009 Tel: 0161-881 8844

VOICEOVERS.CO.UK
Ford Park House
24 Ford Park Road, Plymouth PL4 6RD
Website: www.voiceovers.co.uk
e-mail: info@voiceovers.co.uk
Fax: 01752 661595 Tel: 0871 3096653

VSI - VOICE & SCRIPT INTERNATIONAL
(Foreign Language Specialists)
132 Cleveland Street, London W1T 6AB
Website: www.vsi.tv
e-mail: info@vsi.tv
Fax: 020-7692 7711 Tel: 020-7692 7700

WILLIAMSON & HOLMES
9 Hop Gardens
St. Martin's Lane, London WC2N 4EH
e-mail: info@williamsonandholmes.co.uk
Fax: 020-7240 0408 Tel: 020-7240 0407

WOOTTON Suzy VOICES
75 Shelley Street
Kingsley, Northampton NN2 7HZ
e-mail: suzy@suzywoottonvoices.com
Fax: 0870 7659668 Tel: 0870 7659660

YAKETY YAK
7A Bloomsbury Square
London WC1A 2LP
Website: www.yaketyyak.co.uk
e-mail: info@yaketyyak.co.uk
Fax: 020-7404 6109 Tel: 020-7430 2600

nidges

casting agency

arguably the north of england's most established casting agency
we have a comprehensive selection of experienced, quality Equity & non-Equity
supporting artistes available for work in any sphere of the theatre,
television, film, video & advertising industries

Half Moon Chambers Chapel Walks Manchester M2 1HN
Tel: 0161 832 8259 Fax: 0161 832 5219 www.nidgescasting.co.uk

2 CASTING AGENCY & MANAGEMENT
Tiptoes House, 2 Collingwood Place
Layton, Blackpool FY3 8HU
e-mail: tiptoes2casting@hotmail.com
Fax: 01253 302610 Tel: 01253 302614

10 TWENTY TWO CASTING ■
PO Box 1022, Liverpool L69 5WZ
Website: www.10twentytwo.com
e-mail: contact@10twentytwo.com
Fax: 0151-207 4230 Tel: 0870 8501022

2020 CASTING Ltd ■
2020 Hopgood Street, London W12 7JU
Website: www.2020casting.com
e-mail: info@2020casting.com
Fax: 020-8735 2727 Tel: 020-8746 2020

ALLSORTS THEATRICAL AGENCY
(Modelling)
Three Mills Film Studios
Unit 1, Sugar House Business Centre
24 Sugar House Lane, London E15 2QS
Website: www.allsortsagency.com
e-mail: bookings@allsortsagency.com
Fax: 020-8555 0909 Tel: 020-8555 0099

ARTIST MANAGEMENT UK Ltd
PO Box 96, Liverpool L9 8WY
Website: www.artistmanagementuk.com
e-mail: chris@artistmanagementuk.com Tel: 0151-7523 6222

AVENUE ARTISTES Ltd
8 Winn Road, Southampton SO17 1EN
Website: www.avenueartistes.com
e-mail: info@avenueartistes.com
Fax: 023-8090 5703 Tel: 023-8055 1000

AWA - ANDREA WILDER AGENCY
23 Cambrian Drive
Colwyn Bay, Conwy LL28 4SL
Website: www.awagency.co.uk
e-mail: casting@awagency.co.uk
Fax: 07092 249314 Mobile: 07919 202401

BALDIES CASTING AGENCY
(The only agency purely for bald people)
6 Marlott Road
Poole, Dorset BH15 3DX
Mobile: 07860 290437 Tel: 01202 666001

BEAVEROCK PRODUCTIONS Ltd
404A Glasgow Road, Clydebank
West Dunbartonshire G81 1PW
Website: www.beaverockproductions.com
e-mail: info@beaverockproductions.com
 Tel/Fax: 0141-952 0437

BIRKETT Hannah CASTING
26 Noko, 3/6 Banister Road
London W10 4AR Mobile: 07957 114175

BIRMINGHAM CENTRAL CASTING
PO Box 145, Inkberrow
Worcestershire WR7 4EL
Website: www.bccasting.co.uk
e-mail: info@mouthpieceuk.co.uk Tel: 08700 427587

BODENS ADVANCED
Bodens Studios & Agency
99 East Barnet Road
New Barnet, Herts EN4 8RF
Website: www.bodensagency.com
e-mail: adultextras@aol.com
Fax: 020-8449 5212 Tel: 020-8447 1226

Who are Walk-on and Supporting Artists?

Sometimes known as 'Extras', walk-on and supporting artists appear in the background of TV and film scenes in order to add a sense of realism, character or atmosphere. They do not have individual speaking roles, unless required to make background / ambient noise. Working as a walk-on or supporting artist does not require any specific 'look', training or experience as such; however it does involve more effort than people think. Artists are often required to start very early in the morning (6am is not uncommon), and days can be long with lots of waiting around, sometimes in tough conditions on location. It is certainly not glamorous, nor is it a way to become a TV or film star! Artists must be reliable and available at very short notice, which can make it difficult to juggle with other work or family commitments. Requirements vary from production to production and, as with mainstream acting work, there are no guarantees that you will get regular work, let alone be able to earn a living as a walk-on.

How should I use these listings?

If you are serious about working as a walk-on artist, you will need to register with an agency in order to be put forward for jobs. In return for finding you work, you can expect an agency to take between 10-15% in commission. The following pages contain contact details of many walk-on and supporting artist agencies. Some will specialise in certain areas, so make sure you research the different companies carefully to see if they are appropriate for you. Many have websites you can visit. It is also worth asking questions about how long an agency has existed, and about their recent production credits. When approaching an agency for representation, you should send them your CV with a covering letter and a recent photograph which is a genuine, natural likeness of you. Enclosing a stamped-addressed envelope (SAE) will give you a better chance of a reply.

Should I pay an Walk-on Agent to join their books? Or sign a contract?

As with other types of agencies, Equity does not generally recommend that artists pay an agent to join their client list. Before signing any contract, you should be clear about the terms and commitments involved. Always speak to Equity (www.equity.org.uk) or BECTU (www.bectu.org.uk) if you have any concerns or queries.

Where can I find more information?

The website (www.hiddenextra.com) is an invaluable source of information for anyone thinking about working a walk-on or supporting artist.
You may also find it useful to contact the Film Artists Association, part of BECTU (www.bectu.org.uk) or the National Association of Supporting Artistes Agents (www.nasaa.org.uk).
NASAA members are shown by the symbol ■ in this book.
Within Equity, the actors' trade union, there is a committee which represents walk-on and supporting artists. As a general rule, walk-on artists can join Equity if they have proof of at least six days' paid work over a period of twelve consecutive months undertaken on an Equity agreement.

For more information visit (www.equity.org.uk)

SARAH DICKINSON is the chairperson of the National Association of Supporting Artistes Agents (NASAA) and director of The Casting Collective Ltd.

She offers the following advice to supporting artists when dealing with agencies:

The idea of being in a film or on TV is very exciting. It is easy to trust someone who says they can turn you into the 'next big thing' or get you on to the next big production.

Unfortunately there are some companies out there who will charge you a lot of money and never get you any work. NASAA was set up to try to prevent this happening.

NASAA is a collection of supporting artist agencies across the UK, who came together to self-regulate their industry. NASAA exists to set the standard of practice for all supporting artiste agents. As a group we are much stronger in our position when working with employers and unions. We also identify problem areas for the industry such as rogue agents and poor conditions and pay for artistes. Every year a new chairperson is elected by the members to oversee the activities of NASAA.

The overwhelming majority of supporting artist agencies operating in the UK do so lawfully and within the strict guidelines of the Employment Agencies Act, always putting the welfare of their artistes uppermost in any decisions they make. Unfortunately, there is also a minority of disreputable agencies who have tainted the industry as a whole.

Our major concern with these disreputable agencies surrounds their 'joining' fees. There may sometimes be a charge for joining an agency to cover photography and / or inclusion in the agency's book, but this should be deductible from your first day's work. By law, the fee must only be to cover these costs, so be very cautious of agencies charging high, upfront 'joining' fees. Steer clear of adverts at the back of magazines or newspapers and if you are in any doubt about an agency, always feel free to contact the NASAA.

NASAA-registered agencies are recognized by the major production companies as being highly reputable and professional companies. NASAA and its members also have the full backing of two unions - Equity and BECTU - as well as the Department for Trade and Industry and the Department of Culture, Media and Sport.

The agencies who belong to NASAA will always adhere to the code of conduct and will set out in writing any terms and conditions (including any and all charges) to which both you and they are expected to comply, so that there can be no misunderstanding by either party.

NASAA is there to ensure that all artistes get a fair day's pay for a fair day's work by not doing deals that undervalue the contribution supporting artistes make to the production.

If you have any questions or would like more information on our code of conduct or our list of members, please visit our website (www.nasaa.org.uk).

If you don't find the answer you're looking for, then you can contact me at (chair@nasaa.org.uk).

NEMESIS

www.nemesisagency.co.uk

Extras, Walk-Ons, Crowd Artistes, Fashion and Photographic Models
Largest selection of professional equity and non equity supporting artistes in North West

Manchester Head Office
tel. 0161 228 6404
sheila@nemesisagency.co.uk

BRISTOL EXTRA SERVICE TEAM (B.E.S.T.)
(Ernest Jones) (Film & TV Actors, Extras, Speciality Artists)
21 Ellesmere, Thornbury, Near Bristol BS35 2ER
Website: www.best-agency.co.uk
e-mail: ejj.best@blueyonder.co.uk
Mobile: 07951 955759 Tel/Fax: 01454 411628

BROAD CASTING AGENCY Ltd
Unit 23 Canalot Studios, 222 Kensal Road, London W10 5BN
e-mail: info@broadcastingcompany.tv
Fax: 020-8960 5031 Tel: 0871 2100035

BROOK Dolly CASTING AGENCY
PO Box 5436, Dunmow CM6 1WW
Fax: 01371 875996 Tel: 01371 875767

CAIRNS AGENCY The
(Maureen Cairns)
188 St Vincent Street, Glasgow G2 5SP
Website: www.west-endmgt.com
Fax: 0141-226 8983 Tel: 0141-226 8941

CAMCAST ■
Laragain, Upper Banavie
Fort William, Inverness-shire PH33 7PB
Website: www.camcast.co.uk
e-mail: anne@camcast.co.uk
Fax: 01397 772456 Tel: 01397 772523

CASTING COLLECTIVE Ltd The ■
Olympic House, 317-321 Latimer Road, London W10 6RA
Website: www.castingcollective.co.uk
e-mail: enquiries@castingcollective.co.uk
Fax: 020-8962 0333 Tel: 020-8962 0099

CASTING FILES
145-157 St John Street, London EC1V 4PY
Website: www.castingfiles.com
e-mail: admin@castingfiles.com

CASTING NETWORK Ltd The ■
2nd Floor, 10 Claremont Road, Surbiton, Surrey KT6 4QU
Website: www.thecastingnetwork.co.uk
e-mail: casting-network@talk21.com
Fax: 020-8390 0605 Tel: 020-8339 9090

CELEX CASTING Ltd ■
(Children available)
11 Glencroft Drive, Stenson Fields, Derby DE24 3LS
e-mail: anne@celex.co.uk
Fax: 01332 232115 Tel: 01332 232445

CENTRAL CASTING Ltd
(See also KNIGHT Ray CASTING)
21A Lambolle Place, Belsize Park, London NW3 4PG
Website: www.rayknight.co.uk
e-mail: casting@rayknight.co.uk
Fax: 020-7722 2322 Tel: 020-7722 4111

CORNWALL FILM AGENCY
Higher Leyonne, Golant, Fowey, Cornwall PL23 1LA
Website: www.cornwallfilmagency.com
e-mail: info.cfa@btconnect.com
Fax: 01726 833004 Tel: 01726 832395

DAVID AGENCY The ■
26-28 Hammersmith Grove, London W6 7BA
Website: www.davidagency.net
e-mail: casting@davidagency.net Tel: 020-7967 7001

Bodens Advanced
Professional & Experienced Adult Supporting Artistes
Film, Television & Commercials in London and the South East
Bodens. 99 East Barnet Road, New Barnet. EN4 8RF
020 8447 1226 07717 502 144 adultextras@aol.com
A branch of 'Bodens Studios & Agency'

London Academy of Radio Film TV
TV Presenter - Acting - Voice - Film - Photography - Make-up - Radio
100 courses Offering an extensive range of full-time, part-time
evening and day courses taught by celebrities and industry professionals.
www.media-courses.com 0870 850 4994

Background & supporting artistes
for the film and television industry

**Online Brochure at
www.10twentytwo.com**

10 TWENTY TWO CASTING

**T 0151 298 1022 | F 0151 207 4230
Production 0151 207 9794 (24Hr)**
email: contact@10twentytwo.com
PO Box 1022 Liverpool L69 5WZ
24 hours, 7 days a week

Member of the National Association of
Supporting Artistes Agents (NASAA)

DOE John ASSOCIATES
26 Noko, 3/6 Banister Road, London W10 4AR
Website: www.johndoeassociates.com
e-mail: info@johndoeassociates.com
Mobile: 07979 558594 Tel: 020-8960 2848

ELITE CASTING AGENCY
(Film & TV Extras)
77 Widmore Road
Bromley, Kent BR1 3AA
Website: www.elitecasting.co.uk
e-mail: admin@elitecasting.co.uk Tel/Fax: 0871 3103438

ELLIOTT AGENCY The ■
94 Roundhill Crescent, Brighton BN2 3FR
Website: www.elliottagency.co.uk
e-mail: info@elliottagency.co.uk Tel: 01273 683882

**EUROKIDS & ADULTS INTERNATIONAL CASTING &
MODEL AGENCY**
The Warehouse Studios
Glaziers Lane, Culcheth
Warrington, Cheshire WA3 4AQ
Website: www.eka-agency.com
e-mail: info@eka-agency.com
Fax: 01925 767563 Tel: 01925 767574

EXTRASPECIAL Ltd
38 Commercial Street, London E1 6LP
e-mail: info@extraspecialartists.com
Fax: 020-7375 1466 Tel: 020-7375 1400

EXTRAS UNLIMITED.COM
137 Freston Road
London W10 6TH
Website: www.extrasunlimited.com
e-mail: info@extrasunlimited.com
Fax: 020-7243 1987 Tel: 020-7229 8413

FACES CASTING AGENCY ■
15A Cambridge Place
Hove, East Sussex BN3 3ED
Website: www.faces-casting.co.uk
e-mail: nick@faces-casting.co.uk
Fax: 01273 719165 Tel: 01273 329436

FBI AGENCY Ltd The ■
PO Box 250, Leeds LS1 2AZ
e-mail: casting@fbi-agency.ltd.uk
Fax: 0113-279 7270 Tel: 07050 222747

FRESH AGENTS Ltd
Suite 5, Saks House, 19 Ship Street, Brighton BN1 1AD
Website: www.freshagents.com
e-mail: info@freshagents.com
Fax: 01273 711778 Tel: 01273 711777

FTS CASTING AGENCY
55 Pullan Avenue, Eccleshill, Bradford BD2 3RP
e-mail: helen@footsteps.fslife.co.uk
Fax: 01274 637429 Tel: 01274 636036

G2 ■
15 Lexham Mews, London W8 6JW
Website: www.g2casting.com
e-mail: email@g2casting.com
Fax: 020-7376 2416 Tel: 020-7376 2133

GUYS & DOLLS CASTING ■
Trafalgar House, Grenville Place
Mill Hill, London NW7 3SA
Fax: 020-8381 0080 Tel: 020-8906 4144

HOWE Janet CASTING AGENCY
40 Princess Street, Manchester M1 6DE
e-mail: info@janethowe.com Tel/Fax: 0161-234 0142
56 The Ironmarket, Newcastle, Staffordshire ST5 1PE
e-mail: janet@jhowecasting.fsbusiness.co.uk
Mobile: 07801 942178 Tel: 01782 661777

INDUSTRY CASTING
Suite 332, Royal Exchange, Manchester M2 7BR
Website: www.industrycasting.co.uk
e-mail: mark@industrypeople.co.uk
Fax: 0161-839 1661 Tel: 0161-839 1551

JACLYN AGENCY ■
52 Bessemer Road, Norwich, Norfolk NR4 6DQ
Website: www.jaclyncastingagency.co.uk
e-mail: info@jaclynagency.co.uk
Fax: 01603 612532 Tel: 01603 622027

Regency Agency Principal: Beverley Coles

Extras and Walk-ons available for Television, Films, Theatre, Commercials

T: 0113-255 8980 25 Carr Road Calverley Leeds LS28 5NE

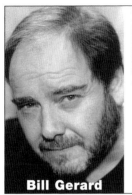

Bill Gerard

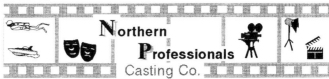

Northern Professionals Casting Co.

Licence No. L1299.....

Casting - Supporting/Principal Artistes
Action Safety Consultant
Diving support teams - Boat Hire - Diving Equipment Hire

Office: 0191 257 8635 Mob: 07860 186978 Fax: 0191 296 3243
21 Cresswell Avenue, North Shields, Near Tyne & Wear NE29 9BQ
www.northernprocasting.co.uk

JB AGENCY ONLINE Ltd ■
Unit 6, 26 Onlsow Gardens
South Kensington, London SW7 3AG
Website: www.ukast.co.uk
e-mail: dazaminton@hotmail.com
Mobile: 07962 434111 Tel: 020-7823 9630

JPM EXTRAS
(A Division of Janet Plater Management Ltd)
D Floor, Milburn House, Dean Street
Newcastle upon Tyne NE1 1LF
Website: www.janetplatermanagement.co.uk
e-mail: magpie@tynebridge.demon.co.uk
Fax: 0191-233 1709 Tel: 0191-221 2491

J.R. FILM ARTISTES
25 Barnes Wallis Road, Segensworth
Fareham PO15 5TT Tel/Fax: 023-8044 6055

KNIGHT Ray CASTING ■
(See also CENTRAL CASTING Ltd)
21A Lambolle Place
Belsize Park, London NW3 4PG
Website: www.rayknight.co.uk
e-mail: casting@rayknight.co.uk
Fax: 020-7722 2322 Tel: 020-7722 4111

KREATE PRODUCTIONS
Unit 232
30 Great Guildford Street
London SE1 0HS
Website: www.kreatepromotions.co.uk
e-mail: enquiries@kreatepromotions.co.uk
Fax: 020-7401 3003 Tel: 020-7401 9007

LEE'S PEOPLE ■
16 Manette Street, London W1D 4AR
Website: www.lees-people.co.uk
e-mail: lee@lees-people.co.uk
Fax: 020-7734 3033 Tel: 020-7734 5775

LEMON CASTING Ltd
Web Film Studios
Ravenscraig Road
Little Hulton, Manchester M38 9PU
e-mail: lemon.tv@btconnect.com Tel: 01204 570373

LINTON MANAGEMENT
3 The Rock, Bury BL9 0JP
e-mail: carol@linton.tv
Fax: 0161-761 1999 Tel: 0161-761 2020

MAC-10 MANAGEMENT ■
Office 69, 2 Hellidon Close
Ardwick, Manchester M12 4AH
Website: www.mac-10.co.uk
e-mail: info@mac-10.co.uk
Fax: 0161-275 9610 Tel: 0161-275 9510

MAD DOG CASTING Ltd ■
Top Floor
15 Leighton Place, London NW5 2QL
e-mail: production@maddogcasting.com
Fax: 020-7284 2689 Tel: 020-7482 4703

M.E.P. MANAGEMENT
1 Malvern Avenue
Highams Park, London E4 9NP
Website: www.global-theatre-company.net
e-mail: mep@btclick.com Tel/Fax: 020-8523 3540

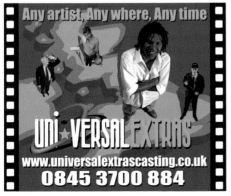
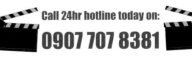

Supplying experienced background artists, walk-ons and photographic characters to the television, film and advertising industries.

Representing a large selection of professional artistes based in the North West.

'No brief is out of our reach'

industrycasting

332 Royal Exchange
Manchester M2 7BR

www.industrypeople.co.uk/casting
mark@industrypeople.co.uk

Tel 0161 839 1551 Fax 0161 839 1661

NEMESIS AGENCY Ltd
Nemesis House, 1 Oxford Court
Bishopsgate, Manchester M2 3WQ
Website: www.nemesisagency.co.uk
e-mail: sheila@nmsmanagement.co.uk
Fax: 0161-228 6727 Tel: 0161-228 6404

NE REPRESENTATION
(Models, Photographers, Hair & make-up artists, Stylists and Film Extras)
38 Coniscliffe Road, Darlington DL3 7RG
Website: www.nerepresentation.co.uk
e-mail: info@nerepresentation.co.uk
Fax: 01325 488390 Tel: 01325 488385

NIDGES CASTING AGENCY
Half Moon Chambers, Chapel Walks, Manchester M2 1HN
e-mail: phil@nidgescasting.co.uk
Fax: 0161-832 5219 Tel: 0161-832 8259

NORTHERN PROFESSIONALS CASTING COMPANY
21 Cresswell Avenue
North Shields, Tyne & Wear NE29 9BQ
Website: www.northernprocasting.co.uk
e-mail: bill@northernprocasting.co.uk
Fax: 0191-296 3243 Tel: 0191-257 8635

ORIENTAL CASTING AGENCY Ltd (Peggy Sirr) ■
(Afro/Asian Artists)
1 Wyatt Park Road
Streatham Hill, London SW2 3TN
Website: www.orientalcasting.com
e-mail: peggy.sirr@btconnect.com
Fax: 020-8674 9303 Tel: 020-8671 8538

PAN ARTISTS AGENCY Ltd
Cornerways, 34 Woodhouse Lane
Sale, Cheshire M33 4JX
e-mail: panartists@btconnect.com
Fax: 0161-962 6571 Tel: 0161-969 7419

PC THEATRICAL & MODEL AGENCY
12 Carlisle Road, Colindale, London NW9 0HL
Website: www.twinagency.com
e-mail: twinagy@aol.com
Fax: 020-8933 3418 Tel: 020-8381 2229

PHA CASTING
Tanzaro House
Ardwick Green North, Manchester M12 6FZ
Website: www.pha-agency.co.uk
e-mail: casting@pha-agency.co.uk
Fax: 0161-273 4567 Tel: 0161-273 4444

PHOENIX CASTING AGENCY ■
PO Box 387, Bristol BS99 3JZ
Website: www.phoenixagency.biz
e-mail: info@phoenixagency.biz
Fax: 0117-973 4160 Tel: 0117-973 1100

POWER MODEL MANAGEMENT CASTING AGENCY
Capitol House
2-4 Heigham Street
Norwich NR2 4TE
Website: www.powermodel.co.uk
e-mail: info@powermodel.co.uk Tel: 01603 621100

PRAETORIAN ASSOCIATES
(Specialist Action Extras)
Room 501
2 Old Brompton Road, London SW7 3DG
Website: www.praetorianasc.com
e-mail: info@praetorianasc.com
Fax: 020-8923 7177 Tel: 020-8923 9075

PRIDE ARTIST MANAGEMENT
The Burnside Centre
Burnside Crescent
Middleton
Manchester M24 5NN
Website: www.pride-media-association.co.uk
e-mail: extras@pride-media-association.co.uk
 Tel/Fax: 0161-643 6266

RAY'S NORTHERN CASTING AGENCY
7 Wince Close, Alkrington
Middleton, Manchester M24 1UJ
e-mail: rayscasting@yahoo.co.uk Tel/Fax: 0161-643 6745

REGENCY AGENCY
25 Carr Road
Calverley, Pudsey
West Yorks LS28 5NE Tel: 0113-255 8980

REYNOLDS Sandra AGENCY
62 Bell Street, London NW1 6SP
Website: www.sandrareynolds.co.uk
e-mail: info@sandrareynolds.co.uk
Fax: 020-7387 5848 Tel: 020-7387 5858

35 St Georges Street, Norwich NR3 1DA
Fax: 01603 219825 Tel: 01603 623842

RHODES AGENCY
5 Dymoke Road
Hornchurch, Essex RM11 1AA
e-mail: rhodesarts@hotmail.com
Fax: 01708 730431 Tel: 01708 747013

faces casting agency

Manager ~ **Nicholas Groush**
15A Cambridge Place Hove BN3 3ED
t: 01273 329436
f: 01273 719165 **e:** nick@faces-casting.co.uk
m: 07876 074606 **w:** www.faces-casting.co.uk

SA19 - THE UNIFORMED ARTISTE AGENCY ■
2020 Hopgood Street
Shepherds Bush, London W12 7JU
Website: www.sa19.co.uk
e-mail: info@sa19.co.uk
Fax: 020-8735 2727 Tel: 020-8746 2523

SAPPHIRES MODEL MANAGEMENT
The Makers Dozen
Studio 11, 8 Wulfruna Street
Wolverhampton WV1 1LW
Website: www.sapphiresmodelmanagement.co.uk
e-mail: ian@sapphiresmodelmanagement.co.uk
Fax: 0870 9127563 Tel: 01902 427740

SCREAM MANAGEMENT
The Red Door, 32 Clifton Street
Blackpool, Lancs FY1 1JP
Website: www.screammanagement.com
e-mail: info@screammanagement.com
Fax: 01253 750829 Tel: 01253 750820

SCREENLITE AGENCY ■
Shepperton Film Studios
Shepperton, Middlesex TW17 0QD
Website: www.screenliteagency.co.uk
e-mail: kerry@screenliteagency.co.uk
Fax: 01932 592507 Tel: 01932 566977

SOHO ARTISTES
The Loft
204 Valley Road, London SW16 2AE
Website: www.sohoartistes.com
e-mail: info@sohoartistes.com
Fax: 020-8769 0811 Tel/Fax: 020-7884 1295

SOLOMON ARTISTES
30 Clarence Street
Southend-on-Sea, Essex SS1 1BD
Website: www.solomon-artistes.co.uk
e-mail: info@solomon-artistes.co.uk
Fax: 01702 392385 Tel: 01702 437118

STAV'S CASTING AGENCY
82 Station Crescent
Tottenham, London N15 5BD
Website: http://stavscast.mysite.wanadoo-members.co.uk
e-mail: stavscast@yahoo.co.uk Mobile: 07757 720406

SUPPORTING ARTIST AGENCY
576 Fulham High Street
Fulham, London SW6 3JJ
Website: www.supportingartistsagency.co.uk
Fax: 020-7610 9565 Tel: 020-7384 2344

TAG FORCE
59 Sylvan Avenue
Wood Green, London N22 5JA
Website: www.tagforce.co.uk
e-mail: info@tagforce.co.uk Tel/Fax: 020-8889 6540

TUESDAYS CHILD Ltd
(Children & Adults)
Oakfield House, Springwood Way
Macclesfield SK10 2XA
Website: www.tuesdayschildagency.co.uk
e-mail: info@tuesdayschildagency.co.uk
 Tel/Fax: 01625 501765

UGLY ENTERPRISES Ltd
Tigris House
256 Edgware Road, London W2 1DS
Website: www.ugly.org
e-mail: info@ugly.org
Fax: 020-7402 0507 Tel: 020-7402 5564

UNIVERSAL MODEL MANAGEMENT Ltd
PO Box 127, Northampton NN1 3PZ
Website: www.universalmodels.tv
e-mail: enquiries@universalmodels.tv Tel/Fax: 01604 454818

ZEN DIRECTORIES
Central House, 1 Ballards Lane, London N3 1LQ
Website: www.zdcl.co.uk
e-mail: info@zdcl.co.uk
Fax: 020-3115 0035 Tel: 020-3115 0010

SÉVA DHALIVAAL M: 07956 553879

A1 ANIMALS
(Farm, Domestic & Exotic Animals)
Cleveley House, Cleveley Road, Enstone, Oxon OX7 4LW
Website: www.a1animals.co.uk
e-mail: info@a1animals.freeserve.co.uk
Tel/Fax: 01608 677348

A-Z ANIMALS Ltd
The Bell House, Bell Lane, Fetcham, Surrey KT22 9ND
e-mail: xlence@a-zanimals.com
Fax: 01372 377666
Tel: 01372 377111

ABBIE@JANIMALS Ltd
T/A Abbie's Animals
Greystones, Spirit Hill, Calne, Wilts SN11 9HW
Website: www.abbiesanimals.co.uk
e-mail: info@abbiesanimals.co.uk
Mobile: 07900 494028
Tel/Fax: 0870 2417693

ABNALLS HORSES
Abnalls Farm, Cross in Hand Lane
Lichfield, Staffs WS13 8DZ
e-mail: carolynsj@dial.pipex.com
Fax: 01543 417226
Tel: 01543 417075

ACTION STUNT DOGS
3 The Chestnuts, Clifton, Deddington, Oxon OX15 0PE
e-mail: gill@stuntdogs.net
Tel/Fax: 01869 338546

ALTERNATIVE ANIMALS
(Animatronics/Taxidermy)
19 Greaves Road, High Wycombe, Bucks HP13 7JU
Website: www.animalworld.org.uk
e-mail: animalworld@bushinternet.com
Fax: 01494 441385
Tel: 01494 448710

ANIMAL ACTING
(Stunts, Prop, Horse-Drawn Vehicles)
15 Wolstenvale Close, Middleton, Manchester M24 2HP
Website: www.animalacting.com
e-mail: information@animalacting.com
Fax: 0161-655 3700
Mobile: 07831 800567

ANIMAL ACTORS
(Animals, Birds, Reptiles)
95 Ditchling Road, Brighton
Sussex BN1 4ST
Tel: 020-8654 0450

ANIMAL AMBASSADORS
Old Forest, Hampstead Norreys Road
Hermitage, Berks RG18 9SA
Website: www.animalambassadors.co.uk
e-mail: kayweston@tiscali.co.uk
Mobile: 07831 558594
Tel/Fax: 01635 200900

ANIMAL ARK
(Animals & Animal Prop Shop)
Studio, 29 Somerset Rd, Brentford, Middx TW8 8BT
Website: www.animal-ark.co.uk
e-mail: info@animal-ark.co.uk
Fax: 020-8560 5762
Tel: 020-8560 3029

ANIMAL ARRANGERS
(Animal Suppliers & Co-ordinators)
28 Greaves Road, High Wycombe, Bucks HP13 7JU
e-mail: trevorsmith@bushinternet.com
Mobile: 07956 564715
Tel: 01494 448710

ANIMAL CASTING
119 Magdalen Road, London SW18 3ES
e-mail: silcresta@aol.com
Mobile: 07956 246450
Tel: 020-8874 9530

ANIMALS GALORE
208 Smallfield Road, Horley, Surrey RH6 9LS
Website: www.animals-galore.co.uk
Fax: 01342 841546
Tel: 01342 842400

ANIMALS O KAY
16 Queen Sreet, Chipperfield, Kings Langley, Herts WD4 9BT
Website: www.animalsokay.com
e-mail: kay@animalsokay.com
Fax: 01923 269076
Tel: 01923 291277

ANIMAL WELFARE FILMING FEDERATION
28 Greaves Road, High Wycombe, Bucks HP13 7JU
e-mail: animalworld@bushinternet.com
Fax: 01494 441385
Mobile: 07770 666088

ANIMAL WORK WITH ANIMAL WORLD
(Trevor Smith)
19 Greaves Road, High Wycombe, Bucks HP13 7JU
Website: www.animalworld.org.uk
e-mail: trevorsmith@bushinternet.com
Fax: 01494 441385
Tel: 01494 442750

CANINE FILM ACADEMY The
57C Cheapside Road, Ascot, Berks SL5 7QR
Website: www.thecaninefilmacademy.com
e-mail: katie.cfa@virgin.net
Mobile: 07767 341424
Tel: 01344 291465

CHEESEMAN Virginia
21 Willow Close, Flackwell Heath
High Wycombe, Bucks HP10 9LH
Website: www.virginiacheeseman.co.uk
e-mail: virginia@virginiacheeseman.co.uk
Tel: 01628 522632

COTSWOLD FARM PARK
(Rare Breed Farm Animals)
Guiting Power, Cheltenham, Gloucestershire GL54 5UG
e-mail: info@cotswoldfarmpark.co.uk
Fax: 01451 850423
Tel: 01451 850307

CREATURE FEATURE
(Animal Agent)
Gubhill Farm, Ae
Dumfries, Scotland DG1 1RL
Website: www.creaturefeature.co.uk
e-mail: david@creaturefeature.co.uk
Mobile: 07770 774866
Tel/Fax: 01387 860648

DOG EXTRAS
33 Harold Avenue, Belvedere, Kent DA17 5NN
Website: www.dog-extras.co.uk
e-mail: info@dog-extras.co.uk
Tel: 01322 448272

DOLBADARN FILM HORSES
Dolbadarn Hotel, High Street
Llanberis, Gwynedd, North Wales LL55 4SU
Website: www.filmhorses.co.uk
e-mail: info@filmhorses.co.uk
Mobile: 07710 461341
Tel/Fax: 01286 870277

DUDLEY Yvonne LRPS
(Glamour Dogs)
55 Cambridge Park, Wanstead
London E11 2PR
Tel: 020-8989 1528

EAST NOLTON RIDING STABLES
Nolton, Nr Newgale, Haverfordwest
Pembrokeshire SA62 3NW
Website: www.noltonstables.com
e-mail: noltonstables@aol.com
Fax: 01437 710967
Tel: 01437 710360

FILM HORSES
(Horses, Saddlery, Equestrian Centre)
Free Range Farm, Oakleigh Green Road
Windsor, Berks SL4 4GW
Website: www.filmhorses.com
e-mail: janetrogers@whsmithnet.co.uk
Mobile: 07831 629662
Tel/Fax: 01628 675105

FREE ANIMAL CONSULTANT SERVICES
28 Greaves Road, High Wycombe, Bucks HP13 7JU
Fax: 01494 441385
Tel: 08000 749383

GET STUFFED
(Taxidermy)
105 Essex Road, London N1 2SL
Website: www.thegetstuffed.co.uk
e-mail: taxidermy@thegetstuffed.co.uk
Fax: 020-7359 8253
Tel: 020-7226 1364

GRAY Robin COMMENTARIES
(Equestrian Equipment)
Comptons, Isington, Alton, Hants GU34 4PL
e-mail: gray@isington.fsnet.co.uk
Mobile: 07831 828424 Tel: 01420 23347

KNIGHTS OF ARKLEY The
Glyn Sylen Farm, Five Roads, Llanelli SA15 5BJ
Website: www.knightsofarkley.co.uk
e-mail: penny@knightsofarkley.fsnet.co.uk
 Tel/Fax: 01269 861001

MILLENNIUM BUGS
(Live Insects)
28 Greaves Road, High Wycombe, Bucks HP13 7JU
e-mail: animalworld@bushinternet.com
Fax: 01494 441385 Tel: 01494 448710

MORTON Geoff
(Shire Horse & Equipment)
Hasholme Carr Farm, Holme on Spalding Moor
York YO43 4BD Tel: 01430 860393

OTTERS
(Tame Otters) (Daphne & Martin Neville)
Baker's Mill, Frampton Mansell, Stroud, Glos GL6 8JH
e-mail: martin.neville@ukgateway.net Tel: 01285 760234

PETMUNCH
114 Mill Lane, West Hampstead, London NW6 1NF
e-mail: info@petmunch.com Tel/Fax: 020-7813 2644

PROP FARM Ltd
(Pat Ward)
Grange Farm, Elmton, Nr Creswell
North Derbyshire S80 4LX
e-mail: pat/les@propfarm.co.uk
Fax: 01909 721465 Tel: 01909 723100

ROCKWOOD ANIMALS ON FILM
Lewis Terrace, Llanbradach, Caerphilly CF83 3JZ
Website: www.rockwoodanimals.com
e-mail: rockwood@gxn.co.uk
Mobile: 07973 930983 Tel: 029-2088 5420

SCHOOL OF NATIONAL EQUITATION Ltd
(Sam Humphrey)
Bunny Hill Top, Costock
Loughborough, Leicestershire LE12 6XE
Website: www.bunny-hill.co.uk
e-mail: sam@bunny-hill.co.uk
Fax: 01509 856067 Tel: 01509 852366

STUDIO & TV HIRE
(Stuffed Animal Specialists)
3 Ariel Way, Wood Lane, White City, London W12 7SL
Website: www.stvhire.com
e-mail: enquiries@stvhire.com
Fax: 020-8740 9662 Tel: 020-8749 3445

TATE'S Nigel DOGSTARS
4 Hoads Wood Gardens, Ashford, Kent TN25 4QB
Website: www.dogstars.co.uk
e-mail: animals@dogstars.co.uk
Fax: 07092 031929 Tel: 01233 635439

TATE Olive
(Trained Dogs & Cats)
49 Upton Road, Bexleyheath, Kent DA6 8LW
Mobile: 07731 781892 Tel/Fax: 020-8303 0683

THORNE'S OF WINDSOR
(Beekeeping & Other Insect Suppliers)
Oakley Green Farm, Oakley Green, Windsor, Berks SL4 4PZ
e-mail: mattallan@aol.com
Fax: 01753 830605 Tel: 01753 830256

WHITE DOVES COMPANY Ltd The
(Provision of up to 150 Doves for Release)
Suite 210 Sterling House
Langston Road, Loughton, Essex IG10 3TS
Website: www.thewhitedovecompany.co.uk
e-mail: thewhitedovecompany@lineone.net
Fax: 020-8502 2461 Tel: 020-8508 1414

WOLF SPECIALISTS The
The UK Wolf Conservation Trust, UK Wolf Centre
Butlers Farm, Beenham, Berks RG7 5NT
Website: www.ukwolf.org
e-mail: ukwct@ukwolf.org Tel: 0118-971 3330

WOODS Sue
(Animal Promotions, Specialising in Dogs, Domestic Cats, Rodents, Poultry & Farm Stock)
White Rocks Farm, Underriver, Sevenoaks, Kent TN15 0SL
Website: www.animalpromotions.co.uk
e-mail: happyhoundschool@yahoo.co.uk
Fax: 01732 763767 Tel: 01732 762913

ALDERSHOT
West End Centre, Queens Road
Aldershot, Hants GU11 3JD
Website: www.westendcentre.co.uk
BO: 01252 330040 Admin: 01252 408040

BANGOR
Theatr Gwynedd
Ffordd Deiniol
Bangor, Gwynedd LL57 2TL
Website: www.theatrgwynedd.co.uk
e-mail: theatr@theatrgwynedd.co.uk
BO: 01248 351708 Admin: 01248 351707

BILLERICAY
Billericay Arts Association
The Fold, 72 Laindon Road
Billericay, Essex CM12 9LD
Secretary: Edmond Philpott Tel: 01277 659286

BINGLEY
Bingley Arts Centre, Main Street
Bingley, West Yorkshire BD16 2LZ
Head of Halls: Mark Davies Tel: 01274 431576

BIRMINGHAM
The Custard Factory, Gibb Street
Digbeth, Birmingham B9 4AA
Website: www.custardfactory.co.uk
e-mail: post@custardfactory.co.uk
Fax: 0121-604 8888 Tel: 0121-693 7777

BIRMINGHAM
Midlands Arts Centre
Cannon Hill Park, Birmingham B12 9QH
Website: www.macarts.co.uk
Director: Dorothy Wilson
BO: 0121-440 3838 Admin: 0121-440 4221

BOSTON
Blackfriars Arts Centre
Spain Lane, Boston
Lincolnshire PE21 6HP
Website: www.blackfriars.uk.com
e-mail: director@blackfriars.uk.com
Contact: Andrew Rawlinson
Fax: 01205 358855 Tel: 01205 363108

BRACKNELL
South Hill Park Arts Centre
Ringmead, Bracknell, Berkshire RG12 7PA
Chief Executive: Ron McAllister
Fax: 01344 411427
BO: 01344 484123 Admin: 01344 484858

BRADFORD
Theatre in The Mill
University of Bradford
Shearbridge Road, Bradford
West Yorkshire BD7 1DP
e-mail: theatre@bradford.ac.uk Tel: 01274 233185

BRAINTREE
The Town Hall Centre, Market Square
Braintree, Essex CM7 3YG
General Manager: Jean Grice Tel: 01376 557776

BRENTFORD
Watermans, 40 High Street
Brentford TW8 0DS
Fax: 020-8232 1030
BO: 020-8232 1010 Admin: 020-8232 1020

BRIDGWATER
Bridgwater Arts Centre
11-13 Castle Street
Bridgwater, Somerset TA6 3DD
Website: www.bridgwaterartscentre.co.uk
e-mail: info@bridgwaterartscentre.co.uk Tel: 01278 422700

BRIGHTON
Gardner Arts Centre
University of Sussex
Falmer, Brighton BN1 9RA
Website: www.gardnerarts.co.uk
e-mail: info@gardnerarts.co.uk
Director: Sue Webster
Fax: 01273 678551
BO: 01273 685861 Admin: 01273 685447

BRISTOL
Arnolfini, 16 Narrow Quay
Bristol BS1 4QA
e-mail: arnolfini@arnolfini.org.uk
Deputy Director: Polly Cole
Director: Tom Trevor
Fax: 0117-917 2303 Tel: 0117-917 2300

BUILTH WELLS
Wyeside Arts Centre
Castle Street
Builth Wells, Powys LD2 3BN
Fax: 01982 553995 Tel: 01982 553668

BURY
The Met Arts Centre
Market Street, Bury, Lancs BL9 0BW
e-mail: post@themet.biz
Director: David Agnew
Fax: 0161-763 5056
BO: 0161-761 2216 Admin: 0161-761 7107

CANNOCK
Prince of Wales Centre
Church Sreet
Cannock, Staffs WS11 1DE
e-mail: princeofwales@cannockchasedc.gov.uk
General Manager: Richard Kay
Fax: 01543 574439
BO: 01543 578672 Tel: 01543 466453

CARDIFF
Chapter Arts Centre
Market Road, Canton
Cardiff CF5 1QE
Theatre Programmer: James Tyson
BO: 029-2030 4400 Admin: 029-2031 1050

CHESTERFIELD
The Arts Centre
Chesterfield College, Sheffield Road
Chesterfield, Derbyshire S41 7LL
Co-ordinator: Joe Littlewood Tel: 01246 500578

CHIPPING NORTON
The Theatre, 2 Spring Street
Chipping Norton
Oxon OX7 5NL
Website: www.chippingnortontheatre.com
e-mail: admin@chippingnortontheatre.com
Director: Caroline Sharman
General Manager: Chris Durham
Fax: 01608 642324
BO: 01608 642350 Admin: 01608 642349

CHRISTCHURCH
The Regent Centre
51 High Street, Christchurch, Dorset BH23 1AS
Website: www.regentcentre.co.uk
e-mail: info@regentcentre.co.uk
General Manager: Keith Lancing
Fax: 01202 479952
BO: 01202 499148 Admin: 01202 479819

CIRENCESTER
Brewery Arts
Brewery Court, Cirencester, Glos GL7 1JH
Website: www.breweryarts.org.uk
e-mail: admin@breweryarts.org.uk
Artistic Director: Dan Scrivener
Fax: 01285 644060 Admin 01285 657181

COLCHESTER
Colchester Arts Centre
Church Street, Colchester, Essex CO1 1NF
Website: www.colchesterartscentre.com
e-mail: info@colchesterartscentre.com
Director: Anthony Roberts Tel: 01206 500900

COVENTRY
Warwick Arts Centre
University of Warwick, Coventry CV4 7AL
Website: www.warwickartscentre.co.uk
e-mail: arts.centre@warwick.ac.uk
Director: Alan Rivett
BO: 024-7652 4524 Admin: 024-7652 3734

CUMBERNAULD
Cumbernauld Theatre
Kildrum, Cumbernauld G67 2BN
General Manager: Debra Jaffray
Fax: 01236 738408
BO: 01236 732887 Admin: 01236 737235

DARLINGTON
Darlington Arts Centre
Vane Terrace, Darlington
County Durham DL3 7AX BO: 01325 486555

DORSET
The Coade Hall Theatre
Blandford Forum, Dorset DT11 0PX
e-mail: clt@bryanston.co.uk
Administrator: Claire Topping
Artistic Director: Jane Quan
Fax: 01258 484506 Tel: 01258 456533

EDINBURGH
Netherbow: Scottish Storytelling Centre
The Netherbow
43-45 High Street, Edinburgh EH1 1SR
Website: www.scottishstorytellingcentre.co.uk
e-mail: scottishstorytellingcentre@uk.uumail.com
Director: Dr Donald Smith Tel: 0131-556 9579

EDINBURGH
Theatre Workshop, 34 Hamilton Place
Edinburgh EH3 5AX
Website: www.theatre-workshop.com
Director: Robert Rae
Fax: 0131-220 0112 Tel: 0131-225 7942

EPSOM
Playhouse, Ashley Avenue, Epsom, Surrey KT18 5AL
Website: www.epsomplayhouse.co.uk
e-mail: tmitchell@epsom-ewell.gov.uk
Venues Manager: Trevor Mitchell
Fax: 01372 726228
BO: 01372 742555 Admin: 01372 742226

EXETER
Exeter Phoenix
Bradninch Place, Gandy Street, Exeter, Devon EX4 3LS
Website: www.exeterphoenix.org.uk
e-mail: admin@exeterphoenix.org.uk
Director: Patrick Cunningham
Fax: 01392 667599
BO: 01392 667080 Admin: 01392 667060

FAREHAM
Ashcroft Arts Centre
Osborn Road, Fareham, Hants PO16 7DX
Website: www.ashcroft.org.uk
e-mail: admin@ashcroft.org.uk
Director/Programmer: Annabel Cook
Fax: 01329 825661
BO: 01329 310600 Tel: 01329 235161

FROME
Merlin Theatre, Bath Road, Frome
Somerset BA11 2HG
Website: www.merlintheatre.co.uk
BO: 01373 465949 Admin: 01373 461360

GAINSBOROUGH
Trinity Arts Centre
Trinity Street, Gainsborough
Lincolnshire DN21 2AL
Fax: 01427 811198 BO/Admin: 01427 676655

GREAT TORRINGTON
The Plough Arts Centre
9-11 Fore Street, Great Torrington, Devon EX38 8HQ
Website: www.plough-arts.org
BO: 01805 624624 Admin: 01805 622552

HARLECH
Theatr Ardudwy, Harlech, Gwynedd LL46 2PU
Theatre Director: Rhian Jones BO: 01766 780667

HAVANT
Havant Arts Centre
East Street, Havant, Hants PO9 1BS
Website: www.havantartscentre.co.uk
e-mail: info@havantartsactive.co.uk
Director: Amanda O'Reilly
Fax: 023-9249 8577
BO: 023-9247 2700 Admin: 023-9248 0113

HELMSLEY
Helmsley Arts Centre
Meeting House Court, Helmsley, York YO62 5DW
Website: www.helmsleyarts.co.uk
e-mail: davidgoodwinhac@yahoo.co.uk
Development Manager: David Goodwin
BO: 01439 771700 Tel: 01439 772112

HEMEL HEMPSTEAD
Old Town Hall Arts Centre
High Street, Hemel Hempstead, Herts HP1 3AE
Website: www.oldtownhall.co.uk
e-mail: othadmin@dacorum.gov.uk
Art & Entertainment Manager: Sara Railson
BO: 01442 228091 Admin: 01442 228095

HEXHAM
Queens Hall Arts
Beaumont Street, Hexham
Northumberland NE46 3LS
Website: www.queenshall.co.uk
e-mail: boxoffice@queenshall.co.uk
Artistic Director: Geof Keys
Fax: 01434 652478 Tel: 01434 652476

HORSHAM
The Capitol, North Street
Horsham, West Sussex RH12 1RG
Website: www.thecapitolhorsham.com
General Manager: Michael Gattrell
Fax: 01403 756092 Tel: 01403 750220

HUDDERSFIELD
Kirklees (various venues)
Kirklees Cultural Services
Red Doles Lane, Huddersfield HD2 1YF
BO: 01484 223200 Admin: 01484 226300

INVERNESS
Eden Court Theatre, Bishop's Road, Inverness IV3 5SA
e-mail: admin@eden-court.co.uk
Director: Colin Marr
BO: 01463 234234 Admin: 01463 239841

JERSEY
Jersey Arts Centre
Phillips Street, St Helier, Jersey JE2 4SW
Website: www.artscentre.je
Director: Daniel Austin
Deputy Directors: Steven Edwards, Graeme Humphries
Fax: 01534 726788
BO: 01534 700444 Admin: 01534 700400

KENDAL
Brewery Arts Centre
Highgate, Kendal, Cumbria LA9 4HE
Website: www.breweryarts.co.uk
e-mail: admin@breweryarts.co.uk
Chief Executive: Sam Mason
BO: 01539 725133 Admin: 01539 722833

KING'S LYNN
King's Lynn Arts Centre
27 King's Street, King's Lynn, Norfolk PE30 1HA
Website: www.kingslynnarts.co.uk
Fax: 01553 762141
BO: 01553 764864 Tel: 01553 765565

LEICESTER
Phoenix Arts Centre
21 Upper Brown Street, Leicester LE1 5TE
e-mail: erika@phoenix.org.uk
BO: 0116-255 4854 Admin: 0116-224 7700

LICHFIELD
Lichfield District Arts Association
Donegal House, Bore Street, Lichfield WS13 6LU
Website: www.lichfieldarts.org.uk
e-mail: info@lichfieldarts.org.uk
Director: Brian Pretty
Fax: 01543 308211 Tel: 01543 262223

LISKEARD
Sterts Theatre & Arts Centre, Upton Cross
Liskeard, Cornwall PL14 5AZ
Tel/Fax: 01579 362382 Tel/Fax: 01579 362962

LONDON
Artsdepot
5 Nether Street, Tally Ho Corner
North Finchley, London N12 0GA
Website: www.artsdepot.co.uk
e-mail: info@artsdepot.co.uk BO: 020-8369 545

LONDON
BAC
Lavender Hill, Battersea, London SW11 5TN
Website: www.bac.org.uk
e-mail: mailbox@bac.org.uk
Fax: 020-7978 5207
BO: 020-7223 2223 Admin: 020-7223 6557

LONDON
Chats Palace
42-44 Brooksby's Walk
Hackney, London E9 6DF
Website: www.chatspalace.com
e-mail: info@chatspalace.com
Administrator: Nick Reed BO/Admin: 020-8533 0227

LONDON
Cockpit Theatre
Gateforth Street
London NW8 8EH
Website: www.cockpittheatre.org.uk
e-mail: dave.wybrow@cwc.ac.uk
Fax: 020-7258 2921
BO: 020-7258 2925 Admin: 020-7258 2920

LONDON
The Drill Hall
16 Chenies Street, London WC1E 7EX
Website: www.drillhall.co.uk
e-mail: admin@drillhall.co.uk
Fax: 020-7307 5062 Tel: 020-7307 5061

LONDON
Hoxton Hall Arts Centre
130 Hoxton Street, London N1 6SH
Website: www.hoxtonhall.co.uk
e-mail: info@hoxtonhall.co.uk
Venue Manager: Mark Hone
Fax: 020-7729 3815 Admin: 020-7684 0060

LONDON
Institute of Contemporary Arts
(No in-house productions or castings)
The Mall, London SW1Y 5AH
Website: www.ica.org.uk
e-mail: vivienneg@ica.org.uk
Performing Arts & International
Projects Director: Vivienne Gaskin
Fax: 020-7306 0122
BO: 020-7930 3647 Admin: 020-7930 0493

LONDON
Islington Arts Factory
2 Parkhurst Road, London N7 0SF
e-mail: iaf@islingtonartsfactory.fsnet.co.uk
Fax: 020-7700 7229 Tel: 020-7607 0561

LONDON
Jacksons Lane
269A Archway Road
London N6 5AA
Website: www.jacksonslane.org.uk
e-mail: mail@jacksonslane.org.uk
Fax: 020-8348 2424
BO: 020-8341 4421 Admin: 020-8340 5226

LONDON
Menier Chocolate Factory
53 Southwark Street
London SE1 1RU
Website: www.menierchocolatefactory.com
e-mail: office@menierchocolatefactory.com
Fax: 020-7378 1713 Admin: 020-7378 1712

LONDON
The Nettlefold
West Norwood Library Centre
1 Norwood High Street, London SE27 9JX
Centre Development Officers: Joanne Johnson,
Mark Sheehan
Fax: 020-7926 8071 Admin/BO: 020-7926 8070

LONDON
October Gallery
24 Old Gloucester Street, London WC1N 3AL
Website: www.octobergallery.co.uk
e-mail: rentals@octobergallery.co.uk
Contact: Rosalind King
Fax: 020-7405 1851 Tel: 020-7831 1618

LONDON
Oval House Theatre
52-54 Kennington Oval, London SE11 5SW
Website: www.ovalhouse.com
e-mail: info@ovalhouse.com
Programmer: Ben Evans
Director: Deborah Bestwick Tel: 020-7582 0080

LONDON
Polish Social & Cultural Association
238-246 King Street
London W6 0RF Tel: 020-8741 1940

LONDON
Riverside Studios, Crisp Road
Hammersmith, London W6 9RL
Website: www.riversidestudios.co.uk
e-mail: admin@riversidestudios.co.uk
Fax: 020-8237 1001
BO: 020-8237 1111 Tel: 020-8237 1000

LONDON
The Stables Gallery & Arts Centre
Gladstone Park, Dollis Hill Lane
London NW2 6HT Tel: 020-8452 8655

LOWESTOFT
Seagull Theatre & Performing Arts Centre
Morton Road, Lowestoft, Suffolk NR33 0JH
Advisory Drama Teacher: Sandra Redsell
Fax: 01502 515338 Tel: 01502 562863

MAIDENHEAD
Norden Farm Centre For The Arts
Altwood Road, Maidenhead SL6 4PF
Website: www.nordenfarm.org
e-mail: admin@nordenfarm.org
Director: Annabel Turpin
Fax: 01628 682525
BO: 01628 788997 Admin: 01628 682555

MAIDSTONE
Corn Exchange Complex/Hazlitt Theatre
Earl Street, Maidstone, Kent ME14 1PL
Commercial Manager: Mandy Hare
Fax: 01622 602194
BO: 01622 758611 Admin: 01622 753922

MANCHESTER
Green Room
54-56 Whitworth Street West
Manchester M1 5WW
Website: www.greenroomarts.org
e-mail: info@greenroomarts.org
Artistic Director: Garfield Allen
Fax: 0161-615 0516
BO: 0161-615 0500 Admin: 0161-615 0515

MANCHESTER
The Lowry
Pier 8, Salford Quays M50 3AZ
Website: www.thelowry.com
e-mail: info@thelowry.com
Theatre Production Bookings: Louise Ormerod
Fax: 0161-876 2021
BO: 0870 1112000 Admin: 0870 1112020

MILFORD HAVEN
Torch Theatre, St Peter's Road
Milford Haven, Pembrokeshire SA73 2BU
Website: www.torchtheatre.org
e-mail: info@torchtheatre.co.uk
Artistic Director: Peter Doran
Fax: 01646 698919
BO: 01646 695267 Admin: 01646 694192

NEWCASTLE UPON TYNE
The Round, 34 Lime Street, Ouseburn
Newcastle Upon Tyne NE1 2PQ
Website: www.the-round.com
Theatre Manager: Ben Fletcher-Watson
Tel: 0191-261 9230 Tel: 0191-260 5605

NEWPORT (Isle of Wight)
Quay Arts, Sea Street
Newport Harbour, Isle of Wight PO30 5BD
Website: www.quayarts.org
Fax: 01983 526606 Tel: 01983 822490

NORWICH
Norwich Arts Centre
St Benedicts Street, Norwich, Norfolk NR2 4PG
Website: www.norwichartscentre.co.uk
e-mail: stuarthobday@norwichartscentre.co.uk
BO: 01603 660352 Admin: 01603 660387

NUNEATON
Abbey Theatre & Arts Centre
Pool Bank Street, Nuneaton, Warks CV11 5DB
Website: www.abbeytheatre.co.uk
e-mail: admin@abbeytheatre.co.uk
Chairman: Tony Deeming
Tel: 024-7632 7359 BO: 024-7635 4090

PLYMOUTH
Plymouth Arts Centre
38 Looe Street, Plymouth, Devon PL4 0EB
Website: www.plymouthac.org.uk
e-mail: arts@plymouthac.org.uk
Director: Ian Hutchinson
Fax: 01752 206118 Tel: 01752 206114

POOLE
Lighthouse Poole Centre for The Arts
Kingland Road, Poole, Dorset BH15 1UG
Website: www.lighthousepoole.co.uk
 BO/Admin: 08700 668701

RADLETT
The Radlett Centre
1 Aldenham Avenue
Radlett, Herts WD7 8HL
Website: www.radlettcentre.co.uk
Fax: 01923 857592 Tel: 01923 857546

ROTHERHAM
Rotherham Theatres
Walker Place, Rotherham
South Yorkshire S65 1JH
Website: www.rotherham.gov.uk
Strategic Leader Culture/Leisure/Lifelong
Learning: Phil Rodgers
BO: 01709 823621 Admin: 01709 823641

SALISBURY
Salisbury Arts Centre
Bedwin Street, Salisbury, Wiltshire SP1 3UT
e-mail: info@salisburyarts.co.uk
Fax: 01722 343030 BO: 01722 321744

SHREWSBURY
Shrewsbury & District Arts Association
The Gateway, Chester Street
Shrewsbury, Shropshire SY1 1NB
e-mail: gateway.centre@shropshire-cc.gov.uk
Tel: 01743 355159

SOUTHPORT
Southport Arts Centre
Lord Street, Southport
Merseyside PR8 1DB
Website: www.seftonarts.co.uk
e-mail: artsops@seftonarts.co.uk
BO: 01704 540011 Admin: 01704 540004

STAMFORD
Stamford Arts Centre
27 St Mary's Street
Stamford, Lincolnshire PE9 2DL
Website: www.stamfordartscentre.co.uk
General Manager: David Popple
Fax: 01780 766690
BO: 01780 763203 Admin: 01780 480846

STIRLING
MacRobert
University of Stirling, Stirling FK9 4LA
Website: www.macrobert.org
Director: Liz Moran
BO: 01786 466666 Admin: 01786 467155

SWANSEA
Taliesin Arts Centre
University of Wales Swansea
Singleton Park, Swansea SA2 8PZ
Website: www.taliesinartscentre.co.uk
e-mail: s.e.crouch@swansea.ac.uk
Head of Cultural Services: Sybil Crouch Tel: 01792 295238

SWINDON
Wyvern Theatre, Theatre Square
Swindon, Wiltshire SN1 1QN
BO: 01793 524481 Admin: 01793 535534

TAUNTON
Brewhouse Theatre & Arts Centre
Coal Orchard
Taunton, Somerset TA1 1JL
Website: www.thebrewhouse.net
e-mail: info@thebrewhouse.net
Director: Robert Miles
BO: 01823 283244 Admin: 01823 274608

TOTNES
Dartington Arts
The Barn, Dartington Hall
Totnes, Devon TQ9 6DE
e-mail: info@dartingtonarts.org.uk
BO: 01803 847070 Admin: 01803 847074

TUNBRIDGE WELLS
Trinity Theatre, Church Road
Tunbridge Wells, Kent TN1 1JP
Director: Adrian Berry
BO: 01892 678678 Admin: 01892 678670

ULEY
Prema
South Street, Uley, Nr Dursley, Glos GL11 5SS
Website: www.prema.demon.co.uk
e-mail: info@prema.demon.co.uk
Director: Gordon Scott Tel: 01453 860703

VALE OF GLAMORGAN
St Donats Arts Centre
St Donats Castle
The Vale of Glamorgan CF61 1WF
e-mail: janetsmith@stdonats.com
General Manager: Janet Smith
Fax: 01446 799101
BO: 01446 799100 Tel: 01446 799099

WAKEFIELD
Wakefield Arts Centre
Wakefield College
Thornes Park Centre
Thornes Park, Horbury Road, Wakefield WF2 8QZ
e-mail: c-clark@wakcoll.ac.uk
Facilities Officer: Carole Clark Tel: 01924 789824

WALLSEND
Buddle Arts Centre
258B Station Road
Wallsend
Tyne & Wear NE28 8RG
Contact: Geoffrey A Perkins
Fax: 0191-200 7142 Tel: 0191-200 7132

WASHINGTON
The Arts Centre Washington
Biddick Lane, Fatfield, Washington
Tyne & Wear NE38 8AB
Fax: 0191-219 3458 Tel: 0191-219 3455

WELLINGBOROUGH
The Castle
Castle Way, Wellingborough
Northants NN8 1XA
Website: www.thecastle.org.uk
e-mail: info@thecastle.org.uk
Executive Director: Gail Arnott
Artistic Director: Bart Lee
Fax: 01933 229888 Tel: 01933 229022

WIMBORNE
Layard Theatre
Canford School, Canford Magna
Wimborne, Dorset BH21 3AD
e-mail: layardtheatre@canford.com
Director of Drama: Stephen Hattersley
Administrator: Christine Haynes
BO/Fax: 01202 847525 Admin: 01202 847529

WINCHESTER
Tower Arts Centre
Romsey Road, Winchester
Hampshire SO22 5PW
Website: www.towerarts.co.uk
Director: John Tellett Tel: 01962 867986

WINDSOR
Windsor Arts Centre
St Leonard's Road, Windsor, Berks SL4 3BL
Website: www.windsorartscentre.org
e-mail: admin@windsorartscentre.org
General Manager: Graham Steel
Fax: 01753 621527
BO: 01753 859336 Admin: 01753 859421

WREXHAM
Wrexham Arts Centre
Rhosddu Road, Wrexham LL11 1AU
e-mail: arts.centre@wrexham.gov.uk
Fax: 01978 292611 Tel: 01978 292093

ARTS COUNCIL ENGLAND, EAST
(Norfolk, Suffolk, Bedfordshire, Cambridgeshire, Essex,
Hertfordshire and the unitary authorities of Luton,
Peterborough, Southend-on-Sea and Thurrock)

Eden House, 48-49 Bateman Street
Cambridge CB2 1LR
Website: www.artscouncil.org.uk
Fax: 0870 2421271 Tel: 0845 3006200

ARTS COUNCIL ENGLAND, EAST MIDLANDS
(Derbyshire, Leicestershire, Lincolnshire excluding North
and North East Lincolnshire, Northamptonshire,
Nottinghamshire and the unitary authorities of Derby,
Leicester, Nottingham and Rutland)

St Nicholas Court, 25-27 Castle Gate
Nottingham NG1 7AR
Website: www.artscouncil.org.uk
Fax: 0115-950 2467 Tel: 0845 3006200

ARTS COUNCIL ENGLAND, LONDON
(Greater London)

2 Pear Tree Court
London EC1R 0DS
Website: www.artscouncil.org.uk
Fax: 020-7608 4100 Tel: 0845 3006200

ARTS COUNCIL ENGLAND, NORTH EAST
(Durham, Northumberland, Metropolitan authorities of
Gateshead, Newcastle upon Tyne, North Tyneside, South
Tyneside, Sunderland and the unitary authorities of
Darlington, Hartlepool, Middlesborough, Red Car and
Cleveland, Stock-on-Tees)

Central Square, Forth Street
Newcastle upon Tyne NE1 3PJ
Website: www.artscouncil.org.uk
Fax: 0191-230 1020 Tel: 0845 3006200

ARTS COUNCIL ENGLAND, NORTH WEST
(Lancashire, Cheshire, Cumbria and the metropolitan
authorities of Bolton, Bury, Knowsley, Liverpool,
Manchester, Oldham, Rochdale, St Helens, Salford, Sefton,
Stockport, Tameside, Trafford, Wigan, Wirrall and the
unitary authories of Blackburn with Darwen, Blackpool,
Halton and Warrington)

Manchester House, 22 Bridge Street
Manchester M3 3AB
Website: www.artscouncil.org.uk
Fax: 0161-834 6969 Tel: 0845 3006200

ARTS COUNCIL ENGLAND, SOUTH EAST
(Buckinghamshire, East Sussex, Hampshire, Isle of Wight,
Kent, Oxfordshire, Surrey, West Sussex and the unitary
authorities of Bracknell Forest. Brighton & Hove, Medway
Towns, Milton Keynes, Portsmouth)

Sovereign House, Church Street
Brighton BN1 1RA
Website: www.artscouncil.org.uk
Fax: 0870 2421257 Tel: 0845 3006200

ARTS COUNCIL ENGLAND, SOUTH WEST
(Cornwall, Devon, Dorset, Gloucestershire, Somerset and
Wiltshire and the unitary authorities of Bristol, Bath,
Bournemouth, Plymouth, Poole, Torbay and Swindon)

Senate Court, Southernhay Gardens
Exeter, Devon EX1 1UG
Website: www.artscouncil.org.uk
Fax: 01392 229229 Tel: 0845 3006200

ARTS COUNCIL ENGLAND, WEST MIDLANDS
(Herefordshire, Worcestershire, Staffordshire,
Warwickshire and Shropshire, Stoke-on-Trent, Telford and
Wrekin and districts of Birmingham, Coventry, Dudley,
Sandwell, Solihull, Walsall & Wolverhampton)

82 Granville Street
Birmingham B1 2LH
Website: www.artscouncil.org.uk
Fax: 0121-643 7239 Tel: 0845 3006200

ARTS COUNCIL ENGLAND, YORKSHIRE
(North Yorkshire, metropolitan authorities of Barnsley,
Bradford, Calderdale, Doncaster, Kirklees, Leeds,
Rotherham, Sheffield, Wakefield and the unitary authorities
of East Riding of Yorkshire, Kingston upon Hull, North
Lincolnshire, North East Lincolnshire, York)

21 Bond Street, Dewsbury
West Yorkshire WF13 1AX
Website: www.artscouncil.org.uk
Fax: 01924 466522 Tel: 0845 3006200

ARTS COUNCIL OF WALES, MID & WEST WALES OFFICE
(Ceredigion, Carmarthenshire, Pembrokeshire, Powys,
Swansea, Neath, Port Talbot)

6 Gardd Llydaw, Lon Jackson
Caerfyrddin SA31 1QD
Website: www.artswales.org
Fax: 01267 233084 Tel: 01267 234248

ARTS COUNCIL OF WALES, NORTH WALES OFFICE
(Isle of Anglesey, Gwynedd, Conwy, Denbighshire,
Flintshire, Wrexham)

36 Prince's Drive, Colwyn Bay
Conwy LL29 8LA
Website: www.artswales.org
Fax: 01492 533677 Tel: 01492 533440

ARTS COUNCIL OF WALES, SOUTH WALES OFFICE
(Vale of Glamorgan, Cardiff, Newport, Monmouthshire,
Torfaen, Blaenau Gwent, Caerphilly
Merthyr Tydfil, Rhonda Cynon Taff, Bridgend)

9 Museum Place
Cardiff CF10 3NX
Website: www.artswales.org
Fax: 029-2022 1447 Tel: 029-2037 6525

Casting Directors

For information regarding membership of
the Casting Directors' Guild (CDG) please contact

PO Box 34403
London W6 0YG
Tel/Fax: 020-8741 1951
Website: www.thecdg.co.uk

Concert & Exhibition Halls
Concert Promoters & Agents
Consultants
Costumes, Wigs & Make-up
Critics

[CONTACTS 2007]

A C A CASTING
(Catherine Arton)
32A Edenvale Street, London SW6 2SF
e-mail: casting@acacasting.com Tel/Fax: 020-7384 2635

ADAMSON CASTING
(Jo Adamson CDG)
4 Hillthorpe Square, Leeds LS28 8NQ
e-mail: watts07@hotmail.com Mobile: 07787 311270

AILION Pippa
3 Towton Road, London SE27 9EE
Tel/Fax: 020-8670 4816 Tel: 020-8761 7095

ALL DIRECTIONS OF LONDON
7 Rupert Court
Off Wardour Street
London W1D 6EB Tel: 020-7437 5879

ANDERSON Jane
e-mail: andersoncasting@yahoo.co.uk

ANDREW Dorothy CASTING
Campus Manor
Childwall Abbey Road
Childwall, Liverpool L16 0JP
Fax: 0151-722 9079 Tel: 0151-737 4044

ARNELL Jane
Flat 2, 39 St Peter's Square, London W6 9NN

ASHTON HINKINSON CASTING
1 Charlotte Street, London W1T 1RD
e-mail: casting@ashtonhinkinson.com
Fax: 020-7636 1657 Tel: 020-7580 6101

BAIG Shaheen CASTING
343B Archway Road, London N6 5AA
e-mail: shaheen.baig@btconnect.com

BALDIES CASTING AGENCY
(The only agency purely for bald people)
6 Marlott Road, Poole, Dorset BH15 3DX
Mobile: 07860 290437 Tel: 01202 666001

BARNES Derek CDG
BBC DRAMA SERIES CASTING
BBC Elstree
Room N221, Neptune House
Clarendon Road, Borehamwood WD6 1JF
Fax: 020-8228 8311 Tel: 020-8228 7096

BARTLETT Carolyn CDG
22 Barton Road, London W14 9HD

BATH Andrea
85 Brightwell Road, Watford WD18 0HR
e-mail: andreabath@btinternet.com Tel: 01923 333067

BEARDSALL Sarah CDG
73 Wells Street, London W1T 3QG
e-mail: casting@beardsall.com
Fax: 020-7436 8859 Tel: 020-7323 4040

BEATTIE Victoria
6 (2) Pilrig Cottages
Edinburgh EH6 5DF Tel: 0131-553 0559

BERTRAND Leila CASTING
53 Hormead Road, London W9 3NQ
e-mail: leilabcasting@aol.com Tel/Fax: 020-8964 0683

BEVAN Lucy
c/o Twickenham Studios, St Margaret's
Twickenham TW1 2AW Tel: 020-8607 8888

BEWICK Maureen CASTING
104A Dartmouth Road, London NW2 4HB

Who are Casting Directors?

Casting directors are employed by directors / production companies to source the best available actors for roles across TV, film, radio, theatre and commercials. They do the ground-work and present a shortlist of artists to the director, who often makes the final selection. Many casting directors work on a freelance basis, others are employed permanently by larger organisations such as the BBC or the National Theatre. Discovering new and emerging talent also plays an important part in their job.

How should I use these listings?

If you are an actor looking for work, you can promote yourself directly to casting directors by sending them your photo and details. They may keep these on file and consider you for future productions. Research the names and companies listed in the following pages so that you can target your letters accordingly. It helps to keep an eye on TV / film / theatre credits so you are familiar with previous productions they have cast. If a casting director has 'CDG' after their name, it means they are a member of the Casting Directors' Guild (www.thecdg.co.uk), the professional organisation of casting directors working in the UK. Remember, casting professionals receive hundreds of letters every week, so try to keep them short, concise, professional and free of 'gimmicks'. Make sure your CV is up-to-date and all the information is accurate and spelt correctly. Never lie: the chances are you will be found out and it may damage your reputation. Your photo should be as recent as possible and an accurate likeness: you are wasting everyone's time if you turn up to an audition looking nothing like it. Remember to label it clearly with your name. Only send a showreel if you have checked with the casting director first. It helps to have a focus to your letter, such as inviting the casting director to see you in a current performance or showcase.

How do I prepare for a casting / audition?

Make sure you are fully prepared with accurate information about the audition time, venue, format and the people you will be meeting. Unless it's a last minute casting, you should always read the script in advance and try to have some opinions on it. If you are asked to prepare a piece, always stick to the brief with something suitable and relevant. On the day, allow plenty of time to get there so you are not flustered when you arrive. Try to be positive and enjoy yourself. Remember, the casting director doesn't want to spend several days auditioning - they want you to get the job! Never criticise previous productions you have worked on. And at the end of the casting, remember to take your script away unless you are asked to leave it, otherwise it can look as if you're not interested.

Should I attend a casting in a house or flat?

Professional auditions are rarely held anywhere other than an official casting studio or venue. Be very wary if you are asked to go elsewhere. Trust your instincts: if something doesn't seem right to you, it probably isn't. Always take someone with you if you are in any doubt.

How do I become a casting director?

The best way to gain experience in this field is to work as a casting assistant. Vacancies are sometimes advertised in The Stage. You may also find it useful to contact The Casting Directors' Guild (www.thecdg.co.uk)

SUSIE FIGGIS has been a Casting director for over twenty years. She started as an assistant to the great Miriam Brickman. Her first big break was GANDHI and since then she has worked on numerous feature films including CRY FREEDOM, THE KILLING FIELDS, THE CRYING GAME, THE FULL MONTY, HARRY POTTER, CHARLIE AND THE CHOCOLATE FACTORY.

She offers the following advice to actors about the casting process:

• **SHOWCASES:** If you are about to leave drama school, it is really worth making an effort to follow up your showcase performance, finding out which agents or casting directors attended and trying to get them to see you again when you are in another piece. If a graduate has the luck to have two or three agents interested in them it is imperative they ask someone in the know which agent would suit them best - I have seen actors doing well at drama school pick the wrong agent because 'they were nice / we got on', then finding their careers getting stuck.

• **AUDITIONS:** Remember that the casting director is on your side and wants you to do well. Different directors like different kinds of auditions: most of the directors I work with often prefer just to meet first and see if they perceive a quality in the actor that fits their vision of the role. Always do your homework before the audition: try to get hold of the script, and if you are going to be asked to read you should be able to see a whole script. Good agents usually get hold of one, and that gives their clients a head-start. If the project is based on a book: read it. Do not be scared to ask the director questions: they are there to help.

• **NETWORKING:** I am not a great believer in networking, and have never done it. I find it slightly humiliating and discomforting. I don't think it really works, and in this profession all too easily we can feel belittled - so why add to it? What I do think is, it shows when you feel good about yourself: so to this end, if you have other strings to your bow you should use them, so that you do not feel you are just sitting waiting for that phone to ring.

• **CONTACT:** Make contact with Casting Directors in order to be seen for projects. Again, do your homework, and only send your CV / photo if you really think there is a role you are suited for. It wastes your money and our time sending these in just because some breakdown service mentions, sometimes erroneously, that a casting director is working on something.

• **SHOWREELS:** Some people like them, others (like me) would rather see one thing that the actor is good in. Either way, tapes / DVDs are becoming more and more vital, so do try to get a piece of your work on tape as soon as you can, even if it is only five minutes. What I don't think works though, is putting yourself on tape doing an audition (unless a casting director has specifically asked for this). Remember this will be judged against tapes where actors have been properly directed.

It is tough out there, but remember, if you don't get a part it is often for arbitrary reasons, such as that another two actors fit together better, or you look too similar to someone already cast. I think if only actors could work in a casting director's office they would go away feeling so much better about why they have not got parts: but please don't apply, I already have a great assistant!

BEXFIELD Glenn
BBC DRAMA SERIES CASTING
BBC Elstree, Room N223 Neptune House
Clarendon Road, Borehamwood WD6 1JF
Fax: 020-8228 8311 Tel: 020-8228 7322

BIG FISH CASTING
(See HAMILTON & CRAWFORD)

BILL The
Thames Television Ltd
Talkbackthames Studios
1 Deer Park Road, Merton
London SW19 3TL Tel: 020-8540 0600

BIRD Sarah CDG
PO Box 32658, London W14 0XA
Fax: 020-7602 8601 Tel: 020-7371 3248

BIRKETT Hannah CASTING
26 Noko, 3/6 Banister Road
London W10 4AR
e-mail: hannah@hbcasting.com
Mobile: 07957 114175 Tel: 020-8960 2848

BRACKE Siobhan CDG
Basement Flat, 22A The Barons
St Margaret's TW1 2AP Tel: 020-8891 5686

BROAD CASTING COMPANY
(Lesley Beastall & Sophie North)
Unit 23 Canalot Studios
222 Kensal Road, London W10 5BN
e-mail: lesley@broad-casting.co.uk
e-mail: sophie@broad-casting.co.uk
Mobile: 07956 516603 (Lesley)
Mobile: 07956 516606 (Sophie) Tel: 020-8969 3020

BUCKINGHAM Jo
(Entertainment - Comedy)
BBC Television Centre
Wood Lane, London W12 7RJ
Fax: 020-8576 4414 Tel: 020-8225 7585

CAIRD Angela
PO Box MT 86, Leeds LS17 8YQ Tel: 0113-288 8014

CANDID CASTING
1st Floor, 32 Great Sutton Street
London EC1V 0NB
e-mail: mail@candidcasting.co.uk
Fax: 020-7490 8966 Tel: 020-7490 8882

CANNON DUDLEY & ASSOCIATES
43A Belsize Square, London NW3 4HN
e-mail: cdacasting@blueyonder.co.uk
Fax: 020-7813 2048 Tel: 020-7433 3393

CANNON John CDG
BBC DRAMA SERIES CASTING
BBC Elstree, Room N222, Neptune House
Clarendon Road, Borehamwood, Herts WD6 1JF
Fax: 020-8228 8311 Tel: 020-8228 7130

CARLING Di CASTING CDG
1st Floor, 49 Frith Street, London W1D 4SG
Fax: 020-7287 6844 Tel: 020-7287 6446

CARROLL Anji CDG
4 Nesfield Drive
Winterley, Cheshire CW11 4NT
e-mail: anjicarrollcdg@yahoo.co.uk Tel: 01270 250240

CASTING ANGELS The
(London & Paris)
Suite 4, 14 College Road, Bromley
Kent BR1 3NS Tel/Fax: 020-8313 0443

CASTING COMPANY (UK) The
(Michelle Guish CDG, Grace Browning)
3rd Floor, 112-114 Wardour Street
London W1F 0TS
Fax: 020-7434 2346 Tel: 020-7734 4954

CASTING CONNECTION The
(Michael Syers)
Dalrossie House, 16 Victoria Grove
Stockport, Cheshire SK4 5BU
Fax: 0161-442 7280 Tel: 0161-432 4122

CASTING COUCH PRODUCTIONS Ltd
(Moira Townsend)
e-mail: moiratownsend@yahoo.co.uk Mobile: 07932 785807

ray fearon

jennifer james

john pearson

david james photography

07808 597362
www.davidjamesphotos.com

CASTING UK
(Andrew Mann)
10 Coptic Street, London WC1A 1NH
Website: www.castinguk.com
e-mail: info@castinguk.com Tel: 020-7580 3456

CASTING UNLIMITED (LONDON)
137 Freston Road, London W10 6TH
e-mail: info@castingdirector.co.uk
Fax: 020-7243 1987 Tel: 020-7229 8413

CASTING UNLIMITED (LOS ANGELES)
e-mail: info@castingdirector.co.uk

CATLIFF Suzy CDG
PO Box 39492, London N10 3YX
e-mail: soose@soose.co.uk Tel: 020-8442 0749

CELEBRITY MANAGEMENT Ltd
13 Montagu Mews South
London W1H 7ER
Website: www.celebrity.co.uk
e-mail: info@celebrity.co.uk Tel: 0871 250 1234

CELEX CASTING Ltd
11 Glencroft Drive
Stenson Fields, Derby DE24 3LS
Website: www.celex.co.uk
e-mail: enquiries@celex.co.uk
Fax: 01332 232115 Tel: 01332 232445

CHAND Urvashi CDG
115A Kilburn Lane
London W10 4AN
e-mail: urvashi@cinecraft.biz Tel/Fax: 020-8968 7016

CHARD Alison CDG
23 Groveside Court
4 Lombard Road
Battersea, London SW11 3RQ
e-mail: alisonchard@castingdirector.freeserve.co.uk
 Tel/Fax: 020-7223 9125

CHARKHAM CASTING
(Beth Charkham & Gary Ford)
Suite 361
14 Tottenham Court Road
London W1T 1JY
e-mail: charkhamcasting@btconnect.com
 Mobile: 07956 456630

CLARK Andrea
(See ZIMMERMANN Jeremy CASTING)

CLAYTON Rosalie
e-mail: rosalie@rosalieclayton.com Tel/Fax: 020-7242 8109

COGAN Ben
BBC DRAMA SERIES CASTING
BBC Elstree, Room N221
Neptune House, Clarendon Road
Borehamwood WD6 1JF
Fax: 020-8228 8311 Tel: 020-8228 7516

COHEN Abi CASTING
e-mail: cohencasting@tinyonline.co.uk Tel: 020-7687 9002

COHEN Yona
9 Seymour Road
Hampton Wick KT1 4HN Mobile: 07841 402951

COLLINS Jayne CASTING
38 Commercial Street, London E1 6LP
Website: www.jaynecollinscasting.com
e-mail: info@jaynecollinscasting.com
Fax: 020-7422 0015 Tel: 020-7422 0014

Laura Main Tom Burke Anna Calder-Marshall

Charlie Carter
P H O T O G R A P H E R

0 2 0 8 2 2 2 8 7 4 2

COLLINS Katrina
BBC DRAMA SERIES CASTING
BBC Elstree, Room N418
Neptune House, Clarendon Road
Borehamwood, Herts WD6 1JF
Fax: 020-8228 8311 Tel: 020-8228 8621

COMMERCIALS CASTING UK Ltd
(Michelle Smith)
220 Church Lane
Woodford, Stockport SK7 1PQ
Fax: 0161-439 0622 Tel: 0161-439 6825

CORDORAY Lin
66 Cardross Street
London W6 0DR

COTTON Irene CDG
25 Druce Road
Dulwich Village
London SE21 7DW
e-mail: irenecotton@btinternet.com
Tel/Fax: 020-8299 2787 Tel: 020-8299 1595

CRAMPSIE Julia
(Casting Executive)
BBC DRAMA SERIES CASTING
BBC Elstree, Room N224
Neptune House, Clarendon Road
Borehamwood WD6 1JF
Fax: 020-8228 8311 Tel: 020-8228 7170
 Mobile: 07976 869442
CRANE Carole CASTING

CRAWFORD Kahleen
(See HAMILTON & CRAWFORD)

CROCODILE CASTING COMPANY The
(Claire Toeman & Tracie Saban)
9 Ashley Close, Hendon, London NW4 1PH
Website: www.crocodilecasting.com
e-mail: croccast@aol.com
Fax: 020-8203 7711 Tel: 020-8203 7009

CROWE Sarah CASTING
75 Amberley Road
London W9 2JL
e-mail: sarah@sarahcrowecasting.co.uk
Fax: 020-7286 5030 Tel: 020-7286 5080

CROWLEY POOLE CASTING
11 Goodwins Court, London WC2N 4LL
Fax: 020-7379 5971 Tel: 020-7379 5965

CROWLEY Suzanne CDG
(See CROWLEY POOLE CASTING)
DAVIES Jane CASTING Ltd
(Jane Davies CDG & John Connor CDG)
PO Box 680, Sutton, Surrey SM1 3ZG
e-mail: info@janedaviescasting.co.uk
Fax: 020-8644 9746 Tel: 020-8715 1036
DAVIS Leo (Miss)
(JUST CASTING)
20th Century Theatre
291 Westbourne Grove, London W11 2QA
Fax: 020-7792 2143 Tel: 020-7229 3471
DAVY Gary CDG
1st Floor, 55-59 Shaftesbury Avenue
London W1D 6LD
Fax: 020-7437 0881 Tel: 020-7437 0880

DAWES Gabrielle CDG
PO Box 52493
London NW3 9DZ
e-mail: gdawescasting@tiscali.co.uk Tel: 020-7435 3645
DAY Kate CDG
Pound Cottage
27 The Green South
Warborough, Oxon OX10 7DR Tel/Fax: 01865 858709
DE FREITAS Paul CDG
PO Box 4903
London W1A 7JZ
DENMAN Jack CASTING
Burgess House
Main Street
Farnsfield
Notts NG22 8EF Tel/Fax: 01623 882272

the
Casting Directors' Guild of Great Britain

1995~2007

The professional organisation for Casting Directors of film, television, theatre and commercials in the UK.

Setting the benchmark of professionalism in the industry since 1995.

Visit our site to find over 100 affiliated
Casting Directors www.thecdg.co.uk

Email: info@cdguild.fsnet.co.uk Tel/Fax: 020 8741 1951
PO Box 34403 London W6 0YG

DENNISON Lee ASSOCIATES
(London & New York)
Fushion (London Office)
27 Old Gloucester Street, London WC1N 3XX
Website: www.ukscreen.com/crew/ldennison
e-mail: leedennison@fushion-uk.com
Fax: 08700 111020 Tel: 08700 111100

DICKENS Laura CDG
197 Malpas Road, London SE4 1BH
e-mail: dickenscasting@aol.com Mobile: 07958 665468

DOWD Kate
74 Wells Street, London W1T 3QG
Fax: 020-7580 6688 Tel: 020-7580 8866

DRURY Malcolm CDG
34 Tabor Road, London W6 0BW Tel: 020-8748 9232

DUDLEY Carol CDG
(See CANNON DUDLEY & ASSOCIATES)

DUFF Julia CDG
73 Wells Street, London W1T 3QG
Fax: 020-7436 8859 Tel: 020-7436 8860

DUFF Maureen CDG
PO Box 47340, London NW3 4TY
e-mail: belgrove@dircon.co.uk
Fax: 020-7681 7172 Tel: 020-7586 0532

DUFFY Jennifer CDG
11 Portsea Mews
London W2 2BN Tel: 020-7262 3326

EAST Irene CASTING CDG
40 Brookwood Avenue
Barnes, London SW13 0LR
e-mail: irneast@aol.com Tel: 020-8876 5686

EJ CASTING
Lower Ground Floor
86 Vassall Road, London SW9 6JA
e-mail: info@ejcasting.com
Mobile: 07891 632946 Tel: 020-7564 2688

EMMERSON Chloe
96 Portobello Road
London W11 2QG
e-mail: c@ChloeEmmerson.com Tel: 020-7792 8823

ET-NIK-A PRIME MANAGEMENT & CASTINGS Ltd
30 Great Portland Street
London W1W 8QU
Website: www.et-nik-a.com
e-mail: castings@et-nik-a.com
Fax: 020-7299 3558 Tel: 020-7299 3555

EVANS Richard CDG
10 Shirley Road, London W4 1DD
Website: www.evanscasting.co.uk
e-mail: contact@evanscasting.co.uk Tel: 020-8994 6304

EYE The
Website: www.theeyecasting.com
e-mail: jody@theeyecasting.com Tel: 020-7735 2094

FEARNLEY Ali
26 Goodge Street, London W1T 2QG
e-mail: cast@alifearnley.com
Fax: 020-7636 8080 Tel: 020-7636 4040

FIGGIS Susie
19 Spencer Rise, London NW5 1AR Tel: 020-7482 2200

FILDES Bunny CASTING CDG
56 Wigmore Street, London W1 Tel: 020-7935 1254

FINCHER Sally CDG
e-mail: sally.fincher@btinternet.com Tel: 020-8347 5945

Yvonne Kaziro

Steve McFadden

Heather Peace

Claire Grogan
P h o t o g r a p h y
020 7272 1845
mobile 07932 635381
www.clairegrogan.co.uk
student rates

Jack Shepherd

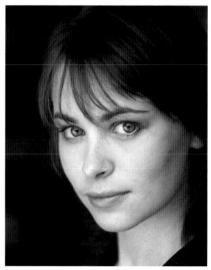

Sarah McNeale

Rupert James Photography

07775941753

rupertjamesphotography.com

FOX Celestia
5 Clapham Common Northside
London SW4 0QW
e-mail: celestia.fox@virgin.net

FRAZER Janie CDG
ITV/Granada
London TV Centre
South Bank, London SE1 9LT
e-mail: janie.frazer@granadamedia.com1 Tel: 020-7261 3848

FRECK Rachel CDG
e-mail: casting@rachelfreck.com Tel/Fax: 020-8673 2455

FRISBY Jane CASTING CDG
51 Ridge Road
London N8 9LJ
e-mail: jane.frisby@tiscali.co.uk
Fax: 020-8348 9122 Tel: 020-8341 4747

FUNNELL Caroline CDG
25 Rattray Road
London SW2 1AZ Tel: 020-7326 4417

GALLIE Joyce
37 Westcroft Square
London W6 0TA Tel: 020-8741 4009

GANE CASTING
(Natasha Gane)
52 Woodhouse Road
London N12 0RJ
e-mail: natasha@ganecasting.com
Fax: 020-8446 2508 Tel: 020-8446 2551

GB CASTING UK Ltd (Karin Grainger)
e-mail: kggbuk@lineone.net Mobile: 07901 553075

p148

GIELGUD Suzanne
(Dancers for Film)
5th Floor, Victoria House
125 Queens Road, Brighton BN1 3WB
e-mail: suzanne.gielgud@gmail.com
Fax: 01273 777753 Tel: 01273 777738

GILLHAM Tracey CDG
(Entertainment - Comedy)
BBC Television Centre
Wood Lane, London W12 7RJ
Fax: 020-8576 4414 Tel: 020-8225 8488

GILLON WOODWARD CASTING
(Tamara Gillon & Tara Woodward CDG)
6 Bythorn Street, London SW9 8AQ
e-mail: gillonwoodward@yahoo.co.uk
Fax: 020-7272 6013 Tel: 020-7274 6557

GOLD Nina CDG
117 Chevening Road
London NW6 6DU
e-mail: info@ninagold.co.uk
Fax: 020-8968 6777 Tel: 020-8960 6099

GOLDWYN Lauren CASTING INC
14 Dean Street
London W1D 3RS
e-mail: entertainment@rentingeyeballs.com
 Tel: 020-7437 4188

GOOCH Miranda CASTING
102 Leighton Gardens
London NW10 3PR
e-mail: mirandagooch@gmail.com
Fax: 020-8962 9579 Tel: 020-8962 9578

GREEN Jill CASTING CDG
Cambridge Theatre, Earlham Street
Seven Dials, Covent Garden, London WC2H 9HU
Fax: 020-7379 4796 Tel: 020-7379 4795

GREENE Francesca CASTING
79 Ashworth Mansions, London W9 1LN
Fax: 020-7266 9001 Tel: 020-7286 5957

GRESHAM Marcia CDG
3 Langthorne Street
London SW6 6JT Tel: 020-7381 2876

GROSVENOR CASTING
(Angela Grosvenor CDG)
27 Rowena Crescent, London SW11 2PT
Fax: 020-7652 6256 Tel: 020-7738 0449

GUISH Michelle CDG
See CASTING COMPANY (UK) The

HALL David CASTING
9 Falconet Court
123 Wapping High Street, London E1W 3NX
e-mail: davidhall@casting.wanadoo.co.uk Tel: 020-7488 9916

HALL Janet
69 Buckstones Road
Shaw, Oldham OL2 8DW
e-mail: stage@hall257.fsbusiness.co.uk
Mobile: 07956 822773 Tel: 01706 291459

HALL Pippa
(Children & Teenagers only)
Rosebank, High Street
Blockley, Glos GL56 9EX
e-mail: pippa@pippahallcasting.com Tel/Fax: 01386 700227

HAMILTON & CRAWFORD
(Des Hamilton & Kahleen Crawford)
Film City Glasgow
4 Summertown Road, Glasgow G51 2LY
Website: www.hamiltonandcrawford.com
e-mail: info@hamiltonandcrawford.com Tel: 0141-425 1725

HAMILTON Des
(See HAMILTON & CRAWFORD)

HAMMOND Louis
30-31 Peter Street, London W1F 0AR
Fax: 020-7439 2522 Tel: 020-7734 0626

HANCOCK Gemma CDG
The Rosary, Broad Street
Cuckfield, West Sussex RH17 5DL
e-mail: gemma.hancock@virgin.net Tel: 01444 441398

HARE Jackie CASTING
e-mail: jackiehare@cast73.fsnet.co.uk Tel: 020-8847 3481

HARKIN Julie CDG
154 Vartry Road, London N15 6HA
e-mail: julieharkincasting@googlemail.com
 Tel: 020-8800 4226

HARRIS Lisa
290 Coulsdon Road, Old Coulsdon
Surrey CR5 1EB Mobile: 07956 561247

HAWSER Gillian CASTING
24 Cloncurry Street, London SW6 6DS
e-mail: gillianhawser@btinternet.com
Fax: 020-7731 0738 Tel: 020-7731 5988

HAYFIELD Judi Ltd CDG
6 Richmond Hill Road
Gatley, Cheadle, Stockport SK8 1QG
e-mail: judi.hayfield@hotmail.co.uk Mobile: 07919 221873

Brenda
Fricker

Ortis
Deley

Hannah
Waterman

PHOTOGRAPHY
01737 224578
Mobile: 07885 966192

• NEAR LONDON • STUDENT RATES •

HICKLING Matthew
Room 344, Design Building
BBC TVC, Wood Lane, London W12 7SB
Fax: 020-8576 8005 Tel: 020-8576 1698

HILL Serena
Sydney Theatre Company
Pier 4, Hickson Road
Walsh Bay, NSW 2000, Australia
e-mail: shill@sydneytheatre.com.au Tel: 00 612 925 01700

HILTON Carrie CASTING ASSOCIATES CDG
20 Cobbold Road, London W12 9LW
Fax: 020-8740 8426 Tel: 020-8749 9242

HOOTKINS Polly CDG
PO Box 52480, London NW3 9DH
e-mail: phootkins@clara.net Tel: 020-7692 1184

HORAN Julia CDG
26 Falkland Road
London NW5 2PX Tel: 020-7267 5261

HORSLEY Juliet
81 Abbey House
1A Abbey Road, London NW8 9BX
e-mail: juliettahorsley@aol.com
Mobile: 07977 506833 Tel: 020-7286 9462

HOWE Gary CASTING
34 Orbit Street, Roath
Cardiff CF24 0JX Tel/Fax: 029-2045 3883

HUBBARD CASTING
(Ros Hubbard, John Hubbard, Dan Hubbard CDG)
24 Poland Street, London W1F 8QL
e-mail: email@hubbardcasting.com
Fax: 020-7287 9200 Tel: 020-7494 3191

HUGHES Sarah
Stephen Joseph Theatre
Westborough, Scarborough
North Yorkshire YO11 1JW Tel: 01723 370540

HUGHES Sylvia
Casting Suite, The Deanwater
Wilmslow Road, Woodford, Cheshire SK7 1RJ
e-mail: sylviahughescastingdirector@hotmail.co.uk
Mobile: 07770 520007 Tel/Fax: 01565 653777

INTERNATIONAL COLLECTIVE CASTING
Golden Cross House
8 Duncannon Street
The Strand, London WC2N 4JF
Website: www.internationalcollective.co.uk
e-mail: enquiries@internationalcollective.co.uk
Fax: 020-7484 5100 Tel: 020-7484 5080

JACKSON Sue CDG
53 Moseley Wood Walk
Leeds LS16 7HQ Tel: 0113-267 0819

JAFFA Janis CASTING CDG
67 Starfield Road, London W12 9SN
e-mail: janis@janisjaffacasting.co.uk
Fax: 020-8743 9561 Tel: 020-7565 2877

JAFFREY Jennifer
136 Hicks Avenue, Greenford, Middlesex UB6 8HB
e-mail: jaffreymag@aol.com
Fax: 020-8575 0369 Tel: 020-8578 2899

JAY Jina CASTING CDG
Office 2, Sound Centre, Twickenham Film Studios,
The Barons, St Margarets, Twickenham, Middlesex TW1 2AW
Fax: 020-8607 8982 Tel: 020-8607 8888

JELOWICKI Ilenka
(Mad Dog Casting Ltd)
15 Leighton Place, London NW5 2QL
e-mail: ilenka@maddogcasting.com
Fax: 020-7284 2689 Tel: 020-7482 4703

JENKINS Lucy CDG
Royal Shakespeare Company
1 Earlham Street WC2H 9LL
e-mail: lucy.jenkins@rsc.org.uk
Fax: 020-7845 0505 Tel: 020-7845 0508

JN PRODUCTION
5A Penton Street, London N1 9PT
e-mail: james@jnproduction.net
Fax: 020-7278 8855 Tel: 020-7278 8800

JOHN Priscilla CDG
PO Box 22477, London W6 0GT
Fax: 020-8741 4005 Tel: 020-8741 4212

JOHNSON Alex CASTING
15 McGregor Road, London W11 1DE
e-mail: alex@alexjon.demon.co.uk
Fax: 020-7229 1665 Tel: 020-7229 8779

JOHNSON Marilyn CDG
1st Floor, 11 Goodwins Court, London WC2N 4LL
e-mail: casting@marilynjohnsoncasting.com
Fax: 020-7497 5530 Tel: 020-7497 5552

JONES Doreen CDG
PO Box 22478, London W6 0WJ
Fax: 020-8748 8533 Tel: 020-8746 3782

JONES Sam CDG
7B Trinity Church Square, London SE1 4HU
e-mail: get@samjones.fsnet.co.uk Tel: 020-7378 0222

JONES Sue CDG Tel: 020-8838 5153

KATE & ALI CASTING
(See FEARNLEY Ali)

KENNEDY Anna CASTING
86 Hydethorpe Road
London SW12 0JB
e-mail: anna@kennedycasting.com Tel: 020-8673 6550

KEOGH Beverley CASTING Ltd
29 Ardwick Green North
Ardwick Green, Manchester M12 6DL
e-mail: beverley@beverleykeogh.tv
Fax: 0161-273 4401 Tel: 0161-273 4400

KESTER Gaby
e-mail: casting@gabykester.com Tel: 020-7580 6867

KNIGHT-SMITH Jerry CDG
Royal Exchange Theatre Company
St Ann's Square, Manchester M2 7DH
Fax: 0161-615 6691 Tel: 0161-615 6761

KOREL Suzy CDG
20 Blenheim Road, London NW8 0LX
e-mail: suzy@korel.org
Fax: 020-7372 3964 Tel: 020-7624 6435

KRUGER Beatrice
(FBI Casting)
46 via della Pelliccia
00153 Roma
Italy
Website: www.fbicasting.com
e-mail: mail@fbicasting.it
Fax: 00 39 06 23328203 Tel: 00 39 06 58332747

KYLE CASTING
The Summerhouse
Thames House
54 Thames Street
Hampton TW12 2DX
e-mail: kylecasting@btinternet.com Tel: 020-8332 2966

LAYTON Claudie CASTING
(Claudie Layton & Alix Charpentier)
Unit 308
Canalot Studios
222 Kensal Road
London W10 5BN
e-mail: casting@claudielayton.com
Fax: 020-8968 1330 Tel: 020-8964 2055

Valerie Colgan

- For professional actors who need a voice production "MOT"
- Private individual classes
- Valerie Colgan and a consortium of tutors as appropriate.

Ex Head of Drama at the City Lit · 5 Drama Schools · The Actors Centre

Tel: **020 7267 2153** The Green, 17 Herbert Street, London NW5 4HA

LESSALL Matthew
e-mail: matt@lessallcasting.com

LEVENE Jon
e-mail: jonlevene@mac.com
Mobile: 07977 570899 — Tel: 020-7792 8501

LEVINSON Sharon
30 Stratford Villas, London NW1 9SG
e-mail: sharonlev@blueyonder.co.uk — Tel: 020-7485 2057

LINDSAY-STEWART Karen CDG
PO Box 2301, London W1A 1PT
Fax: 020-7439 0548 — Tel: 020-7439 0544

LIP SERVICE CASTING
(Voice-overs only)
60-66 Wardour Street, London W1F 0TA
Website: www.lipservice.co.uk
e-mail: bookings@lipservice.co.uk
Fax: 020-7734 3373 — Tel: 020-7734 3393

LUNN Maggie
Unit HG14, Aberdeen Centre
22-24 Highbury Grove, London N5 2EA
e-mail: maggie@maggielunn.co.uk — Tel: 020-7226 7502

MAGSON Kay CDG
PO Box 175, Pudsey, Leeds LS28 7WY
e-mail: kay.magson@btinternet.com — Tel/Fax: 0113-236 0251

MANN Andrew
(See CASTING UK)

MANNING John
44 The Glades, Aldridge, Walsall
West Midlands WS9 8RN — Tel: 01922 743366

MARCH Heather CASTING
The Aberdeen Centre
22-24 Highbury Grove, London N5 2EA
e-mail: hm@heathermarchcasting.com
Fax: 020-7704 6085 — Tel: 020-7704 6464

McCANN Joan CDG
26 Hereford Road, London W3 9JW
Fax: 020-8992 8715 — Tel: 020-8993 1747

McLEOD Carolyn
PO Box 26495
London SE10 0WO
e-mail: carolyn@cmcasting.eclipse.co.uk
Tel/Fax: 07044 001720

McLEOD Thea
e-mail: mcleodcasting@hotmail.com
Mobile: 07941 541314 — Tel: 020-8888 8993

McMURRICH Chrissie
16 Spring Vale Avenue
Brentford, Middlesex TW8 9QH — Tel: 020-8568 0137

McSHANE Sooki CDG
8A Piermont Road
East Dulwich
London SE22 0LN — Tel: 020-8693 7411

McWILLIAMS Debbie
Eon House
138 Piccadilly, London W1J 7NR
e-mail: debbiemcwilliams@hotmail.com — Tel: 020-7493 7953

MEULENBERG Thea
Keizersgracht 116, 1015 CW
Amsterdam, The Netherlands
Website: www.theameulenberg.com
e-mail: info@theameulenberg.com
Fax: 00 31 20 622 9894 — Tel: 00 31 20 626 5846

MILLER Hannah CDG
Birmingham Repertory Theatre
Centenary Square
Broad Street
Birmingham B1 2EP — Tel: 0121-245 2023

MOISELLE Frank
7 Corrig Avenue
Dun Laoghaire, Co. Dublin, Eire
Fax: 00 353 1 2803277 — Tel: 00 353 1 2802857

MOISELLE Nuala
7 Corrig Avenue
Dun Laoghaire, Co. Dublin, Eire
Fax: 00 353 1 2803277 — Tel: 00 353 1 2802857

MOORE Stephen
e-mail: stephen@stephenmoorecasting.co.uk
Tel: 020-8400 5661

MORGAN Andy
(See RHODES JAMES Kate CDG)

MORRISON Melika
12A Rosebank, Holyport Road
London SW6 6LG Tel/Fax: 020-7381 1571

MUGSHOTS
(Becky Kidd)
153 Buckhurst Avenue
Carshalton, Surrey SM5 1PD
e-mail: mail@mugshots.co.uk
Fax: 020-8296 8056 Tel: 020-8296 0393

NATIONAL THEATRE CASTING DEPARTMENT
(Head of Casting: Wendy Spon CDG, Casting Assistant:
Alastair Coomer)
Upper Ground
South Bank, London SE1 9PX
Fax: 020-7452 3340 Tel: 020-7452 3336

NEEDLEMAN Sue
19 Stanhope Gardens, London NW7 2JD
Fax: 020-8959 0225 Tel: 020-8959 1550

NOA PRODUCTIONS
(Casting & Production Services)
23 Beechcroft Avenue
London NW11 8BJ
Mobile: 07815 048238 Mobile: 07944 953540

NORCLIFFE Belinda
(Belinda Norcliffe & Matt Selby)
23 Brougham Road, London W3 6JD
e-mail: belinda@bncasting.co.uk
Fax: 020-8992 5533 Tel: 020-8992 1333

O'BRIEN Debbie
72 High Street, Ashwell
Nr Baldock, Herts SG7 5NS
Fax: 01462 743110 Tel: 01462 742919

PALMER Helena
(See CANNON DUDLEY & ASSOCIATES)

PARRISS Susie CASTING CDG
PO Box 40, Morden SM4 4WJ
Fax: 020-8543 3327 Tel: 020-8543 3326

PERRYMENT Mandy CASTING
e-mail: mail@mandyperryment.com
Fax: 01372 472795 Tel: 01372 472794

PETTS Tree CASTING
125 Hendon Way
London NW2 2NA
e-mail: casting@treepetts.co.uk Tel: 020-8458 8898

PLANTIN Kate
4 Riverside
Lower Hampton Road
Sunbury on Thames TW16 5PWL
e-mail: kateplantin@hotmail.com
Fax: 01932 783235 Tel: 01932 782350

POLENTARUTTI Tania CASTING CDG
Top Floor
37 Berwick Street, London W1F 8RS
Fax: 020-7734 3549 Tel: 020-7734 1819

Marc Baylis

Photography by

ANGUS DEUCHAR

t. 020 8286 3303
m. 07973 600728

www.ActorsPhotos.co.uk

Daisy Bates

AWP
Photographic Studio

London W13
020 8998 2579

Katherine Stavros Sophie

photo@actors-world-production.com

POOLE Gilly CDG
(See CROWLEY POOLE CASTING)

PROCTOR Carl CDG
66 Great Russell Street
London WC1B 3BN
e-mail: carlproctor@btconnect.com
Fax: 020-7405 0564 Tel: 020-7405 0561

PRYOR Andy CDG
Suite 3, 15 Broad Court, London WC2B 5QN
Fax: 020-7836 8299 Tel: 020-7836 8298

RAFTERY Francesca CASTING CDG
51 Purley Vale
Purley
Surrey CR8 2DU
Website: www.francescaraftery.com
e-mail: info@francescaraftery.com Tel/Fax: 020-8763 0105

REGAN Leigh-Ann
(Welsh Language/English) TV, Film & Commercials
Ynyslas Uchaf Farm
Blackmill
Bridgend CF35 6DW
Fax: 01656 841815 Tel: 01656 841841

REICH Liora
25 Manor Park Road
London N2 0SN Tel: 020-8444 1686

REYNOLDS Gillian
The Mews, The Rear
14 Rathdown Road, Dublin 7, Eire
Website: www.gillianreynoldscasting.com
e-mail: grc1@eircom.net Tel: 00 353 1 8823997

REYNOLDS Simone CDG
60 Hebdon Road, London SW17 7NN
Fax: 020-8767 0280 Tel: 020-8672 5443

RHODES JAMES Kate CDG
Suite 6, 135 High Street
Teddington TW11 8HH
Fax: 020-8977 2624 Tel: 020-8977 1191

RIPLEY Jane
20 Weston Park
London N8 9TJ
e-mail: janeripley@blueyonder.co.uk Tel: 020-8342 8216

ROBERTSON Sasha CASTING CDG
19 Wendell Road, London W12 9RS
e-mail: casting@sasharobertson.com
Fax: 020-8740 1396 Tel: 020-8740 0817

ROYAL SHAKESPEARE COMPANY
Casting Department
1 Earlham Street, London WC2H 9LL
Website: www.rsc.org.uk
Fax: 020-7845 0505 Tel: 020-7845 0500

SALBERG Jane
8 Halstow Road
Greenwich, London SE10 0LD
e-mail: janesalberg@aol.com
Fax: 020-8516 9365 Tel: 020-8858 1114

SAUNDERS Claire
4 Cavendish Mansions
Mill Lane, London NW6 1TE
e-mail: mail@clairesaunderscasting.com Tel: 020-7419 1259

SCHILLER Ginny CDG
180A Graham Road, London E8 1BS
e-mail: ginny.schiller@virgin.net
Fax: 020-8525 1049 Tel: 020-8525 1637

SCOTT Laura CDG
56 Rowena Crescent
London SW11 2PT
Website: www.castingdirectorsguild.co.uk
e-mail: laurascottcasting@mac.com
Fax: 020-7924 1907 Tel: 020-7978 6336

SEARCHERS The
70 Sylvia Court
Cavendish Street, London N1 7PG
e-mail: waynerw.searchers@blueyonder.co.uk
Fax: 020-7684 5763 Mobile: 07958 922829

SEECOOMAR Nadira
PO Box 167
Twickenham TW1 2UP
Fax: 020-8744 1274 Tel: 020-8892 8478

SHAW David
(See KEOGH Beverley CASTING Ltd)

SHAW Phil
Suite 476, 2 Old Brompton Road
South Kensington, London SW7 3DQ
e-mail: shawcastlond@aol.com Tel: 020-8715 8943

SHEPHERD Debbie CASTING
Suite 16
63 St Martin's Lane
London WC2N 4JS
e-mail: debbie@debbieshepherd.com
Fax: 020-7240 4640 Tel: 020-7240 0400

London Academy of Radio Film TV
TV Presenter - Acting - Voice - Film - Photography - Make-up - Radio
100 courses Offering an extensive range of full-time, part-time
evening and day courses taught by celebrities and industry professionals.
www.media-courses.com 0870 850 4994

SID PRODUCTIONS
Suite 84
The London Fruit & Wool Exchange
Brushfield Street, London E1 6EP
Website: www.sidproductions.co.uk
e-mail: casting@sidproductions.co.uk
Fax: 020-7247 8810 Tel: 020-7655 4477

SINGER Sandra ASSOCIATES
21 Cotswold Road
Westcliff-on-Sea
Essex SS0 8AA
Website: www.sandrasinger.com
e-mail: sandrasinger@btconnect.com
Fax: 01702 339393 Tel: 01702 331616

SMITH Michelle CDG
220 Church Lane
Woodford, Stockport SK7 1PQ
Fax: 0161-439 0622 Tel: 0161-439 6825

SMITH Suzanne CDG
33 Fitzroy Street, London W1T 6DU
e-mail: zan@dircon.co.uk
Fax: 020-7436 9690 Tel: 020-7436 9255

STAFFORD Emma CASTING
The Royal Exchange
St Ann's Square, Manchester M2 7BR
Website: www.emmastafford.tv
e-mail: info@emmastafford.tv
Fax: 0161-833 4264 Tel: 0161-833 4263

STARK CASTING
e-mail: stark.casting@virgin.net
Mobile: 07956 150689 Tel: 020-8800 0060

STEELE Mandy
65 Mayfield Road, London N8 9LN
e-mail: mandy@mandysteele.com
Fax: 0870 1329017 Tel: 020-8374 2899

STEVENS Gail CASTING CDG
Greenhill House
90-93 Cowcross Street
London EC1M 6BF
Fax: 020-7253 6574 Tel: 020-7253 6532

STEVENSON Sam CDG
103 Whitecross Street
London EC1Y 8JD
e-mail: sam@hancockstevenson.com Tel: 020-7256 5727

Majid Iqbal

Lindsay Davies

Photography

TEL 07870 625 701

STEWART Amanda CASTING
Apartment 1, 35 Fortress Road
London NW5 1AD Tel: 020-7485 7973

STOLL Liz
BBC DRAMA SERIES CASTING
BBC Elstree, Room N223
Neptune House, Clarendon Road
Borehamwood WD6 1JF
Fax: 020-8228 8311 Tel: 020-8228 8285

STYLE Emma CDG
7 Chamberlain Cottages
Camberwell Grove, London SE5 8JD Tel: 020-7701 7750

SUMMERS Mark (LONDON)
See CASTING UNLIMITED (LONDON)

SUMMERS Mark (LOS ANGELES)
See CASTING UNLIMITED (LOS ANGELES)

SYERS Michael
(See CASTING CONNECTION The)

SYSON Lucinda CDG
1st Floor, 33 Old Compton Street, London W1D 5JT
e-mail: office@lucindasysoncasting.com
Fax: 020-7287 3629 Tel: 020-7287 5327

TABAK Amanda CDG
(See CANDID CASTING)

TEECE Shirley
106 North View Road, London N8 7LP
e-mail: casting@teece.demon.co.uk Tel: 020-8347 9241

TOPOLSKI Tessa
25 Clifton Hill
London NW8 0QE Tel: 020-7328 6393

TOPPS CASTING
(Nicola Topping)
The Media Centre
7 Northumberland Street HD1 1RL
e-mail: info@toppscasting.co.uk Mobile: 07802 684256

TRAMONTANO Luisa
138 Peckham Rye
East Dulwich, London SE22 9QH
Website: www.luisatcasting.co.uk
e-mail: luisa@luisatcasting.co.uk
Fax: 020-8299 6948 Mobile: 07767 438787

TREVELLICK Jill CDG
123 Rathcoole Gardens
London N8 9PH
e-mail: jill@trevellick.force9.co.uk
Fax: 020-8348 7400 Tel: 020-8340 2734

TREVIS Sarah CDG
PO Box 47170, London W6 6BA
e-mail: info@sarahtrevis.com
Fax: 020-7602 8110 Tel: 020-7602 5552

TWIST & FLIC CASTING
(Penny Burrows)
1A Carlton Avenue
Dulwich Village
London SE21 7DE
Website: www.sportsmodels.com
e-mail: info@sportsmodels.com
Mobile: 07973 863263 Tel: 020-8299 8800

VALENTINE HENDRY Kelly
202C Muswell Hill Road, London N10 3NH
e-mail: kelly@valentinehendry.com Tel/Fax: 020-8883 7705

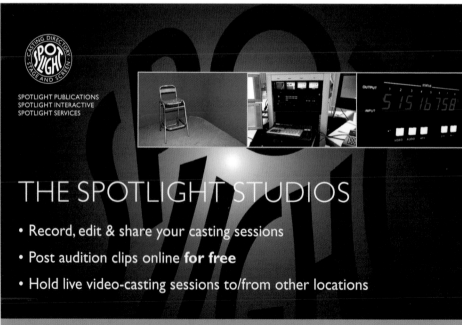

Stuart Boother

Charlene Ford

Michael Cormick

Nick james
photographer 07961 122030

VAN OST & MILLINGTON CASTING
(Valerie Van Ost & Andrew Millington)
PO Box 115, Petersfield GU31 5BB Tel: 01730 821530

VAUGHAN Sally
2 Kennington Park Place
London SE11 4AS Tel: 020-7735 6539

VITAL PRODUCTIONS
PO Box 26441
London SE10 9GZ
e-mail: mail@vital-productions.co.uk
Mobile: 07957 284709 Tel: 020-8316 5336

VOSSER Anne CASTING CDG
e-mail: anne@vosser-casting.co.uk Mobile: 07968 868712

WATSON Tim
BBC DRAMA SERIES CASTING
BBC Elstree
Room N202
Neptune House, Clarendon Road
Borehamwood WD6 1JF Tel: 020-8228 7109

WEIR Fiona
c/o Twickenham Studios, St Margaret's
Twickenham TW1 2AW Tel: 020-8607 8888

WEST June
Granada Television
Quay Street, Manchester M60 9EA
Fax: 0161-827 2853 Tel: 0161-832 7211

WESTERN Matt CASTING CDG
2nd Floor, 59-61 Brewer Street, London W1F 9UN
e-mail: matt@mattwestern.co.uk
Fax: 020-7439 1941 Tel: 020-7434 1230

WHALE Toby CDG
80 Shakespeare Road
London W3 6SN
Website: www.whalecasting.com
e-mail: toby@whalecasting.com
Fax: 020-8993 8096 Tel: 020-8993 2821

WILLIS Catherine
e-mail: catherine@cwcasting.co.uk Tel: 020-7697 4482

YOUNGSTAR CASTING
(Specialist in Children & Teenagers only)
e-mail: info@youngstar.tv

ZIMMERMANN Jeremy CASTING
36 Marshall Street, London W1F 7EY
Fax: 020-7437 4747 Tel: 020-7478 5161

CONCERT & EXHIBITION HALLS

CONCERT & EXHIBITION HALLS

AMADEUS CENTRE The
50 Shirland Road, London W9 2JA
e-mail: info@amadeuscentre.co.uk
Fax: 020-7266 1225 Tel: 020-7286 1686

BAC VENUES
Battersea Arts Centre
Lavender Hill, Battersea, London SW11 5TN
Website: www.bacvenues.org.uk
e-mail: venues@bac.org.uk Tel: 020-7326 8211

BARBICAN EXHIBITION CENTRE
Barbican, Silk Street, London EC2Y 8DS
Fax: 020-7382 7263 Tel: 020-7382 7053

BIRMINGHAM SYMPHONY HALL
Broad Street, Birmingham B1 2EA
Website: www.symphonyhall.co.uk
e-mail: feedback@symphonyhall.co.uk
BO: 0121-780 3333 Admin: 0121-200 2000

BLACKHEATH HALLS
23 Lee Road, Blackheath, London SE3 9RQ
Website: www.blackheathhalls.com
e-mail: mail@blackheathhalls.com
Fax: 020-8852 5154 BO: 020-8463 0100

CENTRAL HALL - WESTMINSTER
Storey's Gate, Westminster, London SW1H 9NH
Website: www.c-h-w.co.uk
e-mail: events@c-h-w.co.uk Tel: 020-7222 8010

EC & O VENUES - EARL'S COURT
The Brewery, Chiswell Street, London EC1Y 4SD
Website: www.thebewery.co.uk Tel: 020-7638 8811

EC & O VENUES - OLYMPIA
Hammersmith Road, London W14 8UX
Website: www.eco.co.uk Tel: 020-7385 1200

EC & O VENUES
Warwick Road, London SW5 9TA
Website: www.eco.co.uk
e-mail: marketing@eco.co.uk Tel: 020-7385 1200

FAIRFIELD HALLS
Park Lane, Croydon CR9 1DG
Website: www.fairfield.co.uk
BO: 020-8688 9291 Tel: 020-8681 0821

FERNEHAM HALL
Osborn Road
Fareham, Hants PO16 7DB
e-mail: boxoffice@fareham.gov.uk Tel: 01329 824864

GORDON CRAIG THEATRE
Stevenage Arts & Leisure Centre
Lytton Way, Stevenage, Herts SG1 1LZ
Website: www.stevenage-leisure.co.uk
e-mail: gordoncraig@stevenage-leisure.co.uk
BO: 08700 131030 Admin: 01438 242679

HEXAGON The
Queen's Walk, Reading RG1 7UA
Website: www.readingarts.com
e-mail: boxoffice@readingarts.com
Fax: 0118-939 0028 Admin: 0118-939 0390

MINERVA STUDIO THEATRE
Oaklands Park, Chichester
West Sussex PO19 6AP
Website: www.cft.org.uk
Fax: 01243 787288 Tel: 01243 784437

NATIONAL CONCERT HALL OF WALES The
St David's Hall
The Hayes, Cardiff CF10 1SH
Website: www.stdavidshallcardiff.co.uk
Fax: 029-2087 8599 Tel: 029-2087 8500

OLYMPIA EXHIBITION CENTRES
Hammersmith Road
Kensington, London W14 8UX
Fax: 020-7598 2500 Tel: 020-7385 1200

RIVERSIDE STUDIOS
Crisp Road, London W6 9RL
Website: www.riversidestudios.co.uk
e-mail: online@riversidestudios.co.uk
BO: 020-8237 1111 Tel: 020-8237 1000

ROUND The
34 Lime Street, Ouseburn
Newcastle Upon Tyne NE1 2PQ
Website: www.the-round.com
Tel: 0191-261 9230 Tel: 0191-260 5605

ROYAL ALBERT HALL
Kensington Gore, London SW7 2AP
Website: www.royalalberthall.com
e-mail: admin@royalalberthall.com
Fax: 020-7823 7725 Tel: 020-7589 3203

SOUTH BANK CENTRE
(Including The Royal Festival Hall
Queen Elizabeth Hall, Purcell Room & Hayward Gallery),
Royal Festival Hall, London SE1 8XX
Website: www.rfh.org.uk
BO: 0870 3828000 Tel: 020-7921 0601

ST JOHN'S
Smith Square, London SW1P 3HA
Website: www.sjss.org.uk
Fax: 020-7233 1618 Tel: 020-7222 2168

WIGMORE HALL
36 Wigmore Street, London W1U 2BP
e-mail: info@wigmore-hall.org.uk BO: 020-7935 2141

ACORN ENTERTAINMENTS Ltd
PO Box 64, Cirencester, Glos GL7 5YD
Website: www.acornents.co.uk
e-mail: info@acornents.co.uk
Fax: 01285 642291 Tel: 01285 644622

ASKONAS HOLT Ltd
(Classical Music)
Lonsdale Chambers, 27 Chancery Lane, London WC2A 1PF
Website: www.askonasholt.co.uk
e-mail: info@askonasholt.co.uk
Fax: 020-7400 1799 Tel: 020-7400 1700

AVALON PROMOTIONS Ltd
4A Exmoor Street, London W10 6BD
Fax: 020-7598 7334 Tel: 020-7598 7333

BARRUCCI LEISURE ENTERPRISES Ltd
(Promoters)
45-47 Cheval Place, London SW7 1EW
e-mail: barrucci@barrucci.com
Fax: 020-7581 2509 Tel: 020-7225 2255

BLOCK Derek ARTISTES AGENCY
70-76 Bell Street, Marylebone, London NW1 6SP
e-mail: dbaa@derekblock.co.uk
Fax: 020-7724 2102 Tel: 020-7724 2101

CITY CONCERT ORGANISATION Ltd The
PO Box 3145, Lichfield WS13 6YN
Website: www.cityconcert.com
e-mail: admin@cityconcert.com Tel/Fax: 01543 262286

FLYING MUSIC
110 Clarendon Road, London W11 2HR
Website: www.flyingmusic.com
e-mail: reception@flyingmusic.com
Fax: 020-7221 5016 Tel: 020-7221 7799

GOLDSMITH Harvey PRODUCTIONS Ltd
(Concert Promotion)
13-14 Margaret Street, London W1W 8RN
Website: www.harveygoldsmith.com
e-mail: mail@harveygoldsmith.com
Fax: 020-7224 0111 Tel: 020-7224 1992

GUBBAY Raymond Ltd
Dickens House, 15 Tooks Court, London EC4A 1QH
Website: www.raymondgubbay.co.uk
e-mail: info@raymondgubbay.co.uk
Fax: 020-7025 3751 Tel: 020-7025 3750

HOBBS Liz CONCERTS & EVENTS Ltd
65 London Road, Newark, Nottinghamshire NG24 1RZ
Website: www.lizhobbsgroup.com
e-mail: events@lizhobbsgroup.com
Fax: 0870 3337009 Tel: 08700 702702

HOCHHAUSER Victor
4 Oak Hill Way, London NW3 7LR
Fax: 020-7431 2531 Tel: 020-7794 0987

IMG ARTS & ENTERTAINMENT
Pier House, Strand on the Green
Chiswick, London W4 3NN
Fax: 020-8233 5001 Tel: 020-8233 5000

McINTYRE Phil ENTERTAINMENT
2nd Floor, 35 Soho Square, London W1D 3QX
e-mail: reception@mcintyre-ents.com
Fax: 020-7439 2280 Tel: 020-7439 2270

RBM
(Comedy)
3rd Floor, 168 Victoria Street, London SW1E 5LB
Website: www.rbmcomedy.com
e-mail: info@rbmcomedy.com
Fax: 020-7630 6549 Tel: 020-7630 7733

ACTOR'S ONE-STOP SHOP The
(Showreels for Performing Artists)
First Floor
Above The Gate Pub
Station Road, London N22 7SS
Website: www.actorsone-stopshop.com
e-mail: info@actorsone-stopshop.com Tel: 020-8888 7006

AGENTFILE
(Software for Agents)
Website: www.agentfile.com
e-mail: admin@agentfile.com Mobile: 07050 683662

ANDREW JENKINS Ltd
St Martin's House
59 St Martin's Lane
London WC2N 4JS
Website: www.andrewjenkinsltd.com
e-mail: info@andrewjenkinsltd.com
Fax: 020-7240 0710 Tel: 020-7240 0607

AON Ltd (Trading as AON/ALBERT G. RUBEN)
(Insurance Brokers)
Pinewood Studios
Pinewood Road
Iver, Bucks SL0 0NH
Website: www.aon.co.uk
Fax: 01753 785861 Tel: 01753 785859

ARIAS Enrique
(Subtitles, Translations & Voice Overs)
21 Middleton Road
London NW11 7NR
Website: www.nwlondon.com/eag
e-mail: enriqueag@gmail.com Mobile: 07956 261568

ARTON Michael PhD
(Historical Research, Technical Advisor)
122 Sunningfields Road
London NW4 4RE Tel/Fax: 020-8203 2733

ARTS VA The
(Bronwyn Robertson)
(Experienced PA and Admin Support)
Website: www.theartsva.com
e-mail: bronwyn@theartsva.com
Fax: 01789 552818 Tel: 01789 552559

ATKINS Chris & COMPANY
(Accountants & Business Consultants)
Astra House
Arklow Road, London SE14 6EB
e-mail: info@chrisatkins.co.uk Tel: 020-8691 4100

BIG PICTURE
(Casual Work in IT Field Marketing)
13 Netherwood Road, London W14 0BL
Website: www.ebigpicture.co.uk
e-mail: info@ebigpicture.co.uk Tel: 020-7371 4455

BLACKMORE Lawrence
(Production Accountant)
Suite 5, 26 Charing Cross Road
London WC2H 0DG
Fax: 020-7836 3156 Tel: 020-7240 1817

BLUE SKY ENTERTAINMENT
(Corporate, Open Air & Specialist Entertainment)
8 Adelaide Road,
London W12 0JJ
Website: www.blueskyentertainment.co.uk
e-mail: info@blueskyentertainment.co.uk
 Tel: 020-8749 4427

BOARDMAN BOOKINGS Ltd
(Events Organisers)
5 Hornton Place
High Street Kensington, London W8 4LZ
Website: www.boardmanbookings.co.uk
e-mail: info@boardmanbookings.co.uk
 Tel/Fax: 020-7937 9923

BOWKER ORFORD
(Chartered Accountants)
15-19 Cavendish Place, London W1G 0DD
e-mail: morford@bowkerorford.com
Fax: 020-7580 3909 Tel: 020-7636 6391

BREBNER ALLEN TRAPP
(Chartered Accountants)
180 Wardour Street, London W1F 8LB
Website: www.brebner.co.uk
e-mail: partners@brebner.co.uk
Fax: 020-7287 5315 Tel: 020-7734 2244

BRECKMAN & COMPANY
(Chartered Certified Accountants)
49 South Molton Street
London W1K 5LH
Website: www.breckmanandcompany.co.uk
 Tel: 020-7499 2292

BRITISH ASSOCIATION FOR DRAMA THERAPISTS The
41 Broomhouse Lane
London SW6 3DP
Website: www.badth.org.uk
e-mail: gillian@badth.demon.co.uk Tel/Fax: 020-7731 0160

Who are 'Consultants'?

Broadly, this section contains listings for a variety of companies and services which exist to help performers with the day-to-day administration of their working lives. It also includes companies with particular specialisms or who offer niche services. Performers need to manage their business affairs personally, in ways that those in 'normal' jobs do not. For example, unlike most employees, a performer does not have an accounts department to work out their tax and national insurance, or an HR department to take care of contracts or health insurance on their behalf. On top of which, performers can often be away on tour or on set for many months and unable to attend to these matters themselves.

Areas covered in this section include:

Finance

Dedicated companies exist which can help you look after key financial issues, including national insurance, taxation, benefits, savings and pensions. Specialist mortgage companies also exist for performers and other self-employed workers within the entertainment industry. See overleaf for specific information about accountancy services. If you are a member of Equity you can also ask them for free financial advice, and an Equity pension scheme exists into which the BBC, ITV, PACT, TV companies and West End Theatre producers will pay when you have a main part with one of them. Similar schemes also exist for dancers and other performers.

Insurance

Performers may often need specialist insurance for specific jobs, as well as the standard life and health insurance policies held by most people. A number of specialist insurers are listed in the pages overleaf. Equity also offers a specialist backstage / accident and public liability insurance policy to all of its members.

Legal

There may be times in a performer's career when he / she needs specialist legal advice or representation. Legal advisors and solicitors are listed in this section. In addition, as part of their membership, Equity performers can also obtain free legal advice regarding professional engagements or personal injury claims.

Health and Wellbeing

The unique pressures of working within the entertainment industry can take their toll on performers' physical and psychological wellbeing. Fortunately there are hundreds of specialist practitioners with years of experience in treating performers and understanding the issues which regularly affect them. See the 'Health and Wellbeing' section of this directory for listings. Equity members can also use the British Performing Arts Medicine Trust Helpline to access advice and information on performance-related medical, psychological and dental problems. (www.bpamt.co.uk)

How should I use these listings?

As when looking to hire any company or individual, contact a number of different companies and carefully compare the services they offer. Ask others in the industry for recommendations. If you are an Equity member, don't forget to check first that the service isn't already available free of charge, as part of your annual membership.

think success

Whether you're just starting out as a performer, or perhaps reaching dizzy new heights, ANNE-MAREE DUNN of accountants Vantis has a few useful tips to performers on how best to manage their finances.

The second-best bit of advice we can suggest is to find yourself an accountant who you get on with; who understands your needs and the intricacies of your business. (The best bit of advice is at the end - peek if you must!)

Whether you have an accountant or not, as a self-employed person you'll need to be aware of some of the implications regarding things like Allowable Expenses, National Insurance, and Tax, as well as paying attention to how you save - you do save for those rainy days, don't you?

• **Allowable Expenses:** Hold on to receipts for dear life. Even if you don't think they could be classed as business expenses, your accountant might disagree. Equity publishes a list of allowable expenses for entertainers that can be offset against their tax bill. However, this list has never been officially agreed with the Inland Revenue, so check individual items with your accountant. It may be possible to class certain expenses as allowable, such as dental, medical or hairdresser's bills, where they are essential for your work. As for agents' fees - yes, they're allowable - but confirm with your adviser first.

• **National Insurance:** As a self-employed person, you'll be paying two sets of contributions, known as Class Two (currently £2.10 a week) and Class Four (currently eight per cent, paid on income between £5,035 and £33,540). Should you secure a contract within film, TV, or theatre it's normal for your 'employer' (the film company, broadcaster etc.) to pay Class One contributions on your behalf while you are contracted to them. Do however ensure your self-employed contributions are still paid - if not you could end up with an unexpected bill, sometimes up to two years after the end of the tax year.
It is also worth reviewing the total amounts paid in the year, you may be able to apply for a refund in some circumstances.

• **Tax:** It's currently estimated that over six million taxpayers in the UK have overpaid their tax bill: as Albert Einstein is purported to have once said: 'The hardest thing in the world to understand is income tax.' When you get paid for a job you might think you're doing better than ever, but has it been taxed? Come January, and then July, you'll receive the demand that gives you just under a month to pay Revenue & Customs. So set up a high interest savings account and transfer around thirty percent of your earnings into it. This should cover you when the tax bill arrives.

• **Savings:** The entertainment business is one where unpredictability of income is a key feature. Do put money aside during the good times to cover you when the phone stops ringing. Aim to keep reserves of approximately three to six months' expenditure in a high interest account. Don't forget to fully utilise your annual Cash ISA allowance - a savings account where you can earn interest, free of tax, on up to £3,000 invested each year.

• **The best bit of advice:** How to save on your accountancy fees. Easy! Invest in a hole-punch and lever arch file - both can be classed as allowable expenses. Instead of presenting your accountant with a carrier bag stuffed with paperwork (yes, it happens), file all invoices, receipts, and any items related to income and expenditure, in chronological order. That way you can rest easy in knowing that your accountant's fees for sorting out your disorganisation won't be greater than your income!

Anne-Maree Dunn is Head of Tax at Vantis in St. Albans and can be contacted on 01727 838 255, or visit (www.vantisplc.com/stalbans)

BYFORD Simon PRODUCTION MANAGEMENT SERVICES
(Production & Event Management)
22 Freshfield Place
Brighton, East Sussex BN2 0BN
e-mail: simon@simonbyfordpms.com
Fax: 01273 606402 Tel: 01273 623972

BYRNE John
(The Stage's Agony Uncle)
Website: www.getmemyagent.com
e-mail: john@getmemyagent.com Tel: 020-7231 4907

CADENZA ENTERTAINMENT SERVICES Ltd
Bedford Chambers, The Piazza
Covent Garden, London WC2E 8HA
Website: www.cadenzaservices.co.uk
e-mail: info@cadenzaservices.co.uk Tel: 020-7836 3401

CARR Mark & Co Ltd
(Chartered Accountants)
Garrick House
26-27 Southampton Street
Covent Garden, London WC2E 7RS
Website: www.markcarr.co.uk
e-mail: mark@markcarr.co.uk Tel: 020-7717 8474

CASTLE MAGICAL SERVICES
(Magical Consultants) (Michael Shepherd)
Broompark, 131 Tadcaster Road
Dringhouses, York YO24 1QJ
e-mail: info@castlemagicalservices.co.uk
 Tel/Fax: 01904 709500

CAULKETT Robin Dip SM, MIIRSM
(Abseiling, Rope Work)
3 Churchill Way, Mitchell Dean
Glos GL17 0AZ Mobile: 07970 442003

CELEBRITIES WORLDWIDE Ltd
(Celebrity on-line Media Database)
39-41 New Oxford Street
London WC1A 1BN
Website: www.celebritiesworldwide.com
e-mail: info@celebritiesworldwide.com
Fax: 020-7836 7701 Tel: 020-7836 7702

CHAPERONE AGENCY The
Mobile: 07960 075928 Mobile: 07958 545741

CIRCUS MANIACS
(Circus, Theatre, Dance, Choreography, Extreme Sports)
Office 8A
The Kingswood Foundation
Britannia Road, Kingswood
Bristol BS15 8DB
Website: www.circusmaniacsagency.com
e-mail: agency@circusmaniacs.com
Mobile: 07977 247287 Tel/Fax: 0117-947 7042

CLASS - CARLINE LUNDON ASSOCIATES
25 Falkner Square
Liverpool L8 7NZ
Website: www.stagescreenandbroadcast.co.uk
e-mail: carline.lundon@ukonline.co.uk
Mobile: 07958 509155 Tel/Fax: 0151-703 0600

COBO MEDIA Ltd
(Performing Arts, Entertainment & Leisure Marketing)
43A Garthorne Road, London SE23 1EP
Website: www.theatrenet.com
e-mail: admin@cobomedia.com
Fax: 020-8291 4969 Tel: 020-8291 7079

COLCLOUGH John
(Practical Independent Guidance for Actors and Actresses)
Website: www.johncolclough.org.uk
e-mail: john@johncolclough.org.uk Tel: 020-8873 1763

COOPER Margaret
(Art Director)
75/1 Old College Street, Sleima, Malta
e-mail: mediacorp1@yahoo.com Mobile: 00 44 7884 074315

COUNT AND SEE LIMITED
(Tax, Accountancy & Book-keeping Services)
219 Macmillan Way
London SW17 6AW
Website: www.countandsee.com
e-mail: info@countandsee.com
Fax: 0845 004 3454 Tel: 020-8767 7882

CREATIVE INDUSTRIES DEVELOPMENT AGENCY (CIDA)
(Professional Development & Business Support for Artists
& Creative Businesses)
Media Centre
Northumberland Street
Huddersfield, West Yorkshire HD1 1RL
Website: www.cida.org
e-mail: info@cida.org
Fax: 01484 483150 Tel: 01484 483140

CROFTS Andrew
(Book Writing Services)
Westlands Grange, West Grinstead
Horsham, West Sussex RH13 8LZ
Website: www.andrewcrofts.com Tel/Fax: 01403 864518

DONOGHUE Phil
(International Artist and Film & Television Production
Designer)
6 Harbour House, Harbour Way
Shoreham Beach
West Sussex BN43 5HZ
Mobile: 07802 179801 Tel/Fax: 01273 465165

DYNAMIC FX Ltd
(Entertainers and Magic Consultants)
Regent House
291 Kirkdale, London SE26 4QD
e-mail: mail@dynamicfx.co.uk
Fax: 0845 0062443 Tel: 0845 0062442

EARLE Kenneth PERSONAL MANAGEMENT
214 Brixton Road
London SW9 6AP
Fax: 020-7274 9529 Tel: 020-7274 1219

EQUIP
11 Balmoral Road, Gidea Park
Romford, Essex RM2 5XD
Website: www.equip-u.com
e-mail: sales@equip-u.com Tel: 01708 479898

EQUITY INSURANCE SERVICES
131-133 New London Road
Chelmsford, Essex CM2 0QZ
Website: www.equity-ins-services.com
e-mail: enquiries@equity-ins-services.com
Fax: 01245 491641 Tel: 01245 357854

FACADE
(Creation & Production of Musicals)
43A Garthorne Road
London SE23 1EP
e-mail: facade@cobomedia.com Tel: 020-8291 7079

FERGUSON Jason
(Broadway & New York Theatre, General Management
Consultant)
Website: www.jasonpferguson.com
e-mail: jason@jasonpferguson.com
Fax: 00 44 800 471 5276

FILMANGEL
(Film Finance & Script Services)
110 Trafalgar Road
Portslade, East Sussex BN41 1GS
Website: www.filmangel.co.uk
e-mail: filmangels@freenetname.co.uk
Fax: 01273 705451 Tel: 01273 277333

FISHER BERGER & ASSOCIATES
(Chartered Accountants)
57 Elm Court Crescent
London NW11 9TA
e-mail: mail@fisherberger.com
Fax: 020-8458 9776 Tel: 020-8458 9770

FLAMES MARTIAL ARTS ACADEMY
(Adam Richards)
Unit 2, 128 Milton Road Business Park
Gravesend, Kent DA12 2PG
Website: www.kuentao.com
e-mail: arstunts@yahoo.co.uk Mobile: 07950 396389

FONTAINE Valley
(Broadcast Careers Mentor/Trainer)
Website: www.valleyfontaine.com
e-mail: info@valleyfontaine.com

FORD Jonathan & Co
(Chartered Accountants)
The Coach House
31 View Road
Rainhill, Merseyside L35 0LF
Website: www.jonathanford.co.uk
e-mail: info@jonathanford.co.uk Tel: 0151-426 4512

FULL EFFECT The
(Live Event Producers including Choreographers)
Exchange Building
16 St Cuthbert's Street
Bedford MK40 3JG
Website: www.thefulleffect.co.uk
e-mail: mark.harrison@tfe.co.uk
Fax: 01234 214445 Tel: 01234 269099

GHOSTWRITER
(John Parker)
21 Hindsleys Place, London SE23 2NF
Website: www.ghostwriteruk.co.uk
e-mail: parkerwrite@aol.com Tel: 020-8244 5816

GILMOUR Dr Glenn J. MscD, SHscD, BCMA
(International Personal Consultant, Clairvoyant, Healer &
Investigator of Psychic
Phenomena/Paranormal/Metaphysics)
Website: www.drglenngilmour.com Mobile: 07737 245103

GORDON LEIGHTON
(Chartered Accountants, Business Advisers)
3rd Floor, 20-23 Greville Street, London EC1N 8SS
Website: www.gordonl.co.uk
e-mail: markg@gordonl.com
Fax: 020-7831 0500 Tel: 020-7831 8300

HANDS UP PUPPETS
7 Cavendish Vale, Sherwood, Nottingham NG5 4DS
Website: www.handsuppuppets.com
e-mail: handsuppuppets@btinternet.com
 Tel: 020-7581 2478

HARLEY PRODUCTIONS
68 New Cavendish Street, London W1G 8TE
e-mail: harleyprods@aol.com
Fax: 020-8202 8863 Tel: 020-7580 3247

HARVEY MONTGOMERY Ltd
(Chartered Accountants)
3 The Fairfield, Farnham, Surrey GU9 8AH
Website: www.harveymontgomery.co.uk
e-mail: peter@harveymontgomery.co.uk
Fax: 01252 734394 Tel: 01252 734388

HATSTAND CIRCUS
(Specialist in Themed Performance for Events &
Promotions)
98 Milligan Street, Westferry, London E14 8AS
Website: www.hatstandcircus.co.uk
e-mail: helenahatstand@btconnect.com
Mobile: 07748 005839 Tel/Fax: 020-7538 3368

HATTON Richard Ltd
29 Roehampton Gate, London SW15 5JR
Fax: 020-8876 8278 Tel: 020-8876 6699

HAYES Susan
(Choreographer/Body Worker)
The Cottage
30 Wildwood Road, London NW11 6TP
e-mail: susan@kw4k.com
Mobile: 07721 927714 Tel/Fax: 020-8457 5950

HERITAGE RAILWAY ASSOCIATION
7 Robert Close, Potters Bar, Herts EN6 2DH
Website: www.heritagerailways.com Tel: 01707 643568

HEWETT Yvonne
(Freelance Television Director & Script Writer)
32 Thames Eyot, Cross Deep
Twickenham TW1 4QL Tel: 020-8892 1403

HOMEMATCH PROPERTY FINANCE
(Mortgages for Entertainers)
Eagle Place, Pheasant Street
Worcester WR1 2EE
e-mail: chrisjcatchpole@aol.com
Fax: 01905 22121 Tel: 01905 22007

HONRI Peter
(Music Hall Consultant)
1 Evingar Road, Whitchurch
Hants RG28 7EY Tel: 01256 892162

IMAGE DIGGERS
(Slide/Stills/Audio/Video Library & Theme Research)
618B Finchley Road, London NW11 7RR
Website: www.imagediggers.netfirms.com
e-mail: lambhorn@tiscali.co.uk Tel: 020-8455 4564

IMPACT AGENCY
(Public Relations)
3 Bloomsbury Place, London WC1A 2QL
e-mail: mail@impactagency.co.uk
Fax: 020-7580 7200 Tel: 020-7580 1770

I R A - INDEPENDENT REVIEWS ARTS SERVICES
(Stories from World of Film/Art/Showbiz)
12 Hemingford Close, London N12 9HF
e-mail: critic@independentradioarts.com
Mobile: 07956 212916 Tel/Fax: 020-8343 7437

JACKSON Kim
(Arts Education Consultancy)
1 Mellor Road, Leicester LE3 6HN
e-mail: kim@jacksongillespie.co.uk Tel: 0116-233 8432

JENKINS Andrew Ltd
(Venue & Production Consultancy, General Management)
St Martin's House
59 St Martin's Lane, London WC2N 4JS
Website: www.andrewjenkinsltd.com
e-mail: info@andrewjenkinsltd.com
Fax: 020-7240 0710 Tel: 020-7240 0607

JFL SEARCH & SELECTION
(Recruitment Consultants)
27 Beak Street, London W1F 9RU
Website: www.jflrecruit.com
Fax: 020-7734 6501 Tel: 020-7009 3500

JORDAN Richard PRODUCTIONS Ltd
(General Management, UK and International Productions, Festivals, Production Consultancy)
Mews Studios, 16 Vernon Yard, London W11 2DX
e-mail: richard.jordan@virgin.net
Fax: 020-7313 9667 Tel: 020-7243 9001

JOSHI CLINIC The
57 Wimpole Street, London W1G 8YW
Fax: 020-7486 9622 Tel: 020-7487 5456

KEAN LANYON Ltd
(Graphic Designers, PR & Marketing Consultants)
Rose Cottage, Aberdeen Centre
22 Highbury Grove, London N5 2EA
Website: www.keanlanyon.com
e-mail: iain@keanlanyon.com
Fax: 020-7359 0199 Tel: 020-7354 3362

KELLER Don
(Marketing Consultancy & Project Management)
65 Glenwood Road, Harringay, London N15 3JS
e-mail: info@dakam.org.uk
Fax: 020-8809 6825 Tel: 020-8800 4882

KERR John CHARTERED ACCOUNTANTS
369-375 Eaton Road, West Derby, Liverpool L12 2AH
e-mail: advice@jkca.co.uk
Fax: 0151-228 3792 Tel: 0151-228 8977

KIEVE Paul
(Magical Effects for Theatre & Film)
23 Terrace Road
South Hackney, London E9 7ES
Website: www.stageillusion.com
e-mail: mail@stageillusion.com Tel/Fax: 020-8985 6188

LAMBOLLE Robert
(Script Evaluation/Editing)
618B Finchley Road, London NW11 7RR
Website: www.readingandrighting.netfirms.com
e-mail: lambhorn@tiscali.co.uk Tel: 020-8455 4564

LARK INSURANCE BROKING GROUP
(Insurance Brokers)
Wigham House, Wakering Road
Barking, Essex IG11 8PJ
e-mail: mailbox@larkinsurance.co.uk
Fax: 020-8557 2430 Tel: 020-8557 2300

LEEP MARKETING & PR
(Marketing, Press and Publicity)
5 Nassau House
122 Shaftesbury Avenue, London W1D 5ER
e-mail: philip@leep.biz
Fax: 020-7439 8833 Tel: 020-7439 9777

LEO FILM & BOOKS AGENCY The
150 Minories, London EC3N 1LS
Website: www.leofilmagency.com
e-mail: info@leofilmagency.com
Fax: 08701 330258 Tel: 020-8905 5191

LOCATION TUTORS NATIONWIDE
(Fully Qualified/Experienced Teachers working with
Children on Film Sets and Covering all Key Stages of
National Curriculum)
16 Poplar Walk, Herne Hill
London SE24 0BU
e-mail: locationtutorsnationwide@hotmail.com
Fax: 020-7207 8794 Tel: 020-7978 8898

LONGREACH INTERNATIONAL Ltd
(Specialist Insurance Brokers)
20-21 Tooks Court, London EC4A 1LB
Website: www.longreachint.com
e-mail: info@longreachint.com
Fax: 020-7421 7550 Tel: 020-7421 7555

LOVE Billie HISTORICAL PHOTOGRAPHS
(Picture Research. Formerly 'Amanda' Theatrical
Portraiture)
3 Winton Street, Ryde
Isle of Wight PO33 2BX
Fax: 01983 616565 Tel: 01983 812572

MAKE IT AMERICA
Suite 04, 1838 El Cerrito Place
Hollywood CA90068
Website: www.makeitamerica.com
e-mail: info@makeitamerica.com
Fax: (323) 436-7561 Tel: (323) 404-1827

McCABE Michael
(Marketing Consultant)
32 Linhope Street
Marylebone, London NW1 6HU
Website: www.michaelmccabe.net
e-mail: mailbox@michaelmccabe.net
Fax: 020-7569 8705 Tel: 020-7569 8701

McGEES Ltd
(Accountants)
Third Floor, 15 King Street
Covent Garden, London WC2E 8HN
Website: www.mcgeesltd.co.uk
Fax: 020-7836 8632 Tel: 020-7836 4344

McKENNA Deborah Ltd
(Celebrity Chefs & Lifestyle Presenters)
Claridge House
29 Barnes High Street
London SW13 9LW
Website: www.deborahmckenna.com
e-mail: info@deborahmckenna.com
Fax: 020-8392 2462 Tel: 020-8876 7566

MEDIA LEGAL
(Education Services)
West End House, 83 Clarendon Road
Sevenoaks, Kent TN13 1ET Tel: 01732 460592

MILDENBERG Vanessa
(Choreographer/Movement Director)
Flat 2, 40 Brondesbury Villas
London NW6 6AB Mobile: 07796 264828

MILITARY ADVISORY & INSTRUCTION SPECIALISTS
(John Sessions) (Advice on Weapons, Drill, Period to
Present. Ex-Army Instructors)
e-mail: higgins5589@ntlworld.com Tel: 01904 491198

MINISTRY OF FUN
(Provision of Performers/PR Marketing Campaigns)
Unit 1, Suffolk Studios
127-129 Great Suffolk Street
London SE1 1PP
Website: www.ministryoffun.net
e-mail: james@ministryoffun.net
Fax: 020-7407 5763 Tel: 020-7407 6077

MODUS OPERANDI
(Military Consultants for Film, Television & Theatre)
Website: www.modusoperandi.org.uk
e-mail: info@modusoperandi.org.uk Mobile: 07714 758595

MORGAN Jane ASSOCIATES (JMA)
(Marketing & Media)
8 Heathville Road, London N19 3AJ
e-mail: morgans@dircon.co.uk
Fax: 020-7263 9877 Tel: 020-7263 9867

MOXON Paul
(Arranger & Composer)
c/o Sandra Singer Associates
21 Cotswold Road, Westcliff-on-Sea
Essex SS0 8AA
Website: www.sandrasinger.com
e-mail: sandrasinger@btconnect.com
Fax: 01702 339393 Tel: 01702 331616

MULLEN Julie
(Improvisors/Comedy Consultancy)
The Impro Lab, 34 Watts Lane
Teddington Lock TW11 8HQ Mobile: 07956 877839

NEATE Rodger PRODUCTION MANAGEMENT
15 Southcote Road, London N19 5BJ
e-mail: rneate@dircon.co.uk
Fax: 020-7697 8237 Tel: 020-7609 9538

CHARTERED ACCOUNTANTS
Business Advisers

GORDON LEIGHTON

20-23 Greville Street
London EC1N 8SS
website: www.gordonl.co.uk

Tel: +44(0)20 7831 8300
Fax: +44(0)20 7831 0500
e-mail: markg@gordonl.com

• STARTING A BUSINESS ? • NEW TO THE PROFESSION ? • TAX PROBLEMS ?
• FORMING A CIVIL PARTNERSHIP ? • NEED FRESH ADVICE ?

Fast, proactive service for Entertainment Industry Professionals to put your financial affairs in order.
For an initial no-obligation discussion, please call:
MARK GIBSON on Freephone: 0800 085 1258

NEOVISION
(Location & Production Services)
7 rue Gardiol
1218 Grand-Saconnex
Geneve, Switzerland
Website: www.neovisionprod.com
e-mail: info@neovisionprod.com
Fax: (41 22) 741 1208 Tel: (41 79) 357 5417

NUTOPIA-CHANG MUSIC
(Music for Film & Television)
Number 8
132 Charing Cross Road
London WC2H 0LA
Website: www.nutopia-chang.com
Fax: 029-2070 5725 Tel: 029-2071 3540

NWA-UK HAMMERLOCK
(Wrestling Events, Training & Promotion)
PO Box 282, Ashford, Kent TN23 7ZZ
e-mail: nwauk@hammerlockwrestling.com
 Tel/Fax: 01233 663828

NYMAN LIBSON PAUL
(Chartered Accountants)
Regina House
124 Finchley Road
London NW3 5JS
Website: www.nlpca.co.uk
e-mail: entertainment@nlpca.co.uk
Fax: 020-7433 2401 Tel: 020-7433 2400

ORANGE TREE STUDIO Ltd & MUSIC SERVICES
(Original Music/Composition & Production)
PO Box 99
Kings Langley WD4 8FB
Website: www.orangetreestudio.com
e-mail: richard@orangetreestudio.com
Mobile: 07768 146200 Tel: 01923 440550

PB PRODUCTIVE
(Photographers' Agent. Shoot, Production & Event
Management)
2 Netherfield Road, London SW17 8AZ
Website: www.pbproductive.com
e-mail: info@pbproductive.com
Mobile: 07957 424776 Tel/Fax: 020-8767 7237

PLANISPHERES
(Buisness & Legal Affairs)
Sinclair House
2 Sinclair Gardens, London W14 0AT
Website: www.planispheres.com
e-mail: info@planispheres.com Tel/Fax: 020-7602 2038

PRODUCTIONS & PROMOTIONS Ltd
Apsley Mills Cottage
London Road
Hemel Hempstead, Herts HP3 9QU
Website: www.prodmotions.com
e-mail: reception@prodmotions.com
Fax: 0845 0095540 Tel: 01442 233372

PSYCHOLOGY GROUP The
(Expert Opinion, Assessments, Psychotherapy &
Counselling, Presentation. Nationwide Service)
Website: www.psychologygroup.co.uk
e-mail: info@psychologygroup.co.uk
Fax: 0845 2805243 Tel: 0870 6092445

PUPPET CENTRE TRUST
(Development & Advocacy Agency for Puppetry
& Related Theatre)
BAC Lavender Hill
London SW11 5TN
Website: www.puppetcentre.org.uk
e-mail: pct@puppetcentre.org.uk Tel: 020-7228 5335

RIPLEY-DUGGAN PARTNERSHIP The
(Tour Booking)
52 Tottenham Street
London W1T 4RN
e-mail: info@ripleyduggan.com Tel: 020-7436 1392

ROBERTS Simon
(Arranger & Composer)
c/o Sandra Singer Associates
21 Cotswold Road
Westcliff-on-Sea, Essex SS0 8AA
Website: www.sandrasinger.com
e-mail: sandrasinger@btconnect.com
Fax: 01702 339393 Tel: 01702 331616

SHAW Bernard
(Specialist in Recording & Directing Voice Tapes)
Horton Manor
Canterbury CT4 7LG
Website: www.bernardshaw.co.uk
e-mail: bernard@bernardshaw.co.uk Tel/Fax: 01227 730843

SINCLAIR Andy
(Mime)
31 Clissbury Gradens
Worthing, West Sussex BN14 0DY
Website: www.andyjsinclair.co.uk
e-mail: andynebular@hotmail.com Mobile: 07831 196675

CONSULTANTS

www.spotlight.com

SPEAKERPOWER.CO.UK
(Speech Training)
48 Fellows Road, London NW3 3LH
Website: www.speakerpower.co.uk
e-mail: barbara@speakerpower.co.uk
Fax: 020-7722 5255 Tel: 020-7586 4361

SPENCER Ivor
(Professional Toastmaster, Events Organiser & Principal of
Ivor Spencer International School for Butlers)
12 Little Bornes, Dulwich, London SE21 8SE
Website: www.ivorspencer.com
Fax: 020-8670 0055 Tel: 020-8670 5585

SPORTS WORKSHOP PROMOTIONS Ltd
(Production Advisors, Sport, Stunts, Safety)
PO Box 878
Crystal Palace National Sports Centre, London SE19 2BH
e-mail: info@sportspromotions.co.uk
Fax: 020-8776 7772 Tel: 020-8659 4561

STAGE CRICKET CLUB
(Cricketers & Cricket Grounds)
39-41 Hanover Steps
St George's Fields, Albion Street, London W2 2YG
Website: www.stagecc.co.uk
e-mail: brianjfilm@aol.com
Fax: 020-7262 5736 Tel: 020-7402 7543

STUNT ACTION SPECIALISTS (S.A.S.)
(Corporate & TV Stunt Work)
110 Trafalgar Road
Portslade, East Sussex BN41 1GS
Website: www.stuntactionspecialists.com
e-mail: wayne@stuntactionspecialists.co.uk
Fax: 01273 708699 Tel: 01273 230214

SUMMERS David & COMPANY
(Chartered Accountants)
Argo House, Kilburn Park Road, London NW6 5LF
e-mail: dsummersfca@hotmail.com
Fax: 020-7644 0678 Tel: 020-7644 0478

TAG FORCE
(Police Personnel & Tactical Arms Group Inc./Riot Police
with Shields)
59 Sylvan Avenue, Wood Green, London N22 5JA
Website: www.tagforce.co.uk
e-mail: info@tagforce.co.uk
Mobile: 07757 279891 Tel: 020-8552 4510

TARLO LYONS
(Solicitors)
Watchmaker Court
33 St John's Lane, London EC1M 4DB
Website: www.tarlolyons.com
e-mail: info@tarlolyons.com
Fax: 020-7814 9421 Tel: 020-7405 2000

TAYLOR Chris
(Arts Administration)
1 Chichester Terrace, Brighton BN2 1FG
e-mail: christaylor@toucansurf.com Tel: 01273 625132

TECHNICAL ADVISOR
(Spencer Duffy, Weapons Training & Tactical Advice)
e-mail: info@swat-uk.co.uk
Mobile: 07921 954218 Tel: 01634 261703

THEATRE PROJECTS CONSULTANTS
4 Apollo Studios, Charlton Kings Road, London NW5 2SW
Website: www.tpcworld.com
Fax: 020-7284 0636 Tel: 020-7482 4224

SPOTLIGHT PUBLICATIONS
SPOTLIGHT INTERACTIVE
SPOTLIGHT SERVICES

www.spotlight.com

The pulse of the profession

TODD Carole
(Director/Choreographer)
c/o Chris Davis, International Artistes (Midlands Office)
Lapley Hall
Lapley, Staffs ST19 9JR
Website: www.caroletodd.me.uk
e-mail: cdavis@intart.co.uk
Fax: 01785 841992 Tel: 01785 841991

TODS MURRAY LLP
(Richard Findlay Entertainment Lawyer)
Edinburgh Quay
133 Fountainbridge
Edinburgh EH3 9AG
e-mail: richard.findlay@todsmurray.com
Fax: 0131-656 2023 Tel: 0131-656 2000

UK THEATRE AVAILABILITY
(Bookings Service for Theatre Producers)
3 Grand Union Walk
Camden Town
London NW1 9LP
Website: www.uktheatreavailability.co.uk
e-mail: info@uktheatreavailability.co.uk Tel: 020-8455 3278

UNITED KINGDOM COPYRIGHT BUREAU
(Script Services)
110 Trafalgar Road
Portslade, East Sussex BN41 1GS
Website: www.copyrightbureau.co.uk
e-mail: info@copyrightbureau.co.uk
Fax: 01273 705451 Tel: 01273 277333

UPFRONT TELEVISION Ltd
(Celebrity Booking for Events)
39-41 New Oxford Street
London WC1A 1BN
Website: www.celebritiesworldwide.com
e-mail: info@upfronttv.com
Fax: 020-7836 7701 Tel: 020-7836 7702

VANTIS
(Accountants. Business & Tax Advisers)
Torrington House, 47 Holywell Hill
St Albans, Hertfordshire AL1 1HD
Website: www.vantisplc.com
e-mail: stalbans@vantisplc.com
Fax: 01727 861052 Tel: 01727 838255

VENTURINO Antonio
(Commedia dell'arte, Mask Specialist & Movement Director)
Coup de Masque
97 Moore Road
Mapperley, Nottingham NG3 6EJ
e-mail: a-and-t@coup-de-masque.fsnet.co.uk
 Tel/Fax: 0115-985 8409

VERNON Doremy
(Author 'Tiller Girls'/Archivist/Dance Routines Tiller
Girl Style)
16 Ouseley Road
London SW12 8EF Tel/Fax: 020-8767 6944

WELBOURNE Jacqueline
(Circus Trainer, Choreographer, Consultant)
c/o Circus Maniacs Agency
Office 8A, The Kingswood Foundation
Britannia Road, Kingswood, Bristol BS15 8DB
e-mail: jackie@circusmaniacs.com
Mobile: 07977 247287 Tel/Fax: 0117-947 7042

WHITE Leonard
(Production & Script Consultant)
Highlands, 40 Hill Crest Road
Newhaven, Brighton
East Sussex BN9 9EG
e-mail: leoguy.white@virgin.net Tel: 01273 514473

WIDDOWSON Alexis CHARTERED ACCOUNTANTS
1 High Street
Welford, Northants NN6 6HT
e-mail: alexiswiddowson@aol.com Tel/Fax: 01858 575734

WILD DREAM CONSULTANCY
(Audition Skills, Public Speaking, Confidence & Personal
Development) Tel: 020-8374 3924

WISE MONKEY FINANCIAL COACHING
(Simonne Gnessen)
14 Eastern Terrace Mews
Brighton BN2 1EP
Website: www.financial-coaching.co.uk
e-mail: simonne@financial-coaching.co.uk Tel: 01273 691223

YOUNG BLOOD Ltd
(Dramatic Action Specialists)
The Rag Factory
16-18 Heneage Street
London E1 5LJ
Website: www.youngblood.co.uk
e-mail: info@youngblood.co.uk Tel: 0845 6449418

YOUNT Bret
(Fight Director, Sword Master, Pre-Production Coaching &
Consultation)
e-mail: swordsman@compuserve.com Mobile: 07958 398207

Rosemarie Swinfield
m a k e - u p d e s i g n e r

Rosie's Make-up Box
6 Brewer Street Soho London W1R 3FS
m: 07976-965520 t: 0845 408 2415
e: rosemarie@rosiesmake-up.co.uk

Author of:
* Stage Make-Up Step By Step
* Period Make-Up For The Stage
* Hair And Wigs For The Stage

Also
Courses, Workshops & Seminars

Hitchcock Blonde Photo: Gautier De Blonde

Diamond Lil Photo: Robert Workman

ACADEMY COSTUMES
50 Rushworth Street, London SE1 0RB
Website: www.academycostumes.com
e-mail: info@academycostumes.com
Fax: 020-7928 6287 Tel: 020-7620 0771

AJ COSTUMES Ltd
(Theatrical Costume Hire, Design & Making)
Sullom Lodge, Sullom Side Lane
Barnacre, Garstang PR3 1GH
Website: www.trendsgroup.co.uk
e-mail: info@trendsgroup.co.uk
Fax: 01253 407715 Tel: 0871 2003343

ALL-SEWN-UP
Mechanics Institute
7 Church Street, Heptonstall, West Yorks HX7 7NS
Website: www.allsewnup.org.uk
e-mail: nwheeler_allsewnup@hotmail.com
Fax: 01422 845070 Tel: 01422 843407

ANELLO & DAVIDE
(Handmade Shoes)
15 St Albans Grove, London W8 5BP Tel: 020-7938 2255

ANGELS
(Fancy Dress & Revue)
119 Shaftesbury Avenue, London WC2H 8AE
Website: www.fancydress.com
e-mail: party@fancydress.com
Fax: 020-7240 9527 Tel: 020-7836 5678

ANGELS THE COSTUMIERS
1 Garrick Road, London NW9 6AA
Website: www.angels.uk.com
e-mail: angels@angels.uk.com
Fax: 020-8202 1820 Tel: 020-8202 2244

ANGELS WIGS
(Wig Hire/Makers, Facial Hair Suppliers)
1 Garrick Road, London NW9 6AA
Website: www.angels.uk.com
e-mail: wigs@angels.uk.com
Fax: 020-8202 1820 Tel: 020-8202 2244

ANTOINETTE COSTUME HIRE
(Stage, Screen and Fancy Dress)
10A Dartmouth Road, London SE23 3XU
Website: www.costumehirelondon.com
e-mail: antoinettehire@aol.com
Fax: 020-8699 1107 Tel: 020-8699 1913

ARMS & ARCHERY
(Armour, Weaponry, Chain Mail, Warrior Costumes, Tents)
The Coach House, London Road, Ware, Herts SG12 9QU
e-mail: armsandarchery@btconnect.com
Fax: 01920 461044 Tel: 01920 460335

ATTLE Jamie COSTUME MAKER
4 Toynbee Road, Wimbledon, London SW20 8SS
e-mail: aalexiscolby@aol.com Tel/Fax: 020-8540 3044

BAHADLY R
(Hair & Make-up Specialist, incl. Bald Caps, Ageing & Casualty)
48 Ivy Meade Road
Macclesfield, Cheshire
Mobile: 07973 553073 Tel: 01625 615878

BBC COSTUME & WIGS
172-178 Victoria Road, North Acton, London W3 6UL
Website: www.bbcresources.co.uk/costumewig
e-mail: costume@bbc.co.uk
Fax: 020-8993 7040 Tel: 020-8576 1761

BEJEWELLED STAGE JEWELLERY
23 Glenrise Close, St Mellows, Cardiff CF3 0AS
Website: www.stagejewellery.co.uk
e-mail: info@stagejewellery.co.uk
Mobile: 07980 242616 Tel/Fax: 029-2021 6655

BERTRAND Henry
(London Stockhouse for Silk)
52 Holmes Road, London NW5 3AB
Website: www.henrybertrand.co.uk
e-mail: sales@henrybertrand.co.uk
Fax: 020-7424 7001 Tel: 020-7424 7000

BIBA LIVES VINTAGE CLOTHING
Alfies Antiques Market
13-25 Church Street, London NW8 8DT
Website: www.bibalives.com
e-mail: bibalives@aol.com Tel: 020-7258 7999

BIRMINGHAM COSTUME HIRE
Suites 209-210, Jubilee Centre
130 Pershore Street, Birmingham B5 6ND
e-mail: info@birminghamcostumehire.co.uk
Fax: 0121-622 2758 Tel: 0121-622 3158

BISHOP Kerry
(Hair & Make-up Artist)
Flat 4, 49 Upper Rock Gardens
Brighton, East Sussex BN2 1QF
e-mail: kerrybishop@email.com Mobile: 07759 704394

BOSANQUET Pamela COSTUME SERVICES
2 Lebanon Park, Twickenham TW1 3DG
e-mail: pamelabosanquet@yahoo.co.uk
Fax: 020-8891 6259 Tel: 020-8891 4346

BRIGGS Ron DESIGN
(Costume Making, Costume Design)
1 Bedford Mews, London N2 9DF
e-mail: costumes@ronbriggs.com Tel: 020-8444 8801

BRYAN PHILIP DAVIES COSTUMES
(Lavish Pantomime, Musical Shows, Opera)
68 Court Road
Lewes, East Sussex BN7 2SA
Website: www.bpdcostumes.co.uk
e-mail: bryan@bpdcostumes.force9.co.uk
Mobile: 07931 249097 Tel/Fax: 01273 481004

BURLINGTONS
(Hairdressers)
14 John Princes Street, London W1G 0JS
Website: www.burlingtonsuk.com Tel: 0870 8701299

CALICO FABRICS
(Suppliers of Unbleached Calico & other Fabrics for Stage,
Costumes, Backdrops etc)
3 Ram Passage, High Street
Kingston-upon-Thames KT1 1HH
Website: www.calicofabrics.co.uk
e-mail: sales@calicofabrics.co.uk
Fax: 020-8546 7755 Tel: 020-8541 5274

CAPEZIO
(Dance Products)
95 Whiffler Road, Norwich, Norfolk NR3 2AW
Website: www.capeziodance.com
e-mail: eusales@balletmakers.com
Fax: 01603 788900 Tel: 01603 405522

CAVALCADE COSTUMES
(Period & Light Entertainment Costumes, Single Outfits to
Full Productions)
57 Pelham Road, London SW19 1NW
Fax: 020-8540 2243 Tel: 020-8540 3513

CHRISANNE Ltd
(Specialist Fabrics & Accessories)
Chrisanne House, 14 Locks Lane
Mitcham, Surrey CR4 2JX
Website: www.chrisanne.com
e-mail: sales@chrisanne.co.uk
Fax: 020-8640 2106 Tel: 020-8640 5921

COLTMAN Mike
(See COSTUME CONSTRUCTION)

COOK Sheila TEXTILES
(Vintage Textiles, Costumes & Accessories for Sale)
(By Appointment)
184 Westbourne Grove, London W11 2RH
Website: www.sheilacook.co.uk
e-mail: sheilacook@sheilacook.co.uk Tel: 020-7792 8001

COSPROP Ltd
(Costumes & Accessories)
469-475 Holloway Road, London N7 6LE
Website: www.cosprop.com
e-mail: enquiries@cosprop.com
Fax: 020-7561 7310 Tel: 020-7561 7300

COSTUME CONSTRUCTION
(Costumes, Masks, Props, Puppets)
Studio 1, Croft Street, Cheltenham GL53 0EE
Website: www.costumeconstruction.co.uk
 Tel/Fax: 01242 581847

COSTUME GUIDE The
(Products & Suppliers Directory)
PO Box 54229, London W14 0SE
e-mail: enquiries@thecostumeguide.com Tel: 020-7602 2857

COSTUME SOLUTIONS
43 Rowan Road, London W6 7DT
Website: www.costumesolutions.co.uk
e-mail: karen@costumesolutions.co.uk Tel: 020-7603 9035

COSTUME STORE Ltd The
(Costume Accessories)
16 Station Street, Lewes, East Sussex BN7 2DB
Website: www.thecostumestore.co.uk
Fax: 01273 477191 Tel: 01273 479727

COSTUME STUDIO Ltd
(Costumes & Wigs)
Montgomery House
159-161 Balls Pond Road
London N1 4BG
Website: www.costumestudio.co.uk
e-mail: costume.studio@btconnect.com
Tel/Fax: 020-7837 6576 Tel: 020-7275 9614

COSTUMIA
Unit 9, Hockley Goods Yard
Pitsford Street, Hockley
Birmingham B18 6PT
Website: www.costumia.co.uk
e-mail: costumia@hotmail.co.uk Tel: 0121-551 2710

COUNTY DRAMA WARDROBE
(Costumes & Wigs - Hire only - & Make-up for Sale)
25 Gwydir Street
Cambridge CB1 2LG Tel: 01223 313423

CRAZY CLOTHES CONNECTION
(1920's-1970's for Sale or Hire)
134 Lancaster Road, Ladbroke Grove
London W11 1QU Tel: 020-7221 3989

DANCIA INTERNATIONAL
187 Drury Lane, London WC2B 5QD
Website: www.dancia.co.uk
e-mail: sales@dancia.co.uk Tel/Fax: 020-7831 9483

DESIGNER ALTERATIONS
(Restyling & Remodelling of Clothes & Costumes)
220A Queenstown Road
Battersea, London SW8 4LP
Website: www.designeralterations.com
Fax: 020-7622 4148 Tel: 020-7498 4360

EASTON Derek
(Wigs For Theatre, Film & TV)
1 Dorothy Avenue
Peacehaven, East Sussex BN10 8LP
Website: www.derekeastonwigs.co.uk
Mobile: 07768 166733 Tel/Fax: 01273 588262

EDA ROSE MILLINERY
(Ladies' Model Hat Design & Manufacture)
Lalique, Mongewell
Wallingford, Oxon OX10 8BP
Website: www.edarosehats.com
Fax: 01491 835909 Tel: 01491 837174

FOX Charles H. Ltd
(Professional Make-up & Wigs)
22 Tavistock Street, London WC2E 7PY
Website: www.charlesfox.co.uk
Fax: 0870 2001369 Tel: 0870 2000369

FREED OF LONDON
(Dancewear & Dance Shoes)
94 St Martin's Lane, London WC2N 4AT
Website: www.freedoflondon.com
e-mail: shop@freed.co.uk
Fax: 020-7240 3061 Tel: 020-7240 0432

FUNN Ltd
(Silk, Cotton Wool Stockings, Opaque Opera Tights & 40's Rayon Stockings)
PO Box 102, Steyning, West Sussex BN44 3EB
e-mail: funn.biz@lycos.com
Fax: 0870 1361780　　　　　　　　Tel: 0870 8810560

GAMBA AND REPETTO
Pointe Shoes & Dancewear
22 rue de la Paix
75002 Paris
UK Marketing: Gavin Roebuck
e-mail: info@gavinroebuck.com　　Tel: 020-7370 7324

GAMBA THEATRICAL
(See THEATRICAL FOOTWEAR COMPANY Ltd The)

GAV NICOLA THEATRICAL FOOTWEAR
West Wick, Marshes, Burnham-on-Crouch, Essex CMO 8NE
e-mail: sale@gavnicola.freeserve.co.uk
Mobile: 07961 974278　　　　　Tel/Fax: 01621 785623

GILLHAM Felicite
(Wig Makers for Theatre, Opera & Film)
Trendle Cottage
Trendle Street, Sherborne, Dorset DT9 3NT
e-mail: f.gillham.wigs@gmx.net
Mobile: 07802 955908　　　　　　Tel: 01935 814328

HAIRAISERS
(Wigs)
9-11 Sunbeam Road, Park Royal, London NW10 6JP
Website: www.hairaisers.com
Fax: 020-8963 1600　　　　　　　Tel: 020-8965 2500

HAND & LOCK
86 Margaret Street, London W1W 8TE
e-mail: enquiries@hand-embroidery.co.uk
Fax: 020-7580 7499　　　　　　　Tel: 020-7580 7488

HARVEYS OF HOVE
(Theatrical Costumes & Military Specialists)
110 Trafalgar Road, Portslade, Sussex BN41 1GS
Website: www.harveysofhove.co.uk
e-mail: harveys.costume@ntlworld.com
Fax: 01273 708699　　　　　　　Tel: 01273 430323

HERALD & HEART HATTERS
(Men's & Women's Hats & Headdresses - Period & Modern)
102 High Street, Rye, East Sussex TN31 7JN
Website: www.heraldandheart.com
e-mail: enquiries@heraldandheart.com　　Tel: 01797 225261

HIREARCHY
(Classic & Contemporary Costume)
45-47 Palmerston Road
Boscombe, Bournemouth, Dorset BH1 4HW
Website: www.hirearchy.co.uk
e-mail: hirearchy1@aol.com　　　　Tel: 01202 394465

HODIN Annabel
(Costume Designer/Stylist)
12 Eton Avenue, London NW3 3EH
e-mail: annabelhodin@aol.com
Mobile: 07836 754079　　　　　　Tel: 020-7431 8761

INCE Katie
(Wig Maker & Make-up Artist)
58 Albert Road, Retford, Nottinghamshire DN22 6JB
e-mail: katieince@gmail.com　　　Tel: 07900 250853

INTERNATIONAL COLLECTIVE (I.N.C.)
Golden Cross House
8 Duncannon Street, The Strand
London WC2N 4JF
Website: www.internationalcollective.co.uk
e-mail: enquiries@internationalcollective.co.uk
Fax: 020-7484 5100　　　　　　　Tel: 020-7484 5080

INTERNATIONAL DANCE SUPPLIES/GRISHKO UK Ltd
(Importer & Distributor of Dance Shoes and Dancewear)
64 Butt Lane, Milton
Cambridge CB4 6DG
Website: www.grishko.co.uk
e-mail: info@grishko.co.uk
Fax: 01223 861490　　　　　　　Tel: 01223 861425

JULIETTE DESIGNS
(Diamante Jewellery Manufacturers)
90 Yerbury Road, London N19 4RS
Website: stagejewellery.com
Fax: 020-7281 7326　　　　　　　Tel: 020-7263 7878

K & D Ltd
(Footwear)
Unit 7A, Thames Road Industrial Estate
Thames Road, Silvertown, London E16 2EZ
Website: www.shoemaking.co.uk
e-mail: k&d@shoemaking.co.uk
Fax: 020-7476 5220 Tel: 020-7474 0500

LANDSFIELD Warren
(Period Legal Wigs)
47 Glenmore Road
London NW3 4DA Tel: 020-7722 4581

LAURENCE CORNER THEATRICALS
(Theatrical Costumiers - Militaria, Uniforms - Hire & Sale)
62-64 Hampstead Road, London NW1 2NU
Fax: 020-7813 1413 Tel: 020-7813 1010

LEWIS HENRY Ltd
(Dress Makers)
111-113 Great Portland Street
London W1W 6QQ Tel: 020-7636 6683

LOTTIE
(Childrens' Period Costume Hire)
Unit 10, Omega Works
167 Hermitage Road, London N4 1LZ
Website: www.lottiecostumehire.com
e-mail: info@lottiecostumehire.com Tel/Fax: 020-8211 8200

MADDERMARKET THEATRE COSTUME HIRE
(Period Clothing, Costume Hire & Wig Hire)
St John's Alley
Norwich NR2 1DR
Website: www.maddermarket.co.uk
e-mail: mmtheatre@btconnect.com
Fax: 01603 661357 Tel: 01603 626292

MINHA CASA LIMITED Suppliers of:
Female Samba Dance Bikinis and Headdresses
Ostrich & Coque Feathers
Feather & Marabou Boas
Salsa / Latin Dance Dresses
Professional "Kryolan" Cosmetics
Loose Cosmetic Glitter
Fully Sequinned Two-Piece Dresses & Ball Gowns

MINHA CASA LIMITED
51 Chalk Farm Road, London NW1 8AN
T: +44 (0)207 428 6900 F: +44 (0) 207 428 6901
www.minha-casa.co.uk

MAKEUP CENTRE The
(Make-up Training & Supplies)
Ealing Studios, Building D
2nd Floor, Ealing Green, London W5 5EP
Website: www.themake-upcentre.co.uk
e-mail: info@themake-upcentre.co.uk Tel/Fax: 020-8579 9511

MASK Kim
(Costume & Make-up Protection masks)
PO Box 37876, London SE23 3ZJ
Website: www.kimmask.com
e-mail: info@kimmask.com Tel: 08450 568482

MASON Sophia
(Hair & Make-up Artist)
24 Churchfields
Burpham, Guildford GU4 7NH
Website: www.sophiamason.co.uk
e-mail: sophia@facetime.co.uk Mobile: 07880 720013

MASTER CLEANERS The
(Theatrical Costumes & Antique Garments)
189 Haverstock Hill
London NW3 4QG Tel: 020-7431 3725

McKAY Glynn MASKS
(Specialists in Special Effect Make-up)
11 Mount Pleasant
Framlingham, Suffolk IP13 9HQ
Mobile: 07780 865073 Tel/Fax: 01728 723865

MEANANDGREEN.COM
17 Lichfield Street
Wolverhampton WV1 1EA
Website: www.meanandgreen.com
e-mail: custserv@meanandgreen.com
Fax: 01902 425564 Tel: 01902 423868

MIDNIGHT
Costume Design & Wardrobe Services
(Music, Theatre, Film, Tours)
e-mail: midnight_wardrobe@hotmail.com
 Mobile: 07722 882847

MINHA CASA Ltd
51 Chalk Farm Road
London NW1 8AN
Website: www.minha-casa.co.uk
Fax: 020-7428 6901 Tel: 020-7428 6900

MUMFORD Jean
(Costume Maker)
36 Ainsdale, Harrington Street
London NW1 3SD Mobile: 07944 601582

NATIONAL THEATRE
(Costume & Furniture Hire)
Chichester House
Kennington Park Estate
1-3 Brixton Road
London SW9 6DE
e-mail: costume_hire@nationaltheatre.org.uk
Tel: 020-7735 4774 (Costume) Tel: 020-7820 1358 (Props)

NEW ID
(Makeover & Photographic Studios)
Third Floor
17-18 Margaret Street, London W1W 8RP
Website: www.newidstudios.com
e-mail: bookings@newidstudios.co.uk Tel: 0870 8701299

NORMAN Sam
(Hair & Make-up)
Website: www.samnorman.co.uk
e-mail: sam@samnorman.co.uk Mobile: 07932 397465

REALISTIC NON-STAIN BLOOD TEL/FAX **01728 723865**

ORIGINAL KNITWEAR
(Inc. Fake Fur) (Gina Pinnick)
Avalon, Tregoney Hill
Mevagissey, Cornwall PL26 6RG
e-mail: okgina@mevweb.com
Mobile: 07957 376855 Tel/Fax: 01726 844807

PATEY (LONDON) Ltd
Unit 1, 9 Gowlett Road
London SE15 4HX
Website: www.pateyhats.com
e-mail: pateyhats@aol.com
Fax: 020-7732 9538 Tel: 020-7635 0030

PINK POINTES DANCEWEAR
1A Suttons Lane
Hornchurch, Essex RM12 6RD
e-mail: pink.pointes@btconnect.com Tel/Fax: 01708 438584

PLAYHOUSE ENTERTAINMENT GROUP
48 Langstone Road
Warstock, Birmingham B14 4QS
Website: www.playhousecostumes.co.uk
e-mail: enquiries@playhousecostumes.co.uk
Tel/Fax: 0121-474 6984

POLAND DENTAL STUDIO
(Film/Stage Dentistry)
1 Devonshire Place, London W1G 6HH
e-mail: polandslab@aol.com
Fax: 020-7486 3952 Tel: 020-7935 6919

PORSELLI
9 West Street
Cambridge Circus, London WC2H 9NE
Website: www.porselli.com
e-mail: porselliuk@aol.com
Fax: 020-7836 6171 Tel: 020-7836 2862

PROBLOOD
11 Mount Pleasant, Framlingham
Suffolk IP13 9HQ Tel/Fax: 01728 723865

PULLON PRODUCTIONS
(Costumiers)
St George's Studio, Wood End Lane
Fillongley, Coventry CV7 8DF
Website: www.pm-productions.co.uk Tel/Fax: 01676 541390

RAINBOW PRODUCTIONS Ltd
(Manufacture & Handling of Costume Characters)
Rainbow House
56 Windsor Avenue, London SW19 2RR
Website: www.rainbowproductions.co.uk
e-mail: info@rainbowproductions.co.uk
Fax: 020-8545 0777 Tel: 020-8545 0700

REPLICA WAREHOUSE
(Costumiers & Props)
200 Main Road
Goostrey, Cheshire CW4 8PD
Website: www.replicawarehouse.co.uk
e-mail: lesleyedwards@replicawarehouse.co.uk
Tel/Fax: 01477 534075

ROBBINS Sheila
(Costumes & Wigs)
Broombarn, 7 Ivy Cottages
Hinksey Hill, Oxford OX1 5BQ Tel/Fax: 01865 735524

ROLANDI Gianluca
(Hair & Make-up)
83 Deroy Lodge
Wicklow Street
London WC1X 3LF
Website: www.gluca.co.uk
e-mail: gluca@gluca.co.uk Mobile: 07990 637299

ROYAL EXCHANGE THEATRE COSTUME HIRE
(Period Costumes & Accessories)
47-53 Swan Street
Manchester M4 5JY
Website: www.royalexchange.co.uk
e-mail: costume.hire@royalexchange.co.uk
Tel/Fax: 0161-615 6800

ROYAL LYCEUM THEATRE COMPANY
(Theatrical Costume Hire)
29 Roseburn Street, Edinburgh EH12 5PE
Website: www.lyceum.org.uk
Fax: 0131-346 8072 Tel: 0131-337 1997

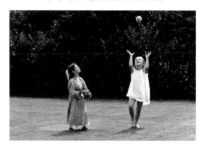

ROYAL SHAKESPEARE COMPANY COSTUME HIRE
Timothy's Bridge Road
Stratford-upon-Avon
Warwickshire CV37 9UY Tel/Fax: 01789 205920

ROYER Hugo INTERNATIONAL Ltd
(Hair & Wig Materials)
10 Lakeside Business Park
Swan Lane, Sandhurst
Berkshire GU47 9DN
Website: www.hugoroyer.com
e-mail: enquiries@royer.co.uk
Fax: 01252 878852 Tel: 01252 878811

RUMBLE Jane
(Masks, Millinery, Helmets Made to Order)
121 Elmstead Avenue
Wembley, Middlesex HA9 8NT Tel: 020-8904 6462

RUSSELL HOWARTH Ltd
35 Hoxton Square, London N1 6NN
Fax: 020-7729 0107 Tel: 020-7739 6960

SCOTT Allan COSTUMES
(Costume Hire, Stage, Film & TV)
Offley Works, Unit F, Prima Road
London SW9 0NA Tel: 020-7793 1197

SEXTON Sally Ann
(Hair & Make-up Designer)
c/o 52 Forty Avenue, Wembley, Middlesex NW9
e-mail: theharrisagency@ukonline.co.uk
Mobile: 07973 802842 Tel: 020-8908 4451

SIDE EFFECTS
(Custom-made Character/FX Costumes)
92 Fentiman Road, London SW8 1LA
e-mail: sfx@lineone.net
Fax: 020-7207 0062 Tel: 020-7857 1116

SINGER Sandra ASSOCIATES
(Make-up Artists, Set Design)
21 Cotswold Road
Westcliff-on-Sea, Essex SS0 8AA
Website: www.sandrasinger.com
e-mail: sandrasinger@btconnect.com
Fax: 01702 339393 Tel: 01702 331616

SLEIMAN Hilary
(Specialist & Period Knitwear)
72 Godwin Road, London E7 0LG
Website: www.hilarysleiman.co.uk
e-mail: hilary.sleiman@ntlworld.com
Mobile: 07940 555663 Tel: 020-8555 6176

SOFT PROPS
(Costume & Model Makers)
92 Fentiman Road, London SW8 1LA
e-mail: jackie@softprops.co.uk
Fax: 020-7207 0062 Tel: 020-7587 1116

SQUIRES & JOHN'S
(Theatrical Costume Hire, Design & Making)
Sullom Lodge, Sullom Side Lane
Barnacre, Garstang PR3 1GH
Website: www.trendsgroup.co.uk
e-mail: info@trendsgroup.co.uk
Fax: 01253 407715 Tel: 0871 2003343

STAGEWORKS WORLDWIDE PRODUCTIONS
(Largest Costume Wardrobe in North)
525 Ocean Boulevard
Blackpool FY4 1EZ
Website: www.stageworkswwp.com
e-mail: simon.george@stageworkswwp.com
Fax: 01253 342702 Tel: 01253 342427

STRIBLING Joan
(Film & Television Make-up, Hair & Prosthetic Designer,
BAFTA. D & AD Awards)
3 Richmond Avenue
Ilfracombe, Devon EX34 8DQ
Website: www.ilfracom.org.uk/stribling
e-mail: joanstribling@hotmail.com Mobile: 07791 758480

SWINFIELD Rosemarie
(Make-up Design & Training)
Rosie's Make-Up Box
6 Brewer Street, Soho, London W1R 3FS
Website: www.rosiesmake-up.co.uk
e-mail: rosemarie@rosiesmake-up.co.uk
Mobile: 07976 965520 Tel: 0845 4082415

TALK TO THE HAND PUPPETS
(Custom Puppets for Television & Theatre)
Studio 268, Wimbledon Art Studios
Riverside Yard, Riverside Road
Earlsfield, London SW17 0BB
Website: www.talktothehandproductions.com
e-mail: info@talktothehandproductions.com
Mobile: 07813 682293 Mobile: 07855 421454

THEATREKNITS
102C Belgravia Workshops
157-163 Marlborough Road, London N19 4NF
e-mail: trevorcollins@blueyonder.co.uk
Tel/Fax: 020-7561 0044

THEATRICAL FOOTWEAR COMPANY Ltd The
(Trading as GAMBA Theatrical)
Unit 14, Chingford Industrial Centre
Hall Lane, Chingford, London E4 8DJ
e-mail: gambatheatrical@tiscali.co.uk
Fax: 020-8529 7995 Tel: 020-8529 9195

THE VINTAGE SHIRT COMPANY
The Old Coach House
Castle Ditch Lane
Lewes, East Sussex BN7 1YJ
Website: www.vintageshirt.co.uk
e-mail: info@vintageshirt.co.uk Tel/Fax: 01273 477699

THREE KINGS THEATRICAL SUPPLY GROUP
(Make-up, Film Production & Theatrical Services)
84 Queens Road
Farnborough, Hampshire GU14 6JR
Website: www.3kmake-up.com
e-mail: info@3kmake-up.com
Fax: 01252 515516 Tel: 01252 371123

TRENDS AGENCY MANAGERS
(Theatrical Costume Hire, Design & Making)
Sullom Lodge, Sullom Side Lane
Barnacre, Garstang PR3 1GH
Website: www.trendsgroup.co.uk
e-mail: info@trendsgroup.co.uk
Fax: 01253 407715 Tel: 0871 2003343

TRYFONOS Mary MASKS
(Designer & Maker of Masks & Costume Properties)
59 Shaftesbury Road, London N19 4QW
e-mail: marytryfonos@aol.com
Mobile: 07764 587433 Tel: 020-7561 9880

WEST YORKSHIRE FABRICS Ltd
(Venetian, Crepe, Suiting, Barathea, Stretch Fabrics,
Linen, Cut Lengths)
West Yorkshire House
High Ash Drive, Leeds LS17 8RA
e-mail: info@stroud-brothers.demon.co.uk
 Tel/Fax: 0870 4439842

WIG EXPECTATIONS
3 Northernhay Walk
Morden, Surrey SM4 4BS
Website: www.wigexpectations.com
e-mail: wigexpectations@aol.com Tel: 020-8540 5667

WIG ROOM The
22 Coronation Road
Basingstoke, Hants RG21 4HA
e-mail: wigroom@fsbdial.co.uk Tel/Fax: 01256 415737

WIG SPECIALITIES Ltd
(Hand Made Wigs & Facial Hair, Hair Extensions etc)
First Floor, 173 Seymour Place
London W1H 4PW
Website: www.wigspecialities.co.uk
e-mail: wigspecialities@btconnect.com
Fax: 020-7723 1566 Tel: 020-7262 6565

WILLIAMS Emma
(Costume Designer & Stylist - Film, TV & Theatre)
e-mail: emmacoz@dsl.pipex.com Mobile: 07710 130345

WILSON Marian WIGS
(Theatrical & Film Wig Maker)
59 Gloucester Street, Faringdon, Oxon SN7 7JA
e-mail: wigmaker@wigmaker.screaming.net
Fax: 01367 242438 Tel: 01367 241696

WOOD Kevin PRODUCTIONS
(Costume Hire)
Langdon Abbey, West Langdon
Dover, Kent CT15 5HJ
e-mail: sylviasims@btconnect.com
Fax: 01304 853506 Tel: 01304 853504

WORLD OF FANTASY
(Costumes & Props)
Swansnest, Rear of 2 Windmill Road
Hampton Hill, Middlesex TW12 1RH
Fax: 020-8783 1366 Tel: 020-8941 1595

WRIGHT Fay
(Freelance Make-up Artist)
37 Veryan, Woking, Surrey GU21 3LL
e-mail: faylin_wright@hotmail.com Mobile: 07816 128575

DAILY EXPRESS Tel: 0871 4341010
Northern Shell Building
10 Lower Thames Street, London EC3R 6EN
Theatre: Sheridan Morley
Films: Alan Hunter
Television: Matt Baylis
Saturday Magazine/Programmes: Pat Stoddart

DAILY MAIL Tel: 020-7938 6000
Northcliffe House
2 Derry Street, Kensington, London W8 5TT
Theatre: Adrian Thrills
Films: Chris Tookey
Television: Peter Paterson, Christopher Matthew

DAILY STAR Tel: 0871 4341010
Northern Shell Building
10 Lower Thames Street, London EC3R 6EN
Show Business & Television: Nigel Pauley
Show Business & Television: Amy Watts
Films & Video: Alan Frank

DAILY TELEGRAPH Tel: 020-7538 5000
1 Canada Square, Canary Wharf, London E14 5DT
Theatre: Charles Spencer
Films: Sukhdev Sandhu
Radio: Gillian Reynolds
Art: Richard Dorment
Dance: Ismene Brown
Music: Geoffrey Norris

FINANCIAL TIMES Tel: 020-7873 3000
1 Southwark Bridge
London SE1 9HL
Theatre: Alastair MacAulay
Films: Nigel Andrews
Television: Martin Hoyle, Karl French

GUARDIAN Tel: 020-7278 2332
119 Farringdon Road
London EC1R 3ER
Theatre: Michael Billington
Films: Peter Bradshaw
Television: Nancy Banks-Smith
Radio: Elisabeth Mahoney

INDEPENDENT Tel: 020-7005 2000
191 Marsh Wall, London E14 9RS
Television: Tom Sutcliffe

LONDON EVENING STANDARD Tel: 020-7938 6000
Northcliffe House
2 Derry Street, Kensington, London W8 5EE
Theatre: Nicholas de Jongh, Fiona Mountford
Films: Derek Malcolm
Opera: Fiona Maddocks
Television: Victor Lewis-Smith, Terry Ramsay
Classical Music: Barry Millington
Radio: Terry Ramsay

MAIL ON SUNDAY Tel: 020-7938 6000
(Review Section)
Northcliffe House, 2 Derry Street, London W8 5TS
Theatre: Georgina Brown
Films: Jason Solomons, Matthew Bond
Television: Jaci Stephen
Radio: Simon Garfield

MIRROR Tel: 020-7510 3000
Mirror Group Newspapers Ltd
1 Canada Square
Canary Wharf, London E14 5AP
Films: Dave Edwards
Television: Nicola Methven

MORNING STAR Tel: 020-8510 0815
William Rust House
52 Beachy Road, London E3 2NS
Theatre & Films: Katie Gilmore

NEWS OF THE WORLD Tel: 020-7782 4000
News International Plc
1 Virginia Street, London E98 1NW
Show Business: Rav Singh
Films: Polly Graham

OBSERVER Tel: 020-7278 2332
3-7 Herbal Hill
London EC1R 5EJ
Theatre: Susanna Clapp
Films: Philip French, Akin Ojumu
Radio: Miranda Sawyer

PEOPLE Tel: 020-7293 3000
1 Canada Square
Canary Wharf, London E14 5AP
Television & Radio: Sarah Moolla
Films: Richard Bacon
Show Business: Debbie Manley
Features: Chris Bucktin

SPORT Tel: 0161-238 8151
Sport Newspapers Ltd
19 Great Ancoats Street, Manchester M60 4BT
Showbusiness/Features: Nicky Tabarn

SUN Tel: 020-7782 4000
News International Plc
1 Virginia Street, Wapping, London E98 1SN
Television: Ally Ross

SUNDAY EXPRESS Tel: 0871 4341010
Northern Shell Building
10 Lower Thames Street, London EC3R 6EN
Theatre: Mark Shenton
Films: Henry Fitzherbert
Television: David Stephenson
Radio & Arts: Rachel Jane

SUNDAY MIRROR Tel: 020-7510 3000
Mirror Group
1 Canada Square
Canary Wharf, London E14 5AP
Theatre & Television: Kevin O'Sullivan
Films: Mark Adams
Showbiz: Suzanne Kerins

SUNDAY TELEGRAPH Tel: 020-7538 5000
1 Canada Square
Canary Wharf, London E14 5DT
Theatre: Rebecca Tyrrel, Susan Irvine
Films: Jenny McCartney, Catherine Shoard
Television: John Preston
Radio: David Sexton

SUNDAY TIMES Tel: 020-7782 5000
News International Plc
1 Pennington Street, London E98 1ST
Films: Cosmo Landesman
Television: A. A. Gill
Radio: Paul Donovan

TIMES Tel: 020-7782 5000
News International Plc
1 Pennington Street, London E98 1TT
Theatre: Benedict Nightingale
Films: James Christopher
Television: Joe Joseph
Video: Geoff Brown
Radio: Chris Campling

DANCE COMPANIES

ABREU Jean DANCE
Arts Services
The Arts Office
Grosvenor House, 1 Station Road
Wivenhoe, Essex CO7 9DH
Website: www.jeanabreu.com
e-mail: fiona@arts-services.co.uk Tel: 01206 825600

AKADEMI SOUTH ASIAN DANCE UK
213 Haverstock Hill
Hampstead Town Hall
Haverstock Hill, London NW3 4QP
Website: www.southasiandance.org.uk
e-mail: info@akademi.co.uk
Fax: 020-7691 3211 Tel: 020-7691 3210

ALSTON Richard DANCE COMPANY
The Place, 17 Duke's Road, London WC1H 9PY
e-mail: radc@theplace.org.uk
Fax: 020-7121 1040 Tel: 020-7121 1011

ANJALI DANCE COMPANY
The Mill Arts Centre
Spice Park, Banbury, Oxford OX16 5QE
Website: www.anjali.co.uk
e-mail: info@anjali.co.uk Tel: 01295 251909

ARTSWORLD PRESENTATIONS Ltd
Vicarage House
58-60 Kensington Church Street, London W8 4DB
Website: www.arts-world.co.uk
e-mail: p@triciamurraybett.com
Fax: 020-7368 3338 Tel: 020-7368 3337

BALLROOM - LONDON THEATRE OF
(Artistic Director - Paul Harris)
24 Ovett Close, Upper Norwood, London SE19 3RX
Website: www.londontheatreofballroom.com
e-mail: office@londontheatreofballroom.com
Mobile: 07958 784462 Tel/Fax: 020-8771 4274

BEDLAM DANCE COMPANY
18 St Augustine's Road, London NW1 9RN
Website: www.bedlamdance.com
e-mail: info@bedlamdance.com Mobile: 07985 730512

BIRMINGHAM ROYAL BALLET
Thorp Street, Birmingham B5 4AU
Website: www.brb.org.uk
e-mail: administrator@brb.org.uk
Fax: 0121-245 3570 Tel: 0121-245 3500

BODY OF PEOPLE
(Jazz Theatre Company)
10 Stayton Road, Sutton, Surrey SM1 1RB
Website: www.bop.org.uk
e-mail: info@bop.org.uk Tel: 020-8641 6959

D

**Dance Companies
Dance Organisations
Dance Training & Professional Classes
Drama Schools (Conference of)
Drama Training, Schools & Coaches**

Abbreviations:

SS Stage School for Children
D Dramatic Art (incl Coaching. Audition Technique etc)
DS Full time Drama Training **E** Elocution Coaching
(incl Correction of Accents. Speech Therapy,
Dialects etc)
S Singing **Sp** Specialised Training

SPOTLIGHT PUBLICATIONS
SPOTLIGHT INTERACTIVE
SPOTLIGHT SERVICES

SPOTLIGHT
DANCERS

Promoting dancers worldwide
www.spotlight.com

[CONTACTS 2007]

BROWN Carole DANCES
(Gwen Van Spijk)
PO Box 563, Banbury OX16 6AQ
Website: www.cueperformance.com
e-mail: gwen@cueperformance.com Tel: 01869 338458

BURROWS Jonathan GROUP
The Place
17 Duke's Road
London WC1H 9PY
e-mail: nigelhinds@jonathanburrows.fsnet.co.uk
 Tel: 020-7383 7935

CANDOCO DANCE COMPANY
2T Leroy House
436 Essex Road, London N1 3QP
Website: www.candoco.co.uk
e-mail: info@candoco.co.uk
Fax: 020-7704 1645 Tel: 020-7704 6845

CHOLMONDELEYS & FEATHERSTONEHAUGHS The
LF1.1
Lafone House
The Leathermarket
11-13 Leathermarket Street
London SE1 3HN
Website: www.thecholmondeleys.org
e-mail: admin@thecholmondeleys.org
Fax: 020-7378 8810 Tel: 020-7378 8800

COMBINATION DANCE COMPANY
Artists in Residence
Whitton School & Sports College
Percy Road, Twickenham TW2 6JW
Website: www.combinationdance.co.uk
e-mail: info@combinationdance.co.uk
Fax: 020-8894 0690 Tel: 020-8894 4503

COMPANY OF CRANKS
1st Floor, 62 Northfield House
Frensham Street, London SE15 6TN
Website: www.brendanmime.freeuk.com
e-mail: mimetic16@yahoo.com Mobile: 07963 617981

DANCE SOUTH WEST
PO Box 5457
Bournemouth
Dorset BH1 1WU
Website: www.dancesouthwest.org.uk
e-mail: info@dancesouthwest.org.uk Tel/Fax: 01202 554131

DARKIN ENSEMBLE
c/o Bemove, London House
271-273 King Street, London W6 9LZ
Website: www.writingthebody.co.uk
e-mail: karen@bemove.co.uk Tel: 020-7149 0250

DAVIES Siobhan DANCE
85 St George's Road, London SE1 6ER
Website: www.siobhandavies.com
e-mail: info@siobhandavies.com
Fax: 020-7091 9669 Tel: 020-7091 9650

DV8 PHYSICAL THEATRE
Arts Admin, Toynbee Studios
28 Commercial Street, London E1 6AB
Website: www.dv8.co.uk
e-mail: dv8@artsadmin.co.uk
Fax: 020-7247 5103 Tel: 020-7655 0977

ENGLISH NATIONAL BALLET Ltd
Markova House
39 Jay Mews, London SW7 2ES
Website: www.ballet.org.uk
e-mail: feedback@ballet.org.uk
Fax: 020-7225 0827 Tel: 020-7581 1245

ENGLISH YOUTH BALLET
85 Brockley Grove
Brockley, London SE4 1DZ
Website: www.englishyouthballet.co.uk
e-mail: misslewis@englishyouthballet.co.uk
 Tel/Fax: 020-8691 2806

FROM HERE TO MATURITY DANCE COMPANY
703 Redwood Housing Co-op
Oxo Tower Wharf, Southbank, London SE1 9GY
e-mail: dickie.ann@virgin.net Tel: 020-7928 0441

GREEN CANDLE DANCE COMPANY
Oxford House, Derbyshire Street
Bethnal Green, London E2 6HG
Website: www.greencandledance.com
e-mail: info@greencandledance.com
Fax: 020-7729 8272 Tel: 020-7739 7722

IJAD
22 Allison Road
London N8 0AT
Website: www.ijad.freeserve.co.uk
e-mail: jouman@ijad.freeserve.co.uk Mobile: 07930 378639

INDEPENDENT BALLET WALES
30 Glasllwch Crescent
Newport, South Wales NP20 3SE
Website: www.welshballet.co.uk
e-mail: dariusjames@welshballet.co.uk
Fax: 01633 221690 Tel: 01633 253985

JEYASINGH Shobana DANCE COMPANY
Moving Arts Base
134 Liverpool Road, Islington, London N1 1LA
Website: www.shobanajeyasingh.co.uk
e-mail: admin@shobanajeyasingh.co.uk Tel: 020-7697 4444

How do I become a professional dancer?

Full-time vocational training can start from as young as ten years old. A good starting point for researching the different schools and courses available is CDET (Council for Dance Education & Training) (www.cdet.org.uk.) There are over fifteen dance colleges offering professional training accredited by CDET, and nearly three hundred university courses which include some form of dance training. It is estimated that over one thousand dancers graduate from vocational training schools or university courses every year, so it is a highly competitive career. Therefore anyone wanting to be a professional dancer must obtain as many years of training and experience as possible, plus go to see plenty of performances spanning different types and genres of dance. If you require further information on vocational dance schools, applying to accredited dance courses, auditions and funding, contact CDET's information line 'Answers for Dancers' on 020 7240 5703.

How should I use these listings?

The following pages will supply you with up-to-date contact details for a wide range of dance companies and organisations, followed by listings for dance training and professional classes. Always research schools and classes thoroughly, obtaining copies of prospectuses where available. Most vocational schools offer two and three year full-time training programmes, many also offer excellent degree programmes. Foundation Courses offer a sound introduction to the profession, but they can never replace a full-time vocational course. Many schools, organisations and studios also offer part-time / evening classes which offer a general understanding of dance and complementary technique or the opportunity to refresh specific dance skills; they will not, however, enable a student to become a professional dancer.

What are dance companies?

There are more than two hundred dance companies in the UK, spanning a variety of dance styles including ballet, contemporary, hip hop and African. A dance company will either be resident in a venue, be a touring company, or a combination of both. Many have websites which you can visit for full information. Most dance companies employ ensemble dancers on short to medium contracts, who may then work on a number of different productions for the same company over a number of months. In addition, the company will also employ principal / leading dancers on a role-by-role basis.

Commercial dance and musical theatre

Dance also plays a role in commercial theatre, musicals, opera, film, television, live music and video, corporate events and many other industries. Dancers wishing to promote themselves to these types of job opportunities should consider joining Spotlight's latest directory for dancers see (www.spotlight.com/dancers): a central directory of dancers which is used by dance employers throughout the UK to locate dancers and send out casting or audition information. Dancers may also want to be represented by an agent. A number of specialist dance agencies are listed in the 'Agents – Dance' towards the front of this directory.

Dance organisations

There are numerous organisations which exist to support professional dancers, covering important areas including health and safety, career development, networking and legal and financial aspects. Other organisations (e.g. Regional / National Dance Agencies) exist to promote dance within the wider community.

Other careers in dance

Opportunities also exist to work as a teacher, choreographer, technician or manager. Dance UK (www.danceuk.org) is a valuable source of information for anyone considering this type of work.

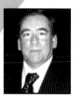

GAVIN ROEBUCK is an international arts consultant to several organisations and producers. He trained in London and danced in classical ballets; an experienced ballet teacher, he has also worked in TV and is a BAFTA member.

When you spend your life in the dance world it can sometimes seem quite small, and one can easily think one knows most people and organisations. It is however much bigger and more diverse than many realise - and becoming more so every day.

In the UK there are thousands of teachers teaching dance to hundreds of thousands of people of all ages. Dance training can be divided into three groups: recreational, vocational and educational. The full-time training area seems to be enlarging with more and more vocational and degree courses on offer - though these don't always lead to professional work.

There are of course many diverse styles and techniques in both the theatrical and ballroom sectors. Professional dance is most usually understood to be one of three main styles: ballet, contemporary and musical theatre. Most people pursuing a career in dance do so within one of these three major categories.

Musicals and the commercial sector are expanding, as well as work in TV commercials and music videos. There is currently a revival of interest in Ballroom and Latin and more examples of ethnic dance are getting increased exposure. The contemporary dance field also incorporates companies that have developed a fusion of western and ethnic styles: from the Asian Kathak through to Afro styles and Hip Hop culture.

Dance is also receiving more exposure in TV and film than ever before - and there are now also many more foreign dance companies visiting Britain with sometimes lengthy tours.

In addition to performers, many professional people, organisations and trades support all of this activity, from dancewear, including specialist shoe manufactures, through to festival organisers and adjudicators, flooring experts, photographers, agents and promoters and many more.

Individually it may sometimes seem to be a small business but collectively Dance is a big sector of the entertainment and arts industry, as this newly expanded section of Contacts demonstrates.

For more information about Gavin's work, please visit (www.gavinroebuck.com).

If you or your company would like to be listed in the Dance section of Contacts next year, please email info@spotlight.com or call 020 7440 5026.

KHAN Akram COMPANY
19-20 Rheidol Mews, London N1 8NU
Website: www.akramkhancompany.net
e-mail: office@akramkhancompany.net
Fax: 020-7354 5554 Tel: 020-7354 4333

KOSH The
(Physical Theatre)
59 Stapleton Hall Road, London N4 3QF
e-mail: info@thekosh.com Tel/Fax: 020-8374 0407

LUDUS DANCE
Assembly Rooms
King Street, Lancaster LA1 1RE
Website: www.ludusdance.org
e-mail: info@ludusdance.org
Fax: 01524 847744 Tel: 01524 35936

MOVING EAST
St Matthias Church Hall
Wordsworth Road, London N16 8DD
Website: www.movingeast.co.uk
e-mail: admin@movingeast.co.uk Tel: 020-7503 3101

MUDRALAYA DANCE THEATRE
(Formerly Pushkala Gopal Unnikrishnan & Co)
(Classical Indian Dance-Theatre)
20 Brisbane Road, Ilford, Essex IG1 4SR
e-mail: pushkala@btinternet.com Tel: 020-8554 4054

NEW ADVENTURES
Sadler's Wells
Rosebery Avenue, London EC1R 4TN
Website: www.new-adventures.net
e-mail: info@new-adventures.net Tel/Fax: 020-7713 6766

NORTHERN BALLET THEATRE
West Park Centre
Spen Lane, Leeds LS16 5BE
e-mail: administration@northernballettheatre.co.uk
Fax: 0113-220 8007 Tel: 0113-274 5355

OGUIKE Henri DANCE COMPANY
Laban, The Cottages
Office No 2 Creekside, London SE8 3DZ
Website: www.henrioguikedance.co.uk
e-mail: info@henrioguikedance.co.uk
Fax: 020-8694 3669 Tel: 020-8694 7444

PHOENIX DANCE THEATRE
3 St Peter's Buildings
St Peter's Square, Leeds LS9 8AH
Website: www.phoenixdancetheatre.co.uk
e-mail: info@phoenixdancetheatre.co.uk
Fax: 0113-244 4736 Tel: 0113-242 3486

PIPER George DANCES
Sadler's Wells, Rosebery Avenue
Islington, London EC1R 4TN
Website: www.gpdances.com
e-mail: contact@gpdances.com
Fax: 020-7278 5684 Tel: 020-7278 5508

PLACE The
Robin Howard Dance Theatre
17 Duke's Road, London WC1H 9BY
Website: www.theplace.org.uk
e-mail: info@theplace.org.uk
Fax: 020-7121 1142 Tel: 020-7121 1000

RAMBERT DANCE COMPANY
94 Chiswick High Road, London W4 1SH
Website: www.rambert.org.uk
e-mail: rdc@rambert.org.uk
Fax: 020-8747 8323 Tel: 020-8630 0600

ROTIE Marie-Gabrielle PRODUCTIONS
7 Trinity Rise, London SW2 2QP
Website: www.rotieproductions.com
e-mail: mgr35@aol.com Tel: 020-8674 1518

ROYAL BALLET The
Royal Opera House
Covent Garden, London WC2E 9DD
Fax: 020-7212 9121 Tel: 020-7240 1200 ext 712

RUSS Claire ENSEMBLE
(Choreography, Contemporary/Commercial)
74A Queens Road
Twickenham TW1 4ET
Website: www.clairerussensemble.com
e-mail: info@clairerussensemble.com
Mobile: 07932 680224 Tel/Fax: 020-8892 9281

SCOTTISH BALLET
261 West Princes Street
Glasgow G4 9EE
Website: www.scottishballet.co.uk
e-mail: sb@scottishballet.co.uk
Fax: 0141-331 2629 Tel: 0141-331 2931

SCOTTISH DANCE THEATRE
Dundee Repertory Theatre
Tay Square, Dundee DD1 1PB
Website: www.scottishdancetheatre.com
e-mail: achinn@dundereptheatre.co.uk
Fax: 01382 228609 Tel: 01382 342600

SMALLPETIT KLEIN DANCE COMPANY
20 Parkleigh Road
London SW19 3BU
Website: www.smallpetitklein.com
e-mail: info@smallpetitklein.com Mobile: 07792 652672

SPRINGS DANCE COMPANY
Jamaica Road
Bermondsey, London SE1
Website: www.springsdancecompany.org.uk
e-mail: springsdc@aol.com Tel: 07775 628442

STOP GAP DANCE COMPANY
Farnham Maltings
Bridge Square
Farnham, Surrey GU9 7QR
Website: www.stopgap.uk.com
e-mail: admin@stopgap.uk.com Tel: 01252 718664

SURAYA DANCE COMPANY
2/76 Priory Road, London NW6 3NT
Website: www.hilaldance.co.uk
e-mail: info@hilaldance.co.uk Tel/Fax: 020-7624 2549

TRANSITIONS DANCE
Creekside, London SE8 3DZ
e-mail: info@laban.org Tel: 020-8691 8600

TRU STREETDANCE
306 The Greenhouse
Custard Factory, Gibb Street
Digbeth, Birmingham B9 4AA
Website: www.trustreetdance.com
e-mail: trustreetdance@fresnomail.com
Fax: 0121-224 8257 Tel: 0121-471 3893

UNION DANCE
Top Floor
6 Charing Cross Road, London WC2H 0HG
Website: www.uniondance.co.uk
e-mail: info@uniondance.co.uk
Fax: 020-7836 7847 Tel: 020-7836 7837

ACCELERATE Ltd
223 Cranbrook Road, Ilford IG1 4TD
Website: www.accelerate-productions.co.uk
e-mail: info@accelerate-productions.co.uk
Fax: 020-8518 4018 Tel: 020-8514 4796

ADAD
c/o Dance UK
Battersea Arts Centre
Lavender Hill, London SW11 5TN
Website: www.adad.org.uk
e-mail: pamela_adad@danceuk.org
Fax: 020-7223 0074 Tel: 020-7228 4990

AKADEMI SOUTH ASIAN DANCE UK
213 Haverstock Hill
Hampstead Town Hall, London NW3 4QP
Website: www.akademi.co.uk
e-mail: info@akademi.co.uk
Fax: 020-7691 3211 Tel: 020-7691 3210

ALLIED DANCING ASSOCIATION
137 Greenhill Road, Mossley Hill
Liverpool L18 7HQ Tel: 0151-724 1829

BLUE EYED SOUL DANCE COMPANY
Joint User Centre, Meadow Farm Drive
Harlescott, Shrewsbury SY1 4NG
Website: www.blueeyedsouldance.com
e-mail: admin@blueeyedsouldance.com Tel: 01743 210830

BRITISH ARTS The
12 Deveron Way, Rise Park
Romford RM1 4UL
Website: www.britisharts.org Tel: 01708 756263

BRITISH ASSOCIATION OF TEACHERS OF DANCING
23 Marywood Square, Glasgow G41 2BP
Website: www.batd.co.uk
e-mail: katrina.allan@batd.co.uk Tel: 0141-423 4029

BRITISH BALLET ORGANISATION
(Dance Examining Society & Teacher Training)
Woolborough House
39 Lonsdale Road, Barnes, London SW13 9JP
Website: www.bbo.org.uk
e-mail: info@bbo.org.uk Tel: 020-8748 1241

BRITISH THEATRE DANCE ASSOCIATION
Garden Street, Leicester LE1 3UA
Website: www.btda.org.uk
e-mail: info@btda.org.uk
Fax: 0845 1662189 Tel: 0845 1662179

CHISENHALE DANCE SPACE
64-84 Chisenhale Road, Bow, London E3 5QZ
Website: www.chisenhaledancespace.co.uk
e-mail: mail@chisenhaledancespace.co.uk
Fax: 020-8980 9323 Tel: 020-8981 6617

COUNCIL FOR DANCE EDUCATION & TRAINING
Old Brewer's Yard
17-19 Neal Street
Covent Garden, London WC2H 9UY
Website: www.cdet.org.uk
e-mail: info@cdet.org.uk
Fax: 020-7240 2547 Tel: 020-7240 5703

DANCE 4
(National Dance Agency)
3-9 Hockley, Nottingham NG1 1FH
Website: www.dance4.co.uk
e-mail: info@dance4.co.uk
Fax: 0115-941 0776 Tel: 0115- 941 0773

DANCE BASE NATIONAL CENTRE FOR DANCE
14-16 Grassmarket, Edinburgh EH1 2JU
Website: www.dancebase.co.uk
e-mail: dance@dancebase.co.uk
Fax: 0131-225 5234 Tel: 0131-225 5525

DANCE CITY
(National Dance Agency)
Peel Lane, Off Waterloo Street
Newcastle-upon-Tyne NE1 4DW
Website: www.dancecity.co.uk
e-mail: info@dancecity.co.uk Tel: 0191-261 0505

DANCE EAST
(National Dance Agency)
Northgate Arts Centre
Sidegate Lane West, Ipswich IP4 3DF
Website: www.danceeast.co.uk
e-mail: info@danceeast.co.uk
Fax: 01473 639236 Tel: 01473 639230

DANCE HOUSE The
304 Maryhill Road, Glasgow G20 7YE
Website: www.dancehouse.org
e-mail: info@dancehouse.org Tel: 0141-332 1490

DANCE IN DEVON
(National Dance Agency)
Exeter Phoenix, Bradnich Place
Gandy Street, Exeter EX4 3LS
Website: www.dancesouthwest.org.uk/devon
e-mail: info@danceindevon.co.uk
Fax: 01392 667599 Tel: 01392 667050

DANCE INITIATIVE GREATER MANCHESTER
(National Dance Agency)
Zion Arts Centre, Stretford Road
Hulme, Manchester M15 5ZA
Website: www.digm.org
e-mail: info@digm.org.uk
Fax: 0161-232 7483 Tel: 0161-232 7179

DANCE NORTHWEST
(National Dance Agency)
PO Box 19, Winsford, Cheshire CW7 2AQ
Website: www.dancenorthwest.org.uk
e-mail: admin@dancenorthwest.org.uk Tel/Fax: 01606 863845

DANCERS' CAREER DEVELOPMENT
220-221 Africa House
64 Kingsway, London WC2B 6BG
Website: www.thedcd.org.uk
e-mail: linda@thedcd.org.uk
Fax: 020-7424 3331 Tel: 020-7404 6141

DANCE SOUTH WEST
PO Box 5457
Bournemouth, Dorset BH1 1WU
Website: www.dancesouthwest.org.uk
e-mail: info@dancesouthwest.org.uk Tel/Fax: 01202 554131

DANCE UK
(Including the Healthier Dancer Programme)
Battersea Arts Centre, Lavender Hill, London SW11 5TN
Website: www.danceuk.org
e-mail: info@danceuk.org
Fax: 020-7223 0074 Tel: 020-7228 4990

DANCE UMBRELLA
20 Chancellors Street, London W6 9RN
Website: www.danceumbrella.co.uk
e-mail: mail@danceumbrella.co.uk
Fax: 020-8741 7902 Tel: 020-8741 4040

DANCEXCHANGE
(National Dance Agency)
Birmingham Hippodrome
Thorpe Street, Birmingham B5 4TB
Website: www.dancexchange.org.uk
e-mail: info@dancexchange.org.uk Tel: 0121-689 3170

DAVIES Siobhan STUDIOS
85 St George's Road, London SE1 6ER
Website: www.siobhandavies.com
e-mail: info@siobhandavies.com
Fax: 020-7091 9669 Tel: 020-7091 9650

EAST LONDON DANCE
Stratford Circus
Theatre Square, London E15 1BX
Website: www.eastlondondance.org
e-mail: office@eastlondondance.org
Fax: 020-8279 1054 Tel: 020-8279 1050

ESSEXDANCE
78 Broomfield Road
Chelmsford, Essex CM1 1SS
Website: www.essexdance.co.uk
e-mail: info@essexdance.co.uk Tel: 01245 346036

FOUNDATION FOR COMMUNITY DANCE
LCB Depot
31 Rutland Street, Leicester LE1 1RE
e-mail: info@communitydance.org.uk
Fax: 0116-261 6801 Tel: 0116-253 3453

GREENWICH DANCE AGENCY
The Borough Hall
Royal Mill, London SE10 8RE
Website: www.greewichdance.org.uk
e-mail: info@greenwichdance.org.uk Tel: 020-8293 9741

IDTA (INTERNATIONAL DANCE TEACHERS' ASSOCIATION)
International House
76 Bennett Road, Brighton
East Sussex BN2 5JL
Website: www.idta.co.uk
e-mail: info@idta.co.uk
Fax: 01273 674388 Tel: 01273 685652

ISLE OF WIGHT DANCE PROJECT
The Guildhall, High Street
Newport, Isle of Wight PO30 1TY
Website: www.isleofwight-arts.co.uk
e-mail: jane.bridle@iow.gov.uk Tel: 01983 823813

LANGUAGE OF DANCE CENTRE The
17 Holland Park
London W11 3TD
Website: www.lodc.org
e-mail: info@lodc.org
Fax: 020-7792 1794 Tel: 020-7229 3780

LONDON CONTEMPORARY DANCE SCHOOL
The Place, 17 Duke's Road
London WC1H 9PY
Website: www.theplace.org.uk
e-mail: lcds@theplace.org.uk
Fax: 020-7121 1142 Tel: 020-7121 1111

MERSEYSIDE DANCE INITIATIVE
(National Dance Agency)
24 Hope Street
Liverpool L1 9BQ
Website: www.merseysidedance.co.uk
e-mail: info@merseysidedance.co.uk
Fax: 0151-707 0600 Tel: 0151-708 8810

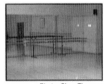
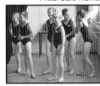

MIDLAND INDEPENDENT DANCE ARTS ASSOCIATION INTERNATIONAL
29A Sycamore Road
Birmingham B23 5QP
Website: www.midaai.co.uk
e-mail: midaai@hotmail.com
Fax: 0121-694 0013 Tel: 0121-694 0012

NATIONAL RESOURCE CENTRE FOR DANCE
University of Surrey, Guildford GU2 7XH
Website: www.surrey.ac.uk/nrcd
e-mail: nrcd@surrey.ac.uk
Fax: 01483 689500 Tel: 01483 689316

PLACE The
(National Dance Agency)
Robin Howard Dance Theatre
17 Duke's Road, London WC1H 9BY
Website: www.theplace.org.uk
e-mail: info@theplace.org.uk
Fax: 020-7121 1142 Tel: 020-7121 1000

PROFESSIONAL TEACHERS OF DANCING
St Georges House, 4A Uplyme Road Business Park
Lentells 1st Floor, Lyme Regis, Dorset DT7 3LS
Website: www.ptdance.com
e-mail: ptd@soton96.freeserve.co.uk Tel: 01297 678565

SOUTH-EAST DANCE
(National Dance Agency)
9-12 Middle Street, Brighton BN1 1AL
e-mail: info@southeastdance.org.uk
Fax: 01273 205540 Tel: 01273 202032

SPACE @ CLARENCE MEWS
40 Clarence Mews, London E5 8HL
e-mail: frith.salem@virgin.net Tel: 020-8986 5260

SURREY COUNTY ARTS DANCE
Westfield School, Bonsey Lane
Woking, Surey GU22 9PR
Website: www.surreycountyarts.org.uk
e-mail: sca.dance@surreycc.gov.uk Tel: 01483 776128

SWINDON DANCE
(National Dance Agency)
Town Hall Studios,
Regent Circus, Swindon SN1 1QF
Website: www.swindondance.org.uk Tel: 01793 463210

TURTLE KEY ARTS
Ladbroke Hall
79 Barlby Road, London W10 6AZ
Website: www.turtlekeyarts.org.uk
e-mail: shaun@turtlekeyarts.org.uk
Fax: 020-8964 4080 Tel: 020-8964 5060

WELSH INDEPENDENT DANCE
Chapter, Market Road
Canton, Cardiff CF5 1QE
Website: www.welshindance.co.uk
e-mail: welshindance@btconnect.com Tel: 029-2038 7314

WHEELCHAIR DANCE ASSOCIATION The
Mrs Dorothy Liddell (National Chairman)
180 St Andrews Road South
St Annes, Lytham, Lancs FY8 1EU
Fax: 01253 726040 Tel: 01253 722303

YORKSHIRE DANCE
(National Dance Agency)
3 St Peter's Buildings
St Peter's Square, Leeds LS9 8AH
Website: www.everybodydances.com
e-mail: admin@everybodydances.com Tel: 0113-243 9867

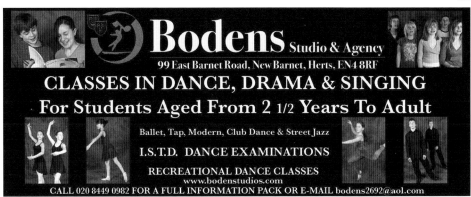

ACADEMY FOR THEATRE ARTS The
1 Vale View, Porthill
Newcastle under Lyme
Staffs ST5 0AF Tel: 01782 751900

ARTS EDUCATIONAL SCHOOLS, LONDON
Cone Ripman House
14 Bath Road, Chiswick, London W4 1LY
Website: www.artsed.co.uk
e-mail: reception@artsed.co.uk Tel: 020-8987 6666

AVIV DANCE STUDIOS
Wren House, 1st Floor
19-23 Exchange Road, Watford WD18 0JD
Website: www.avivdance.com
e-mail: nikki@avivdance.com Tel/Fax: 01923 250000

BALLROOM - LONDON THEATRE OF
(Artistic Director - Paul Harris, Mentor "Faking It")
24 Ovett Close, Upper Norwood, London SE19 3RX
Website: www.londontheatreofballroom.com
e-mail: office@londontheatreofballroom.com
Mobile: 07958 784462 Tel/Fax: 020-8771 4274

BENESH INSTITUTE The
36 Battersea Square, London SW11 3RA
Website: www.rad.org.uk
e-mail: marketing@rad.org.uk Tel: 020-7326 8000

BHAVAN CENTRE
4A Castletown Road, London W14 9HE
Website: www.bhavan.net
e-mail: info@bhavan.net Tel: 020-7381 3086

BIRD COLLEGE DANCE & THEATRE PERFORMANCE
(Dance & Theatre Performance Diploma/BA (Hons)
Degree Course)
Birkbeck Centre, Birkbeck Road, Sidcup, Kent DA14 4DE
Website: www.birdcollege.co.uk
Fax: 020-8308 1370 Tel: 020-8300 6004

BODENS STUDIOS
(Performing Arts Classes)
Bodens Studios & Agency
99 East Barnet Road, New Barnet, Herts EN4 8RF
Website: www.bodenstudios.com
e-mail: bodens2692@aol.com
Fax: 020-8449 5212 Tel: 020-8449 0982

BRIGHTON DANCE DIVERSION
93 Sea Lane, Rustington, West Sussex BN16 2RS
Website: www.bdd.me.uk
e-mail: info@brightondancediversion.com Tel: 01903 770304

CAMBRIDGE PERFORMING ARTS AT BODYWORK
Bodywork Company Dance Studios
25-29 Glisson Road, Cambridge CB1 2HA Tel: 01223 314461

CANDOCO DANCE COMPANY
2T Leroy House, 436 Essex Road, London N1 3QP
Website: www.candoco.co.uk
e-mail: foundationcourse@candoco.co.uk Tel: 020-7704 6845

CENTRAL SCHOOL OF BALLET
(Dance Classes & Professional Training)
10 Herbal Hill, Clerkenwell Road, London EC1R 5EG
Website: www.centralschoolofballet.co.uk
e-mail: info@csbschool.co.uk
Fax: 020-7833 5571 Tel: 020-7837 6332

CENTRE - PERFORMING ARTS COLLEGE The
Building 62, Level 4, 37 Bowater Road
Charlton, London SE18 5TF
e-mail: dance@thecentrepac.com
Fax: 020-8855 6662 Tel: 020-8855 6661

COLIN'S PERFORMING ARTS Ltd
The Studios, 219B North Street, Romford RM1 4QA
Website: www.colinsperformingarts.co.uk
e-mail: admin@colinsperformingarts.co.uk
Fax: 01708 766077 Tel: 01708 766007

COLLECTIVE DANCE & DRAMA
The Studio, Rectory Lane
Rickmansworth, Herts WD3 1FD Tel/Fax: 020-8428 0037

CONTI Italia ACADEMY OF THEATRE ARTS
(Full-time 3 year Musical Theatre Course)
Italia Conti House, 23 Goswell Road, London EC1M 7AJ
e-mail: admin@italiaconti.co.uk
Fax: 020-7253 1430 Tel: 020-7608 0044

**COUNCIL FOR DANCE EDUCATION
& TRAINING (CDET) The**
Old Brewer's Yard, 17-19 Neal Street
Covent Garden, London WC2H 9UY
Website: www.cdet.org.uk e-mail: info@cdet.org.uk
Fax: 020-7240 2547 Tel: 020-7240 5703

CUSTARD FACTORY
(Professional Dance Classes & Dance Studio Hire)
Gibb Street, Digbeth, Birmingham B9 4AA
e-mail: post@custardfactory.com
Fax: 0121-604 8888 Tel: 0121-224 7777

D & B SCHOOL OF PERFORMING ARTS
Central Studios, 470 Bromley Road, Bromley, Kent BR1 4PN
Website: www.dandbperformingarts.co.uk
e-mail: bonnie@dandbmanagement.com
Fax: 020-8697 8100 Tel: 020-8698 8880

DANCE BASE NATIONAL CENTRE FOR DANCE
14-16 Grassmarket, Edinburgh EH1 2JU
Website: www.dancebase.co.uk
e-mail: dance@dancebase.co.uk
Fax: 0131-225 5234 Tel: 0131-225 5525

DANCE HOUSE The
304 Maryhill Road, Glasgow G20 7YE
Website: www.dancehouse.org
e-mail: info@dancehouse.org Tel: 0141-332 1490

DANCE RESEARCH COMMITTEE - IMPERIAL SOCIETY OF TEACHERS OF DANCING
(Training in Early Historical Dance)
c/o Ludwell House, Charing, Kent TN27 0LS
Website: www.istd.org
e-mail: n.gainesarmitage@tiscali.co.uk
Fax: 01233 712768 Tel: 01233 712469

DANCEWORKS
(Also Fitness, Yoga & Martial Arts Classes)
16 Balderton Street, London W1K 6TN Tel: 020-7629 6183

D M AGENCY The
The Studios, Briggate, Shipley, Bradford, W Yorks BD17 7BT
Website: www.dmacademy.co.uk
e-mail: info@dmacademy.co.uk
Fax: 01274 592502 Tel: 01274 585317

DUFFILL Drusilla THEATRE SCHOOL
Grove Lodge, Oakwood Road
Burgess Hill, West Sussex RH15 0HZ
Website: www.drusilladuffilltheatreschool.co.uk
e-mail: drusilladschool@btclick.com
Fax: 01444 232680 Tel: 01444 232672

EAST LONDON DANCE
Stratford Circus, Theatre Square, London E15 1BX
Website: www.eastlondondance.org
e-mail: kdavidson@newvic.ac.uk
Fax: 020-8279 1054 Tel: 020-8279 1050

ELIE Mark DANCE FOUNDATION
The Tabernacle, Powis Square, London W11 2AY
Website: www.markelie-dancefoundation.co.uk
e-mail: markeliedancefoundation@uk2.net
 Mobile: 07947 484021

ELMHURST - SCHOOL FOR DANCE
249 Bristol Road, Edgbaston, Birmingham B5 7UH
Website: www.elmhurstdance.co.uk
e-mail: enquiries@elmhurstdance.co.uk
Fax: 0121-472 6654 Tel: 0121-472 6655

ENGLISH NATIONAL BALLET SCHOOL
Carlyle Building, Hortensia Road, London SW10 0QS
Website: www.enbschool.org.uk
e-mail: info@enbschool.org.uk
Fax: 020-7376 3404 Tel: 020-7376 7076

EXCEL SCHOOL OF PERFORMING ARTS
KT Summit House, 100 Hanger Lane, Ealing, London W5 1EZ
Website: www.ktioe-excel.org
e-mail: excel@kt.com Tel: 020-8799 6117

EXPRESSIONS ACADEMY OF PERFORMING ARTS
3 Newgate Lane, Mansfield, Nottingham NG18 2LB
Website: www.expressions-uk.com
e-mail: expressions-uk@btconnect.com
Fax: 01623 647337 Tel: 01623 424334

GREASEPAINT ANONYMOUS
4 Gallus Close, Winchmore Hill, London N21 1JR
e-mail: info@greasepaintanonymous.co.uk
Fax: 020-8882 9189 Tel: 020-8886 2263

HAMMOND SCHOOL The
Hoole Bank, Mannings Lane, Chester CH2 4ES
Website: www.thehammondschool.co.uk
e-mail: info@thehammondschool.co.uk
Fax: 01244 305351 Tel: 01244 305350

HARRIS Paul
(Movement for Actors, Choreography, Tuition in Traditional & Contemporary Social Dance)
24 Ovett Close, Upper Norwood, London SE19 3RX
Website: www.paulharris.uk.com
e-mail: office@paulharris.uk.com
Mobile: 07958 784462 Tel: 020-8771 4274

ISLINGTON ARTS FACTORY
2 Parkhurst Road, London N7 0SF
e-mail: islington@artsfactory.fsnet.co.uk
Fax: 020-7700 7229 Tel: 020-7607 0561

LABAN
Creekside, London SE8 3DZ
Website: www.laban.org
e-mail: info@laban.org
Fax: 020-8691 8400 Tel: 020-8691 8600

LAINE THEATRE ARTS
The Studios, East Street, Epsom, Surrey KT17 1HH
Website: www.laine-theatre-arts.co.uk
e-mail: webmaster@laine-theatre-arts.co.uk
Fax: 01372 723775 Tel: 01372 724648

LEE Lynn THEATRE SCHOOL The
(Office)
126 Church Road, Benfleet, Essex SS7 4EP
e-mail: lynn@leetheatre.fsnet.co.uk Tel: 01268 795863

LIVERPOOL THEATRE SCHOOL
19 Aigburth Road, Liverpool, Merseyside L17 4JR
Website: www.liverpooltheatreschool.co.uk
e-mail: info@liverpooltheatreschool.co.uk
Fax: 0151-728 9852 Tel: 0151-728 7800

LONDON CONTEMPORARY DANCE SCHOOL
(Full-time Vocational Training at Degree, Certificate & Postgraduate Level)
The Place, 17 Duke's Road, London WC1H 9PY
Website: www.theplace.org.uk
e-mail: lcds@theplace.org.uk
Fax: 020-7121 1145 Tel: 020-7121 1111

LONDON STUDIO CENTRE
42-50 York Way, London N1 9AB
Website: www.london-studio-centre.co.uk
e-mail: info@london-studio-centre.co.uk
Fax: 020-7837 3248 Tel: 020-7837 7741

MANN Stella COLLEGE
(Professional Training Course for Performers & Teachers)
10 Linden Road, Bedford, Beds MK40 2DA
Website: www.stellamanncollege.co.uk
e-mail: info@stellamanncollege.co.uk
Fax: 01234 217284 Tel: 01234 213331

MIDLANDS ACADEMY OF DANCE & DRAMA
Century House, Building B
428 Carlton Hill, Nottingham NG4 1QA
Website: www.maddcollege.co.uk
e-mail: admin@maddcollege.supanet.com
 Tel/Fax: 0115-911 0401

MILLENNIUM DANCE 2000 Ltd
Hampstead Town Hall Centre
213 Haverstock Hill, London NW3 4QP
Website: www.md2000.co.uk
e-mail: md2000hampstead@aol.com
 Tel/Fax: 020-7916 9335

eric
richmond
PHOTOGRAPHY

T: 0208 8806909
M: 07866 766240
E: eric@ericrichmond.net
W: www.ericrichmond.net





The Council for Dance Education and Training is the national standards body of the professional dance industry. It accredits programmes of training in vocational dance schools and holds the Register of Dance Awarding Bodies - the directory of teaching societies whose syllabuses have been inspected and approved by the Council. It is the body of advocacy of the dance education and training communities and offers a free and comprehensive information service - *Answers for Dancers* - on all aspects of vocational dance provision to students, parents, teachers dance artists and employers.

The Conference of Professional Dance Schools (CPDS) is a committee of the Council and provides a forum in which representatives from vocational dance training institutions may discuss policy and recommend action in relation to vocational dance training.

- Arts Educational School, Tring
- ArtsEd London
- Bird College
- Cambridge Performing Arts
- Elmhurst
- Hammond School
- Italia Conti Academy of Theatre Arts Ltd
- LABAN
- Laine Theatre Arts
- London Contemporary Dance School
- London Studio Centre
- Northern Ballet School
- Performers College
- Stella Mann College
- Urdang Academy

For more info on the CPDS and CDET:

Contact:

Council for Dance Education & Training
Old Brewer's Yard
17-19 Neal Street
Covent Garden, London WC2H 9UY
Tel: 020 7240 5703
Email: info@cdet.org.uk
Website: www.cdet.org.uk

ALRA (ACADEMY OF LIVE AND RECORDED ARTS)
Studio One
The Royal Victoria Patriotic Building
Fitzhugh Grove, Trinity Road, London SW18 3SX
Website: www.alra.co.uk
e-mail: enquiries@alra.co.uk
Fax: 020-8875 0789 Tel: 020-8870 6475

ARTS EDUCATIONAL SCHOOLS LONDON
14 Bath Road , London W4 1LY
Website: www.artsed.co.uk
e-mail: drama@artsed.co.uk
Fax: 020-8987 6699 Tel: 020-8987 6666

BIRMINGHAM SCHOOL OF ACTING
Millennium Point, Curzon Street
Birmingham B4 7XG
Website: www.bsa.uce.ac.uk
e-mail: info@bsa.uce.ac.uk
Fax: 0121-331 7221 Tel: 0121-331 7200

BRISTOL OLD VIC THEATRE SCHOOL
2 Downside Road
Clifton, Bristol BS8 2XF
Website: www.oldvic.ac.uk
e-mail: enquiries@oldvic.ac.uk
Fax: 0117-923 9371 Tel: 0117-973 3535

CENTRAL SCHOOL OF SPEECH & DRAMA
Embassy Theatre
64 Eton Avenue , Swiss Cottage, London NW3 3HY
Website: www.cssd.ac.uk
e-mail: enquiries@cssd.ac.uk Tel: 020-7722 8183

CONTI Italia ACADEMY OF THEATRE ARTS
Avondale
72 Landor Road, London SW9 9PH
Website: www.italiaconti-acting.co.uk
e-mail: acting@lsbu.ac.uk
Fax: 020-7737 2728 Tel: 020-7733 3210

CYGNET TRAINING THEATRE
New Theatre
Friars Gate Exeter, Devon EX2 4AZ
e-mail: cygnetarts@btinternet.com Tel/Fax: 01392 277189

DRAMA CENTRE LONDON
Central Saint Martins College of Art & Design
Saffron House, 10 Back Hill, London EC1R 5LQ
Website: www.csm.arts.ac.uk/drama
e-mail: drama@arts.ac.uk
Fax: 020-7514 8777 Tel: 020-7514 8778

DRAMA STUDIO LONDON
Grange Court, 1 Grange Road, London W5 5QN
Website: www.dramastudiolondon.co.uk
e-mail: registrar@dramastudiolondon.co.uk
Fax: 020-8566 2035 Tel: 020-8579 3897

EAST 15 ACTING SCHOOL
The University of Essex
Hatfields & Corbett Theatre
Rectory Lane, Loughton, Essex IG10 3RY
Website: www.east15.ac.uk
e-mail: east15@essex.ac.uk
Fax: 020-8508 7521 Tel: 020-8508 5983

GSA CONSERVATOIRE
Millmead Terrace
Guildford, Surrey GU2 4YT
Website: www.conservatoire.org
e-mail: enquiries@conservatoire.org Tel: 01483 560701

GUILDHALL SCHOOL OF MUSIC & DRAMA
Silk Street
Barbican, London EC2Y 8DT
Website: www.gsmd.ac.uk
e-mail: info@gsmd.ac.uk
Fax: 020-7256 9438 Tel: 020-7628 2571

LAMDA
155 Talgarth Road, London W14 9DA
Website: www.lamda.org.uk
e-mail: enquiries@lamda.org.uk
Fax: 020-8834 0501 Tel: 020-8834 0500

LIVERPOOL INSTITUTE FOR PERFORMING ARTS The
Mount Street
Liverpool L1 9HF
Website: www.lipa.ac.uk
e-mail: reception@lipa.ac.uk
Fax: 0151-330 3131 Tel: 0151-330 3000

MANCHESTER METROPOLITAN UNIVERSITY SCHOOL OF THEATRE
The Mabel Tylecote Building
Cavendish Street
Manchester M15 6BG
Website: www.capitoltheatre.co.uk Tel: 0161-247 1305

MOUNTVIEW
Academy of Theatre Arts
Ralph Richardson Memorial Studios
Clarendon Road, London N22 6XF
Website: www.mountview.ac.uk
e-mail: enquiries@mountview.ac.uk
Fax: 020-8829 0034 Tel: 020-8881 2201

OXFORD SCHOOL OF DRAMA The
Sansomes Farm Studios
Woodstock, Oxford OX20 1ER
Website: www.oxforddrama.ac.uk
e-mail: info@oxforddrama.ac.uk
Fax: 01993 811220 Tel: 01993 812883

QUEEN MARGARET UNIVERSITY COLLEGE
The Gateway Theatre
Elm Row, Edinburgh EH7 4AH
Website: www.qmuc.ac.uk
e-mail: admissions@qmuc.ac.uk
Fax: 0131-317 3902 Tel: 0131-317 3900

ROSE BRUFORD COLLEGE
Lamorbey Park, Burnt Oak Lane
Sidcup, Kent DA15 9DF
Website: www.bruford.ac.uk
Fax: 020-8308 0542 Tel: 020-8308 2600

ROYAL ACADEMY OF DRAMATIC ART
62-64 Gower Street, London WC1E 6ED
Website: www.rada.org
e-mail: enquiries@rada.ac.uk
Fax: 020-7323 3865 Tel: 020-7636 7076

ROYAL SCOTTISH ACADEMY OF MUSIC & DRAMA
100 Renfrew Street, Glasgow G2 3DB
Website: www.rsamd.ac.uk
e-mail: registry@rsamd.ac.uk Tel: 0141-332 4101

ROYAL WELSH COLLEGE OF MUSIC & DRAMA
Drama Department
Castle Grounds, Cathays Park, Cardiff CF10 3ER
Website: www.rwcmd.ac.uk
e-mail: drama.admissions@rwcmd.ac.uk
Fax: 029-2039 1302 Tel: 029-2039 1327

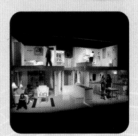

THE CONFERENCE OF DRAMA SCHOOLS

The Conference of Drama Schools comprises Britain's 22 leading Drama Schools. CDS exists to set and maintain the highest standards of training within the vocational drama sector and to make it easier for prospective students to understand the range of courses on offer and the application process. CDS member schools offer courses in Acting, Musical Theatre, Directing and Technical Theatre training.

CDS members offer courses which are:
Professional – you will be trained to work in the theatre by staff with professional experience and by visiting professionals.
Intensive – courses are full-time
Work Orientated – you are being trained to do a job – these courses are practical training for work.

CDS publishes *The Conference of Drama Schools – Guide to Professional Training in Drama and* *Technical Theatre 2007* and *The CDS Guide to Careers Backstage*.

For links to CDS schools please visit the website at **www.drama.ac.uk**

The full texts of both guides are available on the website – if you would like a hard copy please contact French's Theatre Bookshop, by phone on 020 7255 4300 or by emailing **theatre@samuelfrench-london.co.uk** or by visiting the shop at 52 Fitzroy Street, London, W1T 5JR. Single copies will be sent free of charge to UK addresses.
To contact CDS please visit the website or write to the Executive Secretary, CDS Ltd, P.O. Box 34252, London NW5 1XJ.

in association with

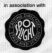

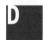

D DRAMA TRAINING, SCHOOLS & COACHES www.spotlight.com

DIALECT COACH

LINDA JAMES R.A.M. Dip. Ed., I.P.D. (Lon Univ), L.R.A.M.

FILMS, T.V., STAGE & PRIVATE COACHING, ERADICATION OF ACCENT

020 8568 2390

A & J THEATRE WORKSHOP
The Open Door Community Centre
Beaumont Road, London SW19
Website: www.ajmanagement.co.uk
Fax: 020-8342 0842　　　　Tel: 020-8342 0542

A B ACADEMY THEATRE SCHOOL
Act Out Ltd, 22 Greek Street
Stockport, Cheshire SK3 8AB
e-mail: ab22actout@aol.com　　Tel/Fax: 0161-429 7413

ACADEMY DRAMA SCHOOL The
DS (Day, Evening, Full-time 1 or 2 yr Courses,
Preparatory to Post-graduate)
189 Whitechapel Road, London E1 1DN
Website: www.the-academy.info
e-mail: ask@the-academy.info　　Tel: 020-7377 8735

ACADEMY OF CREATIVE TRAINING
8-10 Rock Place
Brighton, East Sussex BN2 1PF
Website: www.actedu.org.uk
e-mail: info@actedu.org.uk　　Tel: 01273 818266

**ACADEMY OF THE SCIENCE OF ACTING
AND DIRECTING The**
67-83 Seven Sisters Road, London N7 6BU
Website: www.asad.org.uk
e-mail: info@asad.org.uk
Fax: 020-7272 0026　　　　Tel: 020-7272 0027

ACADEMY SCHOOL OF PERFORMING ARTS The
(Drama, Singing, Dance)
PO Box 432, Oldham, Lancashire OL9 8ZS
Website: www.academy-sopa.co.uk
e-mail: theacademy@ntlworld.com　　Tel: 0161-287 9700

ACE ACCOMPANIST
S (Coaching/Accompanist)
165 Gunnersbury Lane
London W3 8LJ　　　　Tel: 020-8993 2111

**ACKERLEY STUDIOS OF SPEECH, DRAMA & PUBLIC
SPEAKING**
Sp D Margaret Christina Parsons (Principal)
5th Floor, Hanover House, Hanover Street
Liverpool L1 3DZ　　　　Tel: 0151-709 5995

ACT ONE DRAMA STUDIO
31 Dobbin Hill, Sheffield S11 7JA
Website: www.actonedrama.co.uk
e-mail: casting@actonedrama.co.uk
Fax: 0870 7058322　　　　Tel: 0114-266 7209

ACT @ SCHOOL
(Drama for Children & Young People)
Part of APM Training Group
PO Box 834, Hemel Hempstead HP3 9ZP
Website: www.apmtraining.co.uk
e-mail: info@apmtraining.co.uk
Fax: 01442 241099　　　　Tel: 01442 252907

ACTING & AUDITION SUCCESS
(Philip Rosch, Association of Guildhall Teachers FVCM,
LGSM, LALAM, ATCL, ANEA, BA Hons) (Audition
Speeches/Effective Sight Reading & Career Guidance)
53 West Heath Court, North End Road
London NW11 7RG　　　　Tel: 020-8731 6686

ACTION LAB
(Part-time Acting Courses, Miranda French & Peter Irving)
18 Lansdowne Road, London W11 3LL
Mobile: 07979 623987　　　Tel: 020-7727 3473

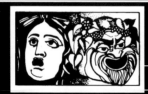

HERTFORDSHIRE
THEATRE SCHOOL
LIMITED

THREE YEAR ACTING & MUSICAL THEATRE COURSE &
ONE YEAR COURSE FOR POSTGRADUATES & TEACHERS

Applications now being accepted for the academic year commencing Sept. 2007
from the U.K. and abroad. Please apply for prospectus and audition details from
The Registrar, Hertfordshire Theatre School, 40 Queen Street, Hitchin, Herts SG4 9TS
or phone 01462 421416. Email: info@htstheatreschool.co.uk Website: www.htstheatreschool.co.uk

p194

Why do I need drama training?

The entertainment industry is an extremely competitive one, with thousands of performers competing for a small number of jobs. In such a crowded market, professional training will increase an actor's chances of success, and professionally trained artists are also more likely to be represented by agencies. Drama training can begin at any age and should continue throughout an actor's career.

What kind of training is available?

For the under 18's, stage schools provide specialist training in acting, singing and dancing. They offer a variety of full and part-time courses. After 18, students can attend drama school. The standard route is to take a three-year, full-time course, in the same way you would take a University degree. Some schools also offer one or two year courses. Full information will be available in each school's prospectus or on their website. Even after drama school, ongoing training is also vital for actors so that they can continue to develop acting techniques, or to prepare for a specific role.

How should I use these listings?

For ease of use, listings are classified with the following abbreviations:

Stage School for Children = SS
Dramatic Art, e.g. Coaching, Audition Technique, etc. = D
Full time Drama Training (includes every school listed in = DS
the Conference of Drama Schools section).
Elocution Coaching e.g. Correction of Accents, Speech Therapy, Dialects, etc. = E
Singing = S
Specialised Training = Sp

Many listings also include a brief description regarding their areas of expertise.

What is the Conference of Drama Schools (CDS)?

The Conference of Drama Schools was founded in 1969 and comprises Britain's twenty two leading Drama Schools. It exists in order to strengthen the voice of the member schools, to set and maintain the highest standards of training within the vocational drama sector, and to make it easier for prospective students to understand the range of courses on offer and the application process. The twenty two member schools listed in the section 'Drama Schools (Conference Of)' offer courses in Acting, Musical Theatre, Directing and Technical Theatre training. Most courses are three years long, although there are one-year postgraduate courses available. The CDS also publishes a free, downloadable guide to drama training.

For more information you can visit their website (www.drama.ac.uk)

JOHN BYRNE is a writer, performer and broadcaster and, in his weekly 'Dear John' column, the career advisor and agony uncle to The Stage newspaper.

When The Stage was first published over 125 years ago, it was among other things a vehicle for providing much needed basic information (on such glamorous issues as bed and breakfasts and theatre opening times) to members of a profession which was still regarded as not very respectable - or, if you happened to be a jobbing actress, bordering on scandalous. As the paper's immediate success demonstrated, it was also an industry woefully under-resourced in terms of support services.

A century later, things have certainly changed. Celebrities - many of them actors and actresses - have become our new 'royalty'. Reality TV shows abound based on 'ordinary members of the public getting their big break'. As a result of all this coverage it is no surprise that there are now more drama and performance courses available than ever before: full-time, part-time and aimed at every age group.

In addition to formal training, there is also a vast array of coaches and private tutors to choose from. Whether you want to brush up on your singing, learn a new dialect or prepare for that all important audition... you name it, there is almost certainly someone out there who will be happy to teach it to you for a price.

Nevertheless, there are two myths which haven't changed over the years. First is the belief that formal training is either the <u>only</u> way to make it as an actor, or a cast iron guarantee of success in the business. Unfortunately it isn't either of those things - there has always been a greater number of talented performers around then there are parts available, and the recent upsurge in interest in performance as a career has only increased this numbers gap.

The realisation that this first myth is a falsehood has led to an equally unhelpful embracing of the second myth, popular among the 'just get out there and do it' school of actors and musicians: that formal training will either 'inhibit your natural talent' or simply waste time when you could be turning up for open auditions or 'keeping it real' in a fringe theatre show or on cable TV.

You should certainly be doing everything you can to use and develop your skills - there is indeed no substitute for experience - but the more auditions and shows you attend the more you'll find that the people who are forging long term careers as opposed to aiming for 'one big break' are the ones who combine talent and perseverance with a commitment to ongoing learning and development and to stretching their existing abilities.

Whether you choose full-time training, part-time training or to work one-to-one with a suitable coach, the clearer you are on what you are trying to achieve, the better you will be able to judge how beneficial the course offered will be to you. You will also need to gather as much information about the real time and money costs involved as you can. Not all courses are funded, and in most cases getting the most value out of training will demand that you say 'no' to other expenditure and pursuits.

From the point of view of the teacher, be it a college or an individual coach, they are providing a service, you are the customer and they should be prepared to deliver whatever it is they are promising and be clear on what they will do to correct the situation if you are not happy that you are getting what you paid for. The best institutions and tutors will always be happy for you to ask 'silly' questions and get the opinion of previous students and clients before you sign on the dotted line, and I strongly recommend you do that. And of course if you do run into challenges during your training or your-hopefully-glittering career, Dear John is always happy to help!

Dear John is featured weekly in The Stage and previously answered questions are archived in the advice section of (www.thestage.co.uk) John Byrne is contactable through The Stage or via (www.getmemyagent.com)

Eileen Benskin
Dialect/Dialogue Coach
R.A.D.A. dip., C.P.E.P. University College London

FILMS • TELEVISION • THEATRE
Specialist in Standard British English (R.P.)
and American, British & Foreign Accents & Dialects
Tel/Fax: 020-8455 9750 *or* The Spotlight 020-7437 7631 Mobile 07785 791715

ACTORS STUDIO
Pinewood Film Studios
Pinewood Road
Iver Heath, Bucks SL0 0NH
Website: www.actorsstudio.co.uk
e-mail: info@actorsstudio.co.uk
Fax: 01753 655622 Tel: 01753 650951

ACTORSPACE.CO.UK
D E Sp (Auditions, Improvisation, Voice & Text, Roleplay and Acting in Business)
6 Chandos Court, The Green
Southgate, London N14 7AA
Website: www.actorspace.co.uk
e-mail: drama@london.com
Fax: 0870 1342719 Tel: 020-8886 8870

ACTOR'S TEMPLE The
13 Warren Street, London W1T 5LG
Website: www.actorstemple.com
e-mail: info@actorstemple.com
Mobile: 07771 734670 Tel: 020-7383 3535

ACTORS' THEATRE SCHOOL
(Foundation Course)
32 Exeter Road, London NW2 4SB
Website: www.theactorstheatreschool.co.uk
e-mail: info@theactorstheatreschool.co.uk
Fax: 020-8450 1057 Tel: 020-8450 0371

ACTS
(Ayres-Clark Theatre School)
12 Gatward Close, Winchmore Hill
London N21 1AS Tel: 020-8360 0352

ACT UP
(Acting Classes for Everyone)
Unit 88, Battersea Business Centre
99-109 Lavender Hill, London SW11 5QL
Website: www.act-up.co.uk
e-mail: info@act-up.co.uk
Fax: 020-7924 6606 Tel: 020-7924 7701

ALEXANDER Helen
(Audition Technique/Drama School Entry)
14 Chestnut Road, Raynes Park
London SW20 8EB Tel: 020-8543 4085

ALLSORTS - DRAMA FOR CHILDREN
(Part-time Courses - Kensington, Notting Hill, Hampstead, Fulham ages 3-18 yrs)
34 Pember Road, London NW10 5LS
Website: www.allsortsdrama.com
e-mail: info@allsortsdrama.com
Fax: 020-8969 3196 Tel: 020-8969 3249

ALRA (ACADEMY OF LIVE & RECORDED ARTS)
See DRAMA SCHOOLS (Conference of)

AMERICAN VOICES
(Lynn Bains) (American Accent/Dialect Coach, Acting Teacher & Director)
20 Craighall Crescent, Edinburgh EH6 4RZ
e-mail: mail@lynnbains.com Mobile: 07875 148755

AND ALL THAT JAZZ
(Eileen Hughes - Accompanist & Vocal Coaching)
165 Gunnersbury Lane, Acton Town
London W3 8LJ Tel: 020-8993 2111

DÉBUT THEATRE SCHOOL & CASTING AGENCY

Branches In Leeds & Bradford

Principals: Jacqui Drake & David Kirk

Classes In:-

Performing Arts - Age 3 to 18 years
Drama - Age 5 to 18 years
Singing - Age 7 to Adult
Piano - Age 6 to Adult

Complete Training for Television, Film & Theatre
Fully qualified caring tuition in a friendly, secure
disciplined environment
but with great emphasis on *enjoyment*
Annual Spectacular Production & Summer School
No Audition Nessessary - *Just enthusiasm*
Interested?

Contact Jacqui Drake on
01274 532347 for more details
or visit our website:-
www.debuttheatreschool.co.uk

"*Train for life in the theatre by working in the theatre*"

Court Theatre Company

BA (HONS) ACTING

Three year acting course
A complete training for actors in an environment of a working theatre focusing on the development of the creative imagination.

POSTGRADUATE DIPLOMA

One year full time courses

Acting Theatre Design
Directing Stage Management

Court Theatre Company
The Courtyard, 10 York Way
King's Cross, London N1 9AA
Tel: 020 7833 0870
E-mail: ctc@thecourtyard.org.uk
Web Site: www.thecourtyard.org.uk

ARDEN SCHOOL OF THEATRE The
City Campus, Whitworth Street, Manchester M1 3HB
e-mail: ast@ccm.ac.uk
Fax: 0161-279 7218 Tel: 0161-279 7257

ARTEMIS SCHOOL OF SPEECH & DRAMA
Peredur Centre of the Arts, West Hoathly Road
East Grinstead, West Sussex RH19 4NF
Website: www.artemisspeechanddrama.org.uk
e-mail: office@artemisspeechanddrama.org.uk
Tel/Fax: 01342 321330

ARTS EDUCATIONAL SCHOOL
(Dance, Drama & Musical Theatre Training School
for 8-18 yrs)
Tring Park, Tring, Herts HP23 5LX
Website: www.aes-tring.com
e-mail: info@aes-tring.com Tel: 01442 824255

ARTS EDUCATIONAL SCHOOLS LONDON
See DRAMA SCHOOLS (Conference of)

ASHCROFT ACADEMY OF DRAMATIC ART The
(Drama LAMDA, Dance ISTD, Singing, Age 4-18 yrs)
Malcolm Primary School
Malcolm Road, Penge, London SE20 8RH
Website: www.ashcroftacademy.com
e-mail: geri.ashcroftacademy@tiscali.co.uk
Mobile: 07799 791586 Tel: 020-8693 8088

ASHFORD Clare BSc, PGCE, LLAM, ALAM (Recital), ALAM (Acting)
D E
20 The Chase,
Coulsdon, Surrey CR5 2EG
e-mail: clareashford@handbag.com Tel: 020-8660 9609

AUDITION COACH
9A Niederwald Road
Sydenham, London SE26 4AD
Website: www.auditioncoach.co.uk
e-mail: info@auditioncoach.co.uk Tel: 020-8291 5545

BAC
(Young People's Theatre Workshops & Performance
Projects, 12-25 yrs)
Lavender Hill, London SW11 5TN
e-mail: mailbox@bac.org.uk
Fax: 020-7978 5207 Tel: 020-7223 6557

BARNES Barbara
(Feldenkrais Practitioner & Voice Coach)
The Studio, Church Road, Ashmanhaugh, Norwich NR12 8YL
Website: www.barbarabarnesvoiceovers.co.uk
e-mail: barbara.barnes@feldenkrais.co.uk
Mobile: 07770 375339 Tel: 01603 781281

BATE Richard MA (Theatre) LGSM (TD), PGCE (FE), Equity
D E
Apt 1, Broom Hall, Broom
Bedfordshire SG18 9ND Mobile: 07940 589295

BECK Eirene
D E (Specialising in Voice & Audition Pieces)
23 Rayne House, 170 Delaware Road
London W9 2LW Tel: 020-7286 0588

BELCANTO LONDON ACADEMY Ltd
(Stage School & Agency)
Performance House, 20 Passey Place
Eltham, London SE9 5DQ
e-mail: bla@dircon.co.uk
Fax: 020-8850 9944 Tel: 020-8850 9888

BENCH Paul MEd, LGSM, ALAM, FRSA, LJBA (Hons), PGCE, ACP (Lings) (Hons), MASC (Ph), MIFA (Reg)
D E
1 Whitehall Terrace
Shrewsbury, Shropshire SY2 5AA
e-mail: pfbench@aol.com Tel/Fax: 01743 233164

BENSKIN Eileen
(Dialect Coach) Tel: 020-8455 9750

BERKERY Barbara
(Dialogue/Dialect Coach
for Film & Television) Tel: 020-7281 3139

BEST THEATRE ARTS
PO Box 749, St Albans AL1 4YW
Website: www.besttheatrearts.com
e-mail: bestarts@aol.com Tel: 01727 759634

BIG LITTLE THEATRE SCHOOL
Unit 305, Green Zone
Maycrete Road, Industrial Park West
Bournemouth Airport
Bournemouth BH23 6NW
Website: www.biglittletheatreschool.co.uk
e-mail: info@biglittletheatreschool.co.uk Tel: 01202 574422

BILLINGS Una
(Dance Training Children 10-16 yrs)
Methodist Church, Askew Road
London W12 9RN Tel: 020-7603 8156

BIRD COLLEGE
(Drama/Musical Theatre College)
Birkbeck Centre, Birkbeck Road, Sidcup, Kent DA14 4DE
Website: www.birdcollege.co.uk
e-mail: admin@birdcollege.co.uk
Fax: 020-8308 1370 Tel: 020-8300 6004

BIRMINGHAM SCHOOL OF ACTING
See DRAMA SCHOOLS (Conference of)

BIRMINGHAM THEATRE SCHOOL
The Old Rep Theatre
Station Street, Birmingham B5 4DY
Website: www.the-birmingham-theatre-school.com
e-mail: info@birminghamtheatreschool.co.uk
 Tel/Fax: 0121-643 3300

BODENS STUDIOS
D S E SS DS
Bodens Studio & Agency
99 East Barnet Road, New Barnet, Herts EN4 8RF
Website: www.bodenstudios.com
e-mail: bodens2692@aol.com
Fax: 020-8449 5212 Tel: 020-8449 0982

BORLAND Denise MA Voice (Perf), LRAM, PG Dip RAM, Perf Dip GSMD, ALCM
(Singing, Acting & Voice Coach)
25 Frogston Road West, Edinburgh EH10 7AB
Website: www.dbsvoicedevelopment.com
e-mail: deniseborland@hotmail.com Tel: 0131-445 7491

BOWES Sara
(Child Acting Coach for Film)
73 Treaty Street, London N1 0TE
e-mail: sara@sarabowes.com
Mobile: 07830 375389 Tel: 020-7833 5977

BOYD Beth
D S
10 Prospect Road, Long Ditton, Surbiton
Surrey KT6 5PY Tel: 020-8398 6768

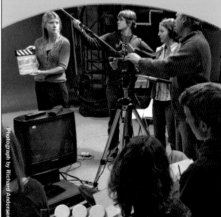

BRADSHAW Irene
(Private Coach. Voice & Audition Preparation)
Flat F, Welbeck Mansions, Inglewood Road
West Hampstead, London NW6 1QX
Website: www.voicepowerworks.com Tel: 020-7794 5721

BRAITHWAITE'S ACROBATIC SCHOOL
8 Brookshill Avenue
Harrow Weald, Middlesex Tel: 020-8954 5638

BRANSTON Dale
(Singing Coach)
Ground Floor Flat
16 Fernwood Avenue
Streatham, London SW16 1RD
e-mail: branpickle@yahoo.co.uk Tel: 020-8696 9958

BRIDGE THEATRE TRAINING COMPANY The
Cecil Sharp House
2 Regent's Park Road, London NW1 7AY
Website: www.thebridge-ttc.org
Fax: 020-7424 9118 Tel: 020-7424 0860

BRIGHTON PERFORMERZONE
(William Pool ARCM, Singing Tuition & Workshops)
33A Osmond Road
Hove, East Sussex BN3 1TD
Website: www.performerzone.co.uk
e-mail: info@performerzone.co.uk Mobile: 07973 518643

BRIGHTON SCHOOL OF MUSIC & DRAMA
96 Claremont Road, Seaford
East Sussex BN25 2QA Tel: 01323 492918

BRISTOL OLD VIC THEATRE SCHOOL
See DRAMA SCHOOLS (Conference of)

B.R.I.T. SCHOOL FOR PERFORMING ARTS & TECHNOLOGY The
60 The Crescent,
Croydon CR0 2HN
Website: www.brit.croydon.sch.uk
e-mail: admin@brit.croydon.sch.uk
Fax: 020-8665 8676 Tel: 020-8665 5242

BRITISH AMERICAN DRAMA ACADEMY
14 Gloucester Gate
Regent's Park, London NW1 4HG
Website: www.badaonline.com
Fax: 020-7487 0731 Tel: 020-7487 0730

BURTON Gwendolen MA, PG Dip (Performance) AOTOS
(Singing Teacher)
London N1
e-mail: singing@symbolic.net Mobile: 07771 657261

CAMERON BROWN Jo PGDVS
(Dialect and Voice)
6 The Bow Brook, Gathorne Street, London E2 0PW
Agent: Representation Joyce Edwards 020-7735 5736
e-mail: jocameronbrown@hotmail.com
Mobile: 07970 026621 Tel: 020-8981 1005

CAMPBELL Kenneth
S E D
Parkhills, 6 Clevelands Park, Northam
Bideford, North Devon EX39 3QH
e-mail: campbell870@btinternet.com Tel: 01237 425217

CAMPBELL Ross ARCM, Dip RCM (Perf)
(Singing Coach, Accompanist & Music Director)
17 Oldwood Chase, Farnborough, Hants GU14 0OS
e-mail: rosscampbell@ntlworld.com Tel: 01252 510228

CAPITAL ARTS THEATRE SCHOOL
(Kathleen Shanks)
Wyllyotts Centre, Darkes Lane
Potters Bar, Herts EN6 2HN
e-mail: capitalarts@btconnect.com
Mobile: 07885 232414 Tel/Fax: 020-8449 2342

CARSHALTON COLLEGE
DS
Nightingale Road, Carshalton, Surrey SM5 2EJ
Website: www.carshalton.ac.uk
e-mail: cs@carshalton.ac.uk
Fax: 020-8544 4440 Tel: 020-8544 4444

CARTEURS THEATRICAL AGENCY
170A Church Road, Hove, East Sussex BN3 2DJ
Website: www.stonelandsschool.co.uk
e-mail: dianacarteur@stonelandsschool.co.uk
Fax: 01273 770444 Tel: 01273 770445

CELEBRATION THEATRE COMPANY FOR THE YOUNG
SS D E S Sp, 48 Chiswick Staithe, London W4 3TP
Website: www.speakwell.co.uk Tel: 020-8994 8886

CENTRAL SCHOOL OF SPEECH & DRAMA
See DRAMA SCHOOLS (Conference of)

CENTRE STAGE SCHOOL OF PERFORMING ARTS
(Students 4-18 yrs) (North London)
The Croft, 7 Cannon Road, Southgate, London N14 7HJ
Website: www.centrestageuk.com
Fax: 020-8886 7555 Tel: 020-8886 4264

CENTRESTAGE SCHOOL OF PERFORMING ARTS
(All Day Saturday Classes, Summer Courses, Private
Coaching for Professionals & Drama School Auditions)
Centrestage House, 117 Canfield Gardens, London NW6 3DY
Website: www.centrestageschool.co.uk
e-mail: vickiwoolf@centrestageschool.co.uk
Tel: 020-7328 0788

CHARD Verona LRAM, Dip RAM (Musical Theatre)
(Singing Tutor)
Ealing House, 33 Hanger Lane, London W5 3HJ
e-mail: verona.chard@vampevents.com　Tel: 020-8992 1571

CHARRINGTON Tim
E D
54 Topmast Point
Strafford Street, London E14 8SN
e-mail: tim.charrington@lycos.co.uk
Mobile: 07967 418236　　　　　　Tel: 020-7987 3028

CHASE Stephan PRODUCTIONS Ltd
The Studio
22 York AvenueLondon SW14 7LG
Website: www.stephanchase.com
e-mail: stephanchase@talktalk.net　　Tel: 020-8878 9112

CHEKHOV Michael CENTRE
19 Chanctonbury Road
Hove, Sussex BN3 6EZ
Website: www.michaelchekhov.org.uk
e-mail: admin@michaelchekhov.org.uk　Tel: 01273 738238

CHRISKA STAGE SCHOOL
37-39 Whitby Road, Ellesmere Port
Cheshire L64 8AA　　　　　　　　Tel: 01928 739166

CHRYSTEL ARTS THEATRE SCHOOL
(Edgware Branch)
38 Cavendish Road, Chesham, Bucks HP5 1RW
e-mail: chrystelarts@beeb.net　　　Tel: 01494 785589

CHURCHER Mel MA
(Acting & Vocal Coach)
Website: www.melchurcher.com
e-mail: melchurcher@hotmail.com　　Tel: 020-7701 4593

CIRCOMEDIA
(Centre for Contemporary Circus & Physical Performance)
Britannia Road, Kingswood, Bristol BS15 8DB
Website: www.circomedia.com
e-mail: info@circomedia.com　　　Tel/Fax: 0117-947 7288

CIRCUS MANIACS SCHOOL OF CIRCUS ARTS
(Full & Part-time Courses,
One-to-One Act Development & Production Support)
Office 8A, The Kingswood Foundation
Britannia Road, Kingswood, Bristol BS15 8DB
Website: www.circusmaniacs.com
e-mail: info@circusmaniacs.com
Mobile: 07977 247287　　　　　　Tel/Fax: 0117-947 7042

CITY LIT The
(Part-time Day & Evening)
Keeley Street, Covent Garden, London WC2B 4BA
Website: www.citylit.ac.uk
e-mail: drama@citylit.ac.uk　　　Tel: 020-7492 2542

CLEMENTS Anne MA, LGSM, FRSA
(Drama/Speech/Auditions/Coaching)
293 Shakespeare Tower, Barbican
London EC2Y 8DR　　　　　　　Tel: 020-7374 2748

COLDIRON M J
(Private Coaching,
Audition Preparation & Presentation Skills)
21 Chippendale Street, London E5 0BB
e-mail: jiggs@blueyonder.co.uk　　Tel: 020-8533 1506

COLGAN Valerie
The Green, 17 Herbert Street
London NW5 4HA　　　　　　　Tel: 020-7267 2153

ArtsEd
LONDON

SCHOOL OF MUSICAL THEATRE
Director Ian Watt-Smith
Tel 020 8987 6677 Fax 020 8987 6680
email mts@artsed.co.uk

BA (Hons) Musical Theatre
A CDET Accredited Course. Validated by City
University.
A full-time 3 yr course (18+). A fully integrated approach
providing outstanding training in dance, acting and singing
by leading professionals. Training the Complete Performer
with excellent employment opportunities for graduates.

SCHOOL OF ACTING
Director Jane Harrison
Associate Director Adrian James
Tel 020 8987 6655
Fax 020 8987 6656
email drama@artsed.co.uk

BA (Hons) Acting
3 Year Acting Course. An NCDT
Accredited Course. Validated by City
University.
A 3 yr course offering the full range of acting skills
to adult students aged 18 or over. The emphasis is
on the actor in performance and the relationship
with an audience. Classes and tutorial work
include: a range of textual, psychological and
physical acting techniques, screen acting and
broadcasting, voice and speech, movement and
dance, mask and theatre history.

MA Acting
1 Year Course. An NCDT Accredited
Course. Validated by City University.
An intensive 1 yr post-graduate acting course
offering a fully integrated ensemble training for
mature students (aged 21 or over) with a degree
or equivalent professional experience. Emphasis is
on the pro-active contemporary performer.

Post Diploma BA (Hons) Performance Studies
Validated by City University.
One-year part-time degree conversion course
for anyone who has graduated since 1995 from
a NCDT/CDET accredited 3 yr acting or
musical theatre course: or for those who can
offer appropriate professional experience.

**Latest Government Inspection
rated ArtsEd "outstanding".
Government funded Dance and
Drama Awards available.**

www.artsed.co.uk

The Arts Educational Schools
14 Bath Road, Chiswick W4 1LY

Member of the Conference of Drama
Schools

COLIN'S PERFORMING ARTS Ltd
(Full-time 3 yr Performing Arts College)
The Studios, 219B North Street, Romford, Essex RM1 4QA
Website: www.colinsperformingarts.co.uk
e-mail: college@colinsperformingarts.co.uk
Fax: 01708 766077 Tel: 01708 766007

COMBER Sharrone BA Hons MAVS (CSSD)
D E Sp (Voice & Speech, Text, Auditions)
67 Colomb Street, Greenwich, London SE10 9EZ
e-mail: sharronecomber@hotmail.com Mobile: 07752 029422

COMEDY WORKSHOPS - Jack Milner
88 Pearcroft Road, London E11 4DR
Website: www.jackmilner.com
e-mail: jack@jackmilner.com Tel: 020-8556 9768

COMPLETE WORKS CREATIVE TRAINING COMPANY Ltd The
The Old Truman Brewery
91 Brick Lane, London E1 6QL
Website: www.tcw.org.uk
e-mail: info@tcw.org.uk
Fax: 0870 1431979 Tel: 0870 1431969

CONTI Dizi
D Sp E
4 Brentmead Place
London NW11 9LH Tel: 020-8458 5535

CONTI Italia ACADEMY OF THEATRE ARTS
SS
Italia Conti House, 23 Goswell Road, London EC1M 7AJ
e-mail: agency@italiaconti.co.uk
Fax: 020-7253 1430 Tel: 020-7608 0044

CONTI Italia ACADEMY OF THEATRE ARTS
See DRAMA SCHOOLS (Conference of)

CORNER Clive AGSM LRAM
(Qualified Teacher, Private Coaching & Audition Training)
3 Bainbridge Close, Ham, Middlesex TW10 5JJ
e-mail: cornerassociates@aol.com Tel/Fax: 020-8332 1910

COURT THEATRE TRAINING COMPANY
The Courtyard Theatre, 10 York Way
King's Cross, London N1 9AA
Website: www.thecourtyard.org.uk
e-mail: info@thecourtyard.org.uk Tel/Fax: 020-7833 0870

CREATIVE PERFORMANCE
(Circus Skills, TIE/Workshops, Children 5-11 yrs Part-time)
20 Pembroke Road, North Wembley
Middlesex HA9 7PD
e-mail: mjennymayers@aol.com Tel/Fax: 020-8908 0502

CROWE Ben
(Acting/Audition Tuition, Accent Coach)
73 Treaty Street, London N1 0TE
e-mail: bencrowe@hotmail.co.uk
Mobile: 07952 784911 Tel: 020-7833 5977

CYGNET TRAINING THEATRE
See DRAMA SCHOOLS (Conference of)

D & B SCHOOL OF PERFORMING ARTS
Central Studios
470 Bromley Road, Bromley BR1 4PN
Website: www.dandbperformingarts.co.uk
e-mail: bonnie@dandbmanagement.com
Fax: 020-8697 8100 Tel: 020-8698 8880

DALLA VECCHIA Sara
(Italian Teacher)
13 Fauconberg Road
London W4 3JZ Mobile: 07877 404743

DAVIDSON Clare
D E
30 Highgate West Hill, London N6 6NP
Website: www.csf.edu
e-mail: cdavidson@csf.edu Tel: 020-8348 0132

DEBUT THEATRE SCHOOL & CASTING AGENCY
1 Thrice Fold
Thackley, Bradford
West Yorkshire BD10 8WW
Website: www.debuttheatreschool.co.uk
Fax: 01274 532353 Tel: 01274 532347

DE COURCY Bridget
S (Singing Teacher)
19 Muswell Road, London N10 Tel: 020-8883 8397

JACK WALTZER ACTING WORKSHOPS

*Excerpt from **Dustin Hoffman**'s letter of recommendation:*
*"After knowing **Jack Waltzer** for many years as a professional actor & teacher and having*
*attended his acting classes in New York City numerous times, I chose his class to appear in my film "**Tootsie**"*
because his work represented for me the best of American acting techniques. I feel it would be most valuable for
*any professional actor to have the opportunity to study and work with **Jack Waltzer**".*

*Excerpt from **Sigourney Weaver**'s letter of recommendation:*
*"**Jack's** script breakdown techniques and his innovative exercises have completely revolutionized the way I prepare*
*for a film. **Jack** is the best teacher I have ever known. He is inspiring, practical and discreet.*
*I cannot recommend **Jack Waltzer** more highly. He is "**The Man**".*

*Excerpt from **Roman Polanski**'s letter of recommendation:*
*"I used **Jack Waltzer**'s expertise on several motion pictures and plays I directed. He helped me immensely*
*coaching the beginners as well as the experienced and accomplished actors. **Jack Waltzer** is the only no-nonsense*
acting teacher I know and recommend. His classes are fascinating. I like to pop in as a sort of "guest student" just
to learn some more. In preparing an actor for a performance he knows how to build a character."

MR. WALTZER *trained extensively as an actor for many years with America's foremost teachers and directors of*
*the **Stanislavsky** system. These include: **Stella Adler**, **Sandford Meisner**, **Lee Strasberg**, **Robert Lewis**, **Uta Hagen***
*and **Elia Kazan**. Acting credits include: Lifetime member of the **Actors Studio**. **Elia Kazan**'s and **Arthur Miller**'s*
*New York Lincoln Center Repertory Company. Students who have studied and coached with **Jack Waltzer** include:*
***Jon Voight**, **David Soul**, **Geena Davis**, **Sharon Stone**, **Teri Garr** and **Sigourney Weaver** among others. In **France**,*
*he has taught and coached many well known actors and actresses. He has also assisted **Roman Polanski** as a*
*drama coach in filming of both "**Bitter Moon**" and "**Death and the Maiden**"*

Paris 00331 48.03.14.82 London 020-8347 6598 New York 001 (212) 840-1234
e-mail: jackwaltzer@yahoo.co.uk Website: www.jackwaltzer.com

Over 600 part-time stage schools worldwide

MORE THAN 33,000 young people enjoy professional
training with us for 3 hours a week alongside the usual
academic year. The skills they learn as they
act, sing and dance don't vanish when the curtain
falls. They are learnt for life.

STAGECOACH
THEATRE ARTS SCHOOLS

The Courthouse, Elm Grove,
Walton-on-Thames, Surrey KT12 1LZ
T: 01932 254 333 F: 01932 222 894
www.stagecoach.co.uk

VOICE CONSULTANT & COACH
Jessica Higgs
Tel/Fax: 020-7359 7848 Mobile: 079-4019 3631
Basic vocal technique - text and acting -
Consultancy in all areas of voice use.

Eirene Beck
ACTRESS ~ TEACHER
Professional Coaching for
Voice - Auditions - Conferences
Telephone: 020-7286 0588

De FLOREZ Jane LGSM PG Dip
(Singing Teacher - Auditions, Musical Theatre Jazz,
Classical)
70 Ipsden Buildings, Windmill Walk
Waterloo, London SE1 8LT
Website: www.session-singer.archangel-promotions.co.uk
Tel: 020-7803 0835

DIGNAN Tess PDVS
(Audition, Text & Voice Coach)
004 Oregon Building, Deals Gateway, Lewisham SE13 7RR
e-mail: tessdignan60@tiscali.co.uk Tel: 020-8691 4275

DI LACCIO Gabriela
S (Singing Teacher & Coach)
165 Gunnersbury Lane, London W3 8LJ Tel: 020-8993 2111

DONNELLY Elaine
(Children's Acting Coach)
Sangwin Associates
Queens Wharf, Queen Charlotte Street
London W6 9RL Tel: 020-8600 2670

DRAGON DRAMA
(Drama for Children)
347 Hanworth Road, Hampton TW12 3EJ
Website: www.dragondrama.co.uk
e-mail: info@dragondrama.co.uk Tel/Fax: 020-8255 8356

DRAMA ASSOCIATION OF WALES
(Summer Courses for Amateur Actors & Directors)
The Old Library, Singleton Road, Splott, Cardiff CF24 2ET
e-mail: aled.daw@virgin.net
Fax: 029-2045 2277 Tel: 029-2045 2200

DRAMA CENTRE LONDON
See DRAMA SCHOOLS (Conference of)

DRAMA STUDIO EDINBURGH The
(Children's weekly drama workshops)
19 Belmont Road
Edinburgh EH14 5DZ
Website: www.thedramastudio.co.uk
e-mail: thedra@thedramastudio.co.uk
Fax: 0131-453 3108 Tel: 0131-453 3284

DRAMA STUDIO LONDON
See DRAMA SCHOOLS (Conference of)

DREAM FACTORY The
(Accredited Professional Creative Arts Training Facility
Located within a UK Prison - Open to Offenders
Ex-offenders & the Wider Community)
PO Box 31855, London SE17 3XP
Website: www.londonshakespeare.org.uk
e-mail: londonswo@hotmail.com Tel: 020-7793 9755

DULIEU John
(Acting Coach, Audition Preparation)
16 Fernwood Avenue
Streatham, London SW16 1RD
e-mail: john_dulieu@yahoo.com
Mobile: 07803 289599 Tel: 020-8696 9958

DUNMORE Simon
(Acting & Audition Tuition)
Website: www.simon.dunmore.btinternet.co.uk
e-mail: simon.dunmore@btinternet.com

Dee Forrest PGDVS Dip.DV. *VOICE & SINGING COACH*
DIALECTS: FILMS & TV - www.deeforrest4voice.com
AUDITIONS · PROJECTION · DIALECTS · INTERPRETATION
VOCAL PROBLEMS · PHONETICS · PRESENTATION SKILLS
Tel: 01273-204779 Mob: 07957 211065 E-mail: dee_forrest@yahoo.com

London Academy of Radio Film TV
TV Presenter - Acting - Voice - Film - Photography - Make-up - Radio
100 courses Offering an extensive range of full-time, part-time
evening and day courses taught by celebrities and industry professionals.
www.media-courses.com 0870 850 4994

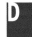

DURRENT Peter
(Audition & Rehearsal Pianist & Vocal Coach)
Blacksmiths Cottage, Bures Road, Sudbury
Little Cornard, Suffolk CO10 0NR Tel: 01787 373483

DYSON Kate LRAM
(Audition Coaching - Drama)
39 Arundel Street
Kemptown BN2 5TH Tel: 01273 607490

EARNSHAW Susi THEATRE SCHOOL
SS
68 High Street, Barnet, London EN5 5SJ
Website: www.susiearnshaw.co.uk
e-mail: casting@susiearnshaw.co.uk
Fax: 020-8364 9618 Tel: 020-8441 5010

EAST 15 ACTING SCHOOL
See DRAMA SCHOOLS (Conference of)

ECOLE INTERNATIONALE DE THEATRE JACQUES LECOQ
57 rue du Faubourg Saint-Denis, 75010 Paris
Website: www.ecole-jacqueslecoq.com
e-mail: contact@ecole-jacqueslecoq.com
Fax: 00 331 45 23 40 14 Tel: 00 331 47 70 44 78

ELLIOTT CLARKE SCHOOL
(Saturday & Evening Classes in Dance, Drama & Singing
RAD, ISTD, LAMDA)
132 Bold Street
Liverpool L1 4EZ Tel: 0151-709 3323

EXCEL SCHOOL OF PERFORMING ARTS
KT Summit House
100 Hanger Lane, Ealing W5 1EZ
Website: www.ktioe-excel.org
e-mail: excel@kt.org Tel: 020-8799 6117

EXPRESSIONS ACADEMY OF PERFORMING ARTS
3 Newgate Lane
Mansfield, Notts NG18 2LB
Website: www.expressions-uk.com
e-mail: expressions-uk@btconnect.com
Fax: 01623 647337 Tel: 01623 424334

FAIRBROTHER Victoria MA, CSSD, LAMDA Dip
15A Devenport Road
Shepherd's Bush, London W12 8NZ
e-mail: victoriafairbrother1@hotmail.com
Mobile: 07789 430535 Tel: 020-8749 1253

FAITH Gordon BA, IPA Dip, REM Sp, MCHC (UK), LRAM
Sp
1 Wavel Mews, Priory Road
London NW6 3AB Tel: 020-7328 0446

FAME FACTORY
3 Grange Street Mews, Grange Street
St Albans, Herts AL3 5NB Tel: 01582 831020

FBI AGENCY Ltd
(Acting Classes for Everyone)
PO Box 250, Leeds LS1 2AZ
e-mail: j.spencer@fbi-agency.ltd.uk Tel/Fax: 07050 222747

FERRIS Anna MA (Voice Studies, CSSD)
D E
Gil'cup Leaze, Hilton
Blandford Forum, Dorset DT11 0DB
e-mail: annaferris@aol.com Mobile: 07963 719386

FINBURGH Nina
D Sp
1 Buckingham Mansions, West End Lane
London NW6 1LR Tel/Fax: 020-7435 9484

FOOTSTEPS THEATRE SCHOOL
(Dance, Drama & Singing Training)
145 Bolton Lane, Bradford BD2 4AA
e-mail: helen@footsteps.fslife.co.uk Tel/Fax: 01274 626353

FORD Carole Ann ADVS
E D Sp
N10 2AL
Fax: 020-8365 3248 Tel: 020-8815 1832

FORREST Dee
(Voice/Dialects, Film & TV)
(London & Brighton. Deputy Head of Voice, Mountview)
Basement Flat 1A, 43 Brunswick Road, Brighton BN3 1DH
Website: www.deeforrest4voice.com
e-mail: dee_forrest@yahoo.com
Mobile: 07957 211065 Tel: 01273 204779

FOX Betty STAGE SCHOOL
The Friends Institute
220 Moseley Road, Birmingham B12 0DG
e-mail: bettyfox.school@virgin.net
Mobile: 07703 436045 Tel/Fax: 0121-440 1635

FRANKLIN Michael
(Meisner Technique)
Correspondence: c/o The Spotlight
7 Leicester Place
London WC2H 7RJ Tel/Fax: 020-8979 9185

FRANKLYN Susan
(Audition Speeches, Interview technique,
Sight Readings, Presentation, Confidence)
Mobile: 07780 742891 Tel: 01306 884913

FRIEZE Sandra
D E Sp (English & Foreign Actors)
London Area NW3/NW6 Mobile: 07802 865305

FUSHION ACADEMY OF PERFORMING ARTS
Parkshot House
5 Kew Road, Richmond, Surrey TW9 2PR
Website: www.fushionacademy.co.uk
e-mail: info@fushionacademy.co.uk
Tel: 020-8334 8800 Fax: 020-8334 8100

GAUNT Julia, ALCM, TD-Musical Theatre
(Singing Teacher)
Nottingham (or East Midlands)
e-mail: joolsmusicbiz@aol.com Mobile: 07712 624083

GETTING THE PART
(Audition and Drama School Coaching)
7 Union Street, High Barnet, London EN5 4HY
Website: www.gettingthepart.com
e-mail: info@gettingthepart.com
Mobile: 07722 168366 Tel: 020-8449 1885

GLYNNE Frances THEATRE STUDENTS
Flat 9, Elmwood
The Avenue, Hatch End HA5 5BL
e-mail: franandmo@yahoo.co.uk Mobile: 07950 918355

GO FOR IT THEATRE SCHOOL
47 North Lane
Teddington, Middlesex TW11 0HU
Website: www.goforitts.com
e-mail: agency@goforitts.com Tel: 020-8943 1120

GRAYSON John
(Coaching for Drama Auditions)
14 Lile Crescent, Hanwell, London W7 1AH
e-mail: john@bizzybee.freeserve.co.uk
Mobile: 07702 188031 Tel: 020-8578 3384

GREASEPAINT ANONYMOUS
(Youth Theatre & Training Company)
4 Gallus Close, Winchmore Hill, London N21 1JR
e-mail: info@greasepaintanonymous.co.uk
Fax: 020-8882 9189 Tel: 020-8886 2263

GREGORY Lynda SCHOOL OF SPEECH & DRAMA
(Speech and Drama Classes, All Ages)
23 High Ash Avenue
Leeds LS17 8RS Tel: 0113-268 4519

GREGORY Paul
(RSC & RNT Actor/Drama Coach)
133 Kenilworth Court, Lower Richmond Road
Putney, London SW15 1HB
Mobile: 07930 900744 Tel: 020-8789 5726

GREVILLE Jeannine THEATRE SCHOOL
Melody House, Gillott's Corner
Henley-on-Thames
Oxon RG9 1QU Tel: 01491 572000

GROUT Philip
(Theatre Director, Drama Coaching)
81 Clarence Road, London N22 8PG
e-mail: philipgrout@hotmail.com Tel: 020-8881 1800

GSA CONSERVATOIRE
See DRAMA SCHOOLS (Conference of)

GUILDHALL SCHOOL OF MUSIC & DRAMA
See DRAMA SCHOOLS (Conference of)

HALL Michael THEATRE SCHOOL & CASTING AGENCY
Performing Arts Centre
19 Preston Old Road
Blackpool, Lancs FY3 9PR
e-mail: frances@thehalls.force9.co.uk Tel: 01253 696990

HANCOCK Allison LLAM
D E (Dramatic Art, Acting,
Voice, Audition Coaching, Elocution, Speech Correction etc)
38 Eve Road
Isleworth
Middlesex TW7 7HS Tel/Fax: 020-8891 1073

HARLEQUIN STUDIOS PERFORMING ARTS SCHOOL
(Drama & Dance Training)
122A Phyllis Avenue
Peacehaven
East Sussex BN10 7RQ Tel: 01273 581742

HARRINGTON Alexandre
(Audition Coach, Voice Consultant)
20 Princes Square
London W2 4NP
e-mail: alexhvoice@tiscali.co.uk Mobile: 07979 963410

HARRIS Sharon NCSD, LRAM, LAM, STSD, IPA Dip DA
(London Univ)
The Harris Drama School
52 Forty Avenue Wembley, Middlesex HA9 8LQ
e-mail: theharrisagency@ukonline.co.uk
Fax: 020-8908 4455 Tel: 020-8908 4451

HERTFORDSHIRE THEATRE SCHOOL
40 Queen Street, Hitchin, Herts SG4 9TS
Website: www.htstheatreschool.co.uk
e-mail: info@htstheatreschool.co.uk Tel: 01462 421416

HESTER John LLCM (TD)
D E (Member of The Society of
Teachers of Speech & Drama)
105 Stoneleigh Park Road, Epsom
Surrey KT19 0RF
e-mail: hjohnhester@aol.com Tel: 020-8393 5705

HEWITT PERFORMING ARTS
(Romford Area)
Website: www.hewittperformingarts.co.uk
e-mail: hewittstudios@aol.com Tel: 01708 727784

HIGGS Jessica
(Voice)
41A Barnsbury Street, London N1 1PW
Mobile: 07940 193631 Tel/Fax: 020-7359 7848

HOFFMANN-GILL Daniel
(Acting & Audition Tuition)
22 Cassis Court, Chigwell Lane, Loughton, Essex IG10 3UA
e-mail: danielhg@gmail.com
Mobile: 07946 433903 Tel: 020-8508 8886

HONEYBORNE Jack
S (Accompanist & Coach)
The Studio, 165 Gunnersbury Lane
London W3 8LJ Tel: 020-8993 2111

HOPE STREET Ltd
DS Sp (Physical & Multi-Media Perfomance, Training for Actors, Designers, Directors & Participatory Arts Workers)
13A Hope Street, Liverpool L1 9BQ
Website: www.hope-street.org
e-mail: arts@hope-street.org
Fax: 0151-709 3242 Tel: 0151-708 8007

HOPNER Ernest LLAM
E D Public Speaking
70 Banks Road, West Kirby CH48 0RD Tel: 0151-625 5641

HOUSEMAN Barbara
(Ex-RSC Voice Dept, Associate Director Young Vic,
Voice/Text/Acting/Confidence)
e-mail: barbarahouseman@hotmail.com Mobile: 07767 843737

HUDDERSFIELD TECHNICAL COLLEGE
(Btec, GCE and HNC Courses
in Acting, Dance & Musical Theatre)
Highfields Annexe
New North Road
Huddersfield HD1 5NN
e-mail: info@huddcoll.ac.uk Tel: 01484 437047

HUGHES-D'AETH Charlie
(Voice Coach)
22 Osborne Road, Brighton BN1 6LQ
e-mail: chdaeth@aol.com Mobile: 07811 010963

HUGHES Dewi
(Voice, Accents, Bodywork, Text, Auditions)
Flat 2, 4 Fielding Road
London W14 0LL
e-mail: dewih@onetel.com Mobile: 07836 545717

IMPULSE COMPANY The
PO Box 158
Twickenham TW1 3WG
e-mail: info@impulsecompany.co.uk Tel/Fax: 020-8892 7292

INDEPENDENT THEATRE WORKSHOP The
2 Mornington Road
Ranelagh, Dublin 6, Eire
Website: www.independent-theatre-workshop.com
e-mail: info@independent-theatre-workshop.com
 Tel/Fax: 00 353 1 4968808

IVES-CAMERON Elaine BA, BA, MA
(Private Coaching, Dialect (USA, European & RP),
Drama School Entrance/Auditions)
29 King Edward Walk
London SE1 7PR
Mobile: 07980 434513 Tel: 020-7928 3814

SUSAN WHITE
BA TEFL LGSM MA Voice Studies *Distinction*
Theatre • Enterprise • Arts — Ensemble & Private Voice Coach
www.per-sona.com 020 7244 0402 susan@per-sona.com

JACK Andrew
Vrouwe Johanna
PO Box 412, Weybridge, Surrey KT13 8WL
Website: www.andrewjack.com Mobile: 07836 615839

JACK Paula
(Dialect Coach & Language Specialist)
24 The Moorings, Willows Riverside
Windsor, Berks SL4 5TG Mobile: 07836 615839

JAMES Linda RAM Dip Ed, IPD, LRAM
(Dialect Coach)
25 Clifden Road, Brentford
Middlesex TW8 0PB Tel: 020-8568 2390

JIGSAW PERFORMING ARTS SCHOOL
64-66 High Street
Barnet, Herts EN5 5SJ
e-mail: admin@jigsaw-arts.co.uk Tel: 020-8447 4530

JONES Desmond
(Mime & Physical Theatre, Master Classes & Short Courses,
Freelance Choreographer, Director, Teacher, Coach)
20 Thornton Avenue, London W4 1QG
Website: www.desmondjones.co.uk
e-mail: enquiries@desmondjones.co.uk Tel/Fax: 020-8747 3537

JUDE'S DRAMA ACADEMY & MANAGEMENT
Manor House, Oldham Road
Springhead, Oldham OL4 4QJ
Website: www.judesdrama.co.uk
e-mail: judesdrama@yahoo.co.uk Tel: 0161-624 5378

JUSTICE Herbert ACADEMY The
PO Box 253, Beckenham, Kent BR3 3WH
Website: www.hjacademy.com
e-mail: mail@hjacademy.com
Fax: 020-8249 2616 Tel: 020-8249 3299

KASTKIDZ
40 Sunnybank Road
Unsworth, Bury BL9 8HF
Website: www.kastkidz.com
e-mail: kastkidz@ntlworld.com
Fax: 0161-796 7073 Mobile: 07905 646832

KENT YOUTH THEATRE
(School & Agency)
Pinks Hill House, Briton Road
Faversham, Kent ME13 8QH
e-mail: info@kyt.org.uk Tel/Fax: 01795 534395

KERR Louise
(Voice Coach)
20A Rectory Road, London E17 3BQ
Website: www.resonancevoice.com
e-mail: louise@louisekerr.com
Mobile: 07780 708102 Tel: 020-8509 2767

KERSLAKE Kelli
137A Culford Road, London N1 4HX
e-mail: noochie05@aol.com
Fax: 020-7684 8091 Mobile: 07833 694743

KIDS AHEAD STAGE SCHOOL OF TOTTENHAM
Johnston & Mathers Associates Ltd
PO Box 3167, Barnet EN5 2WA
e-mail: joinkidsahead@aol.com
Fax: 020-8449 2386 Tel: 020-8449 4968

LAINE THEATRE ARTS
(Betty Laine)
The Studios, East Street
Epsom, Surrey KT17 1HH
Website: www.laine-theatre-arts.co.uk
e-mail: info@laine-theatre-arts.co.uk
Fax: 01372 723775 Tel: 01372 724648

LAMDA
See DRAMA SCHOOLS (Conference of)

LAMONT DRAMA SCHOOL & CASTING AGENCY
94 Harington Road
Formby, Liverpool L37 1PZ
Website: www.lamontcasting.co.uk
e-mail: diane@lamontcasting.co.uk Mobile: 07736 387543

LAURIE Rona
(Coach for Auditions & Voice & Speech Technique)
Flat 1, 21 New Quebec Street
London W1H 7SA Tel: 020-7262 4909

LEAN David Lawson BA Hons, PGCE
(Acting Tuition for Children, LAMDA Exams, Licensed
Chaperone)
72 Shaw Drive, Walton-on-Thames
Surrey KT12 2LS Tel: 01932 230273

LEE STAGE SCHOOL The
(Office)
126 Church Road
Benfleet, Essex SS7 4EP
e-mail: lynn@leetheatre.fsnet.co.uk Tel: 01268 795863

LESLIE Maeve
(Singing, Voice Production, Presentation)
60 Warwick Square
London SW1V 2AL Tel: 020-7834 4912

LEVENTON Patricia BA Hons
D E Sp (Audition & Dialect Coach)
113 Broadhurst Gardens
West Hampstead, London NW6 3BJ
e-mail: patricia@lites2000.com
Mobile: 07703 341062 Tel: 020-7624 5661

MEL CHURCHER Voice & Acting Coach
R.S.C., Regent's Park, Royal Court, Young Vic.
'Eragon' 'Unleashed', 'The Count Of Monte Cristo', 'The Hole', 'The Fifth Element', 'Lara Croft, Tomb Raider'.
'Acting for Film: Truth 24 Times a Second' Virgin Books 2003.
Tel/Fax: 020 7701 4593 Mobile: 07778 773019 Email: melchurcher@hotmail.com www.melchurcher.com

The David Morris School for Performing Arts

Centres for 6 to 16 year Olds
Saturdays 10 am to 1 pm

"Have Fun and Learn"
"Where everyone has a chance to shine"

Drama
Dance
♪♪
Singing

Franchise opportunities available

www.davidmorrisschool.com **Tel: 020 8924 0197**

LIVE & LOUD
(Children & Teenage Drama Coaching)
The S.P.A.C.E., 2nd Flr, 188 St Vincent's St, Glasgow G2 5SP
e-mail: info@west-endmgt.com
Fax: 0141-226 8983 Tel: 0141-222 2942

LIVERPOOL INSTITUTE FOR PERFORMING ARTS The
See DRAMA SCHOOLS (Conference of)

LIVINGSTON Dione LRAM, FETC
Sp E D
7 St Luke's St, Cambridge CB4 3DA Tel: 01223 365970

LOCATION TUTORS NATIONWIDE
(Fully Qualified/Experienced Teachers Working with Children on Film Sets & Covering all Key Stages of National Curriculum)
16 Poplar Walk, Herne Hill SE24 0BU
e-mail: locationtutorsnationwide@hotmail.com
Fax: 020-7207 8794 Tel: 020-7978 8898

LONDON ACADEMY OF PERFORMING ARTS (LAPA)
St Matthew's Church,
St Petersburgh Place, London W2 4LA
Website: www.lapadrama.com
e-mail: admin@lapadrama.com
Fax: 020-7727 0330 Tel: 020-7727 0220

LONDON ACTORS WORKSHOP
124D Lavender Hill, Battersea, London SW11 5RB
Website: www.londonactorsworkshop.co.uk
e-mail: info@londonactorsworkshop.co.uk
Mobile: 07748 846294

LONDON DRAMA SCHOOL
(Acting, Speech Training, Singing)
30 Brondesbury Park, London NW6 7DN
Website: www.startek-uk.com
e-mail: enquiries@startek-uk.com
Fax: 020-8830 4992 Tel: 020-8830 0074

DSL

Drama Studio London

＊**One year full time ACTING Course**
Established 1966 (Accredited by NCDT)

＊**One year full time DIRECTING Course**
Established 1978

＊**Excellent graduate employment record**

＊**For postgraduate and mature students**

＊**Comprehensive training includes regular productions of classical and modern texts, TV acting and employment classes**

Drama Studio London,
Grange Court, Grange Road, London W5 5QN
Tel: 020 8579 3897 Fax: 020 8566 2035
e-mail: registrar@dramastudiolondon.co.uk
www.dramastudiolondon.co.uk

DSL is supported by Friends of Drama Studio London
a registered charity: no 1051375 - President Dame Judi Dench

LONDON INTERNATIONAL SCHOOL OF PERFORMING ARTS
Unit 8
Latimer Road, London W10 6RQ
Website: www.lispa.co.uk
e-mail: welcome@lispa.co.uk Tel/Fax: 020-8969 7004

LONDON SCHOOL OF DRAMATIC ART
4 Bute Street
South Kensington, London SW7 3EX
Website: www.lsda-acting.com
e-mail: enquiries@lsda-acting.com Tel/Fax: 020-7581 6100

LONDON SCHOOL OF MUSICAL THEATRE
83 Borough Road
London SE1 1DN
e-mail: enquiries@lsmt.co.uk Tel/Fax: 020-7407 4455

LONDON STUDIO CENTRE
42-50 York Way
London N1 9AB
Website: www.london-studio-centre.co.uk
e-mail: info@london-studio-centre.co.uk
Fax: 020-7837 3248 Tel: 020-7837 7741

MACKINNON Alison
London SE6
e-mail: alison.mackinnon@tesco.net Mobile: 07973 562132

MADDERMARKET THEATRE
(Education Officer)
Education Department
St John's Alley, Norwich NR2 1DR
Website: www.maddermarket.co.uk
e-mail: mmtedu@btconnect.com
Fax: 01603 661357 Tel: 01603 628600

MANCHESTER METROPOLITAN UNIVERSITY SCHOOL OF THEATRE
See DRAMA SCHOOLS (Conference of)

MANCHESTER SCHOOL OF ACTING
29 Ardwick Green North, Manchester M12 6DL
Website: www.manchesterschoolofacting.com
e-mail: actorclass@aol.com Tel/Fax: 0161-273 4738

MARLOW Jean LGSM
D E
32 Exeter Road, London NW2 4SB Tel: 020-8450 0371

MARTIN Liza GRSM ARMCM (Singing), ARMCM (Piano)
(Singing Tuition, Sounds Sensational) Tel: 020-8348 0346

MASTERS PERFORMING ARTS COLLEGE Ltd
(Musical Theatre/Dance Course)
Arterial Road, Rayleigh
Essex SS6 7UQ Tel: 01268 777351

McCRACKEN Jenny
First Floor Flat
316A Chiswick High Road
London W4 5TA Tel: 020-8747 6724

McDAID Marj
1 Chesholm Road
Stoke Newington, London N16 0DP
e-mail: marjmcdaid@hotmail.com
Fax: 020-7502 0412 Tel: 020-7923 4929

McKEAND Ian
12 Linnet Close
Birchwood, Lincoln LN6 0JQ
Website: http://homepage.ntlworld.com/ian.mckeand1
e-mail: ian.mckeand@ntlworld.com Tel: 01522 805966

R.
A.
D.
A.

The Royal Shakespeare Company · Rose Bruford College

TESS DIGNAN PDVS
(preparing to audition...need some help?!)
Auditions, Sight Reading, Text Work, Voice & Speech, R.P....**Tel: 020-8691 4275**

The Moscow Arts Theatre School · BBC · LAMDA

C.
S.
S.
D.

McKELLAN Martin
P2 Abbey Orchard Street, London SW1P 2DP
e-mail: mckellan@macunlimited.net Tel: 020-7222 1875

MELLECK Lydia
S (Pianist & Coach for Auditions & Repertoire - RADA)
10 Burgess Park Mansions
London NW6 1DP Tel: 020-7794 8845

METHOD STUDIO, LONDON The
Conway Hall
25 Red Lion Square, London WC1R 4RL
Website: www.themethodstudio.com
e-mail: info@themethodstudio.com
Fax: 020-7831 8319 Tel: 020-7831 7335

MICALLEF Marianne
56 Broughton Court
Broughton Road
Ealing, London W13 8QN
e-mail: mariannemicallef@hotmail.com
 Mobile: 07974 203001

MICHEL Hilary ARCM
(Singing Teacher, Vocal Coaching, Accompanist, Auditions,
Technique)
82 Greenway, Totteridge, London N20 8EJ
Mobile: 07775 780182 Tel: 020-8343 7243

MIRACLE TREE PRODUCTIONS
(The Spiritual Psychology of Acting)
Website: www.miracletreeproductions.com
e-mail: info@miracletreeproductions.com
 Tel: 020-8653 7735

MONTAGE THEATRE ARTS
(Dance, Drama, Singing - Children & Adults)
(Artistic Director Judy Gordon)
The Albany, Douglas Way, London SE8 4AG
Website: www.montagetheatre.com
e-mail: office@montagetheatre.com Tel: 020-8692 7007

MORLEY ADULT EDUCATION COLLEGE
(Day & Evening LOCN Accredited, Acting School
Programme)
61 Westminster Bridge Road
London SE1 7HT
Website: www.morleycollege.ac.uk
e-mail: keith.brazil@morleycollege.ac.uk
Fax: 020-7928 4074 Tel: 020-7450 1832

MORRIS David SCHOOL FOR PERFORMING ARTS The
6 Sussex Close
Redbridge
Essex IG4 5DP
Mobile: 07973 129130 Tel: 020-8924 0197

MORRISON Stuart
(Voice & Speech Coach)
64 St Asaph Road
London SE4 2EL
e-mail: stuartvoicecoach@yahoo.co.uk Mobile: 07867 808648

MOUNTVIEW
See DRAMA SCHOOLS (Conference of)

MRS WORTHINGTON'S WORKSHOPS
SS S Md
(Part-time Performing Arts for Children 6-17 yrs)
16 Ouseley Road
London SW12 8EF Tel: 020-8767 6944

MURRAY Barbara LGSM, LALAM
129 Northwood Way
Northwood
Middlesex HA6 1RF Tel: 01923 823182

NATHENSON Zoe
(Film Acting, Audition Technique & Sight Reading)
66E Priory Road, London N8 7EX
Website: www.zoenathenson.com
e-mail: zoe.act@btinternet.com
Mobile: 07956 833850 Tel: 020-8347 7799

NATIONAL PERFORMING ARTS SCHOOL & AGENCY The
The Factory Rehearsal Studios
35A Barrow Street, Dublin 4, Eire
e-mail: info@npas.ie Tel/Fax: 00 353 1 6684035

NEIL Andrew
2 Howley Place, London W2 1XA
e-mail: andrew5@onetel.com
Mobile: 07979 843984 Tel/Fax: 020-7262 9521

NEW PRODUCERS ALLIANCE
Unit 1.07, The Tea Building
56 Shoreditch High Street E1 6JJ
Website: www.npa.org.uk
e-mail: queries@npa.org.uk
Fax: 020-7729 1852 Tel: 020-7613 0440

NEWNHAM Caryll
(Singing Teacher)
35 Selwyn Crescent
Hatfield, Herts AL10 9NL
e-mail: caryll@ntlworld.com
Mobile: 07976 635745 Tel: 01707 267700

NORTH LONDON PERFORMING ARTS CENTRE
(Performing Arts Classes 3-19 yrs, Dance, Drama, Music.
GCSE Courses & LAMDA)
76 St James Lane
Muswell Hill, London N10 3DF
Website: www.nlpac.co.uk
e-mail: nlpac@aol.com
Fax: 020-8444 4040 Tel: 020-8444 4544

NORTHERN ACADEMY OF PERFORMING ARTS
Anlaby Road, Hull HU1 2PD
Website: www.northernacademy.org.uk
e-mail: napa@northernacademy.org.uk
Fax: 01482 212280 Tel: 01482 310690

NORTHERN FILM & DRAMA
PO Box 76, Leeds LS25 9AG
Website: www.northernfilmanddrama.com
e-mail: info@northernfilmanddrama.com
 Tel/Fax: 01977 681949

The Actors Company
Auditioning now for October 2007

Photograph courtesy of Marilyn Kingwill

Not a drama school…but an acclaimed company in training

The Actors Company is a one year programme for mature graduates – 22 to 70. The Company offers intensive vocational training (40 hours per week) and a six week repertory season at the Jermyn Street Theatre in the West End of London. The course is 48 weeks in length – 36 of which are arranged so that Company members support themselves in employment during training.

Much Ado About Nothing
Jermyn Street,
Repertory Season

★★★★
What's On

"Pure Magic"
Paul Vale, The Stage

Some recent successful graduates

Bill Ward	**Houda Echouafni**	**Ben James**	**Mark Extance**	**Tim Daish**
Charlie Stubbs	Waking the Dead	This Is Elvis	You Never Can Tell	A Man For All Seasons
Coronation Street	2006/7	Tour and West End	Peter Hall Company	Theatre Royal, Haymarket

LONDON CENTRE FOR THEATRE STUDIES

For a prospectus contact:
London Centre for Theatre Studies, 12–18 Hoxton Street, London N1 6NG
Telephone: 020 7739 5866 / Email: ldncts@aol.com

BRIGHTON PERFORMERZONE - INSPIRATIONAL SINGING TUITION
YOUTH THEATRE TRAINING

William Pool ARCM. Private Singing Lessons in London and Brighton

All Styles of Singing - Drama - Dance

Brighton Young Performers Drama School (5-14 years), Performerzone (14-21 years), Group Singing Classes, Summer Schools, Shows. William Pool is an experienced performer who also trains students at Mountview, ArtsEd and Laine Theatre Arts Academies with many pupils in West End Shows.

e: info@performerzone.co.uk **07973 518643** www.performerzone.co.uk

NUTOPIA-CHANG ACTORS STUDIO LONDON
(Camera Acting & Presenting Courses)
Number 8, 132 Charing Cross Road, London WC2H 0LA
Website: www.nutopia-chang.com
Fax: 029-2070 5725 Tel: 029-2071 3540

O'FARRELL STAGE & THEATRE SCHOOL
(Dance, Drama, Singing)
36 Shirley Street, Canning Town
London E16 1HU Tel/Fax: 020-7511 9444

OLLERENSHAW Maggie BA (Hons), Dip Ed
D Sp (TV & Theatre Coaching, Career Guidance)
151D Shirland Road, London W9 2EP
e-mail: maggieoll@aol.com Tel: 020-7286 1126

OLSON Lise
(American Accents, Practical Voice, Working with Text)
North West Based, LIPA, Mount St, Liverpool
e-mail: l.olson@lipa.ac.uk
Mobile: 07790 877145 Tel: 0151-625 5667

OMOBONI Lino
Sp
2nd Floor, 12 Weltje Road, London W6 9TG
e-mail: bluewandproltd@btinternet.com
Mobile: 07885 528743 Tel/Fax: 020-8741 2038

OPEN VOICE
(Consultancy, Auditions, Personal Presentation - Catherine Owen)
9 Bellsmains, Gorebridge
Near Edinburgh EH23 4QD Tel: 01875 820175

ORAM Daron
(Voice Coach)
155A Browning Road, London E12 6PB
e-mail: darono@yahoo.com Mobile: 07905 332497

ORTON Leslie LRAM, ALAM, ANEA
E D Sp
141 Ladybrook Lane
Mansfield, Notts NG18 5JH Tel: 01623 626082

OSBORNE HUGHES John
(Spiritual Psychology of Acting)
Miracle Tree Productions Training Department
51 Church Road, London SE19 2TE
Website: www.miracletreeproductions.com
e-mail: johughes@miracletreeproductions.com
Mobile: 07801 950916 Tel: 020-8653 7735

OSCARS COLLEGE OF PERFORMANCE ARTS Ltd
103 Fitzwilliam Street
Huddersfield HD1 5PS
e-mail: oscars.college@virgin.net
Fax: 01484 545036 Tel: 01484 545519

OVERSBY William
(Singing & Vocal Projection)
Petersfield
Hants
e-mail: billo363@msn.com
Mobile: 07811 946663 Tel: 01420 538549

OXFORD SCHOOL OF DRAMA The
See DRAMA SCHOOLS (Conference of)

PALMER Jackie STAGE SCHOOL
30 Daws Hill Lane
High Wycombe
Bucks HP11 1PW
Website: www.jackiepalmer.co.uk
e-mail: jackie.palmer@btinternet.com
Fax: 01494 510479 Tel: 01494 510597

PARKES Frances MA, AGSM
(Voice & Acting Coach)
451A Kingston Road
London SW20 8JP
Website: www.makethemostofyourvoice.com
e-mail: frances25@blueyonder.co.uk Tel/Fax: 020-8542 2777

PAUL'S THEATRE SCHOOL
Fairkytes Arts Centre
51 Billet Lane
Hornchurch
Essex RM11 1AX
Website: www.paulstheatreschool.co.uk
e-mail: info@paulstheatreschool.co.uk
Fax: 01708 475286 Tel: 01708 447123

PERFORM
SS
66 Churchway
London NW1 1LT
Website: www.perform.org.uk
e-mail: enquiries@perform.org.uk
Fax: 020-7691 4822 Tel: 0845 4004000

John Colclough Advisory

Practical independent guidance for actors and actresses

t: 020 8873 1763 e: john@johncolclough.org.uk www.johncolclough.org.uk

PERFORMANCE BUSINESS The
78 Oatlands Drive
Weybridge, Surrey KT13 9HT
Website: www.theperformance.biz
e-mail: michael@theperformance.biz Tel: 01932 888885

PERFORMERS COLLEGE
(Brian Rogers - Susan Stephens)
Southend Road, Corringham, Essex SS17 8JT
Website: www.performerscollege.co.uk
e-mail: pdc@dircon.co.uk
Fax: 01375 672353 Tel: 01375 672053

PERFORMERS THEATRE SCHOOL
Hope Street, Liverpool & Royal Victoria
Patriotic Buildings, London
Website: www.performerstheatre.co.uk
e-mail: info@performerstheatre.co.uk
Tel: 0151-708 4000 Tel: 020-8479 3000

PHELPS Neil
D Sp (Private Coaching for Auditions,
Schools, Showbiz, etc)
61 Parkview Court, London SW6 3LL
e-mail: nphelps@usa.com Tel: 020-7731 3419

PILATES INTERNATIONAL
(Physical Coaching, Stage, Film & Dance)
Unit 1, Broadbent Close
20-22 Highgate High Street, London N6 5JG
Website: www.pilatesinternational.co.uk
 Tel/Fax: 020-8348 1442

PLAIN SPEAKING
1 Semer Cottages, Caters Road
Bredfield, Suffolk IP13 6BE
Website: www.plainspeaking.co.uk
e-mail: enquiries@plainspeaking.co.uk Tel/Fax: 01473 737605

PLAYHOUSE ENTERTAINMENT GROUP
48 Langstone Road, Warstock
Birmingham B14 4QS Tel/Fax: 0121-474 6984

POLLYANNA CHILDREN'S TRAINING THEATRE
PO Box 30661, London E1W 3GG
Website: www.pollyannatheatre.co.uk
e-mail: pollyanna_mgmt@btinternet.com
Fax: 020-7480 6761 Tel: 020-7481 1911

POOR SCHOOL
242 Pentonville Road, London N1 9JY
Website: www.thepoorschool.com
e-mail: acting@thepoorschool.com
Fax: 020-7837 5330 Tel: 020-7837 6030

PRECINCT THEATRE The
Units 2/3 The Precinct
Packington Square, London N1 7UP
Website: www.breakalegman.com
e-mail: theatre@breakalegman.com
Fax: 020-7359 3660 Tel: 020-7359 3594

QUEEN MARGARET UNIVERSITY COLLEGE
See DRAMA SCHOOLS (Conference of)

QUESTORS THEATRE EALING The
12 Mattock Lane
London W5 5BQ
Website: www.questors.org.uk
e-mail: admin@questors.org.uk
Fax: 020-8567 8736 Admin: 020-8567 0011

RADCLIFFE Tom
(Sanford Meisner Technique/Actor Training)
203A Waller Road, New Cross Gate
London SE14 5LX Tel: 020-7207 0499

ACTING
MUSICALTHEATRE
TECHNICAL THEATRE
SCREEN & RADIO
THEATRE DIRECTING
CLASSICAL ACTING
ACTING
MUSICALTHEATRE
TECHNICAL THEATRE
SCREEN & RADIO
THEATRE DIRECTING
CLASSICAL ACTING

MOUNTVIEW ACADEMY OF THEATRE ARTS

www.mountview.ac.uk
Tel: 020 8881 2201
Mountview is committed to equal opportunities

Michael Vivian Actor ▌ Director ▌ Writer

Productions at Arts Ed., Mountview, Guildford
Also QDOS, UK Productions & various reps.
Voice Speech & Drama, Audition Coaching, Private Tuition

Tel: 020-8876 2073 Mob: 07958-903911

RAVENSCOURT THEATRE SCHOOL Ltd
8-30 Galena Road
Hammersmith, London W6 0LT
Website: www.ravenscourt.net
e-mail: info@ravenscourt.net
Fax: 020-8741 1786 Tel: 020-8741 0707

REBEL SCHOOL OF THEATRE ARTS AND CASTING AGENCY
46 North Park Avenue, Roundhay, Leeds LS8 1EJ
e-mail: rebeltheatre@aol.com
Mobile: 07808 803637 Tel: 0113-305 3796

RED ONION PERFORMING ARTS CENTRE
(Drama, Dance & Vocal Training, Age 8 yrs to Adult)
Hilton Grove Business Centre
25 Hilton Grove
Hatherley Mews, London E17 4QP
Website: www.redonion.uk.com
e-mail: info@redonion.uk.com
Fax: 020-8521 6646 Tel: 020-8520 3975

REDROOFS THEATRE SCHOOL
DS SS D S Sp
Littlewick Green, Maidenhead, Berks SL6 3QY
Website: www.redroofs.co.uk Tel: 01628 822982

REP COLLEGE The
17 St Mary's Avenue, Purley on Thames, Berks RG8 8BJ
Website: www.repcollege.com
e-mail: tudor@repcollege.co.uk Tel: 0118-942 1144

REYNOLDS Sandra COLLEGE
(Modelling & Grooming School)
35 St Georges Street, Norwich NR3 1DA
Website: www.sandrareynolds.co.uk
e-mail: recruitment@sandrareynolds.co.uk
Fax: 01603 219825 Tel: 01603 623842

RICHMOND DRAMA SCHOOL
DS (One Year Course)
Parkshot Centre, Parkshot, Richmond, Surrey TW9 2RE
e-mail: david.whitworth@racc.ac.uk Tel: 020-8439 8944

RIDGEWAY STUDIOS PERFORMING ARTS COLLEGE
Fairley House, Andrews Lane, Cheshunt, Herts EN7 6LB
Website: www.ridgewaystudios.co.uk
e-mail: info@ridgewaystudios.co.uk
Fax: 01992 633844 Tel: 01992 633775

RISING STARS DRAMA SCHOOL
PO Box 6281
Dorchester, Dorset DT1 9BB
Website: www.risingstarsdramaschool.co.uk
e-mail: info@risingstarsdramaschool.co.uk Tel: 0845 2570127

ROFFE Danielle
71 Mornington Street
London NW1 7QE Tel: 020-7388 1898

ROSCH Philip
(Association of Guildhall Teachers, FVCM, LALAM, ATCL,
LGSM, ANEA, BA Hons) (Audition Speeches/Effective
Sight-reading, Career Guidance)
53 West Heath Court
London NW11 7RG Tel: 020-8731 6686

ROSE BRUFORD COLLEGE
See DRAMA SCHOOLS (Conference of)

ROSSENDALE DANCE & DRAMA CENTRE
52 Bridleway, Waterfoot, Rossendale, Lancs BB4 9DS
e-mail: rddc@btinternet.com Tel: 01706 211161

ROYAL ACADEMY OF DRAMATIC ART
See DRAMA SCHOOLS (Conference of)

ROYAL ACADEMY OF MUSIC
Marylebone Road, London NW1 5HT
Website: www.ram.ac.uk Tel: 020-7873 7373

ROYAL SCOTTISH ACADEMY OF MUSIC & DRAMA
See DRAMA SCHOOLS (Conference of)

ROYAL WELSH COLLEGE OF MUSIC & DRAMA
See DRAMA SCHOOLS (Conference of)

RYDER Richard
(Voice & Speech Coach)
15A Worlingham Road
East Dulwich, London SE22 9HD
e-mail: richard_j_ryder@hotmail.com Tel: 020-8378 1805

SCALA SCHOOL OF PERFORMING ARTS
42 Rufford Avenue
Yeadon, Leeds LS19 7QR
Website: www.scalakids.com
e-mail: office@scalakids.com
Fax: 0113-250 8806 Tel: 0113-250 6823

SHAW Phil
(Audition Technique/Voice Coaching)
Suite 476, 2 Old Brompton Road
South Kensington, London SW7 3DQ
e-mail: shawcastlond@aol.com Tel: 020-8715 8943

SHENEL Helena
(Singing Teacher)
80 Falkirk House, 165 Maida Vale
London W9 1QX Tel: 020-7328 2921

SIMPKIN Heather
Morriston, Fairmile
Henley-on-Thames, Oxon RG9 2JX
Website: www.heathersimpkin.com
e-mail: heather@heathersimpkin.com Tel: 01491 574349

SINGER Sandra ASSOCIATES
21 Cotswold Road
Westcliff-on-Sea, Essex SS0 8AA
Website: www.sandrasinger.com
e-mail: sandrasinger@btconnect.com
Fax: 01702 339393 Tel: 01702 331616

SINGER STAGE SCHOOL
(School & Summer School)
21 Cotswold Road, Westcliff-on-Sea, Essex SS0 8AA
Website: www.sandrasinger.com
e-mail: sandrasinger@btconnect.com
Fax: 01702 339393 Tel: 01702 331616

SOCIETY OF TEACHERS OF SPEECH & DRAMA The
73 Berry Hill Road
Mansfield, Notts NG18 4RU
Website: www.stsd.org.uk
e-mail: ann.k.jones@btinternet.com Tel: 01623 627636

Offering top class training and individual attention in a glorious setting

THE OXFORD SCHOOL OF DRAMA

Three Year Diploma in Acting
One Year Acting Course

- Accredited by The National Council for Drama Training

- Financial support available through the Government Dance and Drama Awards Scheme

- Chosen by the BBC as one of the top five drama schools in the UK

Six Month Foundation Course

For a prospectus or further information please contact:

The Administrative Director
The Oxford School of Drama
Sansomes Farm Studios
Woodstock, Oxford OX20 1ER

Tel: **01993 812883**
Fax: **01993 811220**
Email: **info@oxforddrama.ac.uk**

www.oxforddrama.ac.uk
Prospectus and enrolment form
available to download online

Member of the Conference of Drama Schools
The Oxford School of Drama
is a registered charity.

SPEAKE Barbara STAGE SCHOOL
East Acton Lane
London W3 7EG
e-mail: cpuk@aol.com Tel/Fax: 020-8743 1306

SPEAKERPOWER.CO.UK
(Speech Training, Business & Social Coach)
48 Fellows Road, London NW3 3LH
Website: www.speakerpower.co.uk
e-mail: barbara@speakerpower.co.uk
Fax: 020-7722 5255 Tel: 020-7586 4361

SPEED Anne-Marie Hon ARAM, MA (Voice Studies), CSSD, ADVS, BA
(Vocal Technique, Coaching, Auditions, Accents)
PO Box 235, 19-21 Crawford Street, London W1H 1PJ
Website: www.thevoiceexplained.com
e-mail: anne-marie.speed@virgin.net
Mobile: 07957 272554 Tel: 020-7644 5947

SPONTANEITY SHOP The
85-87 Bayham Street, London NW1 0AG
Website: www.the-spontaneity-shop.com
e-mail: info@the-spontaneity-shop.com Tel: 020-7788 4080

STAGE 84 YORKSHIRE SCHOOL OF PERFORMING ARTS
(Evening & Weekend Classes & Summer Schools)
Old Bell Chapel, Town Lane, Idle, West Yorks BD10 8PR
e-mail: valeriejackson@stage84.com
Mobile: 07785 244984 Tel: 01274 569197

STAGE DOOR THEATRE SCHOOL
The Stage Door Centre
27 Howard Business Park
Waltham Abbey, Essex EN9 1XE
Website: www.stagedoorschool.co.uk
e-mail: stagedoorschool@aol.com
Fax: 01992 652171 Tel: 01992 717994

STAGECOACH TRAINING CENTRES FOR THE PERFORMING ARTS
The Courthouse, Elm Grove
Walton-on-Thames, Surrey KT12 1LZ
Website: www.stagecoach.co.uk
e-mail: mail@stagecoach.co.uk
Fax: 01932 222894 Tel: 01932 254333

STAGEFIGHT
138 Wilden Lane
Stourport-on-Severn
Worcestershire DY13 9LP
Website: www.stagefight.co.uk
e-mail: raph@stagefight.co.uk Mobile: 07813 308672

STAR-BRIGHT DRAMA WORKSHOPS
Royal Exchange
St Ann's Square
Manchester M2 7BR
Website: www.emmastafford.tv
e-mail: workshops@emmastafford.tv
Fax: 0161-833 4264 Tel: 0161-833 4263

STEPHENSON Sarah
(Vocal Coach, Pianist, Musical Director)
8A Edgington Road
Streatham, London SW16 5BS
e-mail: sarahjanestephenson@tiscali.co.uk
Mobile: 07957 477642 Tel: 020-8425 1225

STEWART Carola LRAM NCSD LUD
13 Church Lane, East Finchley, London N2 8DX
e-mail: carolastewart@msn.com Tel: 020-8444 5994

STOCKTON RIVERSIDE COLLEGE
(Education & Training)
Harvard Avenue, Thornaby, Stockton TS17 6FB
Website: www.stockton.ac.uk Tel: 01642 865566

www.zoenathenson.com

ZOË NATHENSON
SCHOOL OF FILM ACTING

- **FILM ACTING, AUDITION TECHNIQUE & SIGHT READING**
- **GROUP WORKSHOPS AND INTENSIVE COURSES AVAILABLE**

Zoe Nathenson School of Film Acting
66E Priory Road, London N8 7EX
Mobile: 07956 833 850 Tel: 020 8347 7799
Email: zoe.act@btinternet.com

STOMP! THE SCHOOL OF PERFORMING ARTS
Holcombe House
The Ridgeway, Mill Hill, London NW7 4HY
Website: www.stompschool.com
e-mail: stompschoolnw7@aol.com Tel/Fax: 020-8959 5353

STONELANDS SCHOOL
(Full-time Training in Ballet & Theatre Arts)
170A Church Road, Hove BN3 2DJ
e-mail: dianacarteur@stonelandsschool.co.uk
Fax: 01273 770444 Tel: 01273 770445

STREETON Jane
(Singing Teacher - RADA)
24 Richmond Road
Leytonstone, London E11 4BA Tel: 020-8556 9297

SUPPORT ACT SERVICES
(Ian McCracken) (Services for Actors including Stage
Combat Instruction)
PO Box 388, Dover CT16 9AJ
Website: www.supportact.co.uk
e-mail: info@supportact.co.uk Tel: 0845 0940796

SWINDON YOUNG ACTORS
65 Stafford Street, Old Town
Swindon, Wiltshire SN1 3PF
e-mail: young.actorsfile@tiscali.co.uk Tel: 01793 423688

SWINFIELD Rosemarie
(Make-Up Design & Training)
Rosie's Make-Up Box, 6 Brewer Street
Soho, London W1R 3FS
Website: www.rosiesmake-up.co.uk
e-mail: rosemarie@rosiesmake-up.co.uk
Mobile: 07976 965520 Tel: 0845 4082415

TALENTED KIDS PERFORMING ARTS SCHOOL & AGENCY
(Drama, Singing, Musical Theatre, Dance Classes For
All Ages)
23 Burrow Manor, Calverstown, Kilcullen, Co. Kildare, Eire
Website: www.talentedkidsireland.com
e-mail: talentedkids@hotmail.com
Mobile: 00 353 872480348 Tel/Fax: 00 353 45 485464

TEAM ACTIVATE
(Performance & Presentation Skills)
38 Highbury Hill, London N5 1AL
Website: www.teamactivate.com
e-mail: teamactivate@fastmail.fm Mobile: 07837 712323

THEATRETRAIN
(6 -18 yrs, Annual West End Productions Involving
all Pupils)
121 Theydon Grove, Epping CM16 4QB
Website: www.theatretrain.co.uk
e-mail: info@theatretrain.co.uk Tel: 01992 577977

THORN Barbara
D Sp
(TV & Theatre Coaching, Career Guidance)
Blackheath
London SE3 Mobile: 07957 227869

TIP TOE STAGE SCHOOL
For correspondence only:
45 Viola Close, South Ockendon, Essex RM15 6JF
Website: www.tiptoestageschool.com
e-mail: julieecarter@aol.com Mobile: 07969 909284

TO BE OR NOT TO BE
(TV/Film Acting Techniques, Showreels, Theatre/Audition
pieces, LAMDA Exams) (Anthony Barnett)
48 Northampton Road, Kettering, Northants NN15 7JU
Website: www.tobeornottobe.tv
e-mail: tobeornottobe@ntlworld.com
Mobile: 07958 996227 Tel/Fax: 01536 526126

TOP HAT STAGE SCHOOL
(Herts Based)
(Weekend Classes in Potters Bar
Welwyn, Stevenage, St Alban's & Hertford)
Potters Bar, Welwyn, Herts AL1 9BR Tel/Fax: 01727 812666

TOP TV ACADEMY
309 Kentish Town Road, London NW5 2TJ
Website: www.toptvacademy.co.uk
e-mail: admin@toptvacademy.co.uk
Fax: 020-7485 7536 Tel: 020-7267 3530

TREMAINE Sally
17 Dartington
Plender Street
London NW1 ODE
Website: www.voiceset.co.uk
e-mail: sally@voiceset.co.uk
Fax: 07970 188945 Tel: 020-7813 9218

TROTTER William BA, MA, PGDVS
D E Sp
25 Thanet Lodge
Mapesbury Road, London NW2 4JA
Website: www.ukspeech.co.uk
e-mail: william.trotter@ukspeech.co.uk Tel/Fax: 020-8459 7594

TUCKER John
(Voice & Speech Coach/Singing Teacher)
503 Mountjoy House, Barbican, London EC2Y 8BP
e-mail: jrtucker@onetel.com Mobile: 07903 269409

TV ACTING CLASSES
(Elisabeth Charbonneau)
14 Triangle Place, Clapham, London SW4 7HS
e-mail: ejcharbonneau@aol.com
Mobile: 07885 621061 Tel: 020-7627 8036

TWICKENHAM THEATRE WORKSHOP FOR CHILDREN
29 Campbell Road
Twickenham
Middlesex TW2 5BY Tel: 020-8898 1447

URQUHART Moray
D Sp (Private Coaching for Auditions)
61 Parkview Court, London SW6 3LL
e-mail: nphelps@usa.com Tel: 020-7731 3604

VALLÉ ACADEMY OF PERFORMING ARTS
The Vallé Academy Studios, Wilton House
Delamare Road, Cheshunt, Herts EN8 9SG
Website: www.valleacademy.co.uk
e-mail: enquiries@valleacademy.co.uk
Fax: 01992 622868 Tel: 01992 622862

VERRALL Charles
19 Matilda Street, London N1 OLA
e-mail: charles.verrall@virgin.net Tel: 020-7833 1971

VIVIAN Michael
15 Meredyth Road, Barnes, London SW13 ODS
e-mail: vivcalling@aol.com Tel: 020-8876 2073

VOCAL CONFIDENCE FOR SPEECH & SINGING
(Alix Longman)
98C Balham Park Road, London SW12 8EA
Website: www.vocalconfidence.com
e-mail: alix@vocalconfidence.com Tel: 020-8767 6463

VOICE & THE ALEXANDER TECHNIQUE
(Robert Macdonald)
Flat 5, 17 Hatton Street, London NW8 8PL
Website: www.voice.org.uk Mobile: 07956 852303

VOICE MASTER
(Specialised Training for Voice-Overs & TV Presenters)
88 Erskine Hill, London NW11 6HR
Website: www.voicemaster.co.uk
e-mail: stevehudson@voicemaster.co.uk Tel: 020-8455 2211

VOICE TAPE SERVICES INTERNATIONAL Ltd
(Professional Voice-Over Direction & CDs)
80 Netherlands Road, New Barnet, Herts EN5 1BS
Website: www.vtsint.co.uk
e-mail: info@vtsint.co.uk
Fax: 020-8441 4828 Tel: 020-8440 4848

VOXTRAINING Ltd
(Voice-Over Training & Demo CDs)
20 Old Compton Street
London W1D 4TW
Website: www.voxtraining.com
e-mail: info@voxtraining.com Tel: 020-7434 4404

WALLACE Elaine BA
D Sp Voice
249 Goldhurst Terrace
London NW6 3EP
e-mail: im@voicebiz.biz Tel: 020-7625 4049

WALSH Anne
(Accents, Dialect, Speech)
45B Windsor Road
Willesden Green
London NW2 5DT
Mobile: 07932 440043 Tel: 020-8459 8071

WALSH Genevieve
(Acting & Audition Tuition)
37 Kelvedon House
Guildford Road
Stockwell London SW8 2DH Tel: 020-7627 0024

WALTZER Jack
(Professional Acting Workshops)
5 Minetta Street Apt 2B
New York NY 10012
Website: www.jackwaltzer.com
e-mail: jackwaltzer@yahoo.co.uk
Tel: 001 (212) 840-1234 Tel: 020-8347 6598

WEBB Bruce
S
Abbots Manor
Kirby Cane
Bungay
Suffolk NR35 2HP Tel: 01508 518703

WELBOURNE Jacqueline
(Circus Trainer, Choreographer, Consultant)
c/o Circus Maniacs Agency
Office 8A Britannia Road
The Kingswood Foundation
Kingswood
Bristol BS15 8DB
Website: www.circusmaniacs.com
e-mail: jackie@circusmaniacs.com
Mobile: 07977 247287 Tel/Fax: 0117-947 7042

WESTMINSTER KINGSWAY COLLEGE
(Performing Arts)
Regent's Park Centre
Longford Street
London NW1 3HB
Website: www.westking.ac.uk
e-mail: courseinfo@westking.ac.uk
Fax: 020-7391 6400 Tel: 0870 0609800

WHITE Susan Voice Studies BA TEFL LGSM
MA Distinction
(Voice Coach)
42 Bramham Gardens
London SW5 0HG
Website: www.per-sona.com
e-mail: susan@per-sona.com Tel: 020-7244 0402

WHITEHALL PERFORMING ARTS CENTRE
Rayleigh Road
Leigh-on-Sea
Essex SS9 5UU Tel: 01702 529290

WHITWORTH Geoffrey LRAM, MA
S (Piano Accompanist)
789 Finchley Road
London NW11 8DP Tel: 020-8458 4281

WILDER Andrea
D E
23 Cambrian Drive
Colwyn Bay, Conwy LL28 4SL
Website: www.awagency.co.uk
e-mail: andrea@awagency.co.uk
Fax: 07092 249314 Mobile: 07919 202401

WILSON Holly
3 Worple Street, Mortlake
London SW14 8HE Tel: 020-8878 0015

WIMBUSH Martin Dip GSMD
D E Sp
(Audition Coaching)
Flat 4, 289 Trinity Road
Wandsworth Common
London SW18 3SN Tel: 020-8877 0086

WINDSOR Judith Ph. D
(American Accents/Dialects)
Woodbine, Victoria Road
Deal, Kent CT14 7AS
e-mail: joyce.edwards@virgin.net
Fax: 020-7820 1845 Tel: 020-7735 5736

Alison Mackinnon
Voice, Dialect and Auditions
07973 562132

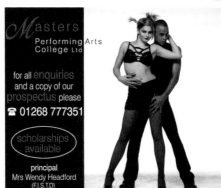

WITH PANACHE THEATRE ACADEMY
22 St. David's Close
Maidenhead
Berkshire SL6 3BB
Website: www.withpanache.co.uk
e-mail: info@withpanache.co.uk Tel: 07881 656575

WOOD Tessa Teach Cert AGSM, CSSD, PGDVS
(Voice Coach)
43 Woodhurst Road
London W3 6SS
e-mail: tessaroswood@aol.com Tel: 020-8896 2659

WOODHOUSE Alan AGSM ADVS
(Voice & Acting Coach)
33 Burton Road
Kingston upon Thames, Surrey KT2 5TG
Website: www.woodhouse-voice.co.uk
e-mail: alanwoodhouse50@hotmail.com Tel/Fax: 020-8549 1374

WOODHOUSE Nan (Playwright & LAMDA Examiner)
LGSM (Hons Medal)
LLAM, LLCM (TD), ALCM Mobile: 07812 921625

WORTMAN Neville
(Voice Training & Speech Coach)
48 Chiswick Staithe
London W4 3TP
Website: www.speakwell.co.uk
e-mail: nevillewortman@beeb.net
Mobile: 07976 805976 Tel: 020-8994 8886

WYNN Madeleine
(Director & Acting Coach)
40 Barrie House
Hawksley Court
Albion Road, London N16 0TX
e-mail: madeleine@onetel.com Tel: 01394 450265

YOUNG ACTORS THEATRE
70-72 Barnsbury Road
London N1 0ES
Website: www.yati.org.uk
e-mail: info@yati.org.uk
Fax: 020-7833 9467 Tel: 020-7278 2101

YOUNG Sylvia THEATRE SCHOOL
SS
Rossmore Road, London NW1 6NJ
e-mail: info@sylviayoungtheatreschool.co.uk
Fax: 020-7723 1040 Tel: 020-7402 0673

YOUNG VICTORIA The
Correspondence:
35 Thorpes Crescent Skelmanthorpe
Huddersfield HD8 9DH Tel: 01484 866401

YOUNG PERFORMERS THEATRE & POP SCHOOL
Unit 3, Ground Floor
Clements Court, Clements Lane
Ilford, Essex IG1 2QY
e-mail: sara@tots-twenties.co.uk
Fax: 020-8553 1880 Tel: 020-8479 3000

YOUNGBLOOD EDUCATION Ltd
34 Pullman Place
Eltham, London SE9 6EG
Website: www.youngblood.co.uk
e-mail: info@youngblood.co.uk Tel: 0845 6449418

YOUNGSTARS
(Part-time Children's Theatre School,
Age 5-16 yrs, Drama, Singing, Dancing, Voice Over)
4 Haydon Dell, Bushey
Herts WD23 1DD
e-mail: youngstars@bigfoot.com
Fax: 020-8950 5701 Tel: 020-8950 5782

YOUNGSTAR TELEVISION & FILM ACTING SCHOOL
(Part-time Schools across the UK, 8-20 yrs)
Head Office:
5 Union Castle House, Canute Road
Southampton SO14 3FJ
Website: www.youngstar.tv
e-mail: info@youngstar.tv
Fax: 023-8045 5816 Tel: 023-8033 9322

ZANDER Peter
D E SP (German)
22 Romilly Street, London W1D 5AG
e-mail: peterzan.berlin@virgin.net Tel: 020-7437 4767

European Trades' & Actor's Unions

For information on the FIA please contact
International Federation of Actors
Guild House, Upper St Martin's Lane
London WC2H GEG
Tel: 020-7379 0900 Fax: 020-7379 8260
e-mail: office@fia-actors.com

[CONTACTS 2007]

BELGIUM
ACV/TRANSCOM - CULTUUR
Steenstraat 29, 1000 Brussels
Website: www.acvcultuur.be
e-mail: jpvandervurst.transcom@acv-csc.be
Fax: 00 32 2 514 1836 Tel: 00 32 2 289 0830

BELGIUM
CENTRALE GÉNÉRALE DES SERVICES PUBLICS
Place Fontainas 9-11
1000 Brussels
Website: www.cgsp.be
e-mail: mylene.paon@cgsp.be
Fax: 00 32 2 508 5902 Tel: 00 32 2 508 5811

DENMARK
DAF - DANSK ARTIST FORBUND
Vendersgade 24, 1363 Copenhagen K
Website: www.artisten.dk
e-mail: artisten@artisten.dk
Fax: 00 45 33 33 73 30 Tel: 00 45 33 32 66 77

DENMARK
DANSK SKUESPILLERFORBUND
Sankt Knuds Vej 26
1903 Frederiksberg C
Website: www.skuespillerforbundet.dk
e-mail: dsf@skuespillerforbundet.dk
Fax: 00 45 33 24 81 59 Tel: 00 45 33 24 22 00

FINLAND
SUOMEN NAYTTELIJALIITTO
Meritullinkatu 33C
00170 Helsinki, Finland
Website: www.nayttelijaliitto.fi
e-mail: toimisto@nayttelijaliitto.fi
Fax: 00 358 9 2511 2139 Tel: 00 353 9 2511 2135

FRANCE
SYNDICAT FRANÇAIS DES ARTISTES-INTERPRÈTES
21 bis, rue Victor Massé, 75009 Paris
Website: www.sfa-cgt.fr
e-mail: info@sfa-cgt.fr
Fax: 00 33 1 53 25 09 01 Tel: 00 33 1 53 25 09 09

GERMANY
GENOSSENSCHAFT DEUTSCHER BUEHNENANGEHOERIGER
Feldbrunnenstrasse 74
20148 Hamburg
Website: www.buehnengenossenschaft.de
e-mail: gdba@buehnengenossenschaft.de
Fax: 00 49 40 45 93 52 Tel: 00 49 40 44 51 85

GREECE
HAU - HELLENIC ACTORS' UNION
33 Kaniggos Street
106 82 Athens
Website: www.sei.gr
e-mail: support@sei.gr
Fax: 00 30 210 380 8651 Tel: 00 30 210 383 3742

GREECE
UGS - UNION OF GREEK SINGERS
130 Patission Street
112 57 Athens
Website: www.tragoudistes.gr
e-mail: eratospe@otenet.gr
Fax: 00 30 210 823 8321 Tel: 00 30 210 823 8335

What are performers unions?

The unions listed in this section exist to protect and improve the rights, interests and working conditions of actors and artists working across Europe.

They offer very important services to their members, such as advice on pay and conditions, help with contracts and negotiations, legal support and welfare advice.

To join a performer's union there is usually a one-off joining fee and then an annual subscription fee calculated in relation to an individual's total yearly earnings. Equity (www.equity.org.uk) is the main performers' union in the UK. See overleaf for more details.

Do similar organisations exist for other sectors of the entertainment industry?

In addition to representation by trade unions, some skill sectors also have professional bodies and guilds which complement the work of trade unions. These include directors, producers, stage managers, designers and casting directors. Please see the 'Organisations' section of this book for these and other listings.

What is the FIA?

The FIA (International Federation of Actors) (www.fia-actors.com) is an organisation which represents performers' trades unions, guilds and associations from all around the world. It tackles the same issues as individual performers' unions, but on an international rather than local level.

I'm a professionally trained artist from overseas and I want to work in the UK. How do I get started?

As with all forms of employment, to work as a performer in the UK you will need to have a relevant work permit / working visa. You might want to visit (www.workingintheuk.gov.uk) for full information. You may also wish to join the UK's actors' union, Equity. For more information please visit their website (www.equity.org.uk)

What do I do if I am a UK resident and I want to work as a performer abroad?

This will depend on the employment legislation in the country in which you are hoping to work. A good starting point would be to contact the relevant union in that country. Information on actors' unions in Europe can be found in this section, or obtained from the FIA (www.fia-actors.com), who in most cases may also be able to advise on what criteria you need to fulfill to be eligible for work.

For example, if you wanted to work in the USA you would either need a green card, or to be a member one of the main artists' unions: SAG (www.sag.org) or AEA (www.actorsequity.org). You will not be eligible to join the USA's leading casting directories e.g. Breakdown Services (www.breakdownservices.com) unless you fulfill these criteria.

LOUISE GRAINGER is the Marketing and Membership Services Manager at Equity, the trade union for the UK entertainment industry.

If you work professionally in the UK as an artist or member of the creative team, you will have been in a workplace where Equity has collectively negotiated the hours you work; the breaks you get; the structure of fees; health and safety; the procedures for dealing with disputes and much more - and you will have been working alongside Equity members.

The best television royalties and residuals structure in the world; contracts and guidelines across the industry; campaigns for an international audiovisual treaty on performers' rights; plans to track your work so you benefit from all the ways in which it is used; theatre funding campaigns; pension schemes; agency regulations; entertainment licensing; television drama production protected by legislation; tax breaks for film - the list goes on and on. Most of this work happens behind the scenes - you may never think about it, but without it, your working life would be riskier and you would be far more open to exploitation.

As the UK trade union Equity genuinely strives to improve the services and support it offers to members and Equity membership gives you access to a range of professional expertise. Non-members do not have this bedrock.

Carrying the Equity card shows you are a professional with a strong support system behind you, no matter where you are working or how your work is used. In return, you are contributing to maintaining the professionalism of the industry.

Equity represents professional artists from across the spectrum of the performing arts and entertainment. The membership includes actors, singers, dancers, variety and circus artists, choreographers, stage management, theatre directors and designers, television and radio presenters, walk-on and supporting artists, stunt performers and co-ordinators and theatre fight directors. To obtain an Equity card, applicants must provide proof (contracts, pay slips etc.) of professional employment within the entertainment industry.

If you are not yet working professionally but are studying on a full-time course lasting one year or more at HND level or higher, then there is the Student Equity Scheme giving you a lot of information and resources to help you when you start your career.

Equity offices provide a service all around the UK: London and Isle of Man: 020-7379 6000; South East England: 020-7670 0229; Wales and South West England: 029-2039 7971; Midlands: 01926 408 638; North West England: 0161-832 3183; North East England: 0114-275 9746; Scotland and Northern Ireland: 0141-248 2472

Full information about the work of the union and membership can be found at (www.equity.org.uk).

IRELAND

IEG- IRISH EQUITY GROUP
Liberty Hall, Dublin 1
Website: www.irishequity.ie
e-mail: equity@siptu.ie
Fax: 00 353 1 874 3691 Tel: 00 353 1 858 6403

ITALY

SINDICATO ATTORI ITALIANI
Via Ofanto 18, 00198 Rome
Website: www.cgil.it/sai-slc
e-mail: sai-slc@cgil.it
Fax: 00 39 06 854 6780 Tel: 00 39 06 841 7303

LUXEMBOURG

ONOFHÄNGEGE GEWERKSCHAFTSBOND LËTZEBUERG
19 rue d'Epernay, B.P. 2031, 1020 Luxembourg
Website: www.ogb-l.lu
e-mail: leon.jenal@ogb-l.lu
Fax: 00 352 486 949 Tel: 00 352 496 005

NETHERLANDS

FNV-KUNSTEN INFORMATIE EN MEDIA
Jan Tooropstraat 1
Postbus 9354, 1006 AJ Amsterdam
Website: www.fnv.nl/kiem
e-mail: algemeen@fnv-kiem.nl
Fax: 00 31 20 355 3737 Tel: 00 31 20 355 3636

NORWAY

NORSK SKUESPILLERFORBUND
Welhavensgate 3, 0166 Oslo
Website: www.skuespillerforbund.no
e-mail: nsf@skuespillerforbund.no
Fax: 00 47 21 02 71 91 Tel: 00 47 21 02 71 90

PORTUGAL

STE-SINDICATO DOS TRABALHADORES DE ESPECTÁCULOS
Rua Da Fe 23, 2do Piso, 1150-149 Lisbon
e-mail: vidi@netcabo.pt
Fax: 00 351 21 885 3787 Tel: 00 351 21 885 2728

SPAIN

COMISIONES OBRERAS-COMUNICATIÓN Y TRANSPORTE
Plaza Cristino Martos 4, 6a Planta, 28015 Madrid
Website: www.ccoo.es
e-mail: sgeneral@fct.ccoo.es
Fax: 00 34 91 548 1613 Tel: 00 34 91 540 9295

SPAIN

FAEE-FEDERACIÓN DE ARTISTAS DEL ESTADO ESPAÑOL
C/ Montera 34, 1ro Piso, 28013 Madrid
Website: www.faee.net
e-mail: faee@wanadoo.es
Fax: 00 34 91 522 6055 Tel: 00 34 91 522 2804

SWEDEN

TF TEATERFÖRBUNDET
Kaplansbacken 2A, Box 12 710, 112 94 Stockholm
Website: www.teaterforbundet.se
e-mail: info@teaterforbundet.se
Fax: 00 46 8 653 9507 Tel: 00 46 8 441 1300

UK

EQUITY
Guild House
Upper St Martin's Lane, London WC2H 9EG
Website: www.equity.org.uk
e-mail: info@equity.org.uk
Fax: 020-7379 7001 Tel: 020-7379 6000

Providing support when your working world turns upside down

Equity

www.equity.org.uk • info@equity.org.uk • 020 7379 6000

Festivals
Film & Television Distributors
Film Preview Theatres
Film & Video Facilities
Film, Radio, Television & Video Production
 Companies

Key to areas of specialisation:
F Films **FF** Feature Films **C** Commercials
CV Corporate Video **D** Drama **Ch** Children's
Entertainment **Co** Comedy & Light Entertainment
Docs Documentaries

Film & Television Schools
Film & Television Studios

ALDEBURGH FESTIVAL OF MUSIC AND THE ARTS
(8 - 24 June 2007)
Aldeburgh Productions
Snape Maltings, Concert Hall
Snape Bridge
Nr Saxmundham, Suffolk IP17 1SP
Website: www.aldeburgh.co.uk
e-mail: enquiries@aldeburgh.co.uk
Fax: 01728 687120
BO: 01728 687110 Admin: 01728 687100

ALMEIDA OPERA
(July 2007)
Almeida Street
Islington, London N1 1TA
Website: www.almeida.co.uk
e-mail: patrick@almeida.co.uk
Fax: 020-7288 4901
BO: 020-7359 4401 Admin 020-7288 4900

ARUNDEL FRINGE FESTIVAL
(Late Aug/Sept 2007)
Dramazone
Arundel Town Hall
Arundel
West Sussex BN18 9AP
Director: Kevin Williams
Website: www.arundelfestival.net
e-mail: arundelfringe@aol.com Tel/Fax: 01903 889821

BARBICAN INTERNATIONAL THEATRE EVENT (BITE)
(Year-Round Festival)
Barbican Theatre
Silk Street
London EC2Y 8DS
Website: www.barbican.org.uk
e-mail: lclark@barbican.org.uk
Fax: 020-7382 7377 Tel: 020-7382 7372

BATH INTERNATIONAL MUSIC FESTIVAL
(18 May - 3 June 2007)
Bath Festivals Trust
Abbey Chambers
Abbey Churchyard
Bath BA1 1LY
Website: www.bathfestivals.org.uk
e-mail: info@bathfestivals.org.uk
Fax: 01225 445551
BO: 01225 463362 Tel: 01225 462231

BATH LITERATURE FESTIVAL
(3 - 11 March 2007)
Bath Festivals Trust
Abbey Chambers
Abbey Churchyard
Bath BA1 1LY
Website: www.bathlitfest.org.uk
e-mail: info@bathfestivals.org.uk
Fax: 01225 445551 Tel: 01225 462231

BELFAST FESTIVAL AT QUEEN'S
8 Fitzwilliam Street
Belfast BT9 6AW
Website: www.belfastfestival.com
e-mail: festival@qub.ac.uk
Fax: 028-9097 1336 Tel: 028-9097 1034

[CONTACTS 2007]

BRIGHTON FESTIVAL
(5 - 27 May 2007)
12A Pavilion Buildings
Castle Square, Brighton BN1 1EE
Artistic Director: Jane McMorrow
Website: www.brightonfestival.org
e-mail: info@brightonfestival.org
BO: 01273 709709 Admin: 01273 700747

BUXTON FESTIVAL
(6 - 22 July 2007)
5 The Square, Buxton
Derbyshire SK17 6AZ
Website: www.buxtonfestival.co.uk
e-mail: info@buxtonfestival.co.uk
BO: 0845 1272190 Admin: 01298 70395

**CARDIFF INTERNATIONAL FESTIVAL OF
MUSICAL THEATRE**
(October 2008)
4th Floor, Market Chambers
5/7 St Mary Street, Cardiff CF10 1AT
Website: www.cardiffmusicals.com
e-mail: enquiries@cardiffmusicals.com
Fax: 029-2037 2011 Tel: 029-2034 6999

CHESTER FESTIVALS
(July 2007)
8 Abbey Square
Chester CH1 2HU
Website: www.chesterfestivals.co.uk BO: 01244 340392

CHICHESTER FESTIVITIES
(Not Chichester Festival Theatre)
(29 June - 15 July 2007)
Canon Gate House, South Street
Chichester, West Sussex PO19 1PU
Website: www.chifest.org.uk
e-mail: info@chifest.org.uk
Fax: 01243 528356 Tel: 01243 785718

DANCE UMBRELLA
(September - November 2007)
Annual Contemporary Dance Festival
20 Chancellors Street
London W6 9RN
Website: www.danceumbrella.co.uk
e-mail: mail@danceumbrella.co.uk
Fax: 020-8741 7902 Tel: 020-8741 4040

DUBLIN THEATRE FESTIVAL
(28 September - 13 October 2007)
44 East Essex Street
Temple Bar, Dublin 2, Eire
Website: www.dublintheatrefestival.com
e-mail: info@dublintheatrefestival.com
Fax: 00 353 1 6797709 Tel: 00 353 1 6778439

EDINBURGH FESTIVAL FRINGE
(5 - 27 August 2007)
Festival Fringe Society Ltd
180 High Street, Edinburgh EH1 1QS
Website: www.edfringe.com
e-mail: admin@edfringe.com
Fax: 0131-226 0016
BO: 0131-226 0000 Tel: 0131-226 0026

EDINBURGH INTERNATIONAL FESTIVAL
(12 Aug - 2 Sept 2007)
The Hub, Castlehill, Edinburgh EH1 2NE
Website: www.eif.co.uk
e-mail: eif@eif.co.uk
BO: 0131-473 2000 Admin: 0131-473 2099

HARROGATE INTERNATIONAL FESTIVAL
(Last week July/First week August 2007)
1 Victoria Avenue
Harrogate, North Yorkshire HG1 1EQ
Website: www.harrogate-festival.org.uk
e-mail: info@harrogate-festival.org.uk
Fax: 01423 521264 Tel: 01423 562303

KING'S LYNN FESTIVAL
(15 - 28 July 2007)
5 Thoresby College
Queen Street
King's Lynn, Norfolk PE30 1HX
Website: www.kingslynnfestival.org.uk
Fax: 01553 767688 Tel: 01553 767557

LIFT, LONDON INTERNATIONAL FESTIVAL OF THEATRE
(Events Year-round)
19-20 Great Sutton Street, London EC1V 0DR
Website: www.liftfest.org.uk
e-mail: info@liftfest.org.uk
Fax: 020-7490 3976 Tel: 020-7490 3964

LLANDOVERY THEATRE ARTS FESTIVAL
Llandovery Theatre
Stone Street, Llandovery
Carmarthenshire SA20 0DQ Tel: 01550 720113

LUDLOW FESTIVAL SOCIETY Ltd
(23 June - 8 July 2007)
Festival Office
Castle Square, Ludlow
Shropshire SY8 1AY
Website: www.ludlowfestival.co.uk
e-mail: rsykes@ludlowfestival.co.uk
Fax: 01584 877673
BO: 01584 872150 Admin: 01584 875070

RE VAMP - READY MADE STREET FESTIVALS
(Complete Touring Festivals)
Ealing House
33 Hanger Lane
London W5 3HJ
e-mail: verona.chard@vampevents.com Tel: 020-8997 3355

THE 51st SUNDAY TIMES NATIONAL STUDENT DRAMA FESTIVAL
(29 March - 4 April 2007)
Unit 5A, 3 Long Street
London E2 8HJ
Website: www.nsdf.org.uk
e-mail: admin@nsdf.org.uk Tel: 020-7739 2306

FILM & TELEVISION DISTRIBUTORS

BLUE DOLPHIN FILM AND VIDEO
(Film Production/Video Distribution)
40 Langham Street, London W1W 7AS
Website: www.bluedolphinfilms.com
e-mail: info@bluedolphinfilms.com
Fax: 020-7580 7670 Tel: 020-7255 2494

CONTEMPORARY FILMS
24 Southwood Lawn Road, London N6 5SF
Website: www.contemporaryfilms.com
e-mail: inquiries@contemporaryfilms.com
Fax: 020-8348 1238 Tel: 020-8340 5715

GUERILLA FILMS Ltd
35 Thornbury Road, Isleworth, Middlesex TW7 4LQ
Website: www.guerilla-films.com
e-mail: david@guerilla-films.com
Fax: 020-8758 9364 Tel: 020-8758 1716

HIGH POINT FILMS & TV
(International Sales), 25 Elizabeth Mews, London NW3 4UH
Website: www.highpointfilms.co.uk
e-mail: sales@highpointfilms.co.uk
Fax: 020-7586 3117 Tel: 020-7586 3686

JACKSON Brian FILMS Ltd
39-41 Hanover Steps
St George's Fields
Albion Street, London W2 2YG
e-mail: brianjfilm@aol.com
Fax: 020-7262 5736 Tel: 020-7402 7543

**NBC/UNIVERSAL INTERNATIONAL
TELEVISION SERVICES Ltd**
Oxford House, 76 Oxford Street, London W1D 1BS
Fax: 020-7307 1301 Tel: 020-7307 1300

PATHÉ DISTRIBUTION Ltd
Kent House, 14-17 Market Place
Great Titchfield Street, London W1W 8AR
Website: www.pathe.co.uk
Fax: 020-7631 3568 Tel: 020-7323 5151

SONY PICTURES
25 Golden Square, London W1F 9LU
Fax: 020-7533 1015 Tel: 020-7533 1000

SOUTHERN STAR SALES
12 Raddington Road
Ladbroke Grove, London W10 5TG
e-mail: sales@sstar.uk.com
Fax: 020-8968 2412 Tel: 020-8968 2424

SQUIRREL FILMS DISTRIBUTION Ltd
Grice's Wharf
119 Rotherhithe Street, London SE16 4NF
Website: www.sandsfilms.co.uk
Fax: 020-7231 2119 Tel: 020-7231 2209

UIP (UK)
12 Golden Square, London W1A 2JL
Website: www.uip.co.uk
Fax: 020-7534 5202 Tel: 020-7534 5200

UNIVERSAL PICTURES INTERNATIONAL
Oxford House
76 Oxford Street, London W1D 1BS
Fax: 020-7307 1301 Tel: 020-7307 1300

WARNER BROS PICTURES
Warner House, 98 Theobald's Road, London WC1X 8WB
Fax: 020-7984 5001 Tel: 020-7984 5000

FILM PREVIEW THEATRES

3 MILLS STUDIOS
Three Mill Lane
London E3 3DU
Website: www.3mills.com
e-mail: info@3mills.com
Fax: 020-8215 3499 Tel: 020-7363 3336

BRITISH ACADEMY OF FILM & TELEVISION ARTS The
195 Piccadilly
London W1J 9LN
Website: www.bafta.org
Fax: 020-7292 5868 Tel: 020-7734 0022

BRITISH FILM INSTITUTE
21 Stephen Street
London W1P 1LM
e-mail: roger.young@bfi.org.uk
Fax: 020-7957 4832 Tel: 020-7957 8976

CENTURY THEATRE
(Twentieth Century Fox)
31 Soho Square, London W1D 3AP
e-mail: projection@fox.com Tel: 020-7753 7135

COLUMBIA TRI STAR FILMS (UK)
25 Golden Square
London W1F 9LU
Fax: 020-7533 1015 Tel: 020-7533 1111

DE LANE LEA
75 Dean Street
London W1D 3PU
Website: www.delanelea.com
e-mail: dll@delanelea.com
Fax: 020-7432 3838 Tel: 020-7432 3800

EXECUTIVE THEATRE
(Twentieth Century Fox)
31 Soho Square, London W1D 3AP
e-mail: projection@fox.com Tel: 020-7753 7135

MR YOUNG'S PREVIEW THEATRE
(AKA Soho Screening Rooms)
14 D'Arblay Street, London W1F 8DY
Website: www.sohoscreeningroom.co.uk
e-mail: enquiries@mryoungs.com
Fax: 020-7734 4520 Tel: 020-7437 1771

NEW PLAYERS THEATRE
The Arches
Off Villiers Street
London WC2N 6NG
Website: www.newplayerstheatre.com
e-mail: info@newplayerstheatre.com
Fax: 0845 6382102 Tel: 020-7930 6601

RSA
(Royal Society of Arts)
(Ruth Lawton)
8 John Adam Street
London WC2N 6EZ
Website: www.thersa.org.uk/hospitality
e-mail: hospitality@rsa.org.uk
Fax: 020-7321 0271 Tel: 020-7839 5049

TRICYCLE CINEMA
269 Kilburn High Road
London NW6 7JR
Website: www.tricycle.co.uk
e-mail: cinema@tricycle.co.uk Tel: 020-7328 1000

ACTOR'S ONE-STOP SHOP The
(Showreels for Performing Artists)
First Floor, Above The Gate Pub
Station Road, London N22 7SS
Website: www.actorsone-stopshop.com
e-mail: info@actorsone-stopshop.com Tel: 020-8888 7006

ANVIL POST PRODUCTION
(Studio Manager - Mike Anscombe)
Perivale Park, Horsenden Lane South, Perivale UB6 7RL
Website: www.anvilpost.com
e-mail: mike.anscombe@thomson.net Tel: 020-8799 0555

ARQIVA SATELLITE MEDIA SOLUTIONS Ltd
PO Box 2287, Gerrards Cross, Bucks SL9 8BF
Fax: 01494 876006 Tel: 01494 878585

ARRI MEDIA
3 Highbridge, Oxford Road
Uxbridge, Middlesex UB8 1LX
Website: www.arrimedia.com
e-mail: info@arrimedia.com
Fax: 01895 457101 Tel: 01895 457100

ASCENT MEDIA CAMDEN Ltd
(Post-Production Film Facilities)
13 Hawley Crescent, London NW1 8NP
Website: www.ascentmedia.co.uk
Fax: 020-7284 1018 Tel: 020-7284 7900

ASCENT MEDIA Ltd
(Post-Production Facilities),
Film House, 142 Wardour Street, London W1F 8DD
Website: www.ascentmedia.co.uk
Fax: 020-7878 7800 Tel: 020-7878 0000

AUTOMOTIVE ACTION STUNTS
(Stunt Rigging & Supplies/Camera Tracking Vehicles)
2 Sheffield House, Park Road
Hampton Hill, Middlesex TW12 1HA
Website: www.carstunts.co.uk
Mobile: 07974 919589 Tel: 01372 461157

AXIS FILMS
(Film Equipment Rental)
Shepperton Studios, Studios Road, Middlesex TW17 0QD
Website: www.axisfilms.co.uk
e-mail: info@axisfilms.co.uk
Fax: 01932 592246 Tel: 01932 592244

CENTRAL FILM FACILITIES
(Camera Tracking Specialists)
c/o The High House
Horderley, Craven Arms, Shropshire SY7 8HT
Website: www.centralfilmfacilities.com
Fax: 0870 7059777 Tel: 0870 7941418

CENTRELINE VIDEO PRODUCTIONS
138 Westwood Road
Tilehurst, Reading RG31 6LL
Website: www.centrelinevideo.com Tel: 0118-941 0033

CHANNEL 2020 Ltd
The Clerkenwell Workshops (G15)
27/31 Clerkenwell Close, London EC1R 0AT
Website: www.channel2020.co.uk
e-mail: info@channel2020.co.uk Tel: 0844 8402020

2020 House
26-28 Talbot Lane, Leicester LE1 4LR
Fax: 0116-222 1113 Tel: 0116-233 2220

CINE TO VIDEO & FOREIGN TAPE CONVERSION & DUPLICATING
(Peter J Snell Enterprises)
Amp House, Grove Road
Rochester, Kent ME2 4BX
e-mail: pjstv@blueyonder.co.uk
Fax: 01634 726000 Tel: 01634 723838

CLICKS
Media Studios
Grove Road
Rochester, Kent ME2 4BX
e-mail: info@clicksstudios.co.uk
Fax: 01634 726000 Tel: 01634 723838

CRYSTAL MEDIA
28 Castle Street
Edinburgh EH2 3HT
Website: www.crystal-media.co.uk
e-mail: hello@crystal-media.co.uk
Fax: 0131-240 0989 Tel: 0131-240 0988

DE LANE LEA
(Film & TV Sound Dubbing & Editing Suite)
75 Dean Street
London W1D 3PU
Website: www.delanelea.com
e-mail: dll@delanelea.com
Fax: 020-7432 3838 Tel: 020-7432 3800

DENMAN PRODUCTIONS
(3D Computer Animation, Film/Video CD Business Card Showreels)
60 Mallard Place, Strawberry Vale
Twickenham TW1 4SR
Website: www.denman.co.uk
e-mail: info@denman.co.uk Tel: 020-8891 3461

DIVERSE PRODUCTIONS
(Pre & Post-Production)
6-12 Gorleston Street
London W14 8XS
Website: www.diverse.tv
e-mail: reception@diverse.tv
Fax: 020-7603 2148 Tel: 020-7603 4567

EXECUTIVE AUDIO VISUAL
(Showreels for Actors & TV Presenters)
80 York Street
London W1H 1QW Tel: 020-7723 4488

FARM DIGITAL POST PRODUCTION The
27 Upper Mount Street
Dublin 2, Eire
Website: www.thefarm.ie
e-mail: info@thefarm.ie
Fax: 00 353 1 676 8816 Tel: 00 353 1 676 8812

FRONTLINE TELEVISION
35 Bedfordbury
Covent Garden, London WC2N 4DU
Website: www.frontline-tv.co.uk
e-mail: info@frontline-tv.co.uk
Fax: 020-7379 5210 Tel: 020-7836 0411

GREENPARK PRODUCTIONS Ltd
(Film Archives)
Illand, Launceston
Cornwall PL15 7LS
Website: www.greenparkimages.co.uk
e-mail: info@greenparkimages.co.uk
Fax: 01566 782127 Tel: 01566 782107

HARLEQUIN PRODUCTIONS
Suite 5, Woodville Court
31 Sylvan Road
London SE19 2SG
Website: www.harlequinproductions.co.uk
e-mail: neill@harlequinproductions.co.uk Tel: 020-8653 2333

HUNKY DORY PRODUCTIONS Ltd
(Facilities & Crew, Also Editing: Non-Linear)
57 Alan Drive
Barnet, Herts EN5 2PW
Website: www.hunkydory.tv Tel: 020-8440 0820

HUNTER Ewan
(Freelance Cameraman)
The Cottage To Be, 2B East Street
Herne Bay, Kent CT6 5HN
e-mail: ewan.hunter@ukonline.co.uk
Mobile: 07770 270856 Tel: 01227 742843

MOVING PICTURE COMPANY The
(Post-Production)
127-133 Wardour Street, London W1F 0NL
Website: www.moving-picture.com
e-mail: mailbox@moving-picture.com
Fax: 020-7287 5187 Tel: 020-7434 3100

OCEAN OPTICS
(Underwater Camera Sales & Operator Rental)
7 & 8 Bush House Arcade
Bush House, Aldwych, London WC2B 4PA
Website: www.oceanoptics.co.uk
e-mail: optics@oceanoptics.co.uk
Fax: 020-7240 7938 Tel: 020-7240 8193

PANAVISION UK
The Metropolitan Centre
Bristol Road, Greenford, Middlesex UB6 8GD
Website: www.panavision.co.uk
Fax: 020-8839 7300 Tel: 020-8839 7333

PEDIGREE PUNKS
(Shooting Crews, Editing, Compositing, Encoding, Mastering
to all formats)
49 Woolstone Road, Forest Hill, London SE23 2TR
Website: www.pedigree-punks.com
e-mail: video@pedigree-punks.com
Fax: 020-8291 5801 Tel: 020-8314 4580

PLACE The
Robin Howard Dance Theatre
17 Duke's Road, London WC1H 9BY
Website: www.theplace.org.uk
e-mail: info@theplace.org.uk
Fax: 020-7121 1142 Tel: 020-7121 1000

PRO-LINK RADIO SYSTEMS Ltd
(Radio Microphones & Communications)
4 Woden Court, Saxon Business Park, Hanbury Road
BromsgroveWorcestershire B60 4AD
Website: www.prolink-radio.com
e-mail: service@prolink-radio.com
Fax: 01527 577757 Tel: 01527 577788

SALON Ltd
(Post-Production & Editing Equipment Hire)
12 Swainson Road, London W3 7XB
Website: www.salonrentals.com
e-mail: hire@salonrentals.com Tel: 020-8746 7611

SOUNDHOUSE The
10th Floor, Ashley House
Quay Street, Manchester M3 4AE
Website: www.thesoundhouse.tv
e-mail: suekeane@thesoundhouse.tv
Fax: 0161-832 7266 Tel: 0161-832 7299

TVMS (SCOTLAND)
(Video & Broadcast Facilities)
3rd Floor
420 Sauchiehall Street
Glasgow G2 3JD
e-mail: mail@tvms.wanadoo.co.uk
Fax: 0141-332 9040 Tel: 0141-331 1993

VIDEO CASTING DIRECTORY Ltd
(Production of Performers Showreels)
(Simon Hicks)
27B Great George Street
Bristol BS1 5QT
e-mail: simon@fightingfilms.com Tel: 0117-927 9281

VIDEO INN PRODUCTION
(AV Equipment Hire)
Glebe Farm
Wooton Road
Quinton, Northampton NN7 2EE
Website: www.videoinn.co.uk
e-mail: andy@videoinn.co.uk Tel: 01604 864868

VIDEOSONICS CINEMA SOUND
(Film & Television Dubbing Facilities)
68A Delancey Street, London NW1 7RY
Website: www.videosonics.com
e-mail: info@videosonics.com
Fax: 020-7419 4470 Tel: 020-7209 0209

VSI - VOICE & SCRIPT INTERNATIONAL
(Dubbing, Editing & DVD Encoding & Authoring Facilities)
132 Cleveland Street
London W1T 6AB
Website: www.vsi.tv
e-mail: info@vsi.tv
Fax: 020-7692 7711 Tel: 020-7692 7700

W6 STUDIO
(Video Production & Editing Facilities)
359 Lillie Road
Fulham, London SW6 7PA
Website: www.w6studio.co.uk
Fax: 020-7381 5252 Tel: 020-7385 2272

30 BIRD PRODUCTIONS
24 Wroxton Road, London SE15 2BN
e-mail: thirtybirdproductions@ntlworld.com Tel: 020-7635 3737

303 PRODUCTIONS
11 D'Arblay Street, London W1F 8DT
e-mail: philburgess@mac.com
Fax: 020-7494 0956 Tel: 020-7494 0955

ACADEMY
16 West Central Street, London WC1A 1JJ
Website: www.academyfilms.com
e-mail: post@academyfilms.com
Fax: 020-7240 0355 Tel: 020-7395 4155

ACTAEON FILMS Ltd
49 Blenheim Gardens, London NW2 4NR
Website: www.actaeonfilms.com
e-mail: info@actaeonfilms.com
Fax: 0870 1347980 Tel: 020-8830 7990

AGILE FILMS
28-30 Coronet Street, London N1 6HD
Website: www.agilefilms.com
Fax: 020-7689 2374 Tel: 020-7689 2373

ALGERNON Ltd
15 Cleveland Mansions, Widley Road, London W9 2LA
Website: www.algernonproductions.com
e-mail: info@algernonproductions.com
Fax: 0870 1388516 Tel: 020-7266 1582

AN ACQUIRED TASTE TV CORP
51 Croham Road, South Croydon CR2 7HD
e-mail: cbennetttv@aol.com
Fax: 020-8686 5928 Tel: 020-8686 1188

ANGLO IRISH ARTS COLLECTIVE
63 Nicholl House, Woodberry Down
Finsbury Park, London N4 2TQ
e-mail: aiac@btinternet.com Tel: 020-8800 0640

APT FILMS
225A Brecknock Road, London N19 5AA
Website: www.aptfilms.com
e-mail: admin@aptfilms.com
Fax: 020-7482 1587 Tel: 020-7284 1695

APTN
The Interchange, Oval Road, Camden Lock, London NW1 7DZ
Fax: 020-7413 8312 Tel: 020-7482 7400

ARIEL PRODUCTIONS Ltd
46 Melcombe Regis Court
59 Weymouth Street
London W1G 8NT Tel/Fax: 020-7935 6636

ARLINGTON PRODUCTIONS Ltd
TV D Co
Cippenham Court, Cippenham Lane
Cippenham, Nr Slough, Berkshire SL1 5AU
Fax: 01753 691785 Tel: 01753 516767

ART BOX PRODUCTIONS
10 Heatherway, Crowthorne, Berkshire RG45 6HG
e-mail: artbox@tonyhart.co.uk Tel/Fax: 01344 773638

ASCENT MEDIA Ltd
Film House, 142 Wardour Street, London W1F 8DD
Website: www.ascentmedia.co.uk
Fax: 020-7878 7870 Tel: 020-7878 0000

ASF PRODUCTIONS Ltd
38 Clunbury Court, Manor Street
Berkhamsted, Herts HP4 2FF
e-mail: info@asfproductions.co.uk
Fax: 01442 872536 Tel: 01442 872999

ASHFORD ENTERTAINMENT CORPORATION Ltd The
20 The Chase, Coulsdon, Surrey CR5 2EG
Website: www.ashford-entertainment.co.uk
e-mail: info@ashford-entertainment.co.uk Tel: 020-8660 9609

ATTICUS TELEVISION Ltd
5 Clare Lawn, London SW14 8BH
e-mail: attwiz@aol.com
Fax: 020-8878 3821 Tel: 020-8487 1173

AVALON TELEVISION Ltd
4A Exmoor Street, London W10 6BD
Fax: 020-7598 7281 Tel: 020-7598 7280

BAILEY Catherine Ltd
110 Gloucester Avenue, Primrose Hill, London NW1 8JA
Fax: 020-7483 2155 Tel: 020-7483 2681

BANANA PARK Ltd
(Animation Production Company)
Banana Park, 6 Cranleigh Mews, London SW11 2QL
Website: www.bananapark.co.uk
e-mail: studio@bananapark.co.uk
Fax: 020-7738 1887 Tel: 020-7228 7136

BARFORD FILM COMPANY The
35 Bedfordbury, London WC2N 4DU
Website: www.barford.co.uk
e-mail: info@barford.co.uk
Fax: 020-7379 5210 Tel: 020-7836 1365

BARRATT Michael
Field House, Ascot Road, Maidenhead, Berkshire SL6 3LD
e-mail: michael@mbarratt.co.uk
Fax: 01628 627737 Tel: 01628 770800

BBC WORLDWIDE Ltd
Woodlands, 80 Wood Lane, London W12 0TT
Fax: 020-8749 0538 Tel: 020-8433 2000

BHP Ltd
2A Utopia Village
7 Chalcot Road, London NW1 8LH
Fax: 020-7722 6229 Tel: 020-7722 2261

BIG MOUTH COMPANY Ltd The
PO Box 619 CT14 9YA
Website: www.thebigmouthcompany.com
e-mail: info@thebigmouthcompany.com Tel/Fax: 0871 7500075

BIG RED BUTTON Ltd
(Write)
91 Brick Lane, London E1 6QL
Website: www.bigredbutton.tv
e-mail: info@bigredbutton.tv

BLACKBIRD PRODUCTIONS
6 Molasses Row, Plantation Wharf
Battersea, London SW11 3UX
e-mail: enquiries@blackbirdproductions.co.uk
 Tel: 020-7924 6440

BLUE FISH MEDIA
39 Ratby Close
Lower Earley, Reading RG6 4ER
Website: www.bfmedia.co.uk
e-mail: ideas@bfmedia.co.uk
Fax: 0118-962 0748 Tel: 0118-975 0272

BLUE WAND PRODUCTIONS Ltd
2nd Floor, 12 Weltje Road, London W6 9TG
e-mail: bluewandproltd@btinternet.com
Mobile: 07885 528743 Tel/Fax: 020-8741 2038

BLUELINE PRODUCTIONS Ltd
16 Five Oaks Close, Woking, Surrey GU21 8TU
e-mail: david@blue-line.tv Tel: 01483 797002

BOWE TENNANT PRODUCTIONS
(Specialist Animal Pet Productions & Supply of
Animals for Film & TV)
Applewood House Studio
Ringshall Road, Dagnall, Berkhamsted
Herts HP4 1RN Tel: 01923 213008

BRUNSWICK FILMS Ltd
(Formula One Grand Prix Film Library)
26 Macroom Road
Maida Vale, London W9 3HY
Website: www.brunswickfilms.com
e-mail: info@brunswickfilms.com
Fax: 020-8960 4997 Tel: 020-8960 0066

BUCKMARK PRODUCTIONS
Commer House, Station Road
Tadcaster, North Yorkshire LS24 9JF
Website: www.buckmark.com
e-mail: info@buckmark.com
Fax: 01937 835901 Tel: 01937 835900

BUENA VISTA PRODUCTIONS
3 Queen Caroline Street
Hammersmith, London W6 9PE
Fax: 020-8222 2795 Tel: 020-8222 1000

BURDER FILMS
37 Braidley Road, Meyrick Park
Bournemouth BH2 6JY
Website: www.johnburder.co.uk
e-mail: burderfilms@aol.com Tel: 01202 295395

CALDERDALE TELEVISION
Dean Clough
Halifax HX3 5AX
e-mail: ctv@calderdaletv.co.uk
Fax: 01422 384532 Tel: 01422 253100

CAMBRIDGE FILM & TELEVISION PRODUCTIONS Ltd
Building 7200
Cambridge Research Park
Beach Drive, Waterbeach
Cambridge CB5 9TF
Website: www.cftp.co.uk
e-mail: contact@cftp.co.uk Tel: 01223 815613

CARDINAL BROADCAST
Cutting Room 13, Pinewood Studios
Iver Heath, Bucks SL0 0NH Tel: 01753 639210

CARNIVAL (FILMS & THEATRE) Ltd
47 Marylebone Lane, London W1U 2NT
Website: www.carnival-films.co.uk
Fax: 020-7317 1380 Tel: 020-7317 1370

CELADOR PRODUCTIONS Ltd
39 Long Acre, London WC2E 9LG
Fax: 020-7845 6975 Tel: 020-7240 8101

CELTIC FILMS ENTERTAINMENT Ltd
31 Sackville Street, London W1S 3DZ
e-mail: info@celticfilms.co.uk
Fax: 020-7734 4744 Tel: 020-7734 4434

CENTRE SCREEN PRODUCTIONS
Eastgate, Castle Street
Castlefield, Manchester M3 4LZ
Website: www.centrescreen.co.uk
e-mail: info@centrescreen.co.uk
Fax: 0161-832 8934 Tel: 0161-832 7151

CHANNEL 2020 Ltd
2020 House,
26-28 Talbot Lane, Leicester LE1 4LR
Website: www.channel2020.co.uk
e-mail: info@channel2020.co.uk
Fax: 0116-222 1113 Tel: 0116-233 2220

CHANNEL TELEVISION PRODUCTION
The Television Centre
La Pouquelaye, St Helier, Jersey JE1 3ZD
e-mail: production@channeltv.co.uk
Fax: 01534 816889 Tel: 01534 816888

CHANNEL X Ltd
2nd Floor
Highgate Business Centre
33 Greenwood Place, London NW5 1LB
e-mail: firstname.lastname@channelx.co.uk
Fax: 020-7428 3998 Tel: 020-7428 3999

CHARISMA FILMS Ltd
Riverbank House
1 Putney Bridge Approach
London SW6 3JD
Fax: 020-7610 6836 Tel: 020-7610 6830

CHILDREN'S FILM & TELEVISION FOUNDATION Ltd
e-mail: annahome@cftf.org.uk Mobile: 07887 573479

CINEMA VERITY PRODUCTIONS Ltd
F TV D Co
11 Addison Avenue, London W11 4QS
Fax: 020-7371 3329 Tel: 020-7460 2777

CLASSIC PICTURES ENTERTAINMENT Ltd
Shepperton Studios
Studios Road
Shepperton, Middlesex TW17 0QD
e-mail: lyn.beardsall@classicpictures.co.uk
Fax: 01932 592046 Tel: 01932 592016

COLLINGWOOD O'HARE ENTERTAINMENT Ltd
10-14 Crown Street
Acton, London W3 8SB
e-mail: info@crownstreet.co.uk
Fax: 020-8993 9595 Tel: 020-8993 3666

Height 5 feet 10 inches (Equity/M.U.) Photo: *Stephen Hough*

Peter Durrent

Pianist ~ Accompanist ~ Composer ~ Vocalist
Audition & Rehearsal Pianist ~ Cocktail Pianist

Tel: 01787 373483 Mob: 07810 613 938

or c/o The Spotlight

FILM, TELEVISION & VIDEO PRODUCTION COMPANIES

www.spotlight.com

COMMERCIAL BREAKS
Anglia House, Norwich NR1 3JG
Website: www.commercialbreaks.co.uk
e-mail: commercialbreaks@itv.com
Fax: 01603 752610 Tel: 01603 752600

COMMUNICATOR Ltd
199 Upper Street, London N1 1RQ
e-mail: info@communicator.ltd.uk
Fax: 020-7704 8444 Tel: 020-7704 8333

COMPLETE WORKS The
The Old Truman Brewery, 91 Brick Lane, London E1 6QL
Website: www.tcw.org.uk
e-mail: info@tcw.org.uk
Fax: 0870 1431979 Tel: 0870 1431969

COMTEC Ltd
Unit 19, Tait Road, Croydon, Surrey CR0 2DP
Website: www.comtecav.co.uk
e-mail: info@comtecav.co.uk
Fax: 020-8684 6947 Tel: 020-8684 6615

CONVERGENCE PRODUCTIONS Ltd
10-14 Crown Street, Acton, London W3 8SB
e-mail: info@crownstreet.co.uk
Fax: 020-8993 9595 Tel: 020-8993 3666

COURTYARD PRODUCTIONS
TV Production Company
Little Postlings Farmhouse
Four Elms, Kent TN8 6NA
e-mail: courtyard@mac.com Tel: 01732 700324

COWBOY FILMS
2nd Floor, 87 Notting Hill Gate, London W11 3JZ
Website: www.crossroadsfilms.com
e-mail: info@crossroadsfilms.co.uk
Fax: 020-7792 0592 Tel: 020-7792 5400

CREATE MEDIA VENTURES/CREATE TV & FILM Ltd
52 New Concordia Wharf, Mill Street, London SE1 2BB
Website: www.createtvandfilm.com
e-mail: info@cmventures.co.uk
Fax: 0871 5750720 Tel: 020-7154 6960

CREATIVE PARTNERSHIP The
13 Bateman Street, London W1D 3AF
Website: www.creativepartnership.co.uk
Fax: 020-7437 1467 Tel: 020-7439 7762

CROFT TELEVISION
Croft House, Progress Business Centre
Whittle Parkway, Slough, Berkshire SL1 6DQ
Fax: 01628 668791 Tel: 01628 668735

CUTHBERT Tony PRODUCTIONS
7A Langley Street, London WC2H 9JA
Website: www.tonycuthbert.com
e-mail: info@tonycuthbert.com
Fax: 020-7734 6579 Tel: 020-7437 8884

DALTON FILMS Ltd
127 Hamilton Terrace, London NW8 9QR
Fax: 020-7624 4420 Tel: 020-7328 6169

DARLOW SMITHSON PRODUCTIONS Ltd
Highgate Studios, 53-79 Highgate Road, London NW5 1TL
Website: www.darlowsmithson.com
e-mail: mail@darlowsmithson.com
Fax: 020-7482 7039 Tel: 020-7482 7027

DAWKINS ASSOCIATES Ltd
PO Box 615
Boughton Monchelsea, Kent ME17 4RN
e-mail: da@ccland.demon.co.uk Tel: 01622 741900

DAWSON FILMS
82 Berwick Street, London W1F 8TP
Website: www.dawsonfilms.com
e-mail: mail@dawsonfilms.com Tel: 020-7734 1400

DIALOGICS
249-251 Kensal Road, London W10 5DB
e-mail: peter@dialogics.com
Fax: 020-8968 1517 Tel: 020-8960 6069

DLT ENTERTAINMENT UK Ltd
10 Bedford Square, London WC1B 3RA
Fax: 020-7636 4571 Tel: 020-7631 1184

DON PRODUCTIONS Ltd
26 Shacklewell Lane, London E8 2EZ
Website: www.donproductions.com
e-mail: info@donproductions.com
Fax: 020-7690 4333 Tel: 020-7690 0108

DRAMA HOUSE The
The Clock House, St Mary's Street
Nether Stowey, Somerset TA5 1LJ
Website: www.dramahouse.co.uk
e-mail: jackemery@dramahouse.co.uk Tel: 01278 733336

DRAMATIS PERSONAE Ltd
(Nathan Silver, Nicolas Kent)
19 Regency Street, London SW1P 4BY
e-mail: nathansilver@btconnect.com Tel: 020-7834 9300

DREAMING WILL INITIATIVE The
PO Box 38155
London SE17 3XP
Website: www.londonshakespeare.org.uk/dw.htm
e-mail: lswprison@europe.com Tel/Fax: 020-7793 9755

DVA
8 Campbell Court, Bramley, Hampshire RG26 5EG
Website: www.dvafacilities.co.uk
e-mail: barrieg@dva.co.uk
Fax: 01256 882024 Tel: 01256 882032

ECOSSE FILMS Ltd
Brigade House
8 Parsons Green, London SW6 4TN
Website: www.ecossefilms.com
e-mail: info@ecossefilms.com
Fax: 020-7736 3436 Tel: 020-7371 0290

EDGE PICTURE COMPANY Ltd The
7 Langley Street, London WC2H 9JA
Website: www.edgepicture.com
e-mail: ask.us@edgepicture.com
Fax: 020-7836 6949 Tel: 020-7836 6262

ENDEMOL UK Plc
(Including Endemol UK Productions, Initial,
Brighter Pictures, Victoria Real & Hawkshead)
Shepherds Building Central, Charecroft Way
Shepherd's Bush, London W14 0EE
Fax: 0870 3331800 Tel: 0870 3331700

ENLIGHTENMENT PRODUCTIONS
CV
East End House, 24 Ennerdale
Skelmersdale WN8 6AJ
Website: www.trainingmultimedia.co.uk Tel: 01695 727555

ENTERTAINMENT RIGHTS Plc
Colet Court
100 Hammersmith Road, London W6 7JP
Fax: 020-8762 6299 Tel: 020-8762 6200

EON PRODUCTIONS Ltd
Eon House, 138 Piccadilly, London W1J 7NR
Fax: 020-7408 1236 Tel: 020-7493 7953

EPA INTERNATIONAL MULTIMEDIA Ltd
31A Regent's Park Road, London NW1 7TL
Fax: 020-7267 8852 Tel: 020-7267 9198

EYE FILM & TELEVISION
Chamberlain House, 2 Dove Street, Norwich NR2 1DE
Website: www.eyefilmandtv.co.uk
e-mail: production@eyefilmandtv.co.uk
Fax: 01603 762420 Tel: 01603 762551

FARNHAM FILM COMPANY The
34 Burnt Hill Road
Lower Bourne, Farnham GU10 3LZ
Website: www.farnfilm.com
e-mail: info@farnfilm.com
Fax: 01252 725855　　　　Tel: 01252 710313

FEELGOOD FICTION Ltd
49 Goldhawk Road, London W12 8QP
Website: www.feelgoodfiction.co.uk
e-mail: feelgood@feelgoodfiction.co.uk
Fax: 020-8740 6177　　　　Tel: 020-8746 2535

FESTIVAL FILM & TELEVISION Ltd
Festival House, Tranquil Passage
Blackheath Village, London SE3 0BJ
Website: www.festivalfilm.com
e-mail: info@festivalfilm.com
Fax: 020-8297 1155　　　　Tel: 020-8297 9999

FILM & GENERAL PRODUCTIONS Ltd
4 Bradbrook House
Studio Place, London SW1X 8EL
Fax: 020-7245 9853　　　　Tel: 020-7235 4495

FILMS OF RECORD Ltd
2 Elgin Avenue, London W9 3QP
e-mail: films@filmsofrecord.com
Fax: 020-7286 0444　　　　Tel: 020-7286 0333

FIRST WRITES RADIO COMPANY
(Radio Drama Company)
Lime Kiln Cottage, High Starlings
Banham, Norfolk NR16 2BS
Website: www.first-writes.co.uk
e-mail: ellen@firstwrites.fsnet.co.uk
Fax: 01953 888874　　　　Tel: 01953 888525

FLASHBACK TELEVISION Ltd
9-11 Bowling Green Lane, London EC1R 0BG
Website: www.flashbacktelevision.com
e-mail: mailbox@flashbacktv.co.uk
Fax: 020-7490 5610　　　　Tel: 020-7490 8996

FLYING DUCKS GROUP
Oakridge, Weston Road, Stafford ST16 3RS
Website: www.flyingducks.biz
e-mail: enquiries@flyingducks.biz
Fax: 01785 252448　　　　Tel: 01785 610966

FLYING SCOTSMAN FILMS
F TV D
The Birches, School Road
Gartocharn, Near Glasgow G83 8RT
e-mail: broncofilm@btinternet.com　　Tel/Fax: 0141-287 6817

FLYNN PRODUCTIONS
Top Floor, Pitfield House
31-35 Pitfield Street, London N1 6HB
Website: www.flynnproductions.com
e-mail: info@flynnproductions.com
Fax: 020-7251 6272　　　　Tel: 020-7251 6197

FOCUS PRODUCTIONS Ltd
58 Shelley Road, Stratford-upon-Avon
Warwickshire CV37 7JS
Website: www.focusproductions.co.uk
e-mail: maddern@focusproductions.co.uk
Fax: 01789 294845　　　　Tel: 01789 298948

FORSTATER Mark PRODUCTIONS
27 Lonsdale Road, London NW6 6RA
Fax: 020-7624 1124　　　　Tel: 020-7624 1123

FREMANTLEMEDIA TALKBACKTHAMES
1 Stephen Street, London W1T 1AL
Fax: 020-7691 6100　　　　Tel: 020-7691 6000

FULL WORKS The
Dassels House, Dassels, Nr Braughing, Ware
Herts SG11 2RW　　　　Tel: 01763 289905

FULMAR TELEVISION & FILM Ltd
Pascoe House, 54 Bute Street
Cardiff Bay, Cardiff CF10 5AF
Fax: 029-2045 5111　　　　Tel: 029-2045 5000

GALA PRODUCTIONS Ltd
25 Stamford Brook Road, London W6 0XJ
Website: www.galaproductions.co.uk
e-mail: info@galaproductions.co.uk
Fax: 020-8741 2323　　　　Tel: 020-8741 4200

GALLEON FILMS Ltd
Greenwich Playhouse, Station Forecourt
189 Greenwich High Road, London SE10 8JA
Website: www.galleonfilms.co.uk
e-mail: alice@galleontheatre.co.uk　Tel/Fax: 020-8310 7276

GAMMOND Stephen ASSOCIATES
24 Telegraph Lane , Claygate, Surrey KT10 0DU
e-mail: stephengammond@hotmail.com　Tel: 01372 460674

GAY Noel TELEVISION Ltd
TV D Ch Co
Shepperton Studios, Studios Road
Shepperton, Middlesex TW17 0QD
e-mail: charles.armitage@virgin.net
Fax: 01932 592172　　　　Tel: 01932 592569

GHA GROUP
1 Great Chapel Street, London W1F 8FA
Website: www.ghagroup.co.uk
e-mail: sales@ghagroup.co.uk
Fax: 020-7437 5880　　　　Tel: 020-7439 8705

GLASS PAGE Ltd The
15 De Montfort Street, Leicester LE1 7GE
Fax: 0116-249 2188　　　　Tel: 0116-249 2199

GOLDHAWK ESSENTIAL
20 Great Chapel Street, London W1F 8FW
e-mail: enquiries@goldhawk.eu
Fax: 020-7287 3597　　　　Tel: 020-7439 7113

GOOD FILMS
Unit 17, Waterside, 44-48 Wharf Road, London N1 7UX
Fax: 020-7253 1117　　　　Tel: 020-7566 0280

GRADE COMPANY The
23 St Edmonds Terrace, London NW8 7QA
Fax: 020-7408 2042　　　　Tel: 020-7586 2420

GRANT NAYLOR PRODUCTIONS Ltd
Rooms 950-951, The David Lean Building
Shepperton Studios, Studios Road, Shepperton TW17 0QD
Fax: 01932 592484　　　　Tel: 01932 592175

GREAT GUNS Ltd
43-45 Camden Road, London NW1 9LR
e-mail: greatguns@greatguns.com
Fax: 020-7692 4422　　　　Tel: 020-7692 4444

GUERILLA FILMS Ltd
35 Thornbury Road, Isleworth, Middlesex TW7 4LQ
Website: www.guerilla-films.com
e-mail: david@guerilla-films.com
Fax: 020-8758 9364 Tel: 020-8758 1716

HAMMERWOOD FILM PRODUCERS
110 Trafalgar Road
Portslade, Sussex BN41 1GS
Website: www.filmangel.co.uk
e-mail: filmangels@freenetname.co.uk
Fax: 01273 705451 Tel: 01273 277333

HARBOUR PICTURES
11 Langton Street, London SW10 0JL
Website: www.harbourpictures.com
e-mail: info@harbourpictures.com
Fax: 020-7352 3528 Tel: 020-7351 7070

HARTSWOOD FILMS
Twickenham Studios, The Barons
St Margaret's, Twickenham, Middlesex TW1 2AW
Fax: 020-8607 8744 Tel: 020-8607 8736

HASAN SHAH FILMS Ltd
153 Burnham Towers, Adelaide Road, London NW3 3JN
Fax: 020-7483 0662 Tel: 020-7722 2419

HAT TRICK PRODUCTIONS Ltd
TV Co
10 Livonia Street, London W1F 8AF
Fax: 020-7287 9791 Tel: 020-7434 2451

HAWK EYE FILMS
82 Kenley Road, St Margarets
Twickenham TW1 1JU Tel: 020-8241 7089

HEAD Sally PRODUCTIONS
Twickenham Film Studios, The Barons
St Margaret's, Twickenham, Middlesex TW1 2AW
e-mail: admin@shpl.demon.co.uk
Fax: 020-8607 8964 Tel: 020-8607 8730

HEAVY ENTERTAINMENT Ltd
222 Kensal Road, London W10 5BN
Website: www.heavy-entertainment.com
e-mail: info@heavy-entertainment.com
Fax: 020-8960 9003 Tel: 020-8960 9001

HENSON Jim COMPANY
30 Oval Road, Camden, London NW1 7DE
Website: www.henson.com
Fax: 020-7428 4001 Tel: 020-7428 4000

HIT ENTERTAINMENT Ltd
5th Floor, Maple House
149 Tottenham Court Road, London W1T 7NF
Website: www.hitentertainment.com
e-mail: creative@hitentertainment.com
Fax: 020-7388 9321 Tel: 020-7554 2500

HOLMES ASSOCIATES & OPEN ROAD FILMS
F TV D
The Studio, 37 Redington Road, London NW3 7QY
e-mail: holmesassociates@blueyonder.co.uk
Fax: 020-7813 4334 Tel: 020-7813 4333

HUDSON FILM Ltd
24 St Leonard's Terrace
London SW3 4QG Tel: 020-7730 0002

HUNGRY MAN Ltd
19 Grafton Mews, London W1T 5JB
Website: www.hungryman.com
e-mail: ukreception@hungryman.com
Fax: 020-7380 8299 Tel: 020-7380 8280

HUNKY DORY PRODUCTIONS Ltd
TV D Co
57 Alan Drive, Barnet, Herts EN5 2PW
Website: www.hunkydory.tv
e-mail: adrian@hunkydory.tv Mobile: 07973 655510

HURRICANE FILMS Ltd
19 Hope Street, Liverpool L1 9BQ
Website: www.hurricanefilms.net
e-mail: sol@hurricanefilms.co.uk
Fax: 0151-707 9149 Tel: 0151-707 9700

IAMBIC PRODUCTIONS Ltd
89 Whiteladies Road, Clifton, Bristol BS8 2NT
e-mail: admin@iambic.tv
Fax: 0117-923 8343 Tel: 0117-923 7222

ICON FILMS Ltd
10 Redland Terrace, Bristol BS6 6TD
Fax: 0117-974 4971 Tel: 0117-970 6882

INFORMATION TRANSFER Ltd
CV (Training Video Packages)
Burleigh House, 15 Newmarket Road, Cambridge CB5 8EG
Fax: 01223 310200 Tel: 01223 312227

INTERESTING TELEVISION Ltd
Oakslade Studios
Station Road, Hatton, Warwick CV35 7LH
Fax: 01926 844045 Tel: 01926 844044

ISIS PRODUCTIONS Ltd
106 Hammersmith Grove, London W6 7HB
Website: www.isisproductions.co.uk
e-mail: isis@isis-productions.com
Fax: 020-8748 3046 Tel: 020-8748 3042

IWC MEDIA
3-6 Kenrick Place, London W1U 6HD
e-mail: info@iwcmedia.co.uk
Fax: 020-7317 2231 Tel: 020-7317 2230

JACKSON Brian FILMS Ltd
F TV Ch
39-41 Hanover Steps, St George's Fields
Albion Street, London W2 2YG
e-mail: brianjfilm@aol.com
Fax: 020-7262 5736 Tel: 020-7402 7543

J. I. PRODUCTIONS
10 Linden Grove, Great Linford
Milton Keynes, Bucks MK14 5HF
Website: www.jasonimpey.co.uk
e-mail: jason.impey@freeuk.com
Mobile: 07732 476409 Tel: 01908 676081

JMS GROUP Ltd
Hethersett, Norwich, Norfolk, NR9 3DL
Website: www.jms-group.com
e-mail: info@jmsradio.co.uk
Fax: 01603 812255 Tel: 01603 811855

JONES THE FILM
32 Rathbone Place, London W1T 1JJ
Website: www.jonesthefilm.com
e-mail: mail@jonesthefilm.com
Fax: 020-7580 3480 Tel: 020-7580 5007

KELPIE FILMS
227 St Andrews Road, Glasgow G41 1PD
Website: www.kelpiefilms.com
e-mail: info@kelpiefilms.com Tel: 0871 8740328

KNOWLES Dave FILMS
(Also Multimedia Interactive CD-Roms)
34 Ashleigh Close, Hythe SO45 3QP
Website: www.dkfilms.co.uk
e-mail: mail@dkfilms.co.uk
Fax: 023-8084 1600 Tel: 023-8084 2190

LANDSEER PRODUCTIONS Ltd
140 Royal College Street, London NW1 0TA
Website: www.landseerfilms.com
e-mail: mail@landseerfilms.com Tel: 020-7485 7333

LITTLE BIRD COMPANY Ltd
9 Grafton Mews, London W1T 5HZ
e-mail: info@littlebird.co.uk
Fax: 020-7380 3981 Tel: 020-7380 3980

LITTLE KING COMMUNICATIONS
The Studio
2 Newport Road
Barnes, London SW13 9PE
Fax: 020-8653 2742 Tel: 020-8741 7658

LONDON COLLEGE OF COMMUNICATION
(Film & Video Division)
Elephant & Castle, London SE1 6SB
Fax: 020-7514 6848 Tel: 020-7514 6500

LONDON FILMS
71 South Audley Street, London W1K 1JA
Website: www.londonfilms.com
Fax: 020-7499 7994 Tel: 020-7499 7800

LONDON SCIENTIFIC FILMS
Dassels House, Dassels
Braughing, Ware
Herts SG11 2RW Tel: 01920 444399

LOOKING GLASS FILMS Ltd
103 Brittany Point, Ethelred Estate
Kennington, London SE11 6UH
e-mail: lookingglassfilm@aol.com Tel/Fax: 020-7735 1363

LOOP COMMUNICATION AGENCY The
Hanover House, Queen Charlotte Street, Bristol BS1 4EX
e-mail: mail@theloopagency.com
Fax: 0117-311 2041 Tel: 0117-311 2040

MAGPIE FILM PRODUCTIONS Ltd
31-32 Cheapside, Birmingham B5 6AY
Website: www.magpiefilms.co.uk
Fax: 0121-666 6077 Tel: 0121-622 5884

MALLINSON TELEVISION PRODUCTIONS
(TV Commercials)
29 Lynedoch Street, Glasgow G3 6EF
e-mail: shoot@mtp.co.uk
Fax: 0141-332 6190 Tel: 0141-332 0589

MALONE GILL PRODUCTIONS Ltd
27 Campden Hill Road, London W8 7DX
e-mail: malonegill@aol.com
Fax: 020-7376 1727 Tel: 020-7937 0557

MANS Johnny PRODUCTIONS Ltd
PO Box 196, Hoddesdon, Herts EN10 7WG
e-mail: real@legend.co.uk
Fax: 01992 470516 Tel: 01992 470907

MANSFIELD Mike TELEVISION Ltd
5th Floor, 41-42 Berners Street, London W1T 3NB
e-mail: mikemantv@aol.com
Fax: 020-7580 2582 Tel: 020-7580 2581

MAP FILMS
21 Little Portland Street, London W1W 8BT
e-mail: mail@mapfilms.com
Fax: 020-7612 0199 Tel: 020-7612 0190

MARTIN William PRODUCTIONS
The Studio, Tubney Warren Barns
Tubney, Oxfordshire OX13 5QJ
Website: www.wmproductions.co.uk
e-mail: info@wmproductions.co.uk
Fax: 01865 390234 Tel: 01865 390258

MAVERICK MEDIA Ltd
Moray House
23-31 Great Titchfield Street, London W1W 7PA
Website: www.maverickmedia.co.uk
e-mail: info@maverickmedia.co.uk
Fax: 020-7323 4143 Tel: 020-7291 3450

MAVERICK TELEVISION
Progress Works
Heath Mill Lane, Birmingham B9 4AL
Website: www.mavericktv.co.uk
e-mail: mail@mavericktv.co.uk
Fax: 0121-771 1550 Tel: 0121-771 1812

MAX MEDIA
The Lilacs, West End, Woodhurst
Huntingdon, Cambridge PE28 3BH
Website: www.therealmaxmedia.com
e-mail: martin@therealmaxmedia.com
Fax: 01487 825299 Tel: 01487 823608

MBP TV
TV
Saucelands Barn, Coolham
Horsham, West Sussex RH13 8QG
Website: www.mbptv.com
e-mail: info@mbptv.com
Fax: 01403 741647 Tel: 01403 741620

McINTYRE Phil ENTERTAINMENT
2nd Floor, 35 Soho Square, London W1D 3QX
e-mail: reception@mcintyre-ents.com
Fax: 020-7439 2280 Tel: 020-7439 2270

MENTORN
43 Whitfield Street, London W1T 4HA
Fax: 020-7258 6888 Tel: 020-7258 6800

MERCHANT IVORY PRODUCTIONS
46 Lexington Street, London W1F 0LP
Website: www.merchantivory.com
e-mail: miplondon@merchantivory.co.uk
Fax: 020-7734 1579 Tel: 020-7437 1200

MERSEY TELEVISION COMPANY Ltd The
TV
Campus Manor, Childwall
Abbey Road, Liverpool L16 0JP
Fax: 0151-722 6839 Tel: 0151-722 9122

MIGHTY MEDIA
Unit M, Bourne End Business Park
Bourne End, Bucks SL8 5AS
Fax: 01628 526530 Tel: 01628 522002

MINAMON FILM
117 Downton Avenue, London SW2 3TX
Website: www.minamonfilm.co.uk
e-mail: min@minamonfilm.co.uk
Fax: 020-8674 1779 Tel: 020-8674 3957

MISTRAL FILM Ltd
31 Oval Road, London NW1 7EA
e-mail: info@mistralfilm.co.uk
Fax: 020-7284 0547 Tel: 020-7284 2300

MODUS OPERANDI FILMS
10 Brackenbury Road
London W6 0BA Tel: 020-7434 1440

MORE Alan FILMS
Pinewood Studios, Pinewood Road
Iver, Bucks SL0 0NH
e-mail: almorefilm@talktalk.net
Fax: 01753 656884 Tel: 01753 656789

MOVE A MOUNTAIN PRODUCTIONS
5 Ashchurch Park Villas, London W12 9SP
Website: www.moveamountain.com
e-mail: mail@moveamountain.com Tel: 020-8743 3017

MURPHY Patricia FILMS Ltd
Lock Keepers Cottage, Lyme Street, London NW1 0SF
e-mail: office@patriciamurphy.co.uk
Fax: 020-7485 0555 Tel: 020-7267 0007

NEAL STREET PRODUCTIONS Ltd
1st Floor, 26-28 Neal Street, London WC2H 9QQ
e-mail: post@nealstreetproductions.com
Fax: 020-7240 7099 Tel: 020-7240 8890

NEBRASKA PRODUCTIONS
12 Grove Avenue, London N10 2AR
e-mail: nebraskaprods@aol.com
Fax: 020-8444 2113 Tel: 020-8444 5317

NEW MOON TELEVISION
8 Ganton Street, London W1F 7QP
Website: www.new-moon.co.uk
e-mail: production@new-moon.co.uk
Fax: 020-7479 7011 Tel: 020-7479 7010

NEXUS PRODUCTIONS Ltd
(Animation for Commercials, Broadcast, Pop Promos & Title Sequences)
113-114 Shoreditch High Street, London E1 6JN
Website: www.nexusproductions.com
e-mail: info@nexusproductions.com
Fax: 020-7749 7501 Tel: 020-7749 7500

NFD PRODUCTIONS Ltd
PO Box 76, Leeds LS25 9AG
Website: www.nfdproductions.com
e-mail: info@nfdproductions.com
Mobile: 07932 653466 Tel/Fax: 01977 681949

NUTOPIA-CHANG FILMS
Number 8, 132 Charing Cross Road, London WC2H 0LA
Website: www.nutopia-chang.com
Fax: 029-2070 5725 Tel: 029-2071 3540

OLD VIC PRODUCTIONS (FILMS) Plc
The Old Vic Theatre, The Cut, Waterloo, London SE1 8NB
e-mail: ros.povey@oldvictheatre.com
Fax: 020-7981 0946 Tel: 020-7928 2651

OMNI PRODUCTIONS Ltd
Unit 35-36, Easton Business Centre
Felix Road, Bristol BS5 0HE
Website: www.omniproductions.co.uk
e-mail: info@omniproductions.co.uk Tel: 0117-941 5820

ON COMMUNICATION
(Work across all Media in Business Communications, Museum Prods & Broadcast Docs)
5 East St Helen Street, Abingdon, Oxford OX14 5EG
Website: www.oncommunication.com
e-mail: info@oncommunication.com
Fax: 01235 530581 Tel: 01235 537400

ON SCREEN PRODUCTIONS Ltd
Ashbourne House, 33 Bridge Street, Chepstow
Monmouthshire NP16 5GA
Website: www.onscreenproductions.co.uk
e-mail: action@onscreenproductions.co.uk
Fax: 01291 636301 Tel: 01291 636300

OPEN MIND PRODUCTIONS
3 Waxhouse Gate, St Albans, Herts AL3 4EW
e-mail:production.manager@openmind.co.uk
 Tel: 0845 8909192

OPEN SHUTTER PRODUCTIONS Ltd
100 Kings Road, Windsor
Berkshire SL4 2AP Tel/Fax: 01753 841309

OPUS PRODUCTIONS Ltd
9A Coverdale Road
Shepherds Bush, London W12 8JJ
Website: www.opusproductions.co.uk
e-mail: claire.bidwell@opusproductions.com
Fax: 020-8749 4537 Tel: 020-8743 3910

ORIGINAL FILM & VIDEO PRODUCTIONS Ltd
84 St Dionis Road, London SW6 4TU
e-mail: original.films@btinternet.com Tel: 020-7731 0012

OVC MEDIA Ltd
88 Berkeley Court, Baker Street, London NW1 5ND
Website: www.ovcmedia.com
e-mail: eliot@ovcmedia.com
Fax: 020-7723 3064 Tel: 020-7402 9111

PALADIN INVISION
8 Barb Mews, London W6 7PA
Fax: 020-7371 2160 Tel: 020-7348 1950

PAPER MOON PRODUCTIONS
Wychwood House, Burchetts Green Lane
Littlewick Green, Maidenhead, Berkshire SL6 3QW
e-mail: david@paper-moon.co.uk
Fax: 01628 825949 Tel: 01628 829819

PARADINE David PRODUCTIONS Ltd
The Penthouse
346 Kensington High Street, London W14 8NS
e-mail: mail@paradine-productions.com
Fax: 020-7602 0411 Tel: 020-7371 3111

PARALLAX INDEPENDENT Ltd
Victoria Chambers, St Runwald Street
Colchester CO1 1HF Tel: 01206 574909

PARAMOUNT FILM SERVICES Ltd
UIP House, 45 Beadon Road, London W6 0EG
Fax: 020-8563 4266 Tel: 020-8563 4158

PARK VILLAGE Ltd
1 Park Village East, London NW1 7PX
e-mail: info@parkvillage.co.uk
Fax: 020-7388 3051 Tel: 020-7387 8077

PASSION PICTURES Ltd
Animation
3rd Floor, 33-34 Rathbone Place, London W1T 1JN
e-mail: info@passion-pictures.com
Fax: 020-7323 9030 Tel: 020-7323 9933

PATHÉ PICTURES Ltd
Kent Hse, 14-17 Market Pl, Grt Titchfield St, London W1W 8AR
Website: www.pathe.co.uk
Fax: 020-7631 3568 Tel: 020-7323 5151

PCI LIVE DESIGN
(Live Events, Live Design Exhibitions, Film & Video, 2D & 3D Design)
G4 Harbour Yard, Chelsea Harbour, London SW10 0XD
Fax: 020-7352 7906 Tel: 020-7544 7500

PERSONIFICATION FILMS Ltd
97 Choumert Road, London SE15 4AP
Website: www.personificationfilms.com
e-mail: rabbie@personificationfilms.com
Tel/Fax: 020-7639 9295

PICTURE PALACE FILMS Ltd
13 Egbert Street, London NW1 8LJ
Website: www.picturepalace.com
e-mail: info@picturepalace.com
Fax: 020-7586 9048 Tel: 020-7586 8763

PIER PRODUCTIONS Ltd
Lower Ground Floor
1 Marlborough Place, Brighton BN1 1TU
e-mail: info@pierproductionsltd.co.uk
Fax: 01273 693658 Tel: 01273 691401

PIEREND PRODUCTIONS
34 Fortis Green, London N2 9EL
e-mail: russell@richardsonassoc.fsnet.co.uk
Tel/Fax: 020-8444 0138

POKER Ltd
143B Whitehall Court
London SW1A 2EL Tel/Fax: 020-7839 6070

POSITIVE IMAGE Ltd
25 Victoria Street, Windsor, Berkshire SL4 1HE
Fax: 01753 830878 Tel: 01753 842248

POT BOILER FILMS
9 Greek Street, London W1D 4DQ
e-mail: info@potboiler.co.uk
Fax: 020-7287 5228 Tel: 020-7734 7372

POZZITIVE TELEVISION Ltd
Paramount House
162-170 Wardour Street, London W1F 8AB
e-mail: pozzitive@pozzitive.co.uk
Fax: 020-7437 3130 Tel: 020-7734 3258

PRETTY CLEVER PICTURES
Iping Mill
Iping, Midhurst, West Sussex GU29 0PE
e-mail: pcpics@globalnet.co.uk
Mobile: 07836 616981 Tel: 01730 817899

PRISM ENTERTAINMENT
(Television Production & Website Design Company)
The Clockhouse, 220 Latimer Road, London W10 6QY
Website: www.prismentertainment.co.uk
e-mail: info@prism-e.com
Fax: 020-8969 1012 Tel: 020-8969 1212

PRODUCERS The
8 Berners Mews, London W1T 3AW
Website: www.theproducersfilms.co.uk
e-mail: info@theproducersfilms.co.uk
Fax: 020-7636 4099 Tel: 020-7636 4226

PRODUCTION LINKS
St Johns Court, Whiteladies Road, Bristol BS8 2QY
Website: www.productionlinks.tv
e-mail: info@productionlinks.tv
Fax: 0117-973 6038 Tel: 0117-973 6037

PRODUCTIONS & PROMOTIONS Ltd
Apsley Mills Cottage, London Road
Hemel Hempstead, Herts HP3 9QU
Website: www.prodmotions.com
e-mail: reception@prodmotions.com
Fax: 0845 0095540 Tel: 01442 233372

PROFESSIONAL MEDICAL COMMUNICATIONS Ltd
Grosvenor House, 1 High Street, Edgware
Middlesex HA8 7TA Tel: 020-8381 1819

PROMENADE ENTERPRISES Ltd
6 Russell Grove, London SW9 6HS
Website: www.promenadeproductions.com
e-mail: info@promenadeproductions.com Tel: 020-7582 9354

PSA Ltd
52 The Downs, Altrincham WA14 2QJ
e-mail: info@psafilms.co.uk
Fax: 0161-924 0022 Tel: 0161-924 0011

PURPLE FROG MEDIA Ltd
19 Westbourne Gardens, Hove BN3 5PL
e-mail: julie@purplefrogmedia.com
Fax: 01273 775787 Tel: 01273 735475

PVA MANAGEMENT Ltd
Hallow Park, Hallow, Worcs WR2 6PG
e-mail: films@pva.co.uk
Fax: 01905 641842 Tel: 01905 640663

QUADRANT TELEVISION Ltd
17 West Hill, London SW18 1RB
Website: www.quadrant-tv.com
e-mail: quadranttv@aol.com Tel: 020-8870 9933

QUADRILLION
The Old Barn, Kings Lane
Cookham Dean, Berkshire SL6 9AY
Website: www.quadrillion.tv
e-mail: enq@quadrillion.tv
Fax: 01628 487523 Tel: 01628 487522

RAW CHARM MEDIA
Ty Cefn, Rectory Road, Cardiff CF5 1QL
Website: www.rawcharm.tv
e-mail: kate@rawcharm.co.uk
Fax: 029-2066 8220 Tel: 029-2064 1511

READ Rodney
45 Richmond Road, Twickenham, Middlesex TW1 3AW
Website: www.rodney-read.com
e-mail: rodney_read@blueyonder.co.uk
Fax: 020-8744 9603 Tel: 020-8891 2875

RECORDED PICTURE COMPANY Ltd
24-26 Hanway Street, London W1T 1UH
Fax: 020-7636 2261 Tel: 020-7636 2251

RED KITE ANIMATION
89 Giles Street, Edinburgh EH6 6BZ
Website: www.redkite-animation.com
e-mail: info@redkite-animation.com
Fax: 0131-553 6007 Tel: 0131-554 0060

RED ROSE CHAIN
1 Fore Hamlet
Ipswich IP3 8AA
Website: www.redrosechain.co.uk
e-mail: info@redrosechain.co.uk Tel: 01473 288886

REDWEATHER PRODUCTIONS
Easton Business Centre, Felix Road, Bristol BS5 0HE
Website: www.redweather.co.uk
e-mail: info@redweather.co.uk
Fax: 0117-941 5851 Tel: 0117-941 5854

REEL THING Ltd The
182 Brighton Road, Coulsdon, Surrey CR5 2NF
Website: www.reelthing.tv
e-mail: info@reelthing.tv Tel: 020-8668 8188

REPLAY Ltd
Museum House, 25 Museum Street, London WC1A 1JT
Website: www.replayfilms.co.uk
e-mail: sales@replayfilms.co.uk Tel: 020-7637 0473

RESOURCE BASE
Fairways Hse, Mount Pleasant Rd, Southampton SO14 0QB
Website: www.resource-base.co.uk
e-mail: post@resource-base.co.uk
Fax: 023-8023 6816 Tel: 023-8023 6806

REUTERS Ltd
The Reuters Building, South Collonade
Canary Wharf, London E14 5EP Tel: 020-7250 1122

REVERE ENTERTAINMENT
91 Berwick Street, London W1F ONE
Fax: 020-7292 7391 Tel: 020-7292 8370

RIVERSIDE TV STUDIOS
Riverside Studios, Crisp Road, London W6 9RL
Website: www.riversidetv.co.uk
e-mail: info@riversidetv.co.uk
Fax: 020-8237 1121 Tel: 020-8237 1123

ROGERS Peter PRODUCTIONS Ltd
Pinewood Studios, Iver Heath
Buckinghamshire SL0 0NH Tel: 01753 651700

ROOKE Laurence PRODUCTIONS
14 Aspinall House, 155 New Park Road, London SW2 4EY
Mobile: 07765 652058 Tel: 020-8674 3128

ROSE HACKNEY BARBER Ltd
5-6 Kingly Street, London W1B 5PF
Fax: 020-7434 4102 Tel: 020-7380 3435

RSA FILMS
42-44 Beak Street, London W1F 9RH
Fax: 020-7734 4978 Tel: 020-7437 7426

RUSSO Denis ASSOCIATES
F TV Animation
161 Clapham Road, London SW9 0PU
Fax: 020-7582 2725 Tel: 020-7582 9664

SAMUELSON PRODUCTIONS Ltd
13 Manette Street, London W1D 4AW
e-mail: samuelsonp@aol.com
Fax: 020-7439 4901 Tel: 020-7439 4900

SANDS FILMS
Grice's Wharf
119 Rotherhithe Street, London SE16 4NF
Website: www.sandsfilms.co.uk
Fax: 020-7231 2119 Tel: 020-7231 2209

SCALA PRODUCTIONS Ltd
4th Floor, Portland House
4 Great Portland Street, London W1W 8QJ
e-mail: scalaprods@aol.com
Fax: 020-7612 0031 — Tel: 020-7612 0060

SCIMITAR FILMS Ltd
219 Kensington High Street, London W8 6BD
e-mail: winner@ftech.co.uk
Fax: 020-7602 9217 — Tel: 020-7734 8385

SCREEN FIRST Ltd
The Studios, Funnells Farm
Down Street, Nutley, East Sussex TN22 3LG
e-mail: paul.madden@virgin.net
Fax: 01825 713511 — Tel: 01825 712034

SCREEN VENTURES
49 Goodge Street
London W1T 1TE — Tel: 020-7580 7448

SEPTEMBER FILMS Ltd
Glen House, 22 Glenthorne Road
Hammersmith, London W6 0NG
Fax: 020-8741 7214 — Tel: 020-8563 9393

SEVEN STONES MEDIA Ltd
The Old Butcher's Shop, St Briavels
Gloucestershire GL15 6TA
e-mail: info@sevenstonesmedia.com
Fax: 01594 530094 — Tel: 01594 530708

SEVENTH ART PRODUCTIONS
63 Ship Street, Brighton BN1 1AE
Website: www.seventh-art.com
e-mail: info@seventh-art.com
Fax: 01273 323777 — Tel: 01273 777678

SHART BROS Ltd
52 Lancaster Road, London N4 4PR
Fax: 020-7436 9233 — Tel: 020-7263 4435

SHELL FILM & VIDEO UNIT
F CV Docs
Shell Centre, York Road, London SE1 7NA
Fax: 020-7934 7490 — Tel: 020-7934 3318

SHELL LIKE
Whitfield House, 81 Whitfield Street, London W1T 4HG
Website: www.shelllike.com
e-mail: enquiries@shelllike.com
Fax: 020-7255 5255 — Tel: 020-7255 5204

SIGHTLINE
(Videos, Commercials, CD-Rom, DVD, Websites)
Dylan House, Town End Street
Godalming, Surrey GU7 1BQ
Website: www.sightline.co.uk
e-mail: action@sightline.co.uk
Fax: 01483 861516 — Tel: 01483 861555

SILK SOUND
13 Berwick Street, London W1F 0PW
Website: www.silk.co.uk
e-mail: bookings@silk.co.uk
Fax: 020-7494 1748 — Tel: 020-7434 3461

SILVER PRODUCTIONS Ltd
Bridge Farm
Lower Road, Britford
Salisbury, Wiltshire SP5 4DY
Website: www.silver.co.uk
Fax: 01722 336227 — Tel: 01722 336221

SINDIBAD FILMS Ltd
5th Floor, 5 Princes Gate, London SW7 1QJ
Website: www.sindibad.co.uk
e-mail: info@sindibad.co.uk
Fax: 020-7823 9137 — Tel: 020-7823 7488

SMITH & WATSON PRODUCTIONS
The Gothic House
Fore Street, Totnes, Devon TQ9 5EH
Website: www.smithandwatson.com
e-mail: info@smithandwatson.com
Fax: 01803 864219 — Tel: 01803 863033

SNEEZING TREE FILMS
C
1-2 Bromley Place, London W1T 6DA
Website: www.sneezingtree.com
e-mail: firstname@sneezingtree.com
Fax: 020-7927 9909 — Tel: 020-7927 9900

SONY PICTURES
25 Golden Square, London W1F 9LU
Fax: 020-7533 1015 — Tel: 020-7533 1000

SOREL STUDIOS
10 Palace Court
Palace Road, London SW2 3ED
e-mail: info@sorelstudios.co.uk — Tel/Fax: 020-8671 2168

SPACE CITY PRODUCTIONS
77 Blythe Road, London W14 0HP
Website: www.spacecity.co.uk
e-mail: info@spacecity.co.uk
Fax: 020-7371 4001 — Tel: 020-7371 4000

SPEAKEASY PRODUCTIONS Ltd
Wildwood House
Stanley, Perth PH1 4PX
Website: www.speak.co.uk
e-mail: info@speak.co.uk
Fax: 01738 828419 — Tel: 01738 828524

SPECIFIC FILMS Ltd
25 Rathbone Street, London W1T 1NQ
e-mail: info@specificfilms.com
Fax: 020-7494 2676 — Tel: 020-7580 7476

SPINSTER Ltd
71 Whinney Hill, Holywood
County Down, Northern Ireland BT18 0HG
Website: www.spinster-associates.com
e-mail: jo.gilbert@gmail.com
Fax: 028-9023 1633 Tel: 028-9042 2088

SPIRAL PRODUCTIONS Ltd
Aberdeen Studios, 22 Highbury Grove, London N5 2EA
Fax: 020-7359 6123 Tel: 020-7354 5492

STAFFORD Jonathan Ltd
1 The Limes, St Nicholas Hill
Leatherhead, Surrey KT22 8NH
Fax: 01372 383060 Tel: 01372 383050

STANDFAST FILMS
F TV D
The Studio, 14 College Road
Bromley, Kent BR1 3NS
Fax: 020-8313 0443 Tel: 020-8466 5580

STANTON MEDIA
6 Kendal Close, Aylesbury, Bucks
Website: www.stantonmedia.com
e-mail: info@stantonmedia.com Tel/Fax: 01296 489539

STEEL SPYDA Ltd
96-98 Undley
Lakenheath, Suffolk IP27 9BY
Website: www.steelspyda.com
e-mail: kay.hill@steelspyda.com
Fax: 01842 862875 Tel: 01842 862880

STONE PRODUCTIONS CREATIVE Ltd
Lakeside Studio, 62 Mill Street
St Osyth, Essex CO16 8EW
Website: www.stone-productions.co.uk
e-mail: info@stone-productions.co.uk
Fax: 01255 822160 Tel: 01255 822172

STUDIO AKA
(Animation)
30 Berwick Street, London W1F 8RH
Website: www.studioaka.co.uk
Fax: 020-7437 2309 Tel: 020-7434 3581

TABARD PRODUCTIONS
Adam House, 7-10 Adam Street, London WC2N 6AA
e-mail: info@tabard.co.uk
Fax: 020-7497 0830 Tel: 020-7497 0850

TABLE TOP PRODUCTIONS
1 The Orchard, Bedford Park, Chiswick, London W4 1JZ
e-mail: berry@tabletopproductions.com
Tel/Fax: 020-8742 0507 Tel: 020-8994 1269

TAKE 3 PRODUCTIONS Ltd
72-73 Margaret Street, London W1W 8ST
Website: www.take3.co.uk
e-mail: mail@take3.co.uk
Fax: 020-7637 4678 Tel: 020-7637 2694

TAKE FIVE PRODUCTIONS
CV Docs
37 Beak Street, London W1F 9RZ
Website: www.takefivestudio.com
e-mail: info@takefivestudio.com
Fax: 020-7287 3035 Tel: 020-7287 2120

TALKBACK THAMES
20-21 Newman Street, London W1T 1PG
Fax: 020-7861 8001 Tel: 020-7861 8000

TALKING PICTURES
Pinewood Studios
Pinewood Road, Iver Heath, Bucks SL0 0NH
Website: www.talkingpictures.co.uk
e-mail: info@talkingpictures.co.uk
Fax: 01753 650048 Tel: 01753 655744

TANDEM TV & FILM Ltd
Charleston House, 13 High Street
Hemel Hempstead, Herts HP1 3AA
Website: www.tandemtv.com
e-mail: info@tandemtv.com
Fax: 01442 219250 Tel: 01442 261576

TAYLOR David ASSOCIATES Ltd
F CV D Ch
83 Westholme Close, Congleton
Cheshire CW12 4FZ Tel/Fax: 01260 279406

TELEVIRTUAL Ltd
Media Lab, 9 Whitlingham Lane
Norwich NK7 0QA
Website: www.televirtual.com
e-mail: tim@televirtual.com Tel: 01603 431030

THIN MAN FILMS
9 Greek Street, London W1D 4DQ
e-mail: info@thinman.co.uk
Fax: 020-7287 5228 Tel: 020-7734 7372

TIGER ASPECT PRODUCTIONS
7 Soho Street, London W1D 3DQ
Website: www.tigeraspect.co.uk
e-mail: general@tigeraspect.co.uk
Fax: 020-7434 1798 Tel: 020-7434 6700

TKO COMMUNICATIONS Ltd
(A Division of The Kruger Organisation Inc)
PO Box 130, Hove, Sussex BN3 6QU
e-mail: tkoinc@tkogroup.com
Fax: 01273 540969 Tel: 01273 550088

TOP BANANA
The Studio, Stourbridge, West Midlands DY9 0HA
Website: www.top-b.com
e-mail: info@top-b.com
Fax: 01562 700930 Tel: 01562 700404

TOPICAL TELEVISION Ltd
61 Devonshire Road, Southampton SO15 2GR
Fax: 023-8033 9835 Tel: 023-8071 2233

TVE Ltd
(Broadcast Facilities, Non-Linear Editing)
TVE House, Wick Drive, New Milton, Hampshire BH25 6RH
e-mail: enquiries@tvehire.com
Fax: 01425 625021 Tel: 01425 625020

TVF
375 City Road, London EC1V 1NB
Fax: 020-7833 2185 Tel: 020-7837 3000

TVMS (SCOTLAND)
3rd Floor, 420 Sauchiehall Street, Glasgow G2 3JD
e-mail: mail@tvms.wanadoo.co.uk
Fax: 0141-332 9040 Tel: 0141-331 1993

TV PRODUCTION PARTNERSHIP Ltd
4 Fullerton Manor, Fullerton, Hants SP11 7LA
Website: www.tvpp.tv
e-mail: dbj@tvpp.tv Tel: 01264 861440

TWENTIETH CENTURY FOX TELEVISION Ltd
Twentieth Century House, 31-32 Soho Square
London W1D 3AP Tel: 020-7437 7766

TWO SIDES TV Ltd
53A Newman Street, London W1F 9UH
e-mail: info@2sidestv.co.uk
Fax: 020-7287 2289 Tel: 020-7439 9882

TWOFOUR PRODUCTIONS Ltd
TwoFour Studios
Estover, Plymouth PL6 7RG
Website: www.twofour.co.uk
e-mail: enq@twofour.co.uk
Fax: 01752 727450 Tel: 01752 727400

TYBURN FILM PRODUCTIONS Ltd
F
Cippenham Court
Cippenham Lane, Cippenham
Nr Slough, Berkshire SL1 5AU
Fax: 01753 691785 Tel: 01753 516767

UNGER Kurt
112 Portsea Hall, Portsea Place, London W2 2BZ
Fax: 020-7706 4818 Tel: 020-7262 9013

VERA
3rd Floor, 66-68 Margaret Street, London W1W 8SR
e-mail: cree@vera.co.uk
Fax: 020-7436 6117 Tel: 020-7436 6116

VERA MEDIA
(Video Production & Training Company)
30-38 Dock Street, Leeds LS10 1JF
e-mail: vera@vera-media.co.uk
Fax: 0113-242 8739 Tel: 0113-242 8646

VIDEO & FILM PRODUCTION
Robin Hill, The Ridge, Lower Basildon, Reading, Berks
Website: www.videoandfilm.co.uk
e-mail: david.fisher@videoandfilm.co.uk
Mobile: 07836 544955 Tel: 0118-984 2488

VIDEO ARTS
6-7 St Cross Street, London EC1N 8UA
e-mail: sales@videoarts.co.uk
Fax: 020-7400 4900 Tel: 020-7400 4800

VIDEO ENTERPRISES
12 Barbers Wood Road
High Wycombe, Buckinghamshire HP12 4EP
Website: www.videoenterprises.co.uk
e-mail: videoenterprises@ntlworld.com
Fax: 01494 534145 Tel: 01494 534144

VIDEOTEL PRODUCTIONS
84 Newman Street, London W1T 3EU
Fax: 020-7299 1818 Tel: 020-7299 1800

VILLAGE PRODUCTIONS
4 Midas Business Centre
Wantz Road, Dagenham, Essex RM10 8PS
e-mail: village000@btclick.com
Fax: 020-8593 0198 Tel: 020-8984 0322

W3KTS Ltd
10 Portland Street, York YO31 7EH
e-mail: chris@w3kts.com
Fax: 08700 554863 Tel: 01904 647822

W6 STUDIO
359 Lillie Road, Fulham, London SW6 7PA
Website: www.w6studio.co.uk
Fax: 020-7381 5252 Tel: 020-7385 2272

WALKOVERS VIDEO
Willow Cottage, Church Lane
Kington Langley, Chippenham, Wiltshire SN15 5NU
e-mail: walkoversvideo@btinternet.com Tel: 01249 750428

WALNUT MEDIA COMMUNICATIONS Ltd
4 Sadler Close, Leeds LS16 8NN
Website: www.walnutmedia.com
e-mail: mail@walnutmedia.com Tel: 0113-285 7906

WALSH BROS Ltd
24 Redding House, Harlinger Street
King Henry's Wharf, London SE18 5SR
Website: www.walshbros.co.uk
e-mail: info@walshbros.co.uk
Tel/Fax: 020-8854 5557 Tel/Fax: 020-8858 6870

WALSH Steve PRODUCTIONS Ltd
78 Fieldview, London SW18 3HF
Website: www.steve-walsh.com
e-mail: info@steve-walsh.com
Fax: 020-7580 6554 Tel: 020-7580 6553

WARNER BROS PRODUCTIONS Ltd
FF
Warner Suite, Leavesden Studios
South Way, Leavesden, Herts WD25 7LT
Fax: 01923 685221 Tel: 01923 685222

WARNER SISTERS PRODUCTIONS Ltd
Ealing Studios
Ealing Green, London W5 5EP
e-mail: ws@warnercini.com Tel: 020-8567 6655

WEST DIGITAL
(Broadcast Post-Production)
65 Goldhawk Road, London W12 8EG
Fax: 020-8743 2345 Tel: 020-8743 5100

WEST ONE FILM PRODUCERS Ltd
(Cooper Murray)
Tennyson House
159-165 Great Portland Street
London W1W 5PA
e-mail: jocorb@hotmail.com
Fax: 020-8224 3518 Tel: 020-8224 8696

WHITEHALL FILMS
10 Lower Common South, London SW15 1BP
e-mail: mwhitehall@msn.com
Fax: 020-8788 2340 Tel: 020-8785 3737

WINNER Michael Ltd
219 Kensington High Street, London W8 6BD
e-mail: winner@ftech.co.uk
Fax: 020-7602 9217 Tel: 020-7734 8385

WORKING TITLE FILMS Ltd
Oxford House
76 Oxford Street, London W1D 1BS
Fax: 020-7307 3001 Tel: 020-7307 3000

WORLD'S END TELEVISION
16-18 Empress Place
London SW6 1TT
Website: www.worldsendproductions.com
e-mail: info@worldsendproductions.com
Fax: 020-7386 4901 Tel: 020-7386 4900

WORLD PRODUCTIONS & WORLD FILM SERVICES Ltd
16 Dufours Place, London W1F 7SP
Website: www.world-productions.com
Fax: 020-7758 7000 Tel: 020-7734 3536

WORLD WIDE PICTURES
21-25 St Anne's Court, London W1F 0BJ
Website: www.worldwidegroup.ltd.uk
e-mail: info@worldwidegroup.ltd.uk
Fax: 020-7734 0619 Tel: 020-7434 1121

WORTHWHILE MOVIE Ltd
(Providing the services of Bruce Pittman as Film Director)
25 Tolverne Road, London SW20 8RA
Fax: 00 1 (416) 4695894 Tel: 00 1 (416) 4690459

XINGU FILMS
12 Cleveland Row, London SW1A 1DH
Fax: 020-7451 0601 Tel: 020-7451 0600

YOUNGSTAR PRODUCTIONS
(Children's TV Series)
5 Union Castle House, Canute Road
Southampton SO14 3FJ
Fax: 023-8045 5816 Tel: 023-8033 9322

ZENITH ENTERTAINMENT Ltd
43-45 Dorset Street, London W1U 7NA
Fax: 020-7224 1027 Tel: 020-7224 2440

ZEPHYR FILMS Ltd
33 Percy Street
London W1T 2DF
e-mail: info@zephyrfilms.co.uk
Fax: 020-7255 3777 Tel: 020-7255 3555

Brighton Film School
Film Director's Courses in Cinematography and Screenwriting
Franz von Habsburg MBKS (BAFTA Member) 01273 302166 www.brightonfilmschool.org.uk
Be in Brighton - where film was pioneered in 1896!

BRIGHTON FILM SCHOOL
(Member of the National Association for Higher Education in the Moving Image (NAHEMI) and the University Film and Video Association (UFVA). Part-time Day or Evening Film Directors' Courses includes Screenwriting, Cinematography etc)
Website: www.brightonfilmschool.org.uk
e-mail: info@brightonfilmschool.org.uk
Fax: 01273 302163 Tel: 01273 302166

LEEDS METROPOLITAN UNIVERSITY
(PG Dip/MA's in Film & Moving Image Production or Fiction Screenwriting, and BA (Hons) in Film & Moving Image Production and Cert HE/FdA in Film & Television Production and BA (Hons) Contemporary Performance)
School of Film & Television & Performing Arts
H505, Calverley Street, Leeds LS1 3HE
Website: www.leedsmet.ac.uk
Fax: 0113-283 8080 Tel: 0113-283 2600

LONDON ACADEMY OF RADIO, FILM & TV
1 Lancing Street
London NW1 1NA
Website: www.media-courses.com
e-mail: daycourses@googlemail.com Tel: 0870 8504994

LONDON FILM ACADEMY
The Old Church
52A Walham Grove, London SW6 1QR
Website: www.londonfilmacademy.com
e-mail: info@londonfilmacademy.com
Fax: 020-7381 6116 Tel: 020-7386 7711

LONDON FILM SCHOOL The
(2-year MA Course in Film Making, 1-year MA in Screenwriting)
24 Shelton Street, London WC2H 9UB
Website: www.lfs.org.uk
e-mail: film.school@lfs.org.uk
Fax: 020-7497 3718 Tel: 020-7836 9642

MIDDLESEX UNIVERSITY
(School of Arts)
Cat Hill
Barnet, Herts EN4 8HT
Website: www.mdx.ac.uk Tel: 020-8411 5555

NATIONAL FILM AND TELEVISION SCHOOL
MA Courses in Directing (Animation, Fiction or Documentary), Cinematography, Composing for Film & Television, Editing, Producing (Film), Producing and Directing for Television Entertainment, Production Design
Beaconsfield Studios, Station Road
Beaconsfield, Bucks HP9 1LG
Website: www.nftsfilm-tv.ac.uk
e-mail: info@nftsfilm-tv.ac.uk
Fax: 01494 674042 Tel: 01494 671234

UCCA - FARNHAM
(3-year BA (Hons) Photography, Film Production, Digital Screen Arts, Arts & Media, Animation)
Falkner Road
Farnham
Surrey GU9 7DS
Website: www.ucreative.ac.uk Tel: 01252 722441

UNIVERSITY OF WESTMINSTER SCHOOL OF MEDIA ARTS & DESIGN
(Undergraduate courses in Film and Television Production and Contemporary Media Practice. Postgraduate Courses in Screenwriting and Producing, Film and Television; Theory, Culture and Industry)
Admissions & Enquiries
Watford Road
Northwick Park
Harrow, Middlesex HA1 3TP
Website: www.wmin.ac.uk/filmschool Tel: 020-7911 5000

FILM LONDON
supports over 1,000
film, TV and advertising
projects every year,
**make us your first
point of contact for
filming in the capital.**

3 MILLS STUDIOS
Three Mill Lane, London E3 3DU
Website: www.3mills.com
e-mail: info@3mills.com
Fax: 020-8215 3499 Tel: 020-7363 3336

ARDMORE STUDIOS Ltd
Herbert Road, Bray
Co. Wicklow, Eire
Website: www.ardmore.ie
e-mail: film@ardmore.ie
Fax: 00 353 1 2861894 Tel: 00 353 1 2862971

BBC SOUTH (Elstree)
BBC Elstree Centre, Clarendon Road
Borehamwood, Herts WD6 1JF Tel: 020-8743 8000

BBC TELEVISION
Television Centre
Wood Lane, Shepherds Bush
London W12 7RJ Tel: 020-8743 8000

BRAY STUDIOS
Down Place, Water Oakley
Windsor Road, Windsor, Berkshire SL4 5UG
Fax: 01628 770381 Tel: 01628 622111

BRIGHTON FILM STUDIOS Ltd
The Brighton Business Centre
95 Ditchling Road, Brighton BN1 4ST
Website: www.brightonfilmstudios.com
e-mail: info@brightonfilmstudios.com
Fax: 01273 302163 Tel: 01273 302166

CAPITAL STUDIOS
Wandsworth Plain, London SW18 1ET
Website: www.capitalstudios.com
e-mail: info@capitalstudios.com
Fax: 020-8877 0234 Tel: 020-8877 1234

CHELTENHAM FILM STUDIOS Ltd
Arle Court, Hatherley Lane
Cheltenham, Gloucestershire GL51 6PN
Website: www.cheltstudio.com
e-mail: info@cheltstudio.com
Fax: 01242 542 701 Tel: 01242 542 700

EALING STUDIOS
Ealing Green, London W5 5EP
Website: www.ealingstudios.com
e-mail: info@ealingstudios.com
Fax: 020-8758 8658 Tel: 020-8567 6655

ELSTREE FILM & TELEVISION STUDIOS
Shenley Road
Borehamwood, Herts WD6 1JG
Website: www.elstreefilmtv.com
e-mail: info@elstreefilmtv.com
Fax: 020-8905 1135 Tel: 020-8953 1600

LONDON STUDIOS The
London Television Centre
Upper Ground, London SE1 9LT
Website: www.londonstudios.co.uk
Fax: 020-7928 8405 Tel: 020-7737 8888

PINEWOOD STUDIOS
Pinewood Road, Iver Heath
Buckinghamshire SL0 0NH
Website: www.pinewoodshepperton.com
Fax: 01753 656844 Tel: 01753 651700

REUTERS TELEVISION
The Reuters Building
South Colonnade, Canary Wharf
London E14 5EP Tel: 020-7250 1122

RIVERSIDE STUDIOS
Crisp Road, London W6 9RL
Website: www.riversidestudios.co.uk
e-mail: online@riversidestudios.co.uk
Fax: 020-8237 1001 Tel: 020-8237 1000

SANDS FILMS/ROTHERHITHE STUDIOS
119 Rotherhithe Street, London SE16 4NF
Fax: 020-7231 2119 Tel: 020-7231 2209

SHEPPERTON STUDIOS
Studios Road
Shepperton
Middlesex TW17 0QD
Website: www.pinewoodshepperton.com
Fax: 01932 592555 Tel: 01932 592000

TEDDINGTON STUDIOS
Broom Road
Teddington, Middlesex TW11 9NT
Website: www.teddington.tv
e-mail: sales@teddington.tv
Fax: 020-8943 4050 Tel: 020-8977 3252

TWICKENHAM FILM STUDIOS Ltd
The Barons, St Margaret's
Twickenham, Middlesex TW1 2AW
Fax: 020-8607 8889 Tel: 020-8607 8888

GOOD DIGS GUIDE

G

Good Digs Guide
Compiled By JANICE CRAMER & DAVID BANKS
This is a list of digs recommended by those who have used them. To keep the list accurate please send recommendations for inclusion to GOOD DIGS GUIDE at The Spotlight. Thanks to all who did so over the last year. Entries in **Bold** have been paid for by the Digs concerned.

ABERDEEN
Milne, Mrs A
5 Sunnyside Walk
Aberdeen AB24 3NZ Tel: 01224 638951

Woods, Pat
62 Union Grove
Aberdeen AB10 6RX Tel: 01224 586324

AYR
Dunn, Sheila
The Dunn-Thing Guest House
13 Park Circus, Ayr KA7 2DJ
Mobile: 07887 928685 Tel: 01292 284531

BATH
Hutton, Celia Mrs
Bath Holiday Homes, Terranova
Shepherds Walk, Bath BA2 5QT
Website: www.bathholidayhomes.co.uk
e-mail: bhh@virgin.net **Tel: 01225 830830**

Tapley, Jane
Camden Lodgings
3 Upper Camden Place
Bath BA1 5HX Tel: 01225 446561

BELFAST
Greer, Nora
59 Rugby Road
Belfast BT7 1PT
Mobile: 07760 370344 Tel: 028-9032 2120

McCully, Mrs S
28 Eglantine Avenue, Belfast BT9 6DX
Mobile: 07985 947673 Tel: 028-9068 2031

BILLINGHAM
Farminer, Anna
168 Kennedy Gardens
Billingham, Cleveland TS23 3RJ
Mobile: 07946 237381 Tel: 01642 530205

Gibson, Mrs S
Northwood, 61 Tunstall Avenue
Billingham TS23 3QB
Mobile: 07813 407674 Tel: 01642 561071

Newton, Mrs Edna
97 Brendon Crescent, Billingham
Cleveland TS23 2QU Tel: 01642 647958

BIRMINGHAM
Baker, Mr N K
41 King Edward Road, Mosley
Birmingham B13 8EL Tel: 0121-449 8220

Matusiak-Varley, Ms B T
Red Gables
69 Handsworth Wood Road
Handsworth Wood
Birmingham B20 2DH
Mobile: 07711 751105 **Tel/Fax: 0121-686 5942**

Mountain, Marlene P
268 Monument Road, Edgbaston
Birmingham B16 8XF **Tel: 0121-454 5900**

Wilson, Mrs
17 Yew Tree Road, Edgbaston
Birmingham B15 2LX Tel: 0121-440 5182

[CONTACTS 2007]

BLACKPOOL

VERY HIGH STANDARD - en suite studios & apartments
• Central Heating • Cooker • Fridge • Microwave & TV - **all new**
Beds • Linen provided • 'Highly recommended' by members of the profession
• 10 minutes walk to the Theatre
Irene Chadderton, 22 Barton Avenue, Blackpool FY1 6AP • Tel/Fax: 01253 346743

BLACKPOOL
Brereton Holiday Flats
186 Promenade
Blackpool FY1 1RJ
e-mail: bookings@selfcateringblackpool.co.uk
Fax: 01253 753038 Tel: 01253 623095

Chapman, Brian & Liz
Hollywood Apartments
2-4 Wellington Road
Blackpool FY1 6AR Tel: 01253 341633

Lees, Jean
Ascot Flats, 6 Hull Road
Central Blackpool FY1 4QB Tel: 01253 621059

Somerset Apartments
22 Barton Avenue
Blackpool FY1 6AP **Tel: 01253 346743**

Waller, Veronica & Bob
The Brooklyn Hotel
7 Wilton Parade
Blackpool FY1 2HE Tel: 01253 627003

BOLTON
Duckworth, Paul
19 Burnham Avenue
Bolton BL1 6DB
Mobile: 07762 545129 Tel: 01204 495732

White, Mrs M
20 Heywood Gardens, Great Lever
Bolton BL3 6RB Tel: 01204 531589

BOURNEMOUTH
Sitton, Martin
Flat 2, 9 St Winifreds Road
Meyrick Park
Bournemouth BH2 6NX Tel: 01202 293318

BRADFORD
Smith, Theresa
8 Moorhead Terrace, Shipley
Bradford BD18 4LA Tel: 01274 778568

BRIGHTON
Benedict, Peter
19 Madeira Place
Brighton BN2 1TN
Mobile: 07752 810122 Tel: 020-7703 4104

Cleveland, Carol
13 Belgrave Street
Brighton BN2 9NS
Mobile: 07973 363939 Tel: 01273 602607

Dyson, Kate
39 Arundel Street
Kemptown BN2 5TH
Mobile: 07812 949575 Tel: 01273 607490

Hamlin, Corinne
Flat 6, Preston Lodge
Little Preston Street
Brighton BN1 2HQ Tel: 01273 321346

Stanfield-Miller, Ms
Flat 1, 154 Freshfield Road
Brighton BN2 9YD
Website: www.geocities.com/rowanstanfield/brightondigs
e-mail: rowanstanfield@yahoo.com
Mobile: 07747 725331 Tel: 01273 696080

BRISTOL
Rozario, Jean
Manor Lodge, 21 Station Road
Keynsham, N Somerset BS31 2BH
Website: www.manorlodge.co.uk
e-mail: stay@manorlodge.co.uk Tel: 0117-986 2191

BURY ST EDMUNDS
Bird, Mrs S
30 Crown Street
Bury St Edmunds
Suffolk IP33 1QU Tel: 01284 754492

Harrington-Spie, Sue
39 Well Street, Bury St Edmunds
Suffolk IP33 1EQ Tel: 01284 768986

BUXTON
Kitchen, Mrs M
Flat 1, 17 Silverlands
Buxton, Derbyshire SK17 6QH Tel: 01298 79381

CANTERBURY
Dolan, Mrs A
12 Leycroft Close
Canterbury
Kent CT2 7LD Tel: 01227 453153

Ellen, Nikki
Crockshard Farmhouse
Wingham, Canterbury CT3 1NY
Website: www.crockshard.com
e-mail: crockshard_bnb@yahoo.com Tel: 01227 720464

Stockbridge, Doris
Tudor House
6 Best Lane, Canterbury
Kent CT1 2JB Tel/Fax: 01227 765650

CARDIFF
Blade, Mrs Anne
25 Romilly Road
Canton, Cardiff CF5 1FH Tel: 029-2022 5860

Lewis, Nigel
66 Donald Street
Roath, Cardiff CF24 4TR
e-mail: nigel.lewis66@btinternet.com
Mobile: 07813 069822 Tel: 029-2049 4008

Nelmes, Michael
12 Darran Street, Cathays, Cardiff
South Glamorgan CF24 4JF Tel: 029-2034 2166

Taylor, T & Chichester, P
32 Kincraig Street, Roath, Cardiff
South Glamorgan CF24 3HW Tel: 029-2048 6785

CHESTERFIELD
Cook, Linda & Chris
27 Tennyson Avenue
Chesterfield
Derbyshire
Mobile: 07929 850561 — Tel: 01246 202631

Forsyth, Mr & Mrs
Anis Louise Guest House
34 Clarence Road
Chesterfield S40 1LN
Website: www.anislouise.com — **Tel: 01246 235412**

Popplewell, Mr & Mrs
23 Tennyson Avenue
Chesterfield
Derbyshire S40 4SN — Tel: 01246 201738

CHICHESTER
Potter, Iain & Lyn
Hunston Mill Cottages
Selsey Road
Chichester PO20 1AU — Tel: 01243 783375

COVENTRY
Snelson, Paddy & Bob
Banner Hill Farmhouse
Rouncil Lane
Kenilworth CV8 1NN — **Tel: 01926 852850**

DARLINGTON
Bird, Mrs
Gilling Old Mill
Gilling West
Richmond
N Yorks DL10 5JD — Tel: 01748 822771

Blindell, Ms M
5 Stanhope Road
Darlington
Durham DL3 7AP — Tel: 01325 462377

Graham, Anne
Holme House
Piercebridge
Darlington DL2 3SY
Website: www.holme-house.co.uk
e-mail: graham.holmehouse@gmail.com — Tel: 01325 374280

Kernon, Mr G
George Hotel, Piercebridge
Darlington DL2 3SW — Tel: 01325 374576

DUNDEE
Hill, Mrs J
Ash Villa
216 Arbroath Road
Dundee DD4 7RZ — Tel: 01382 450831

EASTBOURNE
Allen, Peter
Flat 1, 16 Enys Road
Eastbourne BN21 2DN
Mobile: 07712 439289 — Tel: 01323 730235

Chant, David E J
Hamdon
49 King's Drive
Eastbourne BN21 2NY — Tel: 01323 722544

Dawson, Jacqui
Lavender House
14 New Upperton Road
Eastbourne BN21 1NN — Tel: 01323 729988

Guess, Maggie
3 Hardy Drive
Langney Point
Eastbourne
East Sussex BN23 6ED
Mobile: 07710 273288 — Tel: 01323 736689

EDINBURGH
Glen Miller, Edna
25 Bellevue Road
Edinburgh EH7 4DL — Tel: 0131-556 4131

Stobbart, Joyce
84 Bellevue Road
Edinburgh EH7 4DE
Mobile: 07740 503951 — Day Tel: 0131-222 9889

Tyrrell, Helen
9 Lonsdale Terrace
Edinburgh EH3 9HN
e-mail: helen.tyrrell@vhscotland.org.uk
Tel: 0131-229 7219 — **Tel: 0131-652 5992 (Office)**

GLASGOW
Baird, David W
6 Beaton Road
Maxwell Park
Glasgow G41 4LA
Mobile: 07752 954176 — Tel: 0141-423 1340

Leslie-Carter, Simon
52 Charlotte Street
Glasgow G1 5DW
Website: www.52charlottestreet.co.uk
e-mail: slc@52charlottestreet.co.uk
Fax: 01436 810520 — Tel: 0845 2305252

Lloyd Jones, David
3 Whittinghame Drive
Kelvinside
Glasgow G12 0XS — Tel: 0141-339 3331

Robinson, Lesley
28 Marywood Square
Glasgow G41 2BJ
Mobile: 07957 188922 — Tel: 0141-423 6920

GLOUCESTER
Blackwell, David
Coach & Horses
2-4 St Catherine Street
Gloucester GL1 2BX — Tel: 01452 422810

GRAVESEND
Greenwood, Mrs S
8 Sutherland Close
Chalk, Gravesend
Kent DA12 4XJ
e-mail: chalkbandb1@activemail.co.uk — Tel: 01474 350819

HULL
The Arches Guesthouse
38 Saner Street
Hull HU3 2TR — Tel: 01482 211558

INVERNESS
Blair, Mrs
McDonald House Hotel
1 Ardross Terrace
Inverness IV3 5NQ — Tel: 01463 232878

INVERNESS cont'd
Kerr-Smith, Jennifer
Ardkeen Tower
5 Culduthel Road
Inverness IV2 4AD — Tel: 01463 233131

IPSWICH
Ball, Bunty
56 Henley Road
Ipswich IP1 3SA — Tel: 01473 256653

Bennett, Liz
Gayfers, Playford
Ipswich IP6 9DR — Tel: 01473 623343

Hyde-Johnson, Anne
64 Benton Street
Hadleigh, Ipswich
Suffolk IP7 5AT — Tel: 01473 823110

ISLE OF WIGHT
Ogston, Sue
Windward House
69 Mill Hill Road, Cowes
Isle of Wight PO31 7EQ — Tel: 01983 280940

KESWICK
Bell, Miss A
Flat 4, Skiddaw View
Penrith Road
Keswick CA12 5HF — Mobile: 07740 949250

KIRKCALDY
Nicol, Mrs
44 Glebe Park, Kirkcaldy
Fife KY1 1BL — Tel: 01592 264531

LEEDS
Baker, Mrs M
2 Ridge Mount (off Cliff Road)
Leeds LS6 2HD — Tel: 0113-275 8735

LINCOLN
Carnell, Andrew
Tennyson Court Cottages
3 Tennyson Street
Lincoln LN1 1LZ
Website: www.tennyson-court.co.uk
Tel: 01522 569892 — Tel: 0800 9805408

Sharpe, Mavis S
Bight House, 17 East Bight
Lincoln LN2 1QH — Tel: 01522 534477

Ye Olde Crowne Inn (Theatre Pub)
Clasketgate
Lincoln LN2 1JS — Tel: 01522 542896

LIVERPOOL
De Leng, Ms S
7 Beach Lawn, Waterloo
Liverpool L22 8QA — Tel: 0151-476 1563

Double, Ross
5 Percy Street
Liverpool L8 7LT — Tel: 0151-708 8821

Maloney, Anne
16 Sandown Lane
Wavertree
Liverpool L15 8HY — Tel: 0151-734 4839

LLANDUDNO
Bell, Alan
Quinton Hotel
36 Church Walks
Llandudno LL30 2HN — Tel: 01492 876879

LONDON
Allen, Mrs I
Flat 2, 9 Dorset Square
London NW1 6QB — Tel: 020-7723 3979

Broughton, Mrs P A
31 Ringstead Road
Catford
London SE6 2BU — Tel: 020-8461 0146

Cardinal, Maggie
17A Gaisford Street
London NW5 2EB — Tel: 020-7681 7376

Maya, Ms Y
7 Cornwall Road
Edmonton N18 2QN — Mobile: 07958 461468

Mesure, Nicholas
16 St Alfege Passage
Greenwich
London SE10 9JS — Tel: 020-8853 4337

Montagu, Beverley
13 Hanley Road
London N4 3DU — Tel: 020-7263 3883

Rothner, Dora
23 The Ridgeway
Finchley
London N3 2PG — Tel: 020-8346 0246

Rothner, Stephanie
44 Grove Road
North Finchley
London N12 9DY
Mobile: 07956 406446 — Tel: 020-8446 1604

Shaw, Lindy
11 Baronsmede, Acton
London W5 4LS — Tel: 020-8567 0877

Walsh, Genevieve
37 Kelvedon House
Guildford Road, Stockwell
London SW8 2DN — Tel: 020-7627 0024

Warren, Mrs Sally
28 Prebend Gardens
Chiswick
London W4 1TW — Tel: 020-8994 0560

MALVERN
Emuss, Mrs
Priory Holme
18 Avenue Road
Malvern WR14 3AR — Tel: 01684 568455

McLeod, Mr & Mrs
Sidney House
40 Worcester Road
Malvern WR14 4AA
Website: www.sidneyhouse.co.uk
e-mail: info@sidneyhouse.co.uk — Tel: 01684 574994

MANCHESTER
Dyson, Mrs Edwina
33 Danesmoor Road
West Didsbury
Manchester M20 3JT — **Tel: 0161-434 5410**

Heaton, Miriam
58 Tamworth Avenue
Whitefield
Manchester M45 6UA — Tel: 0161-773 4490

 Two 18th Century beamed cosy cottages with 2 bedrooms. All essential amenities and long cottage garden. Tranquil haven, yet bus and Metro only 2-5 mins away. Located in Whitefield. 5 miles from city. 10 mins by car. M60 Jn17 and 24-hr Tesco within 1/2 mile.

Terms: £140 per week, plus gas and electricity. Long term preferred but short term considered. **Contact Miss Patricia Jones on 0161-766 9243**

Jones, P M
375 Bury New Road, Whitefield
Manchester M45 7SU Tel: 0161-766 9243

Martin, David & Dolan, Jez
86 Stanley Road, Old Trafford
Manchester M16 9DH Tel: 0161-848 9231

Prichard, Fiona & John
45 Bamford Road, Didsbury
Manchester M20 2QP Tel: 0161-434 4877

Twist, Susan
45 Osborne Road
Levenshulme
Manchester M19 2DU Tel: 0161-225 1591

MARGATE
Ramsay, Grant
45 Goodwin Road
Cliftonville CT9 8HE Tel: 020-8767 6687

MILFORD HAVEN
Henricksen, Bruce & Diana
Belhaven House Hotel Ltd
29 Hamilton Terrace
Milford Haven SA73 3JJ
Website: www.west-wales-hotels.com
e-mail: bruce@westwaleshotels.com
Fax: 01646 690787 Tel: 01646 695983

NEWCASTLE UPON TYNE
Guy, Thomas
2 Pine Avenue, Fawdon
Newcastle upon Tyne NE3 2AJ
e-mail: thomas-guy@freeuk.com Tel: 0191-285 7057

Kalaugher, Mary
4 Tankerville Terrace, Jesmond
Newcastle upon Tyne NE2 3AH Tel: 0191-281 0475

Moffatt, Madaleine
9 Curtis Road
Fenham NE4 9BH Tel: 0191-272 5318

Stansfield, Mrs P
Rosebery Hotel
2 Rosebery Crescent, Jesmond
Newcastle upon Tyne NE2 1ET
Website: www.roseberyhotel.co.uk Tel: 0191-281 3363

NEWPORT
Price, Mrs Dinah
Great House, Isca Road
Old Village, Caerleon
Gwent NP18 1QG
Website: www.visitgreathouse.co.uk
e-mail: dinah.price@amserve.net Tel: 01633 420216

NORWICH
Busch, Julia
8 Chester Street
Norwich NR2 2AY
Mobile: 07920 133250 Tel: 01603 612833

Calver, Michael
14 Binyon Gardens
Taverham
Norwich NR8 6SS Tel: 01603 869260

Youd, Cherry
Whitegates, 181 Norwich Road
Wroxham NR12 8RZ Tel: 01603 781037

NOTTINGHAM
Davis, Barbara
3 Tattershall Drive
The Park, Nottingham NG7 1BX Tel: 0115-947 4179

Offord, Mrs
5 Tattershall Drive, The Park
Nottingham NG7 1BX Tel: 0115-947 6924

Santos, Mrs S
Eastwood Farm
Hagg Lane, Epperstone
Nottingham NG14 6AX Tel: 0115-966 3018

Walker, Christine
18A Cavendish Crescent North
The Park, Nottingham NG7 1BA Tel: 0115-947 2485

OXFORD
Petty, Susan
74 Corn Street
Witney, Oxford OX28 6BS Tel: 01993 703035

PLYMOUTH
Carson, Mr & Mrs
6 Beech Cottages
Parsonage Road
Newton Ferrers
Nr Plymouth PL8 1AX Tel: 01752 872124

Humphreys, John & Sandra
Lyttleton Guest House (Self-Catering)
4 Crescent Avenue
Plymouth PL1 3AN Tel: 01752 220176

Mead, Teresa
Ashgrove Hotel
218 Citadel Road
The Hoe, Plymouth PL1 3BB Tel: 01752 664046

Spencer, Hugh & Eloise
10 Grand Parade
Plymouth PL1 3DF
Mobile: 07966 412839 Tel: 01752 664066

POOLE
Burnett, Mrs
63 Orchard Avenue
Parkstone
Poole, Dorset BH14 8AH Tel: 01202 743877

Moore, Sarah
Harbour View
11 Harbour View Road
Poole BH14 0PD Tel: 01202 734763

POOLE Cont'd
Saunders, Mrs
1 Harbour Shallows
15 Whitecliff Road
Poole BH14 8DU — Tel: 01202 741637

READING
Estate Office
Mapledurham House and Watermill
Mapledurham Estate
Reading RG4 7TR — Tel: 0118-972 3350

SALISBURY
Brumfitt, Ms S
26 Victoria Road
Salisbury
Wilts SP1 3NG — Tel: 01722 334877

SHEFFIELD
Craig, J & Rosen, B
59 Nether Edge Road
Sheffield S7 1RW — Tel: 0114-258 1337

Gillespie, Carole
251 Western Road
Crookes, Sheffield S10 1LE — Mobile: 07791 484320

Slack, Penny
Rivelin Glen Quarry
Rivelin Valley Road
Sheffield S6 5SE
Website: www.quarryhouse.org.uk
e-mail: pennyslack@aol.com — Tel: 0114-234 0382

SOUTHSEA & PORTSMOUTH
Tyrell, Wendy
Douglas Cottage
27 Somerset Road
Southsea PO5 2NL — Tel: 023-9282 1453

STOKE-ON-TRENT
Griffiths, Dorothy
40 Princes Road
Hartshill, Stoke-on-Trent
Mobile: 07719 925345 — Tel: 01782 416198

Hindmoor, Mrs
Verdon Guest House, 44 Charles Street
Hanley, Stoke-on-Trent ST1 3JY — Tel: 01782 264244
Meredith, Mr K
Bank End Farm Cottage
Hammond Avenue, Brown Edge
Stoke-on-Trent, Staffs ST6 8QU — Tel: 01782 502160

STRATFORD-UPON-AVON
Caterham House Hotel, 58-59 Rother Street
Stratford-upon-Avon CV37 6LT — Tel: 01789 267309

TORQUAY
Horton, John & Kay
Chatsworth Holiday Apts
217 St Marychurch Road, Torquay TQ1 3JT
Website: www.chatsworthapartmentstorquay.co.uk
Tel/Fax: 01803 327147

WESTCLIFF
Hussey, Joy
42A Ceylon Road
Westcliff-on-Sea SS0 7HP — Mobile: 07946 413496

WOKING
Goodson, Pat
1A Horsell Moor
Woking GU21 4NH — Tel: 01483 760208

WOLVERHAMPTON
Bell, Julia
Treetops, The Hem
Shifnal, Shropshire TF11 9PS — Tel: 01952 460566

Nixon, Sonia
39 Stubbs Road, Pennfields
Wolverhampton WV3 7DJ — Tel: 01902 339744

Riggs, Peter A
'Bethesda', 56 Chapel Lane
Codsall, Nr Wolverhampton WV8 2EJ
Mobile: 07930 967809 — Tel: 01902 844068

WORTHING
Stewart, Mollie
School House, 11 Ambrose Place
Worthing BN11 1PZ — Tel: 01903 206823

Symonds, Val
23 Shakespeare Road
Worthing BN11 4AR — Tel: 01903 201557

YORK
Blacklock, Tom
155 Lowther Street
York YO3 7LZ — Tel: 01904 620487

Blower, Iris & Dennis
Dalescroft Guest House
10 Southlands Road, York YO23 1NP
Website: www.dalescroft-york.co.uk
e-mail: info@dalescroft-york.co.uk — Tel: 01904 626801

Harrand, Greg
Hedley House Hotel & Apts
3 Bootham Terrace
York YO3 7DH — Tel: 01904 637404

Please note that while The Spotlight takes every care in screening the companies featured in this section, it cannot be held responsible for services or treatments received.

ALEXANDER ALLIANCE
(Alexander Technique, Voice & Audition Coaching)
3 Hazelwood Drive, St Albans, Herts
Website: www.alextech.co.uk
e-mail: bev.keech@ntlworld.com Tel: 01727 843633

ALEXANDER CENTRE The Bloomsbury
(Alexander Technique)
Bristol House, 80A Southampton Row, London WC1B 4BB
Website: www.alexcentre.com
e-mail: bloomsbury.alexandercentre@btinternet.com
 Tel: 020-7404 5348

ALEXANDER TECHNIQUE
(Jackie Coote MSTAT)
27 Britannia Road, London SW6 2HJ
Website: www.alexandertec.co.uk
e-mail: jackiecoote@alexandertec.co.uk Tel: 020-7731 1061

ALEXANDER TECHNIQUE AND VOICE
(Robert Macdonald)
Flat 5, 17 Hatton Street, London NW8 8PL
Website: www.voice.org.uk Mobile: 07956 852303

ARTS CLINIC The
(Psychological Counselling, Personal & Professional Development)
14 Devonshire Place, London W1G 6HX
e-mail: mail@artsclinic.co.uk
Fax: 020-7224 6256 Tel: 020-7935 1242

ASPEY ASSOCIATES
(Management & Team Training, Executive Coaching, Human Resources)
90 Long Acre, Covent Garden, London WC2E 9RZ
Website: www.aspey.com
e-mail: hr@aspey.com Tel: 0845 1701300

BODYWISE
(Yoga and Complimentary Therapies)
119 Roman Road, London E2 0QN
Website: www.bodywisehealth.org
e-mail: info@bodywisehealth.org Tel: 020-8981 6938

BRITISH DOULAS
(Baby Care Services)
49 Harrington Gardens, London SW7 4JU
Website: www.britishdoulas.co.uk
e-mail: info@britishdoulas.co.uk
Fax: 020-7244 9035 Tel: 020-7244 6053

BURGESS Chris
(Counselling for Performing Artists)
81 Arne House, Tyers Street
London SE11 5EZ Tel: 020-7582 8229

COCKBURN Daisy
Alexander Technique Teacher (MSTAT)
Bloomsbury Alexander Centre, Bristol House
80A Southampton Row, London WC1B 4BB
e-mail: cockburn@dircon.co.uk Mobile: 07734 725445

CONSTRUCTIVE TEACHING CENTRE Ltd
(Alexander Technique Teacher Training)
18 Lansdowne Road, London W11 3LL
Website: www.alexandertek.com
e-mail: info@alexandertek.com Tel: 020-7727 7222

CORTEEN Paola MSTAT
(Alexander Technique)
10A Eversley Park Road, London N21 1JU
e-mail: pmcorteen@yahoo.co.uk Tel: 020-8882 7898

COURTENAY Julian
(NLP Hypnotherapy)
42 Langdon Park Road, London N6 5QG
e-mail: julian@mentalfitness.uk.com Tel: 020-8348 9033

[CONTACTS 2007]

CUSSONS Nicola Dip ITEC
(Holistic Massage Therapist, Qualified & Insured)
The Factory Fitness & Dance Centre
407 Hornsey Road, London N19 4DX
e-mail: info@tangolondon.com Tel: 020-7272 1122

DAWN ELIZABETH
(Hair, Beauty & Tanning)
Unit 3, Crown House
71 High Street, Wickham Market
Woodbridge, Suffolk IP13 ORA
Mobile: 07708 854282 Tel: 01728 746168

DREAM
(Massage, Reflexology & Yoga for Events in the Workplace
and Home)
117B Gaisford Street, London NW5 2EG
Website: www.dreamtherapies.co.uk
e-mail: heidi@dreamtherapies.co.uk Mobile: 07973 731026

EDWARDS Simon MCA Hyp
(Hypnotherapy for Professionals in Film, TV & Theatre)
15 Station Road, Quainton
Nr Aylesbury, Buckinghamshire HP22 4BW
e-mail: hypnotherapisttothestars@o2.co.uk
Mobile: 07889 333680 Tel: 01296 651259

FAITH Gordon BA DHC MCHC (UK)
(Hypnotherapy, Obstacles to Performing, Positive
Affirmation, Focusing)
1 Wavel Mews, Priory Road
London NW6 3AB Tel: 020-7328 0446

FITNESS COACH The
(Jamie Baird)
Agua at The Sanderson, 50 Berners Street, London W1T 3NG
e-mail: jamie@thefitnesscoach.com
Mobile: 07970 782476 Tel: 020-7300 1414

FOAD Gene Dip Hyp GHR Reg GQHP
(Life Coaching/Counselling. Performance
Enhancement and Hypnotherapy)
Kingston
e-mail: genefoad@hotmail.com
Mobile: 07813 259099 Tel: 020-8549 4691

HAMMOND John B. Ed (Hons) ICHFST
(Fitness Consultancy, Sports & Relaxation Massage)
4 Glencree, Billericay
Essex CM11 1EB
Mobile: 07703 185198 Tel/Fax: 01277 632830

HYPNOSIS WORKS
Tulip House
70 Borough High Street, London SE1 1XE
Website: www.hypnosisdoeswork.net
e-mail: sssp@hypnosisdoeswork.net Tel: 020-7237 5815

HYPNOTHERAPY & PSYCHOTHERAPY
(Including Performance Improvement,
Karen Mann DCH DHP)
9 Spencer House, Vale of Health
Hampstead, London NW3 1AS
Website: www.karenmann.co.uk Tel: 020-7794 5843

KI BALANCE
21 Warren Bank, Simpson
Milton Keynes, Bucks MK6 3AQ
Website: www.shiatsuhealth.com
e-mail: japaneseyoga@btinternet.com Mobile: 07905 504418

LIFE COACHING
(Including Career, Relationship, Self-Confidence Coaching)
Dr Elspeth Reid, 102 Clarence Road
Wimbledon SW19 8QD
Website: www.elspethreid.com
e-mail: coach@elspethreid.com Tel: 020-8879 7676

smile
design

@ Woodford House
Dental Practice

SMILE DESIGN

- ✳ **Tooth Whitening:** Look years younger with a brighter whiter smile
- ✳ **Smile Design**: Gaps and uneven/misshapen teeth can be corrected with beautiful veneers
- ✳ **Fresh Breath:** Confidence at close quarters
- ✳ **Dental Implants:** The natural tooth replacement

Creating Beautiful Smiles Uniquely Designed For You

www.improveyoursmile.co.uk

t: 020 8504 2704 f: 020 8252 0835

THE AESTHETIC DENTAL SPA @ WOODFORD HOUSE DENTAL PRACTICE

162 High Road, Woodford Green, Essex IG8 9EF

ThePsychologyGroup Ltd.

The British Psychological Society

Chartered Psychologist

- Psychotherapy & Counselling
- Life Coaching
- Occupational Assessments
- Expert Opinion
- Career Transition
- Stress Audits

Phone: 0870 609 2445 **Fax:** 0845 280 5243

Email: info@psychologygroup.co.uk

www.psychologygroup.co.uk

MAGIC KEY PARTNERSHIP The
(Lyn Burgess - Life Coach)
4 Bewley Street, London SW19 1XB
Website: www.magickey.co.uk
e-mail: lyn@magickey.co.uk Tel: 0845 1297401

MATRIX ENERGY FIELD THERAPY
121 Church Road
Wimbledon, London SW19 5AH
e-mail: donnie@lovingorganization.org
Mobile: 07762 821828 Tel: 020-8946 8534

McCALLION Anna
(Alexander Technique)
Flat 2
11 Sinclair Gardens
London W14 0AU
e-mail: hildagarde007@yahoo.com Tel: 020-7602 5599

MINDSCI CLINIC
(Clinical Hypnotism)
34 Willow Bank, Ham
Richmond, Surrey TW10 7QX
Website: www.mindsci-clinic.com
e-mail: bt@mindsci-clinic.com Tel/Fax: 020-8948 2439

MONSHIN Deborah J.
(Healing with Hypnosis, Holistic Healing)
Grumbleknot, Yealmpton, Devon PL8 2NS
Website: www.devonhypnosis.co.uk
e-mail: debsmonshin@yahoo.co.uk Tel: 01752 880880

NORTON Michael R
(Implant/Reconstructive Dentistry)
98 Harley Street, London W1G 7HZ
Website: www.nortonimplants.com
e-mail: linda@nortonimplants.com
Fax: 020-7486 9119 Tel: 020-7486 9229

OGUNLARU Rasheed
(Life & Business Coach)
The Coaching Studio
223A Mayall Road, London SE24 0PS
Website: www.rasaru.com
e-mail: rasaru_coaching@yahoo.com Tel: 020-7207 1082

PEAK PERFORMANCE TRAINING
(Tina Reibl, Hypnotherapy, NLP, Success Strategies)
42 The Broadway
Maidenhead, Berkshire SL6 1LU
e-mail: tina.reibl@tesco.net Tel: 01628 633509

POLAND DENTAL STUDIOS
(Film/Stage Dentistry)
1 Devonshire Place, London W1G 6HH
Fax: 020-7486 3952 Tel: 020-7935 6919

PRYCE Jacqui-Lee OCR ABA BAWLA GKFO
(Personal Training & Group Sessions, Boxing, Kick/Muay Thai Boxing)
e-mail: getfitquick@hotmail.com Mobile: 07930 304809

SELFSIGHT
(Counselling & EMDR)
111 Rainville Road, London W6 9HJ
Website: www.selfsight.com
e-mail: rf@selfsight.com
Mobile: 07961 152740 Tel: 020-7381 0202

SEYRI Kayvan BSc, NSCA-CPT*D
(Personal Training & Nutrition Advice)
Cannons, Sidmouth Road
Brondesbury Park, London NW2 1EU
Website: www.ultimatefitpro.com
e-mail: info@ultimatefitpro.com
Mobile: 07941 161431 Mobile: 07881 554636

SHER SYSTEM The
(Helping Skin with Acne & Rosacea)
30 New Bond Street, London W1S 2RN
Website: www.sher.co.uk
e-mail: skincare@sher.co.uk
Fax: 020-7629 7021 Tel: 020-7499 4022

SMILE SOLUTIONS
(Dental Practice)
24 Englands Lane, London NW3 4TG
Website: www.smile-solutions.info
e-mail: enquiries@smile-solutions.info
Fax: 020-7449 1769 Tel: 020-7449 1760

STAT (The Society of Teachers of the Alexander Technique)
1st Floor Linton House
39-51 Highgate Road, London NW5 1RS
Website: www.stat.org.uk
e-mail: enquiries@stat.org.uk
Fax: 020-7482 5435 Tel: 0845 2307828

THEATRICAL DENTISTRY
(Richard D Casson)
6 Milford House
7 Queen Anne Street, London W1G 9HN
Website: www.richardcasson.com
e-mail: smile@richardcasson.com
Tel/Fax: 020-7935 6511 Tel/Fax: 020-7935 8854

TURNER Jeff
(Psychotherapy, Counselling & Performance Coaching)
Life Management Systems
14 Randell's Road, London N1 0DH
Website: www.lifemanagement.co.uk
e-mail: info@lifemanagement.co.uk Tel: 020-7837 9871

VITAL TOUCH The
(On-Site Massage Company)
11 Evering Road, London N16 7PX
Website: www.thevitaltouch.com
e-mail: suzi@thevitaltouch.com
Mobile: 07976 263691 Tel: 020-7249 4209

WELLBEING
(Leigh Jones) (Personal Training, Yoga, Tai Chi)
86 Beaufort Street
London SW3 6BU
e-mail: williamleighjones@hotmail.com Mobile: 07957 333921

WOODFORD HOUSE DENTAL PRACTICE
162 High Road, Woodford Green, Essex IG8 9EF
Website: www.improveyoursmile.co.uk
e-mail: mmalik-whdp@yahoo.co.uk
Fax: 020-8252 0835 Tel: 020-8504 2704

smile @richardcasson.com

cosmetic fillings, orthodontics, bleaching, veneers
crowns and bridges, implants, hygienist

Dr. Richard Casson, Dental Care
For further information phone 020 7935 6511 or 020 7935 8854
Flat 6, Milford House, 7 Queen Anne Street, London W1G 9HN
Website: www.richardcasson.com

smilestudio
teethwhitening
100% performance at 70% of the cost

ACT NOW

Spotlight members are entitled to
a 30% discount on all usual prices
of our teeth whitening treatments
at Shaftesbury Avenue. We also
offer anti-wrinkle treatments and
same day teeth veneers. Act now!
Contact **smile**studio today for a
free consultation.
Call us now! **020 7439 0888**
www.smilestudiolondon.co.uk

O

Opera Companies
Organisations

ARTSWORLD PRESENTATIONS Ltd
Vicarage House
58-60 Kensington Church Street
London W8 4DB
Website: www.arts-world.co.uk
e-mail: p@triciamurraybett.com
Fax: 020-7368 3338 Tel: 020-7368 3337

CARL ROSA OPERA
359 Hackney Road
London E2 8PR
e-mail: mail@carlrosaopera.co.uk
Fax: 020-7613 0859 Tel: 020-7613 0777

DUAL CONTROL THEATRE COMPANY
The Admiral's Offices
The Historic Dockyard
Chatham, Kent ME4 4TZ
Website: www.ellenkent.com
e-mail: info@ellenkentinternational.co.uk
Fax: 01634 819149 Tel: 01634 819141

ENGLISH NATIONAL OPERA
London Coliseum
St Martin's Lane, London WC2N 4ES
Website: www.eno.org
Fax: 020-7845 9277 Tel: 020-7836 0111

ENGLISH TOURING OPERA
(James Conway)
1st Floor
52-54 Rosebery Avenue
London EC1R 4RP
Website: www.englishtouringopera.org.uk
e-mail: admin@englishtouringopera.org.uk
Fax: 020-7713 8686 Tel: 020-7833 2555

GLYNDEBOURNE FESTIVAL OPERA
Glyndebourne, Lewes
East Sussex BN8 5UU Tel: 01273 812321

GRANGE PARK OPERA
The Coach House
12 St Thomas Street
Winchester SO23 9HF
Website: www.grangeparkopera.co.uk
e-mail: info@grangeparkopera.co.uk
Fax: 01962 868968 Tel: 01962 868600

GUBBAY Raymond Ltd
Dickens House
15 Tooks Court
London EC4A 1QH
Website: www.raymondgubbay.co.uk
e-mail: mail@raymondgubbay.co.uk
Fax: 020-7025 3751 Tel: 020-7025 3750

KENTISH OPERA
Watermede
Wickhurst Road
Sevenoaks
Weald, Kent TN14 6LX
Website: www.kentishopera.fsnet.co.uk Tel: 01732 463284

LONDON OPERA PLAYERS
32 Trinity Court
170A Gloucester Terrace
London W2 6HN
Website: www.operaplayers.co.uk
e-mail: info@operaplayers.co.uk
Fax: 0700 5802121 Mobile: 07779 225921

[CONTACTS 2007]

MUSIC THEATRE LONDON
Chertsey Chambers
12 Mercer Street
London WC2H 9QD
Website: www.mtl.org.uk
e-mail: musictheatre.london@virgin.net
Fax: 020-7240 0805 Tel: 020-7240 0919

OPERA DELLA LUNA
7 Cotmore House
Fringford, Bicester
Oxfordshire OX27 8RQ
Website: www.operadellaluna.org
e-mail: operadellaluna@aol.com
Fax: 01869 323533 Tel: 01869 325131

OPERA NORTH
Grand Theatre
46 New Briggate, Leeds LS1 6NU
Website: www.operanorth.co.uk
Fax: 0113-244 0418 Tel: 0113-243 9999

OPUS 1 MUSIC Ltd
Waverley House
Waverley Road
Huddersfield
West Yorkshire HD1 5NA
Website: www.opus1music.co.uk
e-mail: info@opus1music.co.uk
Fax: 01484 432030 Tel: 01484 422030

PEGASUS OPERA COMPANY Ltd
The Brix
St Matthew's
Brixton Hill, London SW2 1JF
Website: www.pegopera.org Tel/Fax: 020-7501 9501

PIMLICO OPERA
The Coach House
12 St Thomas Street
Winchester SO23 9HF
Website: www.grangeparkopera.co.uk
e-mail: pimlico@grangeparkopera.co.uk
Fax: 01962 868968 Tel: 01962 868600

ROYAL OPERA The
Royal Opera House
Covent Garden, London WC2E 9DD
Website: www.roh.org.uk Tel: 020-7240 1200

SCOTTISH OPERA
39 Elmbank Crescent
Glasgow G2 4PT
Website: www.scottishopera.org.uk Tel: 0141-248 4567

WELSH NATIONAL OPERA
Wales Millennium Centre
Bute Place, Cardiff CF10 5AL
Website: www.wno.org.uk
e-mail: marketing@wno.org.uk
Fax: 029-2063 5099 Tel: 029-2063 5000

ACTING POSITIVE
22 Chaldon Road, London SW6 7NJ
e-mail: ianflintoff@aol.com Tel: 020-7385 3800

ACTORS' ADVISORY SERVICE
29 Talbot Road, Twickenham
Middlesex TW2 6SJ Tel: 020-8287 2839

ACTORS' BENEVOLENT FUND
6 Adam Street, London WC2N 6AD
Website: www.actorsbenevolentfund.co.uk
e-mail: office@abf.org.uk
Fax: 020-7836 8978 Tel: 020-7836 6378

ACTORS CENTRE The (LONDON)
1A Tower Street, London WC2H 9NP
Website: www.actorscentre.co.uk
e-mail: admin@actorscentre.co.uk
Fax: 020-7240 3896 Tel: 020-7240 3940

ACTORS CENTRE The (MIDLANDS)
Alan Geale House, University of Birmingham
Selly Oak Campus, Bristol Rd South, Birmingham B29 6LL
Website: www.actorscentremidlands.co.uk
e-mail: info@theactorscentremidlands.co.uk
 Tel: 0121-472 2100

ACTORS CENTRE The (NORTH-EAST)
2nd Floor, 1 Black Swan Court
Westgate Road, Newcastle upon Tyne NE1 1SG
Website: www.actorscentrene.co.uk
e-mail: allan@actorscentrene.co.uk Tel: 0191-221 0158

ACTORS CENTRE (NORTHERN)
(See NORTHERN ACTORS CENTRE)

ACTORS' CHARITABLE TRUST
Africa House, 64-78 Kingsway, London WC2B 6BD
e-mail: robert@tactactors.org
Fax: 020-7242 0234 Tel: 020-7242 0111

ACTORS' CHURCH UNION
St Paul's Church, Bedford Street, London WC2E 9ED
e-mail: actors-church.union@tiscali.co.uk
 Tel: 020-7240 0344

ADVERTISING ASSOCIATION
7th Floor North, Artillery House
11-19 Artillery Row, London SW1P 7RT
Website: www.adassoc.org.uk
e-mail: aa@adassoc.org.uk
Fax: 020-7222 1504 Tel: 020-7340 1100

AFTRA
(American Federation of Television & Radio Artists)
260 Madison Avenue, New York NY 10016
Website: www.aftra.org
Fax: (212) 545-1238 Tel: (212) 532-0800

5757 Wilshire Boulevard, 9th Floor, Los Angeles CA 90036
Fax: (323) 634-8246 Tel: (323) 634-8100

AGENTS' ASSOCIATION (Great Britain)
54 Keyes House, Dolphin Square, London SW1V 3NA
Website: www.agents-uk.com
e-mail: association@agents-uk.com
Fax: 020-7821 0261 Tel: 020-7834 0515

ARTS & BUSINESS
Nutmeg House, 60 Gainsford Street
Butlers Wharf, London SE1 2NY
Website: www.aandb.org.uk
e-mail: head.office@aandb.org.uk
Fax: 020-7407 7527 Tel: 020-7378 8143

ARTS & ENTERTAINMENT TECHNICAL
TRAINING INITIATIVE (AETTI)
261 Baker Street, Derby DE24 8SG
Website: www.aetti.org.uk
e-mail: aetti@sumack.freeserve.co.uk Tel: 01332 751740

ARTS CENTRE GROUP The
Menier Chocolate Factory
51 Southwark Street, London SE1 1RU
Website: www.artscentregroup.org.uk
e-mail: info@artscentregroup.org.uk Tel: 0845 4581881

ARTS COUNCIL ENGLAND
14 Great Peter Street, London SW1P 3NQ
Website: www.artscouncil.org.uk
e-mail: enquiries@artscouncil.org.uk
Fax: 020-7973 6590 Tel: 0845 300 6200

ARTS COUNCIL NORTHERN IRELAND
MacNeice House, 77 Malone Road, Belfast BT9 6AQ
Website: www.artscouncil-ni.org
Fax: 028-9066 1715 Tel: 028-9038 5200

ARTS COUNCIL OF WALES The
9 Museum Place, Cardiff CF10 3NX
Website: www.artswales.org.uk
e-mail: info@artswales.org.uk
Fax: 029-2022 1447 Tel: 029-2037 6500

ARTSLINE
(Disability Access Information Service)
54 Chalton Street, London NW1 1HS
Website: www.artslineonline.com
e-mail: admin@artsline.org.uk
Fax: 020-7383 2653 Tel: 020-7388 2227

ASSITEJ UK
(UK Centre of the International Association of Theatre for
Children and Young People)
c/o Kevin Lewis, Secretary, Theatre Iolo
The Old School Building,
Cefn Road, Mynachdy, Cardiff CF14 3HS
Website: www.assitejuk.org
e-mail: admin@theatriolo.com Tel: 029-2061 3782

ASSOCIATION OF BRITISH THEATRE TECHNICIANS
4th Floor, 55 Farringdon Road, London EC1M 3JB
Website: www.abtt.org.uk e-mail: office@abtt.org.uk
Fax: 020-7242 9303 Tel: 020-7242 9200

ASSOCIATION OF LIGHTING DESIGNERS
PO Box 680, Oxford OX1 9DG
Website: www.ald.org.uk
e-mail: office@ald.org.uk Mobile: 07817 060189

ASSOCIATION OF MODEL AGENTS
122 Brompton Road, London SW3 1JE
e-mail: amainfo@btinternet.com
Info. Line: 09068 517644 Tel: 020-7584 6466

BATTERSEA WRITERS' GROUP
(Founder & Chairman: Jason Young)
Website: www.thebatterseawritersgroup.blogspot.com
e-mail: jasonyoung72@yahoo.com Mobile: 07970 715080

BECTU
(See BROADCASTING ENTERTAINMENT CINEMATOGRAPH &
THEATRE UNION)

BRITISH ACADEMY OF COMPOSERS & SONGWRITERS The
2nd Flr, British Music Hse, 26 Berners St, London W1T 3LR
Website: www.britishacademy.com
e-mail: info@britishacademy.com
Fax: 020-7636 2212 Tel: 020-7636 2929

BRITISH ACADEMY OF FILM & TELEVISION ARTS The
195 Piccadilly, London W1J 9LN
Website: www.bafta.org
e-mail: membership@bafta.org
Fax: 020-7292 5868 Tel: 020-7734 0022

BRITISH ACADEMY OF FILM & TELEVISION ARTS/
LOS ANGELES The
8533 Melrose Avenue, Suite D, West Hollywood, CA 90069
e-mail: info@baftala.org
Fax: (310) 854-6002 Tel: (310) 652-4121

The Actors Centre is the UK's premier resource for actors, providing them with further development of the highest quality and the opportunity to improve every aspect of their craft.

the actors centre

We enable the pursuit of excellence by promoting high artistic standards across the profession and initiating innovative work.

A friendly meeting place at the heart of the profession where actors can share information and exchange ideas.

Patron: Julie Walters
Artistic Director: Matthew Lloyd

Workshops and Classes

Audition Technique
TV and Film
Dialect
Musical Theatre
Sightreading
Singing
Radio
Voice
Shakespeare
Directing
Writing
Alexander Technique
Stage Combat
Physical Theatre
Dance
Career Advice
Casting Sessions
Financial Advice

Tristan Bates Theatre

Studio theatre space with a vibrant and varied programme of new and developing work. To discuss hire contact:
act@actorscentre.co.uk

Green Room Bar and Cafe

Relaxed and friendly atmosphere, drinks and snacks, internet access. Available for special events, contact:
greenroom@actorscentre.co.uk

Studio Hire

Range of studios for hire for casting sessions, auditions and meetings. To book, contact:
roomhire@actorscentre.co.uk

Want to join?

For further information about joining the Actors Centre please contact:
members@actorscentre.co.uk

**The Actors Centre, 1a Tower Street, London, WC2H 9NP
Tel 020 7240 3940 Fax 020 7240 3896 www.actorscentre.co.uk**

BRITISH ACADEMY OF STAGE & SCREEN COMBAT
Suite 280, 14 Tottenham Court Road, London W1T 1JY
Website: www.bassc.org
e-mail: info@bassc.org Tel: 07981 806265

BRITISH ASSOCIATION FOR PERFORMING ARTS MEDICINE
4th Floor, Totara Park House
34-36 Gray's Inn Road, London WC1X 8HR
Website: www.bapam.org.uk
e-mail: clinic@bapam.org.uk Tel: 020-7404 5888

BRITISH ASSOCIATION OF DRAMA THERAPISTS The
41 Broomhouse Lane, London SW6 3DP
Website: www.badth.co.uk
e-mail: gillian@badth.demon.co.uk Tel/Fax: 020-7731 0160

BRITISH BOARD OF FILM CLASSIFICATION
3 Soho Square, London W1D 3HD
Website: www.bbfc.co.uk
Fax: 020-7287 0141 Tel: 020-7440 1570

BRITISH COUNCIL The
(Performing Arts Department)
10 Spring Gardens, London SW1A 2BN
Website: www.britishcouncil.org/arts
e-mail: theatredance@britishcouncil.org Tel: 020-7389 3010

BRITISH EQUITY COLLECTING SOCIETY
66 Great Russell Street, London WC1B 3BN
Website: www.equitycollecting.org.uk
e-mail: info@equitycollecting.org.uk
Fax: 020-7831 1171 Tel: 020-7242 8082

BRITISH FILM INSTITUTE
21 Stephen Street, London W1T 1LN
Website: www.bfi.org.uk
e-mail: library@bfi.org.uk
Fax: 020-7436 2338 Tel: 020-7255 1444

BRITISH LIBRARY SOUND ARCHIVE
96 Euston Road, London NW1 2DB
Website: www.bl.uk/soundarchive
e-mail: sound-archive@bl.uk
Fax: 020-7412 7441 Tel: 020-7412 7676

BRITISH MUSIC HALL SOCIETY
(Secretary: Daphne Masterton)
Meander, 361 Watford Road
Chiswell Green, St Albans
Herts AL2 3DB Tel: 01727 768878

BROADCASTING ENTERTAINMENT CINEMATOGRAPH & THEATRE UNION (BECTU) (Formerly BETA & ACTT)
375-377 Clapham Road, London SW9 9BT
e-mail: smacdonald@bectu.org.uk
Fax: 020-7346 0901 Tel: 020-7346 0900

CASTING DIRECTORS' GUILD
PO Box 34403, London W6 0YG
Website: www.thecdg.co.uk Tel/Fax: 020-8741 1951

CATHOLIC STAGE GUILD
(Write SAE)
Ms Molly Steele (Hon Secretary)
1 Maiden Lane, London WC2E 7NB
e-mail: mary40steele@btinternet.com Tel: 020-7240 1221

CELEBRITY SERVICE Ltd
4th Floor, Kingsland House, 122-124 Regent Street W1B 5SA
e-mail: celebritylondon@aol.com
Fax: 020-7494 3500 Tel: 020-7439 9840

CHILDREN'S FILM & TELEVISION FOUNDATION Ltd
e-mail: annahome@cftf.org.uk Mobile: 07887 573479

CHRISTIANS IN ENTERTAINMENT
(Charity)
PO Box 51, Teignmouth, Devon TQ14 8WX
Website: www.cieweb.org.uk
e-mail: chris@cieweb.org.uk Tel: 01737 550375

CIDA (CREATIVE INDUSTRIES DEVELOPMENT AGENCY)
(Professional Development & Business Support for Artists & Creative Businesses)
Media Centre, Northumberland Street
Huddersfield, West Yorkshire HD1 1RL
Website: www.cida.org
e-mail: info@cida.org
Fax: 01484 483150 Tel: 01484 483140

CINEMA & TELEVISION BENEVOLENT FUND (CTBF)
22 Golden Square, London W1F 9AD
Website: www.ctbf.co.uk
e-mail: charity@ctbf.co.uk
Fax: 020-7437 7186 Tel: 020-7437 6567

CINEMA EXHIBITORS' ASSOCIATION
22 Golden Square, London W1F 9JW
e-mail: cea@cinemauk.ftech.co.uk
Fax: 020-7734 6147 Tel: 020-7734 9551

CLUB FOR ACTS & ACTORS
(Incorporating Concert Artistes Association)
20 Bedford Street, London WC2E 9HP
Website: www.thecaa.org
e-mail: office@thecaa.org
Office: 020-7836 3172 Members: 020-7836 2884

COI COMMUNICATIONS
(Television)
Hercules House, Hercules Road, London SE1 7DU
e-mail: eileen.newton@coi.gsi.gov.uk
Fax: 020-7261 8776 Tel: 020-7261 8220

COMPANY OF CRANKS
1st Floor, 62 Northfield House
Frensham Street, London SE15 6TN
e-mail: mimetic16@yahoo.com Mobile: 07963 617981

CONCERT ARTISTES ASSOCIATION
(See CLUB FOR ACTS & ACTORS)

CONFERENCE OF DRAMA SCHOOLS
(Saul Hyman, Executive Secretary)
PO Box 34252, London NW5 1XJ
Website: www.drama.ac.uk
e-mail: info@cds.drama.ac.uk

COUNCIL FOR DANCE EDUCATION & TRAINING (CDET) The
Old Brewer's Yard
17-19 Neal Street, London WC2H 9UY
Website: www.cdet.org.uk
e-mail: info@cdet.org.uk
Fax: 020-7240 2547 Tel: 020-7240 5703

CPMA
(Co-operative Personal Management Association)
The Secretary, c/o 1 Mellor Road, Leicester LE3 6HN
Website: www.cpma.co.uk
e-mail: cpmauk@yahoo.co.uk Mobile: 07981 902525

CRITICS' CIRCLE The
c/o 69 Marylebone Lane, London W1U 2PH
Website: www.criticscircle.org.uk Tel: 020-7224 1410

DANCE UK
(Including the Healthier Dancer Programme & 'The UK Choreographers' Directory')
Website: www.danceuk.org
e-mail: info@danceuk.org
Fax: 020-7223 0074 Tel: 020-7228 4990

DENVILLE HALL
(Nursing Home)
62 Ducks Hill Road, Northwood, Middlesex HA6 2SB
Website: www.denvillehall.org
e-mail: denvillehall@yahoo.com
Fax: 01923 841855
Residents: 01923 820805 Office: 01923 825843

DEVOTEES of HAMMER FILMS PRESERVATION SOCIETY The
(Fan Club)
14 Kingsdale Road, Plumstead
London SE18 2DG Tel: 020-8854 7383

DIRECTORS' & PRODUCERS' RIGHTS SOCIETY
20-22 Bedford Row, London WC1R 4EB
Website: www.dprs.org
e-mail: info@dprs.org
Fax: 020-7269 0676 Tel: 020-7269 0677

DIRECTORS GUILD OF GREAT BRITAIN
Top Floor, Julian House
4 Windmill Street, London W1T 2HZ
Website: www.dggb.org
e-mail: guild@dggb.org
Fax: 020-7580 9132 Tel: 020-7580 9131

DON CAPO ENTERTAINMENT PRODUCTIONS
Suite B, 5 South Bank Terrace, Surbiton, Surrey KT6 6DG
Website: www.doncapo.com
e-mail: info@doncapo.com
Mobile: 07884 056405 Tel/Fax: 020-8390 8535

D'OYLY CARTE OPERA COMPANY
The Powerhouse, 6 Sancroft Street, London SE11 5UD
Website: www.doylycarte.org.uk
e-mail: ian@doylycarte.org.uk
Fax: 020-7793 7300 Tel: 020-7793 7100

DRAMA ASSOCIATION OF WALES
(Specialist Drama Lending Library)
The Old Library, Singleton Road
Splott, Cardiff CF24 2ET
e-mail: aled.daw@virgin.net
Fax: 029-2045 2277 Tel: 029-2045 2200

DRAMATURGS' NETWORK
(Network of Professional Dramaturgs)
10 Glengarry Road
East Dulwich, London SE22 8PZ
Website: www.dramaturgy.co.uk
e-mail: info@dramaturgy.co.uk Mobile: 07939 270566

ENGLISH FOLK DANCE & SONG SOCIETY
Cecil Sharp House
2 Regent's Park Road
London NW1 7AY
Website: www.efdss.org
e-mail: info@efdss.org
Fax: 020-7284 0534 Tel: 020-7485 2206

EQUITY inc Variety Artistes' Federation
Guild House
Upper St Martin's Lane, London WC2H 9EG
Website: www.equity.org.uk
e-mail: info@equity.org.uk
Fax: 020-7379 7001 Tel: 020-7379 6000

(North West)
Conavon Court
12 Blackfriars Street, Salford M3 5BQ
e-mail: info@manchester-equity.org.uk
Fax: 0161-839 3133 Tel: 0161-832 3183

(Scotland & Northern Ireland)
114 Union Street, Glasgow G1 3QQ
e-mail: igilchrist@glasgow.equity.org.uk
Fax: 0141-248 2473 Tel: 0141-248 2472

(Wales & South West)
Transport House
1 Cathedral Road, Cardiff CF11 9SD
e-mail: info@cardiff-equity.org.uk
Fax: 029-2023 0754 Tel: 029-2039 7971

ETF (Equity Trust Fund)
Suite 222, Africa House
64 Kingsway, London WC2B 6BD
Fax: 020-7831 4953 Tel: 020-7404 6041

FAA
(See FILM ARTISTS ASSOCIATION)

FILM ARTISTS ASSOCIATION
(Amalgamated with BECTU)
373-377 Clapham Road, London SW9
Fax: 020-7346 0925 Tel: 020-7346 0900

FILM LONDON
Suite 6.10, The Tea Building
56 Shoreditch High Street, London E1 6JJ
Website: www.filmlondon.org.uk
e-mail: info@filmlondon.org.uk
Fax: 020-7613 7677 Tel: 020-7613 7676

GLASGOW FILM FINANCE
(Production Finance for Feature Films)
City Chambers, Glasgow G2 1DU
Fax: 0141-287 0311 Tel: 0141-287 0424

GRAND ORDER OF WATER RATS
328 Gray's Inn Road, London WC1X 8BZ
Website: www.gowr.net
e-mail: water.rats@virgin.net
Fax: 020-7278 1765 Tel: 020-7278 3248

GROUP LINE
(Group Bookings for London Theatre)
22-24 Torrington Place, London WC1E 7HJ
Website: www.groupline.com
e-mail: tix@groupline.com
Fax: 020-7436 6287 Tel: 020-7580 6793

INDEPENDENT THEATRE COUNCIL (ITC)
12 The Leathermarket, Weston Street, London SE1 3ER
Website: www.itc-arts.org
e-mail: admin@itc-arts.org
Fax: 020-7403 1745 Tel: 020-7403 1727

INSIGHT ARTS
7-15 Greatorex Street, London E1 5NF
e-mail: info@insightarts.org
Fax: 020-7247 8077 Tel: 020-7247 0778

INTERNATIONAL FEDERATION OF ACTORS (FIA)
Guild House, Upper St Martin's Lane, London WC2H 9EG
Website: www.fia-actors.com
e-mail: office@fia-actors.com
Fax: 020-7379 8260 Tel: 020-7379 0900

IRISH EQUITY GROUP (SIPTU)
9th Floor, Liberty Hall, Dublin 1, Eire
Website: www.irishequity.ie
e-mail: equity@siptu.ie
Fax: 00 353 1 8743691 Tel: 00 353 1 8586403

IRVING SOCIETY The
(Michael Kilgarriff, Hon. Secretary)
10 Kings Avenue, London W5 2SH
e-mail: secretary@theirvingsociety.org.uk
 Tel: 020-8566 8301

ITC
(See INDEPENDENT THEATRE COUNCIL)

ITV Plc
200 Gray's Inn Road, London WC1X 8HF
Website: www.itv.com
Fax: 020-7843 8158 Tel: 020-7843 8000

LONDON SCHOOL OF CAPOEIRA The
Units 1 & 2 Leeds Place, Tollington Park, London N4 3RF
Website: www.londonschoolofcapoeira.co.uk
e-mail: info@londonschoolofcapoeira.co.uk
 Tel: 020-7281 2020

LONDON SHAKESPEARE WORKOUT
PO Box 31855
London SE17 3XP
Website: www.londonshakespeare.org.uk
e-mail: londonswo@hotmail.com Tel/Fax: 020-7793 9755

MANDER & MITCHENSON THEATRE COLLECTION
Jerwood Library of the Performing Arts
King Charles Building
Old Royal Naval College
Greenwich, London SE10 9JF
e-mail: rmangan@tcm.ac.uk
Fax: 020-8305 9426 Tel: 020-8305 4426

MUSICIANS' UNION
60-64 Clapham Road
London SW9 0JJ
Website: www.musiciansunion.org.uk
Fax: 020-7582 9805 Tel: 020-7582 5566

NATIONAL ASSOCIATION OF SUPPORTING ARTISTES AGENTS
(NASAA)
Website: www.nasaa.org.uk
e-mail: info@nasaa.org.uk

NATIONAL ASSOCIATION OF YOUTH THEATRES (NAYT)
Arts Centre, Vane Terrace
Darlington, County Durham DL3 7AX
Website: www.nayt.org.uk
e-mail: nayt@btconnect.com
Fax: 01325 363313 Tel: 01325 363330

NATIONAL CAMPAIGN FOR THE ARTS
1 Kingly Street
London W1B 5PA
Website: www.artscampaign.org.uk
e-mail: nca@artscampaign.org.uk
Fax: 020-7287 4777 Tel: 020-7287 3777

NATIONAL COUNCIL FOR DRAMA TRAINING
1-7 Woburn Walk
Bloomsbury, London WC1H 0JJ
Website: www.ncdt.co.uk
e-mail: info@ncdt.co.uk
Fax: 020-7387 3860 Tel: 020-7387 3650

NATIONAL ENTERTAINMENT AGENTS COUNCIL
PO Box 112, Seaford
East Sussex BN25 2DQ
Website: www.neac.org.uk
e-mail: chrisbray@neac.org.uk
Fax: 0870 7557613 Tel: 0870 7557612

NATIONAL FILM THEATRE
South Bank, London SE1 8XT
Website: www.bfi.org.uk Tel: 020-7928 3535

NATIONAL RESOURCE CENTRE FOR DANCE
University of Surrey
Guildford, Surrey GU2 7XH
Website: www.surrey.ac.uk/nrcd
e-mail: nrcd@surrey.ac.uk Tel: 01483 689316

NEW PRODUCERS ALLIANCE
Unit 1.07, The Tea Building
56 Shoreditch High Street, London E1 6JJ
Website: www.npa.org.uk
e-mail: queries@npa.org.uk
Fax: 020-7729 1852 Tel: 020-7613 0440

NODA (National Operatic & Dramatic Association)
Noda House
58-60 Lincoln Road
Peterborough PE1 2RZ
Website: www.noda.org.uk
e-mail: everyone@noda.org.uk
Fax: 0870 7702490 Tel: 0870 7702480

NORTH AMERICAN ACTORS ASSOCIATION
(Phone or e-mail only)
1 De Vere Cottages, Canning Place, London W8 5AA
Website: www.naaa.org.uk
e-mail: americanactors@aol.com Tel/Fax: 020-7938 4722

NORTH WEST PLAYWRIGHTS
18 Express Networks
1 George Leigh Street, Manchester M4 5DL
Website: www.newplaysnw.com
e-mail: newplaysnw@hotmail.com Tel/Fax: 0161-237 1978

NORTHERN ACTORS CENTRE
21-23 Oldham Street
Manchester M1 1JG
Website: www.northernactorscentre.co.uk
e-mail: info@northernactorscentre.co.uk
 Tel/Fax: 0161-819 2513

OFCOM
Ofcom Media Office
Riverside House
2A Southwark Bridge Road
London SE1 9HA
Website: www.ofcom.org.uk
e-mail: mediaoffice@ofcom.org.uk Tel: 020-7981 3033

PACT (PRODUCERS ALLIANCE FOR CINEMA & TELEVISION)
(Trade Association for Independent Television, Feature Film & New Media Production Companies)
2nd Floor, The Eye
1 Procter Street, London WC1V 6DW
Website: www.pact.co.uk
e-mail: enquiries@pact.co.uk
Fax: 020-7067 4377 Tel: 020-7067 4367

PERFORMING RIGHT SOCIETY Ltd
29-33 Berners Street, London W1T 3AB
Website: www.mcps-prs-alliance.co.uk
Fax: 020-7306 4455 Tel: 020-7580 5544

PERSONAL MANAGERS' ASSOCIATION Ltd
Rivercroft, 1 Summer Road
East Molesey, Surrey KT8 9LX
Website: www.thepma.com
e-mail: info@thepma.com Tel/Fax: 020-8398 9796

ROYAL TELEVISION SOCIETY
Kildare House, 3 Dorset Rise, London EC4Y 8EN
Website: www.rts.org.uk
e-mail: info@rts.org.uk
Fax: 020-7822 2811 Tel: 020-7822 2810

ROYAL THEATRICAL FUND
11 Garrick Street, London WC2E 9AR
e-mail: admin@trtf.com
Fax: 020-7379 8273 Tel: 020-7836 3322

S A G
(Screen Actors Guild)
5757 Wilshire Boulevard
Los Angeles, CA 90036-3600
Fax: (323) 549-6656 Tel: (323) 954-1600

360 Madison Avenue, 12th Floor
New York NY 10017
Website: www.sag.org Tel: (212) 944-1030

SAMPAD SOUTH ASIAN ARTS DEVELOPMENT
(Promotes the appreciation & practice of South Asian Arts)
c/o Mac, Cannon Hill Park
Birmingham B12 9QH
Website: www.sampad.org.uk
e-mail: info@sampad.org.uk
Fax: 0121-440 8667 Tel: 0121-446 4312

SAVE LONDON'S THEATRES CAMPAIGN
Guild House
Upper St Martin's Lane, London WC2H 9EG
Website: www.savelondonstheatres.org.uk
e-mail: contactus@savelondonstheatres.org.uk
Fax: 020-7379 7001 Tel: 020-7670 0270

SCOTTISH ARTS COUNCIL
12 Manor Place, Edinburgh EH3 7DD
Website: www.scottisharts.org.uk
e-mail: help.desk@scottisharts.org.uk
Fax: 0131-225 9833 Tel: 0131-226 6051

SCOTTISH SCREEN PRODUCTION & DEVELOPMENT
249 West George Street
Glasgow G2 4QE
Website: www.scottishscreen.com
e-mail: info@scottishscreen.com
Fax: 0141-302 1711 Tel: 0141-302 1700

SCRIPT
(West Midlands Playwrights, Scriptwriters - Training & Support)
Unit 107 The Greenhouse
The Custard Factory
Gibb Street, Birmingham B9 4AA
Website: www.scriptonline.net Tel: 0121-224 7415

SHOW-PAIRS - GUY Gillian ASSOCIATES
84A Tachbrook Street, London SW1V 2NB
Website: www.show-pairs.co.uk
Fax: 020-7976 5885 Tel: 020-7976 5888

SOCIETY FOR THEATRE RESEARCH The
c/o The Theatre Museum
1E Tavistock Street, London WC2E 7PR
Website: www.str.org.uk
e-mail: e.cottis@btinternet.com

SOCIETY OF AUTHORS
84 Drayton Gardens, London SW10 9SB
Website: www.societyofauthors.org
e-mail: info@societyofauthors.org Tel: 020-7373 6642

SOCIETY OF BRITISH THEATRE DESIGNERS
4th Floor, 55 Farringdon Road, London EC1M 3JB
Website: www.theatredesign.org.uk
e-mail: office@abtt.org.uk
Fax: 020-7242 9303 Tel: 020-7242 9200

SOCIETY OF LONDON THEATRE (SOLT)
32 Rose Street, London WC2E 9ET
e-mail: enquiries@solttma.co.uk
Fax: 020-7557 6799 Tel: 020-7557 6700

SOCIETY OF TEACHERS OF SPEECH & DRAMA The
Registered Office:
73 Berry Hill Road, Mansfield, Nottinghamshire NG18 4RU
Website: www.stsd.org.uk
e-mail: ann.k.jones@btinternet.com Tel: 01623 627636

SOCIETY OF THEATRE CONSULTANTS
4th Floor, 55 Farringdon Road, London EC1M 3JB
e-mail: office@abtt.org.uk
Fax: 020-7242 9303 Tel: 020-7242 9200

STAGE CRICKET CLUB
39-41 Hanover Steps, St George's Fields
Albion Street, London W2 2YG
Website: www.stagecc.co.uk
e-mail: brianjfilm@aol.com
Fax: 020-7262 5736 Tel: 020-7402 7543

STAGE GOLFING SOCIETY
Sudbrook Park, Sudbrook Lane, Richmond
Surrey TW10 7AS Tel: 020-8940 8861

STAGE MANAGEMENT ASSOCIATION
55 Farringdon Road, London EC1M 3JB
Website: www.stagemanagementassociation.co.uk
e-mail: admin@stagemanagementassociation.co.uk
Fax: 020-7242 9303 Tel: 020-7242 9250

**STAGE ONE (Formerly The Theatre
Investment Fund Ltd)**
32 Rose Street, London WC2E 9ET
Website: www.stageone.uk.com
e-mail: enquiries@stageone.uk.com
Fax: 020-7557 6799 Tel: 020-7557 6737

THEATRECARES
(Theatre Fundraising Committee of Crusaid - The National
Fundraiser for HIV & Aids)
1st Floor, 1-5 Curtain Road, London EC2A 3JX
Website: www.theatrecares.org.uk
e-mail: info@theatrecares.org.uk
Fax: 020-7539 3890 Tel: 020-7539 3880

THEATRE MUSEUM The
1E Tavistock Street, London WC2E 7PR
Website: www.theatremuseum.org
Fax: 020-7943 4777 Tel: 020-7943 4700

THEATRES TRUST The
22 Charing Cross Road, London WC2H 0QL
Website: www.theatrestrust.org.uk
e-mail: info@theatrestrust.org.uk
Fax: 020-7836 3302 Tel: 020-7836 8591

THEATRE WRITING PARTNERSHIP
Nottingham Playhouse, Wellington Circus, Notts NG1 5AF
e-mail: esther@theatrewritingpartnership.com
Fax: 0115-947 5759 Tel: 0115-947 4361

THEATRICAL GUILD The
PO Box 22712, London N22 5WQ
Website: www.the-theatrical-guild.org.uk
e-mail: admin@the-theatrical-guild.org.uk Tel: 020-8889 7570

THEATRICAL MANAGEMENT ASSOCIATION
(See TMA)

TMA
(Theatrical Management Association)
32 Rose Street, London WC2E 9ET
Website: www.tmauk.org
e-mail: enquiries@solttma.co.uk
Fax: 020-7557 6799 Tel: 020-7557 6700

UK CHOREOGRAPHERS' DIRECTORY The
(See DANCE UK)

UK FILM COUNCIL
10 Little Portland Street, London W1W 7JG
Website: www.ukfilmcouncil.org.uk
e-mail: info@ukfilmcouncil.org.uk
Fax: 020-7861 7862 Tel: 020-7861 7861

UK THEATRE CLUBS
54 Swallow Drive, London NW10 8TG
e-mail: uktheatreclubs@aol.com Tel/Fax: 020-8459 3972

UNITED KINGDOM COPYRIGHT BUREAU
110 Trafalgar Road
Portslade, East Sussex BN41 1GS
Website: www.copyrightbureau.co.uk
e-mail: info@copyrightbureau.co.uk
Fax: 01273 705451 Tel: 01273 277333

VARIETY & LIGHT ENTERTAINMENT COUNCIL
54 Keyes House
Dolphin Square, London SW1V 3NA
Fax: 020-7821 0261 Tel: 020-7798 5622

VARIETY CLUB CHILDREN'S CHARITY
Variety Club House
93 Bayham Street, London NW1 0AG
Website: www.varietyclub.org.uk
e-mail: info@varietyclub.org.uk
Fax: 020-7428 8111 Tel: 020-7428 8100

VOICE GUILD OF GREAT BRITAIN The
c/o 4 Turner Close, London SW9 6UQ
Fax: 020-7820 1845 Tel: 020-7735 5736

WOLFF Peter THEATRE TRUST The
Flat 22, 7 Princess Gate, London SW7 1QL
e-mail: pmwolff@msn.com Mobile: 07767 242552

WOMEN IN FILM AND TELEVISION
6 Langley Street, London WC2H 9JA
e-mail: info@wftv.org.uk
Fax: 020-7379 1625 Tel: 020-7240 4875

WRITERNET
Cabin V, Clarendon Buildings
25 Horsell Road, London N5 1XL
Website: www.writernet.org.uk
e-mail: info@writernet.org.uk
Fax: 020-7609 7557 Tel: 020-7609 7474

WRITERS' GUILD OF GREAT BRITAIN The
15 Britannia Street, London WC1X 9JN
Website: www.writersguild.org.uk
e-mail: admin@writersguild.org.uk
Fax: 020-7833 4777 Tel: 020-7833 0777

WWW.ANACTORDESPAIRS.CO.UK
(Survival Guide for Performers)
6 Bath Road, Chadwell Heath
Romford, Essex RM6 6NH
Website: www.anactordespairs.co.uk
e-mail: enquiries@anactordespairs.co.uk

YOUTH MUSIC THEATRE: UK
1st Floor, Swiss Centre
10 Wardour Street, London W1D 6QF
Website: www.youth-music-theatre.org.uk
e-mail: mail@youth-music-theatre.org.uk Tel: 0870 240 5057

WE CAN HELP ACTORS' CHILDREN

Are you:

- **a professional actor?**
- **the parent of a child under 21?**
- **having trouble with finances?**

Please get in touch for a confidential chat.

The Actors' Charitable Trust
020 7242 0111
admin@tactactors.org

TACT can help in many ways: with regular monthly payments, one-off grants, and long-term support and advice.
We help with clothing, child-care, music lessons, school trips, special equipment and adaptations, and in many other ways.

Our website has a link to a list of all the theatrical and entertainment charities which might be able to help you if you do not have children: www.tactactors.org

TACT, Africa House, 64 Kingsway, London WC2B 6BD.
Registered charity number 206809.

TACT

Photographers

Each photographer listed in this section has taken an advertisement in this edition.
See Index to Advertisers pages 387-389 to view each advertisement.

Press Cutting Agencies
Promotional Services
(CVs, Showreels, Websites etc)
Properties & Trades
Publications
Publicity & Press Representatives

ACTORHEADSHOTS.CO.UK
Mobile: 07740 507970

ACTOR'S ONE-STOP SHOP
Website: www.actorsone-stopshop.com
Tel: 020-8888 7006

ACTORS WORLD PRODUCTION
e-mail: photo@actors-world-production.com
Tel: 020-8998 2579

AIRSTUDIO
Website: www.airstudio.co.uk
Tel: 020-7434 0649

ALLEN Stuart
Website: www.stuartallenphotos.com
Mobile: 07776 258829

AN ACTOR PREPARES
Mobile: 07870 625701

ANNAND Simon
Website: www.simonannand.com
Mobile: 07884 446776
Tel: 020-7241 6725

APSION Georgia
Mobile: 07973 269155
Tel: 01273 503857

ARTSHOT.CO.UK
e-mail: angela@artshot.co.uk
Website: www.artshot.co.uk
Mobile: 07931 537363
Tel: 020-8521 7654

BACON Ric
Website: www.ricbacon.co.uk
Mobile: 07970 970799

BAKER Chris
e-mail: chrisbaker@photos2000.demon.co.uk
Website: www.chrisbakerphotographer.com
Tel: 020-8441 3851

BAKER Sophie
Tel: 020-8340 3850

BARRASS Paul
Website: www.paulbarrass.co.uk
Mobile: 07973 265931
Tel: 020-7690 5520

BARTLETT Helen
Website: www.helenbartlett.co.uk
Tel: 0845 6031373

BISHOP Brandon
Website: www.brandonbishopphotography.com
Mobile: 07931 383830
Tel: 020-7275 7468

[CONTACTS 2007]

How do I find a photographer?

Having a good quality, up-to-date promotional headshot is crucial for every performer. Make sure you choose your photographer very carefully: do some research and try to look at different examples. Photographers' adverts run throughout this book, featuring many sample shots, although to get a real feel for their work you should also try to see their portfolio or website since this will give a more accurate impression of the quality of their photography.

If you live in or around London, please feel free to visit the Spotlight offices and look through current editions of our directories to find a style you like. We also have nearly sixty photographers' portfolios available for you to browse, many of them from photographers listed over the next few pages. Our offices are open Monday - Friday, 10.00am - 5.30pm at 7 Leicester Place, London WC2H 7RJ (nearest tube is Leicester Square).

The photo shoot

When it comes to your photoshoot, bear in mind that a casting director, agent or production company will want to see a photo of the 'real' you. Keep your appearance as neutral as possible so that they can imagine you in many different roles, rather than type-casting yourself from the outset and limiting your opportunities.

Your eyes are your most important feature, so make sure they are visible: face the camera straight-on and try not to smile too much because it makes them harder to see. Wear something simple and avoid jewellery, hats, scarves, glasses or props, since these will all add character. Do not wear clothes that detract from your face such as polo necks, big collars, busy patterns or logos. Always keep your hands out of the shot.

Also consider the background: some photographers like to do outdoor shots. A contrast between background and hair colour works well, whereas dark backgrounds work less well with dark hair, and the same goes for light hair on light backgrounds.

Choosing your photograph

When you get your contact sheet back from the photographer, make sure you choose a photo that looks like you - not how you would like to look. If you are unsure, ask friends or your agent for an honest opinion. Remember, you will be asked to attend meetings and auditions on the basis of your photograph, so if you turn up looking completely different you will be wasting everyone's time.

Due to copyright legislation, you must always credit the photographer when using the photo.

Submitting photos for Spotlight

The annual deadlines for submitting new photos for the Spotlight books are as follows:

- Actors: 15th October • Actresses: 15th April • Child Artists: 15th November
- Dancers: 1st November • Graduates 2-3 year course: 15th October
- Postgraduates: 24th November • Presenters: 10th July

Photographers can get very busy, so try to start organising your photos a couple of months in advance.

Every Spotlight artist can also add up to four extra photographs onto their Internet CV, in addition to their 'principal photograph'. These are called 'portfolio photos', and they give you the opportunity to show yourself in a range of different shots and / or roles.

For more information please visit (www.spotlight.com/artists/multimedia/portfolio.html)

BLUMENAU Jack
e-mail: info@blumenauphotography.co.uk
Website: www.blumenauphotography.co.uk
Mobile: 07742 506757
Tel: 020-8133 7012

BROWN Kelvin
Website: www.kelvinbrown.co.uk
Mobile: 07771 946640

BURNETT Sheila
Website: www.sheilaburnett-photography.com
Tel: 020-7289 3058

CABLE Paul
e-mail: info@paulcable.com
website: www.paulcable.com
Mobile: 07958 932764

CAMPLING Jon
e-mail: photo@joncampling.com
Website: www.joncampling.com
Mobile: 07941 421101
Tel: 020-8679 8671

CARTER Charlie
Tel: 020-8222 8742

CASTING SHOTS
Website: www.castingshots.co.uk
Tel: 0800 0681246

CLARK John
Website: www.johnclarkphotography.com
e-mail: info@johnclarkphotography.com
Mobile: 07702 627237
Tel: 020-8854 4069

DANCE SCENE PHOTOGRAPHIC
Mobile: 07702 747123
Tel: 01737 552874

DEBAL
e-mail: debal@abeautifulimage.com
Tel: 020-8568 2122

DE LENG Stephanie
e-mail: sa@deleng.co.uk
Website: www.stephaniedeleng.co.uk
Mobile: 07740 927765

DEUCHAR Angus
Website: www.actorsphotos.co.uk
Mobile: 07973 600728
Tel: 020-8286 3303

DOHERTY Charles
e-mail: cdohertyphotography@hotmail.com
Mobile: 07717 055055

DUNKIN Mary
Website: www.marydunkinphotography.co.uk
Tel: 020-8969 8043

DWP PORTRAIT PHOTOGRAPHY
Mobile: 07802 819308

DYE Debbie
Website: www.debbiedye.com
Mobile: 07944 155454

EDDOWES Mike
e-mail: mike@photo-publicity.co.uk
Website: www.theatre-photography.co.uk
Mobile: 07970 141005
Tel: 01903 882525

FURNESS Keith
e-mail: keith@f4photos.wanadoo.co.uk
Mobile: 07949 407176
Tel: 01992 638115

GALLOWAY Brian
Website: www.gallowayphoto.co.uk
Mobile: 07973 386904

GAP PHOTOGRAPHY
e-mail: giovanni@gapphotography.com
Website: www.gapphotography.com
Mobile: 07939 072419

GILL James
Tel: 020-7735 5632

GOWLETT Karla
Website: www.karlagowlett.co.uk
Mobile: 07941 871271

GREENBERG Natasha
Website: www.ngphotography.co.uk
Mobile: 07932 618111
Tel: 020-8653 5399

GREGAN Nick
Website: www.nickgregan.com
Mobile: 07774 421878
Tel: 020-7538 1249

GRÉGOIRE Stéphan
Website: www.studio-sg.com
Mobile: 07869 141510

GRIFFIN Charles
Website: www.charlesgriffinphotography.co.uk
Tel: 01244 535252

GROGAN Claire
Website: www.clairegrogan.co.uk
Mobile: 07932 635381
Tel: 020-7272 1845

HALL Peter
Website: www.peterhall-photo.co.uk
Mobile: 07803 345495
Tel: 020-8981 2822

HARWOOD-STAMPER Daniel
e-mail: dan@denbryrepros.com
Mobile: 07779 165777
Tel: 020-7930 1372

HASTINGS Magnus
Website: www.magnushastings.co.uk/headshots
Mobile: 07905 304705

HUGHES Jamie
Website: www.jamiehughesphotography.com/headshots
Mobile: 07850 122977

HUNTER Remy
Website: www.remyhunter.co.uk
Mobile: 07766 760724
Tel: 020-7431 8055

IMAGE 1ST
Website: www.img1st.com
Mobile: 07758 600581

JAMES David
Website: www.davidjamesphotos.com
Mobile: 07808 597362

JAMES Nick
Mobile: 07961 122030

JAMES Rupert
Website: www.rupertjamesphotography.com
Mobile: 07775 941753

JAMIE Matt
e-mail: photos@mattjamie.co.uk
Website: www.mattjamie.co.uk/portraits
Mobile: 07976 890643

JEFFERSON Paris
Mobile: 07876 586601

JK PHOTOGRAPHY
Website: www.jk-photography.net
Mobile: 07816 825578

JOHNSON Jaime
e-mail: jaime@jaimejohnson.co.uk
Website: www.jaimejohnson.co.uk
Mobile: 07971 539857

JOHNSTON Stephen Marshall
Website: www.castingphoto.co.uk
Mobile: 07775 991834

JONES Denis
Website: www.djpix.co.uk
Mobile: 07836 241158

KENNEDY Tiggy
Website: www.tiggykennedy.com
Mobile: 07973 563011

LADENBURG Jack
e-mail: info@jackladenburg.com
Mobile: 07932 053743

LATIMER Carole
Website: www.carolelatimer.com
Fax: 020-7229 9306
Tel: 020-7727 9371

LAWTON Steve
Website: www.stevelawton.com
Mobile: 07973 307487

LB PHOTOGRAPHY
Mobile: 07885 966192
Tel: 01737 224578

LEA Suzannah
e-mail: info@suzannah-lea-photography.com
Website: www.suzannah-lea-photography.com
Mobile: 07702 839995

LE MAY Pete
e-mail: enquiries@petelemay.co.uk
Website: www.petelemay.co.uk
Mobile: 07703 649246

LE MAY Tony
e-mail: tonylemayphoto@aol.com
Website: www.tonylemayphotography.com
Tel: 01845 526668

LIGHT STUDIOS The
Tel: 020-7610 6677

LONDON Joe
Website: www.joelondonphotography.com
Mobile: 07941 686203

M.A.D. PHOTOGRAPHY
Website: www.mad-photography.co.uk
Mobile: 07949 581909
Tel: 020-8363 4182

MARCAR Pierre
Website: www.pierremarcarpeople.com
Mobile: 07956 485584

MARCUS Raymondo
e-mail: r.marcus@raymondomarcus.com
Website: www.raymondomarcus.com
Mobile: 07831 649000
Tel: 01628 485692

MARTIN Murray
Tel: 020-8952 6198

MASON Neil
e-mail: info@neilmasonphotography.com
Website: www.neilmasonphotography.com
Mobile: 07940 507965
Tel: 020-8788 2449

MASTERS Seamus
e-mail: info@seamusmasters.com
Website: www.seamusmasters.com
Mobile: 07879 620111

MAXWELL Earl
Website: www.earlmaxwell.co.uk
Mobile: 07831 425809

MOLLIÈRE Pascal
e-mail: info@pascalphoto.co.uk
Website: www.pascalphoto.co.uk
Mobile: 07713 242948

MOORE Casey
e-mail: casey@caseymoore.com
Website: www.caseymoore.com
Mobile: 07974 188105
Tel: 020-7193 1868

MOUNT Gemma
Website: www.gemmamountphotography.com
Mobile: 07976 824923
Tel: 020-8342 9318

NAMDAR Fatimah
e-mail: fn@fatimahnamdar.com
Website: www.fatimahnamdar.com
Mobile: 07973 287535
Tel: 020-8341 1332

NEWMAN-WILLIAMS Claire
e-mail: claire@clairenewmanwilliams.com
Website: www.clairenewmanwilliams.com
Mobile: 07963 967444

OVER THE RAINBOW
e-mail: otrimaging@aol.com
Website: www.otrimaging.com
Tel: 020-8367 5900

PASSPORT PHOTO SERVICE
Website: www.passportphoto.co.uk
Tel: 020-7629 8540

PHOTOMEGORGEOUS
Website: www.photomegorgeous.com
Tel: 01580 893040

PHOTOS FOR ACTORS (Maxine Evans)
e-mail: maxinevans@aol.com
Website: www.photosforactors.co.uk
Mobile: 07966 130426
Tel: 020-8534 3002

PLATMAN Lara
e-mail: lara@platmanphotography.com
Mobile: 07973 747248

POLLARD Michael
e-mail: info@michaelpollard.co.uk
Website: www.michaelpollard.co.uk
Tel: 0161-456 7470

PRICE David
Website: www.davidpricephotography.co.uk
Mobile: 07950 542494

PROFILE PHOTOGRAPHY
Website: www.profile-london.com
Mobile: 07971 431798
Tel: 020-7289 1088

RABIN Dan
Mobile: 07940 519331

RAFIQUE Harry
Website: www.hr-photographer.co.uk
Mobile: 07986 679498
Tel: 020-7266 5398

REDONDO Rocco
e-mail: rocco@roccoredondo.co.uk
Website: www.roccoredondo.com
Mobile: 07770 694686

RENDELL Jeremy
e-mail: rendellphotography@mac.com
Website: www.jeremyrendell.com
Mobile: 07860 277411

RICHMOND Eric
e-mail: eric@ericrichmond.net
Website: www.ericrichmond.net
Mobile: 07866 766240
Tel: 020-8880 6909

ROBBIE'S PHOTOGRAPHICS
Tel: 020-8767 4222

S. Mike PHOTOGRAPHY
e-mail: mike@mbmphoto.fsnet.co.uk
Website: www.mikephotos.co.uk
Mobile: 07850 160311
Tel: 0121-323 4459

SANGES Marco
e-mail: contact@marcosanges.com
Website: www.marcosanges.com
Mobile: 07738 937804

SAVAGE Rob
Website: www.robsavage.co.uk
Mobile: 07901 927597

SAYER Howard
e-mail: howard@howardsayer.com
Website: www.howardsayer.com
Tel: 020-8123 0251

SCOTT Karen
Website: www.karenscottphotography.com
Mobile: 07958 975950

SEYMOUR Darren
Mobile: 07712 605486

SHAKESPEARE LANE Catherine
Tel: 020-7226 7694

SHOT BY THE SHERIFF PHOTOGRAPHY (Keith Sheriff)
e-mail: contacts@shotbythesheriff.co.uk
Website: www.shotbythesheriff.co.uk
Tel: 0800 0377703

SIMPKIN Peter
e-mail: petersimpkin@aol.com
Website: www.petersimpkin.co.uk
Tel: 020-8883 2727

SLAVICKY Stuart Josef
Website: sjsphoto.co.uk
Mobile: 07733 107146

SMITH Lucy
Website: www.thatlucy.co.uk
Tel: 020-8521 1347

SMITH Michael David
Website: mds-photography.com
Mobile: 07903 948603

SUMMERS Caroline
Website: www.homepage.mac.com/carolinesummers
Mobile: 07931 301234
Tel: 020-7223 7669

THOMSON Keith
e-mail: keith.thomson4@ntlworld.com
Website: www.ktphotography.co.uk
Mobile: 07870 578747
Tel: 01509 827464

THORNE Philip
Website: www.philipthorne.co.uk
Tel: 01582 873165

TM PHOTOGRAPHY
e-mail: tm.photography@ntlworld.com
Website: www.tmphotography.co.uk
Tel: 020-8924 4694

TSANTILIS Dan
Mobile: 07967 632216
Tel: 020-8994 6551

TUCK Simon J.
Website: www.simonjtuck.co.uk
Mobile: 07879 643925

TWITCHETT Oliver
e-mail: olivertwitchett@hotmail.com
Mobile: 07787 505069

ULLATHORNE Steve
Website: www.steveullathorne.com
Mobile: 07961 380969

USBORNE Martin
Website: www.martinusborne.com
Mobile: 07747 607930

VANDYCK Katie
Website: www.iphotou.co.uk
Mobile: 07941 940259

VARLEY Luke
Website: www.lukevarley.com
Mobile: 07711 183631
Tel: 020-8674 9919

WHYTE Chalky
e-mail: chalkywhyte@supanet.com
Mobile: 07880 735912
Tel: 020-8451 7629

WILL C
e-mail: billy_snapper@hotmail.com
Website: www.london-photographer.com
Mobile: 07712 669953
Tel: 020-8438 0303

WOODWARD Sarah
Mobile: 07973 158901

WORKMAN Robert
Website: www.robertworkman.demon.co.uk
Tel: 020-7385 5442

YOUNGER BY THE DAY IMAGES
Website: www.ybtd.co.uk
Mobile: 07951 572726

PRESS CUTTING AGENCIES

DURRANTS
(Media Monitoring Agency)
Discovery House
28-42 Banner Street, London EC1Y 8QE
Website: www.durrants.co.uk
e-mail: sales@durrants.co.uk
Fax: 020-7674 0222 Tel: 020-7674 0200

INFORMATION BUREAU The
51 The Business Centre
103 Lavender Hill, London SW11 5QL
Website: www.informationbureau.co.uk
e-mail: info@informationbureau.co.uk
Fax: 020-7738 2513 Tel: 020-7924 4414

INTERNATIONAL PRESS-CUTTING BUREAU
224-236 Walworth Road
London SE17 1JE
Website: www.ipcb.co.uk
e-mail: info@ipcb.co.uk
Fax: 020-7701 4489 Tel: 020-7708 2113

McCALLUM MEDIA MONITOR
Tower House
10 Possil Road, Glasgow G4 9SY
Website: www.press-cuttings.com
Fax: 0141-333 1811 Tel: 0141-333 1822

TNS MEDIA INTELLIGENCE
6th Floor
292 Vauxhall Bridge Road
London SW1V 1AE
Fax: 020-7963 7609 Tel: 0870 2020100

websites for performing artists

ACTORS ILLUMINATED.COM

A1 VOX Ltd
(Spoken Word Audio, ISDN Links, Demo CDs & Audio Clips)
20 Old Compton Street
London W1D 4TW
Website: www.a1vox.com
e-mail: info@a1vox.com Tel: 020-7434 4404

ACTOR'S CV
(Websites for Actors)
PO Box 54745, London NW9 1DL
Website: www.actorscv.com Tel: 020-8200 0899

ACTOR'S ONE-STOP SHOP The
(Showreels for Performing Artists)
First Floor
Above The Gate Pub
Station Road, London N22 7SS
Website: www.actorsone-stopshop.com
e-mail: info@actorsone-stopshop.com Tel: 020-8888 7006

ACTORS ILLUMINATED.COM
(Websites for Performing Artists)
90 Brondesbury Road
London NW6 6RX
Website: www.actorsilluminated.com
e-mail: mail@actorsilluminated.com Mobile: 07769 626074

ACX MEDIA
(Showreels Production/Editing, Casting & Rehearsals)
Studio 12-13
Stephen House
1B Darnley Road E9 6QH
Website: www.acx-media.co.uk
e-mail: alex@acx-media.co.uk Mobile: 07957 750246

AN ACTOR PREPARES
222A Seven Sisters Road
London N4 3NX
Website: www.an-actor-prepares.com
e-mail: s_b_management@hotmail.com Mobile: 07870 625701

BEWILDERING PICTURES
(Showreel Service) (Graeme Kennedy)
110-116 Elmore Street
London N1 3AH
Website: www.bewildering.co.uk
e-mail: gk@bewildering.co.uk
Mobile: 07974 916258 Tel: 020-7354 9101

CHASE Stephan PRODUCTIONS Ltd
(Voice Over Demo CDs)
The Studio, 22 York Avenue
London SW14 7LG
Website: www.stephanchase.com
e-mail: stephanchase@talktalk.net Tel: 020-8878 9112

CLICKS
Media Studios, Grove Road
Rochester, Kent ME2 4BX
e-mail: info@clicksstudios.co.uk
Fax: 01634 726000 Tel: 01634 723838

COURTWOOD PHOTOGRAPHIC Ltd
(Photographic Processing)
Courtwood Film Service Ltd
Freepost TO55, Penzance, Cornwall TR18 2DQ
Website: www.courtwood.co.uk
e-mail: people@courtwood.co.uk
Fax: 01736 350203 Tel: 01736 365222

modelcards
Free Scanning, Free Design, Free Delivery

www.modelcards.co.uk

London Academy of Radio Film TV
TV Presenter - Acting - Voice - Film - Photography - Make-up - Radio
100 courses Offering an extensive range of full-time, part-time evening and day courses taught by celebrities and industry professionals.

www.media-courses.com 0870 850 4994

What are Promotional services?

This section contains listings for a variety of companies who provide practical services which help performers to promote themselves effectively and professionally.

These include companies who can help artists to design and print their CVs; record a demo showreel; build their own websites; record voice-clips; duplicate CDs; or print photographic repros and Z-cards.

Why do I need to promote myself?

Performers need to invest in marketing and promotion as much as any other self-employed business-person: for example a plumber or a freelance make-up artist!

Even if you have trained at a leading drama school, have a well-known agent, or have just finished work on a popular TV series, you should never sit back and wait for your phone to ring or for the next job opportunity just to knock on your door. In such a competitive industry, successful performers are usually the ones who market themselves pro-actively and treat their careers as a 'business'.

Having up-to-date and well-produced promotional material makes a performer look professional and serious about their career: and hence an appealing person for a director or agent to work with.

The tools of the trade

Every performer should have a well-presented CV which is kept to a maximum of one page. Updates should be made regularly, including adding new credits, otherwise it may look as if you haven't been working and this can put some casting directors off.

Your CV should feature, or be accompanied by, a recent headshot which is an accurate current likeness. See the 'Photographers' section of Contacts for more information about promotional photography. You may need to print copies of your headshot through a repro company, some of whom are listed over the next few pages.

Up-to-date showreels and voice-reels are also invaluable promotional tools. These help casting directors and agents to build up a more detailed impression of your skills and your versatility, prior to meeting you. An actor's voice is in many ways as important as their physical appearance, so having a voice-reel should be as common as having a headshot photo.

Showreels and voice-reels should be professionally recorded and edited, with good sound and / or visual quality. Always use a variety of clips to demonstrate versatility, or a range of accents, pitch and tone. They can be extracts from previous work you've done, or recorded from scratch in a professional studio.

If you are a member of Spotlight, you should also add showreels and voice-reels to your online CV, for casting professionals to access via the Spotlight website.

Some performers also have their own websites where they feature more detail about themselves and their careers. Ideally the website should be professionally designed and updated regularly so as not to look amateur or out-of-date. Having a website can save money in the long-term since you may not need to send out as many copies of your CV, photos and showreels / voice-reels: you can just showcase them online.

How should I use these listings?

If you are looking for a company to help you with any of these promotional items, browse through this section carefully and get quotes from a number of places to compare. If you are a Spotlight member, some companies offer a discount on their services. Always ask to see samples of a company's work, and ask friends in the industry for their own recommendations.

CROWE Ben
(Voice Clip Recording)
73 Treaty Street, London N1 0TE
e-mail: bencrowe@hotmail.co.uk
Mobile: 07952 784911 Tel/Fax: 020-7833 5977

CRYING OUT LOUD
(Voice-Over Specialists/Voice-Over Demo CDs)
Website: www.cryingoutloud.co.uk
e-mail: simon@cryingoutloud.co.uk
Mobile: 07796 266265 Tel: 020-8980 0124

CRYSTAL MEDIA
28 Castle Street, Edinburgh EH2 3HT
Website: www.crystal-media.co.uk
e-mail: hello@crystal-media.co.uk
Fax: 0131-240 0989 Tel: 0131-240 0988

CUT GLASS PRODUCTIONS
(Voice-Over Showreels/Voice-Over Production)
7 Crouch Hall Road, Crouch End, London N8 8HT
Website: www.cutglassproductions.com
e-mail: phil@cutglassproductions.com Tel/Fax: 020-8374 4701

DARK SIDE
(Photographic Repro Service)
4 Helmet Row, London EC1V 3QJ
Website: www.darksidephoto.co.uk
e-mail: info@darksidephoto.co.uk
Fax: 020-7250 1771 Tel: 020-7250 1200

DBUG MULTIMEDIA
(Showreels)
39A Ridgemount Gardens, London WC1E 7AT
Website: www.dbug.info
e-mail: info@dbug.info Tel: 020-7637 2935

DESIGN CREATIVES & OCTOPUS REACH
(Artistic Promotions & Graphic/Web Design & Hosting,
Anthony Rosato)
Suite B, 5 South Bank Terrace, Surbiton, Surrey KT6 6DG
Website: www.octopusreach.com
e-mail: octopusreach1@aol.com
Mobile: 07884 056405 Tel/Fax: 020-8390 8535

EXECUTIVE AUDIO VISUAL
(Showreels for Actors & Presenters)
80 York Street, London W1H 1QW Tel/Fax: 020-7723 4488

FLYING DUCKS GROUP Ltd The
(Conference, Multimedia & Video Production)
Oakridge, Weston Road, Staffordshire ST16 3RS
Website: www.flyingducks.biz
e-mail: enquiries@flyingducks.biz
Fax: 01785 252448 Tel: 01785 610966

FREE ELECTRON
(Website Design)
45 Alpha Street, Slough, Berks SL1 1RA
Website: www.free-electron.co.uk
e-mail: info@free-electron.co.uk Tel/Fax: 01753 693074

GENESIS UK.COM
18 Pendre Enterprise Park, Tywyn, Gwynedd LL36 9LW
Website: www.genesis-uk.com
e-mail: info@genesis-uk.com
Fax: 01654 712461 Tel: 01654 710137

INIMITABLE
(Flash Website Design)
PO Box 147, Dewsbury WF12 0WZ
Website: www.inimitable.us
e-mail: info@inimitable.us

MINAMON FILM
(Specialist in Showreels)
117 Downton Avenue, London SW2 3TX
e-mail: min@minamonfilm.co.uk
Fax: 020-8674 1779 Tel: 020-8674 3957

MODELCARDS
Website: www.modelcards.co.uk
e-mail: studio@modelcards.co.uk

MOTIVATION SOUND STUDIOS
35A Broadhurst Gardens, London NW6 3QT
Website: www.motivationsound.co.uk
e-mail: info@motivationsound.co.uk
Fax: 020-7624 4879 Tel: 020-7328 8305

MY-SHOWREEL.COM
PO Box 801, Wembley, Middlesex HA9 0QX
Website: www.my-showreel.com
e-mail: sales@my-showreel.com Mobile: 07961 278879

MYCLIPS
Flat 1, 2 Blackdown Close, East Finchley, London N2 8JF
Website: www.myclipsdvd.com
e-mail: info@myclipsdvd.com Tel: 020-8371 9526

PERFORMERS ONLINE Ltd
(Design, Web & Print)
6A Palace Gates Road, London N22 7BN
Website: www.performersonline.co.uk
e-mail: info@performersonline.co.uk Tel: 020-8365 8522

PROFILE PRINTS
(Photographic Printers)
St Michael's Street, Penzance TR18 2DQ
Website: www.courtwood.co.uk
e-mail: sales@courtwood.co.uk
Fax: 01736 350203 Tel: 01736 365222

REPLAY Ltd
(Showreels & Performance Recording)
Museum House, 25 Museum Street, London WC1A 1JT
Website: www.replayfilms.co.uk
e-mail: sales@replayfilms.co.uk Tel: 020-7637 0473

ROUND ISLAND SHOWREELS
Website: www.roundisland.net
e-mail: showreeloffer@myway.com

SCARLET INTERNET
Suite 4, 15 Market Sq, Bishop's Stortford, Herts CM23 3UT
Website: www.scarletinternet.com
e-mail: info@scarletinternet.com
Fax: 0870 2241418 Tel: 0870 7771820

SHAW Bernard
(Specialist in Recording & Directing Voice Tapes)
Horton Manor, Canterbury CT4 7LG
Website: www.bernardshaw.co.uk
e-mail: bernard@bernardshaw.co.uk Tel/Fax: 01227 730843

SHOWREEL DOCTOR
(James Sharpe)
7 Pippin Close, Shenley, Herts WD7 9EU
Website: www.sheilasreels.info
e-mail: showreels4u@hotmail.com Tel: 01923 442236

SHOWREELS 1
c/o Nought E Casting Studios
45 Poland Street, London W1F 7NA
Website: www.ukscreen.com/company/showreels1
e-mail: showreels1@aol.com
Fax: 020-7437 2830 Mobile: 07932 021232

SHOWREEL The
(Voice-Over Showreels, Digital Editing etc)
Knightsbridge House, 229 Acton Lane, London W4 5DD
Website: www.theshowreel.com
e-mail: info@theshowreel.com
Fax: 020-8995 2144 Tel: 020-7043 8660

SHOWREELZ
59 Church Street
St Albans, Herts AL3 5NG
Website: www.showreelz.com e-mail: brad@showreelz.com
Mobile: 07885 253477 Tel: 01727 752960

SILVER-TONGUED PRODUCTIONS
(Specializing in the recording and production
of Voice Reels)
Website: www.silver-tongued.co.uk
e-mail: contactus@silver-tongued.co.uk Tel: 020-8309 0659

SMALL SCREEN VIDEO
(Showreels)
The Production Office
Small Screen Video
Dartford, Kent DA1 3JN
Website: www.smallscreenvideo.com
e-mail: showreels@smallscreenvideo.com Tel: 020-8816 8896

STAGES CAPTURE THE MOMENT
(Showreels)
31 Evensyde, Croxley Green
Watford, Herts WD18 8WN
Website: www.stagescapturethemoment.com/showreels
e-mail: info@stagescapturethemoment.com
 Tel: 020-7193 8519

SUPPORT ACT SERVICES
(Ian McCracken) (CD Duplication & Web Design)
PO Box 388, Dover CT16 9AJ
Website: www.supportact.co.uk
e-mail: info@supportact.co.uk Tel: 0845 0940796

TAKE FIVE CASTING STUDIO
(Showreels)
37 Beak Street
London W1F 9RZ
Website: www.takefivestudio.com
e-mail: info@takefivestudio.com
Fax: 020-7287 3035 Tel: 020-7287 2120

TM DESIGN SERVICES
(Web Design, Model Cards, Actors CVs)
Website: www.tmphotography.co.uk
e-mail: tm.photography@ntlworld.com Tel: 020-8924 4694

TO BE OR NOT TO BE
(Showreels, Corporate Films) (Anthony Barnett)
48 Northampton Road
Kettering, Northants NN15 7JU
Website: www.tobeornottobe.tv
e-mail: tobeornottobe@ntlworld.com
Mobile: 07958 996227 Tel/Fax: 01536 526126

TOUCHWOOD AUDIO PRODUCTIONS
6 Hyde Park Terrace
Leeds, West Yorkshire LS6 1BJ
Website: www.touchwoodaudio.com
e-mail: bruce@touchwoodaudio.com Tel: 0113-278 7180

TTA PRODUCTIONS
34A Pollard Road, Morden, Surrey SM4 6EG
Website: www.tv-training.co.uk
e-mail: contact@tv-training.co.uk Tel: 020-8665 2275

VOICE MASTER
(Specialised Training for Voice-Overs & TV Presenters)
88 Erskine Hill, London NW11 6HR
Website: www.voicemaster.co.uk
e-mail: stevehudson@voicemaster.co.uk Tel: 020-8455 2211

VOICE OVER DEMOS
61 Cropley Street, London N1 7JB
Website: www.voiceoverdemos.co.uk
e-mail: daniel@voiceoverdemos.co.uk Tel: 020-7684 1645

VOICE TAPE SERVICES INTERNATIONAL Ltd
(Professional Voice-Over Direction & CDs)
80 Netherlands Road
New Barnet, Herts EN5 1BS
Website: www.vtsint.co.uk
e-mail: info@vtsint.co.uk
Fax: 020-8441 4828 Tel: 020-8440 4848

WILDE DESIGNS
115 Manor Road, Stoke Newington, London N16 5PB
Website: www.wildedesigns.com
e-mail: info@wildedesigns.com
Mobile: 07778 766688 Tel: 020-8211 7591

MARCUS HALL PROPS

PROP BUYING, MAKING, SOURCING & SUPERVISING

MarcusHall Props • 80 Malyons Road • Ladywell • London • SE13 7XG
Chris Marcus 07802 873127 • Jonathan Hall 07813 491560

www.marcushallprops.com info@marcushallprops.com

3D CREATIONS
(Production Design, Scenery Contractors, Prop Makers &
Scenic Artists)
9A Bells Road, Gorleston-on-Sea
Great Yarmouth, Norfolk NR31 6BB
Website: www.3dcreations.co.uk
e-mail: 3dcreations@rjt.co.uk
Fax: 01493 443124 Tel: 01493 652055

10 OUT OF 10 PRODUCTIONS Ltd
(Lighting, Sound, AV Hire, Sales & Installation)
Unit 14 Forest Hill Business Centre
Clyde Vale, London SE23 3JF
Website: www.10outof10.co.uk
e-mail: sales@10outof10.co.uk
Fax: 020-8699 8968 Tel: 0845 1235664

07000 BIG TOP
(Big Top, Seating, Circus)
The Arts Exchange, Congleton, Cheshire CW12 1JG
Website: www.arts-exchange.com
e-mail: phillipgandey@netcentral.co.uk
Fax: 01260 270777 Tel: 01260 276627

ACROBAT PRODUCTIONS
(Artistes & Advisors)
12 Oaklands Court
Hempstead Road, Watford WD17 4LF
Website: www.acrobatproductions.com
e-mail: info@acrobatproductions.com Tel: 01923 224938

ADAMS ENGRAVING
Unit G1A, The Mayford Centre
Mayford Green, Woking GU22 0PP
Website: www.adamsengraving.co.uk
e-mail: adamsengraving@pncl.co.uk
Fax: 01483 751787 Tel: 01483 725792

AFX (UK) Ltd
(Incorporating Kirby's Flying Ballets)
8 Greenford Avenue, Hanwell, London W7 3QP
Website: www.kirbysflying.co.uk
e-mail: mail@afxuk.com
Mobile: 07958 285608 Tel/Fax: 020-8723 8552

AIRBOURNE SYSTEMS INTERNATIONAL
(All Skydiving Requirements Arranged. Parachute Hire -
Period & Modern)
8 Burns Crescent, Chelmsford
Essex CM2 0TS Tel: 01245 268772

ALCHEMICAL LABORATORIES ETC
(Medieval Science & Technology Recreated for
Museums & Films)
2 Stapleford Lane, Coddington
Newark, Nottinghamshire NG24 2QZ
Website: www.jackgreene.co.uk Tel: 01636 707836

ALL SCENE ALL PROPS
(Props, Masks, Painting & Scenery Makers)
Units 2 & 3, Spelmonden Farm
Goudhurst, Kent TN17 1HE
Website: www.allscene.net
e-mail: info@allscene.net
Fax: 01580 211131 Tel: 01580 211121

ANCHOR MARINE FILM & TELEVISION
(Boat Location, Charter, Maritime Co-ordinators)
Spikemead Farm, Poles Lane
Lowfield Heath, West Sussex RH11 0PX
e-mail: amsfilm@aol.com
Fax: 01293 551558 Tel: 01293 538188

ANELLO & DAVIDE
(Handmade Shoes)
15 St Albans Grove, London W8 5BP
Website: www.handmadeshoes.co.uk Tel: 020-7938 2255

ANGLO PACIFIC INTERNATIONAL Plc
(Freight Forwarders & Removal Services)
Unit 1, Bush Industrial Estate
Standard Road, North Acton, London NW10 6DF
Website: www.anglopacific.co.uk
Fax: 020-8965 4954 Tel: 020-8965 1234

ANIMAL ARK
(Animals & Natural History Props)
The Studio, 29 Somerset Road
Brentford, Middlesex TW8 8BT
Website: www.animal-ark.co.uk
e-mail: info@animal-ark.co.uk
Fax: 020-8560 5762 Tel: 020-8560 3029

ANNUAL CLOWNS DIRECTORY The
(Salvo The Clown)
13 Second Avenue, Kingsleigh Park
Thundersley, Essex SS7 3QD
Website: www.annualclownsdirectory.com
e-mail: salvo@annualclownsdirectory.co.uk
 Tel: 01268 745791

AQUARIUS
(Film & TV Stills Library)
PO Box 5, Hastings TN34 1HR
Website: www.aquariuscollection.com
e-mail: aquarius.lib@clara.net
Fax: 01424 717704 Tel: 01424 721196

AQUATECH
(Camera Boats)
Cobbies Rock, Epney
Gloucestershire GL2 7LN
Website: www.aquatech-uk.com
e-mail: office@aquatech-uk.com
Fax: 01452 741958 Tel: 01452 740559

ARCHERY CENTRE The
PO Box 39, Battle
East Sussex TN33 0ZT Tel: 01424 777183

ARMS & ARCHERY
(Armour, Weaponry, Chainmail, X-bows, Longbows, Tents)
The Coach House, London Road
Ware, Herts SG12 9QU
e-mail: armsandarchery@btconnect.com
Fax: 01920 461044 Tel: 01920 460335

ART*
(Art Consultant, Supplier of Paintings & Sculpture)
66 Josephine Avenue, London SW2 2LA
Website: www.artstar.clara.net
e-mail: h_artstar@hotmail.com
Fax: 07970 455956 Mobile: 07967 294985

ART DIRECTORS & TRIP PHOTO LIBRARY
(Digital Scans, Colour Slides - All Subjects)
57 Burdon Lane, Cheam, Surrey SM2 7BY
Website: www.artdirectors.co.uk
e-mail: images@artdirectors.co.uk
Fax: 020-8395 7230 Tel: 020-8642 3593

A. S. DESIGNS
(Theatrical Designer, Sets, Costumes, Heads, Masks,
Puppets etc)
Website: www.astheatricaldesign.co.uk
e-mail: maryannscadding@btinternet.com
Fax: 01279 435642 Tel: 01279 722416

ASH Riky
(Equity Registered Stunt Performer/Co-ordinator)
c/o 65 Britania Avenue, Nottingham NG6 0EA
Website: www.fallingforyou.tv
Mobile: 07850 471227 Tel: 0115-849 3470

AWESOME
(Designers & Manufacturers of Bespoke Upholstery)
The Stables, Grange Farm, Green End
Great Stukeley, Huntingdon, Cambridgeshire PE28 4AE
Website: www.awesome.eu.com
e-mail: glenn@awesome.eu.com
Fax: 01480 464879 Tel: 01480 457007

BAPTY 2000 Ltd
(Weapons, Dressing, Props etc)
Witley Works, Witley Gardens
Norwood Green, Middlesex UB2 4ES
e-mail: hire@bapty.demon.co.uk
Fax: 020-8571 5700 Tel: 020-8574 7700

BARNES CATERERS Ltd
8 Ripley Drive, Normanton, Wakefield
West Yorkshire WF6 1QT Tel/Fax: 01924 892332

BARTON Joe
(Puppeteer, Model & Prop Maker)
7 Brands Hill Avenue, High Wycombe
Buckinghamshire Tel: 01494 439056

BASINGSTOKE PRESS The
Digital House
The Loddon Centre, Wade Road
Basingstoke, Hampshire RG24 8QW
Website: www.basingstokepress.co.uk
e-mail: sales@baspress.co.uk
Fax: 01256 840383 Tel: 01256 467771

BEAT ABOUT THE BUSH Ltd
(Musical Instrument Hire)
Unit 23, Enterprise Way, Triangle Business Centre
Salter Street (Off Hythe Road)
London NW10 6UG
Website: www.beataboutthebush.com
e-mail: info@beataboutthebush.com
Fax: 020-8969 2281 Tel: 020-8960 2087

BEAVEROCK PRODUCTIONS Ltd
(Location & Transport services)
404A Glasgow Road
Clydebank, West Dunbartonshire G81 1PW
Website: www.beaverockproductions.com
e-mail: info@beaverockproductions.com
Tel/Fax: 0141-952 0437

BIANCHI AVIATION FILM SERVICES
(Historic & Other Aircraft)
Wycombe Air Park, Booker Marlow
Buckinghamshire SL7 3DP
Website: www.bianchiaviation.com
e-mail: info@bianchiaviation.com
Fax: 01494 461236 Tel: 01494 449810

BAPTY LIMITED

Props in Action...Worldwide

WEAPONRY HIRE
WITLEY WORKS, WITLEY GARDENS, NORWOOD GREEN,
MIDDLESEX UB2 4ES
TEL: 020 8574 7700 FAX: 020 8571 5700
EMAIL: HIRE@BAPTY.DEMON.CO.UK

BIDDLES Ltd
(Quality Book Binders & Printers)
Unit 24-26, Rollesby Road
Hardwick Industrial Estate
King's Lynn, Norfolk PE30 4LS
Website: www.biddles.co.uk
e-mail: enquiries@biddles.co.uk
Fax: 01553 764633 Tel: 01553 764728

BIZLEY Tim
(Paint Finishes, Graining, Marbling, Scenic Art)
10 Dollis Park, Finchley
London N3 1HG Tel: 020-8349 0195

BLUE MILL Ltd
(Dyers & Finishers)
84 Halstead Street, Leicester LE5 3RD
Website: www.bluemill.co.uk
e-mail: tom@bluemill.co.uk
Fax: 0116-253 7633 Tel: 0116-253 8534

BLUEBELL RAILWAY Plc
(Steam Locomotives, Pullman Coaches, Period Stations,
Much Film Experience)
Sheffield Park Station
East Sussex TN22 3QL
Website: www.bluebell-railway.co.uk
Fax: 01825 720804 Tel: 01825 720800

BOLD BLUE DESIGN Ltd
(Design, Web & Print)
6A Palace Gates Road, London N22 7BN
Website: www.boldblue.co.uk
e-mail: info@boldblue.co.uk
Tel: 020-8365 8522 Mobile: 07985 245971

BOLDGATE Ltd
The Crossbow Centre, 40 Liverpool Road
Slough, Berkshire SL1 4QZ
Fax: 01753 610587 Tel: 01753 610525

BOSCO LIGHTING
(Design/Technical Consultancy)
63 Nimrod Road, London SW16 6SZ
e-mail: boscolx@lineone.net Tel: 020-8769 3470

BRISTOL (UK) Ltd
(Scenic Paint & StageFloor Duo Suppliers, VFX Solutions)
Unit 3, Sutherland Court, Tolpits Lane, Watford WD18 9SP
Website: www.bristolpaint.com
Fax: 01923 779666 Tel: 01923 779333

BRITISH-FOOD-GROCERIES
(British Food Export Service for British People Working
Overseas)
46 Burrage Place, Plumstead, London SE18 7BE
Website: www.british-food-groceries.co.uk
e-mail: sales@directfoods.uk.com Tel/Fax: 01322 448272

BRODIE & MIDDLETON Ltd
(Theatrical Suppliers, Paints, Powders, Glitter etc)
68 Drury Lane, London WC2B 5SP
Website: www.brodies.net e-mail: info@brodies.net
Fax: 020-7497 0554 Tel: 020-7836 3289

BULL Richard MEDIA DIVING SERVICES Ltd
14 Townsend, Lower Almondsbury
South Gloucestershire BS32 4EN
e-mail: richard.bull6@btopenworld.com
Mobile: 07766 674356 Tel/Fax: 01454 613357

CAMDEN ATTIC
(Period Prop Hire & Making)
Location House, 5 Dove Lane, Bristol BS2 9HP
Website: www.camdenattic.co.uk
e-mail: gene.lowson@virgin.net
Fax: 0117-955 2480 Fax: 0117-941 1869

CANDLE MAKERS SUPPLIES
The Wax & Dyecraft Centre
28 Blythe Road, London W14 0HA
Website: www.candlemakers.co.uk
e-mail: candles@candlemakers.co.uk
Fax: 020-7602 2796 Tel: 020-7602 4031

CHALFONT CLEANERS & DYERS Ltd
(Dry Cleaners, Launderers & Dyers, Stage Curtains &
Costumes)
222 Baker Street, London NW1 5RT Tel: 020-7935 7316

CHEVALIER EVENT DESIGN
(Corporate Hospitality Caterers)
Studio 4-5, Garnett Close, Watford, Herts WD24 7GN
Website: www.chevalier.co.uk
e-mail: enquiries@chevalier.co.uk
Fax: 01923 211704 Tel: 01923 211703

CHRISANNE Ltd
(Specialist Fabrics & Accessories for Theatre & Dance)
Chrisanne House, 14 Locks Lane, Mitcham, Surrey CR4 2JX
Website: www.chrisanne.co.uk
e-mail: sales@chrisanne.co.uk
Fax: 020-8640 2106 Tel: 020-8640 5921

CIRCUS MANIACS
(Circus Equipment, Rigging & Training)
Office 8A, The Kingswood Foundation
Britannia Road, Kingswood, Bristol BS15 8DB
Website: www.circusmaniacs.com
e-mail: info@circusmaniacs.com
Mobile: 07977 247287 Tel/Fax: 0117-947 7042

CIRCUS PROMOTIONS
(Entertainers)
36 St Lukes Road, Tunbridge Wells
Kent TN4 9JH Tel: 01892 537964

CLARK DAVIS
(Stationery & Office Equipment)
Units 5 & 6, Meridian Trading Estate
20 Bugsbys Way Charlton, London SE7 7SJ
e-mail: info@clarkdavis.co.uk
Fax: 020-8331 2091 Tel: 020-8331 2090

CLEANING & FLAME RETARDING SERVICE The
Grove Farm, Grove Farm Road
Tolleshunt Major, Maldon, Essex CM4 8LR
Website: www.flameretarding.co.uk
e-mail: email@flameretarding.co.uk
Fax: 07092 036931 Tel: 01621 818477

COBO MEDIA Ltd
(Performing Arts, Entertainment & Leisure Marketing)
43A Garthorne Road, London SE23 1EP
Website: www.theatrenet.com
e-mail: admin@cobomedia.com
Fax: 020-8291 4969 Tel: 020-8291 7079

COLE MANSON
(Ex-Grenadier Guards. Drill Instructor)
3 Bond Street, London W4 1QZ Tel: 020-8747 3510

COMBAT THROUGH THE AGES
(Medieval Displays, Combat Display Team, Stunt Action Specialists)
110 Trafalgar Road, Portslade, East Sussex BN41 1GS
Fax: 01273 708699 Tel: 01273 411862

COMPTON Mike & Rosi
(Costumes, Props & Models)
11 Woodstock Road, Croydon, Surrey CR0 1JS
e-mail: mikeandrosicompton@btopenworld.com
Fax: 020-8681 3126 Tel: 020-8680 4364

CONCEPT ENGINEERING Ltd
(Smoke, Fog, Snow etc)
7 Woodlands Business Park, Woodlands Park Avenue
Maidenhead, Berkshire SL6 3UA
Website: www.concept-smoke.co.uk
Fax: 01628 826261 Tel: 01628 825555

COOK Sheila
(Textiles, Costumes & Accessories for Hire/Sale)
184 Westbourne Grove, London W11 2RH
e-mail: sheilacook@sheilacook.co.uk Tel: 020-7792 8001

CREATIVE WORKS UK Ltd
(Floral Design)
Unit 1, The Stable Block, Brewer Street
Bletchingley, Surrey RH1 4QP
Website: www.ckworks.net
e-mail: info@ckworks.net Tel: 01883 742999

CRESTA BLINDS Ltd
(Supplier of Vertical Blinds)
Crown Works, Tetnall Street, Dudley DY2 8SA
Website: www.crestablindsltd.co.uk
e-mail: info@crestablindsltd.co.uk
Fax: 01384 457675 Tel: 01384 255523

CROCKSHARD FARMHOUSE
(Bed & Breakfast, Contact: Nicola Ellen)
Wingham, Canterbury, Kent CT3 1NY
Website: www.crockshard.com
e-mail: crockshard_bnb@yahoo.com Tel: 01227 720464

CROFTS Andrew
(Book Writing Services)
Westlands Grange, West Grinstead
Horsham, West Sussex RH13 8LZ
Website: www.andrewcrofts.com Tel/Fax: 01403 864518

CUE ACTION POOL PROMOTIONS
(Advice for UK & US Pool, Snooker, Trick Shots)
PO Box 3941, Colchester, Essex CO2 8HN
Website: www.stevedaking.com
e-mail: sales@cueaction.com
Fax: 01206 729480 Tel: 07000 868689

DAVEY Brian
(See NOSTALGIA AMUSEMENTS)

DESIGN ASYLUM
(Design, Web & Print)
Crown House, North Circular Road
Park Royal, London NW10 7PN
Website: www.designasylum.co.uk
e-mail: info@designasylum.co.uk Tel/Fax: 020-8838 3555

DESIGN PROJECTS
Perrysfield Farm, Broadham Green
Old Oxted, Surrey RH8 9PG
Fax: 01883 723707 Tel: 01883 730262

DEVEREUX DEVELOPMENTS Ltd
(Removals, Haulage, Trucking)
Daimler Drive, Cowpen Industrial Estate
Billingham, Cleveland TS23 4JD
Fax: 01642 566664 Tel: 01642 560854

DORANS PROPMAKERS/SET BUILDERS
53 Derby Road, Ashbourne, Derbyshire DE6 1BH
Website: www.doransprops.com
e-mail: props@dorans.demon.co.uk Tel/Fax: 01335 300064

DRIVING CENTRE The
(Expert Driving Instructors on All Vehicles)
6 Marlott Road, Poole, Dorset BH15 3DX
Mobile: 07860 290437 Tel: 01202 666001

DURRENT Peter
(Audition & Rehearsal Pianist, Cocktail Pianist, Composer, Vocalist)
Blacksmiths Cottage, Bures Road, Little Cornard, Sudbury
Suffolk CO10 0NR Tel: 01787 373483

EAT TO THE BEAT
(Production & Location Caterers)
Studio 4-5, Garnett Close, Watford, Herts WD24 7GN
Website: www.eattothebeat.com
e-mail: enquiries@eattothebeat.com
Fax: 01923 211704 Tel: 01923 211702

ECCENTRIC TRADING COMPANY Ltd
(Antique Furniture & Props) incorporating COMPUHIRE
(Computer Hire)
Unit 2, Frogmore Estate, Acton Lane, London NW10 7NQ
Website: www.compuhire.com
e-mail: info@compuhire.com Tel: 020-8453 1125

ELECTRO SIGNS Ltd
97 Vallentin Road, London E17 3JJ
Fax: 020-8520 8127 Tel: 020-8521 8066

ELMS LESTERS PAINTING ROOMS
(Scenic Painting)
1-3-5 Flitcroft Street, London WC2H 8DH
e-mail: office@elmslesters.co.uk
Fax: 020-7379 0789 Tel: 020-7836 6747

ESCORT GUNLEATHER
(Custom Leathercraft)
602 High Road, Benfleet, Essex SS7 5RW
Website: www.escortgunleather.com
e-mail: info@escortgunleather.com
Fax: 01268 566775 Tel: 0870 7515957

EVANS Peter STUDIOS Ltd
(Scenic Embellishment, Vacuum Forming)
12-14 Tavistock Street, Dunstable, Bedfordshire LU6 1NE
e-mail: sales@peterevansstudios.co.uk
Fax: 01582 481329 Tel: 01582 725730

F-LOANS
Room 42, Millfield Business Centre
TM House, Ashwells Road, Brentwood, Essex CM15 9ST
Website: www.floans.co.uk
e-mail: pb@floans.co.uk
Fax: 01277 375808 Tel: 0845 0656267

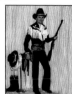

ALEX LAREDO Expert with Ropes, Bullwhips, Shooting & Riding
Also qualified **N.R.A. RANGE CONDUCTING OFFICER** at Bisley
Record Breaker
INSTRUCTOR AND TECHNICAL ADVISER TO THE STARS...
Such As: Barbara Windsor, Brian Dennehy, Toyah Willcox, Valerie Leon, Luke Baxter, Martin Henderson.
Credits: Revenge of the Pink Panther, Calamity Jane, The Milky Bar Kid, KP Rancheros, The Best Little Whorehouse in Texas,
Fool For Love, Foreign Affair, Oklahoma! **Various Tours:** U.S.A., Europe, Far East & Middle East. **TV Appearances:** Opportunity
Knocks, Larry Grayson Show, Record Breakers, Generation Game, Michael Barrymore Show, Ant & Dec, James Whale and Bonkers.
DORKING: 01306 889423

FACADE
(Musical Production Services)
43A Garthorne Road, London SE23 1EP
e-mail: facade@cobomedia.com Tel: 020-8291 7079
FAIRGROUNDS TRADITIONAL
Halstead, Fovant, Salisbury, Wiltshire SP3 5NL
Website: www.pozzy.co.uk
e-mail: s-vpostlethwaite@fovant.fsnet.co.uk
Mobile: 07710 287251 Tel: 01722 714786
FILM MEDICAL SERVICES
Units 5 & 7, Commercial Way, Park Royal, London NW10 7XF
Website: www.filmmedical.co.uk
e-mail: filmmed@aol.com
Fax: 020-8961 7427 Tel: 020-8961 3222
FIND ME ANOTHER
(Theatrical Prop Hire & Services. Gardenalia, Kitchenalia,
Dairy & Farming Bygones. Some 1960's)
(Appointment Only)
Mill Barns, c/o 10 Tenzing Grove, Luton, Bedfordshire LU1 5JJ
Website: www.findmeanother.co.uk
e-mail: info@findmeanother.co.uk
Mobile: 07885 777751 Tel/Fax: 01582 415834
FIREBRAND
(Flambeaux Hire & Sales)
Leac na ban, By Lochgilphead, Argyll PA31 8PF
e-mail: alex@firebrand.fsnet.co.uk Tel/Fax: 01546 870310
FLAMENCO PRODUCTIONS
(Entertainers)
Sevilla 4 Cormorant Rise, Lower Wick
Worcester WR2 4BA Tel: 01905 424083
FLINT HIRE & SUPPLY Ltd
Queen's Row, London SE17 2PX
Website: www.flints.co.uk
e-mail: sales@flints.co.uk
Fax: 020-7708 4189 Tel: 020-7703 9786
FLYING BY FOY
(Flying Effects for Theatre, TV, Corporate Events etc)
Unit 4, Borehamwood Enterprise Centre
Theobald Street, Borehamwood, Herts WD6 4RQ
Website: www.flyingbyfoy.co.uk
e-mail: mail@flyingbyfoy.co.uk
Fax: 020-8236 0235 Tel: 020-8236 0234
FOXTROT PRODUCTIONS Ltd
(Armoury Services, Firearms, Weapons & Costume Hire)
Unit 46 Canalot Production Studios, 222 Kensal Road
London W10 5BN Tel: 020-8964 3555
FREEDALE PRESS
(Printing)
36 Hedley StreetMaidstone, Kent ME14 5AD
e-mail: michael@freedale.co.uk
Fax: 01622 200131 Tel: 01622 200123
FROST John NEWSPAPERS
(Historical Newspaper Service)
22B Rosemary Avenue, Enfield, Middlesex EN2 0SS
Website: www.johnfrostnewspapers.com
e-mail: andrew@johnfrostnewspapers.com
Tel: 020-8366 1392

GARRATT Jonathan FRSA
(Suppliers of Unusual Garden Pots & Installations. Glazed
Tableware)
Hare Lane Farmhouse, Cranborne, Dorset BH21 5QT
Website: www.jonathangarratt.com
e-mail: jonathan.garratt@talk21.com Tel: 01725 517700
GAV NICOLA THEATRICAL FOOTWEAR
West Wick, Marshes
Burnham-on-Crouch, Essex CM0 8NE
e-mail: sale@gavnicola.freeserve.co.uk
Mobile: 07961 974278 Tel/Fax: 01621 785623
GET STUFFED
(Taxidermy)
105 Essex Road, London N1 2SL
Website: www.thegetstuffed.co.uk
e-mail: taxidermy@thegetstuffed.co.uk
Fax: 020-7359 8253 Tel: 020-7226 1364
GLOBAL CEILINGS & TILES
(Designers, Suppliers, Installers)
1B Argyle Road, Argyle Corner, Ealing, London W13 0LL
Website: www.globalceiling.co.uk
Mobile: 07976 159402 Tel: 020-8810 5914
GORGEOUS GOURMETS Ltd
(Caterers & Equipment Hire)
Gresham Way, Wimbledon SW19 8ED
Website: www.gorgeousgourmets.co.uk
e-mail: antoniaf@gorgeousgourmets.co.uk
Fax: 020-8946 1639 Tel: 020-8944 7771
GOULD Gillian ANTIQUES
(Scientific & Marine Antiques & Collectables)
18A Belsize Park Gardens
Belsize Park, London NW3 4LH
Website: www.gilliangouldantiques.co.uk
e-mail: gillgould@dealwith.com
Mobile: 07831 150060 Tel: 020-7419 0500
GRADAV HIRE & SALES Ltd
(Lighting & Sound Hire/Sales)
Units C6 & C9 Hastingwood Trading Estate
Harbet Road, Edmonton, London N18 3HU
e-mail: office@gradav.co.uk
Fax: 020-8803 5060 Tel: 020-8803 7400
GRAY Robin COMMENTARIES
(Saddles, Bridles, Racing Colours & Hunting Attire)
Comptons, Isington, Alton, Hampshire GU34 4PL
e-mail: gray@islington.fsnet.co.uk
Mobile: 07831 828424 Tel/Fax: 01420 23347
GREENPROPS
(Prop Suppliers, Artificial Trees, Plants,
Flowers, Fruit, Grass etc)
West Bovey Farm, Waterrow, Somerset TA4 2BA
Website: www.greenprops.com
e-mail: trevor@greenprops.com
Fax: 01398 361307 Tel: 01398 361531
HAMPTON COURT HOUSE
(1757 Country House & Grounds)
East Molesey KT8 9BS
Website: www.hamptoncourthouse.com
Fax: 020-8977 5357 Tel: 020-8943 0889

HANDS UP PUPPETS
c/o Peter Charlesworth & Associates
68 Old Brompton Road, London SW7 3LD
Website: www.handsupuppets.com
e-mail: handsuppuppets@btinternet.com Tel: 020-7581 2478

HARLEQUIN Plc (BRITISH HARLEQUIN Plc)
(Floors for Stage, Opera, Dance, Concert, Shows & Events)
Festival House, Chapman Way
Tunbridge Wells, Kent TN2 3EF
Website: www.harlequinfloors.com
e-mail: sales@harlequinfloors.co.uk
Fax: 01892 514222 Tel: 01892 514888

HAWES Joanne
(Children's Administrator for Theatre, Film & TV)
21 Westfield Road, Maidenhead, Berkshire SL6 5AU
e-mail: jo.hawes@virgin.net
Fax: 01628 672884 Tel: 01628 773048

HERON & DRIVER
(Scenic Furniture & Prop Makers)
Unit 7, Dockley Road Industrial Estate
Rotherhithe, London SE16 3SF
Website: www.herondriver.co.uk
e-mail: mail@herondriver.co.uk
Fax: 020-7394 8680 Tel: 020-7394 8688

HEWER Richard
(Props Maker)
7 Sion Lane, Bristol BS8 4BE Tel/Fax: 0117-973 8760

HI-FLI (Flying Effects)
2 Boland Drive, Manchester M14 6DS
e-mail: mikefrost@hi-fli.co.uk Tel/Fax: 0161-224 6082

HISTORICAL INTERPRETER & ROLE PLAYING
(Donald Clarke)
80 Warden Avenue, Rayners Lane
Harrow, Middlesex HA2 9LW
Website: www.historicalinterpretations.co.uk
Mobile: 07811 606285 Tel: 020-8866 2997

HISTORY IN THE MAKING Ltd
(Historical & Military Advisors)
2C Kirby Road, North End, Portsmouth PO2 0PA
Website: www.history-making.com Tel: 023-9265 2301

HOWARD Rex DRAPES Ltd
Acton Park Industrial Estate
Eastman Road, The Vale, London W3 7QS
e-mail: rexdrapes@yahoo.com
Fax: 020-8740 5994 Tel: 020-8740 5881

IMPACT DISTRIBUTION & MARKETING
(Leaflet & Poster Distribution & Display)
Tuscany Wharf, 4B Orsman Road, London N1 5QJ
Website: www.impact.uk.com
e-mail: admin@impact.uk.com
Fax: 020-7729 5994 Tel: 020-7729 5978

IMPACT PERCUSSION
(Percussion Instruments for Sale)
Unit 7 Goose Green Trading Estate
47 East Dulwich Road, London SE22 9BN
e-mail: sales@impactpercussion.com
Fax: 020-8299 6704 Tel: 020-8299 6700

JAPAN PROMOTIONS
(Organise Japanese Events)
200 Russell Court, 3 Woburn Place, London WC1H 0ND
Website: www.japan-promotions.co.uk
e-mail: info@japan-promotions.co.uk Tel/Fax: 020-7278 4099

JULIETTE DESIGNS
(Diamante Jewellery Manufacturer, Necklaces, Crowns etc)
90 Yerbury Road, London N19 4RS
Website: www.stagejewellery.com
Fax: 020-7281 7326 Tel: 020-7263 7878

K & D Ltd
(Footwear)
Unit 7A, Thames Road Industrial Estate
Thames Road, Silvertown, London E16 2EZ
Website: www.shoemaking.co.uk
e-mail: k&d@shoemaking.co.uk
Fax: 020-7476 5220 Tel: 020-7474 0500

KENSINGTON EYE CENTRE Ltd
(Special Eye Effects)
37 Kensington Church Street, London W8 4LL
Fax: 020-7937 8969 Tel: 020-7937 8282

KEW BRIDGE STEAM MUSEUM
(Steam Museum)
Green Dragon Lane, Brentford, Middlesex TW8 0EN
Website: www.kbsm.org e-mail: jo@kbsm.org
Fax: 020-8569 9978 Tel: 020-8568 4757

KNEBWORTH HOUSE, GARDENS & PARK
(Knebworth)
Herts SG3 6PY Tel: 01438 812661

LAREDO Alex
(Expert with Ropes, Bullwhips, Shooting, Riding)
29 Lincoln Road, Dorking, Surrey RH4 1TE
Mobile: 07906 271766 Tel: 01306 889423

LAREDO WILD WEST TOWN
(Wild West Entertainment)
1 Bower Walk, Staplehurst, Tonbridge, Kent TN12 0LU
Website: www.laredo.org.uk
e-mail: enquiries@laredo.org.uk
Mobile: 07947 652771 Tel: 01580 891790

LEES-NEWSOME Ltd
(Manufacturers of Flame Retardant Fabrics)
Ashley Street, Westwood, Oldham, Lancashire OL9 6LS
e-mail: info@leesnewsome.co.uk
Fax: 0161-627 3362 Tel: 0161-652 1321

LEIGHTON HALL
(Historic House)
Carnforth, Lancashire LA5 9ST
Website: www.leightonhall.co.uk
e-mail: info@leightonhall.co.uk
Fax: 01524 720357 Tel: 01524 734474

LEVRANT Stephen - HERITAGE ARCHITECTURE Ltd
(Historic Buildings & Interiors Consultants)
363 West End Lane, West Hampstead, London NW6 1LP
e-mail: slevrant@heritagemail.co.uk
Fax: 020-7794 9712 Tel: 020-7435 7502

LONDON BUSINESS EQUIPMENT
(Authorised Canon Dealer)
527-529 High Road
Leytonstone, London E11 4PB
Website: www.londonbusinessequipment.com
e-mail: sales@londonbusinessequipment.com
Fax: 020-8556 4865 Tel: 020-8558 0024

LONO DRINKS COMPANY The
The Hawthorns, Driffield, Cirencester
Gloucestershire GL7 5PY
Website: www.lono.co.uk
e-mail: info@lono.co.uk
Fax: 01285 850455 Tel: 01285 850682

LOS KAOS
(Street Theatre, Circus, Puppetry & Animatronics)
Crown Lodge, Tintern, Chepstow, Wales NP16 6TF
Website: www.loskaos.co.uk Tel/Fax: 01291 680074

LYON EQUIPMENT
(Petzl & Beal Rope Access Equipment (PPE) for Industrial &
Theatrical Work)
Rise Hill Mill, Dent
Sedbergh, Cumbria LA10 5QL
Website: www.lyon.co.uk
e-mail: info@lyon.co.uk
Fax: 01539 625454 Tel: 01539 625493

M A C
(Sound Hire)
1-2 Attenburys Park, Park Road
Altrincham, Cheshire WA14 5QE
Website: www.macsound.co.uk
e-mail: hire@macsound.co.uk
Fax: 0161-962 9423 Tel: 0161-969 8311

MACKIE Sally LOCATIONS
(Location Finding & Management)
Cownham Farm, Broadwell
Moreton-in-Marsh, Gloucestershire GL56 0TT
Website: www.sallymackie-locations.com
e-mail: sally@mackie.biz Tel: 01451 830294

MADDERMARKET THEATRE
(Contact Rhett Davies, Resident Stage Manager)
St John's Alley, Norwich NR2 1DR
Website: www.maddermarket.co.uk
e-mail: mmtheatre@btconnect.com
Fax: 01603 661357 Tel: 01603 626560

MAGICAL MART
(Magic, Ventriloquists' Dolls, Punch & Judy, Hire & Advising.
Callers by Appointment)
42 Christchurch Road
Sidcup, Kent DA15 7HQ
Website: www.johnstylesentertainer.co.uk
 Tel/Fax: 020-8300 3579

MARCUS HALL PROPS
80 Malyons Road
Ladywell, London SE13 7XG
Website: www.marcushallprops.com
e-mail: info@marcushallprops.com
Mobile: 07802 873127 Tel: 020-8690 2901

MARKSON PIANOS
8 Chester Court
Albany Street, London NW1 4BU
Website: www.pianosuk.co.uk
e-mail: info@pianosuk.co.uk
Fax: 020-7224 0957 Tel: 020-7935 8682

MIDNIGHT ELECTRONICS
(Sound Hire)
Off Quay Building, Foundry Lane
Newcastle upon Tyne NE6 1LH
Website: www.midnightelectronics.co.uk
e-mail: info@midnightelectronics.co.uk
Fax: 0191-224 0080 Tel: 0191-224 0088

MILITARY, MODELS & MINATURES
(Model Figures)
38A Horsell Road, London N5 1XP
Website: www.modelsculpture.com
e-mail: figsculpt@aol.com
Fax: 020-7700 4624 Tel: 020-7700 7036

MODEL BOX
(Computer Aided Design & Design Services)
2 Saddlers Way, Okehampton, Devon EX20 1TL
Website: www.modelbox.co.uk
e-mail: info@modelbox.co.uk Tel/Fax: 01837 54026

MODERNEON LONDON Ltd
(Lighting)
Cromwell House, 27 Brabourne Rise
Park Langley, Beckenham, Kent BR3 6SQ
Website: www.moderneon.org
e-mail: moderneon@tiscali.co.uk
Fax: 020-8658 2770 Tel: 020-8650 9690

MOORFIELDS PHOTOGRAPHIC Ltd
2 Old Hall Street, Liverpool L3 9RQ
Website: www.moorfieldsphoto.com
e-mail: info@moorfieldsphoto.com
Fax: 0151-236 1677 Tel: 0151-236 1611

MORTON G & L
(Horses/Farming)
Hashome Carr, Holme-on-Spalding Moor
Yorkshire YO43 4BD Tel: 01430 860393

MOULDART
(Mouldmaking, Props, Sculpture)
Trent House Studios
Trent Walk, Hanley, Stoke-on-Trent ST1 3HE
Website: www.mouldart.com
e-mail: mouldart@aol.com
Mobile: 07743 319748 Tel: 01782 209002

NEWMAN HIRE COMPANY
16 The Vale, Acton, London W3 7SB
e-mail: info@newmanhire.co.uk Tel: 020-8743 0741

NORTHERN LIGHT
Assembly Street, Leith, Edinburgh EH6 7RG
Website: www.northernlight.co.uk
e-mail: enquiries@northernlight.co.uk
Fax: 0131-622 9101 Tel: 0131-622 9100

NOSTALGIA AMUSEMENTS
(Brian Davey)
22 Greenwood Close, Thames Ditton, Surrey KT7 0BG
Mobile: 07973 506869 Tel: 020-8398 2141

**NOTTINGHAM JOUSTING ASSOCIATION SCHOOL OF
NATIONAL EQUITATION Ltd**
(Jousting & Medieval Tournaments, Horses & Riders for
Films & TV)
Bunny Hill Top, Costock
Loughborough, Leicestershire LE12 6XE
Website: www.bunny-hill.co.uk
e-mail: info@bunny-hill.co.uk
Fax: 01509 856067 Tel: 01509 852366

OCEAN LEISURE
(Scuba Diving, Watersports Retail)
11-14 Northumberland Avenue, London WC2N 5AQ
e-mail: info@oceanleisure.co.uk
Fax: 020-7930 3032 Tel: 020-7930 5050

OFFSTAGE
(Theatre & Film Bookshop)
34 Tavistock Street, London WC2E 7PB
Website: www.offstagebooks.com
e-mail: info@offstagebooks.com Tel: 020-7240 3883

P. A. LEISURE
(Specialists in Amusements & Fairground Equipment)
Delph House, Park Bridge Road
Towneley Park, Burnley, Lancs BB10 4SD
Website: www.paleisure.com
e-mail: paleisure@btconnect.com
Fax: 01282 420467 Tel: 01282 453939

PATCHETTS EQUESTRIAN CENTRE
(Location)
Hillfield Lane, Aldenham
Watford, Herts WD25 8PE
Website: www.patchetts.co.uk
Fax: 01923 859289 Tel: 01923 852255

PATERSON Helen
(Typing Services)
40 Whitelands House, London SW3 4QY
e-mail: pater@waitrose.com Tel: 020-7730 6428

PERIOD PETROL PUMP COLLECTION
c/o Diss Ironworks
7 St Nicholas Street
Diss, Norfolk IP22 4LB
Website: www.periodpetrolpump.co.uk Tel: 01379 643978

PHOSPHENE
(Lighting, Sound & Accessories. Design, Sales, Hire)
Milton Road South
Stowmarket, Suffolk IP14 1EZ
Website: www.phosphene.co.uk
e-mail: cliff@phosphene.freeserve.co.uk Tel: 01449 770011

PIANO PEOPLE The
(Piano Transport)
Website: www.pianopeople.co.uk
e-mail: info@pianopeople.co.uk
Fax: 01646 661439 Tel: 0845 6076713

PICKFORDS Ltd
Heritage House
345 Southbury Road, Enfield EN1 1UP
Fax: 020-8219 8001 Tel: 020-8219 8000

PICTURES PROPS CO Ltd
(TV, Film & Stage Hire)
12-16 Brunel Road, London W3 7XR
Fax: 020-8740 5846 Tel: 020-8749 2433

PINK POINTES DANCEWEAR
1A Suttons Lane, Hornchurch, Essex RM12 6RD
e-mail: pink.pointes@btconnect.com Tel/Fax: 01708 438584

PLAYBOARD PUPPETS
2 Ockendon Mews
London N1 3JL Tel/Fax: 020-7226 5911

PLAYHOUSE ENTERTAINMENT GROUP The
48 Langstone Road, Warstock
Birmingham B14 4QS Tel/Fax: 0121-474 6984

POLAND Anna: SCULPTOR AND MODELMAKER
(Sculpture, Models, Puppets, Masks etc)
Salterns, Old Bursledon
Southampton, Hampshire SO31 8DH
e-mail: polandanna@hotmail.com Tel: 023-8040 5166

POLLEX PROPS / FIREBRAND
(Prop Makers)
Leac na Ban, Tayvallich
Lochgilphead, Argyll PA31 8PF
e-mail: alex@firebrand.fsnet.co.uk Tel/Fax: 01546 870310

**PRAETORIAN ASSOCIATES/PROCUREMENT
SERVICES - SA**
(Personal Safety & Anti-Stalking Consultancy & services for
Film/TV industry within South Africa)
Suite 501, 2 Old Brompton Road, London SW7 3DG
Website: www.praetorianasc.com
e-mail: martin.beale@praetorianasc.com
Fax: 020-8923 7177 Tel: 020-8923 9075

PROBLOOD
11 Mount Pleasant, Framlingham
Suffolk IP13 9HQ Tel/Fax: 01728 723865

PROFESSOR PATTEN'S PUNCH & JUDY
(Hire & Performances/Advice on Traditional Show)
14 The Crest, Goffs Oak
Hertfordshire EN7 5NP
Website: www.dennispatten.co.uk Tel: 01707 873262

PROP FARM Ltd
(Pat Ward)
Grange Farm, Elmton
Nr Creswell, North Derbyshire S80 4LX
e-mail: pat/les@propfarm.co.uk
Fax: 01909 721465 Tel: 01909 723100

PROP ROTATION
41 Trelawney Road, Cotham
Bristol BS6 6DY Tel: 0117-974 1058

PROPS GALORE
(Period Textiles/Jewellery)
15 Brunel Road, London W3 7XR
e-mail: propsgalore@farley.co.uk
Fax: 020-8354 1866 Tel: 020-8746 1222

PROPS STUDIOS Ltd
Unit 3, Old Kiln Works
Ditchling Common Industrial Estate
Hassocks, East Sussex BN6 8SG
Website: www.propsstudios.co.uk
e-mail: info@propsstudios.co.uk
Fax: 0870 7700961 Tel: 0870 7700960

PUNCH & JUDY PUPPETS & BOOTHS
(Hire & Advisory Service, Callers by Appointment)
42 Christchurch Road, Sidcup, Kent DA15 7HQ
Website: www.johnstylesentertainer.co.uk
 Tel/Fax: 020-8300 3579

Q2Q Ltd
(Production Solutions)
Lyric Theatre, Shaftesbury Avenue, London W1D 7ES
Website: www.q2qgroup.com
e-mail: solutions@q2qgroupcom
Fax: 0870 9506727 Tel: 0870 9505727

RAINBOW PRODUCTIONS Ltd
(Creation & Appearances of Costume Characters/Stage
Shows)
Rainbow House, 56 Windsor Avenue, London SW19 2RR
Website: www.rainbowproductions.co.uk
e-mail: info@rainbowproductions.co.uk
Fax: 020-8545 0777 Tel: 020-8545 0700

RC-ANNIE Ltd
(For Dramatic Fight Services & Theatrical Blood Supplies)
34 Pullman Place, London SE9 6EG
Website: www.rc-annie.com
e-mail: info@rc-annie.com Tel: 020-8123 5936

RENT-A-CLOWN
(Mattie Faint)
37 Sekeforde Street, Clerkenwell
London EC1R 0HA Tel/Fax: 020-7608 0312

REPLAY Ltd
(Showreels & TV Facilities Hire)
Museum House
25 Museum Street, London WC1A 1JT
Website: www.replayfilms.co.uk
e-mail: sales@replayfilms.co.uk Tel: 020-7637 0473

RETROGRAPH NOSTALGIA ARCHIVE
(Posters & Packaging 1880-1970, Picture Library/Photo
Stills/Ephemera/Fine Arts 1870-1970)
10 Hanover Crescent, Brighton, East Sussex BN2 9SB
Website: www.retrograph.com
e-mail: jillianarb@aol.com Tel: 01273 687554

ROBERTS Chris INTERIORS
(Film Set & Property Maintenance)
17 Colebrook Lane
Loughton IG10 2HP Mobile: 07956 512074

ROOTSTEIN Adel Ltd
(Mannequin Hire)
9 Beaumont Avenue, London W14 9LP
Fax: 020-7381 3263 Tel: 020-7381 1447

ROYAL HORTICULTURAL HALLS & CONFERENCE CENTRE
(Film Location: Art Deco & Edwardian Buildings)
80 Vincent Square, London SW1P 2PE
Website: www.horticultural-halls.co.uk
e-mail: horthalls@rhs.org.uk
Fax: 020-7834 2072 Tel: 020-7828 4125

RUDKIN DESIGN
(Design Consultants, Brochures, Advertising,
Corporate etc)
10 Cottesbrooke Park, Heartlands Business Park
Daventry, Northamptonshire NN11 5YL
Website: www.rudkindesign.com
e-mail: studio@rudkindesign.com
Fax: 01327 872728 Tel: 01327 301770

RUMBLE Jane
(Props to Order, No Hire)
121 Elmstead Avenue, Wembley
Middlesex HA9 8NT Tel: 020-8904 6462

S + H TECHNICAL SUPPORTS Ltd
(Starcloths, Drapes)
Starcloth Way, Mullacourt Industrial Estate
Ilfracombe, Devon EX34 8PL
Website: www.starcloth.co.uk
e-mail: shtsg@aol.com
Fax: 01271 865423 Tel: 01271 866832

SABAH
(Stylist, Costumes, Wardrobe, Sets, Props)
2841 N. Ocean Blvd, Apt 501
Fort Lauderdale, Florida 33308 USA
e-mail: sabah561@aol.com
Mobile: (954) 383-2179 Tel/Fax: (954) 566-6219

SAPEX SCRIPTS
Millennium Studios, 5 Elstree Way
Borehamwood, Herts WD6 1SF
Website: www.sapex.co.uk
e-mail: scripts@sapex.co.uk
Fax: 020-8236 1591　　　　　　　　Tel: 020-8236 1600

SCENE TWO HIRE
(Prop Hire Specialist 50's - 70's)
Unit 1, Powergate Business Park
Volt Avenue, Park Royal NW10 6PW
Website: www.superhire.com
Fax: 020-8961 1462　　　　　　　　Tel: 020-8961 1452

SCENICS
Copse Field Farm, Cawlow Lane, Warslow
Buxton SK17 0HE　　　　　　　　　Tel: 01298 84762

SCHULTZ & WIREMU FABRIC EFFECTS
(Dyeing/Printing/Distressing)
Unit B202 Faircharm Studios
8-12 Creekside, London SE8 3DX
Website: www.schultz-wiremufabricfx.co.uk
e-mail: swfabricfx@tiscali.co.uk　　Tel/Fax: 020-8469 0151

SCRIPTRIGHT
(S.C. Hill - Script/Manuscript Typing Services/Script
Reading Services)
6 Valetta Road, London W3 7TN
e-mail: samc.hill@virgin.net
Fax: 020-8740 6486　　　　　　　　Tel: 020-8740 7303

SCRIPTS BY ARGYLE
(Play, Film & Book. Word Processing, Copying & Binding)
St John's Buildings, 43 Clerkenwell Road, London EC1M 5RS
Website: www.scriptsbyargyle.co.uk
e-mail: info@scriptsbyargyle.co.uk
Fax: 0871 4336130　　　　　　　　Tel: 020-7608 2095

SFD
Ground Floor, Sunningdale, The Belfry
Colonial Way, Watford, Herts WD24 4WH
Fax: 01923 232326　　　　　　　　Tel: 01923 232425

SHAOLIN WAY
(Martial Arts Supplies, Lion Dance & Kung Fu Instruction)
10 Little Newport Street, London WC2H 7JJ
e-mail: shaolinway@btconnect.com
Fax: 020-7287 6548　　　　　　　　Tel: 020-7734 6391

SHAOLIN WAY
21 Baron Street, Angel, London N1 9EX
e-mail: shaolinway@btconnect.com　　Tel: 020-7833 8388

SHIRLEY LEAF & PETAL COMPANY Ltd
(Flower Makers Museum)
58A High Street, Old Town, Hastings
East Sussex TN34 3EN　　　　　　Tel/Fax: 01424 427793

SIDE EFFECTS
(Props, Models & FX)
92 Fentiman Road, London SW8 1LA
e-mail: sfx@lineone.net
Fax: 020-7207 0062　　　　　　　　Tel: 020-7587 1116

SMITH Tom
(Blacksmith)
Unit 2, Lopen Works, Lopen Road
Edmonton, London N18 1PU　　　　Tel/Fax: 020-8884 2626

SNOW BUSINESS
(Snow/Winter Effects on Any Scale)
The Snow Mill, Bridge Road, Ebley
Stroud, Gloucestershire GL5 4TR
Website: www.snowfx.com
e-mail: snow@snowbusiness.com　　Tel/Fax: 01453 840077

SOFT PROPS
(Costume & Modelmakers)
92 Fentiman Road, London SW8 1LA
e-mail: jackie@softprops.co.uk
Fax: 020-7207 0062　　　　　　　　Tel: 020-7587 1116

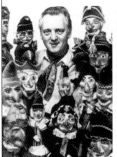

STEELDECK RENTALS/SALES Ltd
(Theatre & Staging Equipment) (Modular Staging)
King's Cross Freight Depot, York Way, London N1 0UZ
e-mail: steeldeck@aol.com
Fax: 020-7278 3403　　　　　　　　Tel: 020-7833 2031

STEVENSON Scott
(Prop Maker)
458A London Road
High Wycombe, Bucks HP11 1LP
Website: www.bodymechprops.co.uk
e-mail: scott@bodymechprops.co.uk　Mobile: 07739 378579

STIRLING Rob
(Carpentry & Joinery)
Copse Field Farm, Cawlow Lane, Warslow
Buxton SK17 0HE　　　　　　　　　Tel: 01298 84762

STUDIO & TV HIRE
(Props)
3 Ariel Way, Wood Lane
White City, London W12 7SL
Website: www.stvhire.com
e-mail: enquiries@stvhire.com
Fax: 020-8740 9662　　　　　　　　Tel: 020-8749 3445

SUPERSCRIPTS
(Audio Typing, Rushes, Post-Prod Scripts)
56 New Road, Hanworth, Middlesex TW13 6TQ
e-mail: jackie@superscripts.fsnet.co.uk
Mobile: 07971 671011　　　　　　　Tel: 020-8898 7933

SUPERSCRIPTS
14 Cambridge Grove Road
Kingston, Surrey KT1 3JJ
Mobile: 07793 160138　　　　　　　Tel: 020-8546 9824

TALK TO THE HAND PUPPETS
(Custom Puppets for Television & Theatre)
Studio 268
Wimbledon Art Studios
Riverside Yard, Riverside Road
Earlsfield, London SW17 0BB
Website: www.talktothehandproductions.com
e-mail: info@talktothehandproductions.com
Mobile: 07813 682293　　　　　　Mobile: 07855 421454

TAYLOR Charlotte
(Stylist/Props Buyer)
18 Eleanor Grove, Barnes, London SW13 0JN
e-mail: charlotte-taylor@breathemail.net
Mobile: 07836 708904　　　　　　Tel/Fax: 020-8876 9085

THEATRESEARCH
(Theatre Consultants)
Dacre Hall, Dacre, North Yorkshire HG3 4ET
Website: www.theatresearch.co.uk
e-mail: info@theatresearch.co.uk
Fax: 01423 781957　　　　　　　　Tel: 01423 780497

THEME TRADERS Ltd
(Props)
The Stadium, Oaklands Road, London NW2 6DL
Website: www.themetraders.com
e-mail: mailroom@themetraders.com
Fax: 020-8450 7322 Tel: 020-8452 8518

TOP SHOW
(Props & Scenery, Conference Specialists)
North Lane, Huntington
Yorks YO32 9SU Tel/Fax: 01904 750022

TRANSCRIPTS
(Audio + LTC/Post-prod)
#2, 6 Cornwall Gardens, London SW7 4AL
e-mail: lucy@transcripts.demon.co.uk
Mobile: 07973 200197 Tel: 020-7584 9758

TRAPEZE & AERIAL COACH/CHOREOGRAPHER
(Jacqueline Welbourne)
c/o Circus Maniacs Agency, Office 8A
The Kingswood Foundation, Britannia Road
Kingswood, Bristol BS15 8DB
Website: www.circusmaniacs.com
e-mail: jackie@circusmaniacs.com
Mobile: 07977 247287 Tel/Fax: 0117-947 7042

TRYFONOS Mary MASKS
(Mask, Headdress & Puppet Specialist)
59 Shaftesbury Road, London N19 4QW
e-mail: marytryfonos@aol.com
Mobile: 07764 587433 Tel: 020-7561 9880

TURN ON LIGHTING
(Antique Lighting c1840-1940)
116-118 Islington High Street
Camden Passage, London N1 8EG Tel/Fax: 020-7359 7616

UPSTAGE
(Event Design & Production Management)
Studio A, 7 Maidstone Building Mews
72-76 Borough High Street, London SE1 1GD
Website: www.upstagelivecom.co.uk
e-mail: post@upstagelivecom.co.uk
Fax: 020-7403 6511 Tel: 020-7403 6510

VENTRILOQUIST DOLLS HOME
(Hire & Helpful Hints, Callers by Appointment)
42 Christchurch Road, Sidcup, Kent DA15 7HQ
Website: www.johnstylesentertainer.co.uk
 Tel/Fax: 020-8300 3579

VENTRILOQUIST DUMMY HIRE
(Dennis Patten - Hire & Advice)
14 The Crest, Goffs Oak, Herts EN7 5NP
Website: www.dennispatten.co.uk Tel: 01707 873262

VINMAG ARCHIVE Ltd
84-90 Digby Road, London E9 6HX
Website: www.vinmagarchive.com
e-mail: piclib@vinmag.com
Fax: 020-8533 7283 Tel: 020-8533 7588

VISUALEYES IMAGING SERVICES
(Photographic Reproduction)
11 West Street, London WC2H 9NE
Website: www.visimaging.co.uk
e-mail: sales@visimaging.co.uk
Fax: 020-7240 0079 Tel: 020-7836 3004

VOCALEYES
(Providers of Audio Description for Theatrical Performance)
1st Floor, 54 Commercial Street, London E1 6LT
Website: www.vocaleyes.co.uk
e-mail: enquiries@vocaleyes.co.uk
Fax: 020-7247 5622 Tel: 020-7375 1043

WALK YOUR DOG
(Dog Walking Service for South East London)
35 Harold Avenue, Belvedere, Kent DA17 5NN
Website: www.walkyourdog.co.uk
e-mail: info@walkyourdog.co.uk
Mobile: 07867 502333 Tel/Fax: 01322 448272

WEBBER Peter HIRE/RITZ STUDIOS
(Music Equipment Hire, Rehearsal Studios)
110-112 Disraeli Road, London SW15 2DX
e-mail: ben@ritzstudios.com
Fax: 020-8877 1036 Tel: 020-8870 1335

WESTED LEATHERS COMPANY
(Suede & Leather Suppliers/Manufacturers)
Little Wested House, Wested Lane, Swanley, Kent BR8 8EF
e-mail: wested@wested.com
Fax: 01322 667039 Tel: 01322 660654

WESTWARD Lynn BLINDS
(Window Blind Specialist)
458 Chiswick High Road, London W4 5TT
Website: www.lynnwestward.com
Fax: 020-8742 8444 Tel: 020-8742 8333

WILLIAMS Frank
(Bottles, Jars, Footwarmers, Flagons, Spitoons, Poisons, Beers & Inks 1870-1940)
33 Enstone Road, Ickenham
Uxbridge, Middlesex
e-mail: wllmsfrn4@aol.com Tel: 01895 672495

WILTSHIRE A. F.
(Agricultural Vehicle Engineers, Repairs, etc)
The Agricultural Centre, Alfold Road
Dunsfold, Surrey GU8 4NP
e-mail: team@afwiltshire.co.uk
Fax: 01483 200491 Tel: 01483 200516

WINSHIP Geoff
Jousting Ltd, 153 Salisbury Road
Burton, Christchurch BH23 7JS
Website: www.jousting.biz
e-mail: geoff@jousting.biz Tel: 01202 483777

WORBEY Darryl STUDIOS
(Specialist Puppet Design)
Ground Floor, 33 York Grove, London SE15 2NY
e-mail: info@darrylworbeystudios.com
Fax: 020-7635 6397 Tel: 020-7639 8090

WORLD OF FANTASY
(Props and Costumes)
Swansnest, Rear of 2 Windmill Road
Hampton Hill, Middlesex TW12 1RH
Website: www.swansflight.com
e-mail: swansflight@aol.com
Fax: 020-8783 1366 Tel: 020-8941 1595

A & C BLACK (Publicity Dept)
38 Soho Square, London W1D 3HB
e-mail: publicity@acblack.com
Fax: 020-7758 0222 Tel: 020-7758 0200

ACADEMY PLAYERS DIRECTORY
(See PLAYERS DIRECTORY)

A C I D PUBLICATIONS
Room 7, Minus One House, Lyttelton Road, London E10 5NQ
e-mail: acidnews@aol.com Tel/Fax: 07050 205206

ACTING: A DRAMA STUDIO SOURCE BOOK
(Peter Owen Publishers)
73 Kenway Road, London SW5 0RE
Website: www.peterowen.com
e-mail: admin@peterowen.com Tel: 020-7373 5628

ACTIONS: THE ACTORS' THESAURUS
(By Marina Caldarone & Maggie Lloyd-Williams)
Nick Hern Books, The Glasshouse
49A Goldhawk Road, London W12 8QP
Website: www.nickhernbooks.co.uk
e-mail: info@nickhernbooks.demon.co.uk
Fax: 020-8735 0250 Tel: 020-8749 4953

ACTORS' YEARBOOK 2007
(A & C Black Publishers)
38 Soho Square, London W1D 3HB
Website: www.acblack.com
e-mail: performing@acblack.com
Fax: 020-7758 0222 Tel: 020-7758 0200

AMATEUR STAGE MAGAZINE & COMMUNITY ARTS DIRECTORY
(Platform Publications Ltd)
Hampden House, 2 Weymouth Street, London W1W 5BT
e-mail: magazine@charlesvance.co.uk
Fax: 020-7636 2323 Tel: 020-7636 4343

ANNUAIRE DU CINEMA BELLEFAYE
(French Actors' Directory, Production, Technicians & All Technical Industries & Suppliers)
30 rue Saint Marc, 75002 Paris
Website: www.bellefaye.com
e-mail: contact@bellefaye.com
Fax: 00 331 42 33 39 00 Tel: 00 331 42 33 52 52

ARTISTES & AGENTS
(Richmond House Publishing Co)
70-76 Bell Street, Marylebone, London NW1 6SP
Website: www.rhpco.co.uk
e-mail: sales@rhpco.co.uk
Fax: 020-7224 9688 Tel: 020-7224 9666

AURORA METRO PRESS (1989)
(Drama, Fiction, Reference & International Literature in English Translation)
2 Oriel Court, 106 The Green
Twickenham TW2 5AG
Website: www.aurorametro.com
e-mail: info@aurorametro.com
Fax: 020-8898 0735 Tel: 020-8898 4488

BIRTH OF THEATRE The - STAGE BY STAGE
(Drama/Theatre Studies/History/Reference)
(Peter Owen Publishers)
73 Kenway Road, London SW5 0RE
e-mail: admin@peterowen.com
Fax: 020-7373 6760 Tel: 020-7373 5628

BRITISH PERFORMING ARTS YEARBOOK
(Rhinegold Publishing)
241 Shaftesbury Avenue, London WC2H 8TF
Website: www.rhinegold.co.uk
e-mail: bpay@rhinegold.co.uk Tel: 01832 270333

BRITISH THEATRE DIRECTORY
(Richmond House Publishing Co)
70-76 Bell Street
Marylebone, London NW1 6SP
Website: www.rhpco.co.uk
e-mail: sales@rhpco.co.uk
Fax: 020-7224 9688 Tel: 020-7224 9666

BROADCAST
33-39 Bowling Green Lane, London EC1R 0DA
Website: www.broadcastnow.co.uk
Fax: 020-7505 8020 Tel: 020-7505 8014

CALDER PUBLICATIONS
(No Unsolicited Manuscripts)
51 The Cut, London SE1 8LF
e-mail: info@calderpublications.com
Fax: 020-7928 5930 Tel: 020-7633 0599

CASTCALL & CASTFAX
(Casting Information Services)
106 Wilsden Avenue, Luton LU1 5HR
Website: www.castcall.co.uk
e-mail: admin@castcall.co.uk
Fax: 01582 480736 Tel: 01582 456213

CASTWEB
7 St Luke's Avenue, London SW4 7LG
Website: www.castweb.co.uk
e-mail: info@castweb.co.uk
Fax: 020-7720 3097 Tel: 020-7720 9002

CELEBRITY BULLETIN The
4th Floor, Kingsland House
122-124 Regent Street, London W1B 5SA
e-mail: celebritylondon@aol.com
Fax: 020-7494 3500 Tel: 020-7439 9840

CELEBRITY SERVICE Ltd
4th Floor, Kingsland House
122-124 Regent Street, London W1B 5SA
e-mail: celebritylondon@aol.com
Fax: 020-7494 3500 Tel: 020-7439 9840

CHAPPELL OF BOND STREET
(Sheet Music, Musical Instruments, Pianos, Synthesizers, Keyboards)
50 New Bond Street, London W1S 1RD
Fax: 020-7491 0133 Tel: 020-7491 2777

CONFERENCE & INCENTIVE TRAVEL MAGAZINE
174 Hammersmith Road, London W6 7JP
Website: www.citmagazine.com
e-mail: cit@haynet.com
Fax: 020-8267 4192 Tel: 020-8267 4307

CREATIVE EDGE AUDIO
(Monthly CD-Roms containing interviews with key industry figures for the Professional Actor)
PO Box 999, Welwyn Garden City, Herts AL7 3DT
Website: www.creativeedgeaudio.com
e-mail: info@creativeedgeaudio.com Tel/Fax: 0845 2576108

CREATIVE HANDBOOK
(Reed Business Information)
Windsor Court, East Grinstead House
East Grinstead, West Sussex RH19 1XA
Website: www.chb.com
e-mail: chb.mktg@reedinfo.co.uk
Fax: 01342 336113 Tel: 01342 332034

DANCE EXPRESSION
(A. E. Morgan Publications Ltd)
9 West Street, Epsom, Surrey KT18 7RL
Website: www.danceexpressionmag.co.uk Tel: 01372 741411

DANCERS SPOTLIGHT
7 Leicester Place, London WC2H 7RJ
Website: www.spotlight.com
e-mail: info@spotlight.com
Fax: 020-7437 5881 Tel: 020-7437 7631

DIRECTING DRAMA
(Peter Owen Publishers)
73 Kenway Road, London SW5 0RE
Website: www.peterowen.com
e-mail: admin@peterowen.com Tel: 020-7373 5628

EQUITY MAGAZINE
Guild House, Upper St Martin's Lane, London WC2H 9EG
Website: www.equity.org.uk
e-mail: mbrown@equity.org.uk
Fax: 020-7379 6074 Tel: 020-7670 0259

FACE 2 FACE ONLINE
Website: www.f2fonline.co.uk
e-mail: info@f2fonline.co.uk

FILMLOG
(Subscriptions)
PO Box 100, Broadstairs, Kent CT10 1UJ
Tel: 01843 860885 Tel: 01843 866538

FORESIGHT
(The Profile Group (UK) Ltd)
Dragon Court, 27-29 Macklin Street, London WC2B 5LX
Website: www.foresightonline.co.uk
Fax: 020-7190 7858 Tel: 020-7190 7780

HERN Nick BOOKS
(Plays, Theatrebooks, Screenplays & Performing Rights)
The Glasshouse, 49A Goldhawk Road, London W12 8QP
Website: www.nickhernbooks.co.uk
e-mail: info@nickhernbooks.demon.co.uk
Fax: 020-8735 0250 Tel: 020-8749 4953

HOLLYWOOD REPORTER The
Endeavour House
189 Shaftesbury Avenue, London WC2H 8TJ
Website: www.hollywoodreporter.com
e-mail: london_one@eu.hollywoodreporter.com
Fax: 020-7420 6054 Tel: 020-7420 6000

KAY'S UK & EUROPEAN PRODUCTION MANUALS
Pinewood Studios, Pinewood Road
Iver Heath, Bucks SL0 0NH
Website: www.kays.co.uk
e-mail: info@kays.co.uk
Fax: 020-8960 6700 Tel: 020-8960 6900

KEMP'S FILM, TV & VIDEO
(Reed Business Information)
East Grinstead House
East Grinstead, West Sussex RH19 1XA
Website: www.kftv.com
e-mail: kemps@reedinfo.co.uk
Fax: 01342 332072 Tel: 01342 335779

KNOWLEDGE The
Harlequin Hse, 7 High St, Teddington, Middlesex TW11 8EL
Website: www.theknowledgeonline.com
e-mail: knowledge@hollis-publishing.com
Fax: 020-8943 5141 Tel: 020-8977 7711

LIMELIGHT The
(Limelight Publications, Contacts & Casting Directory)
Postal Address: PO Box 760, Randpark Ridge
2156, Gauteng, South Africa
Website: www.limelight.co.za
e-mail: info@limelight.co.za Tel/Fax: 00 27 11 793 7231

MAKE IT AMERICA
Suite 04, 1838 El Cerrito Place
Hollywood, Los Angeles, California CA90068
Website: www.makeitamerica.com
e-mail: info@makeitamerica.com
Fax: 001 (323) 436 7561 Tel: 001 (323) 404 1827

MAKING OF THE PROFESSIONAL ACTOR The
(Peter Owen Publishers)
73 Kenway Road, London SW5 0RE
Website: www.peterowen.com
e-mail: admin@peterowen.com Tel: 020-7373 5628

MOVIE MEMORIES MAGAZINE
(Devoted to Films & Stars of the 40s, 50s & 60s)
10 Russett Close, Scunthorpe, N. Lincs DN15 8YJ
Website: www.moviememoriesmagazine.com

MUSIC WEEK DIRECTORY/MUSIC WEEK
CPMi
1st Floor, Ludgate Hse, 245 Blackfriars Rd, London SE1 9UR
Website: www.musicweek.com
e-mail: mwdirectory@cmpi.biz

MUSICAL STAGES
(Musical Theatre Magazine)
Box 8365, London W14 0GL
Website: www.musicalstages.co.uk
e-mail: editor@musicalstages.co.uk Tel/Fax: 020-7603 2221

OFFICIAL LONDON SEATING PLAN GUIDE The
(Richmond House Publishing Co)
70-76 Bell Street, Marylebone, London NW1 6SP
Website: www.rhpco.co.uk
e-mail: sales@rhpco.co.uk
Fax: 020-7224 9668 Tel: 020-7224 9666

PA ENTERTAINMENT
292 Vauxhall Bridge Road, Victoria, London SW1V 1AE
Website: www.pa-entertainment.co.uk
e-mail: arts@pa-entertainment.co.uk
Fax: 020-7963 7805 Tel: 020-7963 7707

PANTOMIME BOOK The
(Peter Owen Publishers)
73 Kenway Road, London SW5 0RE
Website: www.peterowen.com
e-mail: admin@peterowen.com Tel: 020-7373 5628

PCR
(See PRODUCTION & CASTING REPORT)

PERFORMING ARTS YEARBOOK FOR EUROPE (PAYE)
(Alain Charles Arts Publishing Ltd)
27 Wilfred Street, London SW1E 6PR
Website: www.api.co.uk
e-mail: paye@alaincharles.com
Fax: 020-7973 0076 Tel: 020-7834 7676

PLAYERS DIRECTORY
2210 W. Olive Avenue, Suite 320
Burbank, California 91506
Website: www.playersdirectory.com
e-mail: info@playersdirectory.com Tel: 00 (310) 247-3058

PLAYS INTERNATIONAL
33A Lurline Gardens
London SW11 4DD Tel/Fax: 020-7720 1950

PRESENTER'S CONTACT FILE The/PRESENTER'S YEAR PLANNER The
Presenter Promotions
123 Corporation Road, Gillingham, Kent ME7 1RG
Website: www.presenterpromotions.com
e-mail: info@presenterpromotions.com Tel/Fax: 01634 851077

PRESENTERS SPOTLIGHT
7 Leicester Place, London WC2H 7RJ
Website: www.spotlight.com
e-mail: info@spotlight.com
Fax: 020-7437 5881 Tel: 020-7437 7631

PRESENTING FOR TV & VIDEO
(Joanne Zorian-Lynn, published by A & C Black)
A & C Black Customer Services
e-mail: mdl@macmillan.co.uk Tel: 01256 302692

PRODUCERS ALLIANCE FOR CINEMA & TELEVISION
(Pact Directory of Independent Producers/Art of the
Deal/Rights Clearance)
The Eye, 2nd Floor
1 Procter Street, London WC1V 6DW
Website: www.pact.co.uk
e-mail: enquiries@pact.co.uk
Fax: 020-7067 4377 Tel: 020-7067 4367

PRODUCTION & CASTING REPORT
(Editorial)
PO Box 11, London N1 7JZ
Website: www.pcrnewsletter.com
Fax: 020-7566 8284 Tel: 020-7566 8282

PRODUCTION & CASTING REPORT
(Subscriptions)
PO Box 100, Broadstairs, Kent CT10 1UJ
Website: www.pcrnewsletter.com
Tel: 01843 860885 Tel: 01843 866538

RADIO TIMES
80 Wood Lane, London W12 0TT
e-mail: radio.times@bbc.co.uk
Fax: 020-8433 3160 Tel: 020-8433 3400

RICHMOND HOUSE PUBLISHING COMPANY Ltd
70-76 Bell Street
Marylebone, London NW1 6SP
Website: www.rhpco.co.uk
e-mail: sales@rhpco.co.uk
Fax: 020-7224 9688 Tel: 020-7224 9666

ROGUES & VAGABONDS
(On-line Theatre Magazine)
13 Elm Road, London SW14 7JL
Website: www.roguesandvagabonds.co.uk
e-mail: contact@roguesandvagabonds.co.uk
 Tel: 020-8876 1175

SBS Ltd
Suite 204
254 Belsize Road, London NW6 4BT
e-mail: office@sbscasting.co.uk
Fax: 020-7372 1992 Tel: 020-7372 6337

SCREEN INTERNATIONAL
33-39 Bowling Green Lane, London EC1R 0DA
Website: www.screendaily.com
e-mail: sade.sharp@emap.com
Fax: 020-7505 8117 Tel: 020-7505 8080

SHOWCALL
47 Bermondsey Street, London SE1 3XT
Website: www.showcall.co.uk
e-mail: marcus@thestage.co.uk
Fax: 020-7378 0480 Tel: 020-7403 1818

SHOWCAST: The AUSTRALASIAN CASTING DIRECTORY
PO Box 2001, Leumeah
NSW 2560 Australia
Website: www.showcast.com.au
e-mail: brian@showcast.com.au
Fax: 02 4647 4167 Tel: 02 4647 4166

SHOWDIGS.CO.UK
PO Box 29307, Glasgow G20 0YQ
Website: www.showdigs.co.uk
e-mail: info@showdigs.co.uk Tel: 0845 4582896

SIGHT & SOUND
(British Film Institute)
21 Stephen Street, London W1T 1LN
Website: www.bfi.org.uk/sightandsound
e-mail: s&s@bfi.org.uk
Fax: 020-7436 2327 Tel: 020-7255 1444

SO YOU WANT TO BE AN ACTOR?
(By Timothy West & Prunella Scales)
Nick Hern Books
The Glasshouse, 49A Goldhawk Road, London W12 8QP
Website: www.nickhernbooks.demon.co.uk
e-mail: info@nickhernbooks.co.uk
Fax: 020-8735 0250 Tel: 020-8749 4953

SO YOU WANT TO BE A THEATRE DIRECTOR?
(By Stephen Unwin)
Nick Hern Books
The Glasshouse, 49A Goldhawk Road, London W12 8QP
Website: www.nickhernbooks.co.uk
e-mail: info@nickhernbooks.demon.co.uk
Fax: 020-8735 0250 Tel: 020-8749 4953

SPEECH FOR THE SPEAKER
(Peter Owen Publishers)
73 Kenway Road, London SW5 0RE
Website: www.peterowen.com
e-mail: admin@peterowen.com Tel: 020-7373 5628

SPOTLIGHT The
7 Leicester Place, London WC2H 7RJ
Website: www.spotlight.com
e-mail: info@spotlight.com
Fax: 020-7437 5881 Tel: 020-7437 7631

STAGE NEWSPAPER Ltd The
47 Bermondsey Street, London SE1 3XT
Website: www.thestage.co.uk
e-mail: editorial@thestage.co.uk
Fax: 020-7357 9287 Tel: 020-7403 1818

TELEVISUAL
50 Poland Street, London W1F 7AX
Website: www.televisual.com
Fax: 020-7970 6733 Tel: 020-7970 6540

THEATRE RECORD
PO Box 38159, London W10 6WN
Website: www.theatrerecord.com
e-mail: editor@theatrerecord.com
Fax: 020-8962 0655 Tel: 020-8960 0740

THEATRE REPORT
(Subscriptions)
PO Box 100, Broadstairs, Kent CT10 1UJ
Website: www.pcrnewsletter.com
Tel: 01843 860885 Tel: 01843 866538

TIME OUT GROUP Ltd
Universal House
251 Tottenham Court Road
London W1T 7AB
Website: www.timeout.com
Fax: 020-7813 6001 Tel: 020-7813 3000

TV TIMES
IPC Media
Kings Reach Tower
Stamford Street, London SE1 9LS
Fax: 020-7261 7888 Tel: 020-7261 7000

VARIETY NEWSPAPER
7th Floor
84 Theobalds Road, London WC1X 8RR
Website: www.variety.com
Fax: 020-7611 4581 Tel: 020-7611 4580

WHITE BOOK The
Bank House, 23 Warwick Road, Coventry CV1 2EW
Website: www.whitebook.co.uk
Fax: 024-7657 1172 Tel: 024-7657 1171

ABM
226 Seven Sisters Road, Finsbury Park, London N4 3GG
Website: www.theabm.com
e-mail: info@theabm.com
Fax: 0870 770 8814 Tel: 0870 770 8818

ARTHUR Leone PR
52 Tottenham Street, London W1T 4RN
Website: www.aapr.co.uk
e-mail: name@aapr.co.uk
Fax: 020-7637 2984 Tel: 020-7637 2994

ASHLEY MERRY & ASSOCIATES
Suite B, 5 South Bank Terrace, Surbiton, Surrey KT6 6DG
Website: www.ashleymerry.co.uk
e-mail: ashleymerry@aol.com
Mobile: 07715 709944 Tel/Fax: 020-8390 8535

AVALON PUBLIC RELATIONS
(Marketing/Arts)
4A Exmoor Street, London W10 6BD
e-mail: edt@avalonuk.com
Fax: 020-7598 7223 Tel: 020-7598 7222

BARLOW Tony ASSOCIATES
(Press & Marketing for Music, Dance & Theatre)
13 Burns Court, Park Hill Road, Wallington SM6 0SF
e-mail: artspublicity@hotmail.com
Mobile: 07711 929170 Tel: 020-8773 8012

BLUEPRINT PUBLIC RELATIONS
(Theatre & Television PR)
84 Turner Road, London E17 3JQ
Website: www.blueprintpr.co.uk
e-mail: kate@blueprintpr.co.uk Tel/Fax: 020-8505 9101

BOLTON Erica & QUINN Jane Ltd
10 Pottery Lane, London W11 4LZ
e-mail: name@boltonquinn.com
Fax: 020-7221 8100 Tel: 020-7221 5000

BORKOWSKI Mark PR & IMPROPERGANDA Ltd
71 Kingsway, Holborn, London WC2B 6ST
Website: www.borkowski.co.uk
e-mail: larry@borkowski.co.uk
Fax: 020-7404 5000 Tel: 020-7404 3000

CAHOOTS PRODUCTION & PR
(Denise Silvey)
11-15 Betterton Street, London WC2H 9BP
Website: www.cahootstheatre.co.uk
e-mail: denise@cahootstheatre.co.uk
Fax: 020-7379 0801 Tel: 020-7470 8812

CENTRESTAGE PUBLIC RELATIONS
Yeates Cottage
27 Wellington Terrace
Woking, Surrey GU21 2AP
e-mail: centrestagepr@talktalk.net Tel: 01483 487808

CHAPMAN Guy ASSOCIATES Ltd
(Marketing & Press Support)
33 Southampton Street, Covent Garden, London WC2E 7HE
e-mail: admin@g-c-a.co.uk
Fax: 020-7379 8484 Tel: 020-7379 7474

CHESTON Judith PUBLICITY
30 Telegraph Street, Shipston-on-Stour
Warwickshire CV36 4DA
e-mail: jcheston@tiscali.co.uk
Fax: 01608 663772 Tel: 01608 661198

CUE CONSULTANTS
18 Barrington Court, London N10 1QG
e-mail: cueconsultants@gmail.com
Mobile: 07974 704909 Tel: 020-8444 6533

DAVEY Christine ASSOCIATES
29 Victoria Road, Eton Wick
Windsor, Berkshire SL4 6LY
Fax: 01753 851123 Tel: 01753 852619

DDA PUBLIC RELATIONS Ltd
192-198 Vauxhall Bridge Road, London SW1V 1DX
Website: www.ddapr.com
e-mail: info@ddapr.com
Fax: 020-7932 4950 Tel: 020-7932 9800

ELSON Howard PROMOTIONS
(Marketing & Management)
16 Penn Avenue, Chesham
Buckinghamshire HP5 2HS
e-mail: helson1029@aol.com
Fax: 01494 784760 Tel: 01494 785873

GADABOUTS Ltd
(Theatre Marketing & Promotions)
54 Friary Road, London N12 9PB
Website: www.gadaboutstravel.com
e-mail: info@gadabouts.co.uk
Fax: 0870 7059140 Tel: 020-8445 5450

GAYNOR Avril ASSOCIATES
32 Brunswick Square
Hove, East Sussex BN3 1ED
e-mail: gaynorama@aol.com Tel/Fax: 01273 821946

GOODMAN Deborah PUBLICITY
25 Glenmere Avenue, London NW7 2LT
e-mail: publicity@dgpr.co.uk
Fax: 020-8959 7875 Tel: 020-8959 9980

HYMAN Sue ASSOCIATES Ltd
St Martin's House
59 Martin's Lane, London WC2N 4JS
Website: www.suehyman.com
e-mail: sue.hyman@btinternet.com
Fax: 020-7379 4944 Tel: 020-7379 8420

IMPACT AGENCY The
3 Bloomsbury Place, London WC1A 2QL
e-mail: mail@impactagency.co.uk
Fax: 020-7580 7200 Tel: 020-7580 1770

KEAN LANYON Ltd
(Sharon Kean)
Rose Cottage, The Aberdeen Centre
22 Highbury Grove, London N5 2EA
Website: www.keanlanyon.com
e-mail: sharon@keanlanyon.com
Fax: 020-7359 0199 Tel: 020-7354 3574

KELLER Don ARTS MARKETING
65 Glenwood Road, Harringay, London N15 3JS
e-mail: info@dakam.org.uk
Fax: 020-8809 6825 Tel: 020-8800 4882

KWPR
(Kevin Wilson Public Relations)
187 Drury Lane, London WC2B 5QD
Website: www.kwpr.co.uk
e-mail: kevinwilsonpr@gmail.com
Fax: 020-7430 0364 Tel: 020-7430 2060

LAKE-SMITH GRIFFIN ASSOCIATES
Walter House, 418 Strand, London WC2R 0PT
e-mail: info@lakesmithgriffin.co.uk
Fax: 020-7836 1040 Tel: 020-7836 1020

LEEP MARKETING & PR
(Marketing, Press and Publicity)
5 Nassau House, 122 Shaftesbury Avenue, London W1D 5ER
e-mail: philip@leep.biz
Fax: 020-7439 8833 Tel: 020-7439 9777

MAYER Anne PR
82 Mortimer Road, London N1 4LH
e-mail: annemayer@btopenworld.com
Fax: 020-7254 8227 Tel: 020-7254 7391

McAULEY ARTS MARKETING
118 Broxholm Road, London SE27 0BT
Website: www.mcauleyartsmarketing.co.uk
e-mail: sam@mcauleyartsmarketing.co.uk
Fax: 020-8670 1609 Tel: 020-8676 4773

MITCHELL Jackie
(JM Communications)
4 Sims Cottages, The Green
Claygate, Surrey KT10 0JH
Website: www.jackiem.com
e-mail: pr@jackiem.com
Fax: 01372 471073 Tel: 01372 465041

MITCHELL Sarah PARTNERSHIP The
Third Floor
87 Wardour Street, London W1F 0UA
Website: www.thesmp.com
e-mail: sarah@thesmp.com
Fax: 020-7434 1954 Tel: 020-7434 1944

MORGAN Jane ASSOCIATES (JMA)
(Marketing & Media)
8 Heathville Road, London N19 3AJ
e-mail: morgans@dircon.co.uk
Fax: 020-7263 9877 Tel: 020-7263 9867

MORGAN Kim MEDIA & MARKETING
2 Averill Street
Hammersmith, London W6 8EB
e-mail: kim@kimmorgan-pr.com
Mobile: 07939 591403 Tel/Fax: 020-7277 9559

NELSON BOSTOCK COMMUNICATIONS
Compass House, 22 Redan Place, London W2 4SA
Website: www.nelsonbostock.com
e-mail: ali.mills@nelsonbostock.com
Fax: 020-7727 2025 Tel: 020-7229 4400

NEWLEY Patrick ASSOCIATES
45 Kingscourt Road, London SW16 1JA
e-mail: patricknewley@yahoo.com Tel/Fax: 020-8677 0477

PARKER James ASSOCIATES
67 Richmond Park Road
London SW14 8JY
e-mail: jimparkerjpa@hotmail.com Tel/Fax: 020-8876 1918

POWELL Martin COMMUNICATIONS
1 Lyons Court
Long Ashton Business Park
Yanley Lane, Bristol BS41 9LB
e-mail: info@martin-powell.com
Fax: 01275 393933 Tel: 01275 394400

PREMIER PR incorporating McDONALD & RUTTER
91 Berwick Street, London W1F 0NE
Website: www.premierpr.com
Fax: 020-7734 2024 Tel: 020-7292 8330

PR PEOPLE The
1 St James Drive, Sale, Cheshire M33 7QX
e-mail: graham@pr-people.uk.com Tel: 0161-976 2729

PUBLIC EYE COMMUNICATIONS Ltd
Suite 318, Plaza
535 Kings Road, London SW10 0SZ
e-mail: ciara@publiceye.co.uk
Fax: 020-7351 1010 Tel: 020-7351 1555

RICHMOND TOWERS Ltd
26 Fitzroy Square, London W1T 6BT
Fax: 020-7388 7761 Tel: 020-7388 7421

RKM PUBLIC RELATIONS Ltd
(London. Los Angeles)
19B Grosvenor Gardens, London SW1W 0BD
Website: www.rkmpr.com
e-mail: info@rkmpr.com
Fax: 020-7821 1369 Tel: 020-7856 2233

S & X MEDIA
(Contact: Roulla Xenides)
411B The Big Peg, Vyse Street, Birmingham B18 6NF
Website: www.sx-media.com
e-mail: roulla@sx-media.com
Fax: 0121-694 6494 Tel: 0121-604 6366

SAVIDENT Paul
(Marketing & Press Management)
The Office, 27 St Dunstan's Road, London W7 2EY
Website: www.savident.com
e-mail: info@savident.com
Fax: 0870 0516418 Tel: 020-8567 2089

SHIPPEN Martin MARKETING & MEDIA
91 Dyne Road, London NW6 7DR
e-mail: m.shippen@virgin.net
Mobile: 07956 879165 Tel/Fax: 020-7372 3788

SINGER Sandra ASSOCIATES
(Corporate Services)
21 Cotswold Road
Westcliff-on-Sea, Essex SS0 8AA
Website: www.sandrasinger.com
e-mail: sandrasinger@btconnect.com
Fax: 01702 339393 Tel: 01702 331616

SMEE'S ADVERTISING Ltd
3-5 Duke Street, London W1U 3BA
Fax: 020-7935 8588 Tel: 020-7486 6644

STOTT Barbara
20 Sunbury Lane, London SW11 3NP
e-mail: b-stott@tiscali.co.uk Tel: 020-7350 1159

TAYLOR HERRING PUBLIC RELATIONS
11 Westway Centre
69 St Marks Road, London W10 6JG
Website: www.taylorherring.com
e-mail: james.herring@taylorherring.com
Fax: 020-8206 5155 Tel: 020-8206 5151

THOMPSON Peter ASSOCIATES
Flat One, 12 Bourchier Street, London W1V 5HN
Fax: 020-7439 1202 Tel: 020-7439 1210

THORNBORROW Bridget
110 Newark Street, London E1 2ES
e-mail: b.thornborrow@btinternet.com
Fax: 020-7377 6452 Tel: 020-7247 4437

TRE-VETT Eddie
Brink House, Avon Castle, Ringwood
Hampshire BH24 2BL Tel: 01425 475544

WILLIAMS Tei PRESS & ARTS MARKETING
Kensel Green Mooring
Ladbroke Grove, London W10 4SR
e-mail: artsmarketing@btconnect.com
Mobile: 07957 664116 Tel: 020-8964 5289

WILSON Stella PUBLICITY & PERSONAL MANAGEMENT
293 Faversham Road, Seasalter
Whitstable, Kent CT5 4BN
e-mail: stella@stellawilson.com Mobile: 07860 174301

WINGHAM Maureen PRESS & PUBLIC RELATIONS
PO Box 125, Stowmarket, Suffolk IP14 1PB
e-mail: maureen.wingham@mwmedia.uk.com
Tel: 01449 771200

WRIGHT Peter
(See CUE CONSULTANTS)

BBC RADIO LONDON

BBC RADIO, Broadcasting House
London W1A 1AA
Tel: 020-7580 4468 (Main Switchboard)

• DRAMA
BBC Radio Drama
Bush House
The Aldwych, London WC2B 4PH
Tel: 020-7580 4468 (Main Switchboard)

Production
Head	Alison Hindell
Production Executive	Rebecca Wilmshurst
Administrator Radio Drama Company	Cynthia Fagan

Executive Producers
World Service	Marion Nancarrow
London	Sally Avens
	David Hunter
	Toby Swift
Manchester	Sue Roberts
Birmingham	Vanessa Whitburn

Producers - London
Marc Beeby	Duncan Minshull
Steven Canny	Tracey Neale
Cherry Cookson	Jonquil Panting
Pam Fraser Solomon	Mary Peate
Claire Grove	Anne Edyvean (World Service)
Peter Kavanagh	

Producers - Manchester
Pauline Harris	Polly Thomas
Nadia Molinari	

Producers Birmingham
Naylah Ahmed (Silver Street)
Julie Beckett (Archers)
Kate Oates (Archers)
James Peries (Silver Street)
Deborah Sathe (Silver Street)
Peter Wild

Diversity Development
Director	Shabina Aslam

Development Producers
Kate Chapman (Birmingham)	Sam Hoyle
Janet Hampson (Manchester)	Conor Lennon
	Toby Swift

Writersroom
Director	Kate Rowland

BROADCAST

Radio Drama - BBC Scotland
Head	Patrick Rayner
Editor, Radio Drama	Bruce Young
Management Assistant	Sue Meek

Producers
Gaynor Macfarlane	David Jackson Young
Lu Kemp	

Radio Drama - BBC Wales
Kate McAll

Radio Drama - BBC Northern Ireland
All enquiries to Anne Simpson

It is essential that anyone undertaking a journey to the studios listed in the Routes section, double checks these routes. Owing to constant changes of rail/bus companies/operators routes may change.

[CONTACTS 2007]

• LIGHT ENTERTAINMENT/RADIO PRODUCTION

Head, Light Entertainment Radio Paul Schlesinger

Producers

Colin Anderson	Katie Marsden
Claire Bartlett	Ed Morrish
Adam Bromley	Simon Nicholls
Dawn Ellis	Will Saunders
Tilusha Ghelani	Carol Smith
Claire Jones	Katie Tyrrell
Victoria Lloyd	

Production Executive Sophie Butler
Radio Administrator Asst Mel Almond

• NEWS AND CURRENT AFFAIRS

BBC News (Television & Radio)
Television Centre
Wood Lane, London W12 7RJ
Tel: 020-8743 8000 (Main Switchboard)

Director News	Helen Boaden
Deputy Director of News	Adrian Van Klaveren
Head of Newsgathering	Fran Unsworth
Head of Political Programmes	
Research & Analysis	Sue Inglish
Head of Radio News	Steve Mitchell
Head of TV News	Peter Horrocks
Director of Sport	Roger Mosey
Controller of Children's	Richard Deverell
Executive Editor for Current Affairs	Gwyneth Williams
Head of News, Resources & Technology	Peter Coles
Head of Communications	Janie Ironside Wood

• RADIO SPORT

Head of Sport Gordon Turnbull

• CONTROLLERS

Director of Radio & Music Jenny Abramsky

RADIO 1
Controller Andy Parfitt

RADIO 2
Controller Lesley Douglas

RADIO 3
Controller Roger Wright

RADIO 4
Controller Mark Damazer

RADIO 5 LIVE
Controller Bob Shennan

• BBC NEW WRITING

BBC Writersroom
Grafton House
379-381 Euston Road
London NW1 3AU Tel: 020-7765 2703
e-mail: writersroom@bbc.co.uk
Website: www.bbc.co.uk/writersroom

Creative Director Kate Rowland
Development Manager Paul Ashton

BBC BEDFORDSHIRE, HERTFORDSHIRE & BUCKINGHAMSHIRE THREE COUNTIES RADIO
1 Hastings Street
Luton LU1 5XL
Website: www.bbc.co.uk/threecounties
e-mail: 3cr@bbc.co.uk
Fax: 01582 401467 Tel: 01582 637400
Managing Editor: Angus Mmoorat

BBC RADIO BRISTOL
PO Box 194, Bristol BS99 7QT
Website: www.bbc.co.uk/bristol
e-mail: radio.bristol@bbc.co.uk
Fax: 0117-923 8323 Tel: 0117-974 1111
Managing & News Editor: Tim Pemberton

BBC CAMBRIDGE
Broadcasting House
104 Hills Road, Cambridge CB2 1LD
Fax: 01223 460832 Tel: 01223 259696
Managing Editor: Jason Horton
Assistant Editor: Alison Dawes

BBC RADIO CLEVELAND
PO Box 95 FM
Broadcasting House, Newport Road
Middlesbrough TS1 5DG
Website: www.bbc.co.uk/tees
Fax: 01642 211356 Tel: 01642 225211
Managing Editor: Peter Cook

BBC RADIO CORNWALL
Phoenix Wharf
Truro, Cornwall TR1 1UA
Website: www.bbc.co.uk/cornwall
Fax: 01872 240679 Tel: 01872 275421
Managing Editor: Pauline Causey

BBC COVENTRY & WARWICKSHIRE
Priory Place, Coventry CV1 5SQ
Website: www.bbc.co.uk/coventry
e-mail: coventry@bbc.co.uk
Fax: 024-7655 2000 Tel: 024-7655 1000
Senior Broadcast Journalist: Tim Atkinson

BBC RADIO CUMBRIA
Annetwell Street
Carlisle, Cumbria CA3 8BB
Website: www.bbc.co.uk/radiocumbria
Fax: 01228 511195 Tel: 01228 592444
Managing Editor: Nigel Dyson

BBC RADIO DERBY
PO Box 104.5, Derby DE1 3HL
Website: www.bbc.co.uk/derby Tel: 01332 361111
Managing Editor: Simon Cornes

BBC RADIO DEVON
PO Box 1034, Plymouth PL3 5YQ
Website: www.bbc.co.uk/devon
Fax: 01752 234564 Tel: 01752 260323
Managing Editor: Robert Wallace

BBC ESSEX
PO Box 765, Chelmsford, Essex CM2 9XB
Website: www.bbc.co.uk/essex
e-mail: essex@bbc.co.uk Tel: 01245 616000
Managing Editor: Margaret Hyde

BBC RADIO GLOUCESTERSHIRE
London Road, Gloucester GL1 1SW
Website: www.bbc.co.uk/gloucestershire Tel: 01452 308585
Managing Editor: Mark Hurrell

BBC RADIO GUERNSEY
Broadcasting House
Bulwer Avenue, St Sampsons
Channel Islands GY2 4LA
Website: www.bbc.co.uk/guernsey
e-mail: radio.guernsey@bbc.co.uk
Fax: 01481 200361 Tel: 01481 200600
Senior Broadcast Journalist: Simon Alexander

BBC HEREFORD & WORCESTER
Hylton Road
Worcester WR2 5WW
Website: www.bbc.co.uk/worcester or hereford
Managing Editor: James Coghill Tel: 01905 748485

BBC RADIO HUMBERSIDE
Queens Court
Queens Gardens, Hull HU1 3RH
Website: www.bbc.co.uk/humber
e-mail: radio.humberside@bbc.co.uk
Fax: 01482 314403 Tel: 01482 323232
Editor: Simon Pattern

BBC RADIO JERSEY
18 & 21 Parade Road
St Helier, Jersey JE2 3PL
Website: www.bbc.co.uk/jersey
Fax: 01534 732569 Tel: 01534 870000
Editor: Denzil Dudley

BBC RADIO KENT
The Great Hall
Mount Pleasant Road
Tunbridge Wells, Kent TN1 1QQ
Website: www.bbc.co.uk/kent
e-mail: radio.kent@bbc.co.uk Tel: 01892 670000
Managing Editor: Paul Leaper

BBC RADIO LANCASHIRE
20-26 Darwen Street
Blackburn, Lancashire BB2 2EA
Website: www.bbc.co.uk/lancashire Tel: 01254 262411
Editor: John Clayton

BBC RADIO LEEDS
BBC Broadcasting Centre
2 St Peter's Square, Leeds LS9 8AH
Website: www.bbc.co.uk/leeds
Fax: 0113-224 7316 Tel: 0113-244 2131
Managing Editor: Phil Roberts

BBC RADIO LEICESTER
9 St Nicholas Place
Leicester LE1 5LB
Website: www.bbc.co.uk/leicester
e-mail: leicester@bbc.co.uk
Fax: 0116-251 1463 Tel: 0116-251 6688
Managing Editor: Kate Squire

BBC RADIO LINCOLNSHIRE
PO Box 219, Newport
Lincoln LN1 3XY
Website: www.bbc.co.uk/lincolnshire
Fax: 01522 511058 Tel: 01522 511411
Managing Editor: Charlie Partridge

BBC LONDON 94.9 FM
35C Marylebone High Street
London W1U 4AA
Website: www.bbc.co.uk/london Tel: 020-7224 2424
Managing Editor: David Robey
Editor: Nikki O'Donnell

BBC RADIO MANCHESTER
PO Box 951, Oxford Road, Manchester M60 1SD
Website: www.bbc.co.uk/manchester
Managing Editor: John Ryan Tel: 0161-200 2000

BBC RADIO MERSEYSIDE
PO Box 95.8, Liverpool L69 1ZJ
Website: www.bbc.co.uk/liverpool
e-mail: radio.merseyside@bbc.co.uk Tel: 0151-708 5500
Managing Editor: Mick Ord

BBC RADIO NEWCASTLE
Broadcasting Centre
Barrack Road, Newcastle upon Tyne NE99 1RN
Website: www.bbc.co.uk/tyne
Fax: 0191-232 5082 Tel: 0191-232 4141
Editor: Graham Moss

BBC RADIO NORFOLK
The Forum, Millennium Plain, Norwich NR2 1BH
Website: www.bbc.co.uk/norfolk
e-mail: radionorfolk@bbc.co.uk
Fax: 01603 284488 Tel: 01603 617411
Managing Editor: David Clayton

BBC NORTHAMPTON
Broadcasting House
Abington Street, Northampton NN1 2BH
Website: www.bbc.co.uk/northamptonshire
e-mail: northampton@bbc.co.uk
Fax: 01604 230709 Tel: 01604 239100
Manager: Laura Moss

BBC RADIO NOTTINGHAM
London Road, Nottingham NG2 4UU
Website: www.bbc.co.uk/nottingham
Fax: 0115-902 1984 Tel: 0115-955 0500
Editor: Mike Bettison
Editor News Gathering: Emma Agnew

BBC RADIO SHEFFIELD
54 Shoreham Street, Sheffield S1 4RS
Website: www.bbc.co.uk/southyorkshire
e-mail: radio.sheffield@bbc.co.uk
Fax: 0114-267 5454 Tel: 0114-273 1177
Managing Editor: Gary Keown
Senior Broadcast Journalist News: Mike Woodcock

BBC RADIO SHROPSHIRE
2-4 Boscobel Drive, Shrewsbury, Shropshire SY1 3TT
Website: www.bbc.co.uk/shropshire
e-mail: radio.shropshire@bbc.co.uk
Fax: 01743 271702 Tel: 01743 248484
Editor: Tim Beech
Senior Broadcast Journalist News: Sharon Simcock

BBC RADIO SOLENT
Broadcasting House
Havelock Road
Southampton SO14 7PW
Website: www.bbc.co.uk/hampshire
e-mail: solent@bbc.co.uk
Fax: 023-8033 9648 Tel: 023-8063 1311
Managing Editor: Mia Costello

BBC RADIO STOKE
Cheapside, Hanley, Stoke-on-Trent
Staffordshire ST1 1JJ
Website: www.bbc.co.uk/stoke
e-mail: radio.stoke@bbc.co.uk
Fax: 01782 289115 Tel: 01782 208080
Managing Editor: Sue Owen

BBC RADIO SUFFOLK
Broadcasting House
St Matthews Street, Ipswich IP1 3EP
Website: www.bbc.co.uk/suffolk
e-mail: radiosuffolk@bbc.co.uk Tel: 01473 250000
Editor: Gerald Main

SOUTHERN COUNTIES RADIO
Broadcasting Centre
Guildford, Surrey GU2 7AP
Website: www.bbc.co.uk/southerncounties
e-mail: southern.counties.radio@bbc.co.uk
Fax: 01483 304952 Tel: 01483 306306
Managing Editor: Nicci Holliday
Assistant Editor: Nick Franklin

BBC RADIO SWINDON & BBC RADIO WILTSHIRE
Broadcasting House
56-58 Prospect Place, Swindon SN1 3RW
Website: www.bbc.co.uk/wiltshire
e-mail: radio.wiltshire@bbc.co.uk
Fax: 01793 513650 Tel: 01793 513626
Manager: Tony Worgan

BBC WM
The Mailbox, Birmingham B1 1RF
Website: www.bbc.co.uk/westmidlands
e-mail: bbcwm@bbc.co.uk Tel: 0845 3009956
Editor Local Services: Keith Beech

BBC RADIO YORK
20 Bootham Row, York YO30 7BR
Website: www.bbc.co.uk/radioyork
e-mail: radio.york@bbc.co.uk
Fax: 01904 610937 Tel: 01904 641351
Managing Editor: Matt Youdale

RADIO (INDEPENDENT LOCAL)

ABERDEEN
Northsound Radio
Abbotswell Road, West Tullos, Aberdeen AB12 3AG
Website: www.northsound.co.uk
e-mail: northsound@srh.co.uk Tel: 01224 337000

AYR
West Sound FM
Radio House, 54A Holmston Road, Ayr KA7 3BE
Website: www.westsound.co.uk
e-mail: westfm@srh.co.uk Tel: 01292 283662

BELFAST
City Beat 96.7 FM
PO Box 967, Belfast BT9 5DF
Website: www.citybeat967.co.uk
e-mail: news@citybeat967.co.uk
Fax: 028-9020 0023 Tel: 028-9020 5967

BELFAST
Cool FM
PO Box 974, Belfast BT1 1RT
Website: www.coolfm.co.uk
e-mail: music@coolfm.co.uk
Fax: 028-9181 4974 Tel: 028-9181 7181

BELFAST
Downtown Radio
Newtownards, Co Down BT23 4ES
e-mail: alastair.mcdowell@downtown.co.uk
 Tel: 028-9181 5555

BERKSHIRE & NORTH HAMPSHIRE
2-Ten FM
PO Box 2020, Reading
Berkshire RG31 7FG
Website: www.2tenfm.co.uk Tel: 0118-945 4400

BIRMINGHAM
96.4 BRMB & Capital Gold
4 Oozells Square
Birmingham B1 2DJ
Website: www.brmb.co.uk
Fax: 0121-566 5209 Tel: 0121-566 2500

BORDERS The
Radio Borders Ltd
Tweedside Park
Galashiels TD1 3TD
Website: www.radioborders.com
e-mail: programming@radioborders.com
Fax: 0845 3457080 Tel: 01896 759444

BRADFORD
Sunrise Radio
55 Leeds Road, Bradford BD1 5AF
Website: www.sunriseradio.fm
Fax: 01274 728534 Tel: 01274 735043

BRADFORD, HUDDERSFIELD, HALIFAX,
KEIGHLEY, DEWSBURY
Pulse Classic Gold
Forster Square, Bradford BD1 5NE
e-mail: general@pulse.co.uk Tel: 01274 203040

BRIGHTON, EASTBOURNE & HASTINGS
Southern FM
Radio House, PO Box 2000
Brighton BN41 2SS
Website: www.southernfm.com
Fax: 01273 316909 Tel: 01273 430111

BRISTOL
GWR FM & Classic Gold 1260
1 Passage Street
PO Box 2000, Bristol BS99 7SN
Website: www.gwrfm.co.uk
Fax: 0117-984 3202 Tel: 0117-984 3200

CAMBRIDGE & NEWMARKET
Q103 FM
Q103, The Vision Park, Chivers Way
Histon, Cambridge CB4 9WW
Website: www.q103.co.uk Tel: 01223 235255

CARDIFF & NEWPORT
Red Dragon FM & Capital Gold
Atlantic Wharf
Cardiff Bay, Cardiff CF10 4DJ
Website: www.reddragonfm.com Tel: 029-2066 2066

CHESTER, NORTH WALES & WIRRAL
Marcher Group & Classic Gold
The Studios
Mold Road, Wrexham LL11 4AF
Website: www.mym.co.uk
e-mail: news@marcherradio.com Tel: 01978 752202
Programme Controller: Lisa Marley

COVENTRY
Mercia FM
Hertford Place, Coventry CV1 3TT
Website: www.musicradio.com
Fax: 024-7655 5444 Tel: 024-7686 8200

COVENTRY
Touch FM
Watch Close, Spon Street
Coventry CV1 3LN
Website: www.intouch.com
Fax: 024-7622 8270 Tel: 024-7652 5656

DUMFRIES
South West Sound FM
Unit 40, The Loreburn Centre
High Street, Dumfries DG1 2BD
Website: www.southwestsound.co.uk
Fax: 01387 265629 Tel: 01387 250999

DUNDEE & PERTH
Tay FM & Radio Tay AM
PO Box 123, 6 North Isla Street, Dundee DD3 7JQ
Website: www.radiotay.co.uk
e-mail: tayfm@radiotay.co.uk Tel: 01382 200800

EDINBURGH
Radio Forth Ltd
Forth House, Forth Street, Edinburgh EH1 3LE
Website: www.forthonline.co.uk
e-mail: info@radioforth.co.uk Tel: 0131-556 9255

EXETER & TORBAY
Gemini Radio Ltd
Hawthorn House, Exeter Business Park, Exeter EX1 3QS
Website: www.geminifm.co.uk
Fax: 01392 354249 Tel: 01392 354200

FALKIRK
Central FM
201-203 High Street, Falkirk FK1 1DU
Website: www.centralfm.co.uk
Fax: 01324 611168 Tel: 01324 611164

GLASGOW
Radio Clyde FM1 & Clyde 2 AM
3 South Avenue, Clydebank Business Park, Glasgow G81 2RX
Website: www.clydeonline.co.uk
Fax: 0141-565 2265 Tel: 0141-565 2200

GLOUCESTER & CHELTENHAM
Severn Sound, FM & Classic Gold
Bridge Studios, Eastgate Centre, Gloucester GL1 1SS
Website: www.severnsound.co.uk
Fax: 01452 572409 Tel: 01452 313200

GREAT YARMOUTH & NORWICH
Radio Broadland & Classic Gold Amber
St Georges Plain, 47-49 Colegate, Norwich NR3 1DB
Website: www.radiobroadland.co.uk
Fax: 01603 671189 Tel: 01603 630621

GUILDFORD
96.4 The Eagle FM & County Sound 1566 MW
Eagle Radio Ltd, Dolphin House
3 North Street, Guildford, Surrey GU1 4AA
e-mail: onair@964eagle.co.uk Tel: 01483 300964

HEREFORD & WORCESTER
Wyvern FM
1st Floor, Kirkham House
John Comyn Drive, Worcester WR3 7NS
Website: www.wyvern.co.uk Tel: 01905 612212

INVERNESS
Moray Firth Radio
PO Box 271, Scorguie Place, Inverness IV3 8UJ
Website: www.mfr.co.uk
e-mail: mfr@mfr.co.uk
Fax: 01463 243224 Tel: 01463 224433

IPSWICH
SGR-FM
Radio House, Alpha Business Park
Whitehouse Road, Ipswich IP1 5LT
Website: www.sgrfm.co.uk
Fax: 01473 467549 Tel: 01473 461000

ISLE OF WIGHT
Isle of Wight Radio
Dodnor Park, Newport
Isle of Wight PO30 5XE
Website: www.iwradio.co.uk
e-mail: admin@iwradio.co.uk
Fax: 01983 821690 Tel: 01983 822557

KENT
Invicta FM & Capital Gold
Radio House, John Wilson Business Park
Whitstable, Kent CT5 3QX
Website: www.invictafm.com Tel: 01227 772004

LEEDS
96.3 Radio Aire & Magic 828
51 Burley Road, Leeds LS3 1LR
Website: www.radioaire.com
Fax: 0113-283 5501 Tel: 0113-283 5500

LEICESTER, NOTTINGHAM & DERBY
Leicester: Leicester Sound
6 Dominus Way, Meridian Business Park
Leicester LE19 1RP
Website: www.classicgolddigital.com/
www.leicestersound.co.uk
Fax: 0116 256 1309 Tel: 0116-256 1300

Nottingham: 96 Trent FM & Classic Gold GEM
29-31 Castle Gate
Nottingham NG1 7AP
Website: www.musicradio.com
Fax: 0115-873 1509 Tel: 0115-873 1500

Derby: Ram FM
35-36 Irongate, Derby DE1 3GA
Website: www.trentfm.co.uk
www.ramfm.co.uk Tel: 01332 324000

LIVERPOOL
Radio City
St Johns Beacon, 1 Houghton Street, Liverpool L1 1RL
Website: www.radiocity.co.uk Tel: 0151-472 6800

LONDON
(Independent Radio News) ITN Radio
200 Gray's Inn Road, London WC1X 8XZ
Website: www.irn.co.uk
e-mail: irn@itn.co.uk Tel: 020-7430 4814

LONDON
102.2 Smooth FM
26-27 Castlereagh Street, London W1H 5DL
Website: www.smoothfm.com
e-mail: reception@smoothfm.com Tel: 020-7706 4100

LONDON
Capital Gold - London
(GCap Media Plc)
30 Leicester Square
London WC2H 7LA
Website: www.capitalradiogroup.com
Fax: 020-7766 6100 Tel: 020-7766 6810

LONDON
Choice FM
(GCap Media Plc)
30 Leicester Square, London WC2H 7LA
Website: www.choicefm.com
Fax: 020-7766 6100 Tel: 020-7766 6810

LONDON
Classic FM
(GCap Media Plc)
30 Leicester Square, London WC2H 7LA
Website: www.classicfm.com
Fax: 020-7344 2700 Tel: 020-7343 9000

LONDON
Heart 106.2 FM
The Chrysalis Building
Bramley Road, London W10 6SP
Website: www.heart1062.co.uk
Fax: 020-7470 1066 Tel: 020-7468 1062

LONDON
London Greek Radio
437 High Road, Finchley, London N12 0AP
Website: www.lgr.co.uk Tel: 020-8349 6950

LONDON
Magic 105.4 FM
Mappin House, 4 Winsley Street
London W1W 8HF
Website: www.magic.fm Tel: 020-7182 8233

LONDON
Time 106.8 FM/Time 107.3 FM
2-6 Basildon Road, London SE2 0EW Tel: 020-8311 3112

LONDON
Virgin Radio
1 Golden Square, London W1F 9DJ
Website: www.virginradio.co.uk
Fax: 020-7434 1197 Tel: 020-7434 1215

LUTON & BEDFORD
97.6 Chiltern FM & Classic Gold Digital 792/828
Broadcast Centre, Chiltern Road
Dunstable LU6 1HQ
Website: www.chilternfm.com
Fax: 01582 676251 Tel: 01582 676200

MANCHESTER
Key 103 FM & Magic 1152
Piccadilly Radio Ltd, Castle Quay
Castle Field, Manchester M15 4PR
Website: www.key103.co.uk
Fax: 0161-288 5071 Tel: 0161-288 5000

MILTON KEYNES
FM 103 Horizon
14 Vincent Avenue
Milton Keynes Broadcast Centre
Crownhill, Milton Keynes MK8 0AD
Website: www.horizonmk.co.uk Tel: 01908 269111

NORTHAMPTON
Northhants 96/Classic Gold 1557 Northamptonshire Digital
19-21 St Edmunds Road
Northampton NN1 5DT
Website: www.northants96.co.uk Tel: 01604 795600

NORTHAMPTONSHIRE
Connect FM 97.2 & 107.4 FM
Centre 2000, Robinson Close
Telford Way Industrial Estate
Kettering
Northamptonshire NN16 8PU
Website: www.connectfm.com
Fax: 01536 517390 Tel: 01536 412413

NOTTINGHAM & DERBY
96 Trent FM
29-31 Castle Gate
Nottingham NG1 7AP
e-mail: admin@musicradio.com Tel: 0115-873 1500

OXFORD & BANBURY
Fox FM
Brush House, Pony Road, Oxford OX4 2XR
Website: www.foxfm.co.uk Tel: 01865 871000

PETERBOROUGH
102.7 Hereward FM & Classic Gold
PO Box 225, Queensgate Centre
Peterborough PE1 1XJ
Website: www.hereward.co.uk Tel: 01733 460460

PLYMOUTH
Plymouth Sound & Classic Gold
Earl's Acre, Alma Road, Plymouth PL3 4HX
Website: www.musicradio.com Tel: 01752 275600

PORTSMOUTH & SOUTHAMPTON
Power, Ocean & Capital Gold
(GCap Media Plc)
Radio House, Whittle Avenue
Segensworth West, Fareham
Hampshire PO15 5SH
Website: www.powerfm.com Tel: 01489 589911

SOMERSET
Orchard FM
Haygrove House
Shoreditch, Taunton TA3 7BT
Website: www.musicradio.com Tel: 01823 338448

SOUTH MANCHESTER
Imagine FM (104.9)
Regent House, Heaton Lane
Stockport, Cheshire SK4 1BX
Website: www.imaginefm.co.uk
e-mail: info@imaginefm.net
Fax: 0161-609 1401 Tel: 0161-609 1400

STOKE-ON-TRENT & STAFFORD
Signal Radio, Stoke Road
Stoke-on-Trent, Staffordshire ST4 2SR
Website: www.signalone.co.uk
e-mail: info@signalradio.com Tel: 01782 441300

SWANSEA
96.4 FM The Wave
Victoria Road
Gowerton, Swansea SA4 3AB
Website: www.thewave.co.uk Tel: 01792 511964

TEESSIDE
TFM 96.6 & Magic 1170
Yale Crescent, Teesdale
Thornaby, Stockton on Tees TS17 6AA
Website: www.tfmradio.co.uk Tel: 01642 888222

TYNE & WEAR & NORTHUMBERLAND, DURHAM
Metro Radio
55 Degrees, Pilgrim Street
Newcastle upon Tyne NE1 6BF
Website: www.metroradio.co.uk Tel: 0191-230 6100

**WOLVERHAMPTON & BLACK COUNTRY/
SHREWSBURY & TELFORD**
West Midlands Beacon FM
267 Tettenhall Road
Wolverhampton WV6 0DE
Website: www.musicradio.co.uk Tel: 01902 461300

YORKSHIRE
Hallam FM & Magic AM
Radio House, 900 Herries Road
Hillsborough, Sheffield S6 1RH
Website: www.hallamfm.co.uk Tel: 0114-209 1000

YORKSHIRE & LINCOLNSHIRE
96.9 Viking FM & Magic 1161 AM
Commercial Road, Hull HU1 2SG
Website: www.vikingfm.co.uk Tel: 01482 325141

ABBEY ROAD STUDIOS
3 Abbey Road
St John's Wood, London NW8 9AY
Website: www.abbeyroad.com
e-mail: bookings@abbeyroad.com
Fax: 020-7266 7250 Tel: 020-7266 7000

AIR-EDEL RECORDING STUDIOS Ltd
18 Rodmarton Street
London W1U 8BJ
e-mail: trevorbest@air-edel.co.uk
Fax: 020-7224 0344 Tel: 020-7486 6466

ANGEL RECORDING STUDIOS Ltd
311 Upper Street
London N1 2TU
e-mail: angel@angelstudio.co.uk
Fax: 020-7226 9624 Tel: 020-7354 2525

ASCENT MEDIA Ltd
Film House
142 Wardour Street
London W1F 8DD
Website: www.ascentmedia.co.uk
Fax: 020-7878 7870 Tel: 020-7878 0000

BLACKHEATH HALLS
23 Lee Road
Blackheath
London SE3 9RQ
Website: www.blackheathhalls.com
e-mail: piershenderson@blackheathhalls.com
Fax: 020-8852 5154 Tel: 020-8318 9758

BLUE JOY STUDIO
12 Rutford Road
London SW16 2DH
Website: www.bluejoystudio.com
e-mail: info@bluejoystudio.com Tel: 020-8516 8804

CHANNEL 2020 Ltd
The Clerkenwell Workshops (G15)
27/31 Clerkenwell Close
London EC1R 0AT Tel: 0844 8402020

2020 House, 26-28 Talbot Lane
Leicester LE1 4LR
Website: www.channel2020.co.uk
e-mail: info@channel2020.co.uk
Fax: 0116-222 1113 Tel: 0116-233 2220

CONCEPT
PO Box 192
Liverpool L69 1JA
Website: www.soundconcept.co.uk
e-mail: info@soundconcept.co.uk Tel: 0151-522 9133

CUT GLASS PRODUCTIONS
(Voice-over Showreels/Voice-over Production)
7 Crouch Hall Road
Crouch End, London N8 8HT
Website: www.cutglassproductions.com
e-mail: phil@cutglassproductions.com
 Tel/Fax: 020-8374 4701

DE LANE LEA SOUND
(Post-Production, Re-Recording Studios)
75 Dean Street
London W1D 3PU
Website: www.delanelea.com
e-mail: dll@delanelea.com
Fax: 020-7432 3838 Tel: 020-7432 3800

ELMS STUDIOS
(Mac G5/Logic Pro 7/02RV2/Composing/Scoring for
Film & TV)
Phil Lawrence, 10 Empress Avenue, London E12 5ES
Website: www.impulse-music.co.uk/elms-studio
e-mail: phillawrence@elmsstudios.com Tel: 020-8518 8629

ESSENTIAL MUSIC
20 Great Chapel Street
London W1F 8FW
e-mail: admin@essentialmusic.co.uk
Fax: 020-7287 3597 Tel: 020-7439 7113

FARM DIGITAL POST-PRODUCTION The
27 Upper Mount Street, Dublin 2, Eire
Website: www.thefarm.ie
e-mail: info@thefarm.ie
Fax: 00 353 1 676 8816 Tel: 00 353 1 676 8812

HEAVY ENTERTAINMENT Ltd
222 Kensal Road, London W10 5BN
Website: www.heavy-entertainment.com
e-mail: info@heavy-entertainment.com
Fax: 020-8960 9003 Tel: 020-8960 9001

JMS GROUP Ltd
3 Montagu Row, London W1U 6DY
e-mail: info@jmslondon.co.uk
Fax: 020-7224 4035 Tel: 020-7224 1031

Hethersett, Norwich, Norfolk NR9 3DL
Website: www.jms-group.com
e-mail: info@jmsradio.co.uk
Fax: 01603 812255 Tel: 01603 811855

KONK STUDIOS
84-86 Tottenham Lane, London N8 7EE
e-mail: linda@konkstudios.com
Fax: 020-8348 3952 Tel: 020-8340 7873

LANSDOWNE RECORDING STUDIOS Ltd
Lansdowne House
Lansdowne Road, London W11 3LP
Website: www.cts-lansdowne.co.uk
e-mail: info@cts-lansdowne.co.uk
Fax: 020-7792 8904 Tel: 020-7727 0041

MOTIVATION SOUND STUDIOS
35A Broadhurst Gardens, London NW6 3QT
Website: www.motivationsound.co.uk
e-mail: info@motivationsound.co.uk
Fax: 020-7624 4879 Tel: 020-7328 8305

MUSIC IN MOTION Ltd
1 Reubens Court, Chaseley Drive
Chiswick, London W4 4BD
Website: www.neilmyers.com
e-mail: neil@neilmyers.com
Mobile: 07813 070961 Tel: 020-8400 3706

ORANGE ROOM MUSIC
(Recording Studios & Artist Management)
4 Kendal Court, Railway Road
Newhaven, East Sussex BN9 0AY
Website: www.orangeroommusic.co.uk
e-mail: office@orangeroommusic.co.uk
Fax: 01273 612811 Tel: 01273 612825

OTHERWISE STUDIOS
61D Gleneldon Road, London SW16 2BH
Website: www.otherwisestudios.com
e-mail: info@otherwisestudios.com Tel: 020-8769 7793

Q SOUND
Queen's Studios
117-121 Salusbury Road
London NW6 6RG
Website: www.qsound.uk.com
e-mail: info@qsound.uk.com Tel: 020-7625 5359

RED FACILITIES
61 Timberbush
Leith
Edinburgh EH6 6QH
Website: www.redfacilities.com
e-mail: doit@redfacilities.com
Fax: 0131-555 0088 Tel: 0131-555 2288

SARM WEST STUDIOS Ltd
8-10 Basing Street, London W11 1ET
Website: www.sarmstudios.com
e-mail: roxanna@spz.com
Fax: 020-7221 9247 Tel: 020-7229 1229

SHAW Bernard
(Specialist in Recording & Directing Voice Tapes)
Horton Manor
Canterbury CT4 7LG
Website: www.bernardshaw.co.uk
e-mail: bernard@bernardshaw.co.uk Tel/Fax: 01227 730843

SILVER-TONGUED PRODUCTIONS
(Specialising in the recording and production of
Voice Reels)
Website: www.silver-tongued.co.uk
e-mail: contactus@silver-tongued.co.uk Tel: 020-8309 0659

SONIC POND STUDIO
70 Mildmay Grove South
Islington, London N1 4PJ
Website: www.sonicpond.co.uk
e-mail: info@sonicpond.co.uk Tel: 020-7249 9490

SOUND COMPANY Ltd The
23 Gosfield Street, London W1W 6HG
Website: www.sound.co.uk
e-mail: info@sound.co.uk
Fax: 020-7580 6454 Tel: 020-7580 5880

SOUND CONCEPTION
The Fire Station
82-84 York Road, Bristol BS3 4AL
Website: www.soundconception.com
e-mail: soundconception@btconnect.com
Fax: 0117-963 5059 Tel: 0117-966 2932

SOUND HOUSE POST PRODUCTION Ltd The
10th Floor, Astley House
Quay Street, Manchester M3 4AE
Website: www.thesoundhouse.tv
e-mail: mail@thesoundhouse.tv
Fax: 0161-832 7266 Tel: 0161-832 7299

STUDIO AVP
82 Clifton Hill, London NW8 0JT
Fax: 020-7624 9112 Tel: 020-7624 9111

UNIVERSAL SOUND (JUST PLAY) Ltd
Old Farm Lane, London Road East
Amersham, Buckinghamshire HP7 9DH
Website: www.universalsound.co.uk
e-mail: foley@universalsound.co.uk
Fax: 01494 723500 Tel: 01494 723400

VSI - VOICE & SCRIPT INTERNATIONAL
(Foreign Language Specialists - Translation, Subtitling,
Casting, Dubbing, Recording Studios, Editing)
132 Cleveland Street, London W1T 6AB
Website: www.vsi.tv
e-mail: info@vsi.tv
Fax: 020-7692 7711 Tel: 020-7692 7700

WARWICK HALL OF SOUND
Warwick Hall, Off Banastre Avenue
Heath, Cardiff CF14 3NR
Website: www.warwickhall.co.uk
e-mail: adamstangroom@btconnect.com
 Tel/Fax: 029-2069 4455

WEST STREET STUDIOS
3 West Street, Buckingham MK18 1HL
Website: www.weststreetstudios.co.uk
e-mail: jamie@weststreetstudios.co.uk
 Tel/Fax: 01280 822564

WFS Ltd
(Sound Transfer/Optical & Magnetic)
Warwick Sound
111A Wardour Street, London W1F 0UJ
Website: www.warwicksound.com
e-mail: studio@warwicksound.com
Fax: 020-7439 0372 Tel: 020-7437 5532

WORLDWIDE SOUND Ltd
21-25 St Anne's Court
Soho, London W1F 0BJ
Website: www.worldwidegroup.ltd.uk
e-mail: sound@worldwidegroup.ltd.uk
Fax: 020-7734 0619 Tel: 020-7494 8000

3 MILLS STUDIOS
Three Mill Lane, London E3 3DU
Website: www.3mills.com
e-mail: info@3mills.com
Fax: 020-8215 3499 Tel: 020-7363 3336

ACTORS CENTRE The (LONDON)
(Audition Space Only)
1A Tower Street, London WC2H 9NP
e-mail: roomhire@actorscentre.co.uk
Fax: 020-7240 3896 Tel: 020-7632 8011

ADI The
218 Lambeth Road, London SE1 7JY
e-mail: playltd@btconnect.com
Fax: 020-7401 2816 Tel: 020-7928 6160

ALFORD HOUSE
Aveline Street, London SE11 5DQ
e-mail: tim@alfordhouse.org.uk Tel: 020-7735 1519

ALRA (Academy of Live and Recorded Arts)
The Royal Victoria Patriotic Building
Fitzhugh Grove, Trinity Road
London SW18 3SX
Website: www.alra.co.uk
e-mail: enquiries@alra.co.uk
Fax: 020-8875 0789 Tel: 020-8870 6475

AMADEUS CENTRE The
50 Shirland Road
London W9 2JA
Website: www.amadeuscentre.co.uk
e-mail: info@amadeuscentre.co.uk
Fax: 020-7266 1225 Tel: 020-7286 1686

AMERICAN CHURCH IN LONDON The
Whitefield Memorial Church
79A Tottenham Court Road
London W1T 4TD
Website: www.latchcourt.com
e-mail: latchcourt@amchurch.fsnet.co.uk
Fax: 020-7580 5013 Tel: 020-7580 2791

ARTSADMIN
Toynbee Studios
28 Commercial Street, London E1 6AB
Website: www.artsadmin.co.uk
e-mail: admin@artsadmin.co.uk
Fax: 020-7247 5103 Tel: 020-7247 5102

AVIV DANCE STUDIOS
Wren House, 1st Floor
19-23 Exchange Road, Watford WD18 6JD
Website: www.avivdance.com
e-mail: nikki@avivdance.com Tel/Fax: 01923 250000

BAC
Lavender Hill, London SW11 5TN
Website: www.bac.org.uk
e-mail: mailbox@bac.org.uk
Fax: 020-7978 5207 Tel: 020-7223 6557

BELSIZE MUSIC ROOMS
(Casting, Auditioning, Filming)
67 Belsize Lane
Hampstead, London NW3 5AX
Website: www.belsize-music-rooms.co.uk
e-mail: info@belsize-music-rooms.co.uk
Fax: 020-7916 0222 Tel: 020-7916 0111

SPOTLIGHT PUBLICATIONS
SPOTLIGHT INTERACTIVE
SPOTLIGHT SERVICES

THE SPOTLIGHT ROOMS

Spacious casting facilities and studios in the heart of the West End

- Free receptionist service
- Large waiting room
- Wireless Internet
- Video-casting on any format
- Live web-streaming
- Free online clips
- Competitive rates

www.spotlight.com/rooms
For bookings: 020 7440 5030 email: casting@spotlight.com
7 Leicester Place London WC2H 7RJ

BIG CITY STUDIOS
Montgomery House
159-161 Balls Pond Road
Islington, London N1 4BG
Website: www.pineappleagency.com
Fax: 020-7241 3006 Tel: 020-7241 6655

BRIXTON ST VINCENT'S COMMUNITY CENTRE
Talma Road, London SW2 1AS
Website: www.bsvcc.org
e-mail: carofunnell@bsvcc.org Tel: 020-7326 4417

CAST IN SPACE
27 Little Russell Street, London WC1A 2HN
Website: www.castinspace.co.uk
e-mail: castinspace@btconnect.com
Fax: 020-7404 9641 Tel: 020-7404 9637

CASTING AT SWEET
Sweet Entertainments Ltd
42 Theobalds Road, London WC1X 8NW
e-mail: casting@sweet-uk.net
Fax: 07092 863782 Tel: 020-7404 6411

CASTING STUDIOS INTERNATIONAL Ltd
Ramillies House
1-2 Ramillies Street, London W1F 7LN
Website: www.castingstudios.com
e-mail: info@castingstudios.com
Fax: 020-7437 2080 Tel: 020-7437 2070

CASTING SUITE The
8-10 Lower James Street
(Off Golden Square), London W1F 9EL
Website: www.thecastingsuite.com
e-mail: info@thecastingsuite.com
Fax: 020-7494 0803 Tel: 020-7434 2331

CECIL SHARP HOUSE
(Pat Nightingale)
2 Regent's Park Road, London NW1 7AY
Website: www.efdss.org
e-mail: hire@efdss.org
Fax: 020-7284 0534 Tel: 020-7485 2206

CENTRAL LONDON GOLF CENTRE
Burntwood Lane, London SW17 0AT
Website: www.clgc.co.uk
Fax: 020-8874 7447 Tel: 020-8871 2468

CENTRAL STUDIOS
470 Bromley Road
Bromley, Kent BR1 4PN
Website: www.dandbperformingarts.co.uk
e-mail: bonnie@dandbmanagement.com
Fax: 020-8697 8100 Tel: 020-8698 8880

CHAIN REACTION THEATRE COMPANY
Three Mills Studios
Sugar House Yard
Sugar House Lane, London E15 2QS
Website: www.chainreactiontheatre.co.uk
e-mail: mail@chainreactiontheatre.co.uk
Tel/Fax: 020-8534 0007

CHATS PALACE ARTS CENTRE
42-44 Brooksby's Walk, Hackney, London E9 6DF
Website: www.chatspalace.com
e-mail: info@chatspalace.com Tel: 020-8533 0227

CHELSEA THEATRE
World's End Place
King's Road, London SW10 0DR
Website: www.chelseatheatre.org.uk
Fax: 020-7352 2024 Tel: 020-7349 7811

CIRCUS MANIACS SCHOOL OF CIRCUS ARTS
(Circus Skills Rehearsal & Casting Facilities)
Office 8A, The Kingswood Foundation
Britannia Road, Kingswood, Bristol BS15 8DB
Website: www.circusmaniacs.com
e-mail: rehearse@circusmaniacs.com
Mobile: 07977 247287 Tel/Fax: 0117-947 7042

CLAPHAM COMMUNITY PROJECT
St Anne's Hall, Venn Street, London SW4 0BN
Website: www.rehearseatccp.co.uk
e-mail: admin@claphamcommunityproject.org.uk
 Tel/Fax: 020-7720 8731

CLEAN BREAK
2 Patshull Road, London NW5 2LB
Website: www.cleanbreak.org.uk
e-mail: general@cleanbreak.org.uk
Fax: 020-7482 8611 Tel: 020-7482 8600

CLUB FOR ACTS & ACTORS
(Incorporating Concert Artistes Association)
20 Bedford Street
London WC2E 9HP
Website: www.thecaa.org
e-mail: office@thecaa.org Tel: 020-7836 3172

COPTIC STREET STUDIO Ltd
9 Coptic Street
London WC1A 1NH
Fax: 020-7636 1414 Tel: 020-7636 2030

COVENT GARDEN CASTING SUITES & AUDITION ROOMS
Marlborough House
10 Earlham Street
London WC2H 9LN
e-mail: castingsuite@aol.com
Fax: 020-7681 0612 Tel: 020-7240 1438

REHEARSAL SPACE
...in the heart of
KENSINGTON, W.8.

Eight-minute walk from High St.
Kensington & Notting Hill Gate tube stations

Excellent facilities

Reasonable daily & weekly rates

020 7937 8885

St Mary Abbots Hall & Theatre
Vicarage Gate W8 4HN

Email: terry.pritchard@stmaryabbotschurch.org

THE ARTS THEATRE

(Great Newport Street, Leicester Square)

Rehearsal Room for Hire
Newly refurbished, 11 x 7 metres, wooden floor,
kitchenette and office space.

Music Studios for Hire
Full Back Line Provided

For information on the above Theatre Hire,
Conferences, Showcases and Play Readings contact
020 78362132 or www.artstheatrelondon.com

CRAGRATS Ltd
The Mill, Dunford Road
Holmfirth, Huddersfield HD9 2AR
Website: www.cragrats.com
e-mail: lindsay@cragrats.com
Fax: 01484 686212 Tel: 01484 686451

CUSTARD FACTORY The
Gibb Street, Digbeth, Birmingham B9 4AA
Website: www.custardfactory.co.uk
e-mail: post@custardfactory.co.uk
Fax: 0121-604 8888 Tel: 0121-224 7777

DANCE ATTIC STUDIOS
368 North End Road
London SW6 Tel: 020-7610 2055

DANCE COMPANY STUDIOS The
76 High Street, Beckenham, Kent BR3 1ED
Website: www.dancecompanystudios.co.uk
e-mail: hire@dancecompanystudios.co.uk
Fax: 020-8402 1414 Tel: 020-8402 2424

DANCEWORKS
16 Balderton Street, London W1K 6TN
Website: www.danceworks.net
Fax: 020-7629 2909 Tel: 020-7318 4100

DIGI_CAST
83 Grand Parade, Leigh-on-Sea, Essex SS9 1DR
Website: www.digicastcards.com
e-mail: gary@digicastcards.co.uk Tel: 01702 470900

DIORAMA ARTS
1 Euston Centre, London NW1 3JG
Website: www.diorama-arts.org.uk
e-mail: admin@diorama-arts.org.uk Tel: 020-7916 5467

DRILL HALL The
16 Chenies Street, London WC1E 7EX
Website: www.drillhall.co.uk
e-mail: box.office@drillhall.co.uk
Fax: 020-7307 5062 Tel: 020-7307 5060

EALING STUDIOS
Ealing Green, London W5 5EP
Website: www.ealingstudios.com
e-mail: bookings@ealingstudios.com
Fax: 020-8758 8658 Tel: 020-8567 6655

ELMS LESTERS PAINTING ROOMS
1-3-5 Flitcroft Street, London WC2H 8DH
e-mail: info@elmslester.co.uk
Fax: 020-7379 0789 Tel: 020-7836 6747

ENGLISH FOLK DANCE & SONG SOCIETY
Cecil Sharp House
2 Regent's Park Road, London NW1 7AY
Website: www.efdss.org
e-mail: info@efdss.org
Fax: 020-7284 0534 Tel: 020-7485 2206

ENGLISH NATIONAL OPERA
Lilian Baylis House
165 Broadhurst Gardens, London NW6 3AX
Website: www.eno.org
e-mail: receptionlbh@eno.org
Fax: 020-7625 3398 Tel: 020-7624 7711

ENGLISH TOURING THEATRE
25 Short Street, Waterloo, London SE1 8LJ
Website: www.ett.org.uk
e-mail: admin@ett.org.uk
Fax: 020-7450 1991 Tel: 020-7450 1990

**Lyric Hammersmith, West London's leading theatre,
now has 2 new spaces for hire...**

Rehearsal Space 1: 11.5m x 10.5m (38ft x 35ft)
Facilities include: sprung wooden floor, air-cooling, double height ceiling,
lighting rig. Comes complete with use of separate Green Room and
Production Office with access to kitchenette, PC, and Internet

Rehearsal Space 2: 13m x 9m (43ft x 30ft)
Facilities include: wooden floor, air-cooling, kitchenette

Piano, PA system, audio and video playback facilities available for hire

2 mins walk from Hammersmith Tube Station / On-site café
Lyric Square, King Street, London, W6 0QL

For prices and further
details call:
020 8741 6834
or email:
events@lyric.co.uk
www.lyric.co.uk

ESSEX HALL
Unitarian Headquarters
1-6 Essex Street, London WC2R 3HY
Fax: 020-7240 3089 Tel: 020-7240 2384

ETCETERA THEATRE
265 Camden High Street, London NW1 7BU
Website: www.etceteratheatre.com
e-mail: etc@etceteratheatre.com
Fax: 020-7482 0378 Tel: 020-7482 4857

ET-NIK-A CASTING STUDIO
30 Great Portland Street, London W1W 8QU
Website: www.et-nik-a.com/castingstudio
e-mail: castingstudio@et-nik-a.com
Fax: 020-7299 3558 Tel: 020-7299 3555

EUROKIDS & ADULTS AGENCY CASTING STUDIOS
The Warehouse Studios
Glaziers Lane, Culcheth
Warrington, Cheshire WA3 4AQ
Website: www.eka-agency.com
e-mail: info@eka-agency.com
Fax: 01925 767563 Tel: 01925 767574

EXPRESSIONS STUDIOS
Linton House, 39-51 Highgate Road, London NW5 1RS
Website: www.expressionsstudios.com
e-mail: info@expressionsstudios.com
Fax: 020-7813 1582 Tel: 020-7813 1580

FACE TO FACE STUDIOS
50 Frith Street, London W1D 4SQ
Fax: 020-7437 0308 Tel: 020-7734 6556

FACTORY DANCE CENTRE
407 Hornsey Road, London N19 4DX
e-mail: info@tangolondon.com
Fax: 020-7272 1327 Tel: 020-7272 1122

FOX CASTING STUDIOS & REHEARSAL SPACE
Pinewood Studios
Pinewood Road, Iver Heath, Bucks SL0 0NH
e-mail: info@actorsstudio.co.uk Tel: 01753 656848

FSU LONDON STUDY CENTRE
98-104 Great Russell Street, London WC1B 3LA
Fax: 020-8202 6797 Tel: 020-7813 3223

GARDEN STUDIOS The
1 Fitzroy Road, Primrose Hill, London NW1 8TU
Website: www.thegardenstudios.com
e-mail: donnaking@btopenworld.com
Mobile: 07802 939601 Tel/Fax: 020-7722 9304

HAMPSTEAD THEATRE
Eton Avenue, Swiss Cottage, London NW3 3EU
Website: www.hampsteadtheatre.com
e-mail: info@hampsteadtheatre.com
Fax: 020-7449 4201 Tel: 020-7449 4200

HAYLOFT The
The Hayloft Rehearsal Room
The Stables Gallery & Arts Centre
Brent Arts Council, Gladstone Park, Dollis Hill Lane
London NW2 6HT Tel: 020-8452 8655

HER MAJESTY'S THEATRE
(Michael Townsend)
Haymarket, London SW1Y 4QL
Website: www.rutheatres.com
e-mail: mike.townsend@rutheatres.com Tel: 020-7494 5200

HOLY INNOCENTS CHURCH
Paddenswick Road, London W6 0UB
e-mail: innocent@fish.co.uk
Fax: 020-8563 8735 Tel: 020-8748 2286

HOPE STREET Ltd
13A Hope Street, Liverpool L1 9BQ
Website: www.hope-street.org
e-mail: arts@hope-street.org
Fax: 0151-709 3242 Tel: 0151-708 8007

HOXTON HALL THEATRE & YOUTH ARTS CENTRE
130 Hoxton Street, London N1 6SH
Website: www.hoxtonhall.co.uk
e-mail: admin@hoxtonhall.co.uk
Fax: 020-7729 3815 Tel: 020-7684 0060

IMT SPACE Ltd
Unit 2, 210 Cambridge Heath Road, London E2 9NQ
Website: www.imagemusictext.com
e-mail: mail@imagemusictext.com Tel: 020-8980 5475

ISLINGTON ARTS FACTORY
2 Parkhurst Road, London N7 0SF
Website: www.islingtonartsfactory.org.uk
e-mail: iaf@islingtonartsfactory.fsnet.co.uk
Fax: 020-7700 7229 Tel: 020-7607 0561

JACKSONS LANE
(Various Spaces incl Rehearsal Rooms & Theatre Hire)
269A Archway Road, London N6 5AA
Website: www.jacksonslane.org.uk
e-mail: mail@jacksonslane.org.uk
Tel: 020-8340 5226 Tel: 020-8340 8902

JERWOOD SPACE
171 Union Street, London SE1 0LN
Website: www.jerwoodspace.co.uk
e-mail: space@jerwoodspace.co.uk
Fax: 020-7654 0172 Tel: 020-7654 0171

K M C AGENCIES
PO Box 122, 48 Great Ancoats Street, Manchester M4 5AB
Website: www.kmcagencies.co.uk
e-mail: casting@kmcagencies.co.uk
Fax: 0161-237 9812 Tel: 0161-237 3009

LA MAISON VERTE
31 Avenue Henri Mas, 34320 Roujan, France
Website: www.lamaisonverte.co.uk
e-mail: nicole.russell@wanadoo.fr Tel: 00 33 4 67 24 88 52

LIVE THEATRE
27 Broad Chare, Quayside, Newcastle upon Tyne NE1 3DQ
Website: www.live.org.uk
e-mail: info@live.org.uk Tel: 0191-261 2694

LONDON BUBBLE THEATRE COMPANY Ltd
5 Elephant Lane, London SE16 4JD
Website: www.londonbubble.org.uk
e-mail: admin@londonbubble.org.uk
Fax: 020-7231 2366 Tel: 020-7237 4434

LONDON SCHOOL OF CAPOEIRA
Units 1 & 2 Leeds Place, Tollington Park, London N4 3RF
Website: www.londonschoolofcapoeira.co.uk
e-mail: info@londonschoolofcapoeira.co.uk
 Tel: 020-7281 2020

LONDON STUDIO CENTRE
42-50 York Way, London N1 9AB
e-mail: info@london-studio-centre.co.uk
Fax: 020-7837 3248 Tel: 020-7837 7741

LONDON WELSH TRUST Ltd
157-163 Gray's Inn Road, London WC1X 8UE
Fax: 020-7837 6268 Tel: 020-7837 3722

LYRIC HAMMERSMITH
Lyric Square, King Street, London W6 0QL
Website: www.lyric.co.uk
e-mail: enquiries@lyric.co.uk
Fax: 020-8741 5965 Tel: 08700 500511

MACKINTOSH Cameron REHEARSAL STUDIO
The Tricycle
269 Kilburn High Road, London NW6 7JR
Website: www.tricycle.co.uk
e-mail: trish@tricycle.co.uk
Fax: 020-7328 0795 Tel: 020-7372 6611

MADDERMARKET THEATRE
St John's Alley
Norwich, Norfolk NR2 1DR
Website: www.maddermarket.co.uk
e-mail: mmtheatre@btconnect.com
Fax: 01603 661357 Tel: 01603 626560

MARIA ASSUMPTA CENTRE
23 Kensington Square, London W8 5HN
Website: www.maria-assumpta.org.uk
e-mail: conf@maria-assumpta.org.uk Tel: 020-7361 4704

MOBERLY SPORTS & EDUCATION CENTRE
Kilburn Lane, London W10 4AH
Fax: 020-7641 5878 Tel: 020-7641 4807

MOUNTVIEW
Academy of Theatre Arts
Ralph Richardson Memorial Studios
Kingfisher Place, Clarendon Road, London N22 6XF
Website: www.mountview.ac.uk
e-mail: enquiries@mountview.ac.uk
Fax: 020-8829 0034 Tel: 020-8881 2201

NATIONAL YOUTH THEATRE OF GREAT BRITAIN
443-445 Holloway Road, London N7 6LW
Website: www.nyt.org.uk
e-mail: info@nyt.org.uk
Fax: 020-7281 8246 Tel: 020-7281 3863

NETTLEFOLD The
West Norwood Library Centre
1 Norwood High Street, London SE27 9JX
e-mail: thenettlefold@lambeth.gov.uk
Fax: 020-7926 8071 Tel: 020-7926 8070

NEW PLAYERS THEATRE
The Arches, Off Villiers Street
London WC2N 6NG
Website: www.newplayerstheatre.com
e-mail: info@newplayerstheatre.com
Fax: 08456 382102 Tel: 020-7930 6601

NORTH LONDON PERFORMING ARTS CENTRE
(Production & Casting Office Facilities)
76 St James Lane, Muswell Hill, London N10 3DF
Website: www.nlpac.co.uk
e-mail: nlpac@aol.com
Fax: 020-8444 4040 Tel: 020-8444 4544

NOUGHTE CASTING STUDIO
c/o Nought E Casting Studios
45 Poland Street, London W1F 7NA
e-mail: alicia.w@noughte.co.uk
Fax: 020-7437 2830 Tel: 020-7437 2823

OCTOBER GALLERY
24 Old Gloucester Street, London WC1N 3AL
Website: www.octobergallery.co.uk
e-mail: rentals@octobergallery.co.uk
Fax: 020-7405 1851 Tel: 020-7831 1618

OLD VIC THEATRE
The Cut, Waterloo Road, London SE1 8NB
Website: www.oldvictheatre.com Tel: 020-7928 2651

OPEN DOOR COMMUNITY CENTRE
Beaumont Road, Wimbledon SW19 6TF
Website: www.wandsworth.gov.uk
e-mail: opendoor@wandsworth.gov.uk
Tel/Fax: 020-8871 8174

OUT OF JOINT
7 Thane Works, Thane Villas, London N7 7NU
Website: www.outofjoint.co.uk
e-mail: ojo@outofjoint.co.uk
Fax: 020-7609 0203 Tel: 020-7609 0207

OVAL HOUSE
52-54 Kennington Oval, London SE11 5SW
Website: www.ovalhouse.com
e-mail: info@ovalhouse.com Tel: 020-7582 0080

PAINES PLOUGH AUDITION SPACE
4th Floor, 43 Aldwych, London WC2B 4DN
Website: www.painesplough.com
e-mail: office@painesplough.com
Fax: 020-7240 4534 Tel: 020-7240 4533

PEOPLE SHOW
People Show Studios
Pollard Row, London E2 6NB
Website: www.peopleshow.co.uk
e-mail: people@peopleshow.co.uk
Fax: 020-7739 0203 Tel: 020-7729 1841

PHA
Tanzaro House, Ardwick Green North
Manchester M12 6FZ
Website: www.pha-agency.co.uk
e-mail: info@pha-agency.co.uk
Fax: 0161-273 4567 Tel: 0161-273 4444

PINEAPPLE DANCE STUDIOS
7 Langley Street, London WC2H 9JA
Website: www.pineapple.uk.com
e-mail: studios@pineapple.uk.com
Fax: 020-7836 0803 Tel: 020-7836 4004

PLACE The
Robin Howard Dance Theatre
17 Duke's Road, London WC1H 9PY
Website: www.theplace.org.uk
e-mail: info@theplace.org.uk
Fax: 020-7121 1142 Tel: 020-7121 1000

PLAYGROUND STUDIO The
Unit 8, Latimer Road, London W10 6RQ
Website: www.the-playground.co.uk
e-mail: info@the-playground.co.uk Tel/Fax: 020-8960 0110

POOR SCHOOL The
242 Pentonville Road
London N1 9JY Tel: 020-7837 6030

PRECINCT THEATRE The
Units 2/3 The Precinct, Packington Square, London N1 7UP
Website: www.breakalegman.com
e-mail: reima@breakalegman.com
Fax: 020-7359 3660 Tel: 020-7359 3594

PUPPET CENTRE TRUST
BAC Lavender Hill, London SW11 5TN
Website: www.puppetcentre.org.uk
e-mail: space@puppetcentre.org.uk Tel: 020-7228 5335

QUESTORS THEATRE EALING The
12 Mattock Lane, London W5 5BQ
Website: www.questors.org.uk
e-mail: alice@questors.org.uk
Fax: 020-8567 8736 Tel: 020-8567 0011

QUICKSILVER THEATRE
The Glasshouse, 4 Enfield Road, London N1 5AZ
Website: www.quicksilvertheatre.org
e-mail: talktous@quicksilvertheatre.org
Fax: 020-7254 3119 Tel: 020-7241 2942

RAMBERT DANCE COMPANY
(Claire Drakeley)
94 Chiswick High Road, London W4 1SH
Website: www.rambert.org.uk
e-mail: rdc@rambert.org.uk
Fax: 020-8747 8323 Tel: 020-8630 0601

REALLY USEFUL THEATRES
(Michael Townsend)
22 Tower Street, London WC2H 9TW
Website: www.rutheatres.com
e-mail: mike.townsend@rutheatres.com
Fax: 020-7240 1292 Tel: 020-7240 0880

RED ONION DANCE STUDIO
25 Hilton Grove, Hilton Grove Business Centre
Hatherley Mews, London E17 4QP
Website: www.redonion-uk.com
e-mail: info@redonion-uk.com
Fax: 020-8521 6646 Tel: 020-8520 3975

RIDGEWAY STUDIOS
Fairley House, Andrews Lane, Cheshunt, Herts EN7 6LB
Fax: 01992 633844 Tel: 01992 633775

ROOFTOP STUDIO THEATRE
Rooftop Studio, Somerfield Arcade
Stone, Staffordshire ST15 8AU
Website: www.rooftopstudio.co.uk
Fax: 01785 818176 Tel: 01785 761233

The Playground Studio
2,500sq.ft beautiful rehearsal space
London W10

Sprung Floor
Mirrored Wall
Natural Day Light

www.the-playground.co.uk
info@the-playground.co.uk
T: 020 8960 0110

The Playground

ROTHERHITHE STUDIOS
119 Rotherhithe Street, London SE16 4NF
Website: www.sandsfilms.co.uk
e-mail: ostockman@sandsfilms.co.uk
Fax: 020-7231 2119 Tel: 020-7231 2209

ROYAL ACADEMY OF DANCE
36 Battersea Square, London SW11 3RA
Website: www.rad.org.uk
e-mail: info@rad.org.uk
Fax: 020-7924 3129 Tel: 020-7326 8000

ROYAL SHAKESPEARE COMPANY
35 Clapham High Street
London SW4 7TW
e-mail: london@rsc.org.uk
Fax: 020-7845 0505 Tel: 020-7845 0500

SADLER'S WELLS
Rosebery Avenue, London EC1R 4TN
Website: www.sadlerswells.com
e-mail: events@sadlerswells.com
Fax: 020-7863 8061 Tel: 020-7863 8065

SEA CADET DRILL HALL
Fairways, Off Broom Road
Teddington TW11 9PL Tel: 01784 241020

SEBBON STREET COMMUNITY CENTRE
Sebbon St, Islington, London N1 2DZ Tel: 020-7354 2015

SHARED EXPERIENCE THEATRE
The Soho Laundry, 9 Dufours Place, London W1F 7SJ
Website: www.sharedexperience.org.uk
e-mail: admin@sharedexperience.org.uk
Fax: 020-7287 8763 Tel: 020-7734 8570

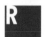

SOHO GYMS
Earl's Court Gym
254 Earl's Court Road
London SW5 9AD
Website: www.sohogyms.com
Fax: 020-7244 6893 Tel: 020-7370 1402

Camden Town Gym
193-199 Camden High Street
London NW1 7JY
Fax: 020-7267 0500 Tel: 020-7482 4524

Clapham Common Gym
95-97 Clapham High Street
London SW4 7TB
Fax: 020-7720 6510 Tel: 020-7720 0321

Covent Garden Gym
12 Macklin Street
London WC2B 5NF
Fax: 020-7242 0899 Tel: 020-7242 1290

SOHO THEATRE
21 Dean Street, London W1D 3NE
e-mail: erin@sohotheatre.com
Fax: 020-7287 5061 Tel: 020-7478 0117

SOUTHALL COMMUNITY CENTRE
(Rehearsal/Location Work)
20 Merrick Road, Southall, London UB2 4AU
Fax: 020-8574 3459 Tel: 020-8574 3458

SPACE ARTS CENTRE The
269 Westferry Road, London E14 3RS
Website: www.space.org.uk
e-mail: adam@space.org.uk Tel: 020-7515 7799

SPACE CITY STUDIOS
77 Blythe Road, London W14 0HP
Website: www.spacecity.co.uk
e-mail: info@spacecity.co.uk
Fax: 020-7371 4001 Tel: 020-7610 5000

SPACE PRODUCTIONS
Media Centre, 67 Dulwich Road
London SE24 0NJ
e-mail: space_productions@yahoo.com
Mobile: 07957 249911 Tel/Fax: 020-7924 9766

S.P.A.C.E. The
(Studio for Performing Arts & Creative Enterprise)
188 St Vincent Street, 2nd Floor, Glasgow G2 5SP
Website: www.west-endmgt.com
e-mail: info@west-endmgt.com
Fax: 0141-226 8983 Tel: 0141-222 2942

SPOTLIGHT The
2nd Floor, 7 Leicester Place WC2H 7RJ
Website: www.spotlight.com/rooms
e-mail: info@spotlight.com
Fax: 020-7437 5881 Tel: 020-7437 7631

ST GEORGE'S CHURCH BLOOMSBURY
Vestry Hall, 6 Little Russell Street, London WC1A 2HR
Website: www.stgeorgesbloomsbury.org.uk
e-mail: stgeorgebloomsbury@hotmail.com
 Tel/Fax: 020-7242 1979

ST JAMES'S CHURCH PICCADILLY
197 Piccadilly, London W1J 9LL
Website: www.st-james-piccadilly.org
e-mail: roomhire@st-james-piccadilly.org
Fax: 020-7734 7449 Tel: 020-7734 4511

ST JOHN'S CHURCH
Waterloo Road, Southbank, London SE1 8TY
Fax: 020-7928 4470 Tel: 020-7633 9819

ST MARY'S CHURCH HALL PADDINGTON
c/o Bill Kenwright Ltd
106 Harrow Road, London W2 1RR
e-mail: zoe.caldwell@kenwright.com
Fax: 020-7446 6222 Tel: 020-7446 6200

ST MARY ABBOTS HALL
Vicarage Gate, Kensington, London W8 4HN
Website: www.stmaryabbotschurch.org
e-mail: terry.pritchard@stmaryabbotschurch.org
Fax: 020-7368 6505 Tel: 020-7937 8885

ST MARY NEWINGTON CHURCH HALL
The Parish Office, 57 Kennington Park Road
London SE11 4JQ Tel: 020-7735 1894

STUDIO 326
Royal Exchange, St Ann's Square, Manchester M2 7BR
Website: www.emmastafford.tv
e-mail: info@emmastafford.tv
Fax: 0161-833 4264 Tel: 0161-833 4263

TAKE FIVE CASTING STUDIO
(Casting Suite)
37 Beak Street, London W1F 9RZ
Website: www.takefivestudio.com
e-mail: info@takefivestudio.com
Fax: 020-7287 3035 Tel: 020-7287 2120

THEATRE ROYAL DRURY LANE
(Michael Townsend)
Catherine Street, London WC2B 5JF
Website: www.rutheatres.com
e-mail: mike.townsend@rutheatres.com Tel: 020-7240 0880

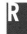
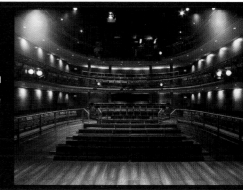
TRESTLE ARTS BASE
(Home of Trestle Theatre Company)
Russet Drive
St Albans
Herts AL4 0JQ
Website: www.trestle.org.uk
e-mail: admin@trestle.org.uk
Fax: 01727 855558 Tel: 01727 850950

TRICYCLE The
269 Kilburn High Road
London NW6 7JR
Website: www.tricycle.co.uk
e-mail: trish@tricycle.co.uk
Fax: 020-7328 0795 Tel: 020-7372 6611

TS
306 The Greenhouse
Custard Factory
Gibb Street, Digbeth
Birmingham B9 4AA
Website: www.myspace.com/trustudies
e-mail: trustreetdance@fresnomail.com
Fax: 0121-224 8257 Tel: 0121-471 3893

TWICKENHAM SEA CADETS
Fairways
Off Broom Road, Teddington
Middlesex TW11 9PL Tel: 01784 241020

UCL BLOOMSBURY The
15 Gordon Street
London WC1H 0AH
Website: www.thebloomsbury.com
e-mail: blooms.theatre@ucl.ac.uk Tel: 020-7679 2777

UNION CHAPEL PROJECT
Compton Avenue, London N1 2XD
Website: www.unionchapel.org.uk
e-mail: spacehire@unionchapel.org.uk
Fax: 020-7354 8343 Tel: 020-7226 3750

URDANG ACADEMY The
Finsbury Town Hall, Rosebery Avenue, London EC1
Website: www.theurdangacademy.com
e-mail: info@theurdangacademy.com
Fax: 020-7836 7010 Tel: 020-7836 5709

WATERMANS
40 High Street
Brentford TW8 0DS
Website: www.watermans.org.uk
e-mail: info@watermans.org.uk
Fax: 020-8232 1030 Tel: 020-8232 1020

YOUNG ACTORS THEATRE
70-72 Barnsbury Road
Islington, London N1 0ES
Website: www.yati.org.uk
e-mail: info@yati.org.uk
Fax: 020-7833 9467 Tel: 020-7278 2101

YOUNG Sylvia THEATRE SCHOOL
Rossmore Road
Marylebone, London NW1 6NJ
e-mail: info@sylviayoungtheatreschool.co.uk
Fax: 020-7723 1040 Tel: 020-7723 0037

Y TOURING THEATRE COMPANY
120 Cromer Street
London WC1H 8BS
e-mail: m.white@ytouring.org.uk Tel: 0870 1127644

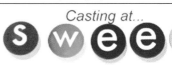

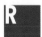
ROLE PLAY COMPANIES/THEATRE SKILLS IN BUSINESS

ACT UP
Unit 88, 99-109 Lavender Hill, London SW11 5QL
Website: www.act-up.co.uk
e-mail: info@act-up.co.uk
Fax: 020-7924 6606 Tel: 020-7924 7701

ACTIVATION
Riverside House, Feltham Avenue
Hampton Court, Surrey KT8 9BJ
Website: www.activation.co.uk
e-mail: info@activation.co.uk
Fax: 020-8783 9345 Tel: 020-8783 9494

APROPOS PRODUCTIONS Ltd
2nd Floor, 91A Rivington Street, London EC2A 3AY
e-mail: aproposprod@aol.com
Fax: 020-7739 3852 Tel: 020-7739 2857

BARKING PRODUCTIONS/INSTANT WIT
(Comedy Improvisation/Corporate Entertainment &
Training)
PO Box 597, Bristol BS99 2BB
Website: www.barkingproductions.co.uk
e-mail: info@barkingproductions.co.uk
Fax: 0117-908 5384 Tel: 0117-939 3171

BUZZWORD FILMS
(Role Play, Film Training Dramas)
Website: www.buzzword-films.co.uk
e-mail: mike.ferrand@buzzword-films.co.uk
Mobile: 07974 355885 Tel: 01395 446895

CRAGRATS Ltd
Cragrats Mill, Dunford Road
Holmfirth, Huddersfield HD9 2AR
Website: www.cragrats.com
e-mail: laurapegg@cragrats.com
Fax: 01484 686212 Tel: 01484 686451

DRAMA FOR TRAINING
Impact Universal
Hopebank House, Woodhead Road
Honley, Huddersfield HD9 6PF
Website: www.impactonlearning.com
e-mail: gideon.clear@impactonlearning.com
Fax: 01484 660088 Tel: 01484 668881

INTERACT
Bowden House
14 Bowden Street, London SE11 4DS
Website: www.interact.eu.com
e-mail: info@interact.eu.com
Fax: 020-7793 7755 Tel: 020-7793 7744

NV MANAGEMENT Ltd
Central Office
4 Carters Leaze
Great Wolford, Warwickshire CV36 5NS
Website: www.nvmanagement.co.uk
e-mail: enquiries@nvmanagement.co.uk Tel: 0800 0830281

PERFORMANCE BUSINESS The
78 Oatlands Drive, Weybridge, Surrey KT13 9HT
Website: www.theperformance.biz
e-mail: michael@theperformance.biz Tel: 01932 888885

ROLEPLAY UK
2 St Mary's Hill, Stamford PE9 2DW
Website: www.roleplayuk.com
Fax: 01780 764436 Tel: 01780 761960

STEPS DRAMA LEARNING DEVELOPMENT
Unit 4.1.1, The Leathermarket
Weston Street, London SE1 3ER
Website: www.stepsdrama.com
e-mail: mail@stepsdrama.com
Fax: 020-7403 0909 Tel: 020-7403 9000

ROUTES TO FILM & TELEVISION STUDIOS

3 MILLS STUDIO
UNDERGROUND – DISTRICT OR HAMMERSMITH & CITY LINE
to Bromley-By-Bow. Buses 52, 108, 25 or N25

BBC TELEVISION
UNDERGROUND – CENTRAL LINE to WHITE CITY. Turn left
from tube, cross zebra crossing. Studios outside station.

BBC South (Elstree) – BOREHAMWOOD
Trains from KINGS CROSS - Thameslink. Take stopping
train to ELSTREE then walk (7/8 mins down Shenley High
St) UNDERGROUND – NORTHERN LINE to EDGWARE or HIGH
BARNET. 107 & 292 BUSES FROM EDGWARE VIA HIGH BARNET
TO BOREHAMWOOD.

BRAY STUDIOS (BRAYSWICK)
BR Train from PADDINGTON to MAIDENHEAD. Then take taxi
to studios. BR WATERLOO - WINDSOR RIVERSIDE. Take taxi.
Coach from VICTORIA to WINDSOR. Take taxi.

THE LONDON STUDIOS
(LONDON TELEVISION CENTRE)
UNDERGROUND (Bakerloo, Jubilee and Northern Lines) to
WATERLOO, take South Bank exit, follow signs to National
Theatre then two buildings along.

PINEWOOD
UNDERGROUND – METROPOLITAN or PICCADILLY LINE to
UXBRIDGE. Taxi rank outside station takes about 10
minutes. BRITISH RAIL WESTERN REGION – PADDINGTON to
SLOUGH. Taxis from SLOUGH - About 10 Minutes.
CHILTERN LINE – Marylebone to Denham. 5 minute taxi.

RIVERSIDE STUDIOS
UNDERGROUND – HAMMERSMITH and CITY, DISTRICT or
PICCADILLY LINE to HAMMERSMITH – then short walk to
studios (behind the Carling Apollo Hammersmith).
Numerous BUS ROUTES from the WEST END. 5 minutes
from Hammersmith Broadway.

ROTHERHITHE STUDIOS
UNDERGROUND – DISTRICT LINE to WHITECHAPEL – then
change to EAST LONDON LINE to ROTHERHITHE.
JUBILEE LINE to CANADA WATER then EAST LONDON LINE to
ROTHERHITHE (5 mins walk).
BUS – 188 from EUSTON STATION via WATERLOO or 47 from
LONDON BRIDGE or 381 from WATERLOO (best one to catch
stops outside Studios).

SHEPPERTON STUDIOS
BRITISH RAIL – SOUTHERN REGION WATERLOO to
SHEPPERTON then BUS Route 400 to studios. Taxi or 15
minute walk.

TEDDINGTON STUDIOS
(THAMES TELEVISION)
BRITISH RAIL – WATERLOO to TEDDINGTON. Cross over
footbridge at station. Come out of Station Road entrance.
Turn left past Garden Centre to Nat West on right hand
side. Turn right, walk 10 mins to set of lights, cross over
into Ferry Road and follow road to studios (next to
Anglers Pub on river).
UNDERGROUND – DISTRICT LINE to RICHMOND – then take
taxi or Bus R68 to TEDDINGTON to top of Ferry Road. Ask
for Landmark Centre then go back to traffic lights, cross
over and continue past the Tide End Public House to
Anglers Pub etc.

TWICKENHAM
BRITISH RAIL – SOUTHERN REGION – WATERLOO to
ST MARGARET'S. UNDERGROUND – DISTRICT LINE to
RICHMOND then SOUTHERN REGION or BUS 37 to
ST MARGARET'S.

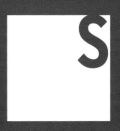

**Set Construction, Lighting,
Sound & Scenery**

3D SET COMPANY
(Sets, Scenery Design & Construction)
8 Temperance Street
Manchester M12 6HR
Website: www.3dsetco.com
e-mail: twalsh@3dsetco.com
Fax: 0161-273 6786 Tel: 0161-273 8831

ALBEMARLE SCENIC STUDIOS
(Suppliers of Scenery & Costumes Construction/Hire)
PO Box 166, Heathfield
East Sussex TN21 8UD
Website: www.freespace.virgin.net/albemarle.productions
e-mail: albemarle.productions@virgin.net
Fax: 01435 867854 Tel: 0845 6447021

ALL SCENE ALL PROPS
(Scenery, Props, Painting Contractors)
Units 2 & 3, Spelmonden Farm
Goudhurst, Kent TN17 1HE
Website: www.allscene.net
e-mail: info@allscene.net
Fax: 01580 211131 Tel: 01580 211121

BIZLEY Tim
(Paint Finishes, Graining, Marbling, Scenic Art)
10 Dollis Park, Finchley
London N3 1HG Tel: 020-8349 0195

BRISTOL (UK) Ltd
(Scenic Paint)
Unit 3, Southerland Court
Tolpits Lane, Watford WD18 9SP
Website: www.bristolpaint.com
e-mail: tech.sales@bristolpaint.com
Fax: 01923 779666 Tel: 01923 779333

CCT LIGHTING UK Ltd
(Lighting, Dimmers, Sound & Stage Machinery)
Unit 3, Ellesmere Business Park
Haydn Road, Sherwood
Nottingham NG5 1DX
Website: www.cctlighting.com
e-mail: office@cctlighting.co.uk
Fax: 0115-985 7091 Tel: 0115-985 8919

CHEWYS
(Design & Construction)
Priory Farm, Colmworth Road
Little Staughton, Beds MK44 2BZ
Fax: 01234 376003 Tel: 01234 376002

COD STEAKS
(Set Construction, Design, Model Making, Exhibitions,
Costume)
2 Cole Road, Bristol BS2 0UG
Website: www.codsteaks.com
e-mail: mail@codsteaks.com Tel: 0117-980 3910

DESIGN 1 INSIGHT
(Sound & Lighting Designs)
Ferrers Centre, Melbourne Road
Staunton Harold Hall
Ashby de la Zouch LE65 1RU
Website: www.1insight.co.uk
e-mail: info@1insight.co.uk
Mobile: 07984 436617 Mobile: 07984 717898

DISPLAY MAINTENANCE Ltd
Unit 4 Redhouse Farm
Bridgehewick, Ripon, North Yorkshire HG4 5AY
Website: www.dmnsolutions.co.uk
e-mail: enquiries@dmnsolutions.co.uk Tel: 0870 8508500

[CONTACTS 2007]

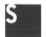
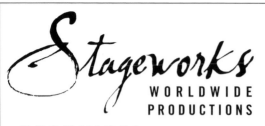
DOBSON SOUND PRODUCTION Ltd
(Sound Hire, Design & Installation)
66 Windsor Avenue
Merton
London SW19 2RR
e-mail: enquiries@dobsonsound.co.uk
Fax: 020-8543 3636 Tel: 020-8545 0202

DOVETAIL SPECIALIST SCENERY
(Scenery, Prop & Furniture Builders)
42-50 York Way
London N1 9AB
e-mail: dovetail.ss@btopenworld.com Tel/Fax: 020-7278 7379

FUTURIST PROJECTS Ltd
136 Thorns Lane
Wakefield
West Yorkshire WF2 7RE
Fax: 01924 298700 Tel: 01924 298900

HALL STAGE Ltd
Unit 4, Cosgrove Way
Luton, Beds LU1 1XL
Website: www.hallstage.com
e-mail: sales@hallstage.com
Fax: 0845 3454256 Tel: 0845 3454255

HARLEQUIN (British Harlequin Plc)
Festival House
Chapman Way
Tunbridge Wells
Kent TN2 3EF
Website: www.harlequinfloors.com
e-mail: sales@harlequinfloors.com
Fax: 01892 514222 Tel: 01892 514888

HENSHALL John
(Director of Lighting & Photography)
68 High Street
Stanford in the Vale
Oxfordshire SN7 8NL
e-mail: john@epi-centre.com Tel: 01367 710191

HERON & DRIVER
(Scenic Furniture & Structural Prop Makers)
Unit 7
Dockley Road Industrial Estate
Rotherhithe
London SE16 3SF
Website: www.herondriver.co.uk
e-mail: mail@herondriver.co.uk
Fax: 020-7394 8680 Tel: 020-7394 8688

KNIGHT Robert
1-2 Wyvern Way
Henwood
Ashford, Kent TN24 8DW
Fax: 01233 634999 Tel: 01233 634777

LEE LIGHTING Ltd
Wycombe Road
Wembley
Middlesex HA0 1QD
e-mail: info@lee.co.uk
Fax: 020-8902 5500 Tel: 020-8900 2900

LIGHT WORKS Ltd
2A Greenwood Road
London E8 1AB
Fax: 020-7254 0306 Tel: 020-7249 3627

LIVERPOOL SCENIC WORKSHOP Ltd
Baltic Road, Bootle
Liverpool L20 1AW
Website: www.liverpoolscenicworkshop.com
e-mail: scenic@liverpoolscenicworkshop.com
Fax: 0151-933 6699 Tel: 0151-933 6677

MALTBURY Ltd
(Portable Staging Sales & Consultancy)
72A Beaconsfield Road
Brighton BN1 6DD
Website: www.maltbury.com
e-mail: info@maltbury.com
Fax: 01273 504748 Tel: 0845 1308881

MASSEY Bob ASSOCIATES
(Electrical & Mechanical Stage Consultants)
9 Worrall Avenue
Arnold
Nottinghamshire NG5 7GN
e-mail: bm.associates@virgin.net Tel/Fax: 0115-967 3969

MODELBOX
(Computer Aided Design & Design Services)
2 Saddlers Way
Okehampton
Devon EX20 1TL
Website: www.modelbox.co.uk
e-mail: info@modelbox.co.uk Tel/Fax: 01837 54026

NEED Paul J
(Lighting Designer)
Unit 14
Forest Hill Business Centre
Clyde Vale, London SE23 3JF
Website: www.10outof10.co.uk
e-mail: paul@10outof10.co.uk
Fax: 020-8699 8968 Tel: 020-8291 6885

NORTHERN LIGHT
(Lighting, Sound, Communications & Stage Equipment)
Assembly Street
Leith
Edinburgh EH6 7RG
Website: www.northernlight.co.uk
e-mail: enquiries@northernlight.co.uk
Fax: 0131-622 9101 Tel: 0131-622 9100

ORBITAL
(Sound Hire & Design)
57 Acre Lane
Brixton, London SW2 5TN
e-mail: hire@orbitalsound.co.uk
Fax: 020-7501 6869 Tel: 020-7501 6868

P.L. PARSONS SCENERY MAKERS
King's Cross Freight Depot
York Way, London N1 0UZ
Fax: 020-7278 3403 Tel: 020-7833 2031

PMB THEATRE & EXHIBITION SERVICES Ltd
The Barn
Kingston Wood Manor
Arrington, Royston
Herts SG8 0AP
Website: www.pmbltd.co.uk
Fax: 01954 718032 Tel: 01954 718227

RE VAMP EVENTS & ENTERTAINMENT
(Cabaret, Decor, Event Management & Entertainment)
Ealing House
33 Hanger Lane
London W5 3HJ
e-mail: verona.chard@vampevents.com Tel: 020-8997 3355

REVOLVING STAGE COMPANY Ltd The
Unit F5
Little Heath Industrial Estate
Old Church Road
Coventry
Warwickshire CV6 7ND
Website: www.therevolvingstagecompany.co.uk
e-mail: enquiries@therevolvingstagecompany.co.uk
Fax: 024-7668 9355 Tel: 024-7668 7055

RURAL PRODUCTIONS Ltd
(Set Design & Build)
Bay 7 Cromwell Works
Boraston Lane
Tenbury Wells
Worcestershire WR15 8GZ
Website: www.ruralproductions.com
e-mail: sales@ruralproductions.com
Fax: 01584 811641 Tel: 01584 819906

RWS ELECTRICAL & AUDIO CONTRACTORS Ltd
(All Aspects of Electrical Services including Installation,
Design & Consultancy)
1 Spinners Close
Biddenden, Kent TN27 8AY
Website: www.rwselectrical.com Tel: 01580 291764

S2 EVENTS
(Production - Lighting, Set Construction & Scenery)
3-5 Valentine Place
London SE1 8QH
Fax: 020-7928 6082 Tel: 020-7928 5474

SCENA PROJECTS Ltd
(Set Construction)
240 Camberwell Road
London SE5 0DP
Website: www.scenapro.com
e-mail: info@scenapro.com
Fax: 020-7703 7012 Tel: 020-7703 4444

SCOTT FLEARY PRODUCTIONS Ltd
Unit 2, Southside Industrial Estate
Havelock Terrace, London SW8 4AH
e-mail: matt@scottflearyltd.com
Fax: 020-7622 0322 Tel: 020-7978 1787

SCOTT MYERS
(Sound Design & Original Music for Theatre)
36 Madras Road
Cambridge CB1 3PX
Website: www.sound.design.freeuk.com
e-mail: scott.myers100@gmail.com
Mobile: 07757 283702 Tel: 01223 415633

SETS IN THE CITY Ltd
Location House
5 Dove Lane
Bristol BS2 9HP
Website: www.setsinthecity.co.uk
e-mail: info@setsinthecity.co.uk
Fax: 0117-955 2480 Tel: 0117-955 5538

STAGECRAFT Ltd
(Hire & Sales of Lighting, Sound, Audio Visual & Staging & Productions for Conference & Live Events)
Ashfield Trading Estate
Salisbury
Wiltshire SP2 7HL
Website: www.stagecraft.co.uk
e-mail: hire@stagecraft.co.uk
Fax: 01722 414076 Tel: 01722 326055

STAGE SYSTEMS
(Designers & Suppliers of Modular Staging, Tiering & Auditorium Seating)
Stage House
Prince William Road
Loughborough LE11 5GU
Website: www.stagesystems.co.uk
e-mail: info@stagesystems.co.uk
Fax: 01509 233146 Tel: 01509 611021

STAGEWORKS WORLDWIDE PRODUCTIONS
(Scenery, Props, Lighting & Sound)
525 Ocean Boulevard
Blackpool FY4 1EZ
Website: www.stageworkswwp.com
e-mail: info@stageworkswwp.com
Fax: 01253 342702 Tel: 01253 342427

STEWART Helen
(Theatre Designer)
432 London Road
Ashford, Middlesex TW15 3AB
Website: www.helenstewart.co.uk
e-mail: design@helenstewart.co.uk Mobile: 07887 682186

STORM LIGHTING Ltd
Unit 6 Wintonlea Industrial Estate
Monument Way West
Woking
Surrey GU21 5EN
e-mail: info@stormlighting.co.uk
Fax: 01483 757710 Tel: 01483 757211

STRAND LIGHTING Ltd
(Lighting Equipment for Stage, Studio, Film & TV)
Unit 3
Hammersmith Studios
Yeldham Road
London W6 8JF
e-mail: sales@stranduk.com
Fax: 020-8735 9799 Tel: 020-8735 9790

SUFFOLK SCENERY
28 The Street
Brettenham
Ipswich IP7 7QP
Website: www.suffolkscenery.info
e-mail: piehatch@aol.com
Fax: 01449 737620 Tel: 01449 736679

THEME PARTY COMPANY The
(Set Design Backdrops & Props)
Unit 6
57 Bushey Grove Road
Watford WD23 2JW
Fax: 01923 247733 Tel: 01923 247979

TMS INTERNATIONAL Ltd
(Set Construction & Painting)
Western Wharf
Livesey Place
Peckham Park Road
London SE15 6SL
e-mail: admin@tmsi.co.uk
Fax: 020-7277 5147 Tel: 020-7277 5156

TOP SHOW
(Props, Scenery, Conference Specialists)
North Lane, Huntington
York YO32 9SU Tel: 01904 750022

WEST John ASSOCIATES
(Designers & Scenic Artists - Film, TV & Display)
103 Abbotswood Close
Winyates Green
Redditch
Worcestershire B98 0QF
e-mail: johnwest@blueyonder.co.uk
Mobile: 07753 637451 Tel/Fax: 01527 516771

WHITE LIGHT Ltd
(Stage & TV Lighting)
20 Merton Industrial Park
Jubilee Way, London SW19 3WL
Website: www.whitelight.ltd.uk
e-mail: info@whitelight.ltd.uk
Fax: 020-8254 4801 Tel: 020-8254 4800

WOOD Rod
(Scenic Artist, Backdrops, Scenery, Props, Design & Fine Art Copies)
41 Montserrat Road
London SW15 2LD
Mobile: 07887 697646 Tel: 020-8788 1941

BBC Television
Wood Lane, London W12 7RJ
Tel: 020-8743 8000

• TALENT RIGHTS GROUP
BBC Finance, Property & Business Affairs
MC1 A2 Media Centre, 201 Wood Lane, London W12 7TQ

Head of Talent Rights Group	Simon Hayward-Tapp

LITERARY COPYRIGHT
Rooms 395 & 396 Design Building
Television Centre, Wood Lane
London W12 7SB

Rights Manager	Neil Hunt
Rights Executives	Sara Ali
	Harriet Coode
	Sharon Cowley
	Sue Dickson
	Julie Gallagher
	Jane Harris
	Rebecca Hogan
	Hazel King
	David Knight
	Wai Lan Lam
	Julieann May
	Sally Millwood
	Hilary Sagar
	Andrew Livingston
	Carolyn Tutt

FACTUAL & CLASSICAL MUSIC
Room 3205, White City Building
Wood Lane, London W12 7TR

Rights Manager	Simon Brown
Rights Executives	Lorraine Clark
	Penelope Davies
	Hilary Dodds
	Selena Harvey
	John Hunter
	Shirley Noel
	Shelagh Morrison
	Jonathan Slack
	Costas Tanti
	Pamela Wise
Rights Assistant	Naomi Anderson

MUSIC COPYRIGHT
Room 201, EBX Blk
Television Centre, Wood Lane
London W12 7SB

Rights Manager	Nicky Bignell
Rights Executives	Sally Dunsford
	Catherine Grimes
	Rosarie O'Sullivan
	Victoria Payne
	Natasha Pullin
	Debbie Rogerson

Where appropriate, Rep periods are indicated,
e.g. (4 Weekly) and matinee times e.g. Th 2.30 for
Thursday 2.30pm.
SD Stage Door
BO Box Office
TIE Theatre in Education (For further details of
TIE/YPT
See Theatre - Children's, Young People's & TIE

[CONTACTS 2007]

• TALENT RIGHTS GROUP Cont'd

DRAMA, ENTERTAINMENT & CHILDRENS
Rooms 341-352
Design Building, Television Centre
Wood Lane, London W12 7RJ

Rights Manager	John Holland

Rights Executives

Stephanie Beynon	Annie Pollard
Mike Bickerdike	Thalia Reynolds
Alex Davenport	Colette Robertson
Sally Dean	Lloyd Shepherd
Matthew Hickling	

ENGLISH REGIONS:

BIRMINGHAM
Level 10, The Mailbox
Birmimgham B1 1RF

Rights Manager (Job Share)	Andrea Coles
	Jill Ridley

BRISTOL
Room 17 TPR, Bristol BH BS8 2LR

Rights Manager	Annie Thomas

MANCHESTER
Room 2030, Manchester NBH
Manchester M60 1SJ

Rights Manager	Shirley Chadwick

• DRAMA

Controller, Continuing Drama Series & Head of Independent Drama	John Yorke
Head of Films & Single Drama	David Thompson
Head of Drama Serials	Laura Mackie
Producer	Sarah Brown

Executive Producers, Drama Series

Kate Harwood	Mervyn Watson
Richard Stokes	

Producers, Drama Series

Beverley Dartnall	Lorraine Newman
Jane Dauncey	Annie Tricklebank
Diana Kyle	

Executive Producers, Drama Serials

Ruth Caleb	Jessica Pope
Philippa Giles	Hilary Salmon
Kate Harwood	

Producers, Drama Serials

Kate Bartlett	Paul Rutman
Kate Lewis	Diederick Santer
Liza Marshall	Pier Wilkie

• COMMISSIONING

Controller Factual Commissioning	Glenwyn Benson
Controller Entertainment Commissioning	Jane Lush
Controller Drama Commissioning	Jane Tranter
Head of Drama Commissioning, Development	
	Sarah Brandist
Head of Drama Commissioning, Independent	John Yorke
Arts Commissioner	Franny Moyle
Current Affairs Commissioner	Gwyneth Williams
Head of Documentaries	Alan Hayling
Commissioning Editor of Specialist Factual	Emma Swain

• NEWS AND CURRENT AFFAIRS

BBC News (Television & Radio)
Television Centre
Wood Lane, London W12 7RJ
Tel: 020-7580 4468 (Main Switchboard)

Director News	Helen Boaden
Deputy Director of News	Adrian Van Klaveren
Head of Newsgathering	Fran Unsworth
Head of Political Programmes	
Research & Analysis	Sue Inglish
Head of Radio News	Steve Mitchell
Head of TV News	Peter Horrocks
Director of Sport	Roger Mosey
Controller of Children's	Richard Deverell
Head of TV Current Affairs	Peter Horrocks
Executive Editor of Current Affairs	Gwyneth Williams
Head of News Resources & Technology	Peter Coles
Head of Communications	Janie Ironside Wood

• DOCUMENTARIES & CONTEMPORARY
FACTUAL GROUP

Controller of DCFG	Sarah Hargreaves
Deputy Controller	Donna Taberer
Head of Production	Phil Checkland
Head of Programmes, Birmingham	Tessa Finch
Head of Programmes, Bristol	Tom Archer

• ARTS

BBC Television (Arts)
201 Wood Lane
London W12 7TS Tel: 020-8752 5490

Head of Arts Studio	Mark Harrison
Editor, Arena	Anthony Wall
Editor, Arts Series	Kim Thomas
Editor, Arts Features	Basil Comely
Series Producer, Imagine	Janet Lee
Editor, Reports & Events	David Okuefuna
Executive Editor, Topical Arts Unit	Eddie Morgan

• MUSIC

Head of Television	
Classical Music & Performance	Peter Maniura
Executive Producer, Classical Music	Caroline Speed
Editor Music Programmes - Television,	
Classical Music & Performance	Oliver Macfarlane

• CHILDREN'S CONTACTS

Controller	Richard Deverell
Creative Director, CBBC	Anne Gilchrist
Creative Director, CBeebies	Michael Carrington
Head of Entertainment	
(inc on-air talent management)	Joe Godwin
Head of Drama	Jon East
Head of Children's Programmes, Scotland	Simon Parsons
Head of News, Factual & Learning	Reem Nouss
Head of Interactive and On-Demand	Rebecca Shallcross

• SPORT

Acting Director of Sport	David Gordon
Director, Sports Rights & Finance	Dominic Coles
Controller Radio Five Live	Bob Shennan
Head of Major Events	David Gordon
Head of Programmes & Planning	Philip Bernie
Head of General Sports	Barbara Slater
Head of Radio Sport	Gordon Turnbull
Head of New Media, Sports News	
& Development	Andrew Thompson

• SCIENCE

Series Producer, Horizon	Andrew Cohen
Director of Development, Science	Michael Mosley
Executive Producers	Jill Fullerton-Smith
	Anne Laking

• NEW WRITING

BBC Writersroom
Grafton House
379-381 Euston Road
London NW1 3AU Tel: 020-7765 2703
e-mail: writersroom@bbc.co.uk
Website: www.bbc.co.uk/writersroom

Creative Director	Kate Rowland
Development Manager	Paul Ashton

• BBC BRISTOL

Broadcasting House
Whiteladies Road
Bristol BS8 2LR Tel: 0117-973 2211

NETWORK TELEVISION AND RADIO FEATURES

Head of Programmes	Tom Archer
Executive Producers	Julian Mercer
	Michael Poole
	Jo Vale

TELEVISION

Producers

Lyn Barlow	Kim Littlemore
Robert Bayley	Jane Lomas
Susan McDermott	Mark Bristow
Julian Mercer	Kathryn Broome
Kathryn Moore	Michelle Burgess
Helen Nabarro	Roy Chapman
David Olusoga	Linda Cleeve
Martin Paithorpe	Hannah Corneck
Ian Pye	Peter Firstbrook
Amanda Reilly	Steve Greenwood
Kelly Richardson	Trevor Hill
Peter Smith	Jeremy Howe
Ben Southwell	Chris Hutchins
Miranda Steed	David Hutt
Jonny Young	Sarah Johnson
Jo Vale	Peter Lawrence
Tom Ware	Christopher Lewis

RADIO

Unit Manager, Radio	Kate Chaney
Editors	Elizabeth Burke
	Fiona Cooper

Producers

Viv Beeby	Paul Dodgson
John Byrne	Jane Greenwood
Frances Byrnes	Jeremy Howe
Sara Davies	Kate McCall
Tim Dee	Lucy Willmore

NATURAL HISTORY UNIT

Head of Natural History Unit	Neil Nightingale
Executive Editor, Natural World	Tim Martin
Series Producer	Alastair Fothergill

Television Producers

Paul Appleby	Sara Ford
Melinda Barker	Liz Green
Miles Barton	Martin Hughes-Games
Karen Bass	Mark Jacobs
Vanessa Belowitz	Hilary Jeffkins
Mike Beynon	Mark Linfield
Lucy Bowden	Neil Lucas
Mark Brownlow	Patrick Morris
Andrew Byatt	Stephen Moss
Paul Chapman	Mike Salisbury
Mary Colwell	Tim Scoones
Huw Cordey	Mary Summerhill
Yvonne Ellis	James Walton
Mark Flowers	
Managing Editor, NHU Radio	Julian Hector
Director of Development	Martin Hughes-Games

• BBC WEST

Whiteladies Road
Bristol BS8 2LR Tel: 0117-973 2211

Head of Regional & Local Programmes, including BBC West, Radio Bristol & Somerset Sound Radio Gloucestershire & BBC Wiltshire Sound	Andrew Wilson
Editor, Output	Anthony Dore
News Gathering	Neil Bennett

• BBC SOUTH WEST

Seymour Road
Mannamead
Plymouth PL3 5BD Tel: 01752 229201

Head of BBC South West	John Lilley
Editor TV Current Affairs	Simon Willis
Output Editor	Simon Read

• BBC SOUTH

Havelock Road
Southampton SO14 7PU Tel: 023-8022 6201

Head of Regional & Local Programmes	Eve Turner
Managing Editor, BBC Oxford	Steve Taschini
Managing Editor, Radio Solent	Mia Costello
Managing Editor, Radio Berkshire	Lizz Loxam

• BBC LONDON

35C Marylebone High Street
London W1M 4AA Tel: 020-7224 2424

BBC London News:
TV: The Politics Show
Radio: BBC London Radio 94.9FM
Online: BBC London online

Executive Editor	Michael MacFarlane
News/Output Editor	Cath Hearne
Editor, Inside Out	Dippy Chaudhary
Managing Editor, BBC Radio London 94.9FM	David Robey
Political Editor	Tim Donovan
Editor, BBC London Online	Claire Timms

• BBC SOUTH EAST

The Great Hall Arcade
Mount Pleasant Road
Tunbridge Wells
Kent TN1 1QQ Tel: 01892 670000

Head of Regional & Local Programmes BBC South East	Mike Hapgood
Managing Editor BBC Radio Kent	Paul Leaper
Managing Editor BBC Southern Counties	Neil Pringle
News Gathering Editor	Tayla Roberson
Editor BBC South East Today	Quentin Smith
Editor Inside Out	Linda Bell
Editor Politics Show	Mark Hayman

• BBC NORTH WEST

New Broadcasting House
Oxford Road
Manchester M60 1SJ Tel: 0161-200 2020
Website: www.bbc.co.uk/manchester

Entertainment & Features

Editor, Entertainment & Features Helen Bullough

Religion & Ethics

Head of Religion & Ethics Alan Bookbinder

Network News & Current Affairs

Editor, Network News
& Current Affairs Dave Stanford

Regional & Local Programmes

Head of Regional & Local
 Programmes North West Leo Devine
Head of Regional & Local
 Programmes Yorks & Lincs Tamsin O'Brien
Head of Regional & Local Programmes
 North East & Cumbria Wendy Pilmer

• BBC BIRMINGHAM

BBC Birmingham
The Mailbox
Birmingham B1 1RF
Fax: 0121-567 6875 Tel: 0121-567 6767

English Regions

Controller, English Regions. Head of Centre
 (Birmingham) Andy Griffee
Head of New Services, English Regions John Allen
Head of Finance, English Regions Julie Bertolini
Manager, Press & PR Caren Davies
Secretary, English Regions Louise Hall
Head of Regional & Local
 Programmes West Midlands David Holdsworth

Factual & Learning
BBC Birmingham

Head of Programmes Tessa Finch
Managing Editor Jane Booth

Network Radio

Editor, Factual Radio &
 Rural Affairs Andrew Thorman
Editor, Specialist
 Programmes, Radio 2 David Barber

Drama

BBC Brimingham TV Drama Village
Archibald House
1059 Bristol Road
Selly Oak
Birmingham B29 6LT Tel: 0121-567 7350
Production Executive, BBC Birmingham Trevor West
Executive Producer Will Trotter

• SCOTLAND

Broadcasting House
Queen Margaret Drive
Glasgow G12 8DG Tel: 0141-338 2000
Website: www.bbc.co.uk/scotland

SCOTTISH DIRECTION GROUP

Controller Scotland	Ken MacQuarrie
Head of Programme and Services	Donalda Mackinnon &
	Maggie Cunningham
Head of Drama, Television	Anne Menzah
Head of Drama, Radio	Patrick Rayner
Head Factual Programmes	Andrea Miller
Head of Gaelic	Margaret Mary Murray
Head of Radio	Jeff Zycinski
Head of News and Current Affairs	Blair Jenkins
Commissioning Editor, Television	Ewan Angus
Head of Finance & Business Affairs	Irene Tweedie
Head of Production	Nancy Braid
Lead HR Partner, Scotland	Steve Ansell
Head of Marketing, Communication and Audiences	
	Mairead Ferguson
Secretary and Head of Public Policy, Scotland	Ian Small

Headquarters of BBC Scotland with centres in
Aberdeen, Dundee, Edinburgh, Dumfries, Inverness,
Orkney, Shetland and Stornaway. Regular and recent
programmes include Reporting Scotland and Sportscene
on television and Good Morning Scotland and Fred
Macaulay on radio.

Aberdeen
Broadcasting House
Beechgrove Terrace
Aberdeen AB15 5ZT Tel: 01224 625233

Dundee
Nethergate Centre
66 Nethergate
Dundee DD1 4ER Tel: 01382 202481

Dumfries
Elmbank
Lover's Walk
Dumfries DG1 1NZ Tel: 01387 268008

Edinburgh
The Tun, Holyrood Road
Edinburgh EH8 8JF Tel: 0131-557 5677

Inverness
7 Culduthel Road
Inverness IV2 4AD Tel: 01463 720720
Editor Ishbel MacLennan

Orkney
Castle Street, Kirkwall
Orkney KW15 1DF Tel: 01856 873939

Portree
Clydesdale Bank Buildings
Somerled Square, Portree
Isle of Skye IV51 9BT Tel: 01478 612005

Selkirk
Unit 1, Ettrick Riverside
Dunsdale Road
Selkirk TD7 5EB Tel: 01750 724567

Shetland
Pitt Lane, Lerwick
Shetland ZE1 0DW Tel: 01595 694747

Stornoway
Radio nan Gaidheal
Rosebank
Church Street
Stornoway
Isle of Lewis HS1 2LS Tel: 01851 705000

• WALES

Broadcasting House
Llandaff
Cardiff CF5 2YQ Tel: 029-2032 2000

Controller	Menna Richards
Head of Programmes (Welsh)	Keith Jones
Head of Programmes (English)	Clare Hudson
Head of Marketing, Communications	
& Public Policy	Huw Roberts
Head of News &	
Current Affairs	Mark O'Callaghan
Head of Personnel	Jude Gray
Head of Finance	Gareth Powell
Head of Drama	Julie Gardner
Head of Sport	Nigel Walker
Head of North Wales	Marian Wyn Jones
Head of Factual	Adrian Davies
Head of Education	Eleri Wyn-Lewis
Editor Radio Wales	Sali Collins
Editor Radio Cymru	Aled Glynne Davies

• NORTHERN IRELAND

Belfast
Ormeau Avenue
Belfast BT2 8HQ Tel: 028-9033 8000

Controller	Anna Carragher
Head of Broadcasting	Peter Johnston
Head of Drama	Patrick Spence
Head of Finance	Crawford MacLean
Head of HR	Laurence Jackson
Head of Learning & Interactive Services	Kieran Hegarty
Head of Marketing, Communications	
& Audiences	Kathy Martin
Head of News & Current Affairs	Andrew Colman
Head of Production,	
Planning and Development	Stephen Beckett
Head of Entertainment, Events and Sport	Mike Edgar
Head of TV Factual	Paul McGuigan
Head of Radio Ulster	Susan Lovell

Londonderry
BBC Radio Foyle Tel: 028-7137 8600
Editor Foyle Paul McCauley

Anglia

ITV ANGLIA

Head Office

Anglia House, Norwich NR1 3JG
Fax: 01603 631032 Tel: 01603 615151
East of England: Weekday & Weekend

Regional News Centres

Cambridge

26 Newmarket Road, Cambridge CB5 8DT
Fax: 01223 467106 Tel: 01223 467076
Reporters: Matthew Hudson, Philippa Heap

Chelmsford

64-68 New London Road
Chelmsford CM1 0YU
Fax: 01245 267228 Tel: 01245 357676
Reporters: Emma Thomas, Victoria Webb

Luton

16 Park Street, Luton LU1 3EP
Fax: 01582 401214 Tel: 01582 729666
Reporters: Charlotte Fisher, Mike Cartwright

Northampton

77B Abington Street, Northampton NN1 2BH
Fax: 01604 629856 Tel: 01604 624343
Reporter: Karl Heidel

Peterborough

6 Bretton Green Village
Rightwell, Bretton, Peterborough PE3 8DY
Fax: 01733 269424 Tel: 01733 269440

Ipswich

Hubbard House
Civic Drive, Ipswich IP1 2QA
Fax: 01473 233279 Tel: 01473 226157
Reporters: Rebecca Atherstone, Simon Newton,
Dianne Stradling

Border

ITV BORDER

Head Office & Studios

The Television Centre
Carlisle CA1 3NT Tel: 01228 525101
Cumbria, South West Scotland,
Scottish Border Region
North Northumberland and the Isle of Man;
Weekday and Weekend

Chairman tba
Managing Director Paddy Merrall
Head of Features Jane Bolesworth

Channel Television

CHANNEL TELEVISION Ltd

Registered Office

The Television Centre
La Pouquelaye, St Helier, Jersey JE1 3ZD
Channel Islands
Fax: 01534 816817 Tel: 01534 816816
Channel Islands: Weekday and Weekend

Managing Director	Michael Lucas
Director of Programmes	Karen Rankine
Head of Sales	Don Miller
Director of Transmission & Resources	Kevin Banner
Director of Finance	Martin Maack
News Editor	Allan Watts

CHANNEL FOUR TELEVISION CORPORATION

London Office

124 Horseferry Road
London SW1P 2TX
Textphone: 020-7396 8691 Tel: 020-7396 4444

Members of the Board

Chairman	Luke Johnson
Deputy Chairman	Lord David Puttnam
Chief Executive	Andy Duncan
Director of Television	Kevin Lygo
Group Finance Director	Anne Bulford
Sales Director	Andy Barnes
New Business Director	Rod Henwood

Non-Executive Directors

Sue Ashtiany	Martha Lane Fox
Karren Brady	Andy Mollett
Tony Hall	Stephen Hill

Heads of Department

Head of Features	Sue Murphy
Head of E4 and Factual Entertainment	Danny Cohen
Head of History, Science & Religion	Hamish Mykura
Controller of Broadcasting	Rosemary Newell
Head of Scheduling and T4	Julie Oldroyd
Head of More 4	Peter Dale
Head of News & Current Affairs	Dorothy Byrne
Head of Entertainment	Andrew Newman
Head of Drama and FilmFour	Tessa Ross
Head of Documentaries	Angus Macqueen
Head of Comedy and Film	Caroline Leddy
Head of Education & Managing Editor Commissioning	Janey Walker

CHANNEL FOUR TELEVISION CORPORATION Cont'd

Head of Information Systems	Ian Dobb
Head of Channel Operations	Stephen White
Controller of Legal & Compliance	Jan Tomalin
Managing Director, New Media	Andy Taylor
Head of Commercial Affairs	Sara Geater
Director of Nations and Regions	Stuart Cosgrove
Director of Corporate Relations	Nick Toon
Head of Corporate Development	Michael Hodgson
Director of Strategy and Research	Jonathan Thompson
Controller of Research & Insight	Claire Grimmond
Director of Human Resources	Diane Herbert
Head of Facilities Management	Julie Kortens
Director of Acquisitions	Jeff Ford
Director of Marketing	Polly Cochrane
Head of Media Planning	Greg Smith
Head of Press and Publicity	Matt Baker
Network Creative Director	Brett Foraker
Head of Marketing	Rufus Radcliffe
Head of Sponsorship	David Charlesworth
Head of Airtime Management	Merlin Inkley
Head of Agency Sales	Matt Shreeve
Head of Strategic Sales	Mike Parker

five

CHANNEL 5 BROADCASTING

22 Long Acre, London WC2E 9LY
Fax: 020-7550 5554 Tel: 020-7550 5555
Website: www.five.tv

Chief Executive	Jane Lighting
Director of Programmes	Dan Chambers
Director of Strategy	Charles Constable
Director of Sales	Mark White
Director of Finance	Grant Murray
Director of Legal & Business Affairs	Colin Campbell
Director of Broadcasting	Susanna Dinnage

Senior Programme Controller	
News & Current Affairs	Chris Shaw
Controller of Entertainment & Features	Ben Frow
Controller of Factual Entertainment	Steve Gowens
Controller, Special Events & Pop Features	Sham Sandhu
Controller of Sport	Robert Charles
Controller, Children's	Nick Wilson
Controller, Daytime Arts & Religion	Kim Peat

GMTV

London Television Centre
Upper Ground, London SE1 9TT
Fax: 020-7827 7001 Tel: 020-7827 7000

Chairman	Clive Jones
Managing Director	Paul Corley
Director of Programmes	Peter McHugh
Finance Director	Rhian Walker
Director of Sales	Clive Crouch
Head of Press	Nikki Johnceline
Managing Editor	John Scammell
Editor	Martin Frizell
Chief Engineer	Geoff Wright

GRAMPIAN TELEVISION LTD

Television Centre
Craigshaw Business Park
West Tullos
Aberdeen AB12 3QH
Fax: 01224 848800 Tel: 01224 848848
Website: www.grampiantv.co.uk

Managing Director	Derrick Thomson
Head of News & Current Affairs	Craig Wilson
Production Resources Manager	Iain Macdonald

ITN

INDEPENDENT TELEVISION NEWS

200 Gray's Inn Rd, London WC1X 8XZ Tel: 020-7833 3000

Chief Executive	Mark Wood
Editor-in-Chief, ITV News	David Mannion
Editor, ITV Networks News	Deborah Turness
Editor, Channel 4 News	Jim Gray

ITV plc
The London Television Centre
Upper Ground
London SE1 9LT

Executive Board:

Chief Executive	tba
Finance Director	Henry Staunton
Chief Executive - Granada	Simon Shaps
Chief Executive - ITV Broadcasting	Mick Desmond
Chief Executive - ITV News Group	Clive Jones
Finance Director - Granada	John Cresswell
Chief Operating Officer - ITV Broadcasting	Ian McCulloch
Chief Operating Officer - ITV News Group	Max Graesser
Managing Director - ITV Sales	Graham Duff

Three divisions:
1. ITV Broadcasting
2. Granada
3. ITV News Group

Licence Companies:
- Anglia Television Limited
- Border Television Limited
- Carlton Broadcasting Limited
- Central Independent Television Limited
- Granada Television Limited
- HTV Group Limited
- LWT (Holdings) Limited
- Meridian Broadcasting Limited
- Tyne Tees Television Limited
- Westcountry Television Limited
- Yorkshire Television Limited

itv Meridian

MERIDIAN BROADCASTING Ltd
Meridian is part of ITV Plc

Forum One, Solent Business Park, Whiteley, Hants PO15 7PA
Fax: 01489 442299 Tel: 01489 442000

MERIDIAN BOARD

Chairman	tba
Chief Executive, ITV Broadcasting	Mick Desmond
Financial Director, ITV News	Mike Fegan
Director of Regional Sales	David Croft
Managing Director, ITV Meridian & Controller of Regional Programmes	Mark Southgate

EXECUTIVES

Managing Director & Controller of Regional Programmes	Mark Southgate
Head of Personnel	Elaine Austin
Finance Manager	Dan Spencer
Head of Regional Affairs	Alison Pope

itv Wales

ITV - WALES

Television Centre, Culverhouse Cross Cardiff CF5 6XJ	Tel: 029-2059 0590
Television Centre, Bath Road Bristol BS4 3HG	Tel: 0117-972 2722

Wales/West of England: All week

Managing Director, Wales	Roger Lewis
Managing Director, West	Mark Haskell
Controller, Wales & Director of Programmes, ITV 1 Wales	Elis Owen
Director of Programmes, ITV 1 West	Jane McCloskey
ITV Wales Head of Drama Development	Peter Edwards

S4C

S4C-THE WELSH FOURTH CHANNEL
Parc Tŷ Glas, Llanishen, Cardiff CF14 5DU
Fax: 029-2075 4444 Tel: 029-2074 7444
e-mail: s4c@s4c.co.uk

The Welsh Fourth Channel Authority

Chair	John Walker Jones OBE
Members:	Dr. Christopher Llewelyn
Eira Davies	Enid Rowlands
Carys Howell	
Sir Roger Jones OBE	
Winston Roddick CB QC	
John Walter Jones OBE	

Senior Staff

Chief Executive	Iona Jones
Director of Programming	Rhian Gibson
Director of Engineering & Technology	Arshad Rasul
Head of Marketing	Eleri Twynog Davies
Director of Finance & Human Resouces	Kathryn Morris
Head of Press	Hannah Thomas
Head of Human Resources	Kay Walters

scottish tv

SCOTTISH TV (Part of SMG Group)
Glasgow Office

200 Renfield Street, Glasgow G2 3PR
Fax: 0141-300 3030 Tel: 0141-300 3000
Website: www.scottishtv.co.uk

Chief Executive (SMG Television)	Donald Emslie
Managing Director	Bobby Hain
Head of News & Current Affairs	Gordon MacMillan

London Office

1st Flr, 3 Waterhouse Sq, 138-142 Holborn, London EC1N 2NY
Fax: 020-7882 1111 Tel: 020-7882 1010

SMG TV PRODUCTIONS
Glasgow Office
200 Renfield Street
Glasgow G2 3PR
Fax: 0141-300 3030 Tel: 0141-300 3000

Chief Executive	Donald Emslie (SMG Television)
Managing Director	Elizabeth Partyka
Head of Drama	Eric Coulter

London Office
1st Floor, 3 Waterhouse Square
138-142 Holborn
London EC1N 2NY Tel: 020-7882 1010

 Tyne Tees

ITV TYNE TEES

ITV Tyne Tees
Television House, The Watermark, Gateshead NE11 9SZ
Fax: 0191-404 8780 Tel: 0191-404 8700

Teesside Studio

Colman's Nook
Belasis Hall Technology Park
Billingham
Cleveland TS23 4EG
Fax: 01642 566560 Tel: 01642 566999

North East and North Yorkshire:
Weekday and Weekend

Chairman	tba
Managing Director, Controller of Programmes	Graeme Thompson
Head of News	Graham Marples
Head of Network Features	Mark Robinson
Head of New Media	Malcolm Wright
Head of Features	Jane Bolesworth

ULSTER TELEVISION

Ormeau Road
Belfast BT7 1EB
Fax: 028-9024 6695 Tel: 028-9032 8122

Northern Ireland: Weekday and Weekend

Chairman	J B McGuckian BSc (Econ)
Group Chief Executive	J McCann BSc, FCA
Group Financial Director	Jim Downey
Head of Television	Michael Wilson
Head of Press & Public Relations	Orla McKibbin
Head of News & Current Affairs	R Morrison
Sales Director	P Hutchinson

itv Yorkshire

ITV - YORKSHIRE
The Television Centre, Leeds LS3 1JS
Fax: 0113-244 5107 Tel: 0113-243 8283

London Office
London Television Centre
Upperground, London SE1 9LT Tel: 020-7620 1620

Hull Office
23 Brook Street
The Prospect Centre, Hull HU2 8PN Tel: 01482 324488

Sheffield Office
Charter Square, Sheffield S1 3EJ Tel: 0114-272 7772

Lincoln Office
88 Bailgate, Lincoln LN1 3AR Tel: 01522 530738

Grimsby Office
Margaret Street, Immingham
North East Lincs DN40 1LE Tel: 01469 515151

York Office
8 Coppergate, York YO1 1NR Tel: 01904 610066

Executives

Managing Director	David M B Croft
Controller of Regional Programmes (North)	Clare Morrow
Director of Business Affairs	Filip Cieslik
Head of News	Will Venters
Controller of Comedy Drama & Drama Features	David Reynolds
Controller of Drama, Leeds	Keith Richardson
Director of Finance	Ian Roe
Director of ITV Productions	John Whiston
Producer of Regional Features	Mark Witty

SKY Satellite Television
BRITISH SKY BROADCASTING LIMITED (BSkyB)
6 Centaurs Business Park
Grant Way, Isleworth, Middlesex TW7 5QD
Fax: 0870 240 3060 Tel: 0870 240 3000

Chief Executive	James Murdoch
Chief Operating Officer	Richard Freudenstein
Chief Financial Officer	Jeremy Darroch
Managing Director, Sky Networks	Dawn Airey
Director for People & Organisational Development	Beryl Cook
Group Commercial and Strategy Director	Mike Darcey
Group Director for Communications	Matthew Anderson
Managing Director, Customer Group and Chief Marketing Officer	Jon Florsheim
Group Director for IT & Strategy	Jeff Hughes
General Counsel	James Conyers
Managing Director, Sky Media	Nick Milligan
Head of Regulatory Affairs	Vicky Sandy
Managing Director, Sky Sports	Vic Wakeling
Group Director of Engineering & Platform Technology	Alun Webber

SPOTLIGHT PUBLICATIONS
SPOTLIGHT INTERACTIVE
SPOTLIGHT SERVICES

THE SPOTLIGHT ROOMS

Spacious casting facilities and studios in the heart of the West End

- Free receptionist service
- Large waiting room
- Wireless Internet
- Video-casting on any format
- Live web-streaming
- Free online clips
- Competitive rates

www.spotlight.com/rooms
For bookings: 020 7440 5030 email: casting@spotlight.com
7 Leicester Place London WC2H 7RJ

30 BIRD PRODUCTIONS
24 Wroxton Road, London SE15 2BN
e-mail: thirtybirdproductions@ntlworld.com
Tel: 020-7635 3737

ACORN ENTERTAINMENTS Ltd
PO Box 64, Cirencester, Glos GL7 5YD
Website: www.acornents.co.uk
e-mail: info@acornents.co.uk
Fax: 01285 642291
Tel: 01285 644622

ACT OUT THEATRE
36 Lord Street, Radcliffe
Manchester M26 3BA
e-mail: nigeladams@talk21.com
Tel/Fax: 0161-724 6625

ACT PRODUCTIONS Ltd
20-22 Stukeley Street, London WC2B 5LR
Website: www.actproductions.co.uk
e-mail: info@act.tt
Fax: 020-7242 3548
Tel: 020-7438 9520

ACTING PRODUCTIONS
Unit 88, Battersea Business Centre
99-109 Lavender Hill, London SW11 5QL
Website: www.acting-productions.co.uk
e-mail: info@acting-productions.co.uk
Fax: 020-7924 6606
Tel: 020-7924 7701

AJTC THEATRE COMPANY
28 Rydes Hill Crescent
Guildford, Surrey GU2 9UH
Website: www.ajtctheatre.co.uk
e-mail: ajtc@ntlworld.com
Tel/Fax: 01483 232795

AKA PRODUCTIONS
First Floor, 115 Shaftesbury Avenue
Cambridge Circus, London WC2H 8AF
Website: www.akauk.com
e-mail: aka@akauk.com
Fax: 020-7836 8787
Tel: 020-7836 4747

ALGERNON Ltd
15 Cleveland Mansions
Widley Road, London W9 2LA
Website: www.algernonproductions.com
e-mail: info@algernonproductions.com
Fax: 0870 1388516
Tel: 020-7266 1582

AMBASSADOR THEATRE GROUP
Duke of York's Theatre
104 St Martin's Lane, London WC2N 4BG
e-mail: atglondon@theambassadors.com
Fax: 020-7854 7001
Tel: 020-7854 7000

ANDREW JENKINS Ltd
St Martin's House, St Martin's Lane, London WC2N 4JS
Website: www.andrewjenkinsltd.com
e-mail: info@andrewjenkinsltd.com
Fax: 020-7240 0710
Tel: 020-7240 0607

ANTIC DISPOSITION
4A Oval Road, London NW1 7EB
Website: www.anticdisposition.co.uk
e-mail: info@anticdisposition.co.uk
Tel: 020-7284 0760

AOD - ACTORS OF DIONYSUS
14 Cuthbert Road, Brighton BN2 0EN
Website: www.actorsofdionysus.com
e-mail: info@actorsofdionysus.com
Tel/Fax: 01273 692604

ARTS MANAGEMENT (Redroofs Associates)
Pinewood Studios
Iver Heath, Buckinghamshire SL0 0NH
Fax: 01753 785443
Tel: 01753 785444

ASHTON GROUP THEATRE The
The Old Fire Station, Abbey Road
Barrow-in-Furness, Cumbria LA14 1XH
Website: www.ashtongroup.co.uk
e-mail: info@ashtongroup.co.uk
Tel/Fax: 01229 430636

ATC
Malvern House
15-16 Nassau Street, London W1W 7AB
Website: www.atc-online.com
e-mail: atc@atc-online.com
Fax: 020-7580 7724
Tel: 020-7580 7723

ATP Ltd
5 Spencer Road, London SW18 2SP
e-mail: atpmedia@btconnect.com
Tel/Fax: 020-7738 9886

ATTIC THEATRE COMPANY (LONDON) Ltd
New Wimbledon Theatre
The Broadway, London SW19 1QG
Website: www.attictheatrecompany.com
e-mail: info@attictheatrecompany.com
Tel: 020-8543 7838

BACKGROUND Ltd
44 Carnaby Street, London W1F 9PP
e-mail: insight@background.co.uk
Fax: 020-7479 4710
Tel: 020-7479 4700

BARKING PRODUCTIONS/INSTANT WIT
(Comedy Improvisation/Corporate Entertainment &
Training)
PO Box 597, Bristol BS99 2BB
Website: www.barkingproductions.co.uk
e-mail: info@barkingproductions.co.uk
Fax: 0117-908 5384
Tel: 0117-939 3171

BARNES Andy
28B Compton Road, London N21 3NX
Website: www.andybarnes.moonfruit.com
e-mail: andybarnes@ukonline.co.uk
Mobile: 07957 313666

BEE & BUSTLE ENTERPRISES
32 Exeter Road, London NW2 4SB
Website: www.beeandbustle.co.uk
e-mail: info@beeandbustle.co.uk
Fax: 020-8450 1057
Tel: 020-8450 0371

BIG DOG PRODUCTIONS Ltd
(Martin Roddy)
16 Kirkwick Avenue, Harpenden, Herts AL5 2QN
e-mail: bigdog@kirkwick.demon.co.uk
Tel/Fax: 01582 467344

BIG NOSE PRODUCTIONS Ltd
220-222 High Street, Barnet, Herts EN5 5SZ
Website: www.bignoseproductions.net
e-mail: helga@bignoseproductions.net Tel/Fax: 020-8440 3060

BIRMINGHAM STAGE COMPANY The
Suite 228 The Linen Hall
162 Regent Street, London W1B 5TG
Website: www.birminghamstage.net
e-mail: info@birminghamstage.net
Fax: 020-7437 3395
Tel: 020-7437 3391

BLUE BOX ENTERTAINMENT Ltd
80-81 St Martin's Lane
London WC2N 4AA
Website: www.blue-box.biz
e-mail: info@blue-box.biz
Fax: 020-7240 2947
Tel: 020-7395 7520

BORDER CROSSINGS
13 Bankside, Enfield EN2 8BN
Website: www.bordercrossings.org.uk
e-mail: borcross@aol.com
Tel/Fax: 020-8366 5239

BORDERLINE THEATRE COMPANY
North Harbour Street, Ayr KA8 8AA
e-mail: enquiries@borderlinetheatre.co.uk Tel: 01292 281010

BREAKWITH PRODUCTIONS
7 London Court, Frogmore, London SW18 1HH
e-mail: breakwith@aol.com
Fax: 020-8871 4999 Tel: 020-8870 4431

BRIT-POL THEATRE Ltd
10 Bristol Gardens, London W9 2JG
Website: www.britpoltheatre.com
e-mail: admin@britpoltheatre.com Tel: 020-7266 0323

BRITISH SHAKESPEARE COMPANY
8 Adelaide Grove, London W12 0JJ
Website: www.britishshakespearecompany.com
e-mail: info@britishshakespearecompany.com
 Tel: 020-8749 4427

BRITISH STAGE PRODUCTIONS
Victoria Buildings, 1B Sherwood Street
Scarborough, North Yorkshire YO11 1SR
e-mail: britstage@aol.com
Fax: 01723 501328 Tel: 01723 507186

BROADHOUSE PRODUCTIONS Ltd
Lodge Rocks House, Bilbrook
Minehead, Somerset TA24 6RD
e-mail: admin@broadhouse.co.uk
Fax: 01984 641027 Tel: 01984 640773

BROOKE Nick Ltd
2nd Floor, 80-81 St Martin's Lane, London WC2N 4AA
e-mail: nick@nickbrooke.com
Fax: 020-7240 2947 Tel: 020-7240 3901

BUSH THEATRE
Shepherd's Bush Green, London W12 8QD
Website: www.bushtheatre.co.uk
e-mail: info@bushtheatre.co.uk
Fax: 020-7602 7614 Tel: 020-7602 3703

BYAM SHAW Matthew for ST ELMO PRODUCTIONS
2nd Floor, 20-22 Stukeley Street, London WC2B 5LR
Fax: 020-7242 3578 Tel: 020-7438 9520

CAHOOTS PRODUCTION & PR
(Denise Silvey)
11-15 Betterton Street, London WC2H 9BP
Website: www.cahootstheatre.co.uk
e-mail: denise@cahootstheatre.co.uk
Fax: 020-7379 0801 Tel: 020-7470 8812

CAP PRODUCTION SOLUTIONS Ltd
20 Merton Industrial Park
Jubilee Way, Wimbledon, London SW19 3WL
e-mail: leigh@leighporter.com
Fax: 07970 763480 Tel: 020-8544 8668

CAPRICORN STAGE (& SCREEN) DIRECTIONS
9 Spencer House, Vale of Health
Hampstead, London NW3 1AS Tel: 020-7794 5843

CASSANDRA THEATRE COMPANY
(Vanessa Mildenberg, Clare Bloomer)
Flat 2, 40 Brondesbury Villas, London NW6 4AB
e-mail: vm_cassandratc@yahoo.co.uk Tel: 020-7624 3885

CAVALCADE THEATRE COMPANY
(Plays, Musicals & Tribute Shows, Cabaret, Children's
Shows)
57 Pelham Road, London SW19 1NW
Fax: 020-8540 2243 Tel: 020-8540 3513

**Richard Jordan
Productions Ltd**

● **Producing**

● **General Management**
UK and International Productions,
and International Festivals

● **Consultancy**

Richard Jordan Productions Ltd
Mews Studios, 16 Vernon Yard
London W11 2DX

Tel: 020 7243 9001
Fax: 020 7313 9667
e-mail: richard.jordan@virgin.net

CELEBRATION
(Theatre Company for the Young)
48 Chiswick Staithe, London W4 3TP Tel: 020-8994 8886

CENTRELINE PRODUCTIONS
Unit 5A, 3 Long Street, London E2 8HJ
Website: www.centrelinenet.com
Fax: 020-7613 4950 Tel: 020-7739 4952

CHAIN REACTION THEATRE COMPANY
Three Mills Studios, Sugar House Yard
Sugar House Lane, London E15 2QS
Website: www.chainreactiontheatre.co.uk
e-mail: mail@chainreactiontheatre.co.uk
 Tel/Fax: 020-8534 0007

CHANNEL THEATRE PRODUCTIONS
Central Studios, 36 Park Place
Margate, Kent CT9 1LE
Website: www.channel-theatre.co.uk
e-mail: info@channel-theatre.co.uk
Fax: 01843 280088 Tel: 01843 280077

CHAPMAN Duggie ASSOCIATES
(Pantomime, Concerts, Musicals)
The Old Coach House
202 Common Edge Road
Blackpool FY4 5DG
Website: www.duggiechapman.co.uk
e-mail: duggie@chapmanassociates.fsnet.co.uk
 Tel/Fax: 01253 691823

CHAPMAN Guy PRODUCTIONS Ltd
33 Southampton Street, London WC2E 7HE
Website: www.g-c-a.co.uk
e-mail: admin@g-c-a.co.uk
Fax: 020-7379 8484 Tel: 020-7379 7474

CHEEK BY JOWL
Stage Door, Barbican Centre
Silk Street, London EC2Y 8DS
Website: www.cheekbyjowl.com Tel: 020-7382 7281

CHEEKY MAGGOT PRODUCTIONS
PO Box 273, 2-3 Bedford Street
London WC2E 9HH
Website: www.cheekymaggot.co.uk
e-mail: info@cheekymaggot.co.uk Mobile: 07854 855331

CHICHESTER FESTIVAL THEATRE
Oaklands Park, Chichester, West Sussex PO19 6AP
Website: www.cft.org.uk
e-mail: admin@cft.org.uk
Fax: 01243 787288 Tel: 01243 784437

CHICKEN SHED THEATRE
Chase Side, Southgate, London N14 4PE
Website: www.chickenshed.org.uk
e-mail: info@chickenshed.org.uk
Minicom: 020-8350 0676 Tel: 020-8351 6161

CHURCHILL THEATRE BROMLEY Ltd
Churchill Theatre, High Street, Bromley, Kent BR1 1HA
Website: www.churchilltheatre.co.uk
Fax: 020-8290 6968 Tel: 020-8464 7131

CLOSE FOR COMFORT THEATRE COMPANY
34 Boleyn Walk, Leatherhead, Surrey KT22 7HU
Website: www.hometown.aol.com/close4comf
e-mail: close4comf@aol.com
Mobile: 07710 258290 Tel: 01372 378613

CLUBWEST PRODUCTIONS
Dramazone, Arundel Town Hall
Arundel, West Sussex BN18 9AP
Website: www.clubwest.co.uk
e-mail: admin@clubwest.co.uk Tel/Fax: 01903 889821

CODRON Michael PLAYS Ltd
Aldwych Theatre Offices, London WC2B 4DF
Fax: 020-7240 8467 Tel: 020-7240 8291

COLE KITCHENN Ltd
Vaudeville Theatre Offices
404 Strand, London WC2R 0NH
Website: www.colekitchenn.com
e-mail: info@colekitchenn.com
Fax: 020-7240 8744 Tel: 020-7836 2502

COMPASS THEATRE COMPANY
Carver Street Institute
24 Rockingham Lane, Sheffield S1 4FW
Website: www.compasstheatrecompany.com
e-mail: info@compasstheatrecompany.com
Fax: 0114-278 6931 Tel: 0114-275 5328

COMPLICITE
14 Anglers Lane, London NW5 3DG
Website: www.complicite.org
e-mail: email@complicite.org
Fax: 020-7485 7701 Tel: 020-7485 7700

CONCORDANCE
(Neil McPherson)
Finborough Theatre
118 Finborough Road, London SW10 9ED
Website: www.concordance.org.uk
e-mail: admin@concordance.org.uk
Fax: 020-7835 1853 Tel: 020-7244 7439

CONTEMPORARY STAGE COMPANY
3 Etchingham Park Road, Finchley, London N3 2DU
Website: www.contemporarystage.co.uk
e-mail: contemp.stage@britishlibrary.net
Fax: 020-8349 2458 Tel: 020-8349 4402

CONWAY Clive CELEBRITY PRODUCTIONS Ltd
32 Grove Street, Oxford OX2 7JT
e-mail: info@celebrityproductions.org
Fax: 01865 514409 Tel: 01865 514830

CREATIVE CONCERTS Ltd
PO Box 745, Guildford, Surrey GU3 1XJ
Website: www.creativeconcerts.co.uk Tel: 01483 813294

CRISP THEATRE
8 Cornwallis Crescent
Clifton, Bristol BS8 4PL
Website: www.crisptheatre.co.uk
e-mail: crisptheatre@btconnect.com Tel: 0117-973 7106

DALE TEATER KOMPANI
434B Hornsey Road, London N19 4EB
Website: www.daletk.co.uk
e-mail: info@daletk.co.uk Tel: 020-7281 4322

DEAD EARNEST THEATRE
The Quadrant
99 Parkway Avenue, Sheffield S9 4WG
Website: www.deadearnest.co.uk
e-mail: info@deadearnest.co.uk Tel: 0114-227 0085

DEAN Lee
PO Box 10703, London WC2H 9ED
e-mail: admin@leedean.co.uk
Fax: 020-7836 6968 Tel: 020-7497 5111

DEBUT PRODUCTIONS
(Actor Showcases in London's West End & Manchester)
29 Station Road, Chertsey, Surrey KT16 8BE
Website: www.debutproductions.co.uk
e-mail: enquiries@debutproductions.co.uk Tel: 01932 423102

DELFONT MACKINTOSH THEATRES Ltd
(Theatre Owners)
The Novello Theatre
Aldwych, London WC2B 4LD
e-mail: info@delfontmackintosh.co.uk
Fax: 020-7240 3831 Tel: 020-7379 4431

DISNEY THEATRICAL PRODUCTIONS (UK)
Lyceum Theatre
21 Wellington Street, London WC2E 7RQ
Fax: 020-7845 0999 Tel: 020-7845 0900

DONEGAN David Ltd
PO Box LB689, London W1A 9LB
e-mail: david@ddonegan.fsbusiness.co.uk Tel: 020-8687 0107

DOODAH THEATRE
10 Shrewsbury Road, Redhill, Surrey RH1 6BH
e-mail: doodahtc@aol.com Tel: 01737 778046

DRAMATIS PERSONAE Ltd
(Nathan Silver, Nicolas Kent)
19 Regency Street, London SW1P 4BY
e-mail: nathansilver@btconnect.com Tel: 020-7834 9300

DUAL CONTROL THEATRE COMPANY
The Admiral's Offices
The Historic Dockyard, Chatham, Kent ME4 4TZ
Website: www.ellenkent.com
e-mail: info@ellenkentinternational.co.uk
Fax: 01634 819149 Tel: 01634 819141

EASTERN ANGLES THEATRE COMPANY
(Touring)
Sir John Mills Theatre
Gatacre Road, Ipswich, Suffolk IP1 2LQ
Website: www.easternangles.co.uk
e-mail: admin@easternangles.co.uk
Fax: 01473 384999 Tel: 01473 218202

ELLIOTT Paul Ltd
(Triumph Entertainment Ltd)
1st Floor, 18 Exeter Street, London WC2E 7DU
e-mail: pelliott@paulelliott.ltd.uk
Fax: 020-7379 4860 Tel: 020-7379 4870

ENGLISH CHAMBER THEATRE The
(No Drama School Applicants)
Flat 3, 6 St Simon's Avenue, London SW15 6DU
Website: www.englishchambertheatre.co.uk
e-mail: jane@janemcculloch.com
Mobile: 07951 912425 Tel: 020-8789 2424

ENGLISH NATIONAL OPERA
London Coliseum
St Martin's Lane, London WC2N 4ES
Website: www.eno.org
Fax: 020-7845 9277 Tel: 020-7836 0111

ENGLISH STAGE COMPANY Ltd
Royal Court
Sloane Square, London SW1W 8AS
Website: www.royalcourttheatre.com
e-mail: info@royalcourttheatre.com
Fax: 020-7565 5001 Tel: 020-7565 5050

ENGLISH THEATRE COMPANY Ltd The
(TMA Member)
Nybrogatan 35
114 39 Stockholm, Sweden
Website: www.englishtheatre.se
e-mail: etc.ltd@telia.com
Fax: 00 46 8660 1159 Tel: 00 46 8662 4133

ENGLISH TOURING THEATRE (ETT)
25 Short Street
London SE1 8LJ
Website: www.ett.org.uk
e-mail: admin@ett.org.uk
Fax: 020-7450 1991 Tel: 020-7450 1990

ENTERTAINMENT BUSINESS Ltd The
2nd Floor
28 Charing Cross Road, London WC2H 0DB
Website: www.cardiffmusicals.com
Fax: 020-7836 3982 Tel: 020-7240 8178

EUROPEAN THEATRE COMPANY The
39 Oxford Avenue, London SW20 8LS
Website: www.europeantheatre.co.uk
e-mail: admin@europeantheatre.co.uk
Fax: 020-8544 1999 Tel: 020-8544 1994

FACADE
(Musicals)
43A Garthorne Road, London SE23 1EP
e-mail: facade@cobomedia.com Tel: 020-8291 7079

FEATHER PRODUCTIONS Ltd
The Studio, 137 Sheen Road
Richmond, Surrey TW9 1YJ
Website: www.featherproductions.com
e-mail: info@featherproductions.com
Fax: 020-8940 2335 Tel: 020-8439 9848

FELL Andrew Ltd
4 Ching Court
49-51 Monmouth Street
London WC2H 9EY
e-mail: hq@andrewfell.co.uk
Fax: 020-7240 2499 Tel: 020-7240 2420

FIELDER Simon PRODUCTIONS Ltd
The Theatre, 7 Church Street
Leatherhead, Surrey KT22 8DN
e-mail: enquiries@simonfielder.com Tel: 01372 365134

FIERY ANGEL Ltd
22-24 Torrington Place, London WC1E 7HJ
Website: www.fiery-angel.com
e-mail: admin@fiery-angel.com
Fax: 020-7580 6652 Tel: 020-7907 7040

FLUTTER THEATRE
(Megan Heffernan/Laura Eades)
21 Hetley Road, London W12 8BA
e-mail: fluttertheatre@googlemail.com Mobile: 07946 458699

FORBIDDEN THEATRE COMPANY
18 Rupert Street, London W1D 6DE
Website: www.forbidden.org.uk
e-mail: info@forbidden.org.uk Tel: 0845 0093084

FORD Vanessa PRODUCTIONS Ltd
Upper House Farm, Upper House Lane
Shamley Green, Surrey GU5 0SX
Website: www.vfpltd.com
e-mail: vfpltd@btinternet.com
Fax: 01483 271509 Tel: 01483 278203

FOX Robert Ltd
6 Beauchamp Place, London SW3 1NG
Website: www.robertfoxltd.com
e-mail: info@robertfoxltd.com
Fax: 020-7225 1638 Tel: 020-7584 6855

FREEDMAN Bill Ltd
Room 311, Bedford Chambers
The Piazza, Covent Garden
London WC2E 8HA
Fax: 020-7836 9903 Tel: 020-7836 9900

FRICKER Ian (THEATRE) Ltd
PO Box 65, Arundel, West Sussex BN18 9WZ
Website: www.ianfricker.com
e-mail: mail@ianfricker.com
Fax: 01903 885372 Tel: 01903 885391

FRIEDMAN Sonia PRODUCTIONS
New Ambassadors Theatre
West Street, London WC2H 9ND
Website: www.soniafriedman.com
e-mail: mail@soniafriedman.com
Fax: 020-7395 5455 Tel: 020-7395 5454

FUTURA MUSIC (PRODUCTIONS) Ltd
(Write only)
29 Emanuel House
Rochester Row, London SW1P 1BS

GALE PRODUCTIONS
24 Wimbledon Park Road
London SW18 1LT
e-mail: gale.prod@which.net
Fax: 020-8875 1582 Tel: 020-8870 1149

GALLEON THEATRE COMPANY Ltd
(Alice De Sousa)
Greenwich Playhouse
Greenwich BR Station Forecourt
189 Greenwich High Road, London SE10 8JA
Website: www.galleontheatre.co.uk
e-mail: boxoffice@galleontheatre.co.uk
Fax: 020-8310 7276 Tel: 020-8858 9256

GBM PRODUCTIONS Ltd
Bidlake Toft, Roadford Lake
Germansweek, Devon EX21 5BD
Website: www.musicaltheatrecreations.com
e-mail: gbm@bidlaketoft.com
Fax: 01837 871123 Tel: 01837 871522

GLASS David ENSEMBLE
59 Brewer Street, London W1F 9UN
Website: www.davidglassensemble.com
e-mail: info@davidglassensemble.com Tel/Fax: 020-7734 6030

GODOT COMPANY
51 The Cut, London SE1 8LF
e-mail: godot@calderpublications.com
Fax: 020-7928 5930 Tel: 020-7633 0599

GOOD COMPANY
at St Michaels
Powis Road, Brighton BN1 3HJ
Fax: 01273 779955 Tel: 01273 771777

GOSS Gerald Ltd
19 Gloucester Street, London SW1V 2DB
e-mail: info@geraldgoss.co.uk
Fax: 020-7592 9301 Tel: 020-7592 9202

GOUCHER Mark Ltd
2nd Floor, 20-22 Stukeley Street, London WC2B 5LR
e-mail: info@markgoucher.com
Fax: 020-7438 9577 Tel: 020-7438 9570

GRAEAE THEATRE COMPANY
LVS Resource Centre
356 Holloway Road, London N7 6PA
Website: www.graeae.org
e-mail: info@graeae.org
Fax: 020-7609 7324 Tel: 020-7700 2455

GRAHAM David ENTERTAINMENT Ltd
72 New Bond Street, London W1S 1RR
Website: www.davidgrahamentertainment.com
e-mail: info@davidgraham.co.uk
Fax: 0870 3211700 Tel: 0870 3211600

GRANT Derek ORGANISATION Ltd
13 Beechwood Road, West Moors, Dorset BH22 0BN
Website: www.derekgrant.co.uk
e-mail: admin@derekgrant.co.uk Tel/Fax: 01202 855777

HAMPSTEAD THEATRE PRODUCTIONS Ltd
Eton Avenue, Swiss Cottage, London NW3 3EU
Website: www.hampsteadtheatre.com
e-mail: info@hampsteadtheatre.com
Fax: 020-7449 4201 Tel: 020-7449 4200

HANDSTAND PRODUCTIONS
13 Hope Street, Liverpool L1 9BH
Website: www.handstand-uk.com
e-mail: info@handstand-uk.com
Fax: 0151-709 3515 Tel: 0151-708 7441

HARLEY PRODUCTIONS
68 New Cavendish Street, London W1G 8TE
e-mail: harleyprods@aol.com
Fax: 020-8202 8863 Tel: 020-7580 3247

HAYMARKET THEATRE COMPANY Ltd
Wote Street, Basingstoke, Hampshire RG21 7NW
Website: www.haymarket.org.uk
e-mail: info@haymarket.org.uk
Fax: 01256 357130 Tel: 0870 7701029

HEADLONG THEATRE Ltd
Chertsey Chambers
12 Mercer Street, London WC2H 9QD
Website: www.headlongtheatre.co.uk
e-mail: info@headlongtheatre.co.uk
Fax: 020-7438 9941 Tel: 020-7438 9940

HENDERSON Glynis PRODUCTIONS Ltd
69 Charlotte Street, London W1T 4PJ
e-mail: info@ghmp.co.uk
Fax: 020-7436 1489 Tel: 020-7580 9644

HENRY Stephen / THEATRE 28 ENSEMBLE
(Write)
187 Drury Lane, Covent Garden, London WC2B 5QD
Website: www.28productions.co.uk
e-mail: info@28productions.co.uk

HESTER John PRODUCTIONS
(Intimate Mysteries Theatre Company)
105 Stoneleigh Park Road
Epsom, Surrey KT19 0RF
e-mail: hjohnhester@aol.com Tel/Fax: 020-8393 5705

HEWITT-JONES Brian
Curlews House, Crowle DN17 4JS
Fax: 01724 711088 Tel: 01724 712459

HISS & BOO COMPANY Ltd The
(Ian Liston)
Nyes Hill, Wineham Lane
Bolney, West Sussex RH17 5SD
Website: www.hissboo.co.uk
e-mail: email@hissboo.co.uk
Fax: 01444 882057 Tel: 01444 881707

HISTORIA THEATRE COMPANY
8 Cloudesley Square, London N1 0HT
Website: www.historiatheatre.com
e-mail: kateprice@lineone.net
Fax: 020-7278 4733 Tel: 020-7837 8008

HOIPOLLOI
Office F, Dale's Brewery
Gwydir Street, Cambridge CB1 2LJ
Website: www.hoipolloi.org.uk
e-mail: info@hoipolloi.org.uk Tel: 01223 322748

HOLLOW CROWN PRODUCTIONS
2 Norfolk Road, London E17 5QS
Website: www.hollowcrown.co.uk
e-mail: enquiries@hollowcrown.co.uk Mobile: 07930 530948

HOLMAN Paul ASSOCIATES Ltd
Morritt House
58 Station Approach
South Ruislip
Middlesex HA4 6SA
Website: www.paulholmanassociates.co.uk
e-mail: enquiries@paulholmanassociates.co.uk
Fax: 020-8839 3124 Tel: 020-8845 9408

HOLT Thelma Ltd
Noël Coward Theatre
85 St Martin's Lane, London WC2N 4AU
Website: www.thelmaholt.co.uk
e-mail: thelma@dircon.co.uk
Fax: 020-7812 7550 Tel: 020-7812 7455

HOUSE OF GULLIVER Ltd
(Write)
55 Goldfield Road, Tring, Herts HP23 4BA

HUGHES PRODUCTIONS (UK) Ltd
PO Box 500
Romsey, Hampshire SO51 5XZ
Website: www.hughes-productions.co.uk
e-mail: steve@hughes-productions.co.uk
 Mobile: 07816 844024

HULL TRUCK THEATRE
Spring Street, Hull HU2 8RW
Website: www.hulltruck.co.uk
e-mail: admin@hulltruck.co.uk
Fax: 01482 581182 Tel: 01482 224800

ICARUS THEATRE COLLECTIVE
105 Bell Street, London NW1 6TL
Website: www.icarustheatre.co.uk
e-mail: info@icarustheatre.co.uk
Fax: 0871 5227001 Tel: 020-7870 3787

IMAGE MUSICAL THEATRE
23 Sedgeford Road
Shepherd's Bush, London W12 0NA
Website: www.imagemusicaltheatre.co.uk
e-mail: brian@imagemusicaltheatre.co.uk
Fax: 020-8749 9294 Tel: 020-8743 9380

IMAGINATION ENTERTAINMENTS
25 Store Street
South Crescent, London WC1E 7BL
Website: www.imagination.com
e-mail: entertainments@imagination.com
Fax: 020-7323 5801 Tel: 020-7323 3300

INCISOR
Flat 4, 2 Somerhill Avenue, Hove BN3 1RJ
Website: www.festival-edinburgh.com
e-mail: sarah.mann5@ntlworld.com
Fax: 020-8830 4992 Mobile: 07979 498450

INDIGO ENTERTAINMENTS
Tynymynydd, Bryneglwys
Corwen, Denbighshire LL21 9NP
Website: www.indigoentertainments.co.uk
e-mail: info@indigoentertainments.com Tel: 01978 790211

INSIDE INTELLIGENCE
(Theatre, Contemporary Opera & Music)
13 Athlone Close, London E5 8HD
Website: www.inside-intelligence.org.uk
e-mail: admin@inside-intelligence.org.uk
Fax: 020-8985 7211 Tel: 020-8986 8013

INTERNATIONAL THEATRE & MUSIC Ltd
(Piers Chater Robinson)
Garden Studios, 11-15 Betterton Street
Covent Garden, London WC2H 9BP
Website: www.internationaltheatreandmusic.com
e-mail: info@internationaltheatreandmusic.com
Fax: 020-7379 0801 Tel: 020-7470 8786

ISLEWORTH ACTORS COMPANY
38 Eve Road, Isleworth
Middlesex TW7 7HS Tel/Fax: 020-8891 1073

JAMES Bruce PRODUCTIONS Ltd
68 St Georges Park Avenue
Westcliff-on-Sea, Essex SS0 9UD
Website: www.brucejamesproductions.co.uk
e-mail: info@brucejamesproductions.co.uk
Mobile: 07850 369018 Tel/Fax: 01702 335970

JENKINS Andrew Ltd
St Martin's House
59 St Martin's Lane, London WC2N 4JS
Website: www.andrewjenkinsltd.com
e-mail: info@andrewjenkinsltd.com
Fax: 020-7240 0710 Tel: 020-7240 0607

JOHNSON David
85B Torriano Avenue
London NW5 2RX
e-mail: david@johnsontemple.co.uk Tel: 020-7284 3733

JOHNSON Gareth Ltd
Plas Hafren, Eglwyswrw
Crymych, Pembrokeshire SA41 3UL
e-mail: gjltd@mac.com
Fax: 07779 007845 Mobile: 07770 225227

JORDAN Andy PRODUCTIONS Ltd
42 Durlston Road, London E5 8RR
e-mail: ANDYJAndyjordan@aol.com Mobile: 07775 615205

JORDAN Richard PRODUCTIONS Ltd
Mews Studios, 16 Vernon Yard, London W11 2DX
e-mail: richard.jordan@virgin.net
Fax: 020-7313 9667 Tel: 020-7243 9001

KELLY Robert C Ltd
The Alhambra Suite
82 Mitchell Street, Glasgow G1 3NA
Website: www.robertckelly.co.uk
e-mail: robert@robertckelly.co.uk
Fax: 0141-229 1441 Tel: 0141-229 1444

KENWRIGHT Bill Ltd
BKL House, 106 Harrow Road
Off Howley Place, London W2 1RR
e-mail: info@kenwright.com
Fax: 020-7446 6222 Tel: 020-7446 6200

KING'S HEAD THEATRE PRODUCTIONS Ltd
115 Upper Street, London N1 1QN
Website: www.kingsheadtheatre.org
Fax: 020-7226 8507 Tel: 020-7226 8561

KIRK David PRODUCTIONS
11A Marwick Terrace
St Leonards-on-Sea, East Sussex TN38 0RE
e-mail: david@kirk01.wanadoo.co.uk Tel: 01424 445081

LATCHMERE THEATRE
(Chris Fisher)
Unit 5A, Imex Business Centre
Ingate Place, London SW8 3NS
e-mail: latchmere@fishers.org.uk
Fax: 020-7978 2631 Tel: 020-7978 2620

LIMELIGHT ENTERTAINMENT PRODUCTIONS Ltd
The Gateway
2A Rathmore Road, London SE7 7QW
e-mail: enquiries@limelightents.co.uk
Fax: 020-8305 2684 Tel: 020-8858 6141

LINNIT PRODUCTIONS Ltd
123A King's Road, London SW3 4PL
Fax: 020-7352 3450 Tel: 020-7352 7722

LIVE NATION
35-36 Grosvenor Street, London W1K 4QX
Website: www.livenation.com
Fax: 020-7529 4345 Tel: 020-7529 4300

LIVE THEATRE
7-8 Trinity Chare, Quayside
Newcastle upon Tyne NE1 3DF
Website: www.live.org.uk Tel: 0191-261 2694

LLOYD-JAMES Adrian
57 Chamberlain Place, London E17 6AZ
e-mail: adrianmljames@aol.com
Fax: 08714 332938 Tel: 020-8527 9255

LONDON BUBBLE THEATRE COMPANY Ltd
5 Elephant Lane
London SE16 4JD
Website: www.londonbubble.org.uk
e-mail: admin@londonbubble.org.uk
Fax: 020-7231 2366 Tel: 020-7237 4434

LONDON CLASSIC THEATRE
The Production Office
63 Shirley Avenue
Sutton, Surrey SM1 3QT
Website: www.londonclassictheatre.co.uk
e-mail: admin@londonclassictheatre.co.uk
 Tel/Fax: 020-8395 2095

LONDON COMPANY INTERNATIONAL PLAYS Ltd The
(No CVs please)
6th Floor, Empire House
175 Piccadilly, London W1J 9TB
e-mail: derek@glynnes.co.uk
Fax: 020-7486 2164　　　　　　　Tel: 020-7486 3166

LONDON PRODUCTIONS Ltd
PO Box 10703, London WC2H 9ED
e-mail: admin@leedean.co.uk
Fax: 020-7836 6968　　　　　　　Tel: 020-7497 5111

LOUDER THAN WORDS Ltd
3 Water Lane, London NW1 8NZ
e-mail: giles@louderthanwords.info
Fax: 07092 304101　　　　　　　Tel: 020-7284 3006

MACKINTOSH Cameron Ltd
1 Bedford Square, London WC1B 3RB
Fax: 020-7436 2683　　　　　　　Tel: 020-7637 8866

MACNAGHTEN PRODUCTIONS Ltd
Dundarave, Bushmills
Co. Antrim, Northern Ireland BT57 8ST
Fax: 028-2073 2575　　　　　　　Tel: 028-2073 1215

MALCOLM Christopher Ltd
11 Claremont Walk, Bath BA1 6HB
Website: www.christophermalcolm.co.uk
e-mail: cm@christophermalcolm.co.uk　Mobile: 07850 555042

MANS Johnny PRODUCTIONS Ltd
PO Box 196, Hoddesdon, Herts EN10 7WG
e-mail: real@legend.co.uk
Fax: 01992 470516　　　　　　　Tel: 01992 470907

MASTERSON Guy PRODUCTIONS
The Bull Theatre
68 High Street, Barnet
Herts EN5 5SJ
Website: www.theatretoursinternational.com
e-mail: admin@theatretoursinternational.com
　　　　　　　　　　　　Tel/Fax: 020-8449 7800

MEADOW Jeremy Ltd
11-15 Betterton Street, London WC2H 9BP
e-mail: info@jeremymeadow.com
Fax: 0870 7627882　　　　　　　Tel: 020-7379 1066

MENZIES Lee Ltd
118-120 Wardour Street
London W1F 0TU
Website: www.leemenzies.co.uk
e-mail: leemenzies@leemenzies.co.uk
Fax: 020-7734 4224　　　　　　　Tel: 020-7734 9559

MIDDLE GROUND THEATRE CO Ltd
3 Gordon Terrace
Malvern Wells
Malvern, Worcestershire WR14 4ER
Website: www.middlegroundtheatre.co.uk
e-mail: middleground@middlegroundtheatre.co.uk
Fax: 01684 574472　　　　　　　Tel: 01684 577231

MIRTOS PRODUCTIONS
3, 307 Norwood Road, London SE24 9AQ
Website: www.mirtosproductions.co.uk
e-mail: info@mirtosproductions.co.uk　Mobile: 07973 302908

MITCHELL Matthew Ltd
New Barn Farm
London Road
Hassocks, West Sussex BN6 9ND
e-mail: matthew@matthewmitchell.org　Tel/Fax: 01273 842572

MJE PRODUCTIONS Ltd
(Carole Winter, Michael Edwards)
Amadeus House, Floral Street
Covent Garden, London WC2E 9DP
Website: www.mjeproductions.com
e-mail: info@mjeproductions.com
Fax: 020-7812 6495　　　　　　　Tel: 020-7812 7290

MONSTER PRODUCTIONS
Buddle Arts Centre
258B Station Road
Wallsend, Tyne & Wear NE28 8RG
Website: www.monsterproductions.co.uk
e-mail: info@monsterproductions.co.uk
Fax: 0191-240 4016　　　　　　　Tel: 0191-240 4011

MORNING VICAR PRODUCTIONS Ltd
(Write)
c/o Cole Kitchenn Ltd
Vaudeville Theatre Offices
404 Strand, London WC2R 0NH
Website: www.morningvicar.co.uk
e-mail: info@morningvicar.co.uk
Fax: 020-7240 8477　　　　　　　Tel: 020-7582 2242

MOVING THEATRE
16 Laughton Lodge
Laughton, Nr Lewes, East Sussex BN8 6BY
Website: www.movingtheatre.com
e-mail: info@movingtheatre.com
Fax: 01323 815736　　　　　　　Tel: 01323 815726

MUSIC THEATRE LONDON
Chertsey Chambers
12 Mercer Street, London WC2H 9QD
Website: www.mtl.org.uk
e-mail: musictheatre.london@virgin.net　Tel: 020-7240 0919

MUZIKANSKY
The Forum, Fonthill
The Common
Tunbridge Wells TN4 8YU
Website: www.mzky.co.uk
e-mail: admin@mzky.co.uk　　　Tel/Fax: 01892 542260

NATIONAL THEATRE
South Bank, London SE1 9PX
Website: www.nationaltheatre.org.uk
Fax: 020-7452 3344　　　　　　　Tel: 020-7452 3333

NEAL STREET PRODUCTIONS Ltd
1st Floor, 26-28 Neal Street
London WC2H 9QQ
e-mail: post@nealstreetproductions.com
Fax: 020-7240 7099　　　　　　　Tel: 020-7240 8890

NEW SHAKESPEARE COMPANY Ltd The
Open Air Theatre, The Iron Works
Inner Circle, Regent's Park, London NW1 4NR
Website: www.openairtheatre.org
Fax: 020-7487 4562　　　　　　　Tel: 020-7935 5756

NEW VIC THEATRE OF LONDON Inc
Suite 42, 91 St Martin's Lane
London WC2H 0DL　　　　　　Tel/Fax: 020-7240 2929

NEW VIC WORKSHOP Ltd
56 Lansdowne Place, Brighton BN3 1FG
e-mail: info@newvicworkshop.co.uk
Fax: 01273 776663　　　　　　　Tel: 01273 775126

NEWPALM PRODUCTIONS
26 Cavendish Avenue, London N3 3QN
Fax: 020-8346 8257　　　　　　　Tel: 020-8349 0802

NITRO
(Formerly Black Theatre Co-operative)
6 Brewery Road, London N7 9NH
Website: www.nitro.co.uk
e-mail: info@nitro.co.uk
Fax: 020-7609 1221 Tel: 020-7609 1331

NML PRODUCTIONS
(Neil Laidlaw)
14 Spectrum Tower
20 Hainault Street, Ilford IG1 4GZ
Website: www.nml.org.uk
e-mail: info@nml.org.uk
Fax: 0870 4601483 Tel: 020-8911 9276

NORDIC NOMAD PRODUCTIONS
65B Kingsmead Road, London SW2 3HZ
Website: www.nordicnomad.com
e-mail: info@nordicnomad.com Mobile: 07980 619165

NORTHERN BROADSIDES THEATRE COMPANY
Dean Clough, Halifax HX3 5AX
Website: www.northern-broadsides.co.uk
e-mail: sue@northern-broadsides.co.uk
Fax: 01422 383175 Tel: 01422 369704

NORTHERN STAGE (THEATRICAL PRODUCTIONS) Ltd
Barras Bridge
Newcastle upon Tyne NE1 7RH
Website: www.northernstage.co.uk
e-mail: info@northernstage.co.uk
Fax: 0191-261 8093 Tel: 0191-232 3366

NORTHUMBERLAND THEATRE COMPANY (NTC)
The Playhouse, Bondgate Without, Alnwick
Northumberland NE66 1PQ
Website: www.ntc-touringtheatre.co.uk
e-mail: admin@ntc-touringtheatre.co.uk
Fax: 01665 605837 Tel: 01665 602586

NORWELL LAPLEY ASSOCIATES
Lapley Hall, Lapley, Staffs ST19 9JR
e-mail: cdavis@intart.co.uk
Fax: 01785 841992 Tel: 01785 841991

NOTIONAL THEATRE Ltd
PO Box 130, Hexham NE46 4WA
Website: www.notionaltheatre.com
e-mail: info@notionaltheatre.org Mobile: 07766 661795

NOT THE NATIONAL THEATRE
(Write) (Small/Mid-Scale Touring - UK & Abroad)
116 Dalberg Road, London SW2 1AW

O'BRIEN Barry (1968) Ltd
26 Cavendish Avenue, London N3 3QN
Fax: 020-8346 8257 Tel: 020-8346 8011

OFF THE CUFF THEATRE COMPANY
2nd Floor
91A Rivington Street, London EC2A 3AY
Website: www.otctheatre.co.uk
e-mail: otctheatre@aol.com
Fax: 020-7739 3852 Tel: 020-7739 2857

OLD VIC PRODUCTIONS Plc
The Old Vic Theatre
The Cut, Waterloo, London SE1 8NB
e-mail: ros.povey@oldvictheatre.com
Fax: 020-7981 0946 Tel: 020-7928 2651

ONE NIGHT BOOKING COMPANY The
3 Grand Union Walk
Camden Town, London NW1 9LP
Website: www.onenightbooking.com
e-mail: mail@onenightbooking.com Tel: 020-8455 3278

OPEN AIR THEATRE
(See NEW SHAKESPEARE COMPANY Ltd The)

OPERATING THEATRE COMPANY
22 Burghley Road, London NW5 1UE
Website: www.operating-theatre.co.uk
e-mail: info@operating-theatre.co.uk Tel: 020-7419 2476

OUT OF JOINT
7 Thane Works, Thane Villas, London N7 7NU
Website: www.outofjoint.co.uk
e-mail: ojo@outofjoint.co.uk
Fax: 020-7609 0203 Tel: 020-7609 0207

OUT OF THE BOX PRODUCTIONS Ltd
48 New Cavendish Street, London W1G 8TG
Website: www.outoftheboxproductions.org
e-mail: info@outoftheboxproductions.org
 Tel/Fax: 020-7935 1360

OVATION
Upstairs at The Gatehouse
The Gatehouse, Highgate Village, London N6 4BD
Website: www.ovationtheatres.com
e-mail: events@ovationproductions.com
Fax: 020-8340 3466 Tel: 020-8340 4256

P&S PRODUCTIONS
Top Flat, 51 Norroy Road, London SW15 1PQ
e-mail: timsawers@msn.com
Fax: 020-8780 9115 Tel: 020-8788 8521

PAINES PLOUGH
Fourth Floor, 43 Aldwych, London WC2B 4DN
Website: www.painesplough.com
e-mail: office@painesplough.com
Fax: 020-7240 4534 Tel: 020-7240 4533

PENDLE PRODUCTIONS
Bridge Farm, 249 Hawes Side Lane, Blackpool FY4 4AA
Website: www.pendleproductions.co.uk
e-mail: admin@pendleproductions.co.uk Tel/Fax: 01253 839375

PENTABUS
(National Touring Company for New Writing)
Bromfield, Ludlow, Shropshire SY8 2JU
Website: www.pentabus.co.uk
e-mail: john@pentabus.co.uk
Fax: 01584 856254 Tel: 01584 856564

PEOPLE SHOW
People Show Studios, Pollard Row, London E2 6NB
Website: www.peopleshow.co.uk
e-mail: people@peopleshow.co.uk
Fax: 020-7739 0203 Tel: 020-7729 1841

PERFORMANCE BUSINESS The
78 Oatlands Drive, Weybridge, Surrey KT13 9HT
Website: www.theperformance.biz
e-mail: info@theperformance.biz Tel: 01932 888885

PILOT THEATRE
(New Writing & Multimedia YPT)
York Theatre Royal, St Leonard's Place, York YO1 7HD
Website: www.pilot-theatre.com
e-mail: info@pilot-theatre.com
Fax: 01904 656378 Tel: 01904 635755

PLANTAGENET PRODUCTIONS
Westridge (Open Centre), (Drawing Room Recitals)
Star Ln, Highclere, Nr Newbury RG20 9PJ Tel: 01635 253322

PLUNGE PRODUCTIONS Ltd
c/o 3rd Floor, 52 Shaftesbury Avenue, London W1D 6LP
Website: www.plungeproductions.com
e-mail: info@plungeproductions.com
Fax: 020-7437 3521 Tel: 020-7439 9486

PLUTO PRODUCTIONS Ltd
New End Theatre, 27 New End
Hampstead, London NW3 1JD
Website: www.newendtheatre.co.uk
e-mail: briandaniels@newendtheatre.co.uk
Fax: 020-7794 4044 Tel: 020-7472 5800

POLKA THEATRE
240 The Broadway, Wimbledon SW19 1SB
Website: www.polkatheatre.com
e-mail: admin@polkatheatre.com
Fax: 020-8545 8365 Tel: 020-8545 8320

POPULAR PRODUCTIONS Ltd
6A Palace Gates Road, London N22 7BN
Website: www.popularproductions.co.uk
e-mail: info@popularproductions.co.uk
Mobile: 07812 859767 Tel: 020-8365 8522

POSTER Kim
4th Floor, 80-81 St Martin's Lane, London WC2N 4AA
e-mail: office@stanhopeprod.com
Fax: 020-7240 2947 Tel: 020-7240 3098

PREMIER SHOWS Ltd
PO Box 65, Arundel, West Sussex BN18 9WZ
Website: www.premiershows.co.uk
e-mail: mail@premiershows.co.uk
Fax: 01903 885372 Tel: 01903 885391

PRODUCING PARTNERSHIP The
3 Greek Street, London W1D 4DA
e-mail: pplinfo@btconnect.com
Fax: 020-7434 1200 Tel: 020-7734 7784

PROMENADE ENTERPRISES Ltd
6 Russell Grove, London SW9 6HS
Website: www.promenadeproductions.com
e-mail: info@promenadeproductions.com Tel: 020-7582 9354

PUGH David Ltd
Wyndhams Theatre
Charing Cross Road, London WC2H 0DA
e-mail: dpl@davidpughltd.com
Fax: 020-7292 0399 Tel: 020-7292 0390

PURSUED BY A BEAR PRODUCTIONS
Farnham Maltings
Bridge Square, Franham GU9 7QR
Website: www.pbab.org
e-mail: pbab@pbab.org Tel: 01252 723237

PW PRODUCTIONS Ltd
2nd Floor, 80-81 St Martin's Lane, London WC2N 4AA
Website: www.pwprods.co.uk
Fax: 020-7240 2947 Tel: 020-7395 7580

QDOS ENTERTAINMENT (THEATRE) Ltd
Qdos House
Queen Margaret's Road
Scarborough, North Yorkshire YO11 2SA
Website: www.qdosentertainment.co.uk
e-mail: info@qdosentertainment.plc.uk
Fax: 01723 361958 Tel: 01723 500038

QUANTUM THEATRE
The Old Button Factory
1-11 Bannockburn Road, Plumstead, London SE18 1ET
Website: www.quantumtheatre.co.uk
e-mail: office@quantumtheatre.co.uk Tel: 020-8317 9000

RAGGED RAINBOW PRODUCTIONS Ltd
45 Nightingale Lane
Crouch End, London N8 7RA
e-mail: rainbowrp@onetel.com Tel/Fax: 020-8341 6241

RAGS & FEATHERS THEATRE COMPANY
80 Summer Road, Thames Ditton, Surrey KT7 0QP
e-mail: jill@ragsandfeathers.freeserve.co.uk
Mobile: 07958 724374 Tel: 020-8224 2203

RAIN OR SHINE THEATRE COMPANY
25 Paddock Gardens, Longlevens, Gloucester GL2 0ED
Website: www.rainorshine.co.uk
e-mail: theatre@rainorshine.co.uk Tel/Fax: 01452 521575

REAL CIRCUMSTANCE THEATRE COMPANY
100 Lexden Road, West Bergholt, Colchester CO6 3BW
Website: www.realcircumstance.com
e-mail: anna@realcircumstance.com

REALLY USEFUL GROUP Ltd The
22 Tower Street, London WC2H 9TW
Fax: 020-7240 1204 Tel: 020-7240 0880

REDINGTON Michael Ltd
10 Maunsel Street, London SW1P 2QL
Fax: 020-7828 6947 Tel: 020-7834 5119

RED ROOM The
Cabin E, Clarendon Buildings
11 Ronalds Road, London N5 1XJ
Website: www.theredroom.org.uk
e-mail: info@theredroom.org.uk Tel: 020-7697 8685

RED ROSE CHAIN
1 Fore Hamlet, Ipswich IP3 8AA
Website: www.redrosechain.co.uk
e-mail: info@redrosechain.co.uk Tel: 01473 288886

RED SHIFT THEATRE COMPANY
Trowbray House, 108 Weston Street, London SE1 3QB
Website: www.redshifttheatreco.co.uk
e-mail: mail@redshifttheatreco.co.uk
Fax: 020-7378 9789 Tel: 020-7378 9787

REFRACTION
59A Great King Street, Edinburgh EH3 6RP
e-mail: claremprenton@hotmail.com Mobile: 07887 932588

REVEAL THEATRE COMPANY
40 Pirehill Lane, Walton, Stone, Staffs ST15 0JN
Website: www.revealtheatre.co.uk
e-mail: enquiries@revealtheatre.co.uk Tel/Fax: 0115-878 0651

RHO DELTA Ltd
(Greg Ripley-Duggan)
52 Tottenham Street, London W1T 4RN
e-mail: info@ripleyduggan.com Tel: 020-7436 1392

RICHMOND PRODUCTIONS
47 Moor Mead Road
St Margarets, Twickenham TW1 1JS
e-mail: alister@richmondproductions.co.uk
Mobile: 07968 026768 Tel/Fax: 020-8891 2280

ROCKET THEATRE
9A Niederwald Road, Sydenham, London SE26 4AD
Website: www.rockettheatre.co.uk
e-mail: martin@rockettheatre.co.uk
Mobile: 07788 723570 Tel: 020-8291 5545

ROSE Michael Ltd
The Old Dairy, Throop Road
Holdenhurst, Bournemouth, Dorset BH8 0DL
e-mail: michaelroseltd@btconnect.com
Fax: 01202 522311 Tel: 01202 522711

ROSENTHAL Suzanna Ltd
PO Box 40001, London N6 4YA
e-mail: admin@suzannarosenthal.com Tel/Fax: 020-8340 4421

ROYAL COURT THEATRE PRODUCTIONS Ltd
Sloane Square, London SW1W 8AS
Website: www.royalcourttheatre.com
e-mail: info@royalcourttheatre.com
Fax: 020-7565 5001 Tel: 020-7565 5050

ROYAL EXCHANGE THEATRE COMPANY
St Ann's Square, Manchester M2 7DH
Website: www.royalexchange.co.uk Tel: 0161-833 9333

ROYAL SHAKESPEARE COMPANY
1 Earlham Street, London WC2H 9LL
Website: www.rsc.org.uk
Fax: 020-7845 0505 Tel: 020-7845 0500

ROYAL SHAKESPEARE THEATRE
Waterside, Stratford-upon-Avon CV37 6BB
Website: www.rsc.org.uk
Fax: 01789 294810 Tel: 01789 296655

RUBINSTEIN Mark Ltd
25 Short Street, London SE1 8LJ
e-mail: info@mrluk.com
Fax: 0870 7059731 Tel: 020-7021 0787

SALBERG & STEPHENSON Ltd
18 Soho Square, London W1D 3QL
e-mail: soholondon@aol.com
Fax: 020-7025 8100 Tel: 020-7025 8701

SANDIS PRODUCTIONS
Suite 365, 78 Marylebone High Street, London W1U 5AP
Website: www.sandisproduction.com
e-mail: info@sandisproduction.com
Fax: 020-7224 2777 Tel: 020-7644 5912

SANDPIPER PRODUCTIONS Ltd
49A Ossington Street, London W2 4LY
e-mail: harold@sanditen.fsworld.co.uk
Fax: 0871 7333998 Tel: 020-7229 6708

SCAMP
Sutherland Callow Arts Management and Production
44 Church Lane, Arlesley, Beds SG15 6UX
Website: www.scamptheatre.com
e-mail: admin@scamptheatre.com
Mobile: 07710 491111 Tel: 01462 734843

SCARLET THEATRE
Studio 4, The Bull, 68 High Street, Barnet, Herts EN5 5SJ
Website: www.scarlettheatre.co.uk
e-mail: admin@scarlettheatre.co.uk Tel: 020-8441 9779

SEABRIGHT James
3rd Floor, 118-120 Wardour Street, London W1F 0TU
Website: www.seabright.info
e-mail: contacts@seabright.info
Fax: 08701 255706 Tel: 020-7439 1173

SGRIPT CYMRU CONTEMPORARY DRAMA WALES
Chapter, Market Road, Canton, Cardiff CF5 1QE
Website: www.sgriptcymru.com
e-mail: sgriptcymru@sgriptcymru.com
Fax: 029-2023 6651 Tel: 029-2023 6650

SHAKESPEARE'S MEN
10 Dee Close, Upminster, Essex RM14 1QD
e-mail: trimedia@talk21.com Tel: 01708 222938

SHARED EXPERIENCE
(National/International Touring)
The Soho Laundry, 9 Dufour's Place, London W1F 7SJ
Website: www.sharedexperience.org.uk
e-mail: admin@sharedexperience.org.uk
Fax: 020-7287 8763 Tel: 020-7434 9248

SHOW OF STRENGTH
74 Chessel Street
Bedminster, Bristol BS3 3DN
Website: www.showofstrength.org.uk
Fax: 0117-902 0196 Tel: 0117-902 0235

SINDEN Marc PRODUCTIONS
3 Grand Union Walk, Camden Town, London NW1 9LP
Website: www.sindenproductions.com
e-mail: mail@sindenproductions.com Tel: 020-8455 3278

SOHO THEATRE COMPANY
21 Dean Street, London W1D 3NE
Website: www.sohotheatre.com
Fax: 020-7287 5061 Tel: 020-7287 5060

SPHINX THEATRE COMPANY
25 Short Street, London SE1 8LJ
Website: www.sphinxtheatre.co.uk
e-mail: info@sphinxtheatre.co.uk
Fax: 020-7401 9995 Tel: 020-7401 9993

SPIEGEL Adam PRODUCTIONS
2nd Floor, 20-22 Stukeley Street, London WC2B 5LR
e-mail: enquiries@adamspiegel.com
Fax: 020-7438 9577 Tel: 020-7438 9565

SPLATS ENTERTAINMENT
5 Denmark Street, London WC2H 8LP
e-mail: admin@splatsentertainment.com
Fax: 020-7240 8409 Tel: 020-7240 8400

SQUIRES & JOHNS PRODUCTIONS Ltd
Sullon Lodge, Sullon Side Lane, Garstang PR3 1GH
Fax: 01253 407715 Tel: 0871 2003343

STACEY Barrie UK PRODUCTIONS Ltd
Flat 8, 132 Charing Cross Road, London WC2H 0LA
Website: www.barriestacey.com
e-mail: hopkinstacey@aol.com
Fax: 020-7836 2949 Tel: 020-7836 6220

STAGE ENTERTAINMENT Ltd
Swan House
52 Poland Street, London W1F 7NH
Fax: 020-7025 6971 Tel: 020-7025 6970

STAGE FURTHER PRODUCTIONS Ltd
Westgate House, Stansted Road
Eastbourne, East Sussex BN22 8LG
e-mail: davidsfp@hotmail.com
Fax: 01323 736127 Tel: 01323 739478

STANHOPE PRODUCTIONS Ltd
4th Floor, 80-81 St Martin's Lane, London WC2N 4AA
e-mail: office@stanhopeprod.com
Fax: 020-7240 2947 Tel: 020-7240 3098

STEAM INDUSTRY The
Finborough Theatre
118 Finborough Road, London SW10 9ED
Website: www.steamindustry.co.uk
e-mail: admin@steamindustry.co.uk
Fax: 020-7835 1853 Tel: 020-7244 7439

STRAIGHT LINE PRODUCTIONS
58 Castle Avenue
Epsom, Surrey KT17 2PH
e-mail: mary@straightlineproductions.com
Fax: 020-8393 8079 Tel: 020-8393 4220

STRANGE CAPERS
110 Woodside Avenue South
Coventry CV3 6BE
Website: www.strangecapers.co.uk Mobile: 07812 577232

SUMMER THEATRE COMPANY Ltd The
(Seymour Matthews)
75 Byron Avenue, Colchester CO3 4HQ
e-mail: seymour_stc@yahoo.co.uk Tel: 01206 768765

SUPPORT ACT PRODUCTIONS
(Ian McCracken)
PO Box 388, Dover CT16 9AJ
Website: www.supportact.co.uk
e-mail: info@supportact.co.uk Tel: 0845 0940796

SUSPECT CULTURE
CCA, 350 Sauchiehall Street, Glasgow G2 3JD
Website: www.suspectculture.com
e-mail: info@suspectculture.com
Fax: 0141-332 8823 Tel: 0141-332 9775

TABS PRODUCTIONS
57 Chamberlain Place, Higham Street
Walthamstow, London E17 6AZ
Website: www.tabsproductions.co.uk
e-mail: adrianmljames@aol.com
Fax: 08714 332938 Tel: 020-8527 9255

TALAWA THEATRE COMPANY
3rd Floor, 23-25 Great Sutton Street
London EC1V 0DN
Website: www.talawa.com
e-mail: hq@talawa.com
Fax: 020-7251 5969 Tel: 020-7251 6644

TAMASHA THEATRE COMPANY Ltd
Unit 220, Great Guildford Business Square
30 Great Guildford Street, London SE1 0HS
Website: www.tamasha.org.uk
e-mail: info@tamasha.org.uk
Fax: 020-7021 0421 Tel: 020-7633 2270

TBA MUSIC
1 St Gabriels Road, London NW2 4DS
e-mail: peter@tbagroup.co.uk
Fax: 0871 9943658 Tel: 0845 1203722

TEG PRODUCTIONS Ltd
11-15 Betterton Street
London WC2H 9BP
e-mail: info@tegproductions.com
Fax: 0870 762 7882 Tel: 020-7379 1066

TENTH PLANET PRODUCTIONS
118-120 Wardour Street
London W1F 0TU
Fax: 020-7434 0932 Tel: 020-7439 1176

75 Woodland Gardens, London N10 3UD
Website: www.10thplanetproductions.com
e-mail: admin@tenthplanetproductions.com
Fax: 020-8883 1708 Tel: 020-8442 2659

THEATRE ABSOLUTE
57-61 Corporation Street
Coventry CV1 1GQ
Website: www.theatreabsolute.co.uk
e-mail: info@theatreabsolute.co.uk Tel: 024-7625 7380

THEATRE ALIVE!
c/o Menier Chocolate Factory
2nd Floor
4 O'Meara Street, London SE1 1TE
Website: www.theatrealive.org.uk
e-mail: theatrealiveinfo@tiscali.co.uk Tel/Fax: 020-7403 4405

THEATRE BABEL
98 Saltmarket, Glasgow G1 5LD
Website: www.theatrebabel.co.uk
e-mail: admin@theatrebabel.co.uk
Fax: 0141-249 9900 Tel: 0141-553 1346

THEATRE NORTH
Woodlands, The Mains, Giggleswick
Settle, North Yorkshire BD24 0AX
Website: www.theatrenorth.co.uk
e-mail: info@theatrenorth.co.uk Tel/Fax: 01729 822058

THEATRE OF COMEDY COMPANY Ltd
Shaftesbury Theatre
210 Shaftesbury Avenue, London WC2H 8DP
Fax: 020-7836 8181 Tel: 020-7379 3345

THEATRE ROYAL HAYMARKET PRODUCTIONS
Theatre Royal Haymarket
18 Suffolk Street, London SW1Y 4HT
e-mail: nigel.everett@trh.co.uk
Fax: 020-7389 9698 Tel: 020-7389 9669

THEATRE ROYAL STRATFORD EAST
Gerry Raffles Square
Stratford, London E15 1BN
Website: www.stratfordeast.com
e-mail: theatreroyal@stratfordeast.com
Fax: 020-8534 8381 Tel: 020-8534 7374

THEATRE SANS FRONTIERES
The Queen's Hall Arts Centre
Beaumont Street, Hexham NE46 3LS
Website: www.tsf.org.uk
e-mail: admin@tsfront.co.uk
Fax: 01434 607206 Tel: 01434 652484

THEATRE SET-UP
12 Fairlawn Close
Southgate, London N14 4JX
Website: www.ts-u.co.uk Tel: 020-8886 9572

THEATRE TOURS INTERNATIONAL
The Bull Theatre
68 The High Street, Barnet, Herts EN5 5SJ
Website: www.theatretoursinternational.com
e-mail: mail@theatretoursinternational.com
Tel/Fax: 020-8449 7800

THEATREWORKS
2 Hanley Road
Malvern Wells, Worcs WR14 4PQ
Website: www.theatreworks.info
e-mail: info@theatreworks.info Tel/Fax: 01684 578342

TIATA FAHODZI
AH 112 Aberdeen Centre
22-24 Highbury Grove, London N5 2EA
Website: www.tiatafahodzi.com
e-mail: info@tiatafahodzi.com Tel/Fax: 020-7226 3800

TOWER THEATRE COMPANY
(Full-time non-professional)
54A Canonbury Road
Islington, London N1 2DQ
Website: www.towertheatre.org.uk
e-mail: info@towertheatre.freeserve.co.uk
Tel/Fax: 020-7226 5111

TREATMENT THEATRE
(Write Only)
135 Dartmouth Road, London NW2 4EN
Website: www.treatmenttheatre.com
e-mail: admin@treatmenttheatre.com

TRESTLE THEATRE COMPANY
(Visual/Physical Theatre, Music, Choreography,
New Writing)
Trestle Arts Base, Russet Drive, Herts, St Albans AL4 0JQ
Website: www.trestle.org.uk
e-mail: admin@trestle.org.uk
Fax: 01727 855558 Tel: 01727 850950

TRIUMPH PROSCENIUM PRODUCTIONS Ltd
1st Floor, 18 Exeter Street, London WC2E 7DU
Fax: 020-7379 4860 Tel: 020-7379 4870

TURTLE KEY ARTS
Ladbroke Hall, 79 Barlby Road, London W10 6AZ
e-mail: admin@turtlekeyarts.org.uk
Fax: 020-8964 4080 Tel: 020-8964 5060

TWIST & CHEETHAM
39 Rosslyn Crescent, Edinburgh EH6 5AT
e-mail: ben.twist@blueyonder.co.uk Tel/Fax: 0131-477 7425

TWO'S COMPANY
244 Upland Road, London SE22 0DN
e-mail: 2scompany@britishlibrary.net
Fax: 020-8299 3714 Tel: 020-8299 4593

UK ARTS INTERNATIONAL
Second Floor, 6 Shaw Street, Worcester WR1 3QQ
Website: www.ukarts.com
e-mail: janryan@ukarts.com
Fax: 01905 22868 Tel: 01905 26424

UK PRODUCTIONS Ltd
Lime House, 78 Meadrow, Godalming, Surrey GU7 3HT
Website: www.ukproductions.co.uk
e-mail: mail@ukproductions.co.uk
Fax: 01483 418486 Tel: 01483 423600

UNRESTRICTED VIEW
Above Hen & Chickens Theatre Bar
109 St Paul's Road, London N1 2NA
Website: www.henandchickens.com
e-mail: james@henandchickens.com Tel: 020-7704 2001

VANCE Charles
CV Productions Ltd, Hampden House
2 Weymouth Street, London W1W 5BT
e-mail: cvtheatre@aol.com
Fax: 020-7636 2323 Tel: 020-7636 4343

VANDER ELST Anthony PRODUCTIONS
The Studio, 14 College Road
Bromley, Kent BR1 3NS
Fax: 020-8313 0443 Tel: 020-8466 5580

VAYU NAIDU COMPANY
Unit LFB2, Lafone House
The Leathermarket
11-13 Leathermarket Street, London SE1 3HN
Website: www.vayunaiducompany.org.uk
e-mail: sud.bash@vayunaiducompany.org.uk
 Tel/Fax: 020-7378 0739

VOLCANO THEATRE COMPANY Ltd
Swansea Institute, Townhill Road, Swansea SA2 0UT
Website: www.volcanotheatre.co.uk
e-mail: volcano.tc@virgin.net
Fax: 01792 281282 Tel: 01792 281280

WALKING FORWARD Ltd
Studio 1, 35 Britannia Row, London N1 8QH
Website: www.walkingforward.co.uk
e-mail: info@walkingforward.co.uk
Fax: 020-7359 5091 Tel: 020-7359 5249

WALLACE Kevin Ltd
10 (H) St Martin's Place, London WC2N 4JL
e-mail: enquiries@kevinwallace.co.uk
Fax: 020-7836 9587 Tel: 020-7836 9586

WAREHOUSE THEATRE COMPANY
Dingwall Road, Croydon CR0 2NF
Website: www.warehousetheatre.co.uk
e-mail: info@warehousetheatre.co.uk
Fax: 020-8688 6699 Tel: 020-8681 1257

WAX Kenneth H Ltd
2nd Floor, 80-81 St Martin's Lane, London WC2N 4AA
e-mail: k.wax@virgin.net
Fax: 020-7240 2947 Tel: 020-7395 7583

WEAVER HUGHES ENSEMBLE
12B Carholme Road, London SE23 2HS
Website: www.weaverhughesensemble.co.uk
e-mail: ensemble@weaverhughesensemble.co.uk
 Tel/Fax: 020-8291 0514

WEYLAND Valerie
3 Greek Street, London W1D 4DA
e-mail: val.pplinfo@btconnect.com
Fax: 020-7434 1200 Tel: 020-7734 7784

WHITALL Keith
25 Solway, Hailsham East
East Sussex BN27 3HB Tel: 01323 844882

WHITEHALL Michael
10 Lower Common South, London SW15 1BP
e-mail: mwhitehall@msn.com
Fax: 020-8788 2340 Tel: 020-8785 3737

WILDCARD THEATRE COMPANY
Suite A, Swan House, White Hart Street
High Wycombe, Bucks HP11 2HL
Website: www.wildcardtheatre.org.uk
e-mail: admin@wildcardtheatre.org.uk
Fax: 07092 024967 Tel: 0870 7606158

WILLS Newton MANAGEMENT
The Studio, 29 Springvale Avenue
Brentford, Middlesex TW8 9QH
e-mail: newtoncttg@aol.com
Fax: 00 33 2418 23108 Mobile: 07989 398381

WINGATE Olivia PRODUCTIONS Ltd
62B Kentish Town Road, London NW1 9PU
e-mail: info@owproductions.co.uk Tel: 020-7485 1861

WOOD Kevin PRODUCTIONS
Langdon Abbey
West Langdon, Dover, Kent CT15 5HJ
e-mail: sylviasims@btconnect.com
Fax: 01304 853506 Tel: 01304 853504

WRESTLING SCHOOL The
(The Howard Baker Company)
42 Durlston Road, London E5 8RR
Website: www.thewrestlingschool.co.uk
 Tel/Fax: 020-8442 4229

YELLOW EARTH THEATRE
18 Rupert Street, London W1D 6DE
Website: www.yellowearth.org
e-mail: admin@yellowearth.org
Fax: 020-7287 3141 Tel: 020-7734 5988

YOUNG VIC THEATRE
66 The Cut, London SE1 8LZ
Website: www.youngvic.org
e-mail: info@youngvic.org
Fax: 020-7922 2801 Tel: 020-7922 2800

7:84 THEATRE COMPANY (SCOTLAND) Ltd
Film City Glasgow
No. 4 Summertown Road, Glasgow G51 2LY
Website: www.784theatre.com
e-mail: admin@784theatre.com Tel: 0141-445 7245

ABERYSTWYTH ARTS CENTRE
Penglais Campus, Aberystwyth, Ceredigion SY23 3DE
Website: www.aber.ac.uk/artscentre
e-mail: ggo@aber.ac.uk
Fax: 01970 622883 Tel: 01970 621512

AGE EXCHANGE THEATRE TRUST
The Reminiscence Centre
11 Blackheath Village, London SE3 9LA
Website: www.age-exchange.org.uk
e-mail: administrator@age-exchange.org.uk
Fax: 020-8318 0060 Tel: 020-8318 9105

ALTERNATIVE ARTS
Top Studio, Bethnal Green Training Centre
Hanbury Street, London E1 5HZ
Website: www.alternativearts.co.uk
e-mail: info@alternativearts.co.uk
Fax: 020-7375 0484 Tel: 020-7375 0441

ANGLES THEATRE The
Alexandra Road, Wisbech
Cambridgeshire PE13 1HQ
e-mail: astromanis@anglestheatre.co.uk
Fax: 01945 581967 Tel: 01945 585587

ASHTON GROUP THEATRE The
The Old Fire Station, Abbey Road
Barrow-in-Furness, Cumbria LA14 1XH
Website: www.ashtongroup.co.uk
e-mail: info@ashtongroup.co.uk Tel/Fax: 01229 430636

ATTIC THEATRE COMPANY (LONDON) Ltd
New Wimbledon Theatre
The Broadway, London SW19 1QG
Website: www.attictheatrecompany.com
e-mail: info@attictheatrecompany.com Tel: 020-8543 7838

BANNER THEATRE
Oaklands New Church Centre
Winleigh Road, Handsworth Wood
Birmingham B20 2HN
e-mail: info@bannertheatre.co.uk Tel: 0845 4581909

BECK THEATRE
Grange Road, Hayes, Middlesex UB3 2UE Tel: 020-8561 7506

BENT BACK TULIPS THEATRE COMPANY
67A Graveney Road, London SW17 0EG
Website: www.bentbacktulips.com
e-mail: info@bentbacktulips.com Mobile: 07971 159940

BLUEYED THEATRE PRODUCTIONS
13A Aubert Park, Highbury, London N5 1TL
Website: www.blueyedtheatreproductions.co.uk
e-mail: info@blueyedtheatreproductions.co.uk
 Mobile: 07957 215965

BLUNDERBUS THEATRE COMPANY Ltd
1st Floor, The Brook Theatre
Old Town Hall, Chatham, Kent ME4 4SE
Website: www.blunderbus.co.uk
e-mail: admin@blunderbus.co.uk
Fax: 01634 818138 Tel: 01634 818136

BORDERLINE THEATRE COMPANY
(Eddie Jackson)
North Harbour Street, Ayr KA8 8AA
Website: www.borderlinetheatre.co.uk
e-mail: enquiries@borderlinetheatre.co.uk
Fax: 01292 263825 Tel: 01292 281010

BRUVVERS THEATRE COMPANY
(Venue - The Round)
36 Lime Street, Ouseburn
Newcastle upon Tyne NE1 2PQ
Website: www.bruvvers.co.uk
e-mail: mikeofbruvvers@hotmail.com Tel: 0191-261 9230

CAPITAL ARTS YOUTH THEATRE
Wyllyotts Centre, Darkes Lane
Potters Bar, Herts EN6 2HN
e-mail: capitalarts@btconnect.com
Mobile: 07885 232414 Tel/Fax: 020-8449 2342

CARIB THEATRE COMPANY
73 Lancelot Road, Wembley, Middlesex HA0 2AN
e-mail: caribtheatre@aol.com Tel/Fax: 020-8903 4592

CAVALCADE THEATRE COMPANY
(Touring Shows - Musicals, Pantomimes, Music Hall,
Comedy & Rock 'n' Roll)
Write
57 Pelham Road
London SW19 1NW Fax: 020-8540 3513

CENTRE FOR PERFORMANCE RESEARCH
6 Science Park
Aberystwyth SY23 3AH
Website: www.thecpr.org.uk
e-mail: cprwww@aber.ac.uk
Fax: 01970 622132 Tel: 01970 622133

CHAIN REACTION THEATRE COMPANY
Three Mills Studios, Sugar House Yard
Sugar House Lane, London E15 2QS
Website: www.chainreactiontheatre.co.uk
e-mail: mail@chainreactiontheatre.co.uk
 Tel/Fax: 020-8534 0007

CHALKFOOT THEATRE ARTS
Central Studios
36 Park Place, Margate, Kent CT9 1LE
Website: www.chalkfoot.org.uk
e-mail: info@chalkfoot.org.uk
Fax: 01843 280088 Tel: 01843 280077

CHATS PALACE ARTS CENTRE
42-44 Brooksby's Walk
Hackney, London E9 6DF
Website: www.chatspalace.com
e-mail: info@chatspalace.com Tel: 020-8533 0227

CHEEKY MAGGOT PRODUCTIONS
PO Box 273
2-3 Bedford Street, London WC2E 9HH
Website: www.cheekymaggot.co.uk
e-mail: info@cheekymaggot.co.uk Mobile: 07854 855331

CHERUB COMPANY LONDON The
Office: 9 Park Hill, London W5 2JS
Website: www.cherub.org.uk
e-mail: mgcherub@yahoo.com
Fax: 020-8248 0318 Tel/Fax: 020-8723 4358

CHICKEN SHED THEATRE
Chase Side
Southgate, London N14 4PE
Website: www.chickenshed.org.uk
e-mail: info@chickenshed.org.uk
Minicom: 020-8350 0676 Tel: 020-8351 6161

CLEAN BREAK
(Theatre Education, New Writing)
2 Patshull Road, London NW5 2LB
Website: www.cleanbreak.org.uk
e-mail: general@cleanbreak.org.uk
Fax: 020-7482 8611 Tel: 020-7482 8600

There are hundreds of theatres in the UK, varying dramatically in size and type. A survey we conducted in 2004 led to the theatre sections being organised under headings which best indicate a theatre's principal area of work. A summary of each of these is below.

Alternative and Community

Many of these companies tour to Arts Centres, small and middle-scale theatres, and non-theatrical venues which do not have a resident company, or they may be commissioned to develop site specific projects. The term 'alternative' is sometimes used to describe work that is more experimental in style and execution.

Children's, Young People's and TIE

The primary focus of these theatre companies is to reach younger audiences. They often tour to smaller theatres, schools and non-theatrical venues. Interactive teaching - through audience participation and workshops - is often a feature of their work.

English Speaking Theatre Companies in Europe

These work principally outside of the UK. Some are based in one venue whilst others are touring companies. Their work varies enormously and includes Young People's Theatre, large scale musicals, revivals of classics and dinner theatre. Actors are employed either for an individual production or a 'season' of several plays.

London Theatres

Larger theatres situated in the West End and Central London. A few are producing houses, but most are leased to Theatre Producers who take responsibility for putting together a company for a run of a single show. In such cases it is they and not the venue who cast productions (often with the help of Casting Directors). Alternatively, a production will open outside London and tour to Provincial Theatres. Then subsequently, if successful, transfer to a London venue.

Outer London, Fringe and Venues

Small and middle-scale theatres in Outer London and around the country. Some are producing houses, others are only available for hire. Many of the London venues have provided useful directions on how they may be reached by public transport.

Provincial / Touring

Theatre Producers and other companies sell their ready-made productions to the Provincial/Touring Theatres, a list of larger venues outside London. A run in each theatre varies between a night and several weeks, but a week per venue for tours of plays is usual. Even if a venue is not usually a producing house, most Provincial Theatres and Arts Centres put on a family show at Christmas.

Puppet Theatre Companies

Some Puppet Theatres are one-performer companies who literally create their own work from scratch. The content and style of productions varies enormously. For example, not all are aimed at children, and some are more interactive than others. Although we list a few theatres with Puppet Companies in permanent residence, this kind of work often involves touring. As with all small and middle scale touring, performers who are willing, and have the skills, to involve themselves with all aspects of company life are always more valuable.

Repertory (Regional) Theatres

Theatres situated outside London which employ a resident company of actors (i.e. the 'repertory company') on a play-by-play basis or for a season of several plays. In addition to the main auditorium (usually the largest acting space) these theatres may have a smaller studio theatre attached, which will be home to an additional company whose focus is education or the production of new plays (see Children's, Young People's and TIE). In recent years the length of repertory seasons has become shorter; this means that a number of productions are no longer in-house. It is common for gaps in the performance calender to be filled by tours mounted by Theatre Producers, other Repertory (Regional) Theatres and non-venue based production companies.

CLOSE FOR COMFORT THEATRE COMPANY
34 Boleyn Walk
Leatherhead, Surrey KT22 7HU
Website: www.hometown.aol.com/close4comf
e-mail: close4comf@aol.com
Mobile: 07710 258290 Tel: 01372 378613

COLLUSION THEATRE COMPANY
131 Renfrew Street, Glasgow G3 6QZ
Website: www.collusiontheatre.co.uk
e-mail: admin@collusiontheatre.co.uk
Fax: 0141-644 4163 Tel: 0141-644 0163

COMPLETE WORKS CREATIVE COMPANY Ltd The
The Old Truman Brewery, 91 Brick Lane, London E1 6QL
Website: www.tcw.org.uk
e-mail: info@tcw.org.uk
Fax: 0870 1431979 Tel: 0870 1431969

CORNELIUS & JONES ORIGINAL PRODUCTIONS
49 Carters Close, Sherington
Newport Pagnell, Buckinghamshire MK16 9NW
Website: www.corneliusjones.com
e-mail: admin@corneliusjones.com Tel/Fax: 01908 612593

CRAGRATS THEATRE
The Mill, Dunford Road, Holmfirth, Huddersfield HD9 2AR
Website: www.cragrats.com
e-mail: theatre@cragrats.com
Fax: 01484 686212 Tel: 01484 686451

CUT-CLOTH THEATRE
41 Beresford Road
Highbury, London N5 2HR Tel: 020-7503 4393

DRAMAZONE
Arundel Town Hall
Arundel, West Sussex BN18 9AP
Website: www.dramazone.net
e-mail: admin@dramazone.net Tel/Fax: 01903 889821

ELAN WALES
(European Live Arts Network)
17 Douglas Buildings
Royal Stuart Lane, Cardiff CF10 5EL
Website: www.elanwales.org
e-mail: david@elanwales.org Tel/Fax: 029-2019 0077

EUROPEAN THEATRE COMPANY The
39 Oxford Avenue, London SW20 8LS
Website: www.europeantheatre.co.uk
e-mail: admin@europeantheatre.co.uk
Fax: 020-8544 1999 Tel: 020-8544 1994

FAMILY CURIOSO THEATRE COMPANY
117 Warham Road
London N4 1AS Tel: 020-8351 1273

FOREST FORGE THEATRE COMPANY
The Theatre Centre
Endeavour Park, Crow Arch Lane
Ringwood, Hampshire BH24 1SF
Website: www.forestforge.co.uk
e-mail: forestforge@btconnect.com
Fax: 01425 471158 Tel: 01425 470188

FOUND THEATRE
12 Blenheim Avenue
Whalley Range, Manchester M16 8JT
Website: www.foundtheatre.org.uk
e-mail: found_theatre@yahoo.co.uk Tel: 0161-861 8219

FOURSIGHT THEATRE Ltd
Newhampton Arts Centre
Dunkley Street, Wolverhampton WV1 4AN
Website: www.foursight.theatre.boltblue.net
e-mail: foursight.theatre@boltblue.com
Fax: 01902 428413 Tel: 01902 714257

FRANTIC THEATRE COMPANY
32 Woodlane
Falmouth TR11 4RF
Website: www.frantictheatre.com
e-mail: info@frantictheatre.com Tel/Fax: 0870 1657350

GALLEON THEATRE COMPANY Ltd
Greenwich Playhouse
Greenwich BR Station Forecourt
189 Greenwich High Road, London SE10 8JA
Website: www.galleontheatre.co.uk
e-mail: alice@galleontheatre.co.uk
Fax: 020-8310 7276 Tel: 020-8858 9256

GRANGE ARTS CENTRE
Rochdale Road, Oldham
Greater Manchester OL9 6EA
Website: www.grangeartsoldham.co.uk
e-mail: grangearts@oldham.ac.uk
Fax: 0161-785 4263 Tel: 0161-785 4239

GREASEPAINT ANONYMOUS
4 Gallus Close
Winchmore Hill, London N21 1JR
e-mail: info@greasepaintanonymous.co.uk
Fax: 020-8882 9189 Tel: 020-8886 2263

HALL FOR CORNWALL
(Community & Education) (Contact Anna Coombs)
Back Quay
Truro, Cornwall TR1 2LL
Website: www.hallforcornwall.co.uk
e-mail: annac@hallforcornwall.org.uk
Fax: 01872 260246 Tel: 01872 321964

HIJINX THEATRE
(Adults with Learning Disabilities, Community)
Wales Millennium Centre
Bute Place, Cardiff CF10 5AL
Website: www.hijinx.org.uk
e-mail: info@hijinx.org.uk
Fax: 029-2063 5621 Tel: 029-2030 0331

HISTORIA THEATRE COMPANY
8 Cloudesley Square
London N1 0HT
Website: www.historiatheatre.com
e-mail: kateprice@lineone.net
Fax: 020-7278 4733 Tel: 020-7837 8008

ICON THEATRE
15 Darcy House
London Fields East Side, London E8 3RY
Website: www.icontheatre.org.uk
e-mail: sally@icontheatre.org.uk Tel/Fax: 020-7923 1800

IMAGE MUSICAL THEATRE
23 Sedgeford Road
Shepherd's Bush, London W12 0NA
Website: www.imagemusicaltheatre.co.uk
e-mail: brian@imagemusicaltheatre.co.uk
Fax: 020-8749 9294 Tel: 020-8743 9380

IMMEDIATE THEATRE
Unit C2/62 Beechwood Road
London E8 3DY
e-mail: info@immediate-theatre.com
Fax: 020-7254 1389 Tel: 020-7683 0233

INOCENTE ART & FILM Ltd
(Film, Multimedia, Music Videos & two Rock 'n' Roll
Musicals)
5 Denmans Lane
Haywards Heath
West Sussex RH16 2LA
e-mail: tarascas@btinternet.com Mobile: 07973 518132

ISOSCELES
7 Amity Grove
Raynes Park, London SW20 0LQ
Website: www.isosceles.freeserve.co.uk
e-mail: patanddave@isosceles.freeserve.co.uk
Tel: 020-8946 3905

JET THEATRE
11 Clovelly Road, London W5 5HF
Website: www.jettheatre.co.uk
e-mail: jettheatre@aol.com
Tel: 020-8579 1029

KOMEDIA
44-47 Gardner Street, Brighton BN1 1UN
Website: www.komedia.co.uk
e-mail: info@komedia.co.uk
Fax: 01273 647102
Tel: 01273 647101

LADDER TO THE MOON ENTERTAINMENT
Unit 105, Battersea Business Centre
99-109 Lavender Hill, London SW11 5QL
e-mail: enquiries@laddertothemoon.co.uk Tel: 020-7228 9700

LIVE THEATRE
(New Writing)
7-8 Trinity Chare, Quayside, Newcastle upon Tyne NE1 3DF
Website: www.live.org.uk
e-mail: info@live.org.uk
Fax: 0191-232 2224
Tel: 0191-261 2694

LONDON ACTORS THEATRE COMPANY
Unit 5A, Imex Business Centre
Ingate Place, London SW8 3NS
e-mail: latchmere@fishers.org.uk
Fax: 020-7978 2631
Tel: 020-7978 2620

LONDON BUBBLE THEATRE COMPANY Ltd
5 Elephant Lane, London SE16 4JD
Website: www.londonbubble.org.uk
e-mail: admin@londonbubble.org.uk
Fax: 020-7231 2366
Tel: 020-7237 4434

LSW JUNIOR INTER-ACT
PO Box 31855, London SE17 3XP
Website: www.londonshakespeare.org.uk
e-mail: londonswo@hotmail.com Tel/Fax: 020-7793 9755

LSW PRISON PROJECT
PO Box 31855, London SE17 3XP
Website: www.londonshakespeare.org.uk
e-mail: londonswo@hotmail.com Tel/Fax: 020-7793 9755

LSW SENIOR RE-ACTION
PO Box 31855, London SE17 3XP
Website: www.londonshakespeare.org.uk
e-mail: londonswo@hotmail.com Tel/Fax: 020-7793 9755

LUNG HA'S THEATRE COMPANY
Eric Liddell Centre
15 Morningside Road, Edinburgh EH10 4DP
Website: www.lunghas.co.uk
e-mail: info@lunghas.co.uk
Fax: 0131-447 3290
Tel: 0131-447 8496

M6 THEATRE COMPANY
Studio Theatre, Hamer CP School
Albert Royds Street, Rochdale OL16 2SU
Website: www.m6theatre.co.uk
e-mail: info@m6theatre.co.uk
Fax: 01706 712601
Tel: 01706 355898

MADDERMARKET THEATRE
(Resident Community Theatre Company & Small-Scale
Producing & Receiving House)
St John's Alley, Norwich NR2 1DR
Website: www.maddermarket.co.uk
e-mail: mmtheatre@btconnect.com
Fax: 01603 661357
Tel: 01603 626560

MANCHESTER ACTORS COMPANY
PO Box 54
Manchester M60 7AB
Website: www.manactco.org.uk
e-mail: dramatic@amserve.com
Tel: 0161-227 8702

MAN MELA THEATRE COMPANY
(Admin Contact: Caroline Goffin)
Brady Centre
192-196 Hanbury Street, London E1 5HU
Website: www.manmela.org.uk
e-mail: dominic@manmela.org.uk
Mobile: 07973 349101
Mobile: 07966 215090

MAYA PRODUCTIONS Ltd
156 Richmond Road
London E8 3HN
Website: www.mayaproductions.co.uk
e-mail: mayachris@aol.com
Tel/Fax: 020-7923 0675

MIKRON THEATRE COMPANY Ltd
Marsden Mechanics
Peel Street, Marsden
Huddersfield HD7 6BW
Website: www.mikron.org.uk
e-mail: admin@mikron.org.uk
Tel: 01484 843701

MONTAGE THEATRE ARTS
(Artistic Director Judy Gordon)
The Albany, Douglas Way, London SE8 4AG
Website: www.montagetheatre.com
Tel: 020-8692 7007

MOVING THEATRE
16 Laughton Lodge
Laughton, Nr Lewes, East Sussex BN8 6BY
Website: www.movingtheatre.com
e-mail: info@movingtheatre.com
Fax: 01323 815736
Tel: 01323 815726

NATURAL THEATRE COMPANY
(Street Theatre & Touring)
Widcombe Institute, Widcombe Hill, Bath BA2 6AA
Website: www.naturaltheatre.co.uk
e-mail: info@naturaltheatre.co.uk
Fax: 01225 442555
Tel: 01225 469131

NET CURTAINS THEATRE COMPANY
The Bath House
96 Dean Street, London W1D 3TD
e-mail: claire@netcurtains.org
Mobile: 07968 564687

NETTLEFOLD The
West Norwood Library Centre
1 Norwood High Street, London SE27 9JX
e-mail: thenettlefold@lambeth.gov.uk
Fax: 020-7926 8071
Tel: 020-7926 8070

NEW PERSPECTIVES THEATRE COMPANY
(Regional/National New Writing Touring Theatre)
1C Park Lane Business Centre
Park Lane, Basford, Nottinghamshire NG6 0DW
Website: www.newperspectives.co.uk
e-mail: info@newperspectives.co.uk
Tel: 0115-927 2334

NORTHERN STAGE THEATRICAL PRODUCTIONS Ltd
Barras Bridge, Newcastle upon Tyne NE1 7RH
Website: www.northernstage.co.uk
e-mail: info@northernstage.co.uk
Fax: 0191-261 8093
Tel: 0191-232 3366

NORTHUMBERLAND THEATRE COMPANY (NTC)
(Touring Regionally & Nationally)
The Playhouse, Bondgate Without, Alnwick
Northumberland NE66 1PQ
Website: www.ntc-touringtheatre.co.uk
e-mail: admin@ntc-touringtheatre.co.uk
Fax: 01665 605837
Tel: 01665 602586

NPVARTS@MAGIC EYE THEATRE
Havil Street, London SE5 7SD
Website: www.npvarts.co.uk
e-mail: admin@npvarts.co.uk Tel: 020-7708 5401

NUFFIELD THEATRE
(Touring & Projects)
University Road, Southampton SO17 1TR
Website: www.nuffieldtheatre.co.uk
e-mail: abi.linnartz@nuffieldtheatre.co.uk
Fax: 023-8031 5511 Tel: 023-8031 5500

OLD TYME PLAYERS THEATRE COMPANY
(Music Hall, Revues - Locally Based)
35 Barton Court Avenue
Barton on Sea, Hants BH25 7EP
Website: www.oldetymeplayers.co.uk
e-mail: oldetymeplayers@tiscali.co.uk Tel: 01425 612830

ONATTI THEATRE COMPANY
9 Field Close, Warwick, Warwickshire CV34 4QD
Website: www.onatti.co.uk
e-mail: info@onatti.co.uk
Fax: 0870 1643629 Tel: 01926 495220

OPEN STAGE PRODUCTIONS
49 Springfield Road
Moseley, Birmingham B13 9NN
e-mail: info@openstage.co.uk Tel/Fax: 0121-777 9086

OXFORDSHIRE TOURING THEATRE COMPANY
The Annexe, SS Mary & John School
Meadow Lane, Oxford OX4 1TJ
Website: www.ottc.org.uk
e-mail: info@ottc.oxfordshire.co.uk
Fax: 01865 247266 Tel: 01865 249444

PASCAL THEATRE COMPANY
35 Flaxman Court, Flaxman Terrace
Bloomsbury, London WC1H 9AR
Website: www.pascal-theatre.com
e-mail: pascaltheatreco@aol.com Tel: 020-7383 0920

PAUL'S THEATRE COMPANY
Fairkytes Arts Centre
51 Billet Lane, Hornchurch, Essex RM11 1AX
Website: www.paulstheatreschool.co.uk
e-mail: info@paulstheatreschool.co.uk
Fax: 01708 475286 Tel: 01708 447123

PEOPLE'S THEATRE COMPANY The
12E High Street, Egham, Surrey TW20 9EA
Website: www.ptc.org.uk
e-mail: admin@ptc.org.uk Tel: 01784 470439

PHANTOM CAPTAIN The
618B Finchley Road, London NW11 7RR
Website: www.phantomcaptain.netfirms.com
e-mail: lambhorn@tiscali.co.uk Tel: 020-8455 4564

PLAYTIME THEATRE COMPANY
18 Bennells Avenue, Whitstable, Kent CT5 2HP
Website: www.playtime.dircon.co.uk
e-mail: playtime@dircon.co.uk
Fax: 01227 266648 Tel: 01227 266272

PRIME PRODUCTIONS
54 Hermiston Village, Currie EH14 4AQ
Website: www.primeproductions.co.uk
e-mail: mheller@primeproductions.fsnet.co.uk
Tel/Fax: 0131-449 4055

PROTEUS THEATRE COMPANY
(Multimedia and Cross-art Form Work)
Queen Mary's College, Cliddesden Road
Basingstoke, Hampshire RG21 3HF
Website: www.proteustheatre.com
e-mail: info@proteustheatre.com Tel: 01256 354541

PURSUED BY A BEAR PODUCTIONS
Farnham Maltings
Bridge Square, Farnham GU9 7QR
Website: www.pbab.org
e-mail: pbab@pbab.org Tel: 01252 723237

Q20 THEATRE COMPANY
19 Wellington Crescent
Shipley, West Yorkshire BD18 3PH
e-mail: info@q20theatre.co.uk Tel: 0845 1260632

QUICKSILVER THEATRE
The Glasshouse, 4 Enfield Road, London N1 5AZ
Website: www.quicksilvertheatre.org
e-mail: talktous@quicksilvertheatre.org
Fax: 020-7254 3119 Tel: 020-7241 2942

RIDING LIGHTS THEATRE COMPANY
Friargate Theatre, Lower Friargate, York YO1 9SL
Website: www.ridinglights.org
e-mail: info@rltc.org
Fax: 01904 651532 Tel: 01904 655317

SALTMINE THEATRE COMPANY
St James House
Trinity Road, Dudley, West Midlands DY1 1JB
Website: www.saltmine.org
e-mail: creative@saltmine.org Tel: 01384 454807

SNAP THEATRE COMPANY
29 Raynham Road
Bishops Stortford, Herts CM23 5PE
Website: www.snaptheatre.co.uk
e-mail: info@snaptheatre.co.uk
Fax: 01279 506694 Tel: 01279 461607

SPANNER IN THE WORKS
155 Station Road
Sidcup, Kent DA15 7AA
Website: www.spannerintheworks.org.uk
e-mail: info@spannerintheworks.org.uk Tel: 020-8304 7660

SPARE TYRE THEATRE COMPANY
(Community Drama & Music Projects)
Hampstead Town Hall
213 Haverstock Hill, London NW3 4QP
Website: www.sparetyretheatrecompany.co.uk
e-mail: sttc@sparetyretheatrecompany.co.uk
Tel/Fax: 020-7419 7007

SPECTACLE THEATRE
Coleg Morgannwg
Rhondda, Llwynypia, Tonypandy CF40 2TQ
Website: www.spectacletheatre.co.uk
e-mail: info@spectacletheatre.co.uk
Fax: 01443 423080 Tel: 01443 430700

SPLITMOON THEATRE COMPANY
Flat 1, 17 Westgrove Lane, London SE10 8QP
Website: www.splitmoontheatre.org
e-mail: info@splitmoontheatre.org Tel: 020-8694 8259

SPONTANEITY SHOP The
85-87 Bayham Street, London NW1 0AG
Website: www.the-spontaneity-shop.com
e-mail: info@the-spontaneity-shop.com Tel: 020-7788 4080

STABLES GALLERY & ARTS CENTRE The
The Hayloft, Gladstone Park
Dollis Hill Lane, London NW2 6HT
e-mail: stablesgallery@msn.com Tel: 020-8452 8655

TAG THEATRE COMPANY
Citizens' Theatre
119 Gorbals Street, Glasgow G5 9DS
Website: www.tag-theatre.co.uk
e-mail: info@tag-theatre.co.uk
Fax: 0141-429 7374 Tel: 0141-429 5561

TARA ARTS GROUP
(Jatinder Verma)
356 Garratt Lane
London SW18 4ES
Website: www.tara-arts.com
Fax: 020-8870 9540 Tel: 020-8333 4457

THEATRE EXPRESS
(Write)
Spindle Cottage, Allens Farm
Digby Fen, Billinghay, Lincoln LN4 4DT
e-mail: perform@theatre-express.com

THEATRE IN EDUCATION TOURS (TIE TOURS)
PO Box 433, Weston Super Mare
Somerset BS24 0WY
Website: www.tietours.com
e-mail: tie@tietours.com Tel: 01934 815163

THEATRE OF LITERATURE The
(Dramatised Readings)
51 The Cut, London SE1 8LF
e-mail: info@calderpublications.com
Fax: 020-7928 5930 Tel: 020-7633 0599

THEATRE WORKSHOP
34 Hamilton Place
Edinburgh EH3 5AX
Website: www.theatre-workshop.com
Fax: 0131-220 0112 Tel: 0131-225 7942

THEATR POWYS
The Drama Centre, Tremont Road
Llandrindod Wells
Powys LD1 5EB
Website: www.theatrpowys.co.uk
e-mail: theatr.powys@powys.gov.uk
Fax: 01597 824381 Tel: 01597 824444

THIRD PARTY PRODUCTIONS Ltd
87 St Thomas' Road, Hastings
East Sussex TN34 3LD
Website: www.thirdparty.org.uk
e-mail: gleave@thirdparty.org.uk
Mobile: 07768 694211 Mobile: 07768 694212

TIME OF OUR LIVES MUSIC THEATRE Ltd
5 Monkhams Drive
Woodford Green
Essex IG8 0LG
Website: www.toolmusictheatre.co.uk
e-mail: dympna@toolmusictheatre.co.uk
 Tel/Fax: 020-8491 6695

TOBACCO FACTORY
Raleigh Road
Southville, Bristol BS3 1TF
Website: www.tobaccofactory.com
e-mail: theatre@tobaccofactory.com
Fax: 0117-902 0162 Tel: 0117-902 0345

TRADING FACES
(Mask & Physical Theatre)
28 Brick Meadow
Bishops Castle
Shropshire SY9 5DH
Website: www.tradingfaces.org.uk
e-mail: admin@tradingfaces.org.uk Tel: 01588 630555

TRICYCLE THEATRE
269 Kilburn High Road
London NW6 7JR
Website: www.tricycle.co.uk
e-mail: admin@tricycle.co.uk
Fax: 020-7328 0795 Tel: 020-7372 6611

WAREHOUSE THEATRE COMPANY
Dingwall Road
Croydon CR0 2NF
Website: www.warehousetheatre.co.uk
e-mail: info@warehousetheatre.co.uk
Fax: 020-8688 6699 Tel: 020-8681 1257

WIGAN PIER THEATRE COMPANY
The Wigan Pier Experience
Wallgate
Wigan WN3 4EU
Website: www.wiganpier.net
e-mail: s.aitken@wlct.org Tel: 01942 709305

WINCHESTER HAT FAIR, FESTIVAL OF STREET THEATRE
5A Jewry Street
Winchester
Hampshire SO23 8RZ
Website: www.hatfair.co.uk
e-mail: info@hatfair.co.uk
Fax: 01962 868957 Tel: 01962 849841

WOMEN & THEATRE BIRMINGHAM Ltd
220 Moseley Road
Highgate
Birmingham B12 0DG
e-mail: info@womenandtheatre.co.uk
Fax: 0121-446 4280 Tel: 0121-440 4203

Y TOURING THEATRE COMPANY
120 Cromer Street
London WC1H 8BS
Website: www.ytouring.org.uk
e-mail: m.white@ytouring.org.uk
Fax: 020-7272 8413 Tel: 0870 1127644

YELLOW EARTH THEATRE
18 Rupert Street
London W1D 6DE
Website: www.yellowearth.org
e-mail: admin@yellowearth.org
Fax: 020-7287 3141 Tel: 020-7734 5988

YORICK INTERNATIONALIST THEATRE ENSEMBLE
(Yorick Theatre & Film)
4 Duval Court
36 Bedfordbury
Covent Garden, London WC2N 4DQ
e-mail: yorickx@hotmail.com Tel/Fax: 020-7836 7637

YORKSHIRE WOMEN THEATRE COMPANY
(Touring Theatre in Health Education)
Host Media Centre
21 Savile Mount
Leeds LS7 3HZ
Website: www.yorkshirewomentheatre.com
e-mail: admin@ywtheatre.com
Fax: 0113-200 7033 Tel: 0113-200 7200

YOUNG VIC THEATRE
66 The Cut
London SE1 8LZ
Website: www.youngvic.org
e-mail: info@youngvic.org
Fax: 020-7922 2801 Tel: 020-7922 2856

ZIP THEATRE
Newhampton Arts Centre
Dunkley Street
Wolverhampton WV1 4AN
Website: www.ziptheatre.co.uk
e-mail: cathy@ziptheatre.co.uk
Fax: 01902 572251 Tel: 01902 572250

ACTION TRANSPORT THEATRE COMPANY
(New Writing, Professional Production for, by and with
Young People)
Whitby Hall, Stanney Lane
Ellesmere Port, Cheshire CH65 9AE
Website: www.actiontransporttheatre.co.uk
e-mail: info@actiontransporttheatre.co.uk Tel: 0151-357 2120

ACTIONWORK
(Theatre & Film Productions with Young People)
PO Box 433, Weston-super-Mare, Somerset BS24 0WY
Website: www.actionwork.com
e-mail: admin@actionwork.com Tel: 01934 815163

ARTY-FACT THEATRE COMPANY Ltd
18 Weston Lane, Crewe, Cheshire CW2 5AN
Website: www.arty-fact.co.uk
Fax: 07020 982098 Tel: 07020 962096

ASHCROFT YOUTH THEATRE
Ashcroft Academy of Dramatic Art, Malcolm Primary
School, Malcolm Road, Penge, London SE20 8RH
Website: www.ashcroftacademy.com
e-mail: geri.ashcroftacademy@tiscali.co.uk
Mobile: 07799 791586 Tel: 020-8693 8088

BARKING DOG THEATRE COMPANY
14 Leaside Mansions
Fortis Green, London N10 3EB
Website: www.barkingdog.co.uk
e-mail: mike@barkingdog.co.uk Tel: 020-8883 0034

BECK THEATRE
Grange Road, Hayes
Middlesex UB3 2UE Tel: 020-8561 7506

BIG WOODEN HORSE THEATRE FOR YOUNG PEOPLE
30 Northfield Road
West Ealing, London W13 9SY
Website: www.bigwoodenhorse.com
e-mail: info@bigwoodenhorse.com Tel: 020-8567 8431

BIRMINGHAM STAGE COMPANY The
Suite 228 The Linen Hall
162 Regent Street, London W1B 5TG
Website: www.birminghamstage.net
e-mail: info@birminghamstage.net
Fax: 020-7437 3395 Tel: 020-7437 3391

BITESIZE THEATRE COMPANY
8 Green Meadows
New Broughton, Wrexham LL11 6SG
Website: www.bitesizetheatre.co.uk
Fax: 01978 358315 Tel: 01978 358320

BLAH BLAH BLAH THEATRE COMPANY The
The West Park Centre
Spen Lane, Leeds LS16 5BE
Website: www.blahs.co.uk
e-mail: admin@blahs.co.uk Tel: 0113-224 0300

BLUE MOON THEATRE COMPANY
20 Sandpiper Road
Blakespool Park, Bridgwater, Somerset TA6 5QU
Website: www.bluemoontheatre.co.uk
e-mail: tillythetalespinner@yahoo.co.uk
 Tel/Fax: 01278 458253

BLUNDERBUS THEATRE COMPANY Ltd
1st Floor, The Brook Theatre
Old Town Hall, Chatham, Kent ME4 4SE
Website: www.blunderbus.co.uk
e-mail: admin@blunderbus.co.uk
Fax: 01634 818138 Tel: 01634 818136

BOOSTER CUSHION THEATRE COMPANY
75 How Wood, Park Street, St Albans, Herts AL2 2RW
Website: www.booster-cushion.co.uk
e-mail: boostercushion@hotmail.com
Fax: 01727 872597 Tel: 01727 873874

BORDERLINE THEATRE COMPANY
(Producer: Eddie Jackson)
North Harbour Street, Ayr KA8 8AA
Website: www.borderlinetheatre.co.uk
e-mail: enquiries@borderlinetheatre.co.uk
Fax: 01292 263825 Tel: 01292 281010

BRIDGE HOUSE THEATRE
Warwick School, Wyton Road, Warwick CV34 6PP
Website: www.bridgehousetheatre.co.uk
Fax: 01926 776476 Tel: 01926 776437

CAUGHT IN THE ACT
The Brix, Brixton Hill, London SW2 1JF
Website: www.caughtintheact.co.uk
e-mail: cita@caughtintheact.co.uk Tel/Fax: 020-7733 2950

CHAIN REACTION THEATRE COMPANY
Three Mills Studios
Sugar House Yard
Sugar House Lane, London E15 2QS
Website: www.chainreactiontheatre.co.uk
e-mail: mail@chainreactiontheatre.co.uk
 Tel/Fax: 020-8534 0007

CHALKFOOT THEATRE ARTS
(Artistic Director: Philip Dart)
Central Studios, 36 Park Place
Margate, Kent CT9 1LE
Website: www.chalkfoot.org.uk
e-mail: info@chalkfoot.org.uk Tel: 01843 280077

CHICKEN SHED THEATRE
(Artistic Director: Mary Ward MBE)
Chase Side, Southgate, London N14 4PE
Website: www.chickenshed.org.uk
e-mail: info@chickenshed.org.uk
Minicom: 020-8350 0676 Tel: 020-8351 6161

CIRCUS MANIACS YOUTH CIRCUS
(International Award-Winning Youth Circus Company)
Office 8A, The Kingswood Foundation
Britannia Road, Kingswood, Bristol BS15 8DB
e-mail: info@circusmaniacs.com
Mobile: 07977 247287 Tel/Fax: 0117-947 7042

CLWYD THEATR CYMRU THEATRE FOR YOUNG PEOPLE
(Contact - Education Administator)
Mold, Flintshire CH7 1YA
Website: www.ctctyp.co.uk
e-mail: education@clwyd-theatr-cymru.co.uk
Fax: 01352 701558 Tel: 01352 701575

COMPLETE WORKS CREATIVE COMPANY Ltd The
(Artistic Director: Phil Evans)
The Old Truman Brewery
91 Brick Lane, London E1 6QL
Website: www.tcw.org.uk
e-mail: info@tcw.org.uk
Fax: 0870 1431979 Tel: 0870 1431969

CRAGRATS Ltd
The Mill, Dunford Road
Holmfirth, Huddersfield HD9 2AR
Website: www.cragrats.com
e-mail: info@cragrats.com
Fax: 01484 686212 Tel: 01484 686451

CTC THEATRE
Arts Centre, Vane Terrace
Darlington, County Durham DL3 7AX
Website: www.ctctheatre.org.uk
e-mail: ctc@ctctheatre.org.uk
Fax: 01325 369404 Tel: 01325 352004

DAYLIGHT THEATRE
66 Middle Street, Stroud
Gloucestershire GL5 1EA Tel: 01453 763808

DONNA MARIA COMPANY
16 Bell Meadow, Dulwich, London SE19 1HP
Website: www.donna-marias-world.co.uk
e-mail: info@donna-marias-world.co.uk Tel: 020-8670 7814

DRAGON DRAMA
(Theatre Company, Tuition, Workshops, Parties)
347 Hanworth Road, Surrey TW12 3EJ
Website: www.dragondrama.co.uk
e-mail: info@dragondrama.co.uk Tel/Fax: 020-8255 8356

EUROPA CLOWN THEATRE SHOW
36 St Lukes Road
Tunbridge Wells, Kent TN4 9JH
Website: www.clownseuropa.co.uk Tel: 01892 537964

EUROPEAN THEATRE COMPANY The
39 Oxford Avenue, London SW20 8LS
Website: www.europeantheatre.co.uk
e-mail: admin@europeantheatre.co.uk
Fax: 020-8544 1999 Tel: 020-8544 1994

FUTURES THEATRE COMPANY
St John's Crypt, 73 Waterloo Road, London SE1 8UD
Website: www.futurestheatrecompany.co.uk
e-mail: info@futurestheatrecompany.co.uk
Fax: 020-7928 6724 Tel: 020-7928 2832

GAZEBO TIE COMPANY Ltd
Unit 37 Imex House, Imex Business Park
Upper Villiers Street, Wolverhampton WV2 4XE
Website: www.gazebotie.co.uk
e-mail: gazebotie@tiscali.co.uk
Fax: 01902 313229 Tel: 01902 313009

GREENWICH & LEWISHAM YOUNG PEOPLES' THEATRE (GLYPT)
Royal Laboratory Office
No 1 Street, Royal Arsenal
Woolwich, London SE18 6ST
Website: www.glypt.co.uk
e-mail: postbox@glypt.co.uk
Fax: 020-8317 8595 Tel: 020-8854 1316

GROUP 64 YOUTH THEATRE
Putney Arts Theatre
Ravenna Road, London SW15 6AW
Website: www.putneyartstheatre.org.uk
Fax: 020-8788 6940 Tel: 020-8788 6935

GWENT TIE COMPANY
The Drama Centre Pen-y-pound
Abergavenny, Monmouthshire NP7 5UD
Website: www.gwenttheatre.com
e-mail: gwenttie@uwclub.net
Fax: 01873 853910 Tel: 01873 853167

HACKNEY YOUNG PEOPLE'S THEATRE
Hoxton Hall Theatre & Arts Centre
130 Hoxton Street, London N1 6SH
Website: www.hoxtonhall.co.uk
e-mail: info@hoxtonhall.co.uk
Fax: 020-7729 3815 Tel: 020-7684 0060

HALF MOON YOUNG PEOPLE'S THEATRE
43 White Horse Road, London E1 0ND
Website: www.halfmoon.org.uk
e-mail: admin@halfmoon.org.uk
Fax: 020-7709 8914 Tel: 020-7265 8138

IMAGE MUSICAL THEATRE
23 Sedgeford Road
Shepherd's Bush, London W12 0NA
Website: www.imagemusicaltheatre.co.uk
e-mail: brian@imagemusicaltheatre.co.uk
Fax: 020-8749 9294 Tel: 020-8743 9380

IMPACT ON LEARNING
Impact Universal, Hopebank House
Woodhead Road
Honley, Huddersfield HD9 6PF
Website: www.impactonlearning.com
e-mail: gideon.clear@impactonlearning.com
Fax: 01484 660088 Tel: 01484 668881

INTERPLAY THEATRE
Armley Ridge Road, Leeds LS12 3LE
Website: www.interplayleeds.co.uk
e-mail: info@interplayleeds.co.uk Tel: 0113-263 8556

KINETIC THEATRE COMPANY Ltd
Suite H, The Jubilee Centre
Lombard Road
Wimbledon, London SW19 3TZ
Website: www.kinetictheatre.co.uk
e-mail: sarah@kinetictheatre.co.uk
Fax: 020-8286 2645 Tel: 020-8286 2613

KOMEDIA
44-47 Gardner Street, Brighton BN1 1UN
Website: www.komedia.co.uk/brighton
e-mail: info@komedia.co.uk
Fax: 01273 647102 Tel: 01273 647100

LANGUAGE ALIVE!/CATALYST THEATRE
The Play House, Longmore Street
Birmingham B12 9ED
Website: www.theplayhouse.org.uk
e-mail: info@theplayhouse.org.uk
Fax: 0121-464 5713 Tel: 0121-464 5712

LEIGHTON BUZZARD YOUTH THEATRE
6 Hillside Road, Leighton Buzzard LU7 3BU
e-mail: info@lbyt.org Tel: 01525 377222

LITTLE ACTORS THEATRE COMPANY
16 Hawthorn Road, Parkgate, Cheshire CH64 6SX
e-mail: info@littleactorstheatre.com
Fax: 0870 1645895 Tel: 0151-336 4302

M6 THEATRE COMPANY
Studio Theatre, Hamer C. P. School
Albert Royds Street, Rochdale OL16 2SU
Website: www.m6theatre.co.uk
e-mail: info@m6theatre.co.uk
Fax: 01706 712601 Tel: 01706 355898

MAGIC CARPET THEATRE
18 Church Street, Sutton-on-Hull HU7 4TS
Website: www.magiccarpettheatre.com
e-mail: admin@magiccarpettheatre.com
Fax: 01482 787362 Tel: 01482 709939

MERSEYSIDE YOUNG PEOPLE'S THEATRE COMPANY
(General Manager: Michael Quirke, Artistic Producer: Kathy McArdle)
13 Hope Street, Liverpool L1 9BH
e-mail: info@mypt.uk.com Tel/Fax: 0151-708 0877

MUZIKANSKY YOUTH & COMMUNITY
The Forum, Fonthill, The Common
Tunbridge Wells, Kent TN4 8YU
Website: www.mzky.co.uk
e-mail: admin@mzky.co.uk Tel/Fax: 01892 542260

NATIONAL ASSOCIATION OF YOUTH THEATRES (NAYT)
Arts Centre, Vane Terrace
Darlington, County Durham DL3 7AX
Website: www.nayt.org.uk
e-mail: nayt@btconnect.com
Fax: 01325 363313 Tel: 01325 363330

NATIONAL STUDENT THEATRE COMPANY
Website: www.studentdrama.org.uk/nstc
e-mail: iain.knox@ukgateway.net Tel/Fax: 01244 400559

NATIONAL YOUTH THEATRE OF GREAT BRITAIN
443-445 Holloway Road, London N7 6LW
Website: www.nyt.org.uk
e-mail: info@nyt.org.uk
Fax: 020-7281 8246 Tel: 020-7281 3863

NETTLEFOLD The
The Nettlefold
West Norwood Library Centre
1 Norwood High Street, London SE27 9JX
e-mail: thenettlefold@lambeth.gov.uk
Fax: 020-7926 8071 Tel: 020-7926 8070

OILY CART
Smallwood School Annexe
Smallwood Road, London SW17 0TW
Website: www.oilycart.org.uk
e-mail: oilies@oilycart.org.uk
Fax: 020-8672 0792 Tel: 020-8672 6329

ONATTI THEATRE COMPANY
(Artistic Director: Andrew Bardwell)
9 Field Close, Warwick, Warwickshire CV34 4QD
Website: www.onatti.co.uk
e-mail: info@onatti.co.uk
Fax: 0870 1643629 Tel: 01926 495220

PANDEMONIUM TOURING PARTNERSHIP
228 Railway Street
Cardiff CF24 2NJ Tel: 029-2047 2060

PANDORA'S BOX THEATRE COMPANY
(National Touring Young Children's Theatre)
(Directors: Ian Sanders & Katy Secombe)
10 Harpurs Road, Glemsford, Sudbury, Suffolk CO10 7RN
Website: www.pandora-box.co.uk
e-mail: info@pandora-box.co.uk Tel/Fax: 01787 282835

PAUL'S THEATRE COMPANY
Fairkytes Arts Centre
51 Billet Lane, Hornchurch, Essex RM11 1AX
Website: www.paulstheatreschool.co.uk
e-mail: info@paulstheatreschool.co.uk
Fax: 01708 475286 Tel: 01708 447123

PIED PIPER COMPANY
(In association with The Yvonne Arnaud Theatre Guildford)
1 Lilian Place, Coxcombe Lane
Chiddingfold, Surrey GU8 4QA
Website: www.piedpipertheatre.co.uk
e-mail: twpiedpiper@aol.com Tel/Fax: 01428 684022

PILOT THEATRE
York Theatre Royal
St Leonard's Place, York YO1 7HD
Website: www.pilot-theatre.com
e-mail: info@pilot-theatre.com
Fax: 01904 656378 Tel: 01904 635755

PLAYTIME THEATRE COMPANY
18 Bennells Avenue, Whitstable, Kent CT5 2HP
Website: www.playtime.dircon.co.uk
e-mail: playtime@dircon.co.uk
Fax: 01227 266648 Tel: 01227 266272

POLKA THEATRE
240 The Broadway, Wimbledon SW19 1SB
Website: www.polkatheatre.com
e-mail: admin@polkatheatre.com
Fax: 020-8545 8365 Tel: 020-8545 8320

Q20 THEATRE COMPANY
19 Wellington Crescent, Shipley
West Yorkshire BD18 3PH
e-mail: info@q20theatre.co.uk Tel: 0845 1260632

QUAKER YOUTH THEATRE
Ground Floor, 1 The Lodge
1046 Bristol Road, Birmingham B29 6LJ
Website: www.leaveners.org
e-mail: qyt@leaveners.org
Fax: 0121-414 0090 Tel: 0121-414 0099

QUANTUM THEATRE FOR SCIENCE
(Artistic Directors: Michael Whitmore, Jessica Selous)
The Old Button Factory
1-11 Bannockburn Road
Plumstead, London SE18 1ET
Website: www.quantumtheatre.co.uk
e-mail: office@quantumtheatre.co.uk Tel: 020-8317 9000

QUICKSILVER THEATRE COMPANY
(National Touring - New Writing for the under 12's)
4 Enfield Road, London N1 5AZ
Website: www.quicksilvertheatre.org
e-mail: talktous@quicksilvertheatre.org
Fax: 020-7254 3119 Tel: 020-7241 2942

RAINBOW BIGBOTTOM & Co Ltd
Vale House, The Studio
17 Vale Road, Chesham, Bucks HP5 3HH
Website: www.rainbowbigbottom.co.uk
e-mail: laneatrainbows@aol.com
Mobile: 07778 106552 Tel: 01444 410558

RED LADDER THEATRE COMPANY Ltd
3 St Peter's Buildings, York Street, Leeds LS9 8AJ
Website: www.redladder.co.uk
e-mail: rod@redladder.co.uk
Fax: 0113-245 5351 Tel: 0113-245 5311

REDROOFS THEATRE COMPANY
The Novello Theatre, Sunninghill
Nr Ascot, Berkshire SL5 9NE Tel: 01344 620881

ROUNDABOUT THEATRE IN EDUCATION
Nottingham Playhouse
Wellington Circus, Nottingham NG1 5AF
e-mail: roundabout@nottinghamplayhouse.co.uk
Fax: 0115-947 5759 Tel: 0115-947 4361

ROYAL & DERNGATE THEATRES
19-21 Guildhall Road, Northampton NN1 1DP
e-mail: education@ntt.org Tel: 01604 627566

ROYAL COURT YOUNG WRITERS PROGRAMME
(Playwriting Projects for Young People aged 13-25)
The Site, Royal Court Theatre
Sloane Square, London SW1W 8AS
Website: www.royalcourttheatre.com
e-mail: ywp@royalcourttheatre.com
Fax: 020-7565 5001 Tel: 020-7565 5050

SCOTTISH YOUTH THEATRE
The Old Sheriff Court
105 Brunswick Street, Glasgow G1 1TF
Website: www.scottishyouththeatre.org
e-mail: info@scottishyouththeatre.org
Fax: 0141-552 7615 Tel: 0141-552 3988

SEAHORSE THEATRE & PARTY COMPANY
Ealing House, 33 Hanger Lane, London W5 3HJ
e-mail: verona.chard@vampevents.com Tel: 020-8997 3355

SHAKESPEARE 4 KIDZ THEATRE COMPANY The
42 Station Road East
Oxted, Surrey RH8 0PG
Website: www.shakespeare4kidz.com
e-mail: theatre@shakespeare4kidz.com
Fax: 01883 730384 Tel: 01883 723444

SHAKESPEAREWORKS
22 Chilswell Road, Oxford OX1 4PJ
e-mail: info@shakespeareworks.co.uk Tel/Fax: 01865 241281

SHARED EXPERIENCE YOUTH THEATRE
The Soho Laundry
9 Dufours Place, London W1F 7SJ
e-mail: admin@sharedexperience.org.uk
Fax: 020-7287 8763 Tel: 020-7434 9248

SHEFFIELD THEATRES
(Education Administrator: Sue Burley,
Education Director: Karen Simpson)
55 Norfolk Street, Sheffield S1 1DA
Website: www.sheffieldtheatres.co.uk/education
Fax: 0114-249 6003 Tel: 0114-249 5999

SNAP THEATRE COMPANY
29 Raynham Road
Bishop's Stortford, Herts CM23 5PE
Website: www.snaptheatre.co.uk
e-mail: info@snaptheatre.co.uk
Fax: 01279 506694 Tel: 01279 461607

SPECTACLE THEATRE
Coleg Morgannwg, Rhondda
Llwynypia, Tonypandy CF40 2TQ
Website: www.spectacletheatre.co.uk
e-mail: info@spectacletheatre.co.uk
Fax: 01443 423080 Tel: 01443 430700

STORYTELLERS THEATRE COMPANY The
Bridge Farm, 249 Hawes Side Lane, Blackpool FY4 4AA
Website: www.pendleproductions.co.uk
e-mail: admin@pendleproductions.co.uk
Fax: 01253 792930 Tel: 01253 839375

SUPPORT ACT PRODUCTIONS
(Ian McCracken)
PO Box 388, Dover CT16 9AJ
Website: www.supportact.co.uk
e-mail: info@supportact.co.uk Tel: 0845 0940796

TEAM PLAYERS THEATRE COMPANY
Lingfield Countryside Centre
Mount Pleasant Way, Coulby Newham
Middlesbrough TS8 0XF
Fax: 01642 577121 Tel: 01642 592648

THEATRE ALIBI
(Adult & Young People)
Northcott Studio Theatre
Emmmanuel Road, Exeter EX4 1EJ
Website: www.theatrealibi.co.uk
e-mail: info@theatrealibi.co.uk Tel/Fax: 01392 217315

THEATRE CENTRE
(National Touring & New Writing for Young Audiences)
Shoreditch Town Hall
380 Old Street, London EC1V 9LT
Website: www.theatre-centre.co.uk
e-mail: admin@theatre-centre.co.uk
Fax: 020-7739 9741 Tel: 020-7729 3066

THEATRE NA N'OG
Unit 3
Millands Road Industrial Estate
Neath SA11 1NJ
Website: www.theatr-nanog.co.uk
e-mail: drama@theatr-nanog.co.uk
Fax: 01639 647941 Tel: 01639 641771

THEATR IOLO Ltd
The Old School Building, Cefn Road
Mynachdy, Cardiff CF14 3HS
Website: www.theatriolo.com
e-mail: admin@theatriolo.com
Fax: 029-2052 2225 Tel: 029-2061 3782

TICKLISH ALLSORTS SHOW
57 Victoria Road, Wilton
Salisbury, Wiltshire SP2 0DZ
Website: www.ticklishallsorts.co.uk
e-mail: garynunn@ntlworld.com Tel/Fax: 01722 744949

TIE ACTION WORK
PO Box 433, Weston-Super-Mare
Somerset BS24 0WY
Website: www.tietours.com
e-mail: tie@tietours.com Tel: 01934 815163

TOURING TALES THEATRE COMPANY Ltd
Suite 228 The Linen Hall
162 Regent Street, London W1B 5TG
Website: www.birminghamstage.net
e-mail: info@birminghamstage.net
Fax: 020-7437 3395 Tel: 020-7437 3391

TRICYCLE THEATRE
(Education Director: Gillian Christie)
269 Kilburn High Road
London NW6 7JR
Website: www.tricycle.co.uk
e-mail: education@tricycle.co.uk Tel/Fax: 020-7372 6611

TWISTING YARN THEATRE
Alhambra Theatre
Morley Street, Bradford BD7 1AJ
Website: www.bradford-theatres.co.uk
e-mail: twisting-yarn@bradford.gov.uk
Fax: 01274 437571 Tel: 01274 437490

UNICORN THEATRE
147 Tooley Street, London SE1 2HZ
Website: www.unicorntheatre.com
e-mail: admin@unicorntheatre.com
Fax: 020-7645 0550 Tel: 020-7645 0500

WEST YORKSHIRE PLAYHOUSE
Playhouse Square
Quarry Hill, Leeds LS2 7UP
e-mail: gail.mcintyre@wyp.org.uk Tel: 0113-213 7225

YOUNG SHAKESPEARE COMPANY
(Artistic Directors: Christopher Geelan & Sarah Gordon)
31 Bellevue Road
Friern Barnet, London N11 3ET
Fax: 020-8368 6713 Tel: 020-8368 4828

■ **AUSTRIA** VIENNA
Vienna's English Theatre
(See website for casting requirements)
UK Representative: VM Theatre Productions Ltd
16 The Street, Ash, Kent CT3 2HJ
Website: www.englishtheatre.at
Casting: Vanessa Mallatratt Tel/Fax: 01304 813330

■ **DENMARK** COPENHAGEN
The English Theatre of Copenhagen
London Toast Theatre, Kochsvej 18
1812 Fred C. Copenhagen Denmark
Website: www.londontoast.dk
e-mail: mail@londontoast.dk Tel: + 45 33 22 8686
Artistic Director: Vivienne McKee
Administrator: Soren Hall

■ **FRANCE** PARIS
ACT Company
25 avenue Mal Leclerc, 92240 Malakoff, France
Website: www.actheatre.com
e-mail: andrew.wilson@wanadoo.fr
Fax: + 33 1 46 56 23 18 Tel: + 33 1 46 56 20 50
Artistic Director: Andrew Wilson
Administrator: Anne Wilson

■ **FRANCE** LYON
Theatre From Oxford (Touring Europe & Beyond)
B.P. 10, F-42750 St-Denis-de-Cabanne
e-mail: theatre.oxford@virgin.net
Contact: Robert Southam (Write)

■ **GERMANY** FRANKFURT
The English Theatre
Kaiserstrasse 34, 60329, Frankfurt, Germany
Website: www.english-theatre.org
e-mail: mail@english-thearte-org
Fax: + 49 69 242 316 14 Tel: + 49 69 242 316 10
Contact: Daniel John Nicolai

■ **GERMANY** HAMBURG
The English Theatre of Hamburg
Lerchenfeld 14, 22081 Hamburg, Germany
Website: www.englishtheatre.de
Fax: + 49 40 229 5040 Tel: + 49 40 227 7089
Contact: Robert Rumpf, Clifford Dean

■ **GERMANY** TOURING GERMANY
White Horse Theatre
Boerdenstrasse 17, 59494 Soest-Muellingsen, Germany
e-mail: theatre@whitehorse.de
Fax: + 49 29 21 33 93 36 Tel: + 49 29 21 33 93 39
Contact: Peter Griffith, Michael Dray

■ **HUNGARY** BUDAPEST
Merlin International Theatre
Gerloczy Utca 4, 1052 Budapest, Hungary
e-mail: angol@merlinszinhaz.hu
Fax: + 36 1 2660904 Tel: + 36 1 3179338
Contact: Laszlo Magacs

■ **ICELAND** REYKJAVIK
Light Nights - The Summer Theatre
The Travelling Theatre
Baldursgata 37, IS-101 Reykjavik, Iceland Tel: + 354 551 9181
Artistic Director: Kristine G Magnus

■ **ITALY** SANREMO
A.C.L.E.
Via Roma 54
18038 Sanremo (IM), Italy
Website: www.acle.org
e-mail: info@acle.org
Fax: + 39 0184 509996 Tel: + 39 0184 506070

■ **SWEDEN** STOCKHOLM
The English Theatre Company
(TMA Member), Nybrogatan 35
114 39 Stockholm, Sweden
Website: www.englishtheatre.se
e-mail: etc.ltd@telia.com
Fax: + 46 8 660 1159 Tel: + 46 8 662 4133
Artistic Director: Christer Berg

■ **UNITED KINGDOM** WARWICK
Onatti Theatre Company
9 Field Close, Warwick
Warwickshire CV34 4QD
Website: www.onatti.co.uk
e-mail: info@onatti.co.uk
Fax: 0870 1643629 Tel: 01926 495220
Contact: Andrew Bardwell

ADELPHI
Strand, London WC2E 7NN
Manager:	--------------------
Stage Door:	020-7836 1166
Box Office:	0870 8955598

ALBERY
(See NOËL COWARD THEATRE The)

ALDWYCH
Aldwych, London WC2B 4DF
Manager:	020-7836 5537
Stage Door:	020-7836 5537
Box Office:	0870 4000845
Website:	www.aldwychtheatre.co.uk

ALMEIDA
Almeida Street, London N1 1TA
Manager:	020-7288 4900
Stage Door:	--------------------
Box Office:	020-7359 4404

APOLLO
Shaftesbury Avenue, London W1D 7EZ
Manager:	020-7494 5834
Stage Door:	020-7851 2711
Box Office:	020-7494 5834
e-mail:	enquiries@nimaxtheatres.com

APOLLO VICTORIA
17 Wilton Road, London SW1V 1LG
Manager:	020-7834 6318
Stage Door:	020-7834 7231
Box Office:	0870 4000650
Website:	www.getlive.co.uk

ARTS
6-7 Great Newport Street
London WC2H 7JB
Manager:	020-7836 2132
Stage Door:	020-7836 2132
Box Office:	020-7836 3334
Website:	www.artstheatrelondon.com

BARBICAN
Barbican, London EC2Y 8DS
Manager:	020-7628 3351
Stage Door:	020-7628 3351
Box Office:	020-7638 8891
Website:	www.barbican.org.uk

THE BUSH
Shepherds Bush Green
London W12 8QD
Manager:	020-7602 3703
Stage Door:	--------------------
BO:	020-7610 4224
Website:	www.bushtheatre.co.uk
e-mail:	info@bushtheatre.co.uk

CAMBRIDGE
Earlham Street, Seven Dials
Covent Garden, London WC2 9HU
Manager:	020-7850 8711
Stage Door:	020-7850 8710
Box Office:	0870 8901102

COLISEUM (English National Opera)
St Martin's Lane
London WC2N 4ES
Manager:	020-7836 0111
Stage Door:	020-7845 9397
Box Office:	020-7632 8300

COMEDY
Panton Street
London SW1Y 4DN
Manager:	020-7321 5310
Stage Door:	020-7321 5300
Box Office:	0870 0606637

CRITERION
2 Jermyn Street
Piccadilly, London SW1Y 4XA
Manager:	020-7839 8811
Stage Door:	020-7839 8811
Box Office:	0870 0602313
Website:	www.criterion-theatre.co.uk
e-mail:	admin@criterion-theatre.co.uk

DOMINION
268-269 Tottenham Court Road
London W1T 7AQ
Manager:	--------------------
Stage Door:	020-7927 0900
Box Office:	0870 1690116
Website:	www.getlive.co.uk/dominion

DONMAR WAREHOUSE
41 Earlham Street
London WC2H 9LX
Manager:	020-7240 4882
Stage Door:	020-7438 9200
Box Office:	0870 060 6624
Website:	www.donmarwarehouse.com
e-mail:	office@donmarwarehouse.com

DRURY LANE
Theatre Royal
Catherine Street, London WC2B 5JF
Manager:	--------------------
Stage Door:	020-7850 8790
Box Office:	020-7494 5060

DUCHESS
Catherine Street, London WC2B 5LA
Manager:	020-7632 9601
Stage Door:	020-7632 9600
Box Office:	020-7632 9602
e-mail:	enquiries@nimaxtheatres.com

DUKE OF YORK'S
St Martin's Lane, London WC2N 4BG
Manager:	020-7836 4615
Stage Door:	020-7836 4615
Box Office:	0870 0606623

FORTUNE
Russell Street
Covent Garden
London WC2B 5HH
Manager:	020-7010 7900
Stage Door:	020-7010 7900
Box Office:	020-7369 1737

GARRICK
Charing Cross Road, London WC2H 0HH
Manager:	020-7520 5692
Stage Door:	020-7520 5690
Box Office:	020-7520 5693
e-mail:	enquiries@nimaxtheatres.com

GIELGUD
Shaftesbury Avenue, London W1D 6AR
Manager:	020-7292 1321
Stage Door:	020-7292 1320
Box Office:	020-7812 7480

HACKNEY EMPIRE
291 Mare Street, London E8 1EJ
Manager:	020-8510 4500
Stage Door:	020-8510 4500
Box Office:	020-8985 2424
Website:	www.hackneyempire.co.uk
e-mail:	info@hackneyempire.co.uk

HAMMERSMITH APOLLO
Queen Caroline Street, London W6 9QH
Manager:	------------------
Stage Door:	------------------
Box Office:	0870 6063400
Website:	www.livenation.co.uk

HAMPSTEAD
Eton Avenue, Swiss Cottage, London NW3 3EU
Manager:	020-7449 4200
Stage Door:	------------------
Box Office:	020-7722 9301
Website:	www.hampsteadtheatre.com
e-mail:	info@hampsteadtheatre.com

HER MAJESTY'S
Haymarket, London SW1Y 4QL
Manager:	020-7850 8750
Stage Door:	020-7850 8750
Box Office:	0870 0600247

LYCEUM
21 Wellington Street, London WC2E 7RQ
Manager:	020-7420 8100
Stage Door:	020-7420 8100
Box Office:	020-7420 8114

LYRIC
29 Shaftesbury Avenue, London W1D 7ES
Manager:	020-7494 5840
Stage Door:	020-7494 5841
Box Office:	020-7494 5842
e-mail:	enquiries@nimaxtheatres.com

LYRIC HAMMERSMITH
King Street, London W6 0QL
Manager:	------------------
Stage Door:	------------------
Box Office:	08700 500511
Website:	www.lyric.co.uk
e-mail:	enquiries@lyric.co.uk

NATIONAL
South Bank, Upper Ground, London SE1 9PX
Manager:	020-7452 3333
Stage Door:	020-7452 3333
Box Office:	020-7452 3000
Website:	www.nationaltheatre.org.uk

NEW AMBASSADORS
West Street, London WC2H 9ND
Manager:	020-7395 5410
Stage Door:	020-7395 5400
Box Office:	0870 0606627
Website:	www.newambassadors.com
e-mail:	newambassadors@theambassadors.com

NEW LONDON
Drury Lane, London WC2B 5PW
Manager:	020-7242 9802
Stage Door:	020-7242 9802
Box Office:	0870 8900141

NEW PLAYERS
The Arches, Off Villiers Street, London WC2N 6NG
Manager:	020-7930 6601
Stage Door:	------------------
Box Office:	------------------
Website:	www.newplayerstheatre.com
e-mail:	info@newplayerstheatre.com

NOËL COWARD THEATRE The
(Formerly ALBERY THEATRE)
85 St Martin's Lane, London WC2N 4AU
Manager:	020-7759 8011
Stage Door:	020-7759 8010
Box Office:	0870 9500920

NOVELLO (Formerly STRAND)
Aldwych, London WC2B 4LD
Manager:	020-7759 9611
Stage Door:	020-7759 9611
Box Office:	0870 9500935

OLD VIC The
Waterloo Road, London SE1 8NB
Manager:	020-7928 2651
Stage Door:	020-7928 2651
Box Office:	0870 0606628
Website:	www.oldvictheatre.com
e-mail:	info@oldvictheatre.com

OPEN AIR THEATRE
Inner Circle, Regent's Park, London NW1 4NR
Manager:	020-7935 5756
Stage Door:	020-7935 5756
Box Office:	08700 601811
Website:	www.openairtheatre.org

PALACE
Shaftesbury Avenue, London W1D 5AY
Manager:	020-7434 0088
Stage Door:	020-7434 0088
Box Office:	0870 8955579
Website:	www.rutheatres.com
e-mail:	info@rutheatres.com

PALLADIUM
Argyll Street, London W1F 7TF
Manager:	020-7850 8777
Stage Door:	020-7850 8770
Box Office:	0870 8901108

PEACOCK
(For Administration see SADLER'S WELLS)
Portugal Street, Kingsway, London WC2A 2HT
Manager:	020-7863 8202
Stage Door:	020-7863 8268
Box Office:	0870 7370337
Website:	www.sadlerswells.com
e-mail:	info@sadlerswells.com

PHOENIX
110 Charing Cross Road, London WC2H OJP
Manager:	-------------------
Stage Door:	020-7438 9600
Box Office:	020-7438 9605

PICCADILLY
Denman Street, London W1D 7DY
Manager:	020-7478 8812
Stage Door:	020-7478 8800
Box Office:	020-7478 8805

PLAYHOUSE
Northumberland Avenue, London WC2N 5DE
Manager:	020-7839 4292
Stage Door:	020-7839 4292
Box Office:	020-7839 4401

PRINCE EDWARD
28 Old Compton Street, London W1D 4HS
Manager:	020-7437 2024
Stage Door:	020-7440 3020
Box Office:	0870 8509191
Website:	www.delfont-mackintosh.com

PRINCE OF WALES
Coventry Street, London W1D 6AS
Manager:	020-7766 2101
Stage Door:	020-7766 2100
Box Office:	020-7766 2104
Website:	www.delfont-mackintosh.com

QUEEN'S
51 Shaftesbury Avenue
London W1D 6BA
Manager:	020-7292 1351
Stage Door:	020-7292 1350
Box Office:	0870 8901110

ROYAL COURT
Sloane Square, London SW1W 8AS
Manager:	020-7565 5050
Stage Door:	020-7565 5050
Box Office:	020-7565 5000
Website:	www.royalcourttheatre.com
e-mail:	info@royalcourttheatre.com

ROYAL OPERA HOUSE
Covent Garden, London WC2E 9DD
Manager:	020-7240 1200
Stage Door:	020-7240 1200
Box Office:	020-7304 4000

SADLER'S WELLS
Rosebery Avenue, London EC1R 4TN
Manager:	020-7863 8034
Stage Door:	020-7863 8198
Box Office:	0870 7377737
Website:	www.sadlerswells.com
e-mail:	info@sadlerswells.com

SAVOY
Strand, London WC2R OET
Manager:	020-7240 1649
Stage Door:	020-7836 8117
Box Office:	0870 0606642

SHAFTESBURY
210 Shaftesbury Avenue, London WC2H 8DP
Manager:	020-7379 3345
Stage Door:	020-7379 3345
Box Office:	020-7379 5399
e-mail:	info@toc.dltentertainment.co.uk

SHAKESPEARE'S GLOBE
21 New Globe Walk, Bankside, London SE1 9DT
Manager:	020-7902 1400
Stage Door:	020-7902 1400
Box Office:	020-7401 9919
Website:	www.shakespeares-globe.org
e-mail:	info@shakespearesglobe.com

SOHO
21 Dean Street, London W1D 3NE
Manager:	020-7287 5060
Stage Door:	-------------------
Box Office:	0870 4296883
Website:	www.sohotheatre.com

ST MARTIN'S
West Street, London WC2H 9NZ
Manager:	020-7497 0578
Stage Door:	020-7836 1086
Box Office:	020-7836 1443

STRAND
(See NOVELLO THEATRE)

THEATRE ROYAL
Haymarket London SW1Y 4HT
Manager:	020-7930 8890
Stage Door:	020-7930 8890
Box Office:	0870 4000858

TRICYCLE THEATRE
269 Kilburn High Road, London NW6 7JR
Manager:	020-7372 6611
Stage Door:	020-7372 6611
Box Office:	020-7328 1000
Website:	www.tricycle.co.uk
e-mail:	info@tricycle.co.uk

UCL BLOOMSBURY
15 Gordon Street, London WC1H OAH
Manager:	020-7679 2777
Stage Door:	020-7679 2922
Box Office:	020-7388 8822
Website:	www.thebloomsbury.com
e-mail:	blooms.theatre@ucl.ac.uk

VAUDEVILLE
404 Strand, London WC2R ONH
Manager:	020-7836 1820
Stage Door:	020-7836 3191
Box Office:	0870 8900511

VICTORIA PALACE
Victoria Street, London SW1E 5EA
Manager:	020-7828 0600
Stage Door:	020-7834 2781
Box Office:	0870 1658787

WYNDHAM'S
Charing Cross Road, London WC2H ODA
Manager:	020-7759 8077
Stage Door:	020-7759 8077
Box Office:	0870 9500925

YOUNG VIC THEATRE
66 The Cut, London SE1 8LZ
Manager:	020-7820 3350
Stage Door:	-------------------
Box Office:	-------------------
Website	www.youngvic.org
e-mail:	info@youngvic.org

ALBANY The
Douglas Way, Deptford, London SE8 4AG
Fax: 020-8469 2253 Tel: 020-8692 4446

ARCOLA THEATRE
(Artistic Director - Mehmet Ergen)
27 Arcola Street, Dalston
(Off Stoke Newington Road), London E8 2DJ
e-mail: info@arcolatheatre.com
BO: 020-7503 1646 Fax/Admin: 020-7503 1645
Route: Victoria Line to Highbury & Islington, then North
London Line to Dalston Kingsland (Main Line) - 5 min walk.
Buses: 38 from West End, 149 from London Bridge or 30, 67,
76, 243

ARTSDEPOT
5 Nether Street, Tally Ho Corner
North Finchley, London N12 0GA
Website: www.artsdepot.co.uk
e-mail: info@artsdepot.co.uk BO: 020-8369 5454

BAC
Lavender Hill, London SW11 5TN
Website: www.bac.org.uk
e-mail: mailbox@bac.org.uk
Fax: 020-7978 5207 Admin: 020-7223 6557
BO: 020-7223 2223
Route: Victoria or Waterloo (Main Line) to Clapham
Junction then 5 min walk or Northern Line to Clapham
Common then 20 min walk

BARONS COURT THEATRE
'The Curtain's Up'
28A Comeragh Road
West Kensington, London W14 9RH
Fax: 020-7603 8935 Admin/BO: 020-8932 4747
Route: West Kensington or Barons Court tube

BATES Tristan THEATRE
(Theatre Manager - Suli Majithia)
The Actors Centre, 1A Tower Street, London WC2H 9NP
e-mail: act@actorscentre.co.uk
Fax: 020-7240 3896 Admin: 020-7240 3940 ext 213
BO: 020-7240 6283

BECK THEATRE
Grange Road, Hayes, Middlesex UB3 2UE
BO: 020-8561 8371 Admin: 020-8561 7506
Route: Metropolitan Line to Uxbridge then buses 427 or
607 to Theatre or Paddington (Main Line) to Hayes
Harlington then buses 90, H98 or 195 (10 min)

BEDLAM THEATRE
11B Bristo Place
Edinburgh EH1 1EZ
Website: www.bedlamfringe.co.uk
e-mail: admin@bedlamfringe.co.uk
BO: 0131-225 9893 Admin/Fax: 0131-225 9873

BELLAIRS PLAYHOUSE
Millmead Terrace, Guildford GU2 4YT
Website: www.conservatoire.org
e-mail: enquiries@conservatoire.org
BO: 01483 444789 Admin: 01483 560701 (Mon-Fri)

BRENTWOOD THEATRE
(Theatre Administrator - Mark P Reed)
15 Shenfield Road
Brentwood, Essex CM15 8AG
Website: www.brentwood-theatre.org
SD: 01277 226658 Admin/Fax: 01277 230833
BO: 01277 200305
Liverpool Street (Main Line) to Shenfield, then 15 min walk

BRIDEWELL THEATRE The
St Bride Institute
Bride Lane, Fleet Street, London EC4Y 8EQ
Website: www.bridewelltheatre.org
e-mail: admin@bridewelltheatre.co.uk
Fax: 020-7353 1547 Admin: 020-7353 3331
BO: 020-7359 5724
Route: District & Circle Line to Blackfriars, Circle Line to St
Paul's. Thameslink. Fifteen different bus routes

BROADWAY The
Broadway, Barking IG11 7LS
Website: www.thebroadwaybarking.com
e-mail: admin@thebroadwaybarking.com
Fax: 020-8507 5611 Admin: 020-8507 5610
BO: 020-8507 5607

BROADWAY THEATRE The
(Director - Martin Costello)
Catford, London SE6 4RU
Website: www.broadwaytheatre.org.uk
e-mail: martin@broadwaytheatre.org.uk
BO: 020-8690 0002 Admin: 020-8690 1000
Route: Charing Cross to Catford Bridge

CAMDEN PEOPLE'S THEATRE
(Artistic Director - Jonathan Salisbury)
58-60 Hampstead Road, London NW1 2PY
Website: www.cptheatre.co.uk
e-mail: admin@cptheatre.co.uk
Fax: 020-7813 3889 Tel: 020-7419 4841
Route: Victoria or Northern Line to Warren Street,
Metropolitan or Circle Line to Euston Square (2 min walk
either way)

CANAL CAFE THEATRE The
(Artistic Director - Emma Taylor)
The Bridge House, Delamere Terrace
Little Venice, London W2 6ND
Website: www.canalcafetheatre.com
e-mail: mail@canalcafetheatre.com
Fax: 020-7266 1717 Admin: 020-7289 6056
BO: 020-7289 6054

CHATS PALACE ARTS CENTRE
(Nick Reed)
42-44 Brooksby's Walk
Hackney, London E9 6DF
Website: www.chatspalace.com
e-mail: info@chatspalace.com Tel: 020-8533 0227

CHELSEA THEATRE
World's End Place
King's Road, London SW10 0DR
e-mail: admin@chelseatheatre.org.uk
Fax: 020-7352 2024 Tel: 020-7349 7811
Route: District or Circle Line to Sloane Square then short
bus ride 11 or 22 down King's Road

CHICKEN SHED THEATRE
(Artistic Director - Mary Ward MBE)
Chase Side, Southgate, London N14 4PE
Website: www.chickenshed.org.uk
e-mail: info@chickenshed.org.uk
Fax: 020-8292 0202 Minicom: 020-8350 0676
BO: 020-8292 9222 Admin: 020-8351 6161
Route: Piccadilly Line to Oakwood, turn left outside tube &
walk 8 min down Bramley Road or take 307 bus. Buses 298,
299, 699 or N19. Car parking available & easy access
parking by reservation

CHRIST'S HOSPITAL THEATRE
(Director - Jeff Mayhew)
Horsham, West Sussex RH13 7LW
e-mail: jm@christs-hospital.org.uk
BO: 01403 247434 Admin: 01403 247435

CLERKENWELL THEATRE The
Exmouth Market, London EC1 4QE
e-mail: tctmatt@btinternet.com Tel/Fax: 020-7274 4888
Route: Nearest stations Angel or Farringdon. 200 yards
from Sadler's Wells.

CLUB FOR ACTS & ACTORS The
(Concert Artistes Association)
(Bill Pertwee, Barbara Daniels)
20 Bedford Street, London WC2E 9HP
Website: www.thecaa.org
e-mail: office@thecaa.org Admin: 020-7836 3172
Route: Piccadilly or Northern Line to Leicester Square then
few mins walk

COCHRANE THEATRE
(Deidre Malynn)
Southampton Row, London WC1B 4AP
e-mail: info@cochranetheatre.co.uk
BO: 020-7269 1606 Admin: 020-7269 1600
Route: Central or Piccadilly Line to Holborn then 3 min
walk

COCKPIT THEATRE
Gateforth Street, London NW8 8EH
Website: www.cockpittheatre.org.uk
e-mail: admin@cockpittheatre.org.uk
Fax: 020-7258 2921
BO: 020-7258 2925 Admin: 020-7258 2920
Route: Tube to Marylebone/Edgware Road then short walk
or bus 139 to Lisson Grove & 6, 8 or 16 to Edgware Road

CORBETT THEATRE
(East 15 Acting School)
The University of Essex
Rectory Lane
Loughton, Essex IG10 3RY
Website: www.east15.ac.uk
e-mail: east15@essex.ac.uk
Fax: 020-8508 7521 BO & Admin: 020-8508 5983
Route: Central Line (Epping Branch) to Debden then 6 min
walk

COURTYARD THEATRE The
(Artistic Director - June Abbott, General Manager - Tim Gill)
10 York Way
King's Cross, London N1 9AA
Website: www.thecourtyard.org.uk
e-mail: info@thecourtyard.org.uk
BO: 0870 1630717 Admin/Fax: 020-7833 0870
Route: Side of King's Cross Station

CROYDON CLOCKTOWER
(Arts Programme Manager - Jonathan Kennedy)
Katharine Street
Croydon CR9 1ET
Website: www.croydon.gov.uk/clocktower
e-mail: jonathan.kennedy@croydon.gov.uk
Fax: 020-8253 1003 Tel: 020-8253 1037
BO: 020-8253 1030

CUSTARD FACTORY
Gibb Street, Digbeth, Birmingham B9 4AA
Website: www.custardfactory.co.uk
e-mail: post@custardfactory.co.uk
Fax: 0121-604 8888 Tel: 0121-224 7777

DARTFORD ORCHARD THEATRE
(Vanessa Hart)
Home Gardens
Dartford, Kent DA1 1ED
Website: www.orchardtheatre.co.uk
Fax: 01322 227122
BO: 01322 220000 Admin: 01322 220099
Route: Charing Cross (Main Line) to Dartford

DIORAMA ARTS CENTRE
(Hire Venue)
1 Euston Centre, London NW1 3JG
Website: www.diorama-arts.org.uk
e-mail: admin@diorama-arts.org.uk
Fax: 020-7813 3116 Admin: 020-7916 5467
Route: Circle & District Line to Great Portland Street then 5
min walk, or Victoria/Northern line to Warren Street then 1
min walk

DRILL HALL The
16 Chenies Street, London WC1E 7EX
Website: www.drillhall.co.uk
e-mail: admin@drillhall.co.uk
Fax: 020-7307 5062 Admin: 020-7307 5061
BO: 020-7307 5060
Route: Northern Line to Goodge Street then 1 min walk

EDINBURGH FESTIVAL FRINGE
180 High Street, Edinburgh EH1 1QS
Website: www.edfringe.com
e-mail: admin@edfringe.com
Fax: 0131-226 0016 Tel: 0131-226 0026

EDINBURGH UNIVERSITY THEATRE COMPANY
(See BEDLAM THEATRE)

EMBASSY THEATRE & STUDIOS
(Central School of Speech & Drama)
64 Eton Avenue, Swiss Cottage, London NW3 3HY
Website: www.cssd.ac.uk
e-mail: enquiries@cssd.ac.uk Tel: 020-7722 8183
Route: Jubilee Line to Swiss Cottage then 1 min walk

ETCETERA THEATRE CLUB
(Directors - Zena Barrie and Michelle Flower)
Oxford Arms
265 Camden High Street, London NW1 7BU
Website: www.etceteratheatre.com
e-mail: etc@etceteratheatre.com
Fax: 020-7482 0378 Admin/BO: 020-7482 4857

FAIRFIELD HALLS
Ashcroft Theatre & Concert Hall
Park Lane, Croydon CR9 1DG
Website: www.fairfield.co.uk
e-mail: info@fairfield.co.uk
BO: 020-8688 9291 Admin & SD: 020-8681 0821
Route: Victoria & London Bridge (Main Line) to East
Croydon then 5 min walk

FINBOROUGH THEATRE
(Artistic Director - Neil McPherson)
The Finborough
118 Finborough Road, London SW10 9ED
Website: www.finboroughtheatre.co.uk
e-mail: admin@finboroughtheatre.co.uk
Fax: 020-7835 1853 Admin: 020-7244 7439
BO: 020-7373 3842
Route: District or Piccadilly Line to Earls Court then 5 min
walk. Buses 74, 328, C1, C3, 74 then 3 min walk

GATE THEATRE
(Artistic Director - Thea Sharrock)
Above Prince Albert Pub
11 Pembridge Road, London W11 3HQ
Website: www.gatetheatre.co.uk
e-mail: gate@gatetheatre.co.uk
Fax: 020-7221 6055 Admin: 020-7229 5387
BO: 020-7229 0706
Route: Central, Circle or District Line to Notting Hill Gate
then 1 min walk

GREENWICH PLAYHOUSE
(Alice de Sousa)
Greenwich BR Station Forecourt
189 Greenwich High Road, London SE10 8JA
Website: www.galleontheatre.co.uk
e-mail: alice@galleontheatre.co.uk
Fax: 020-8310 7276 Tel: 020-8858 9256
Route: Main Line from Charing Cross, Waterloo East or
London Bridge, DLR to Greenwich

GREENWICH THEATRE
(Executive Director - Hilary Strong)
Crooms Hill
Greenwich, London SE10 8ES
Website: www.greenwichtheatre.org.uk
e-mail: info@greenwichtheatre.org.uk
Fax: 020-8858 8042 Admin: 020-8858 4447
BO: 020-8858 7755
Route: Jubilee Line (change Canary Wharf) then DLR to
Greenwich Cutty Sark, 3 min walk or Charing Cross (Main
Line) to Greenwich, 5 min walk

GUILDHALL SCHOOL OF MUSIC & DRAMA
Silk Street, Barbican, London EC2Y 8DT
e-mail: info@gsmd.ac.uk
Fax: 020-7256 9438 Tel: 020-7628 2571
Route: Hammersmith & City, Circle or Metropolitan line to
Barbican or Moorgate (also served by Northern line) then 5
min walk

HACKNEY EMPIRE THEATRE
291 Mare Street, Hackney, London E8 1EJ
BO: 020-8985 2424 Press/Admin: 020-8510 4500

HEN & CHICKENS THEATRE
Unrestricted View, Above Hen & Chickens Theatre Bar
109 St Paul's Road, Islington, London N1 2NA
Website: www.henandchickens.com
e-mail: james@henandchickens.com Tel: 020-7704 2001
Route: Victoria Line or Main Line to Highbury & Islington
directly opposite station

ICA THEATRE
(No CVs, Venue only)
The Mall, London SW1Y 5AH
Website: www.ica.org.uk
Fax: 020-7873 0051 Admin: 020-7930 0493
BO: 020-7930 3647
Route: Nearest stations Piccadilly & Charing Cross

JACKSONS LANE
269A Archway Road, London N6 5AA
Website: www.jacksonslane.org.uk
e-mail: mail@jacksonslane.org.uk Tel: 020-8340 5226

JERMYN STREET THEATRE
(Administrator - Penny Horner)
16B Jermyn Street, London SW1Y 6ST
Website: www.jermynstreettheatre.co.uk
Fax: 020-7287 3232 Admin: 020-7434 1443
BO: 020-7287 2875

KING'S HEAD THEATRE
115 Upper Street, Islington, London N1 1QN
Website: www.kingsheadtheatre.org
BO: 020-7226 1916 Admin: 020-7226 8561
Route: Northern Line to Angel then 5 min walk. Approx
halfway between Angel and Highbury & Islington tube
stations

KING'S LYNN CORN EXCHANGE
Tuesday Market Place, King's Lynn, Norfolk PE30 1JW
Website: www.kingslynncornexchange.co.uk
e-mail: entertainment_admin@west-norfolk.gov.uk
Fax: 01553 762141 Admin: 01553 765565
BO: 01553 764864

KOMEDIA
(Artistic Directors: Theatre & Comedy - David Lavender.
Music, Cabaret & Children's Theatre - Marina Kobler,
Laurence Hill)
44-47 Gardner Street, Brighton BN1 1UN
Website: www.komedia.co.uk/brighton
e-mail: info@komedia.co.uk
Fax: 01273 647102 Tel: 01273 647101
BO: 01273 647100

LANDMARK ARTS CENTRE
Ferry Road, Teddington Lock, Middlesex TW11 9NN
Website: www.landmarkartscentre.org
e-mail: info@landmarkartscentre.org
Fax: 020-8977 4830 Tel: 020-8977 7558

LANDOR THEATRE The
(Artistic Director - Robert McWhir)
70 Landor Road, London SW9 9PH
Website: www.landortheatre.co.uk
e-mail: info@landortheatre.co.uk Admin/BO: 020-7737 7276
Route: Northern Line Clapham North then 2 min walk

LEIGHTON BUZZARD THEATRE
Lake Street, Leighton Buzzard, Bedfordshire LU7 1RX
Website: www.leightonbuzzardtheatre.co.uk
BO: 01525 378310 Tel: 01525 850290

LILIAN BAYLIS THEATRE
(Information: Sadler's Wells Theatre)
Rosebery Avenue, London EC1R 4TN
Website: www.sadlerswells.com
e-mail: info@sadlerswells.com
BO: 0870 7377737 SD: 020-7863 8198

LIVE THEATRE
27 Broad Chare, Quayside
Newcastle upon Tyne NE1 3DQ
Website: www.live.org.uk
e-mail: info@live.org.uk
Fax: 0191-232 2224 Admin: 0191-261 2694
BO: 0191-232 1232

MACOWAN THEATRE
(LAMDA)
1-2 Logan Place, London W8 6QN
Website: www.lamda.org.uk
Fax: 020-7370 1980 Tel: 020-7244 8744
Route: District or Piccadilly Line to Earl's Court then 6 min
walk

MADDERMARKET THEATRE
(General Manager - Michael Lyas)
St John's Alley, Norwich NR2 1DR
Website: www.maddermarket.co.uk
e-mail: mmtheatre@btconnect.com
Fax: 01603 661357 Admin: 01603 626560
BO: 01603 620917

MENIER CHOCOLATE FACTORY
53 Southwark Street, London SE1 1RU
Website: www.menierchocolatefactory.com
e-mail: office@menierchocolatefactory.com
Fax: 020-7378 1713 Tel: 020-7378 1712

MILLFIELD ARTS CENTRE
Silver Street, London N18 1PJ
Website: www.millfieldtheatre.co.uk
e-mail: info@millfieldtheatre.co.uk
Fax: 020-8807 3892 Admin: 020-8803 5283
BO: 020-8807 6680
Route: Liverpool Street (Main Line) to Silver Street or tube
to Turnpike Lane then bus 144, 15 min to Cambridge
Roundabout

MYERS STUDIO THEATRE The
(Venues Manager - Trevor Mitchell)
The Epsom Playhouse
Ashley Avenue
Epsom, Surrey KT18 5AL
Website: www.epsomplayhouse.co.uk
e-mail: tmitchell@epsom-ewell.gov.uk
Fax: 01372 726228 Tel: 01372 742226
BO: 01372 742555

NETHERBOW SCOTTISH STORYTELLING CENTRE The
(Donald Smith)
43-45 High Street
Edinburgh EH1 1SR
Website: www.scottishstorytellingcentre.co.uk
 Tel: 0131-556 9579

NETTLEFOLD The
West Norwood Library Centre
1 Norwood High Street, London SE27 9JX
e-mail: thenettlefold@lambeth.gov.uk
Fax: 020-7926 8071 Admin/BO: 020-7926 8070
Route: Victoria, West Croydon or London Bridge (Main Line)
to West Norwood then 2 min walk, or tube to Brixton then
buses 2, 196, 322, 432, or buses 68, 468

NEW END THEATRE
27 New End, Hampstead, London NW3 1JD
Website: www.newendtheatre.co.uk
Fax: 020-7794 4044 Admin: 020-7472 5800
BO: 0870 0332733
Route: Northern Line to Hampstead then 2 min walk off
Heath Street

NEW PLAYERS THEATRE The
(Formerly The Players Theatre)
The Arches, Villiers Street
London WC2N 6NG BO: 020-7930 6601

NEW WIMBLEDON THEATRE & STUDIO
The Broadway
Wimbledon, London SW19 1QG
Website: www.newwimbledontheatre.co.uk
Fax: 020-8543 6637 Admin: 020-8545 7900
BO: 0870 0606646
Route: Main Line or District Line to Wimbledon, then 3 min
walk. Buses 57, 93, 155

NORTHBROOK THEATRE The
(Theatre Co-ordinator - Conor McGivern)
Littlehampton Road, Goring-by-Sea
Worthing, West Sussex BN12 6NU
Website: www.northbrooktheatre.co.uk
e-mail: box.office@nbcol.ac.uk
Fax: 01903 606141 BO/Admin: 01903 606162

NORWICH PUPPET THEATRE
St James, Whitefriars, Norwich NR3 1TN
Website: www.puppettheatre.co.uk
e-mail: info@puppettheatre.co.uk
Fax: 01603 617578 Admin: 01603 615564
BO: 01603 629921

NOVELLO THEATRE The
(Redroofs Theatre Company)
2 High Street, Sunninghill
Nr Ascot, Berkshire Tel: 01344 620881
Route: Waterloo (Main Line) to Ascot then 1 mile from
station

OLD RED LION THEATRE PUB
(Theatre Manager - Helen Devine)
418 St John Street, Islington
London EC1V 4NJ Admin/Fax: 020-7833 3053
BO: 020-7837 7816
Route: Northern Line to Angel then 1 min walk

ORANGE TREE
(Artistic Director - Sam Walters)
1 Clarence Street, Richmond TW9 2SA
e-mail: admin@orange-tree.demon.co.uk
Fax: 020-8332 0369 Admin: 020-8940 0141
BO: 020-8940 3633
Route: District Line, Waterloo (Main Line) or North London
Line then virtually opposite station

OVAL HOUSE THEATRE
52-54 Kennington Oval, London SE11 5SW
Website: www.ovalhouse.com
e-mail: info@ovalhouse.com
Fax: 020-7820 0990 Admin: 020-7582 0080
BO: 020-7582 7680
Route: Northern Line to Oval then 1 min walk, Victoria Line
& Main Line to Vauxhall then 10 min walk

PAVILION THEATRE
Marine Road
Dun Laoghaire, County Dublin, Eire
Website: www.paviliontheatre.ie
e-mail: info@paviliontheatre.ie
Fax: 353 1 663 6328 Tel: 353 1 231 2929

PENTAMETERS
The Horseshoe, 28 Heath Street
London NW3 6TE BO/Admin: 020-7435 3648
Route: Northern Line to Hampstead then 1 min walk

PLACE The
(Main London Venue for Contemporary Dance)
17 Duke's Road, London WC1H 9PY
Website: www.theplace.org.uk
e-mail: theatre@theplace.org.uk
BO: 020-7387 0031 Admin: 020-7380 1268
Route: Northern or Victoria Line to Euston or King's Cross
then 5 min walk (Opposite rear of St Pancras Church)

PLEASANCE ISLINGTON
(Anthony Alderson)
Carpenters Mews, North Road
(Off Caledonian Road), London N7 9EF
Website: www.pleasance.co.uk
e-mail: info@pleasance.co.uk
Fax: 020-7700 7366 Admin: 020-7619 6868
BO: 020-7609 1800
Route: Piccadilly Line to Caledonian Road, turn left, walk
50 yds, turn left into North Road, 2 min walk. Buses 17, 91,
259, N91, 393

POLISH THEATRE
(Polish Social & Cultural Association Ltd)
238-246 King Street
London W6 ORF
BO: 020-8741 0398 Admin: 020-8741 1940
Route: District Line to Ravenscourt Park, or District,
Piccadilly or Metropolitan Lines to Hammersmith then 7
min walk. Buses 27, 267, 190, 391, H91

POLKA THEATRE
240 The Broadway
Wimbledon SW19 1SB
Website: www.polkatheatre.com
e-mail: admin@polkatheatre.com
Fax: 020-8545 8365 Admin: 020-8545 8320
BO: 020-8543 4888
Route: Waterloo (Main Line) or District Line to Wimbledon
then 10 min walk. Northern Line to South Wimbledon then
10 min walk. Tram to Wimbledon, Buses 57, 93, 219, 493

PRINCESS THEATRE HUNSTANTON
The Green
Hunstanton, Norfolk PE36 5AH
Fax: 01485 534463 Admin: 01485 535937
BO: 01485 532252

PUTNEY ARTS THEATRE
Ravenna Road, Putney SW15 6AW
Website: www.putneyartstheatre.org.uk
e-mail: mail@putneyartstheatre.org.uk
Fax: 020-8788 6940 Tel: 020-8788 6943

QUEEN'S THEATRE
(Artistic Director - Bob Carlton)
Billet Lane
Hornchurch, Essex RM11 1QT
Website: www.queens-theatre.co.uk
e-mail: info@queens-theatre.co.uk
Fax: 01708 462363 SD/Admin 01708 462362
BO: 01708 443333
Route: District Line to Hornchurch, Main Line to
Romford/Gidea Park. 15 miles from West End take A13,
A1306 then A125 or A12 then A127

QUESTORS THEATRE EALING The
12 Mattock Lane, London W5 5BQ
Website: www.questors.org.uk
e-mail: enquiries@questors.org.uk
Fax: 020-8567 8736 Admin: 020-8567 0011
BO: 020-8567 5184
Route: Central or District Line to Ealing Broadway then 5
min walk. Buses 207, 83, 65

RICHMOND THEATRE
(Karin Gartzke)
The Green, Richmond, Surrey TW9 1QJ
Website: www.richmondtheatre.net
e-mail: richmondstagedoor@theambassadors.com
Fax: 020-8948 3601 Admin & SD: 020-8940 0220
BO: 0870 0606651
Route: 20 minutes from Waterloo (South West Trains) or
District Line or Silverlink to Richmond then 2 min walk

RIDWARE THEATRE
(Alan & Margaret Williams)
(Venue only. No resident peforming company)
Wheelwright's House
Pipe Ridware, Rugeley, Staffs WS15 3QL
e-mail: alan@christmas-time.com Tel: 01889 504380

RIVERSIDE STUDIOS
Crisp Road, London W6 9RL
Website: www.riversidestudios.co.uk
e-mail: info@riversidestudios.co.uk
BO: 020-8237 1111 Admin: 020-8237 1000
Route: District, Piccadilly or Hammersmith & City Line to
Hammersmith Broadway then 5 min walk. Buses 9, 11, 27,
73, 91, 220, 283, 295

ROM THEATRE
167 Ardleigh Green Road
Hornchurch, Essex RM11 2LF
Website: www.romtheatre.org
e-mail: mark@romtheatre.org Mobile: 07813 667319

ROSEMARY BRANCH THEATRE
2 Shepperton Road, London N1 3DT
Website: www.rosemarybranch.co.uk
e-mail: cecilia@rosemarybranch.co.uk Tel: 020-7704 6665

SEVENOAKS PLAYHOUSE
(Artistic Director - Julian Woolford, Executive Director -
Helen Winning)
London Road, Sevenoaks, Kent TN13 1ZZ
Website: www.sevenoaksplayhouse.co.uk
BO: 01732 450175 Admin: 01732 451548
Route: Charing Cross (Main Line) to Sevenoaks then 15 min
up the hill from station

SHADY DOLLS THEATRE COMPANY
9 Upper Handa Walk, London N1 2RG
Website: www.shadydolls.com
e-mail: info@shadydolls.com Mobile: 07796 353531

SHAW THEATRE The
100-110 Euston Road, London NW1 2AJ
Fax: 020-7388 7555 Admin: 020-7388 2555
BO: 0870 0332600

SOUTH HILL PARK ARTS CENTRE
Bracknell, Berkshire RG12 7PA
Website: www.southhillpark.org.uk
e-mail: admin@southhillpark.org.uk
BO: 01344 484123 Admin & SD: 01344 484858
Route: Waterloo (Main Line) to Bracknell then 10 min bus
ride or taxi rank at station

SOUTH LONDON THEATRE
(Bell Theatre & Prompt Corner)
2A Norwood High Street, London SE27 9NS
Website: www.southlondontheatre.co.uk
e-mail: southlondontheatre@yahoo.co.uk Tel: 020-8670 3474
Route: Victoria or London Bridge (Main Line) to West
Norwood then 2 min walk, or Victoria Line to Brixton then
buses 2, 68, 196, 322

SOUTHWARK PLAYHOUSE
(Chief Executive - Juliet Alderdice, Education Director -
Tom Wilson, General Manager - Chris Smyrnios)
5 Playhouse Court
62 Southwark Bridge Road, London SE1 0AT
Website: www.southwarkplayhouse.co.uk
e-mail: admin@southwarkplayhouse.co.uk
BO: 0870 0601761 Admin: 020-7620 3494
Route: Northern Line to Borough or Jubilee Line/Main Line
to London Bridge. Buses 133, 35, 344, 40, P3

SPACE ARTS CENTRE The
269 Westferry Road, London E14 3RS
Website: www.space.org.uk
e-mail: adam@space.org.uk Tel: 020-7515 7799

THEATRE 503
The Latchmere Pub
503 Battersea Park Road
London SW11 3BW
Website: www.theatre503.com
e-mail: info@theatre503.com BO: 020-7978 7040
Route: Victoria or Waterloo (Main Line) to Clapham
Junction then 10 min walk or buses 44, 219, 319, 344, 345 or
tube to South Kensington then buses 49 or 345 or tube to
Sloane Square then bus 319

THEATRE OF ALL POSSIBILITIES
(Artistic Director - Kathlin Gray)
24 Old Gloucester Street
London WC1N 3AL
Website: www.allpossibilities.org
e-mail: engage@allpossibilities.org Tel: 020-7242 9831

THEATRE ROYAL STRATFORD EAST
(Artistic Director - Kerry Michael)
Gerry Raffles Square
London E15 1BN
Website: www.stratfordeast.com
e-mail: theatreroyal@stratfordeast.com
Fax: 020-8534 8381 Admin: 020-8534 7374
BO: 0800 1831188
Route: Central or Jubilee Line to Stratford then 2 min walk

THEATRO TECHNIS
(Artistic Director - George Eugeniou)
26 Crowndale Road, London NW1 1TT
Website: www.theatrotechnis.com
e-mail: info@theatrotechnis.com BO & Admin: 020-7387 6617
Route: Northern Line to Mornington Crescent then 3 min
walk

TRICYCLE THEATRE
(Artistic Director - Nicolas Kent,
General Manager - Mary Lauder)
269 Kilburn High Road, London NW6 7JR
Website: www.tricycle.co.uk
e-mail: admin@tricycle.co.uk
Fax: 020-7328 0795 Admin: 020-7372 6611
BO: 020-7328 1000
Route: Jubilee Line to Kilburn then 5 min walk or buses 16,
189, 32 pass the door, 98, 31, 206, 316 pass nearby

TRON THEATRE
63 Trongate, Glasgow G1 5HB
Website: www.tron.co.uk
Fax: 0141-552 6657 Admin: 0141-552 3748
BO: 0141-552 4267

UCL BLOOMSBURY THEATRE
15 Gordon Street, Bloomsbury, London WC1H 0AH
Website: www.thebloomsbury.com
e-mail: blooms.theatre@ucl.ac.uk
BO: 020-7388 8822 Admin: 020-7679 2777
Route: Tube to Euston, Euston Square or Warren Street

UNION THEATRE The
(Artistic Director - Sasha Regan, Resident Director -
Ben De Wynter, Technical Director - Steve Miller)
(All Casting Enquiries - Paul Flynn)
204 Union Street, Southwark, London SE1 0LX
Website: www.uniontheatre.org
e-mail: sasha@uniontheatre.freeserve.co.uk
 Tel/Fax: 020-7261 9876
Route: Jubilee Line to Southwark then 2 min walk

UPSTAIRS AT THE GATEHOUSE
(Ovation Theatres Ltd)
The Gatehouse Pub
Corner of Hampstead Lane/North Road
London N6 4BD
Website: www.upstairsatthegatehouse.com
e-mail: events@ovationproductions.com
BO: 020-8340 3488 Admin: 020-8340 3477
Route: Northern Line to Highgate then 10 min walk. Buses
143, 210, 214, 271

VENUE The
5 Leicester Place
Off Leicester Square
London WC2H 7BP Tel: 0870 8993335

WAREHOUSE THEATRE
(Artistic Director - Ted Craig)
Dingwall Road
Croydon CR0 2NF
Website: www.warehousetheatre.co.uk
e-mail: info@warehousetheatre.co.uk
Fax: 020-8688 6699 Admin: 020-8681 1257
BO: 020-8680 4060
Route: Adjacent to East Croydon (Main Line). Direct from
Victoria (15 min), Clapham Junction (10 min) or by
Thameslink from West Hampstead, Kentish Town, Kings
Cross, Blackfriars & London Bridge

WATERMANS
40 High Street
Brentford TW8 0DS
Website: www.watermans.org.uk
e-mail: info@watermans.org.uk
Fax: 020-8232 1030 Admin: 020-8232 1020
BO: 020-8232 1010
Route: Buses: 237, 267, 65, N9. Tube: Gunnersbury or South
Ealing. Main Line: Kew Bridge then 5 min walk, Gunnersbury
then 10 min walk, or Brentford

WESTRIDGE (OPEN CENTRE)
(Drawing Room Recitals)
Star Lane, Highclere, Nr Newbury
Berkshire RG20 9PJ Tel: 01635 253322

WHITE BEAR THEATRE
(Favours New Writing)
138 Kennington Park Road, London SE11 4DJ
e-mail: utopianking2002@yahoo.co.uk
 Admin/BO: 020-7793 9193
Route: Northern Line to Kennington

WILTONS MUSIC HALL
Graces Alley, Off Ensign Street, London E1 8JB
Website: www.wiltons.org.uk
Fax: 0871 2532424 Tel: 020-7702 9555
Route: Tube: Under 10 minutes walk from Aldgate East (exit
for Leman Street)/Tower Hill. DLR: Shadwell or Tower
Gateway. Car: Follow the yellow AA signs to Wiltons Music
Hall from the Highway, Aldgate or Tower Hill

WIMBLEDON STUDIO THEATRE
(See NEW WIMBLEDON THEATRE & STUDIO)

WYCOMBE SWAN
St Mary Street, High Wycombe
Buckinghamshire HP11 2XE
Website: www.wycombeswan.co.uk
e-mail: enquiries@wycombeswan.co.uk
BO: 01494 512000 Admin: 01494 514444

ABERDEEN
His Majesty's Theatre
Rosemount Viaduct
Aberdeen AB25 1GL
Box Office: 01224 641122
Stage Door: 01224 337654
Admin: 0845 2708200
Website: www.boxofficeaberdeen.com
e-mail: info@hmtheatre.com

ABERYSTWYTH
Aberystwyth Arts Centre
University of Wales, Aberystwyth SY23 3DE
Box Office: 01970 623232
Stage Door: 01970 624239
Admin: 01970 622882
Website: www.aber.ac.uk/artscentre
e-mail: ggo@aber.ac.uk

ASHTON-UNDER-LYNE
Tameside Hippodrome
Oldham Road, Ashton-under-Lyne OL6 7SE
Box Office: 0870 6021175
Stage Door: ------------------
Admin: 0161-330 2095
Website: www.livenation.co.uk/tameside

AYR
Gaiety Theatre
Carrick Street, Ayr KA7 1NU
Box Office: 01292 611222
Stage Door: ------------------
Admin: 01292 617400
Website: www.gaietytheatre.co.uk
e-mail: gaiety.theatre@south-ayrshire.co.uk

BACUP
Royal Court Theatre
Rochdale Road, Bacup OL13 9NR
Box Office: 01706 874080
Stage Door: ------------------
Admin: ------------------

BASINGSTOKE
Haymarket Theatre
Wote Street, Basingstoke RG21 7NW
Box Office: 01256 465566
Stage Door: 0870 7701029
Admin: 0870 7701029
Website: www.haymarket.org.uk
e-mail: info@haymarket.org.uk

BATH
Theatre Royal
Sawclose, Bath BA1 1ET
Box Office: 01225 448844
Stage Door: 01225 448815
Admin: 01225 448815
Website: www.theatreroyal.org.uk
e-mail: forename.surname@theatreroyal.org.uk

BELFAST
Grand Opera House
Great Victoria Street
Belfast BT2 7HR
Box Office: 028-9024 1919
Stage Door: 028-9024 0411
Admin: 028-9024 0411
Website: www.goh.co.uk
e-mail: info@goh.co.uk

BILLINGHAM
Forum Theatre
Town Centre, Billingham TS23 2LJ
Box Office: 01642 552663
Stage Door: ------------------
Admin: 01642 551389
Website: www.forumtheatrebillingham.co.uk
e-mail: forumtheatre@btconnect.com

BIRMINGHAM
Alexandra Theatre
Station Street
Birmingham B5 4DS
Box Office: 0870 6077533
Stage Door: 0121-230 9102
Admin: 0121-643 5536
Website: www.livenation.co.uk/birmingham

BIRMINGHAM
Hippodrome
Hurst Street, Birmingham B5 4TB
Box Office: 0870 7301234
Stage Door: 0870 7302040
Admin: 0870 7305555

BLACKPOOL
Grand Theatre - National Theatre of Variety
33 Church Street, Blackpool FY1 1HT
Box Office: 01253 290190
Stage Door: 01253 743218
Admin: 01253 290111
Website: www.blackpoolgrand.co.uk
e-mail: box@blackpoolgrand.co.uk

BLACKPOOL
Opera House
Church Street
Blackpool FY1 1HW
Box Office: 01253 292029
Stage Door: 01253 625252 ext 148
Admin: 01253 625252
Website: www.blackpoollive.com

BOURNEMOUTH
Pavilion Theatre
Westover Road
Bournemouth BH1 2BU
Box Office: 0870 1113000
Stage Door: 01202 451863
Admin: 01202 456400

BRADFORD

Alhambra Theatre
Morley Street, Bradford BD7 1AJ
Box Office: 01274 432000
Stage Door: 01274 432375
Admin: 01274 432375
Website: www.bradford-theatres.co.uk
e-mail: administration@ces.bradford.gov.uk

BRADFORD

Theatre in the Mill
University of Bradford
Shearbridge Road, Bradford BD7 1DP
Box Office: 01274 233200
Stage Door: 01274 233187
Admin: 01274 233185
Website: www.bradford.ac.uk/theatre
e-mail: theatre@bradford.ac.uk

BRIGHTON

Theatre Royal
New Road, Brighton BN1 1SD
Box Office: 0870 0606650
Stage Door: 01273 764400
Admin: 01273 764400
Website: www.theambassadors.com/theatreroyal
e-mail: brightontheatremanager@theambassadors.com

BRIGHTON

The Dome, Corn Exchange & Pavilion Theatres
29 New Road, Brighton BN1 1UG
Box Office: 01273 709709
Stage Door: 01273 261550
Admin: 01273 700747
e-mail: info@brightondome.org

BRISTOL

Hippodrome
St Augustines Parade, Bristol BS1 4UZ
Box Office: 0870 6077500
Stage Door: 0117-302 3251
Admin: 0117-302 3310
Website: www.getlive.co.uk/bristol

BROXBOURNE (Herts)

Broxbourne Civic Hall
High Street, Hoddesdon, Herts EN11 8BE
Box Office: 01992 441946
Stage Door: ------------------
Admin: 01992 441931
Website: www.broxbourne.gov.uk
e-mail: civic.leisure@broxbourne.gov.uk

BURY ST EDMUNDS

Theatre Royal
Westgate Street
Bury St Edmunds IP33 1QR
Box Office: 01284 769505
Stage Door: 01284 755127
Admin: 01284 755127
Website: www.theatreroyal.org
e-mail: admin@theatreroyal.org

BUXTON

Buxton Opera House
Water Street
Buxton SK17 6XN
Box Office: 0845 1272190
Stage Door: 01298 72524
Admin: 01298 72050
Website: www.buxton-opera.co.uk
e-mail: admin@buxtonopera.co.uk

CAMBERLEY

The Camberley Theatre
Knoll Road
Camberley, Surrey GU15 3SY
Box Office: 01276 707600
Stage Door: ------------------
Admin: 01276 707512
Website: www.camberleytheatre.biz
e-mail: camberleytheatre@surreyheath.gov.uk

CAMBRIDGE

Cambridge Arts Theatre
6 St Edward's Passage
Cambridge CB2 3PJ
Box Office: 01223 503333
Stage Door: 01223 578933
Admin: 01223 578933
Website: www.cambridgeartstheatre.com
e-mail: info@cambridgeartstheatre.com

CAMBRIDGE

Mumford Theatre
Anglia Ruskin University
East Road, Cambridge CB1 1PT
Box Office: 0845 1962320
Stage Door: 0845 1962848
Admin: 0845 1962848
e-mail: mumford@anglia.ac.uk

CANTERBURY

Gulbenkian Theatre
University of Kent
Canterbury CT2 7NB
Box Office: 01227 769075
Stage Door: ------------------
Admin: 01227 827861
Website: www.gulbenkiantheatre.co.uk
e-mail: gulbenkian@kent.ac.uk

CANTERBURY

The Marlowe Theatre
The Friars, Canterbury CT1 2AS
Box Office: 01227 787787
Stage Door: 01227 763262
Admin: 01227 763262
Website: www.marlowetheatre.com
e-mail: mark.everett@canterbury.gov.uk

CARDIFF

New Theatre
Park Place, Cardiff CF10 3LN
Box Office: 029-2087 8889
Stage Door: 029-2087 8900
Admin: 029-2087 8787

CARDIFF
Wales Millennium Centre
Bute Place, Cardiff CF10 5AL
Box Office: 0870 0402000
Stage Door: 029-2063 4700
Admin: 029-2063 6400
Website: www.wmc.org.uk

CHELTENHAM
Everyman Theatre
Regent Street, Cheltenham GL50 1HQ
Box Office: 01242 572573
Stage Door: 01242 512515
Admin: 01242 512515
Website: www.everymantheatre.org.uk
e-mail: admin@everymantheatre.org.uk

CHESTER
Gateway Theatre
Hamilton Place, Chester, Cheshire CH1 2BH
Admin: 01244 354951
Stage Door: ------------------
Box Office: 01244 340392
Website: www.chestergateway.co.uk
e-mail: jasmine.hendry@chestergateway.co.uk

CHICHESTER
Festival Theatre
Oaklands Park, Chichester PO19 6AP
Box Office: 01243 781312
Stage Door: 01243 784437
Admin: 01243 784437
Website: www.cft.org.uk
e-mail: admin@cft.org.uk

CRAWLEY
The Hawth
Hawth Avenue, Crawley, West Sussex RH10 6YZ
Box Office: 01293 553636
Stage Door: ------------------
Admin: 01293 552941
Website: www.hawth.co.uk
e-mail: info@hawth.co.uk

CREWE
Lyceum Theatre
Heath Street, Crewe CW1 2DA
Box Office: 01270 537333
Stage Door: 01270 537336
Admin: 01270 537243

DARLINGTON
Civic Theatre
Parkgate, Darlington DL1 1RR
Box Office: 01325 486555
Stage Door: ------------------
Admin: 01325 387775
Website: www.darlingtonarts.co.uk

DUBLIN
Gaiety Theatre
South King Street, Dublin 2
Box Office: 00 353 1 6771717
Stage Door: 00 353 1 6795622
Admin: 00 353 1 6795622
Website: www.gaietytheatre.ie

DUBLIN
Gate Theatre
1 Cavendish Row, Dublin 1
Box Office: 00 353 1 8744045
Stage Door: ------------------
Admin: 00 353 1 8744368
Website: www.gate-theatre.ie
e-mail: info@gate-theatre.ie

DUBLIN
Olympia Theatre
72 Dame Street, Dublin 2
Box Office: 00 353 1 6793323
Stage Door: 00 353 1 6771400
Admin: 00 353 1 6725883
Website: www.olympia.ie
e-mail: info@olympia.ie

EASTBOURNE
Congress Theatre
Admin: Winter Garden, Compton Street, Eastbourne BN21 4BP
Box Office: 01323 412000
Stage Door: 01323 410048
Admin: 01323 415500
Website: www.eastbournetheatres.co.uk
e-mail: theatres@eastbourne.gov.uk

EASTBOURNE
Devonshire Park Theatre
Admin: Winter Garden, Compton Street, Eastbourne BN21 4BP
Box Office: 01323 412000
Stage Door: 01323 410074
Admin: 01323 415500
Website: www.eastbournetheatres.co.uk
e-mail: theatres@eastbourne.gov.uk

EDINBURGH
King's Theatre
2 Leven Street, Edinburgh EH3 9LQ
Box Office: 0131-529 6000
Stage Door: 0131-229 3416
Admin: 0131-662 1112
Website: www.eft.co.uk
e-mail: empire@eft.co.uk

EDINBURGH
Playhouse Theatre
18-22 Greenside Place, Edinburgh EH1 3AA
Box Office: 0870 6063424
Stage Door: 0131-524 3324
Admin: 0131-524 3333
Website: www.livenation.co.uk/edinburgh

GLASGOW
King's Theatre
297 Bath Street, Glasgow G2 4JN
Box Office: 0141-240 1111
Stage Door: 0141-240 1300
Admin: 0141-240 1300
Website: www.kings-glasgow.co.uk

GLASGOW
Theatre Royal
282 Hope Street, Glasgow G2 3QA
Box Office: 0870 0606647
Stage Door: 0141-332 3321
Admin: 0141-332 3321
Website: www.theambassadors.com

GRAYS THURROCK

Thameside Theatre
Orsett Road, Grays Thurrock RM17 5DX
Box Office: 01375 383961
Stage Door: ------------------
Admin: 01375 382555
Website: www.thurrock.gov.uk/theatre
e-mail: mallinson@thurrock.gov.uk

HARLOW

The Playhouse
Playhouse Square, Harlow CM20 1LS
Box Office: 01279 431945
Stage Door: ------------------
Admin: 01279 446760
Website: www.playhouseharlow.com
e-mail: playhouse@harlow.gov.uk

HARROGATE

Harrogate International Centre
Kings Road, Harrogate HG1 5LA
Box Office: 01423 537230
Stage Door: ------------------
Admin: 01423 500500
Website: www.harrogateinternationalcentre.co.uk
e-mail: sales@harrogateinternationalcentre.co.uk

HASTINGS

White Rock Theatre
White Rock, Hastings TN34 1JX
Box Office: 0870 1451133
Stage Door: ------------------
Admin: 01424 462280

HAYES (Middlesex)

Beck Theatre
Grange Road, Hayes, Middlesex UB3 2UE
Box Office: 020-8561 8371
Stage Door: ------------------
Admin: 020-8561 7506
Website: www.getlive.co.uk/hayes

HIGH WYCOMBE

Wycombe Swan
St Mary Street, High Wycombe HP11 2XE
Box Office: 01494 512000
Stage Door: 01494 514444
Admin: 01494 514444
Website: www.wycombeswan.co.uk
e-mail: enquiries@wycombeswan.co.uk

HUDDERSFIELD

Cragrats Ltd
The Mill, Dunford Road, Holmfirth, Huddersfield HD9 2AR
Box Office: ------------------
Stage Door: ------------------
Admin: 01484 686451
Website: www.cragrats.com
e-mail: emma@cragrats.com

HUDDERSFIELD

Lawrence Batley Theatre
Queen Street, Huddersfield HD1 2SP
Box Office: 01484 430528
Stage Door: 01484 484501
Admin: 01484 484412
e-mail: theatre@lbt-uk.org

HULL

Hull New Theatre
Kingston Square, Hull HU1 3HF
Box Office: 01482 226655
Stage Door: 01482 318300
Admin: 01482 613818
e-mail: theatre.management@hullcc.gov.uk

HULL

Hull Truck Theatre
Spring Street, Hull HU2 8RW
Box Office: 01482 323638
Stage Door: ------------------
Admin: 01482 224800
Website: www.hulltruck.co.uk
e-mail: admin@hulltruck.co.uk

ILFORD

Kenneth More Theatre
Oakfield Road, Ilford IG1 1BT
Box Office: 020-8553 4466
Stage Door: 020-8553 4465
Admin: 020-8553 4464
Website: www.kenneth-more-theatre.co.uk
e-mail: kmtheatre@aol.com

IPSWICH

Sir John Mills Theatre (Hire Only)
Gatacre Road, Ipswich IP1 2LQ
Box Office: 01473 211498
Stage Door: ------------------
Admin: 01473 218202
Website: www.easternangles.co.uk
e-mail: admin@easternangles.co.uk

JERSEY

Opera House
Gloucester Street, St Helier, Jersey JE2 3QR
Box Office: 01534 511115
Stage Door: ------------------
Admin: 01534 511100
e-mail: ian@jerseyoperahouse.co.uk

KIRKCALDY

Adam Smith Theatre
Bennochy Road, Kirkcaldy KY1 1ET
Box Office: 01592 412929
Stage Door: ------------------
Admin: 01592 412567

LEATHERHEAD

The Leatherhead Theatre
7 Church Street, Leatherhead, Surrey KT22 8DN
Box Office: 01372 365141
Stage Door: ------------------
Admin: 01372 365130
Website: www.the-theatre.org
e-mail: info@the-theatre.org

LEEDS

City Varieties Music Hall
Swan Street, Leeds LS1 6LW
Box Office: 0845 6441881
Stage Door: ------------------
Admin: 0845 1260696
Website: www.cityvarieties.co.uk
e-mail: info@cityvarieties.co.uk

LEEDS

Grand Theatre & Opera House
46 New Briggate, Leeds LS1 6NZ
Box Office: 0113-222 6222
Stage Door: 0113-245 6014
Admin: 0113-245 6014

LICHFIELD

The Lichfield Garrick
Castle Dyke, Lichfield WS13 6HR
Box Office: 01543 412121
Stage Door: ------------------
Admin: 01543 412110
Website: www.lichfieldgarrick.com

LINCOLN

Theatre Royal
Clasketgate, Lincoln LN2 1JJ
Box Office: 01522 525555
Stage Door: 01522 545490
Admin: 01522 523303
Website: www.theatreroyallincoln.com
e-mail: trl@dial.pipex.com

LIVERPOOL

Empire Theatre
Lime Street, Liverpool L1 1JE
Box Office: 0870 6063536
Stage Door: 0151-708 3200
Admin: 0151-708 3200
Website: www.livenation.co.uk/liverpool

MALVERN

Malvern Theatres (Festival & Forum Theatres)
Grange Road, Malvern WR14 3HB
Box Office: 01684 892277
Stage Door: ------------------
Admin: 01684 569256
Website: www.malvern-theatres.co.uk
e-mail: post@malvern-theatres.co.uk

MANCHESTER

Manchester Apollo
Stockport Road, Ardwick Green, Manchester M12 6AP
Box Office: 0870 4018000
Stage Door: 0161-273 2416
Admin: 0161-273 6921
Website: www.getlive.co.uk

MANCHESTER

Opera House
Quay Street, Manchester M3 3HP
Box Office: 0870 4019000
Stage Door: 0161-828 1700
Admin: 0161-828 1700
Website: www.getlive.co.uk/manchester

MANCHESTER

Palace Theatre
Oxford Street, Manchester M1 6FT
Box Office: 0870 4013000
Stage Door: 0161-245 6600
Admin: 0161-245 6600
Website: www.livenation.co.uk/manchester

MARGATE

Theatre Royal
Addington Street, Margate, Kent CT9 1PW
Box Office: 0845 1301786
Stage Door: 01843 293397
Admin: 01843 293397
Website: www.theatreroyalmargate.co.uk

MILTON KEYNES

Milton Keynes Theatre
500 Marlborough Gate, Central Milton Keynes MK9 3NZ
Box Office: 0870 0606652
Stage Door: 01908 547500
Admin: 01908 547500

NEWARK

Palace Theatre
Appletongate, Newark NG24 1JY
Box Office: 01636 655755
Stage Door: ------------------
Admin: 01636 655750
Website: www.palacenewark.com
e-mail: david.piper@nsdc.info

NEWCASTLE UPON TYNE

Northern Stage
Barras Bridge, Haymarket, Newcastle upon Tyne NE1 7RH
Box Office: 0191-230 5151
Stage Door: ------------------
Admin: 0191-232 3366
Website: www.northernstage.co.uk
e-mail: info@northernstage.co.uk

NEWCASTLE UPON TYNE

Theatre Royal
Grey Street, Newcastle upon Tyne NE1 6BR
Box Office: 0870 9055060
Stage Door: 0191-244 2500
Admin: 0191-232 0997

NORTHAMPTON

Royal & Derngate Theatres
19-21 Guildhall Road, Northampton NN1 1DP
Box Office: 01604 624811
Stage Door: ------------------
Admin: 01604 626222
Website: www.royalandderngate.co.uk
e-mail: postbox@royalandderngate.co.uk

NORWICH

Theatre Royal
Theatre Street, Norwich NR2 1RL
Box Office: 01603 630000
Stage Door: 01603 598500
Admin: 01603 598500
Website: www.theatreroyalnorwich.co.uk

NOTTINGHAM

Theatre Royal & Royal Concert Hall
Theatre Square, Nottingham NG1 5ND
Box Office: 0115-989 5555
Stage Door: 0115-989 5500
Admin: 0115-989 5500
Website: www.royalcentre-nottingham.co.uk
e-mail: enquiry@royalcentre-nottingham.co.uk

OXFORD

New Theatre
George Street, Oxford OX1 2AG
Box Office: 0870 6077484
Stage Door: 01865 320760
Admin: 01865 320761

OXFORD

Oxford Playhouse
Beaumont Street, Oxford OX1 2LW
Box Office: 01865 305305
Stage Door: 01865 305301
Admin: 01865 305300
Website: www.oxfordplayhouse.com
e-mail: admin@oxfordplayhouse.com

POOLE

Lighthouse, Poole's Centre for The Arts
Kingland Road, Poole BH15 1UG
Box Office: 0870 0668701
Stage Door: 01202 781300
Admin: ------------------
Website: www.lighthousepoole.co.uk

READING

The Hexagon
Queen's Walk, Reading RG1 7UA
Box Office: 0118-960 6060
Stage Door: 0118-939 0018
Admin: 0118-939 0123

RICHMOND (N Yorks)

Georgian Theatre Royal
Victoria Road, Richmond, North Yorkshire DL10 4DW
Box Office: 01748 825252
Stage Door: ------------------
Admin: 01748 823710
Website: www.georgiantheatreroyal.co.uk

RICHMOND (Surrey)

Richmond Theatre
The Green, Richmond, Surrey TW9 1QJ
Box Office: 0870 0606651
Stage Door: 020-8940 0220
Admin: 020-8940 0220
Website: www.richmondtheatre.net

SHEFFIELD

Sheffield Theatres - Crucible, Lyceum & Crucible Studio
55 Norfolk Street, Sheffield S1 1DA
Box Office: 0114-249 6000
Stage Door: 0114-249 5999
Admin: 0114-249 5999
Website: www.sheffieldtheatres.co.uk
e-mail: info@sheffieldtheatres.co.uk

SHERINGHAM

The Little Theatre
2 Station Road, Sheringham, Norfolk NR26 8RE
Stage Door: 01263 826173
BO: 01263 822347
Admin: 01263 822117
Website: www.sheringhamlittletheatre.com
e-mail: enquiries@sherringhamlittletheatre.com

SOUTHAMPTON

The Mayflower
Commercial Road
Southampton SO15 1GE
Box Office: 023-8071 1811
Stage Door: ------------------
Admin: 023-8071 1800
Website: www.the-mayflower.com
e-mail: info@mayflower.org.uk

SOUTHEND

Southend Theatres
(Cliffs Pavilion, Palace & Dixon Theatres)
Cliffs Pavilion, Station Road
Westcliff-on-Sea, Essex, SS0 7RA
Box Office: 01702 351135
Stage Door: 01702 347394
Admin: 01702 390657
Website: www.thecliffspavilion.co.uk
e-mail: info@cliffspavilion.demon.co.uk

ST ALBANS

Abbey Theatre
Holywell Hill, St Albans AL1 2DL
Box Office: 01727 857861
Stage Door: ------------------
Admin: 01727 847472
Website: www.abbeytheatre.org.uk
e-mail: manager@abbeytheatre.org.uk

ST ALBANS

Alban Arena
Civic Centre, St Albans AL1 3LD
Box Office: 01727 844488
Stage Door: ------------------
Admin: 01727 861078
Website: www.alban-arena.co.uk
e-mail: alban.arena@leisureconnection.co.uk

ST HELENS

Theatre Royal
Corporation Street
St Helens WA10 1LQ
Box Office: 01744 756000
Stage Door: ------------------
Admin: 01744 756333
Website: www.sthelenstheatreroyal.co.uk

STAFFORD

Stafford Gatehouse Theatre
Eastgate Street, Stafford ST16 2LT
Box Office: 01785 254653
Stage Door: ------------------
Admin: 01785 253595
e-mail: gatehouse@staffordbc.gov.uk

STEVENAGE

Gordon Craig Theatre
Arts & Leisure Centre
Lytton Way, Stevenage SG1 1LZ
Box Office: 08700 131030
Stage Door: 01438 242629
Admin: 01438 242679
Website: www.gordon-craig.co.uk
e-mail: gordoncraig@stevenage-leisure.co.uk

STRATFORD-UPON-AVON
Royal Shakespeare Theatre
Waterside
Stratford-upon-Avon CV37 6BB
Box Office: 0870 6091110
Stage Door: 01789 296655
Admin: 01789 296655
Website: www.rsc.org.uk
e-mail: info@rsc.org.uk

SUNDERLAND
Sunderland Empire
High Street West
Sunderland SR1 3EX
Box Office: 0870 6021130
Stage Door: 0191-566 1057
Admin: 0191-566 1040

SWANAGE
Mowlem Theatre
Shore Road, Swanage BH19 1DD
Box Office: 01929 422239
Stage Door: ------------------
Admin: 01929 422229

TAMWORTH
Assembly Rooms
Corporation Street, Tamworth B79 7BX
Box Office: 01827 709618
Stage Door: ------------------
Admin: 01827 709620

TEWKESBURY
The Roses
Sun Street
Tewkesbury GL20 5NX
Box Office: 01684 295074
Stage Door: ------------------
Admin: 01684 290734
e-mail: admin@rosestheatre.org

TORQUAY
Babbacombe Theatre
Babbacombe Downs
Torquay TQ1 3LU
Box Office: 01803 328385
Stage Door: 01803 328385
Admin: 01803 322233
Website: www.babbacombe-theatre.com
e-mail: mail@matpro-show.biz

TORQUAY
Princess Theatre
Torbay Road
Torquay TQ2 5EZ
Box Office: 0870 2414120
Stage Door: 01803 290068
Admin: 01803 290288
Website: www.livenation.co.uk/torquay

TRURO
Hall For Cornwall
Back Quay, Truro, Cornwall TR1 2LL
Box Office: 01872 262466
Stage Door: 01872 262465
Admin: 01872 262465
Website: www.hallforcornwall.co.uk
e-mail: admin@hallforcornwall.org.uk

WINCHESTER
Theatre Royal
21-23 Jewry Street, Winchester SO23 8SB
Box Office: 01962 840440
Stage Door: ------------------
Admin: 01962 844600
e-mail: marketing@theatre-royal-winchester.co.uk

WOLVERHAMPTON
Grand Theatre
Lichfield Street, Wolverhampton WV1 1DE
Box Office: 01902 429212
Stage Door: 01902 573320
Admin: 01902 573300
Website: www.grandtheatre.co.uk
e-mail: marketing@grandtheatre.co.uk

WORCESTER
Swan Theatre
The Moors, Worcester WR1 3EF
Box Office: 01905 611427
Stage Door: ------------------
Admin: 01905 726969
Website: www.huntingdonarts.com
e-mail: chris@huntingdonarts.com

WORTHING
Connaught Theatre
Union Place, Worthing BN11 1LG
Box Office: 01903 206206
Stage Door: ------------------
Admin: 01903 231799
Website: www.worthingtheatres.co.uk

YEOVIL
Octagon Theatre
Hendford, Yeovil BA20 1UX
Box Office: 01935 422884
Stage Door: ------------------
Admin: 01935 845900
Website: www.octagon-theatre.co.uk
e-mail: octagontheatre@southsomerset.gov.uk

YORK
Grand Opera House
Cumberland Street, York YO1 9SW
Box Office: 0870 6063595
Stage Door: ------------------
Admin: 01904 678700
Website: www.livenation.co.uk/york

AUTHENTIC PUNCH & JUDY
(Puppets, Booths & Presentations) (John Styles)
42 Christchurch Road
Sidcup
Kent DA15 7HQ
Website: www.johnstylesentertainer.co.uk
Tel/Fax: 020-8300 3579

BUCKLEY Simon
(Freelance Puppeteer/Presenter)
12 College Green
55-57 Barrington Road
London SW9 7JG
Website: www.simonbuckley.co.uk
e-mail: puppet.buckley@virgin.net Mobile: 07976 290351

COMPLETE WORKS CREATIVE COMPANY Ltd The
(Artistic Director: Phil Evans)
The Old Truman Brewery
91 Brick Lane
London E1 6QL
Website: www.tcw.org.uk
e-mail: info@tcw.org.uk
Fax: 0870 1431979 Tel: 0870 1431969

CORNELIUS & JONES
49 Carters Close
Sherington
Newport Pagnell
Buckinghamshire MK16 9NW
Website: www.corneliusjones.com
e-mail: admin@corneliusjones.com
Tel/Fax: 01908 612593

DYNAMIC NEW ANIMATION
Unit 13, The Watermark
Ribbleton Lane
Preston PR1 5EZ
Website: www.dynamicnewanimation.co.uk
e-mail: info@dynamicnewanimation.co.uk
Mobile: 07976 946003 Tel: 01772 253100

GRIFFITHS Marc
(Ventriloquist & Motivational Speaker)
The Mega Centre
Bernard Road
Sheffield S2 5BQ
Website: www.mega-u.com Tel: 0114-284 6007

INDIGO MOON THEATRE
35 Waltham Court
Beverley
East Yorkshire HU17 9JF
Website: www.indigomoontheatre.com
e-mail: info@indigomoontheatre.com Mobile: 07855 328552

JACOLLY PUPPET THEATRE
Kirkella Road
Yelverton
West Devon PL20 6BB
Website: www.jacolly-puppets.co.uk
e-mail: theatre@jacolly-puppets.co.uk Tel: 01822 852346

LITTLE ANGEL THEATRE
14 Dagmar Passage
Cross Street
London N1 2DN
Website: www.littleangeltheatre.com
e-mail: info@littleangeltheatre.com Tel: 020-7226 1787

MAJOR MUSTARD'S TRAVELLING SHOW
1 Carless Avenue
Harborne
Birmingham B17 9EG
e-mail: mm@majormustard.com
Fax: 0121-427 2358 Tel: 0121-426 4329

NORWICH PUPPET THEATRE
St James, Whitefriars
Norwich NR3 1TN
Website: www.puppettheatre.co.uk
e-mail: info@puppettheatre.co.uk
Fax: 01603 617578 Tel: 01603 615564

PEKKO'S PUPPETS
(Director: Stephen Novy)
92 Stanley Avenue
Greenford, Middlesex UB6 8NP Tel: 020-8575 2311

PICCOLO PUPPET COMPANY
Maythorne Higher Park Road
Braunton
North Devon EX33 2LF
e-mail: flychek@yahoo.co.uk Tel: 01271 815984

PLAYBOARD PUPPETS
2 Ockenden Mews
London N1 3JL
Website: www.buttonmoon.tv
e-mail: thebuttonmoon@aol.com Tel/Fax: 020-7226 5911

POM POM PUPPETS
9 Fulham Park Gardens
London SW6 4JX
Website: www.pompompuppets.co.uk
Mobile: 07974 175247 Tel: 020-7736 6532

PROFESSOR PATTEN'S PUNCH & JUDY
(Puppetry & Magic)
14 The Crest
Goffs Oak
Herts EN7 5NP
Website: www.dennispatten.co.uk Tel: 01707 873262

TALK TO THE HAND PRODUCTIONS
Studio 268
Wimbledon Art Studios
Riverside Yard, Riverside Road
Earlsfield, London SW17 0BB
Website: www.talktothehandproductions.com
e-mail: info@talktothehandproductions.com
Mobile: 07813 682293 Mobile: 07855 421454

THEATR BYPEDAU SBLOT (Splott Puppet Theatre)
22 Starling Road
St Athan, Vale of Glamorgan CF62 4NJ
e-mail: splottpuppets@aol.com Tel: 01446 790634

TICKLISH ALLSORTS SHOW
57 Victoria Road, Wilton
Salisbury
Wiltshire SP2 0DZ
Website: www.ticklishallsorts.co.uk
e-mail: garynunn@ntlworld.com Tel/Fax: 01722 744949

TOPPER Chris PUPPETS
(Puppets Created & Performed)
75 Barrows Green Lane
Widnes, Cheshire WA8 3JH
Website: www.christopperpuppets.co.uk
e-mail: christopper@ntlworld.com Tel: 0151-424 8692

ALDEBURGH
Summer Theatre (July & August) The Jubilee Hall
Crabbe Street, Aldeburgh IP15 5BW
BO: 01728 453007/454022　Admin: (Oct-May) 020-7724 5432
　　　　　　　　　　　　　Admin: (June-Sept) 01502 723077
Website: www.southwoldtheatre.org

BASINGSTOKE
Haymarket Theatre Company
Wote Street, Basingstoke RG21 7NW
Fax: 01256 357130
BO: 01256 465566　　　　　　　Admin: 0870 7701029
Website: www.haymarket.org.uk
e-mail: info@haymarket.org.uk
Artistic Director: John Adams
Chief Executive: Elizabeth Jones

BELFAST
Lyric Theatre
55 Ridgeway Street, Belfast BT9 5FB
Fax: 028-9038 1395
BO: 028-9038 1081　　　　　　Admin: 028-9038 5685
Website: www.lyrictheatre.co.uk
e-mail: info@lyrictheatre.co.uk
Artistic Director: Paula McFetridge
Production Manager: Marianne Crossle
Administration Manager: Clare Gault

BIRMINGHAM
Birmingham Stage Company
The Old Rep Theatre, Station Street, Birmingham B5 4DY
BO: 0121-303 2323　　　　　　Admin: 0121-643 9050
Website: www.birminghamstage.net
e-mail: info@birminghamstage.net
Actor/Manager: Neal Foster
Administrator: Philip Compton

London Office:
Suite 228 The Linen Hall
162 Regent Street, London W1B 5TG
Fax: 020-7437 3395　　　　　　Admin: 020-7437 3391

BIRMINGHAM
Repertory Theatre
Centenary Square, Broad Street, Birmingham B1 2EP
Press Office: 0121-245 2075
BO: 0121-236 4455　　　　　　Tel: 0121-245 2000
e-mail: info@birmingham-rep.co.uk
Artistic Director: Rachel Kavanaugh
Executive Director: Stuart Rogers
Casting Director: Hannah Miller

BOLTON
Octagon Theatre
Howell Croft South, Bolton BL1 1SB
Fax: 01204 556502
BO: 01204 520661　　　　　　Admin: 01204 529407
Artistic Director: Mark Babych
Executive Director: John Blackmore
Head of Administration: Lesley Etherington
Head of Production: Paul Sheard

BRISTOL
Theatre Royal and Studio
(3/4 Weekly) Eves 7.30pm Thurs & Sat Mats 2.00pm
Bristol Old Vic, King Street, Bristol BS1 4ED
Fax: 0117-949 3996
BO: 0117-987 7877　　　　　　Tel: 0117-949 3993
Website: www.bristol-old-vic.co.uk
e-mail: admin@bristol-old-vic.co.uk
Artistic Director: Simon Reade
Administrative Director: Rebecca Morland

BROMLEY
Churchill Theatre
High Street, Bromley, Kent BR1 1HA
Fax: 020-8290 6968
BO: 0870 0606620　　　　　　Tel: 020-8464 7131
Website: www.churchilltheatre.co.uk
Chief Executive: Derek Nicholls
Operations Manager: Christopher Glover
Production Manager: Digby Robinson
Financial Controller: Liz Gentry

CARDIFF
Sherman Theatre
Senghennydd Road CF24 4YE
Fax: 029-2064 6902
BO: 029-2064 6900　　　　　　Tel: 029-2064 6901
Director: Phil Clark
General Manager: Margaret Jones

CHELMSFORD
Civic Theatre
(2 Weekly) (Nov-Feb)
Fairfield Road, Chelmsford, Essex CM1 1JG
Admin: 01245 268998　　　　Tel: 020-8349 0802 (London)
Artistic Director: John Newman (Newpalm Prods)

CHICHESTER
Chichester Festival Theatre
(May-Oct & Touring) Eves 7.30pm Thurs & Sat Mats 2.30pm
Oaklands Park, Chichester, West Sussex PO19 6AP
Fax: 01243 787288
BO: 01243 781312　　　　　　SD & Admin: 01243 784437
Website: www.cft.org.uk
e-mail: admin@cft.org.uk
Theatre Manager: Janet Bakose
Artistic Director: Jonathan Church

CHICHESTER
Minerva Theatre at Chichester Festival Theatre
Oaklands Park, Chichester, West Sussex PO19 6AP
Fax: 01243 787288
BO: 01243 781312　　　　　　SD & Admin: 01243 784437
Website: www.cft.org.uk
e-mail: admin@cft.org.uk
Theatre Manager: Janet Bakose
Artistic Director: Jonathan Church

COLCHESTER
Mercury Theatre
Balkerne Gate, Colchester, Essex CO1 1PT
Fax: 01206 769607
BO: 01206 573948　　　　　　Admin: 01206 577006
Website: www.mercurytheatre.co.uk
e-mail: info@mercurytheatre.co.uk
Chief Executive: Dee Evans
General Manager: Adrian Grady

COVENTRY
Belgrade Theatre & Belgrade Studio
Belgrade Square, Coventry, West Midlands CV1 1GS
BO: 024-7655 3055　　　　　　Admin: 024-7625 6431
Website: www.belgrade.co.uk
e-mail: admin@belgrade.co.uk
Theatre Director & Chief Executive: Hamish Glen
Special Projects Producer Freelance: Jane Hytch
Executive Director: Joanna Reid
Director of Marketing: Antony Flint

DERBY
Derby Playhouse
(4 Weekly)
Theatre Walk, Eagle Centre, Derby DE1 2NF
Fax: 01332 547200
BO: 01332 363275　　　　　　SD/Admin: 01332 363271
Website: www.derbyplayhouse.co.uk
e-mail: admin@derbyplayhouse.co.uk
Creative Producer: Stephen Edwards
Chief Executive: Karen Hebden

DUBLIN
Abbey Theatre & Peacock Theatre
The National Theatre Society Limited
26 Lower Abbey Street, Dublin 1, Eire
Fax: 00 353 1 872 9177
BO: 00 353 1 878 7222 Admin: 00 353 1 887 2200
Website: www.abbeytheatre.ie
e-mail: mail@abbeytheatre.ie
Artistic Director: Fiach MacConghail

DUNDEE
Dundee Repertory Theatre
Tay Square, Dundee DD1 1PB
Fax: 01382 228609
BO: 01382 223530 Admin: 01382 227684
Website: www.dundeereptheatre.co.uk
Artistic Directors: James Brining, Dominic Hill
Executive Director: Lorna Duguid

EDINBURGH
Royal Lyceum Theatre Company
30B Grindlay Street, Edinburgh EH3 9AX
Fax: 0131-228 3955
BO: 0131-248 4848 SD & Admin: 0131-248 4800
Website: www.lyceum.org.uk
e-mail: info@lyceum.org.uk
Artistic Director: Mark Thomson

EDINBURGH
Traverse Theatre
(New Writing, Own Productions, Touring & Visiting
Companies)
10 Cambridge Street
Edinburgh EH1 2ED
Fax: 0131-229 8443
BO: 0131-228 1404 Admin: 0131-228 3223
Website: www.traverse.co.uk
e-mail: admin@traverse.co.uk
Artistic Director: Philip Howard
Administrative Director: Mike Griffiths

EXETER
Northcott Theatre
(3/4 Weekly)
Stocker Road, Exeter, Devon EX4 4QB
Fax: 01392 223996
BO: 01392 493493 Admin: 01392 223999
Website: www.northcott-theatre.co.uk
Artistic Director: Ben Crocker
Executive Director: Shea Connolly

EYE THEATRE
Eye Theatre
(4 Weekly) Sat 4.00pm
Broad Street, Eye, Suffolk IP23 7AF
Fax: 01379 871142 Tel: 01379 870519
e-mail: tomscott@eyetheatre.freeserve.co.uk
Artistic Director: Tom Scott
Associate Director: Janeena Sims

FRINTON
Frinton Summer Theatre
(July-Sept)
7 Garden Court, The Esplanade, Frinton on Sea CO13 9DR
BO: 01255 674443 (July-Sept Only) Mobile: 07977 256201
Producer and Artistic Director: Edward Max

GLASGOW
Citizens Theatre
Gorbals, Glasgow G5 9DS
Fax: 0141-429 7374
BO: 0141-429 0022 Admin: 0141-429 5561
Website: www.citz.co.uk
e-mail: info@citz.co.uk
Artistic Directors: Jeremy Raison, Guy Hollands
General Manager: Anna Stapleton

GUILDFORD
Yvonne Arnaud Theatre
Millbrook, Guildford, Surrey GU1 3UX
Fax: 01483 564071
BO: 01483 440000　　　　Admin: 01483 440077
Website: www.yvonne-arnaud.co.uk
e-mail: yat@yvonne-arnaud.co.uk
Director: James Barber

HARROGATE
Harrogate Theatre
(3-4 weekly) 2.30pm Sat
Oxford Street, Harrogate HG1 1QF
Fax: 01423 563205
BO: 01423 502116　　　　Admin: 01423 502710
e-mail: christianname.surname@harrogatetheatre.co.uk
Chief Executive: David Bown

HULL
Hull Truck Theatre
Spring Street, Hull HU2 8RW
Fax: 01482 581182　　　　Tel: 01482 224800
Website: www.hulltruck.co.uk
e-mail: admin@hulltruck.co.uk
Artistic Director: John Godber
Executive Director: Joanne Gower
Associate Artistic Director: Gareth Tudor Price

IPSWICH
The New Wolsey Theatre
Civic Drive, Ipswich, Suffolk IP1 2AS
Admin Fax: 01473 295910
BO: 01473 295900　　　　Admin: 01473 295911
Website: www.wolseytheatre.co.uk
e-mail: info@wolseytheatre.co.uk
Artistic Director: Peter Rowe
Chief Executive: Sarah Holmes

KESWICK
Theatre by the Lake
Lakeside, Keswick, Cumbria CA12 5DJ
Fax: 017687 74698
BO: 017687 74411　　　　Admin: 017687 72282
Website: www.theatrebythelake.com
e-mail: enquiries@theatrebythelake.com
Artistic Director: Ian Forrest

LANCASTER
The Dukes
Moor Lane, Lancaster, Lancashire LA1 1QE
Fax: 01524 598519
BO: 01524 598500　　　　Admin: 01524 598505
Website: www.dukes-lancaster.org
e-mail: info@dukes-lancaster.org
Artistic Director: Ian Hastings
Chief Executive: Amanda Belcham

LEEDS
The West Yorkshire Playhouse
Playhouse Square, Quarry Hill, Leeds LS2 7UP
Fax: 0113-213 7250
BO: 0113-213 7700　　　　Admin: 0113-213 7800
Website: www.wyp.org.uk
Artistic Director (Chief Executive): Ian Brown
Executive Director: Lesley Jackson
Producer: Henrietta Duckworth

LEICESTER
Leicester Haymarket Theatre & Studio
Belgrave Gate, Leicester LE1 3YQ
Fax: 0116-251 3310
BO: 0870 3303131　　　　Admin: 0116-253 0021
Website: www.lhtheatre.co.uk
e-mail: enquiry@lhtheatre.co.uk
Artistic Director: Paul Kerryson, Kully Thiarai
Chief Executive: Maggie Saxon

LIVERPOOL
Everyman & Playhouse Theatres
Everyman: 13 Hope Street
Liverpool L1 9BH
Playhouse: Williamson Square, Liverpool L1 1EL
Fax: 0151-709 0398
BO: 0151-709 4776　　　　Admin: 0151-708 0338
Website: www.everymanplayhouse.com
e-mail: reception@everymanplayhouse.com
Artistic Director: Gemma Bodinetz
Executive Director: Deborah Aydon

MANCHESTER
Contact Theatre Company
Oxford Road, Manchester M15 6JA
Fax: 0161-274 0640
BO: 0161-274 0600　　　　Admin: 0161-274 0623
Website: www.contact-theatre.org
e-mail: info@contact-theatre.org.uk
Chief Executive/Artistic Director: John Edward McGrath

MANCHESTER
Library Theatre Company
St Peter's Square
Manchester M2 5PD
Fax: 0161-228 6481
BO: 0161-236 7110　　　　Admin: 0161-234 1913
Website: www.librarytheatre.com
e-mail: ltcadmin@manchester.gov.uk
Artistic Director: Chris Honer
General Manager: Adrian J. P. Morgan

MANCHESTER
Royal Exchange Theatre
St Ann's Square, Manchester M2 7DH
Fax: 0161-832 0881
BO: 0161-833 9833　　　　SD & Admin: 0161-833 9333
Website: www.royalexchange.co.uk
Artistic Directors: Braham Murray, Gregory Hersov
Executive Director: Patricia Weller
Associate Artistic Directors: Sarah Frankcom, Jacob Murray
Producer (Studio): Richard Morgan
Casting Director: Jerry Knight-Smith
Director of Finance and Administration: Barry James

MILFORD HAVEN
Torch Theatre
St Peter's Road, Milford Haven
Pembrokeshire SA73 2BU
Fax: 01646 698919
BO: 01646 695267　　　　Admin: 01646 694192
Website: www.torchtheatre.org.uk
e-mail: info@torchtheatre.co.uk
Artistic Director: Peter Doran

MOLD
Clwyd Theatr Cymru
(Repertoire, 4 Weekly, also touring)
Mold, Flintshire, North Wales CH7 1YA
Fax: 01352 701558
BO: 0845 3303565　　　　Admin: 01352 756331
Website: www.clwyd-theatr-cymru.co.uk
e-mail: drama@celtic.co.uk

MUSSELBURGH
The Brunton Theatre
(Annual programme of Theatre, Dance, Music, Comedy &
Children's Work)
Ladywell Way
Musselburgh EH21 6AA
Fax: 0131-665 3665
BO: 0131-665 2240　　　　Admin: 0131-665 9900
General Manager: Lesley Smith

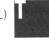

NEWBURY
Watermill Theatre
(4-7 Weekly) (Feb-Jan)
Bagnor, Nr Newbury, Berkshire RG20 8AE
Fax: 01635 523726
BO: 01635 46044
SD: 01635 44532 Admin: 01635 45834
Website: www.watermill.org.uk
e-mail: admin@watermill.org.uk
Executive Director: James Sargant
General Manager: Clare Lindsay

NEWCASTLE UPON TYNE
Northern Stage (Theatrical Productions) Ltd
Barras Bridge
Newcastle upon Tyne NE1 7RH
Fax: 0191-261 8093
BO: 0191-230 5151 Admin: 0191-232 3366
Website: www.northernstage.co.uk
e-mail: info@northernstage.co.uk
Chief Executive: Erica Whyman

NEWCASTLE-UNDER-LYME
New Vic Theatre
(3-4 Weekly)
Theatre in the Round, Etruria Road
Newcastle-under-Lyme
Staffordshire ST5 0JG
Fax: 01782 712885
BO: 01782 717962 Tel: 01782 717954
Website: www.newvictheatre.org.uk
e-mail: casting@newvictheatre.org.uk
Artistic Director: Theresa Heskins
General Manager: Nick Jones

NORTHAMPTON
Royal & Derngate Theatres
Guildhall Road, Northampton
Northamptonshire NN1 1DP
TIE: 01604 655740
BO: 01604 624811 Admin: 01604 626222
Chief Executive: Donna Mundy
Artistic Director: Rupert Goold
Associate Director: Simon Godwin

NOTTINGHAM
Nottingham Playhouse
(3/4 Weekly)
(Nottingham Playhouse Trust Ltd)
Wellington Circus, Nottingham NG1 5AF
Fax: 0115-947 5759
BO: 0115-941 9419 Admin: 0115-947 4361
Website: www.nottinghamplayhouse.co.uk
Chief Executive: Stephanie Sirr
Artistic Director: Giles Croft
Roundabout TIE Director: Andrew Breakwell

OLDHAM
Coliseum Theatre
(3-4 Weekly)
Fairbottom Street
Oldham, Lancashire OL1 3SW
Fax: 0161-624 5318
BO: 0161-624 2829 Admin: 0161-624 1731
Website: www.coliseum.org.uk
e-mail: mail@coliseum.org.uk
Chief Executive: Kevin Shaw

PERTH
Perth Repertory Theatre
(2-3 Weekly)
185 High Street, Perth PH1 5UW
Fax: 01738 624576
Admin: 01738 472700 BO: 01738 621031
Website: www.horsecross.co.uk
e-mail: info@horsecross.co.uk
Artistic Directors: Graham McLaren, Ian Grieve
Head of Planning & Resources: Paul Hackett
Chief Executive: Jane Spiers

PETERBOROUGH
Key Theatre
(Touring & Occasional Seasonal)
Embankment Road
Peterborough
Cambridgeshire PE1 1EF
Fax: 01733 567025
BO: 01733 552439 Admin: 01733 552437
e-mail: michael.cross@peterborough.gov.uk

PITLOCHRY
Pitlochry Festival Theatre
Pitlochry
Perthshire PH16 5DR
Fax: 01796 484616
Admin: 01796 484600 BO: 01796 484626
Website: www.pitlochry.org.uk
e-mail: admin@pitlochry.org.uk
Chief Executive: Nikki Axford
Artistic Director: John Durnin

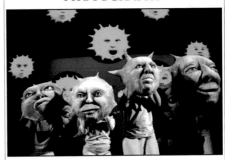

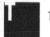

PLYMOUTH
Theatre Royal & Drum Theatre
Royal Parade, Plymouth, Devon PL1 2TR
Fax: 01752 671179 Admin: 01752 668282
Website: www.theatreroyal.com
e-mail: s.stokes@theatreroyal.com
Artistic Director: Simon Stokes
Chief Executive: Adrian Vinken

SALISBURY
Playhouse & Salberg Studio
(3-4 Weekly)
Malthouse Lane, Salisbury, Wiltshire SP2 7RA
Fax: 01722 421991
BO: 01722 320333 Admin: 01722 320117
Website: www.salisburyplayhouse.com
e-mail: info@salisburyplayhouse.com
Artistic Director: Joanna Read

SCARBOROUGH
Stephen Joseph Theatre
(Repertoire/Repertory)
Westborough, Scarborough, North Yorkshire YO11 1JW
Fax: 01723 360506
BO: 01723 370541
SD: 01723 507047 Admin: 01723 370540
e-mail: enquiries@sjt.uk.com
Artistic Director: Alan Ayckbourn
Executive Director: Stephen Wood

SHEFFIELD
Crucible, Studio & Lyceum Theatres
55 Norfolk Street, Sheffield S1 1DA
Fax: 0114-249 6003
BO: 0114-249 6000 Admin: 0114-249 5999
Website: www.sheffieldtheatres.co.uk
e-mail: initial.surname@sheffieldtheatres.co.uk
Artistic Director: Samuel West
Chief Executive: Angela Galvin

SHERINGHAM
Summer Repertory
The Little Theatre, 2 Station Road
Sheringham, Norfolk NR26 8RE BO: 01263 822347
Website: www.sheringhamlittletheatre.com
e-mail: enquiries@sheringhamlittletheatre.com
Producer: Sheringham Little Theatre
Artistic Director: Debbie Thompson

SIDMOUTH
Manor Pavilion Theatre
(Weekly) (July-Sept)
Manor Road, Sidmouth, Devon EX10 8RP
BO: 01395 579977 (Season Only)
 Tel: 020-7636 4343 Charles Vance

SONNING THEATRE
The Mill at Sonning Theatre
(5-6 Weekly)
Sonning Eye, Reading RG4 6TY
SD: 0118-969 5201
BO: 0118-969 8000 Admin: 0118-969 6039
Artistic Director: Sally Hughes
Assistant Administrator: Ann Seymour

SOUTHAMPTON
Nuffield Theatre
(Sept-July, Sunday Night Concerts, Occasional Tours)
University Road, Southampton SO17 1TR
Fax: 023-8031 5511
BO: 023-8067 1771 Admin: 023-8031 5500
Website: www.nuffieldtheatre.co.uk
Artistic Director: Patrick Sandford
Administrative Director: Kate Anderson

SOUTHWOLD
Summer Theatre
(July-Sept)
St Edmund's Hall
Cumberland Road, Southwold IP18 6JP
 Admin: (Oct-May) 020-7724 5432
 Admin: (June-Sept) 01502 723077
Website: www.southwoldtheatre.org
e-mail: jill@southwoldtheatre.org
Producer: Jill Freud & Company

ST ANDREWS
Byre Theatre
Abbey Street, St Andrews KY16 9LA
Fax: 01334 475370
BO: 01334 475000 Admin: 01334 476288
Website: www.byretheatre.com
e-mail: enquiries@byretheatre.com
Artistic Director: Stephen Wrentmore
Managing Director: Tom Gardner

STRATFORD-UPON-AVON
Swan Theatre, Royal Shakespeare Theatre
& Courtyard Theatre
Waterside, Stratford-upon-Avon CV37 6BB
Fax: 01789 294810
BO: 0870 6091110 Admin: 01789 296655
Website: www.rsc.org.uk
e-mail: info@rsc.org.uk

WATFORD
Watford Palace Theatre
(3-4 Weekly) Weds 2.30pm, Sat 3pm
Clarendon Road
Watford, Herts WD17 1JZ
Fax: 01923 819664
BO: 01923 225671 Admin: 01923 235455
Website: www.watfordpalacetheatre.co.uk
e-mail: enquiries@watfordpalacetheatre.co.uk
Artistic Director: Birgid Larmour

WINDSOR
Theatre Royal
(2-3 Weekly) (Thurs 2.30pm Sat 4.45pm)
Thames Street
Windsor, Berkshire SL4 1PS
Fax: 01753 831673
BO: 01753 853888 Admin/SD: 01753 863444
Website: www.theatreroyalwindsor.co.uk
e-mail: info@theatreroyalwindsor.co.uk
Executive Director: Mark Piper

WOKING
New Victoria Theatre, The Ambassadors
Peacocks Centre
Woking GU21 6GQ
SD: 01483 545855
BO: 01483 545900 Admin: 01483 545800
Website: www.theambassadors.com/woking
e-mail: boxoffice@theambassadors.com

YORK
Theatre Royal
St Leonard's Place, York YO1 7HD
Fax: 01904 550164
BO: 01904 623568 Admin: 01904 658162
Website: www.yorktheatreroyal.co.uk
e-mail: admin@yorktheatreroyal.co.uk
Artistic Director: Damian Cruden
Chief Executive: Daniel Bates

ACTION CARS Ltd
(Steven Royffe)
Room 586, East Side Complex
Pinewood Studios
Pinewood Road
Iver Heath, Bucks SL0 0NH
Website: www.actioncars.co,uk
e-mail: info@actioncars.co.uk
Fax: 01753 652027 Tel: 01753 785690

AMERICAN DREAMS
47 Wilsons Lane
Mark's Tey, Essex CO6 1HP
Website: www.americandreams.co.uk
e-mail: tphj47@aol.com Tel: 01255 479534

ANCHOR MARINE FILM & TELEVISION
(Boat Location, Charter, Marine Co-ordinators)
Spike Mead Farm
Poles Lane, Lowfield Heath
West Sussex RH11 0PX
e-mail: amsfilms@aol.com
Fax: 01293 551558 Tel: 01293 538188

ANGLO PACIFIC INTERNATIONAL Plc
(Freight Forwarders to the Performing Arts)
Unit 1 Bush Industrial Estate, Standard Road
North Acton, London NW10 6DF
Website: www.anglopacific.co.uk
e-mail: info@anglopacific.co.uk
Fax: 020-8965 4945 Tel: 020-8965 1234

AUTOMOTIVE ACTION
(Suppliers of H1 Hummers)
2 Sheffield House
Park Road, Hampton Hill
Middlesex TW12 1HA
Website: www.carstunts.co.uk
e-mail: carstunts@hotmail.co.uk
Mobile: 07974 919589 Tel: 020-8977 6186

BIANCHI AVIATION FILM SERVICES
(Historic & Other Aircraft)
Wycombe Air Park, Booker
Nr Marlow, Buckinghamshire SL7 3DP
Website: www.bianchiaviation.com
e-mail: info@bianchiaviation.com
Fax: 01494 461236 Tel: 01494 449810

BLUEBELL RAILWAY Plc
(Steam Locomotives, Pullman Coaches, Period Stations.
Much Film Experience)
Sheffield Park Station
East Sussex TN22 3QL
Website: www.bluebell-railway.co.uk
Fax: 01825 720804 Tel: 01825 720800

BRUNEL'S THEATRICAL SERVICES
Unit 4, Crown Industrial Estate
Crown Road, Warmley
Bristol BS30 8JB
e-mail: info@brunels.co.uk
Fax: 0117-907 7856 Tel: 0117-907 7855

CARLINE & CREW TRANSPORTATION
(Celebrity Services)
12A Bridge Industrial Estate
Balcombe Road
West Sussex RH6 9HU
Website: www.carlineprivatehire.co.uk
e-mail: carlinehire@btconnect.com
Fax: 01293 400508 Tel: 01293 400505

CLASSIC CAR AGENCY The
(Film, Promotional, Advertising, Publicity)
PO Box 427
Dorking
Surrey RH5 6WP
Website: www.theclassiccaragency.com
e-mail: theclassiccaragency@btopenworld.com
Mobile: 07788 977655 Tel: 01306 731052

CLASSIC CAR HIRE
(Classic & Vintage Cars including 1927 Rolls Royce Phantom 1)
Unit 2 Hampton Court Estate
Summer Road
Thames Ditton KT7 0RG
Website: www.classic-hire.com
e-mail: info@classic-hire.co.uk
Fax: 020-8398 9234 Tel: 020-8398 8304

CLASSIC OMNIBUS
(Vintage Open-Top Buses & Coaches)
44 Welson Road
Folkestone, Kent CT20 2NP
Website: www.opentopbus.co.uk
Fax: 01303 241245 Tel: 01303 248999

DEVEREUX DEVELOPMENTS Ltd
(Removals, Haulage, Trucking)
Daimler Drive
Cowpen Industrial Estate
Billingham
Cleveland TS23 4JD
e-mail: mike.bell@kdevereux.co.uk
Fax: 01642 566664 Tel: 01642 560854

DREAM DESTINATIONS
(Corporate & Stretch Limousines)
PO Box 6990
Mansfiled
Nottinghamshire NG19 9EW
Website: www.dreamdestinationsonline.co.uk
e-mail: info@dreamdestinationsonline.co.uk Tel: 0800 0191345

EST Ltd
(Trucking - Every Size & Country)
Marshgate Sidings
Marshgate Lane, London E15 2PB
Website: www.yourockweroll.com
e-mail: delr@est-uk.com
Fax: 020-8522 1002 Tel: 020-8522 1000

FELLOWES Mark TRANSPORT SERVICES
(Transport/Storage)
59 Sherbrooke Road
London SW6 7QL
Website: www.fellowesproductions.com
Mobile: 07850 332818 Tel: 020-7386 7005

FRANKIE'S YANKEES
(Classic 1950s American Cars, Memorabilia & New
Superstretch Limos)
283 Old Birmingham Road
Bromsgrove B60 1HQ Tel: 0121-445 5522

HOME JAMES CHAUFFEUR SERVICE
Moor Lane, Witton
Birmingham B6 7HH
Website: www.homejamescars.com
e-mail: julie.homejames@virgin.net Tel: 0121-323 4717

IMPACT
(Private & Contract Hire of Coaches)
1 Leighton Road
Ealing, London W13 9EL
Website: www.impactgroup.co.uk
e-mail: sales@impactgroup.co.uk
Fax: 020-8840 4880 Tel: 020-8579 9922

JASON'S
(Up-market Cruising Canal Wideboat, Daily Scheduled Trips
to Camden Lock) (3 Boats Available)
Opposite 60 Blomfield Road
Little Venice, London W9 2PD
Website: www.jasons.co.uk
e-mail: enquiries@jasons.co.uk
Fax: 020-7266 4332 Tel: 020-7286 3428

KEIGHLEY & WORTH VALLEY LIGHT RAILWAY Ltd
(Engines, Stations, Carriages, Props & Crew)
The Railway Station
Haworth, Keighley
West Yorkshire BD22 8NJ
Website: www.kwvr.co.uk
e-mail: admin@kwvr.co.uk
Fax: 01535 647317 Tel: 01535 645214

LUCKINGS
(Transporters/Storage/Stage Hands)
63 Kew Green
Richmond, Surrey TW9 3AH
Website: www.luckings.co.uk
e-mail: enquiries@luckings.co.uk
Fax: 020-8332 3000 Tel: 020-8332 2000

MAINSTREAM LEISURE GROUP
(Riverboat/Canal Boat Hire)
5 The Mews
6 Putney Common
London SW15 1HL
Website: www.mainstreamleisure.co.uk
Fax: 020-8788 0073 Tel: 020-8788 2669

McNEILL Brian
(Vintage Truck & Coaches)
Hawk Mount, Kebcote
Todmorden
Lancashire OL14 8SB
Website: www.rollingpast.com
e-mail: autotrans@uk2.net
Fax: 01706 812292 Tel: 01706 812291

MOTORHOUSE HIRE Ltd
(Period Vehicles 1900-80) (Michael Geary)
Weston Underwood, Olney
Buckinghamshire MK46 5LD
e-mail: michael@motorhouseltd.co.uk
Fax: 01234 240393 Tel: 020-7495 1618

M V DIXIE QUEEN
Thames Luxury Charters
5 The Mews
6 Putney Common
London SW15 1HL
Website: www.thamesluxurycharters.co.uk
e-mail: sales@thamesluxurycharters.co.uk
Fax: 020-8788 0072 Tel: 020-8780 1562

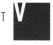

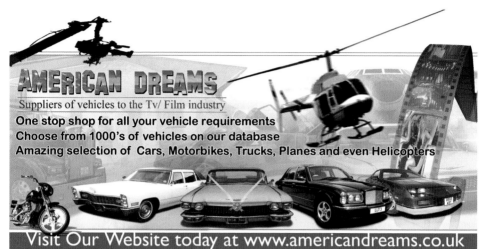

NATIONAL MOTOR MUSEUM
John Montagu Building, Beaulieu
Brockenhurst, Hampshire SO42 7ZN
Website: www.beaulieu.co.uk
e-mail: info@beaulieu.co.uk
Fax: 01590 612624 Tel: 01590 612345

NINE-NINE CARS Ltd
Hyde Meadow Farm, Hyde Lane
Hemel Hempstead HP3 8SA
e-mail: david@nineninecars.com Tel: 01923 266373

PICKFORDS REMOVALS Ltd
Heritage House, 345 Southbury Road
Enfield, Middlesex EN1 1UP
Website: www.pickfords.com
e-mail: enquiries@pickfords.com
Fax: 020-8219 8001 Tel: 020-8219 8000

PLUS FILM Ltd
(All Periods Vehicle Hire)
1 Mill House Cottages
Winchester Road
Bishop's Waltham SO32 1AH
e-mail: stephen@plusfilms7.freeserve.co.uk
Tel/Fax: 01489 895559

STOKE BRUERNE BOAT COMPANY Ltd
(Passenger & Commercial Boats)
29 Main Road, Shutlanger
Northamptonshire NN12 7RU
Website: www.stokebruerneboats.co.uk
Fax: 01604 864098 Tel: 01604 862107

THAMES LUXURY CHARTERS Ltd
5 The Mews
6 Putney Common, London SW15 1HL
Website: www.thamesluxurycharters.co.uk
e-mail: sales@thamesluxurycharters.co.uk
Fax: 020-8788 0072 Tel: 020-8780 1562

THE WAY TO GO LIMOUSINES
Queenshead Cottage, 43 The Street
Wittersham, Kent TN30 7EA
Website: www.thewaytogolimousines.co.uk
e-mail: twtg@aol.com
Fax: 01797 270190 Tel: 01797 270672

TOTAL LOGISTICS MANAGEMENT
(Close Proximity to Heathrow)
Unit 1
Lakeside Industrial Estate
Colnbrook
Berkshire SL3 0ED
Website: www.tlmltd.co.uk
e-mail: sales@tlmltd.co.uk
Fax: 01753 689004 Tel: 01753 689003

UK SAME DELIVERY SERVICE
(Philip Collings)
18 Billingshurst Road
Broadbridge Heath
West Sussex RH12 3LW
Fax: 01403 266059 Mobile: 07785 717179

VINTAGE CARRIAGES TRUST
(Owners of the Museum of Rail Travel at Ingrow Railway Centre)
Keighley
West Yorkshire BD22 8NJ
Website: www.vintagecarriagestrust.org
e-mail: admin@vintagecarriagestrust.org
Fax: 01535 610796 Tel: 01535 680425

ACCOMMODATION

Patricia Jones	255
Manor Guest House	256
Somerset Apartments	252
www.showdigs.co.uk	256

ACCOUNTANTS

Brebner, Allen, Trapp	57
Breckman & Company	163
Fisher Berger & Associates	20
Gordon Leighton	167
McGees Ltd	168
David Summers & Co	6
Vantis Plc	165

AGENTS

10 Twenty Two Casting	128
Academy Castings	9
Accelerate Productions Ltd	22
Act 1 Kidz	100
Activate	93
Juliet Adams Model & Talent Castings Agency	90
Agency Planitology	87
Allstars Casting	102
Alphabet Kidz	95
AMCK Management Ltd	52
Artist Management UK Ltd	76
Avenue Artistes Ltd	124
Baby Bodens	101
BizzyKidz Agency	94
Bodens Advanced	127
Bodens Agency	14, 90
The Michelle Bourne Academy & Agency	100
Byron's Management	34, 102
Carteurs Theatrical Agency	96
Casting Files	152
CBA International	14
CS Management	101
Culverhouse & James Ltd	109
Cutglass Voices	116
D & B Management	95
Direct Personal Management	24
DRB Entertainment Agency	28
Elite Casting	129
Elliott Agency	131
Ethnics Artiste Agency	30
Et-Nik-A, Prime Management & Castings Ltd	40
Euro Kids & Adults Ltd	93, 131

Expressions Casting Agency	94
Faces Casting Agency	130
Anna Fiorentini Theatre & Film School & Agency	99
Global Artists	29
GP Associates	103
Harris Personal Management	53
Hobson's	13
Icon Actors Management	52
I-mage Hospitality & Castings	38
Industry Casting	130
Jacob Dramatics Management	87
Jigsaw Arts Management	104
JK Dance Productions	105
The Joneses	119
K.M.C. Agencies	75
Sasha Leslie Management	98
Life & Soul Theatre Agency	96
Linton Management	96
Markham & Marsden	58
Billy Marsh Drama Ltd	60
NE Representation	81
Nemesis	127
Nidges	124
Northern Professionals	129
Nyland Management	60
Oriental Casting Agency Ltd	56
Orr Management Agency	9
Jackie Palmer Agency	93
P.C. Theatrical & Model Agency	58
Performers Theatre School	101
Personal Appearances	68
PLA	64
Pure Actors Agency	69
Rascals Model Agency	101
Real Talent Real People	18
Regency Agency	74, 128
Scallywags Agency	90
Smile Talent	54
Elisabeth Smith	94
Sole Kidz	191
Stagecoach Agency	97
Stageworks Worldwide Productions	62
Stardom Casting Agency	102
Stomp! Management	97
Success	80
Thames Valley Theatrical Agency	100
Thornton Agency	70
Truly Scrumptious	103
Tommy Tucker Agency	84
Tuesdays Child	99
Uni-versal Extras Ltd	129
Urban Talent	83

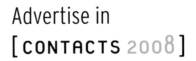
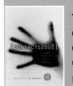

Notes

Notes

Notes

Notes

Notes